GW01043989

John Tapp.

Oct. 2023

Australia

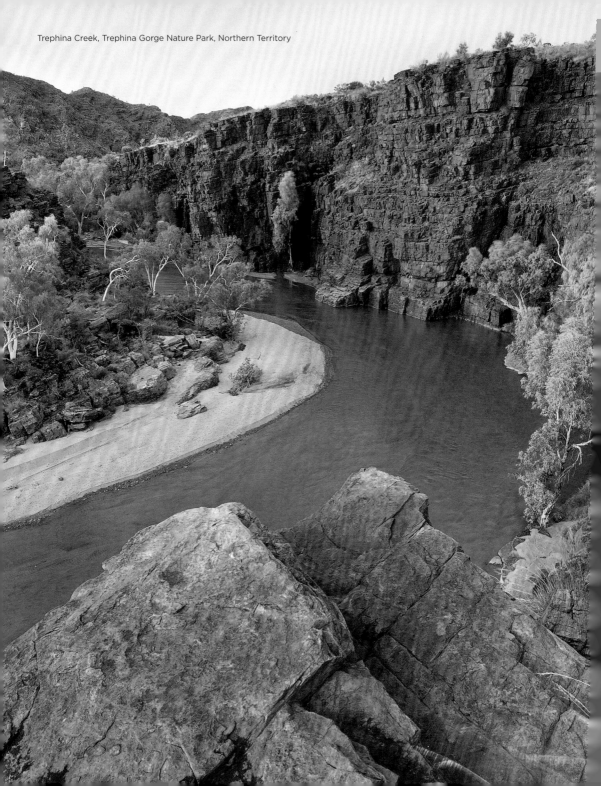
Trephina Creek, Trephina Gorge Nature Park, Northern Territory

Australia

Anthony Ham
Donna Wheeler

ÉDITIONS
PLACE DES
VICTOIRES

KÖNEMANN

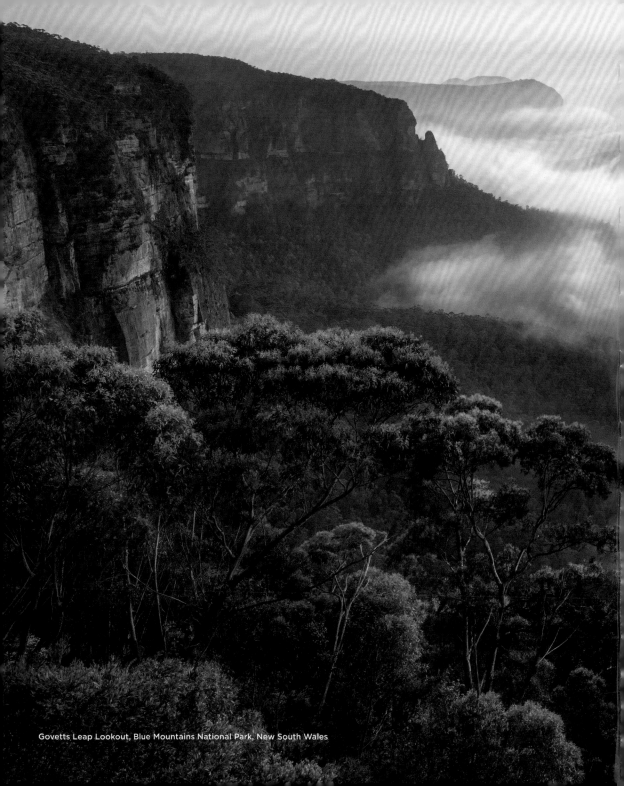

Govetts Leap Lookout, Blue Mountains National Park, New South Wales

Atherton Tablelands, Queensland

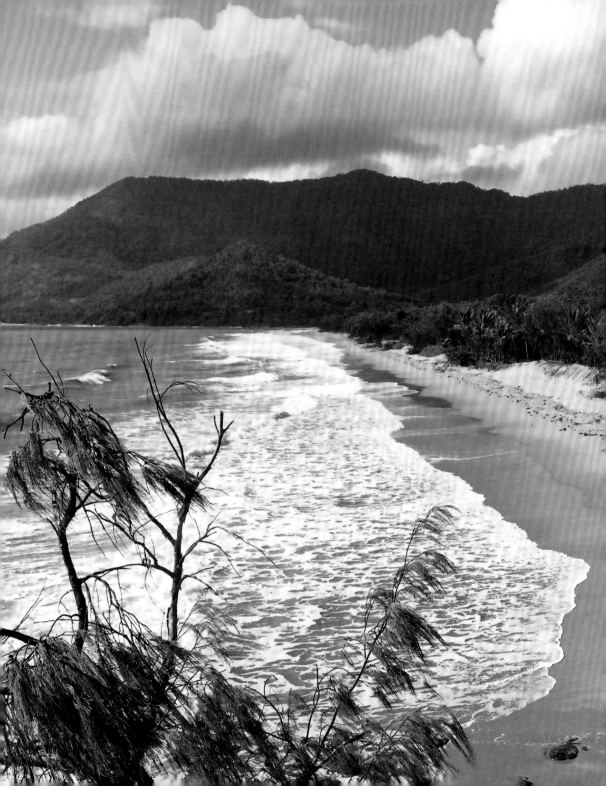

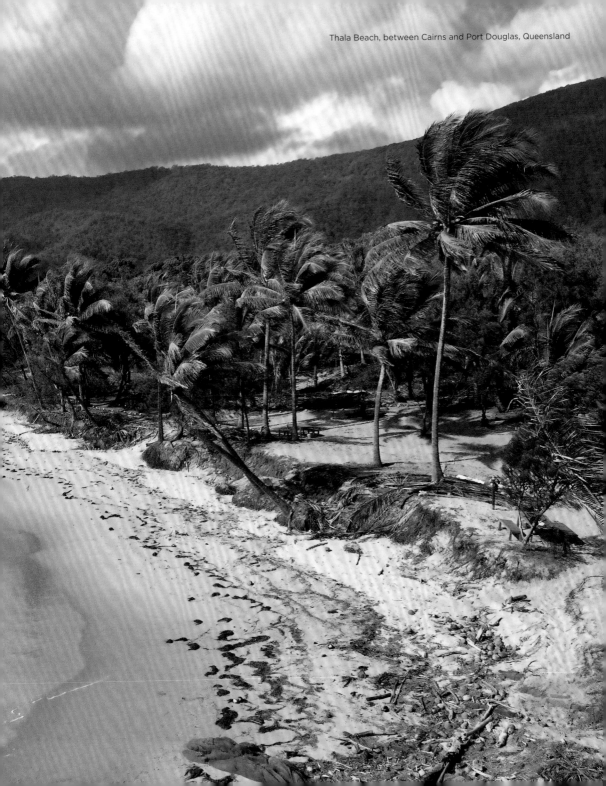
Thala Beach, between Cairns and Port Douglas, Queensland

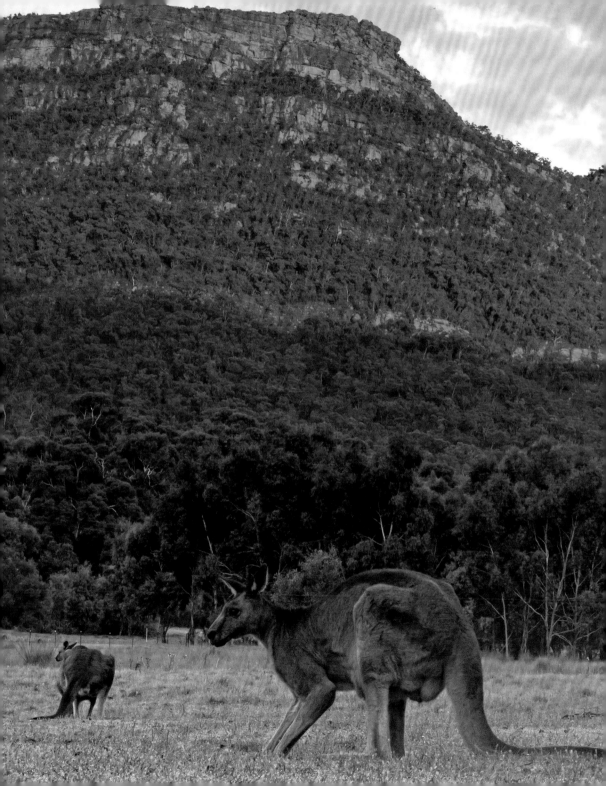

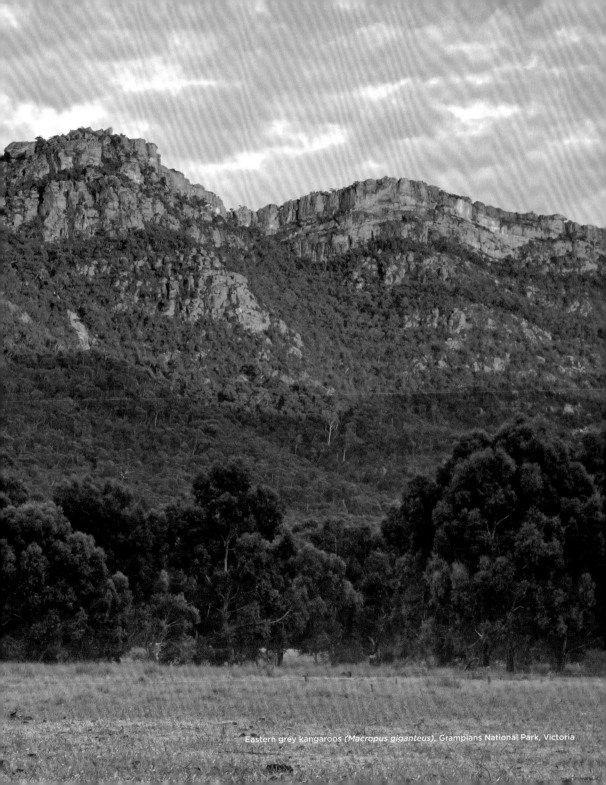

Eastern grey kangaroos *(Macropus giganteus)*, Grampians National Park, Victoria

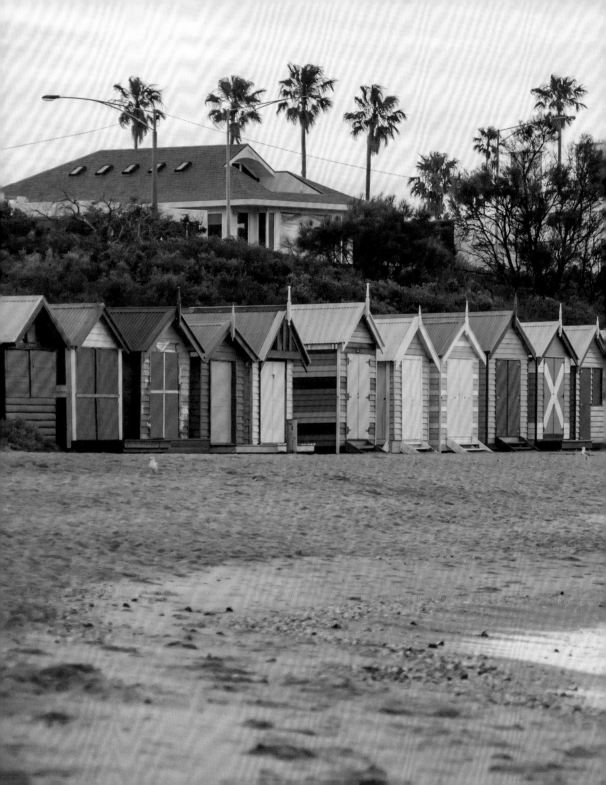

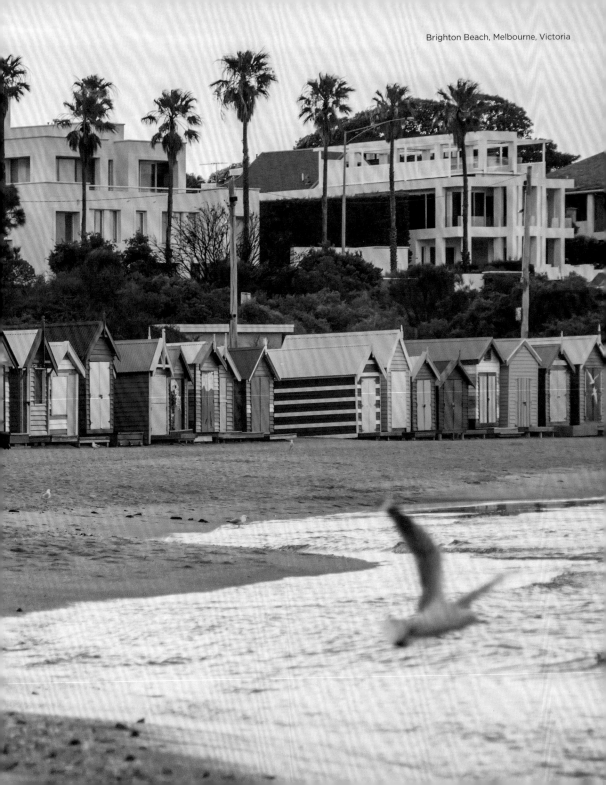

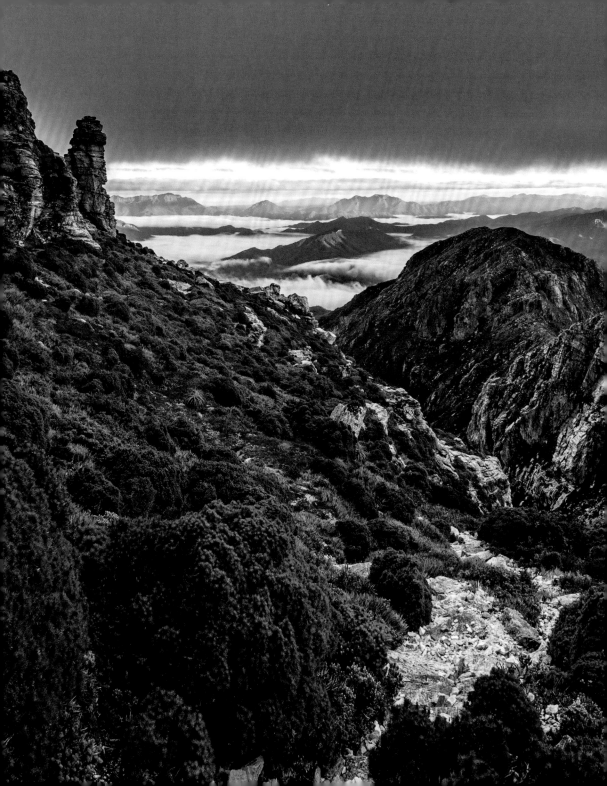

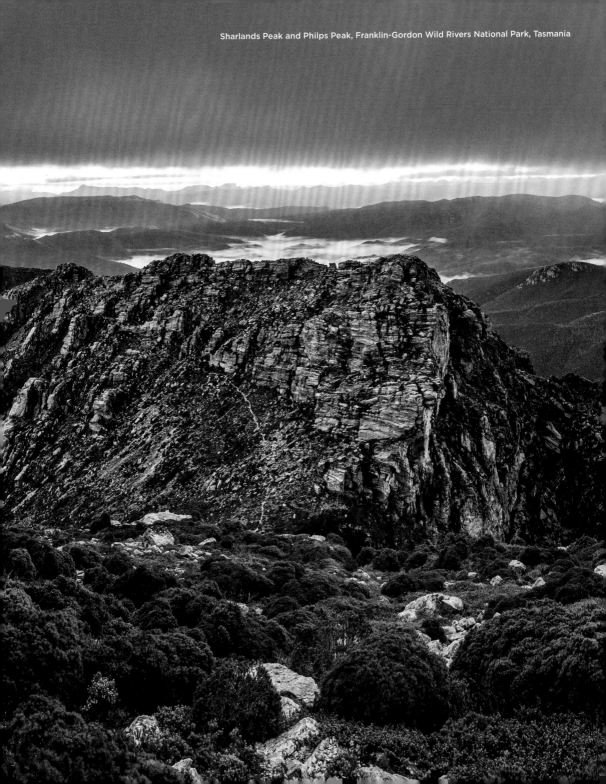

Sharlands Peak and Philps Peak, Franklin-Gordon Wild Rivers National Park, Tasmania

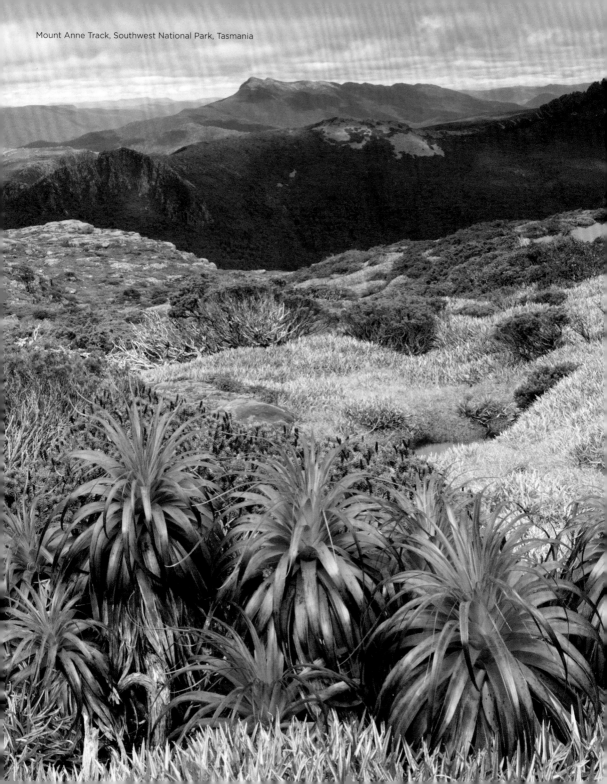

Mount Anne Track, Southwest National Park, Tasmania

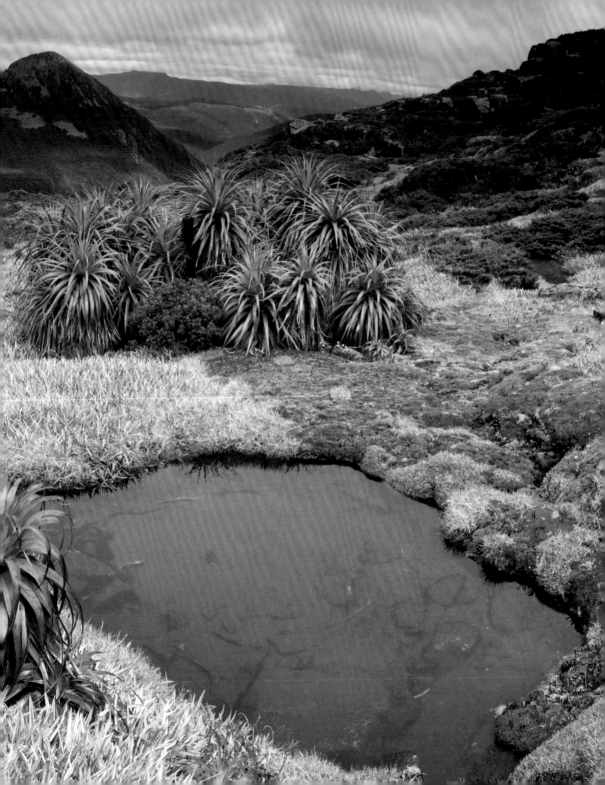

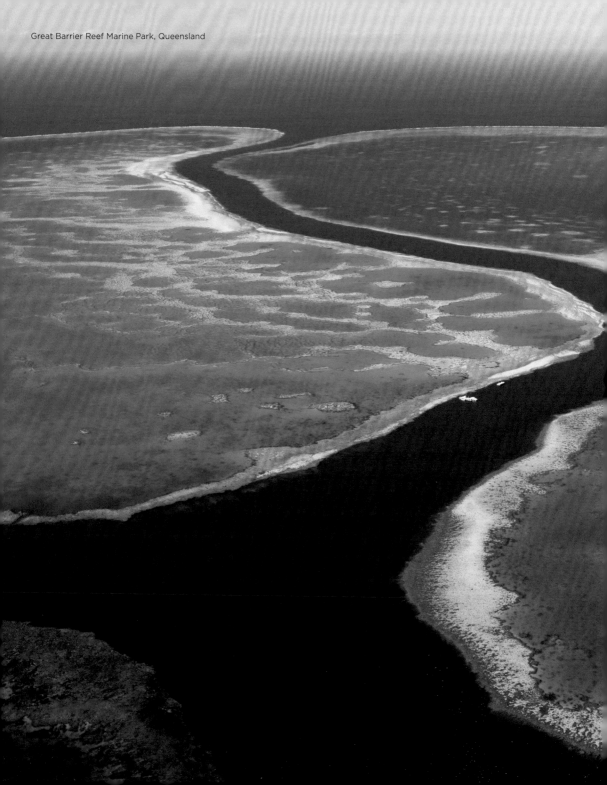

Content · Sommaire · Inhalt · Índice · Indice · Inhoud

Australia

Cinematic in scale and beauty, both a continent and a country, Australia is one of the most spectacular nations on the planet. Its coastline is extraordinary, fringed with epic coral reefs on both sides of the country, and draped with mile after mile of seemingly endless beaches, rugged cliffs and rainforests that nearly touch the sea. It is around this coastline that so many of Australia's sophisticated urban centres reside—Sydney, Melbourne and Adelaide, to name just three, frequently appear near the top of the lists that celebrate the world's most liveable cities. Other lesser-known cities, such as Canberra, Hobart and Brisbane, are emerging regional cultural capitals; Canberra in particular considers itself the true guardian of the nation's memory. From sub-Antarctic islands, through the snow-capped Alps and inland Tasmania, to the Tropics, Australia spans the full range of climatic and vegetation zones that the Southern Hemisphere has to offer. And Australia is also a wilderness destination par excellence, nowhere more so than its Outback interior and coastal hinterland – Uluru, Cape York Peninsula, Kakadu National Park, and the great deserts that lie in between are soulful landscapes, at once remote and hauntingly pretty close to sunset. Adding depth to such an astonishing color palette iş Australia's Indigenous inhabitants, who have been here for more than 60,000 years, and it is their story—as well as their arts—that marks Australia out as a true destination of the spirit.

Australie

Cinématographique par son échelle comme par sa beauté, tout à la fois continent et pays, l'Australie est l'une des nations les plus spectaculaires de la planète. Bordé de somptueux récifs coralliens et orné sur des kilomètres de plages infinies, de falaises escarpées et de forêts tropicales, son littoral est extraordinaire. C'est autour de cette côte que se trouvent les métropoles sophistiquées d'Australie – Sydney, Melbourne et Adélaïde, pour n'en nommer que trois, figurent ainsi fréquemment en tête des listes des villes les plus agréables à vivre au monde. D'autres agglomérations moins connues, comme Canberra, Hobart et Brisbane, sont des capitales culturelles régionales émergentes ; Canberra en particulier se considère comme la véritable gardienne de la mémoire nationale. Des îles subantarctiques aux tropiques, en passant par les Alpes enneigées et la Tasmanie intérieure, l'Australie couvre toute la gamme des zones climatiques et végétales que l'hémisphère sud peut offrir. Mais l'Australie est aussi une destination sauvage par excellence, nulle part ailleurs plus que dans son arrière-pays intérieur et côtier – Uluru, la péninsule du Cap York, le parc national de Kakadu et les grands déserts qui se trouvent entre les deux sont des paysages émouvants, à la fois éloignés et envoûtants, aux couleurs proches de celles d'un coucher de soleil. Les habitants indigènes d'Australie, qui y résident depuis plus de 60 000 ans, ajoutent de la profondeur à cet étonnant panorama et c'est leur histoire – ainsi que leurs arts – qui font de ce pays une destination spirituelle.

Australien

Australien ist unvergleichlich in seiner Größe und Schönheit, ist Kontinent und Land zugleich und zählt zu den spektakulärsten Nationen der Welt. Seine Küstenlinie ist außergewöhnlich: gesäumt von einzigartigen Korallenriffen auf beiden Seiten des Landes und kilometerlangen Stränden, zerklüfteten Klippen und Regenwäldern, die fast das Meer berühren. An dieser Küste befinden sich viele der urbanen Zentren Australiens – Sydney, Melbourne und Adelaide, um nur drei zu nennen, erscheinen häufig an der Spitze der Listen, die die lebenswertesten Städte der Welt feiern. Andere weniger bekannte Städte wie Canberra, Hobart und Brisbane sind neue regionale Kulturhauptstädte; Canberra versteht sich insbesondere als Hüterin des Gedächtnisses des Landes. Von den subantarktischen Inseln über die schneebedeckten Alpen und das Landesinnere Tasmaniens bis hin zu den Tropen umfasst Australien die gesamte Bandbreite der Klima- und Vegetationszonen, die die südliche Hemisphäre zu bieten hat. Und Australien ist Ziel vieler Menschen, die echte Wildnis erleben wollen: ob im Outback oder im Küstenhinterland – Uluru, Cape York Peninsula, der Kakadu Nationalpark und die großen Wüsten sind seelenvolle Landschaften, in denen Sonnenuntergang und rote Erde ein einzigartiges Farbspektakel bieten. Diese erstaunliche Farbpalette wird durch die indigenen Bewohner Australiens vertieft, die seit mehr als 60 000 Jahren hier leben, und es ist ihre Geschichte – ebenso wie ihre Kunst – die Australien als wahres Ziel des Geistes auszeichnet.

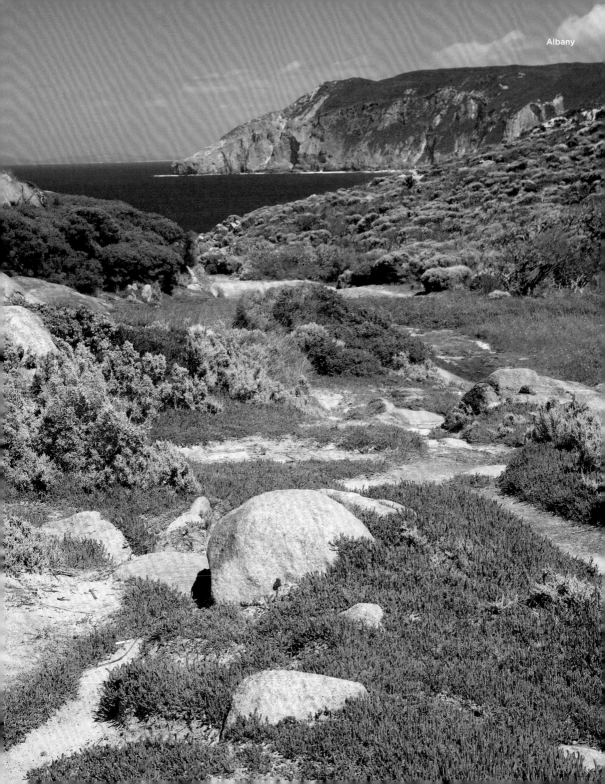

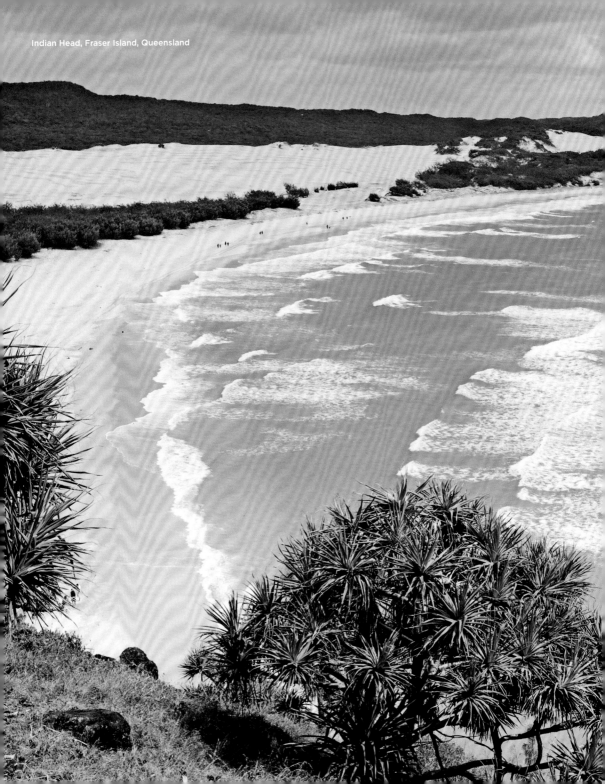

Indian Head, Fraser Island, Queensland

Australia

Australia, país y continente a la vez, es incomparable por sus dimensiones y bellezay es una de las naciones más espectaculares del planeta. Su costa es extraordinaria, bordeada de arrecifes de coral únicos a ambos lados del país, ofrece kilómetros y kilómetros de playas aparentemente interminables, acantilados escarpados y bosques pluviales que casi tocan el mar. En esta costa se enclavan muchas zonas urbanas de Australia como Sídney, Melbourne y Adelaida, por nombrar sólo tres.Estas ciudades ocupan con frecuencia los primeros lugares de las listas de ciudades más habitables del mundo. Otras localidades menos conocidas, como Canberra, Hobart y Brisbane, son capitales culturales regionales emergentes; Canberra en particular es considerada como verdadera guardiana de la memoria de la nación. Desde las islas subantárticas, pasando por los Alpes nevados y el interior de Tasmania, hasta los trópicos, Australia abarca toda la gama de zonas climáticas y de vegetación que ofrece el hemisferio sur. También es el destino de naturaleza salvaje por excelencia para muchas personas, ya que en el *Outback* y en el interior se encuentran Uluru, la península del Cabo York, elparque nacional de Kakadu, y los grandes desiertos conmovedores en los que la tierra roja y la puesta de sol se funden en un espectáculo de color. Los habitantes indígenas de Australia que han estado aquí durante más de 60.000 años, añaden profundidad a una paleta de colores tan asombrosa comosu historia y su arte, algo que caracteriza a Australia como un auténtico destino místico.

Australia

Senza uguali per dimensioni e bellezza, continente e paese al contempo, l'Australia è una delle terre più spettacolari del pianeta. La sua linea costiera è straordinaria, circondata da barriere coralline mozzafiato su due lati e orlata da spiagge apparentemente infinite, scogliere a picco sul mare e foreste pluviali che quasi si allungano fino al litorale. È proprio lungo la costa che si trovano molti dei centri urbani dell'Australia – Sydney, Melbourne e Adelaide, per citarne solo tre, appaiono spesso in cima alle liste delle città più vivibili al mondo. Altre città meno conosciute, come Canberra, Hobart e Brisbane, sono centri culturali emergenti. Canberra, in particolare, è considerata come la vera custode della memoria della nazione. Dalle isole subantartiche, passando per le Alpi innevate e le regioni dell'interno della Tasmania, fino ai tropici, l'Australia copre l'intera gamma di zone climatiche e di vegetazione che l'emisfero australe ha da offrire. E l'Australia è anche la meta per eccellenza per chi voglia fare l'esperienza della *wildnis*, nell'*outback* o nelle regioni lungo la costa. L'Uluru, la penisola di Cape York, il Kakadu National Park e i grandi deserti dell'interno sono connotati da paesaggi che hanno del mistico, dove i tramonti e la terra rossa creano uno spettacolo incomparabile. Ad aggiungere spessore ad una tavolozza di colori già di per sé così sorprendente sono gli aborigeni australiani, presenti qui da più di 60.000 anni, ed è la loro storia – così come la loro arte – che fa dell'Australia una destinazione di forte impatto.

Australië

Australië, filmisch zowel in omvang als in schoonheid, is zowel een continent als een land en een van de spectaculairste naties ter wereld. De kustlijn is buitengewoon: omgeven door unieke koraalriffen aan weerskanten van het land en kilometerslange stranden, rotsachtige klippen en regenwouden die bijna tot aan de zee reiken. Juist langs deze kustlijn liggen veel van de stedelijke centra van Australië: Sydney, Melbourne en Adelaide, om er maar drie te noemen, staan vaak in de top-tien van lijsten met de meest leefbare steden ter wereld. Andere minder bekende steden, zoals Canberra, Hobart en Brisbane, zijn regionale culturele hoofdsteden in opkomst. Met name Canberra ziet zichzelf als de ware hoeder van het nationale geheugen. Van subantarctische eilanden, door met sneeuw bedekte bergketens en het binnenland van Tasmanië tot de tropen – Australië omvat het volledige scala aan klimaat- en vegetatiezones dat het zuidelijk halfrond te bieden heeft. En Australië is ook een wildernisbestemming bij uitstek, nergens meer dan in het binnenland van de outback en het achterland van de kust: Uluru, Cape York Peninsula, Kakadu National Park, en de grote woestijnen die daartussen liggen, zijn bezielde landschappen, tegelijkertijd afgelegen en vlak voor zonsondergang spookachtig mooi. De inheemse bewoners van Australië, die hier al meer dan 60.000 jaar wonen, voegen diepte toe aan het verbazingwekkende kleurenpalet en het is hun verhaal – evenals hun kunst – dat van Australië een echt bezielde bestemming maakt.

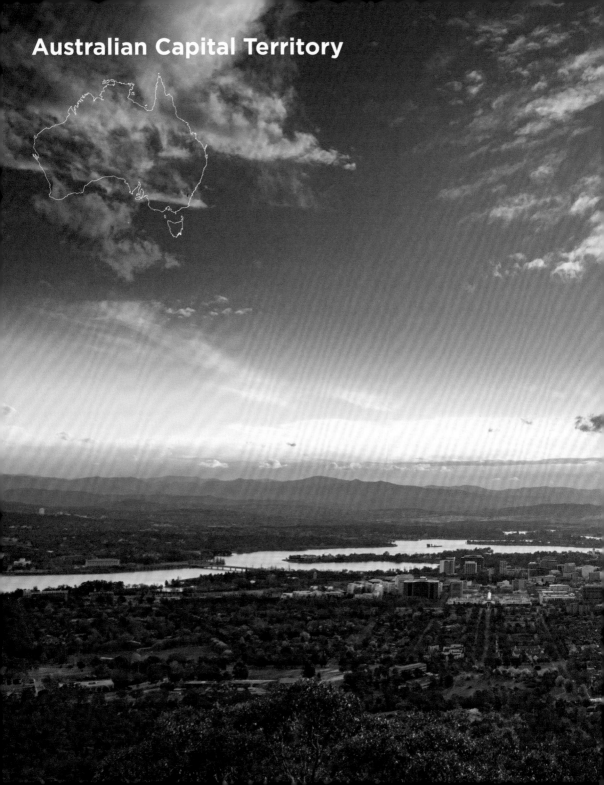

Australian Capital Territory

View of Canberra

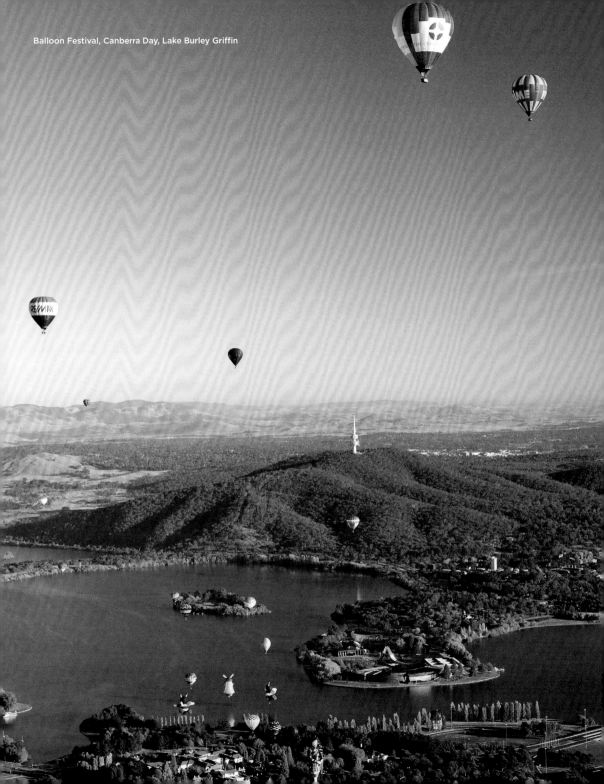

Balloon Festival, Canberra Day, Lake Burley Griffin

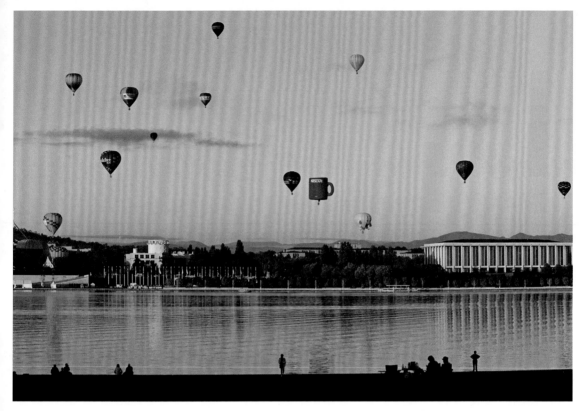

Balloon Festival, Canberra Day, Lake Burley Griffin

Australian Capital Territory (ACT)

Australia's custom-built national capital, founded early in the 20th century to counter Sydney-Melbourne rivalry, is defined by carefully planned road network and lack of historic architectural appeal. Canberra is also the repository of the nation's cultural memory, with exceptional museums spanning Indigenous and more recent Australian history.

Territoire de la capitale australienne (ACT)

La capitale nationale australienne, d'abord conçue sur plan au début du XXᵉ siècle pour contrer la rivalité Sydney-Melbourne, est connue pour son réseau routier soigneusement organisée, mais aussi pour son peu d'attrait architectural historique. Canberra est pourtant le dépositaire de la mémoire culturelle de la nation, avec des musées exceptionnels couvrant l'histoire indigène comme plus récente de l'Australie

Australian Capital Territory (ACT)

Australiens maßgeschneiderte Hauptstadt, die Anfang des 20. Jahrhunderts gegründet wurde, um der Rivalität zwischen Sydney und Melbourne entgegenzuwirken, zeichnet sich durch ein sorgfältig geplantes Straßennetz und fehlende historische Architektur aus. Canberra ist mit seinen Museen auch der Ort, an dem das kulturelle Gedächtnis des Landes bewahrt wird.

Australian Capital Territory (ACT)

El Territorio de la Capital Australiana, se fundó a principios del siglo XX para contrarrestar la rivalidad entre Sídney y Melbourne. Se define por una red de carreteras cuidadosamente planificada y por la falta de arquitectura histórica. Canberra es también el lugar en el que se conmemora la cultura de la nación, con museos excepcionales que abarcan desde los indígenas hasta la historia australiana más reciente.

Australian Capital Territory (ACT)

La capitale australiana, fondata all'inizio del XX secolo per porre fine alla rivalità tra Sydney e Melbourne, è caratterizzata da una rete stradale attentamente pianificata e dall'assenza di architetture storiche. Con i suoi musei, Canberra è anche la depositaria della memoria culturale del paese.

Australian Capital Territory (ACT)

De op maat gemaakte hoofdstad van Australië, aan het begin van de 20e eeuw gesticht om de rivaliteit tussen Sydney-Melbourne tegen te werken, wordt gekenmerkt door een zorgvuldig gepland wegennet en een gebrek aan historische architectuur. Canberra is met enkele uitzonderlijke musea ook de bewaarplaats van 's lands culturele geheugen.

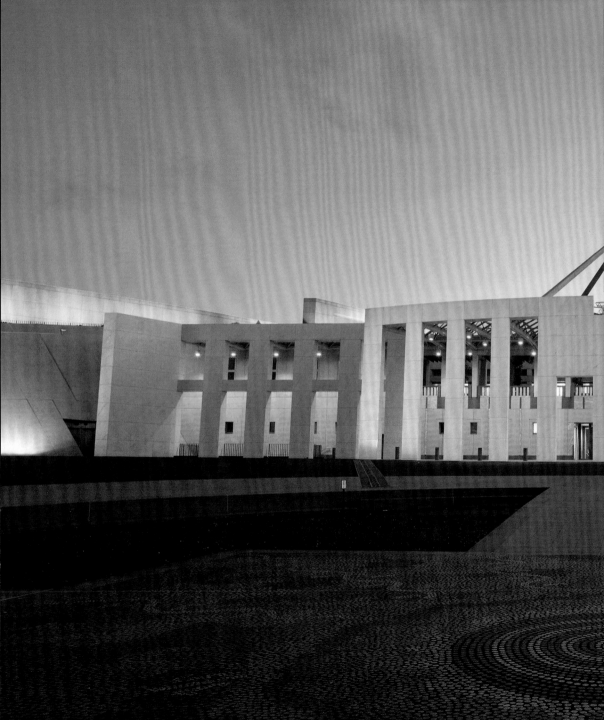

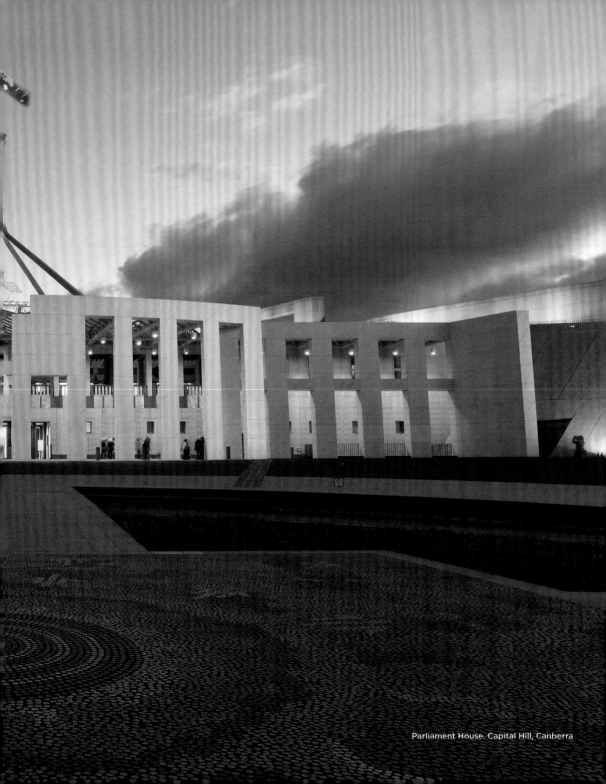

Parliament House, Capital Hill, Canberra

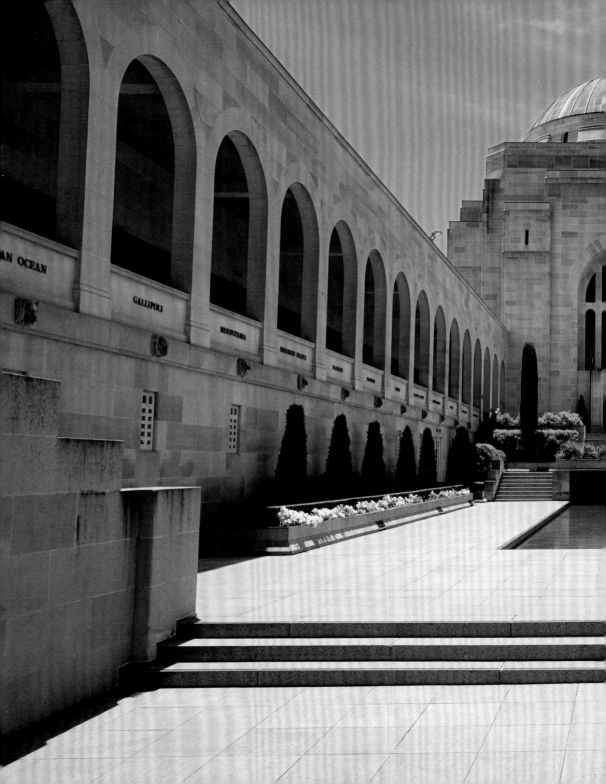

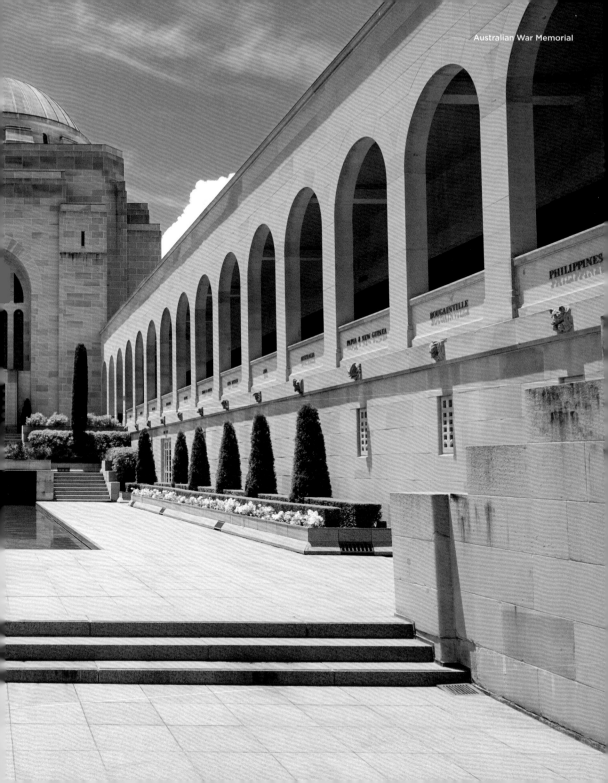

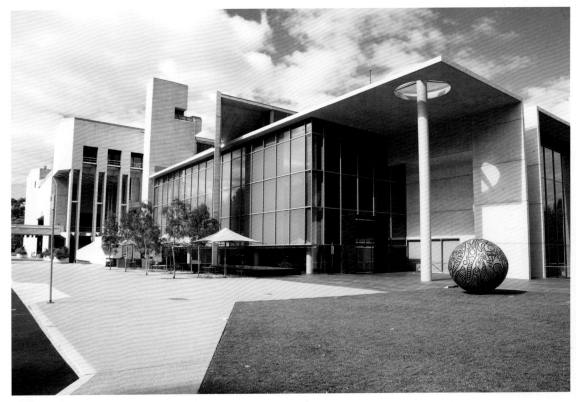

National Gallery of Australia

Canberra – Art and Lifestyle

The National Gallery of Australia was
a long time in the making: plans were
hatched in 1910 but it's opening wasn't
until 1982. The impressive Brutalist building
contains more than 166,000 works of art.
A more recent addition to ACT cultural life
has been New Acton's galleries, studios,
hotel, shops and cinemas, centered around
the striking Nishi building.

Canberra – Art et mode de vie

La National Gallery of Australia a mis
beaucoup de temps à voir le jour : les plans
ont été élaborés en 1910, mais elle n'a ouvert
qu'en 1982. L'impressionnant bâtiment
brutaliste contient plus de 166 000 œuvres
d'art. Les galeries, les studios, les hôtels,
les boutiques et les cinémas de NewActon,
centrés autour de l'imposant édifice Nishi,
sont venus plus récemment compléter la vie
culturelle d'ACT.

Canberra – Kunst und Lifestyle

Die National Gallery of Australia hatte
eine ungewöhnlich lange Entstehungszeit:
1910 wurden Pläne ausgearbeitet, aber
die Eröffnung erfolgte erst 1982. Das
beeindruckende brutalistische Gebäude
beherbergt mehr als 166 000 Kunstwerke.
Eine neuere Ergänzung des ACT-
Kulturlebens sind die Galerien, Ateliers,
Hotels, Geschäfte und Kinos von New
Acton, die sich um das markante Nishi-
Gebäude angesiedelt haben.

Canberra – arte y estilo de vida

La Galería Nacional de Australia tardó
mucho tiempo en construirse; los planos
se trazaron en 1910, pero su inauguración
no tuvo lugar hasta 1982. El impresionante
edificio alberga más de 166.000 obras
de arte. Las galerías, estudios, hoteles,
tiendas y cines de NewActon, centrados
alrededor del sorprendente edificio Nishi
son un nuevo acicate de la vida cultural del
Territorio de la Capital Australiana.

Canberra – Arte e stile di vita

La storia della progettazione della National
Gallery of Australia è insolitamente lunga:
nonostante i primi progetti risalgano al
1910, la sua apertura è avvenuta solo nel
1982. L'imponente edificio brutalista ospita
più di 166.000 opere d'arte. Un'aggiunta
più recente alla vita culturale dell'ACT sono
le gallerie, gli atelier, gli hotel, i negozi
e i cinema di New Acton, che sono sorti
intorno all'imponente edificio di Nishi.

Canberra – kunst en levensstijl

De National Gallery of Australia was
langdurig in de maak: plannen ervoor
werden al in 1910 gemaakt, maar
de opening was pas in 1982. Het
indrukwekkende brutalistische gebouw
herbergt meer dan 166.00 kunstwerken.
Een recentere toevoeging aan het
culturele leven van ACT zijn de galeries,
studio's, hotels, winkels en bioscopen van
NewActon, die rond het opvallende Nishi-
gebouw staan.

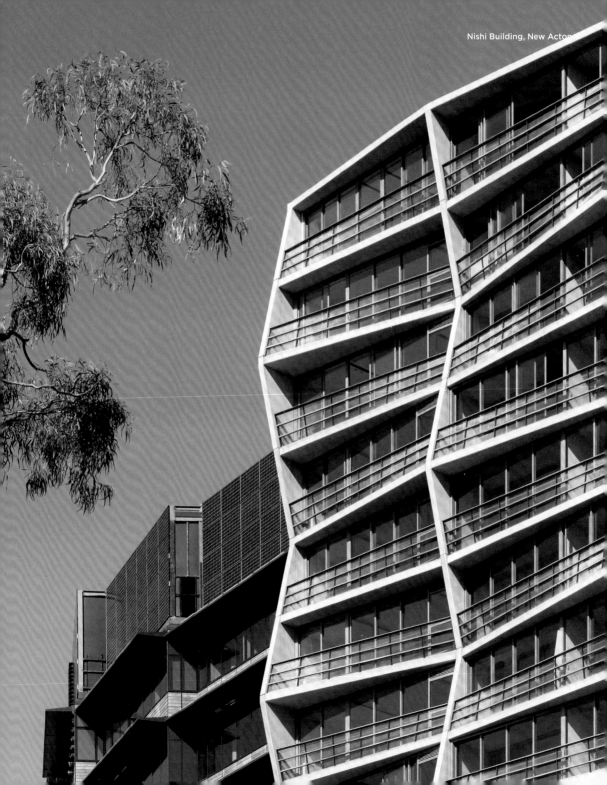

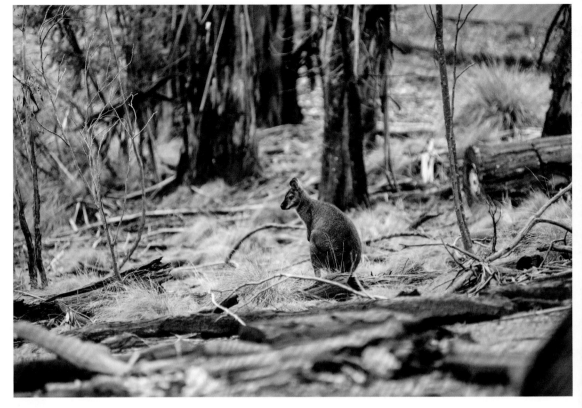

Southern Brush-tailed Rock-wallaby *(Petrogale penicillata)*, Tidbinbilla Nature Reserve

Wild ACT

Canberra's abundant green spaces are suitably home to a dense concentration of a wild Australian icon: kangaroos are commonly seen in parkland throughout the city. Just beyond the ever-expanding city fringe, Namadgi National Park is home to granite mountains, snow gum forests, and signature wildlife species such as kangaroo, wallabies and wombats.

Vie sauvage de l'ACT

Les espaces verts abondants de Canberra contient une concentration dense de kangourous, l'icône australienne sauvage, que l'on peut aisément observer dans les parcs de la ville. Juste au-delà de la périphérie de la métropole en constante expansion, le parc national de Namadgi abrite des montagnes de granit, des forêts de gommiers des neiges et des espèces sauvages caractéristiques telles que des kangourous, des wallabies et des wombats.

Das wilde Seite des ACT

Die üppigen Grünflächen von Canberra bieten einer australischen Ikone die passende Heimat: Wilde Kängurus werden häufig in den Parklandschaften der ganzen Stadt gesehen. Jenseits des sich ständig ausdehnenden Stadtrands beherbergt der Namadgi Nationalpark Granit-Formationen, Schnee-Eukalyptuswälder und charakteristische Wildtierarten wie Wallabys und Wombats.

El lado salvaje de la ACT

Las abundantes zonas verdes de Canberra representan el hogar de uno de los íconos del país: los canguros salvaje se ven con frecuencia en los parques de toda la ciudad. Más allá de la periferia de la ciudad, en constante expansión, el Parque Nacional de Namadgi alberga montañas de granito, bosques de eucaliptos nevados y especies de fauna característicascomo canguros, walabíes y wombats.

Il lato selvaggio dell'ACT

Gli abbondanti spazi verdi di Canberra sono l'habitat ideale di una tipica icona australiana: i canguri selvaggi vengono spesso avvistati nei parchi di tutta la città. Appena oltre la periferia della città in continua espansione, il Namadgi National Park comprende montagne di granito, foreste di eucalipto del genere detto "gomma da neve" e specie faunistiche autoctone come canguri, wallaby e wombat.

Wild ACT

Canberra's overvloedige groen biedt een Australisch icoon de gewenste habitat: wilde kangoeroes zijn vaak te zien in parken verspreid over de stad. In Namadgi National Park, net voorbij de steeds verder opschuivende stadsrand, zijn granietformaties, eucalyptusbossen en kenmerkende wilde dieren zoals kangoeroes, wallaby's en wombats te vinden.

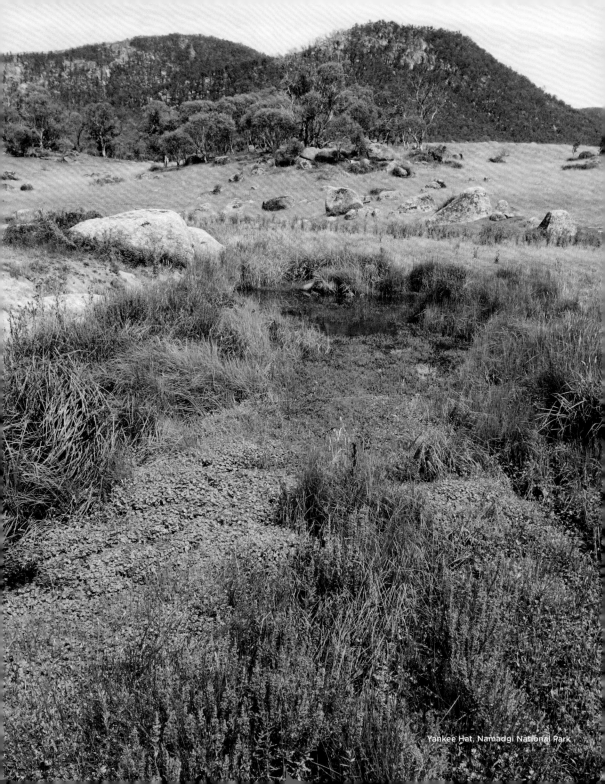

Yankee Hat, Namadgi National Park

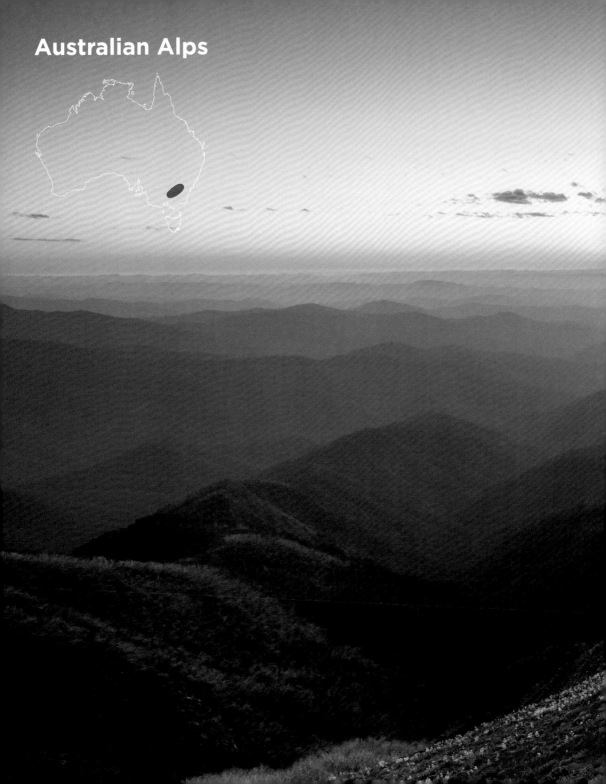

Australian Alps

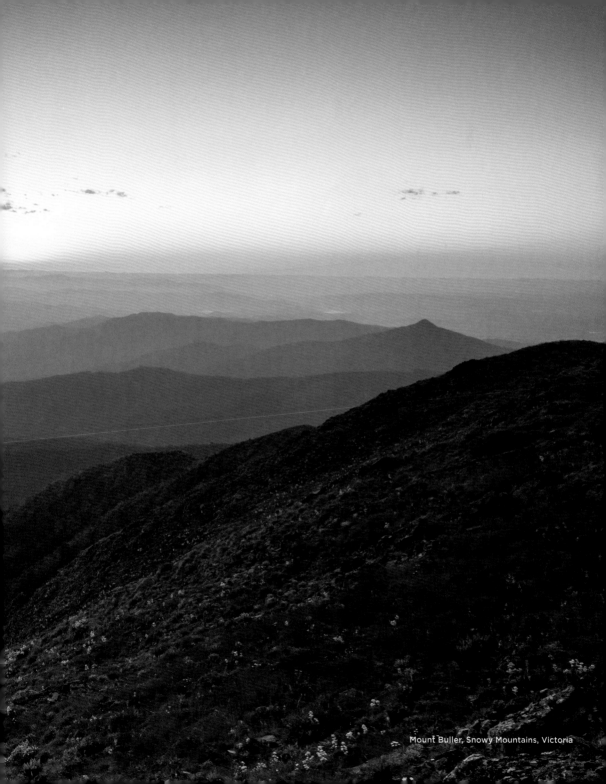

Mount Buller, Snowy Mountains, Victoria

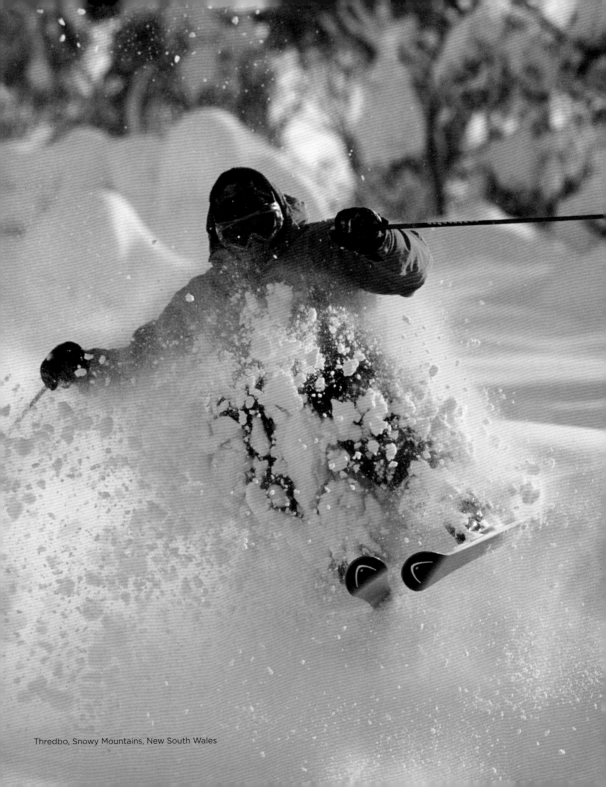

Thredbo, Snowy Mountains, New South Wales

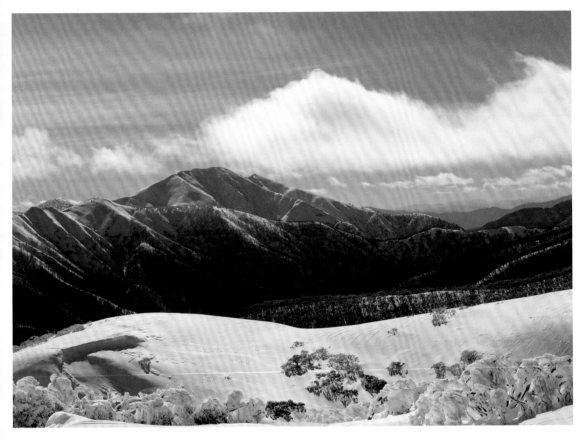

Mount Feathertop, Alpine National Park, Victoria

Australian Alps

Ranged along the state borders of Victoria and New South Wales in the country's southeast, the Alps shelter Australia's premier ski resorts, including Thredbo and Mt Buller. The ski season can, in a good year, begin as early as April and last until November, although the most reliable months for snowfalls are usually June through to August.

Alpes Australianos

Los Alpes se extienden a lo largo de las fronteras estatales de Victoria y Nueva Gales del Sur, en el sureste del país, y albergan las principales estaciones de esquí de Australia, como Thredbo y Mt Buller. La temporada de esquí puede, en un buen año, comenzar en abril y durar hasta noviembre, aunque los meses más fiables para las nevadas suelen ser de junio a agosto.

Alpes australiennes

Situées le long des frontières des états du Victoria et de la Nouvelle-Galles du Sud, dans le sud-est du pays, les Alpes abritent les principales stations de ski australiennes, dont Thredbo et Mount Buller. La saison de ski peut, dans une bonne année, commencer dès le mois d'avril et durer jusqu'en novembre, bien que les mois les plus fiables pour les chutes de neige soient habituellement de juin à août.

Alpi Australiane

Distese lungo il confine tra lo stato del Victoria e quello del Nuovo Galles del Sud nel sud-est del paese, le Alpi sono sede delle principali stazioni sciistiche australiane, tra cui Thredbo e Mt Buller. Se l'annata è buona, la stagione sciistica può iniziare già ad aprile e durare fino a novembre, anche se i mesi più sicuri per le nevicate sono solitamente da giugno ad agosto.

Australische Alpen

Das Gebirge liegt an der Staatsgrenze zwischen Victoria und New South Wales und beherbergt die wichtigsten Skigebiete Australiens, darunter Thredbo und Mt Buller. Die Skisaison kann in einem guten Jahr von April bis November dauern, obwohl die zuverlässigsten Monate für Schneefälle in der Regel Juni bis August sind.

Australische Alpen

De Australische Alpen, die zich uitstrekken langs de staatsgrenzen van Victoria en New South Wales in het zuidoosten van het land, herbergen de belangrijkste skigebieden, waaronder Thredbo en Mount Buller. Het skiseizoen kan in een goed jaar al in april beginnen en tot november duren, hoewel de betrouwbaarste maanden voor sneeuwval meestal juni, juli en augustus zijn.

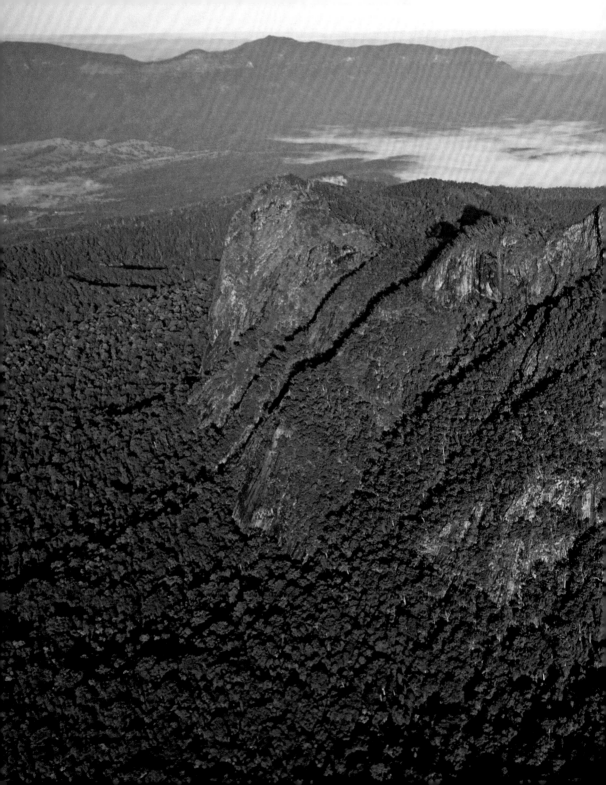

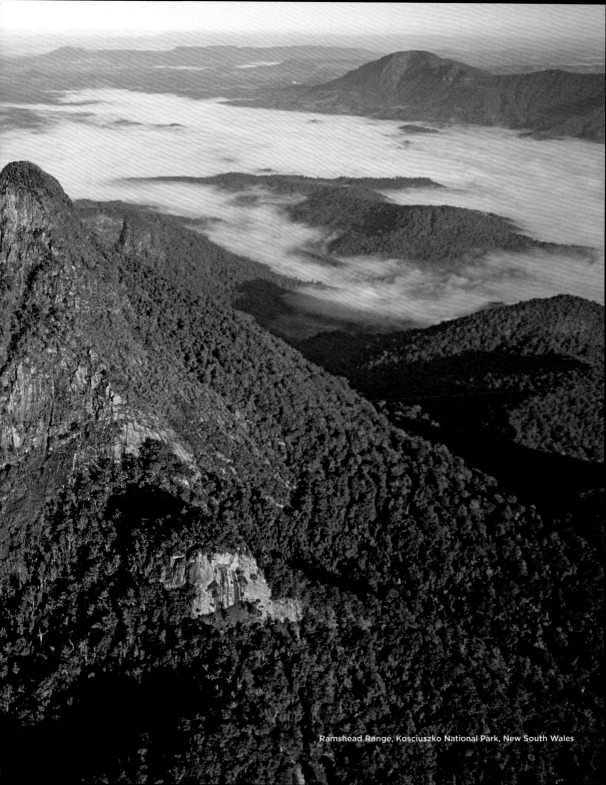

Ramshead Range, Kosciuszko National Park, New South Wales

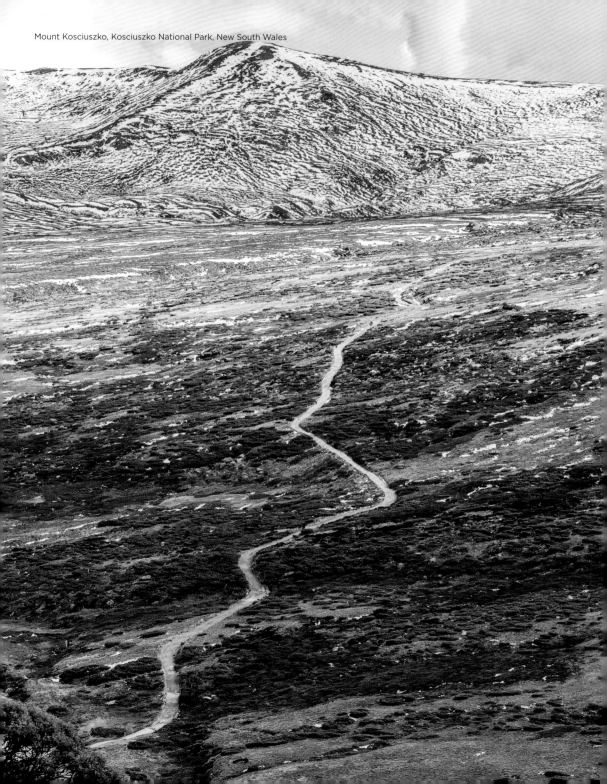

Mount Kosciuszko, Kosciuszko National Park, New South Wales

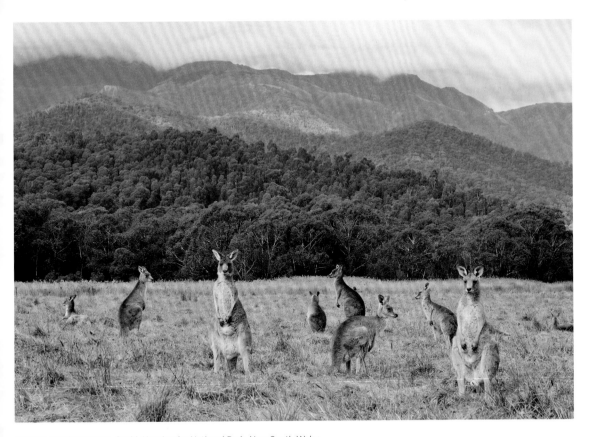

Eastern grey kangaroos, Geehi, Kosciuszko National Park, New South Wales

Australia's Highest Mountain

Rising above the Australian Alps is the continent's highest mountain, Mt Kosciuzko (2228 m). Dominating the national park of the same name, it can be climbed by anyone of reasonable fitness; until recent decades, it was possible to drive to the summit. Dense eucalypt forests, abundant wildlife and hiking trails follow the mountainous contours.

La montaña más alta de Australia

Por encima de los Alpes Australianos se encuentra la montaña más alta del continente, el monte Kosciuszko (2.228 m). Dominando el parque nacional del mismo nombre, puede ser escalada por cualquiera que tenga unas aptitudes razonables; hasta hace pocas décadas, era posible conducir hasta la cumbre. La montaña posee densos bosques de eucaliptos, abundante vida silvestre y senderos para practicar senderismo.

La plus haute montagne d'Australie

Surplombant les Alpes australiennes, la plus haute montagne du continent, le mont Kosciuszko, s'élève à 2 228 m. Dominant le parc national du même nom, il peut être escaladé relativement facilement ; jusqu'à ces dernières décennies, il était même possible d'y accéder en voiture. De denses forêts d'eucalyptus, une faune abondante et des sentiers de randonnée pédestre suivent les contours des montagnes.

La montagna più alta d'Australia

La montagna più alta del continente, il monte Kosciuszko (2.228 m), sovrasta le Alpi Australiane. Con la sua altezza domina sull'omonimo parco nazionale e può essere scalato da chiunque sia in buona forma fisica; fino a qualche decennio fa era possibile raggiungere la vetta in auto. Lungo le coste del monte, tra folti boschi di eucalipto e sentieri escursionistici, vive una fauna ricca.

Australiens höchster Berg

Über den australischen Alpen erhebt sich der höchste Berg, der Mount Kosciuszko (2228 m). Er dominiert den gleichnamigen Nationalpark und kann von jedem mit durchschnittlicher Fitness bestiegen werden; bis in die letzten Jahrzehnte war es möglich, auf den Gipfel zu fahren. Dichte Eukalyptuswälder, eine reiche Tierwelt und Wanderwege folgen den bergigen Konturen.

Hoogste berg van Australië

Mount Kosciuszko (2.228 m) steekt boven de Australische Alpen uit en is de hoogste berg van het continent. Hij domineert het gelijknamige nationale park en kan door iedereen met een redelijke conditie worden beklommen. Tot een paar decennia geleden was het mogelijk om naar de top te rijden. Dichte eucalyptusbossen, een overvloed aan wilde dieren en wandelpaden volgen de bergachtige contouren.

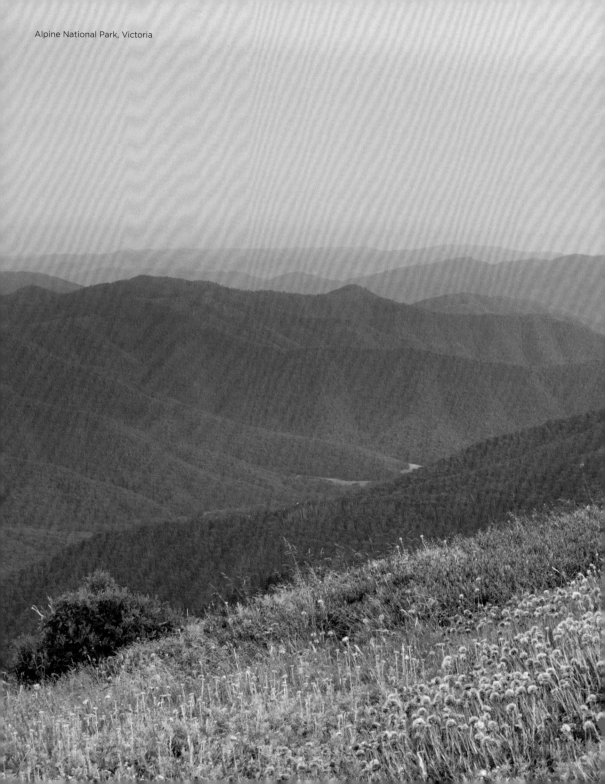
Alpine National Park, Victoria

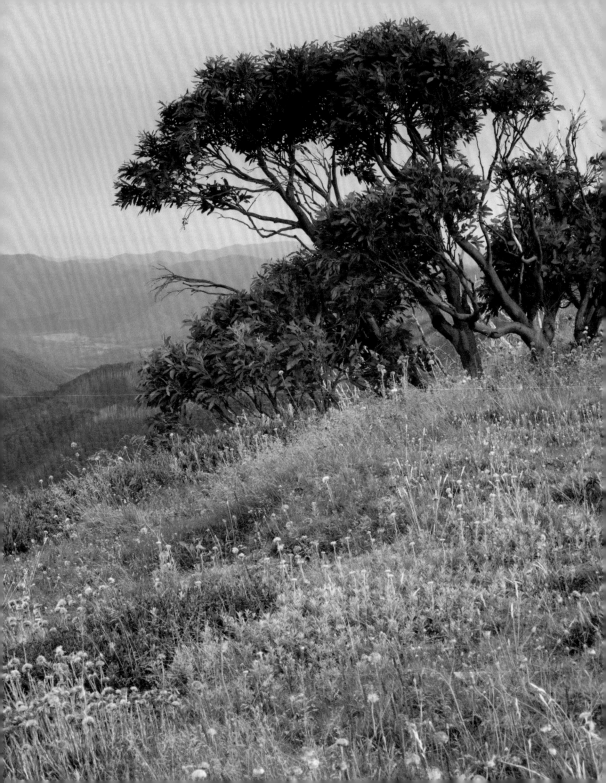

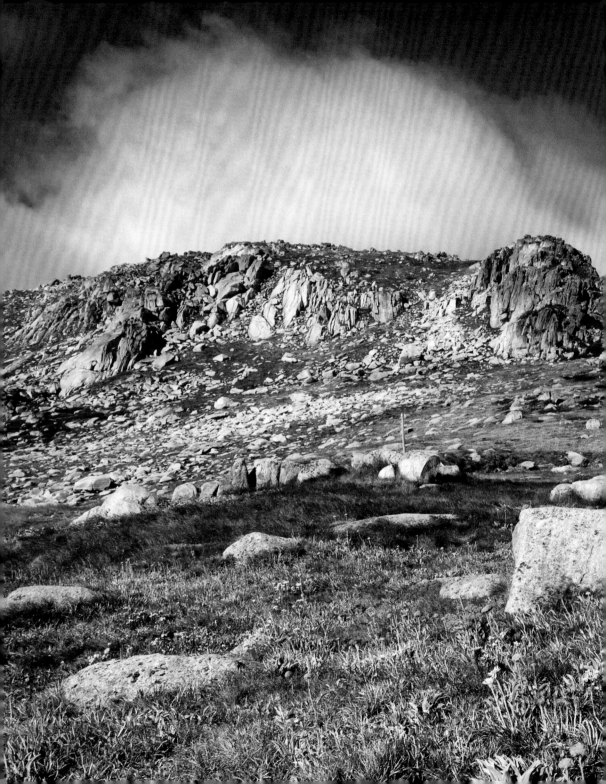

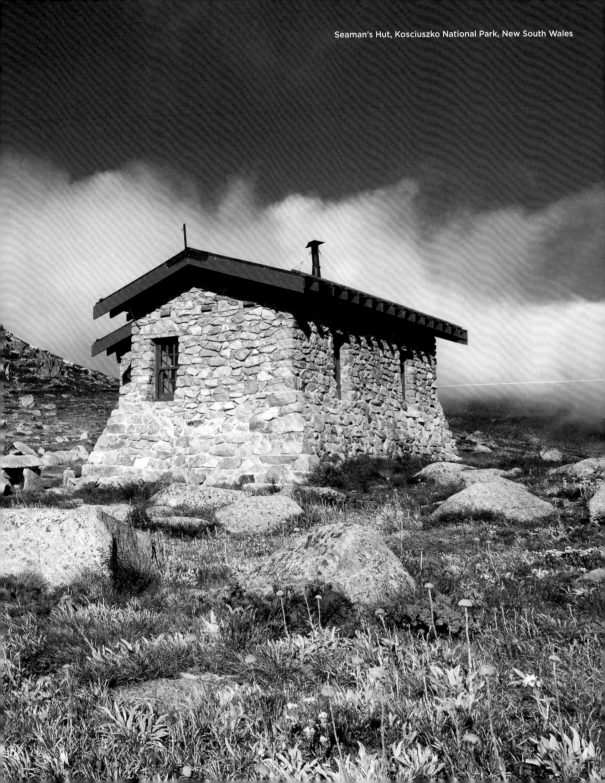
Seaman's Hut, Kosciuszko National Park, New South Wales

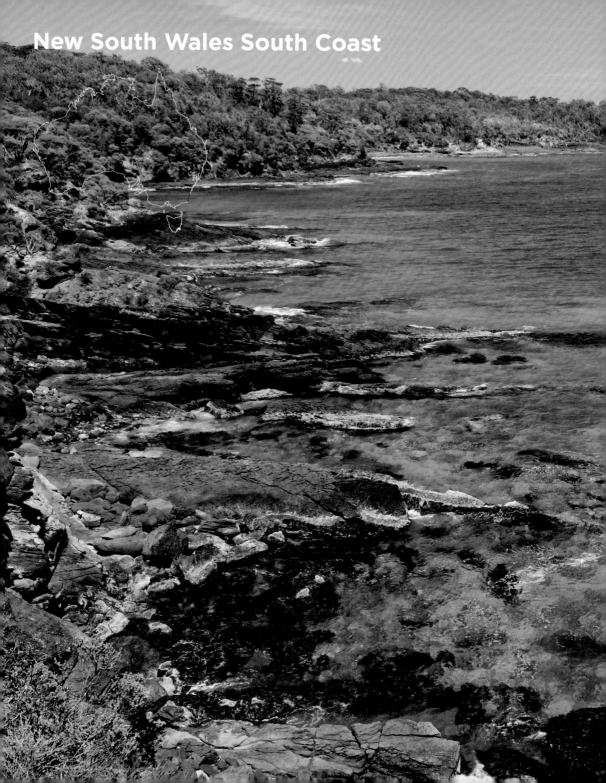

New South Wales South Coast

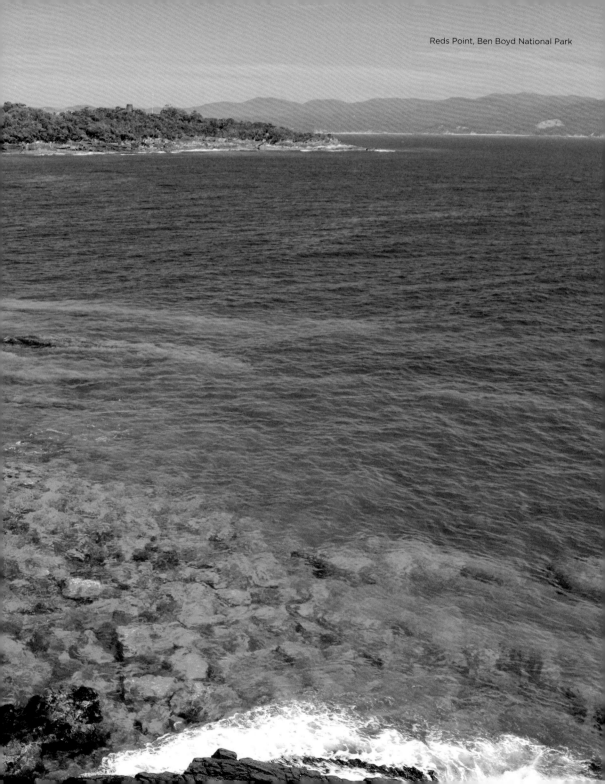

Reds Point, Ben Boyd National Park

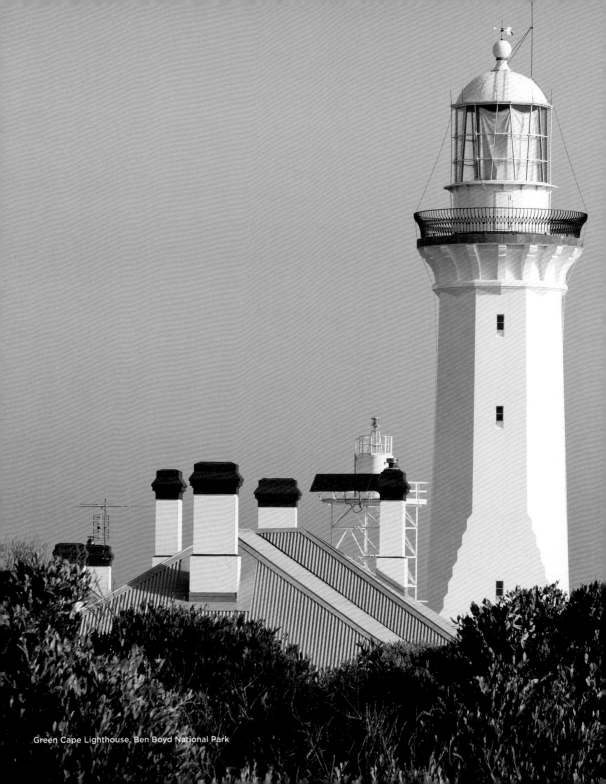

Green Cape Lighthouse, Ben Boyd National Park

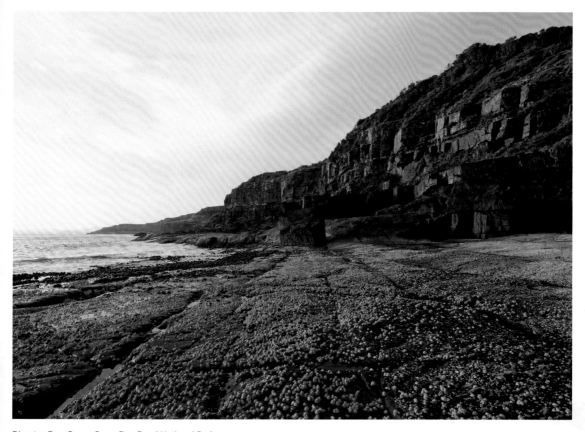

Disaster Bay, Green Cape, Ben Boyd National Park

New South Wales South Coast

The South Coast of New South Wales is among Australia's most popular summer playgrounds. The main roads, including the long route between Melbourne and Sydney, bypass pretty coastal villages and picturesque national parks. The natural drama contrasts with quiet, casual towns, such as Bermagui with its growing reputation for culinary excellence.

Costa sur de Nueva Gales del Sur

La costa sur de Nueva Gales del Sur es uno de los espacios lúdicos veraniegos más populares de Australia. Las carreteras principales, incluida la extensa ruta entre Melbourne y Sídney, circunvalan bonitos pueblos costeros y pintorescos parques nacionales. El tremenda naturaleza contrasta con ciudades tranquilas e informales, como Bermagui, con una reputación al alza por su excelencia culinaria.

Côte sud de Nouvelle-Galles du Sud

La côte sud de la Nouvelle-Galles du Sud est l'une des destinations estivales les plus populaires d'Australie. Les routes principales, y compris celle qui relie Melbourne à Sydney, contournent de jolis villages côtiers et de pittoresques parcs nationaux. La nature théâtrale contraste avec les villes calmes et décontractées, comme Bermagui, dont la réputation d'excellence culinaire ne cesse de croître.

Costa meridionale del Nuovo Galles del Sud

La costa meridionale del Nuovo Galles del Sud è una delle mete estive più popolari dell'Australia. Le strade principali, compreso il lungo percorso tra Melbourne e Sydney, attraversano graziosi villaggi costieri e pittoreschi parchi nazionali. Il paesaggio naturale fa da contrasto a città tranquille e disinvolte come Bermagui, che oggi gode di un'ottima reputazione come centro di eccellenza culinaria.

New South Wales South Coast

Die Südküste von New South Wales gehört zu den beliebtesten Sommerzielen Australiens. Die Hauptstraßen, einschließlich der langen Strecke zwischen Melbourne und Sydney, umschlängeln hübsche Küstendörfer und malerische Nationalparks. Das Naturpanorama steht im Kontrast zu ruhigen, lässigen Städten wie Bermagui, das in Feinschmeckerkreisen mittlerweile einen ausgezeichneten Ruf genießt.

New South Wales South Coast

De zuidkust van New South Wales is in de zomer een van de populairste bestemmingen van Australië. De hoofdwegen, waaronder de lange route tussen Melbourne en Sydney, lopen langs mooie kustdorpen en pittoreske nationale parken. De dramatische natuur contrasteert met rustige steden, zoals Bermagui, dat bij fijnproevers een voortreffelijke naam heeft.

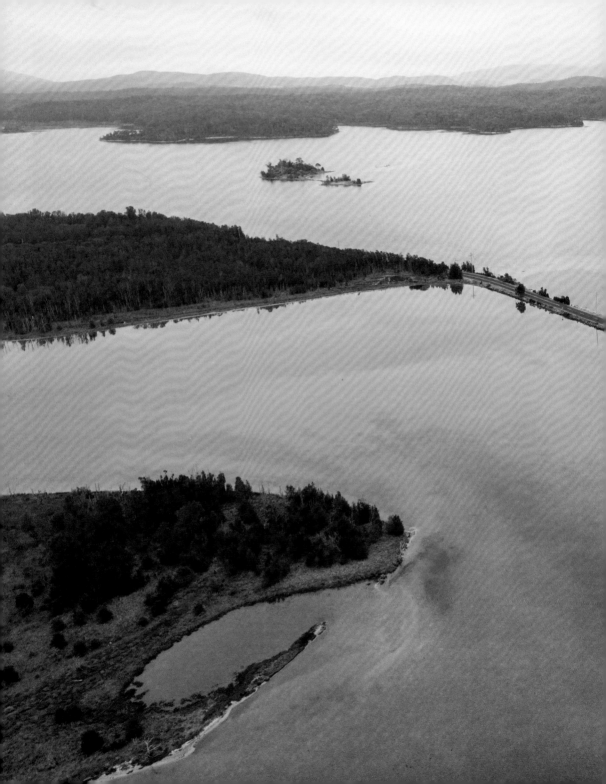

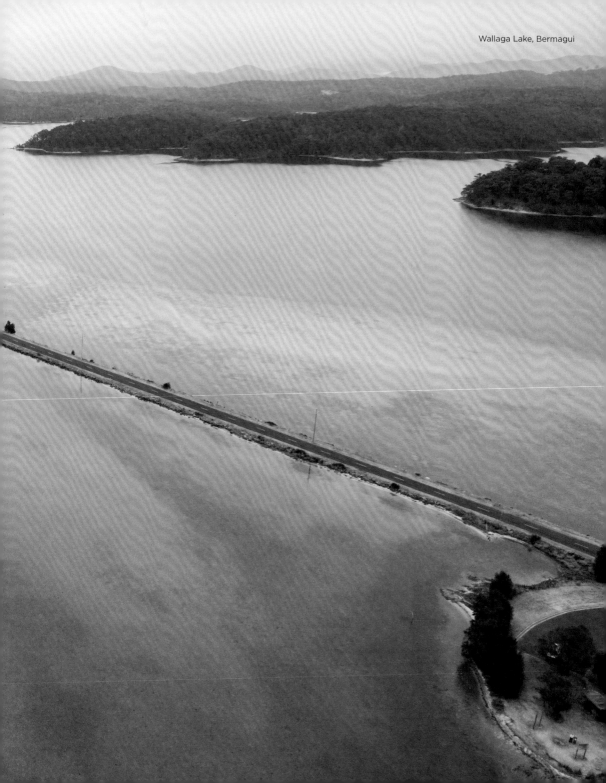

Wallaga Lake, Bermagui

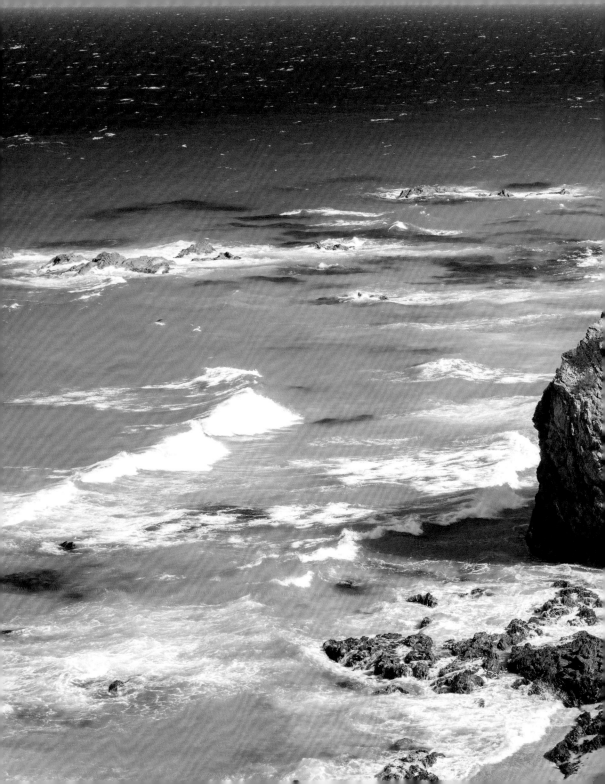

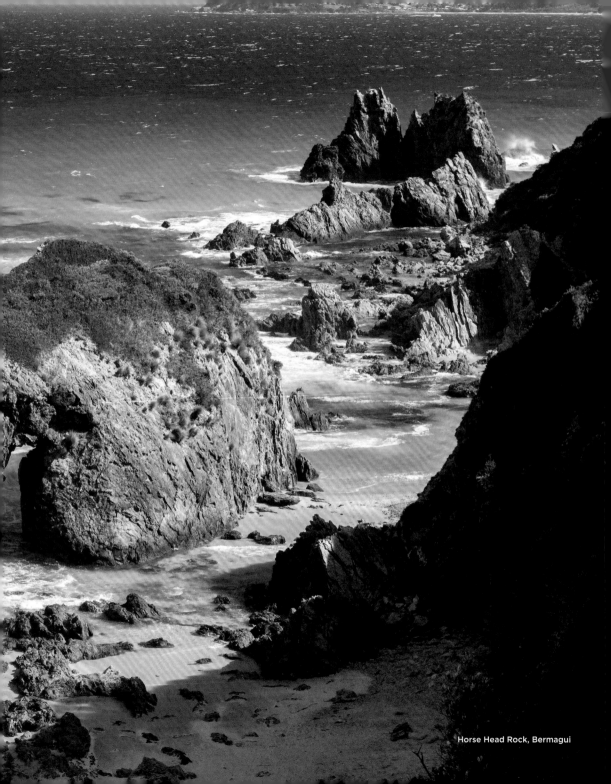
Horse Head Rock, Bermagui

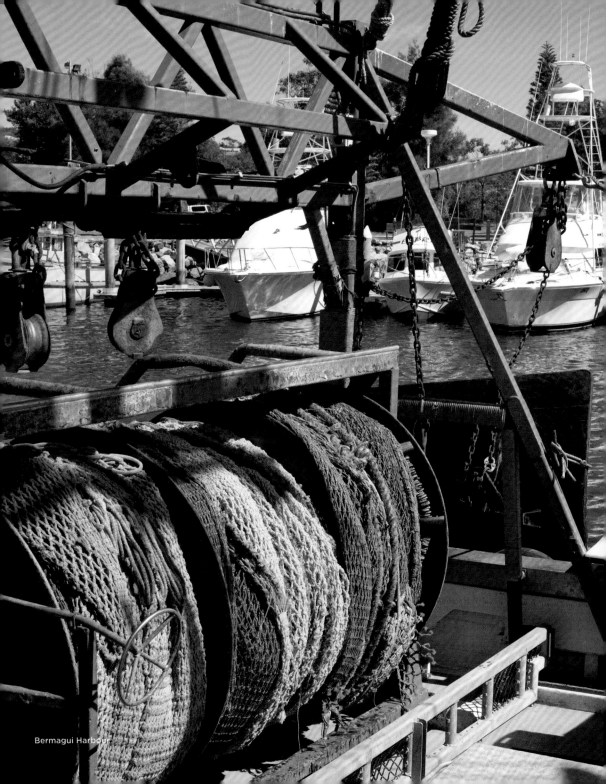

Bermagui Harbour

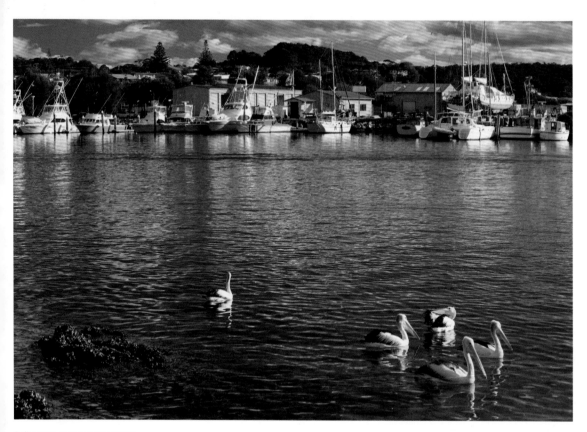

Pelicans In Bermagui Harbour

South Coast Fishing

Seafood feasts are a popular way to mark Christmas and the summer holidays in this region and Batemans Bay, Narooma, Bermagui and Eden all have commercial fishing fleets. The industry is varied with ocean trap and line, lobster pots, ocean haul, longline tuna fishing and estuary catches used to fill supply.

Pesca en la costa sur

Los festivalesde marisco son una forma popular de celebrar la Navidad y las vacaciones de verano en esta región. Batemans Bay, Narooma, Bermagui y Eden tienen flotas pesqueras comerciales. La industria es diversa, con trampas marinas y pesca con sedal, nasas para langostas, transporte marítimo, pesca de atún con palangre y capturas en estuarios para completar la oferta.

Pêche sur la côte sud

Les festins de fruits de mer sont une manière populaire de marquer Noël et les vacances d'été dans cette région et Batemans Bay, Narooma, Bermagui et Eden possédent tous une flotte de pêche commerciale. L'industrie est variée et comprend le piégeage et la pêche à la ligne, les casiers à homard, le transport océanique, la pêche au thon à la palangre et les prises dans l'estuaire.

Pesca sulla costa meridionale

Le feste a base di frutti di mare sono un modo popolare per celebrare il Natale e le vacanze estive in questa regione e Batemans Bay, Narooma, Bermagui e Eden hanno flotte da pesca commerciale. L'industria ittica qui è molto variegata, la pesca avviene con trappole e lenze, nasse per aragoste, cala oceanica, pesca del tonno con palangari e pesca lungo gli estuari, a cui si ricorre per soddisfare l'offerta.

Fischerei an der Südküste

Meeresfrüchtefeste sind eine beliebte Möglichkeit, Weihnachten und die Sommerferien in dieser Region zu feiern, und Bermagui verfügt wie die meisten kleinen Küstenstädte über eine kommerzielle Fischereiflotte. Die Branche ist vielfältig: Meeresfallen und Leinenfischerei, Hummertöpfe, Seefracht, Langleinen-Thunfischfang und Mündungsfänge, die zur Versorgung dienen.

Vissen aan de zuidkust

Zeevruchtenfeesten zijn in deze regio een populaire manier om Kerstmis en de zomervakantie te vieren, en Batemans Bay, Narooma, Bermagui en Eden beschikken allemaal over een commerciële vissersvloot. De visvangst is gevarieerd, met fuiken en lijnen, korven, sleepnetten, tonijnvisserij met sleeplijn en vangst in zeemondingen om de aanvoer aan te vullen.

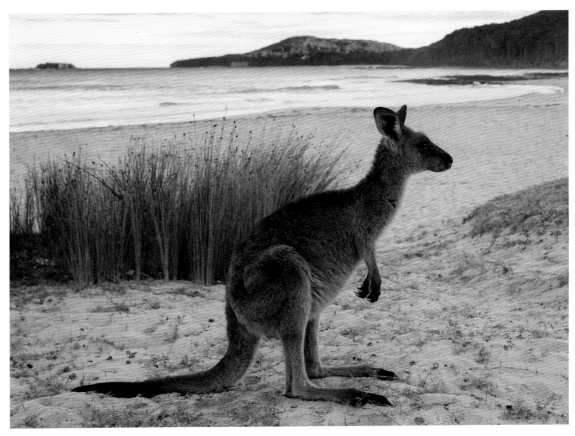

Eastern Grey Kangaroo on Pebbly Beach

Mimosa Rocks National Park
This coastal national park is known for its fabulous castle-like rock formations and the pink-tinged sunrise view from Bunga Head. A popular camping destination, it's accessed by a winding unsealed road through dense virgin bush, Four distinct sites offer white sand beaches, pure lagoons and friendly roving kangaroos and wallabies.

Parc national de Mimosa Rocks
Ce parc national côtier est connu pour ses fabuleuses formations rocheuses ressemblant à des châteaux et pour son lever du soleil rose que l'on peut admirer depuis Bunga Head. Destination de camping populaire, on y accède par une route sinueuse non goudronnée, à travers une brousse vierge dense. Quatre sites distincts offrent des plages de sable blanc, des lagunes cristallines et permettent de croiser des kangourous et des wallabies.

Mimosa Rocks National Park
Dieser Küsten-Nationalpark ist bekannt für seine fabelhaften schlossartigen Felsformationen und seine rosa gefärbten Sonnenaufgänge. Ein beliebtes Campingziel, das über eine kurvenreiche, unbefestigte Straße durch dichtes, unberührtes Buschwerk erreicht wird, und weiße Sandstrände bietet sowie reine Lagunen und wilde, aber freundliche Kängurus und Wallabys.

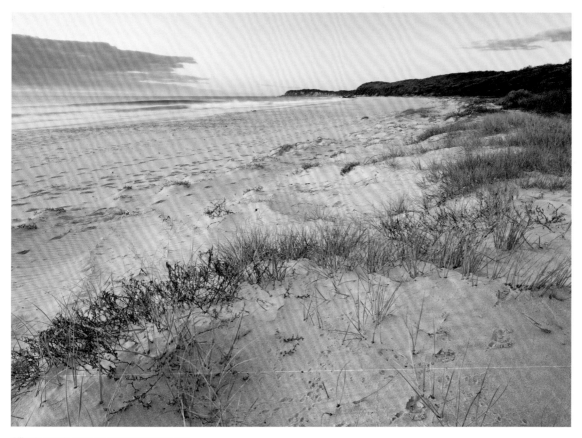

Gillards Beach, Mimosa Rocks National Park

Mimosa Rocks National Park

Este parque nacional costero es conocido por sus fabulosas formaciones rocosas que parecen castillos y por sus amaneceres teñidos de rosa que se pueden apreciar desde Bunga Head. Es un destino popular para acampar, al que se accede a través de una carretera sin asfaltar a través de un denso arbusto virgen. Ofrece playas de arena blanca, lagunas salvajes y puras, así como simáticos canguros y walabíes.

Mimosa Rocks National Park

Questo parco nazionale lungo il litorale costiero è noto per le sue favolose formazioni rocciose simili a castelli e per le albe sfumate di rosa che si possono ammirare da Bunga Head. Questa è una meta popolare tra i campeggiatori e vi si accede tramite una tortuosa strada che attraversa una fitta macchia incontaminata. In quattro aree distinte si trovano spiagge di sabbia bianca, lagune vere e proprie e simpatici canguri e wallaby che si muovono indisturbati per il paesaggio.

Mimosa Rocks National Park

Dit beschermde kustgebied staat bekend om zijn prachtige kasteelachtige rotsformaties en de roze getinte zonsopgang die prachtig te zien is vanaf Bunga Head. Deze populaire kampeerbestemming is toegankelijk via een kronkelende onverharde weg door dicht, ongerept struikgewas. Hier zijn witte zandstranden, kristalheldere lagunes en rondzwervende kangoeroes en wallaby's.

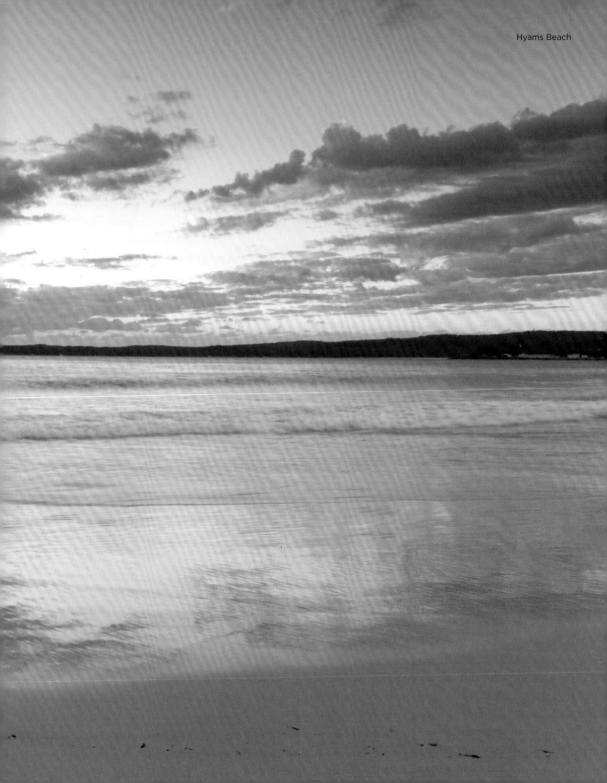

Hyams Beach

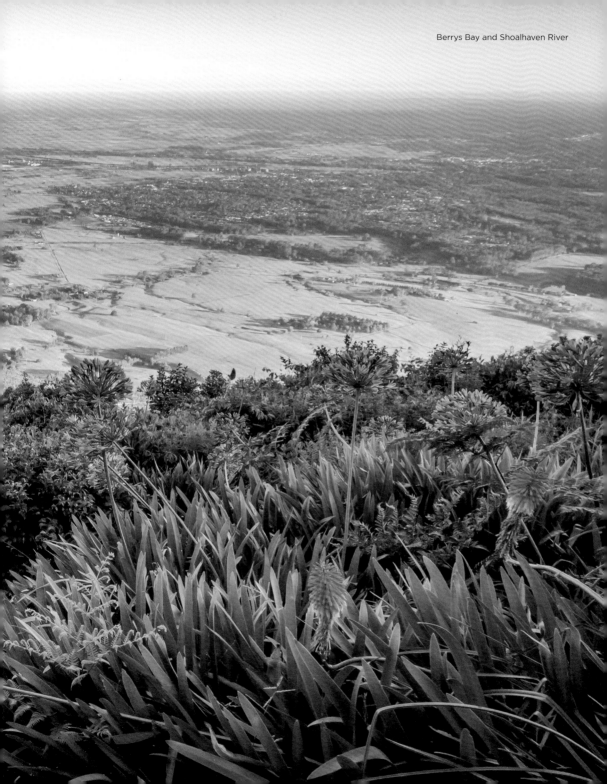

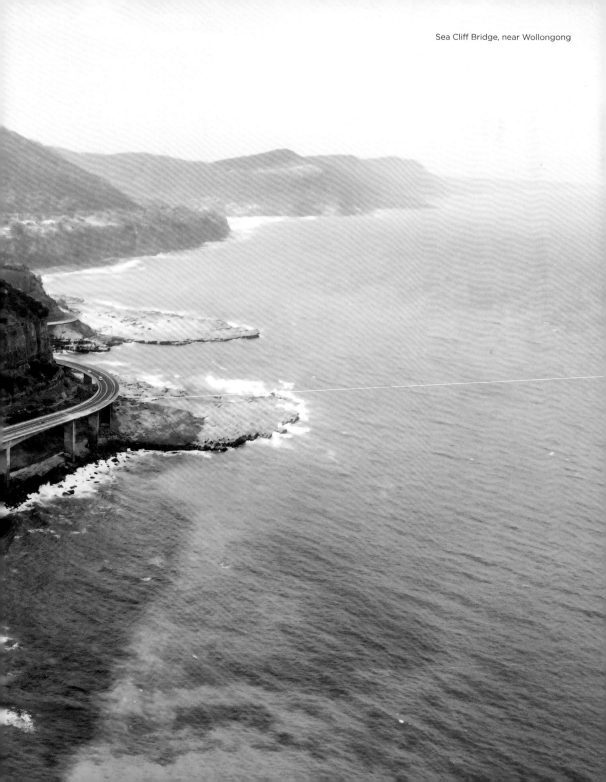

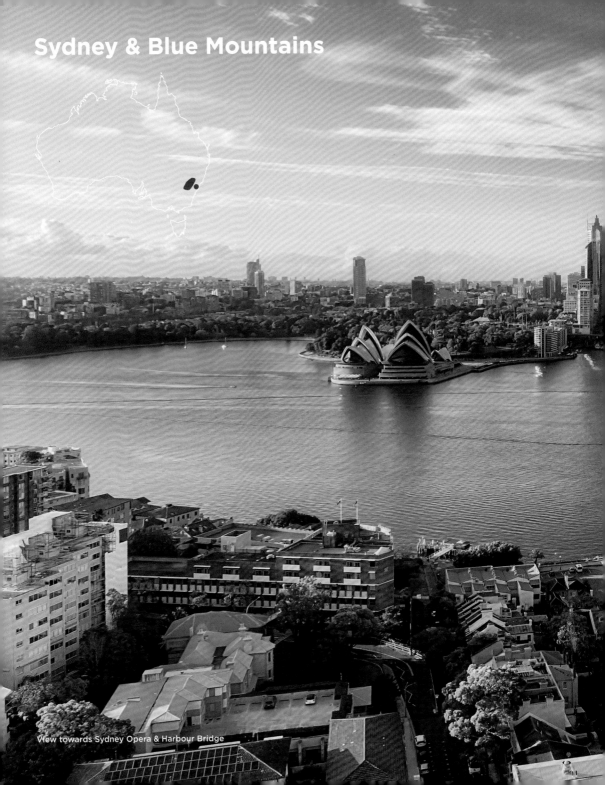

Sydney & Blue Mountains

View towards Sydney Opera & Harbour Bridge

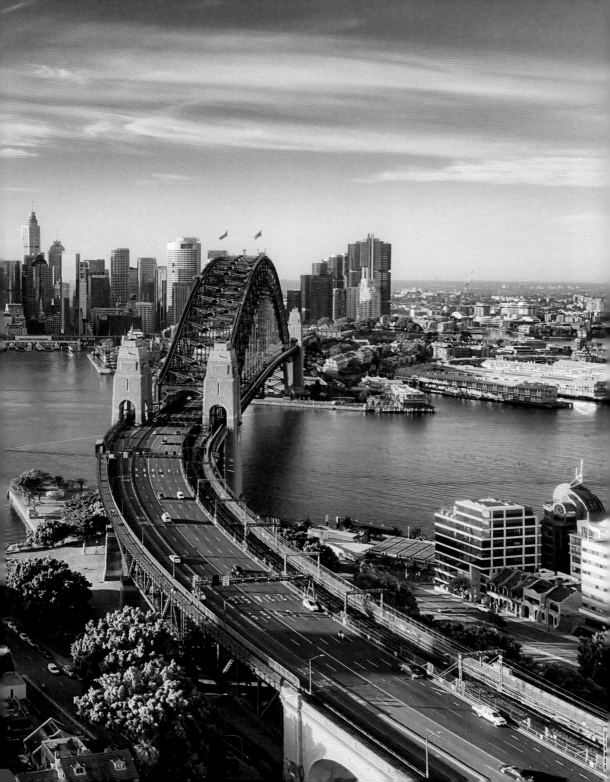

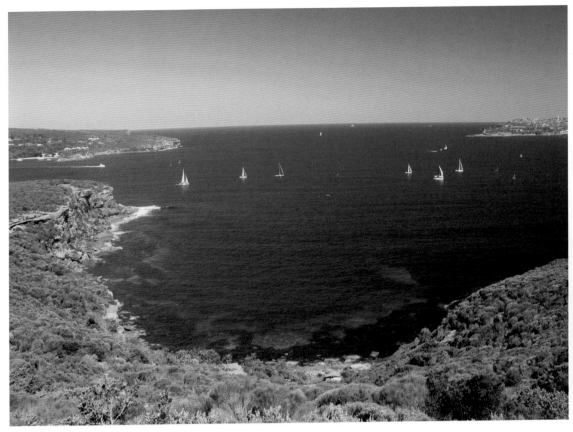

North Head & South Head (The Heads), Entrance to Sydney Harbour

Sydney & Blue Mountains

Australia's largest city is also its most beautiful. A tight clutch of skyscrapers marks the city centre, but it's the harbour—considered the world's finest—that is its true heart and its beaches and bays, foreshore parks and steep inner city streets where Sydneysiders spend their free time. Day or night, winter or summer, it's a hedonistic place.

Sydney & les Blue Mountains

La plus grande ville d'Australie est aussi sa plus belle. Le centre-ville est cerclé de gratte-ciels, mais c'est surtout son port – considéré comme l'un des plus charmants du monde – qui constitue son véritable cœur, avec ses plages et ses baies, ses parcs et ses rues escarpées où les habitants passent leur temps libre. De jour comme de nuit, d'hiver comme d'été, l'endroit semble dédié au plaisir.

Sydney & Blue Mountains

Australiens größte Stadt ist auch die schönste. Das Stadtzentrum ist zwar durch eine Reihe von Wolkenkratzern nicht zu übersehen, aber es ist der Hafen – der als der schönste der Welt gilt– der das wahre Herz der Stadt ist. Es sind die Strände, Buchten, und die Parks auf den Landzungen, die steil abfallenden Innenstadtstraßen, in denen die Bewohner Sydneys ihre Freizeit verbringen. Tag oder Nacht, Winter oder Sommer, es ist ein hedonistischer Ort.

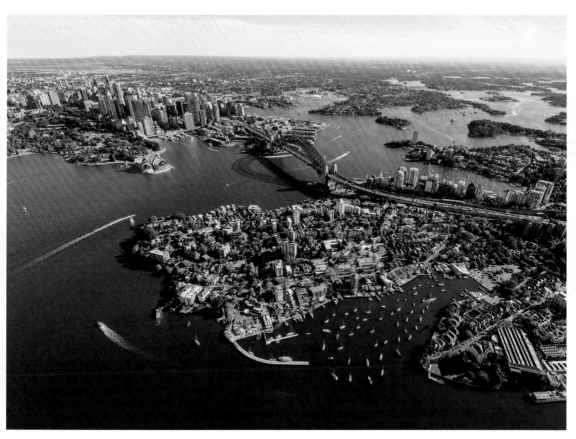

Aerial View of Sydney Harbour

Sydney & Blue Mountains

La ciudad más grande de Australia es también la más hermosa. El centro de la ciudad está marcado por una serie de rascacielos, pero es el puerto, considerado el mejor del mundo, es el auténtico centro de la ciudad, con sus playas y bahías, parques costeros y empinadas calles del centro de la ciudad donde los habitantes de Sídney pasan su tiempo libre. De día o de noche, en invierno o en verano, es un lugar para disfrutar.

Sydney & Blue Mountains

La città più grande dell'Australia è anche la più bella. Una folta schiera di grattacieli demarca il centro cittadino, ma è il porto – considerato il più bello al mondo – che ne costituisce il vero cuore, così come le sue spiagge e baie, I parchi costieri e le ripide vie del centro città, dove gli abitanti di Sydney trascorrono il loro tempo libero. Di giorno o di notte, d'inverno o d'estate, questo è il luogo edonistico per eccellenza.

Sydney & Blue Mountains

De grootste stad van Australië is meteen ook de mooiste. Een conglomeraat van wolkenkrabbers markeert het centrum van de stad, maar de haven – beschouwd als de mooiste ter wereld – is het echte hart en daar en aan de stranden en baaien, parken langs de kust en steile straatjes in het stadshart brengen Sydneysiders hun vrije tijd door. Het is overdag en 's nachts, 's winters en 's zomers, een genotzuchtige plek.

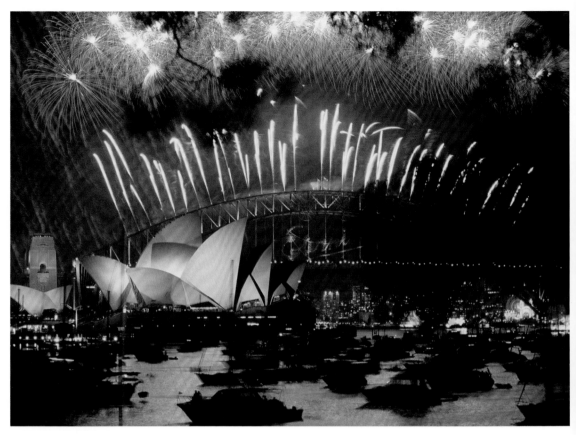

New Years Eve fireworks

New Year's Pyrotechnics

Sydney knows how to throw a party. Fireworks seem to fill the sky on many a night, but it's the annual New Year's Eve celebration that attracts a global audience of a billion or so online or via TV. After a 9 pm show for families the main pyrotechnic display kicks off at midnight. Lasting for twelve minutes to symbolize the months of the year, it costs over $ 7 million dollars and attracts a million Sydneysiders to every harbour vantage point. The Harbour Bridge is always the centre point, with a new and more spectacular design and theme each year. A constant every year is, though, a cascade of fireworks which flow directly down to the water.

Feux d'artifice du Nouvel An

Sydney sait faire la fête. Si les feux d'artifice égayent communément le ciel de la ville, c'est la célébration annuelle du Nouvel An qui plait le plus au public : environ un milliard de personnes la suivent en ligne ou à la télévision. Après un spectacle familial, à 21 h, l'attraction principale débute à minuit. D'une durée de douze minutes – symbolisant les mois de l'année – il coûte plus de 7 millions de dollars et attire un million d'habitants, parsemés le long du port. Le Harbour Bridge est toujours le point central, avec un nouveau design et un thème plus spectaculaire à chaque édition. Seule constante : tous les ans, une cascade de feux d'artifice s'écoule directement dans l'eau.

Neujahrsfeuerwerk

Sydney weiß, wie man eine Party schmeißt. Feuerwerke scheinen in vielen Nächten den Himmel zu füllen, aber es ist die jährliche Silvesterfeier, die ein globales Publikum von etwa einer Milliarde Menschen anzieht, online oder über das Fernsehen. Nach einer Familienshow um 21 Uhr beginnt um Mitternacht die pyrotechnische Show. Zwölf Minuten lang, um die Monate des Jahres zu symbolisieren, kostet es über 7 Millionen Dollar und zieht eine Million Menschen an jeden Hafenaussichtspunkt. Die Harbour Bridge ist immer der Mittelpunkt, mit einem immer neuen und spektakuläreren Design und Thema jedes Jahr.

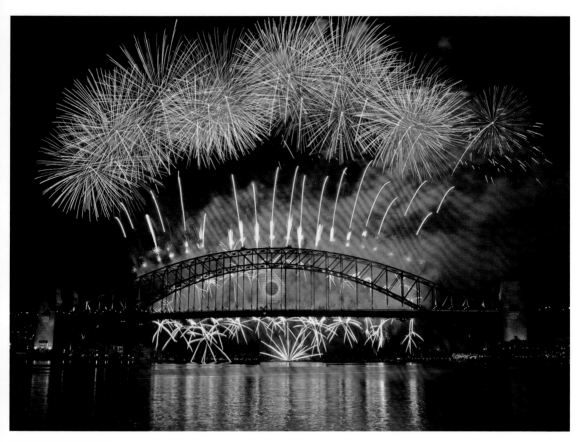

New Years Eve fireworks

Fuegos artificiales de Año Nuevo

Sídney sabe cómo celebrar. Los fuegos artificiales parecen llenar el cielo en muchas noches, pero es la celebración anual de Nochevieja la que atrae a una público global de más o menos mil millones de personas que siguen el evento en línea o a través de la televisión. El principal espectáculo pirotécnico comienza a la medianoche, después de un espectáculo para las familias a las 21:00 horas. Su duración es de doce minutos para simbolizar los meses del año, cuesta más de 7 millones de dólares y atrae a un millón de habitantes de Sídney a los miradores del puerto. El puente del puerto es siempre el punto neurálgico, con un nuevo diseño aún más espectacular y un tema que varía cada año. Sin embargo, la cascada de fuegos artificiales que fluyen directamente al agua es un clásico.

Fuochi d'artificio di Capodanno

Sydney sa come festeggiare. I fuochi d'artificio sembrano riempire il cielo di notte in molte occasioni, ma è la festa annuale di Capodanno che attira gente da tutto il mondo, un miliardo di persone circa che la seguono online o in televisione. Dopo lo spettacolo delle 21 per le famiglie, il principale spettacolo pirotecnico prende il via a mezzanotte. A simboleggiare i mesi dell'anno dura dodici minuti, costa oltre 7 milioni di dollari e attira un milione di persone che si distribuiscono per i vari punti panoramici del porto. Con un design e un tema nuovi e sempre più spettacolari di anno in anno, l'Harbour Bridge è sempre l'attrazione maggiore della notte. Ogni anno una cascata di fuochi d'artificio scende direttamente in acqua.

Vuurwerk

Sydney weet hoe je een feestje moet vieren. Vuurwerk lijkt de hemel op menig avond te vullen, maar de jaarlijkse nieuwjaarsviering wordt wereldwijd door circa 1 miljard mensen online of op tv gekeken. Na een voorstelling voor gezinnen om 21.00 uur begint om middernacht de belangrijkste pyrotechnische voorstelling. Die duurt twaalf minuten, om de maanden van het jaar te symboliseren, kost meer dan 7 miljoen dollar en trekt een miljoen Sydneysiders naar alle havenuitkijkpunten. De Harbour Bridge is altijd het middelpunt, maar elk jaar is er een nieuw en spectaculairder ontwerp en thema.

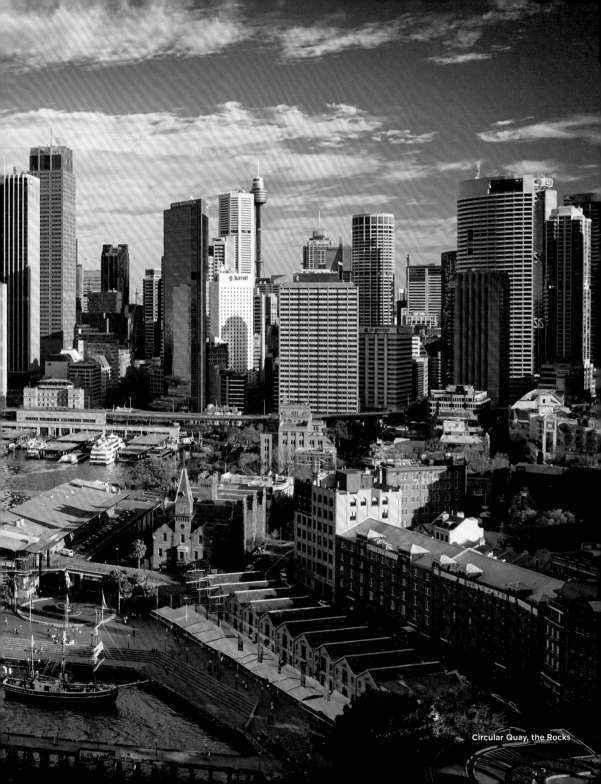
Circular Quay, the Rocks

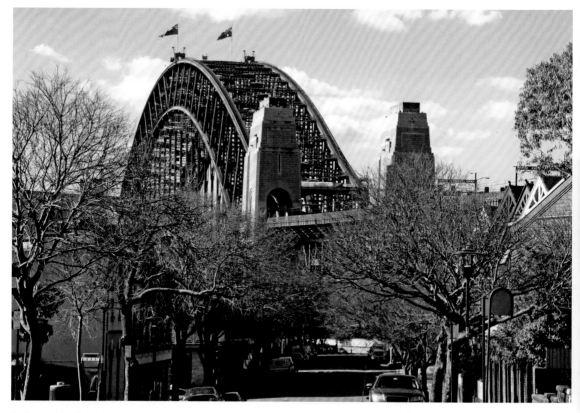

Harbour Bridge from The Rocks

Harbour Bridge

Known by its nickname 'the coathanger', or more often just 'the Bridge', the iconic span joins the Central Business District CBD with the North Shore. It was opened in 1932 and is still the world's tallest steel arch bridge. A popular experience for visitors is BridgeClimb, which takes climbers either to the top of the bridge along the upper arch, or along the shorter inner arch.

Harbour Bridge

Conocido por su apodo "el perchero", o más a menudo simplemente "el puente", la icónica estructura une el Central Business District (CBD) con la costa norte. Fue inaugurado en 1932 y sigue siendo el puente de arco de acero más alto del mundo. *BridgeClimb* es una experiencia popular para los visitantes que lleva a los escaladores a la cima del puente a lo largo del arco superior o a lo largo del arco interior más corto.

Harbour Bridge

Connue sous son surnom de « Coathanger » (« le cintre »), ou plus souvent de « The Bridge » (« le pont »), l'emblématique Harbour Bridge relie le centre des affaires à la rive nord. Inauguré en 1932, il est toujours le plus haut pont en arche d'acier du monde. *BridgeClimb* propose aux visiteurs de grimper à son sommet via les arches supérieure ou inférieure : une expérience très populaire.

Harbour Bridge

Conosciuto con il soprannome di "appendiabiti" o anche solo come "il ponte", l'iconica campata unisce il Central Business District (o CBD) con la North Shore. Inaugurato nel 1932, è ancora oggi il ponte ad arco in acciaio più alto del mondo. Un'esperienza popolare per i visitatori è il *BridgeClimb*, che permette agli scalatori di arrampicarsi sia lungo l'arco superiore che lungo quello interno più corto.

Harbour Bridge

Als „Kleiderbügel" oder auch nur „die Brücke" bekannt, verbindet sie den Central Business District (CDB) mit dem North Shore (Sydneys Nordufer). Im Jahr 1932 eröffnet, ist sie die höchste Stahlbogenbrücke der Welt. Ein beliebtes Erlebnis für Besucher ist der *BridgeClimb*, der die Kletterer entweder auf die Spitze der Brücke entlang des oberen Bogens oder entlang des kürzeren Innenbogens führt.

Harbour Bridge

Bekend onder zijn bijnaam 'de kapstok', of vaker gewoon 'de brug', verbindt deze brug het Central Business District (CDB) met Sydney's North Shore. Hij werd geopend in 1932 en is nog steeds de hoogste stalen boogbrug ter wereld. Een populaire ervaring voor bezoekers is de *BridgeClimb*, die klimmers langs de bovenste boog of langs de kortere binnenste boog naar de top van de brug brengt.

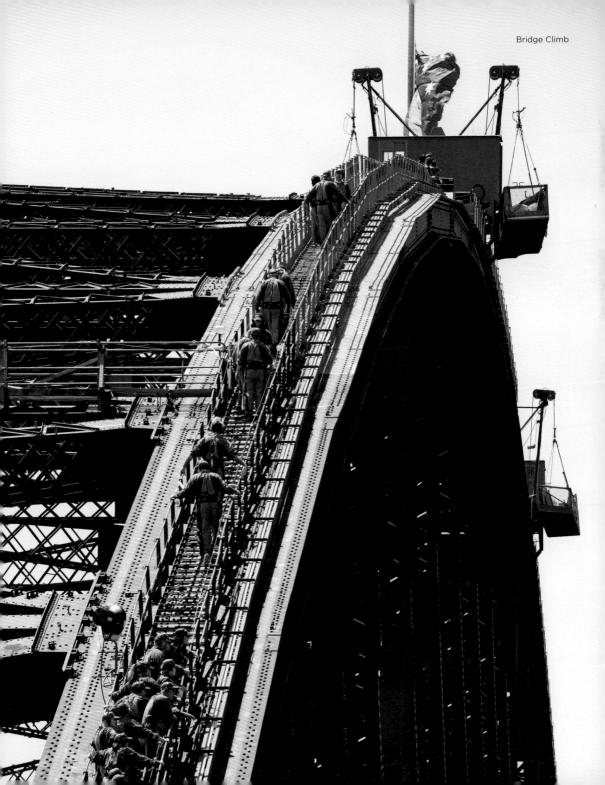

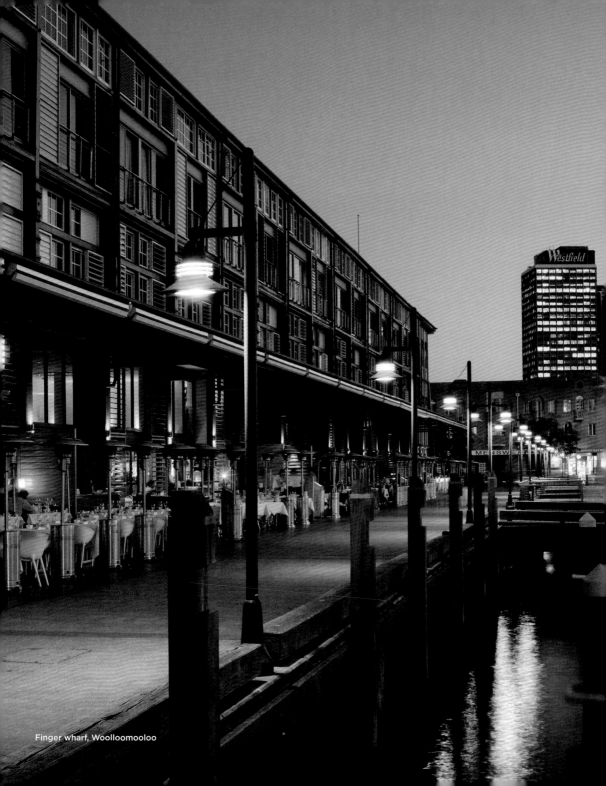

Finger wharf, Woolloomooloo

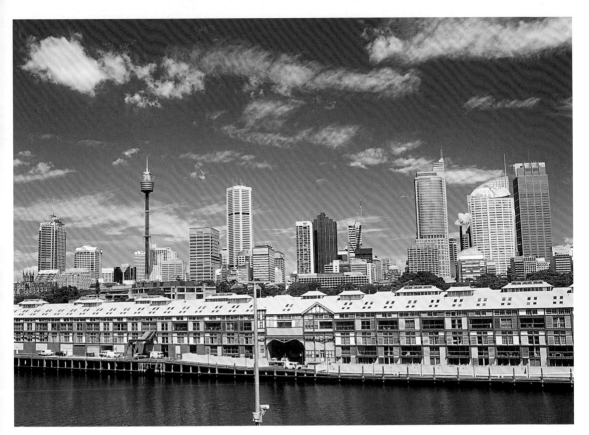

Finger wharf, Woolloomooloo

Finger Wharf

Otherwise known by the glorious moniker of *Woolloomooloo Wharf*, Finger Wharf is, at 410 m, the longest timber-piled wharf in the world. It opened in 1915 and for almost seven decades, Australian soldiers departed for war from here, and migrants first stepped ashore on the wharf. It now houses a hotel, restaurants and apartments.

Finger Wharf

También conocido por el glorioso apodo de *Woolloomooloo Wharf*, el muelle de Finger es, con sus 410 m, el muelle apilado de madera más largo del mundo. Se inauguró en 1915 y durante casi siete décadas, los soldados australianos partieron de aquí para la guerra, y los migrantes desembarcaron por primera vez en el muelle. Actualmente alberga un hotel, restaurantes y apartamentos.

Finger Wharf

Connu également sous le glorieux nom de *Woolloomooloo Wharf*, Finger Wharf est, avec ses 410 m, le plus long quai en bois du monde. Il a ouvert ses portes en 1915 ; les migrants y ont d'abord débarqué, puis, pendant près de sept décennies, il a été le point de départ des soldats australiens en partance pour la guerre. Il abrite aujourd'hui un hôtel, des restaurants et des appartements.

Finger Wharf

Conosciuto anche con il glorioso soprannome di *Woolloomooloo Wharf*, con la sua struttura di 410 m Finger Wharf è il molo in legno più lungo al mondo. Inaugurato nel 1915, per quasi sette decenni i soldati australiani in partenza per le guerre si sono imbarcati da qui ed è qui che i migranti mettevano piede per la prima volta sul suolo australiano. Oggi ospita un hotel, ristoranti e appartamenti.

Finger Wharf

Finger Wharf, auch bekannt als *Woolloomooloo Wharf*, ist mit 410 m der längste Fachwerk-Kai der Welt. Seit seiner Eröffnung 1915 zogen fast sieben Jahrzehnte lang australische Soldaten von hier aus in den Krieg, und Migranten setzten hier den ersten Fuß an Land. Heute beherbergt es ein Hotel, Restaurants und Appartements.

Finger Wharf

Finger Wharf, ook wel bekend als *Woolloomooloo Wharf*, is met 410 m de langste werf op houten palen ter wereld. Hij werd in 1915 geopend en gedurende bijna 70 jaar vertrokken Australische soldaten hiervandaan naar oorlogsgebieden, en zetten migranten hier voor het eerst voet aan wal. Er zitten nu een hotel, restaurants en appartementen in.

HOTEL CENTENNIA

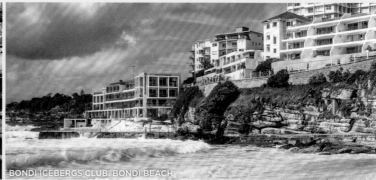

BONDI ICEBERGS CLUB, BONDI BEACH

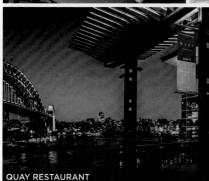

QUAY RESTAURANT

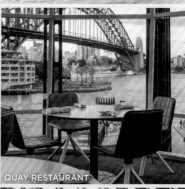

QUAY RESTAURANT

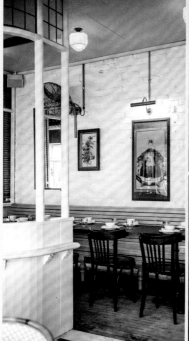

QUEEN CHOW

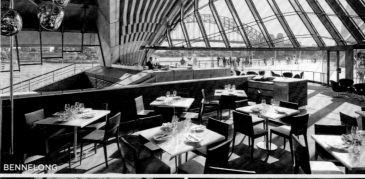

BENNELONG

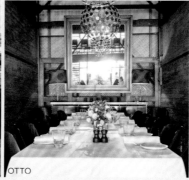

OTTO

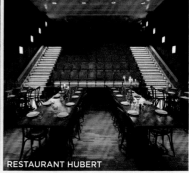

RESTAURANT HUBERT

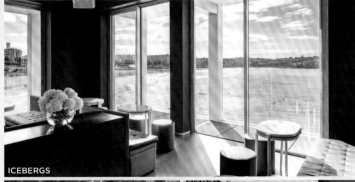

ICEBERGS

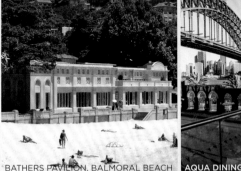

BATHERS PAVILION, BALMORAL BEACH

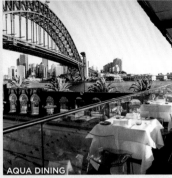

AQUA DINING

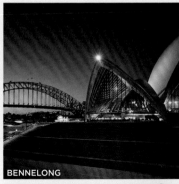

BENNELONG

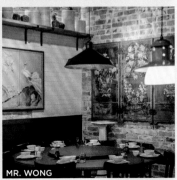

MR. WONG

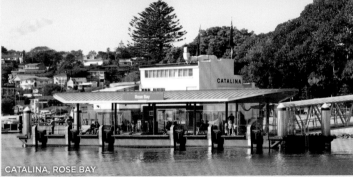

CATALINA, ROSE BAY

Restaurants

Sydney has a vibrant scene where international trends, the techniques of kitchens from around the world and stellar local produce mix. Fine dining places offer up tables with water views, a succession of edgy degustation dishes and pour stratospherically priced wine, while low key places in the inner city highlight boutique ingredients, natural wines and a casual familiarity.

Restaurants

Sydney possède une scène gastronomique vibrante où se mêlent tendances internationales, techniques du monde entier et produits locaux. Les restaurants huppés offrent des tables avec vue sur l'eau, une succession de plats et de vins à prix stratosphériques, tandis que les endroits discrets du centre-ville mettent l'accent sur les ingrédients, les vins naturels et une ambiance familiale.

Restaurants

In Sydneys pulsierender Restaurant-Szene vermischen sich internationale Trends, Küchentraditionen aus aller Welt mit hervorragenden lokalen Produkten. Gehobene Restaurants bieten Tische mit Blick auf das Wasser, eine Reihe von ausgefallenen Gerichten und exquisite Weine, während einfache Locations in der Innenstadt mit besonderen Zutaten und einer ungezwungenen Vertrautheit punkten.

Restaurantes

Sídney tiene una escena vibrante donde se mezclan las tendencias internacionales, las técnicas de las cocinas de todo el mundo y los productos locales estelares. Los restaurantes de lujo ofrecen mesas con vistas al agua, una sucesión de platos de degustación y catas de vino a precios estratosféricos, mientras que en los lugares más sencillos del centro del centro destacan los ingredientes especiales, los vinos naturales y una familiaridad casual.

Ristoranti

La scena gastronomica di Sydney è molto dinamica. Qui si mescolano trend internazionali, tradizioni culinarie da tutto il mondo e eccellenti prodotti locali. Raffinati ristoranti offrono tavoli con vista sull'acqua, un'infinità di piatti variegati e vini squisiti, mentre i locali più semplici del centro cercano di farsi notare con ingredienti ricercati e l'atmosfera informale e familiare.

Restaurants

Sydney heeft een levendige restaurantscene waar internationale trends, culinaire technieken uit de hele wereld en fantastische lokale producten zich mengen. Verfijnde eetgelegenheden bieden tafels met uitzicht op het water, een opeenvolging van spannende gerechtjes en astronomisch geprijsde wijnen, terwijl eenvoudigere zaakjes in de binnenstad scoren met hippe ingrediënten en een ongedwongen vertrouwdheid.

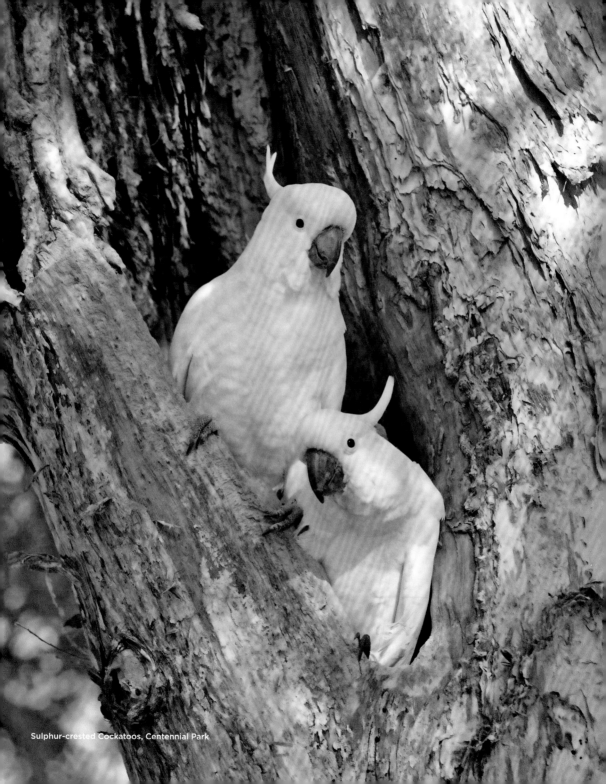
Sulphur-crested Cockatoos, Centennial Park

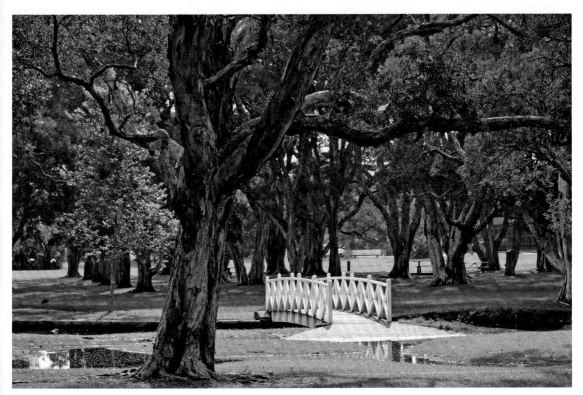

Centennial Park

Centennial Park

One of Sydney's largest inner-city green spaces, Centennial Park is a 2.2 km² collection of pasture and lightly wooded spaces, built on a former swamp. It's Victorian design also contains ponds, avenues, sporting fields and formal gardens and it's a favourite for dog walking and horseriding. It was also the site of Australia's formal inauguration as a nation.

Centennial Park

Centennial Park, uno de los espacios verdes más grandes del centro de Sídney, es una colección de zonas verdes y espacios ligeramente arbolados de 2,2 km², construido sobre un antiguo pantano. Su diseño victoriano también incluye estanques, avenidas, campos deportivos y jardines formales y es una de las zonas de las preferidas para pasear perros y montar a caballo. También fue el lugar de la inauguración formal de Australia como nación.

Parc du Centenaire

L'un des plus grands espaces verts du centre-ville de Sydney, le parc Centennial, est un ensemble de 2,2 km² de pâturages et d'espaces légèrement boisés, construit sur un ancien marais. Sa conception victorienne comprend également des étangs, des avenues, des terrains de sport et des jardins à la française et c'est un endroit privilégié pour la promenade canine et l'équitation. C'est aussi là que l'Australie a été officiellement inaugurée en tant que nation.

Centennial Park

Uno dei più grandi spazi verdi del centro di Sydney, il Centennial Park, è un insieme di pascoli e spazi leggermente boscosi, che si estende su 2,2 km² su quella che un tempo era una palude. Il parco in stile vittoriano comprende stagni, viali, campi sportivi nonché giardini all'italiana ed è uno dei luoghi preferiti per passeggiate a piedi e a cavallo. È stato anche il luogo della fondazione ufficiale dell'Australia come nazione.

Centennial Park

Der Centennial Park, mit 2,2 km² die größte Grünfläche der Stadt, ist angelegt auf einem ehemaligen Sumpf. Das viktorianische Design umfasst auch Teiche, Alleen, Sportplätze und formale Gärten und ist ein Favorit für Ausflüge zu Pferd oder mit dem Hund. Es war auch der Ort der offiziellen Gründung Australiens als Nation.

Centennial Park

Centennial Park, met 2,2 km² het grootste groengebied in de binnenstad van Sydney, is aangelegd op een voormalig moeras. Het victoriaanse ontwerp omvat ook vijvers, lanen, sportvelden en formele tuinen en het is een populair gebied om honden uit te laten en paard te rijden. Het was ook de plaats van de formele inauguratie van Australië als natie.

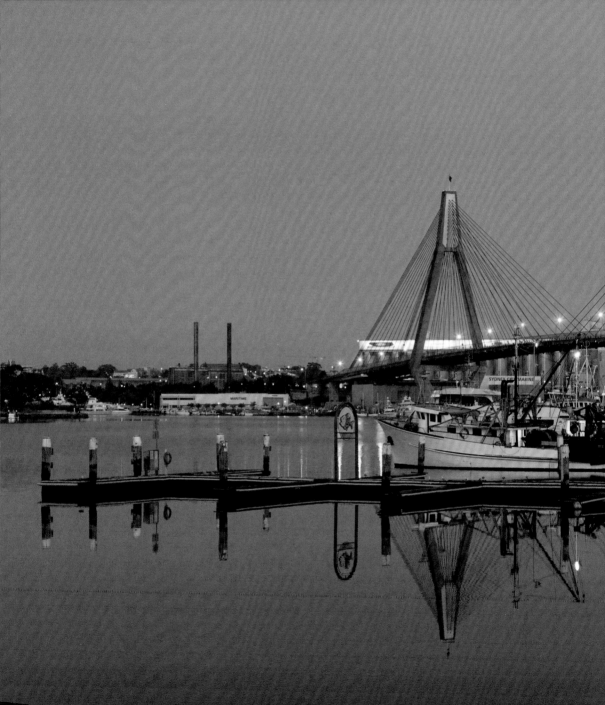

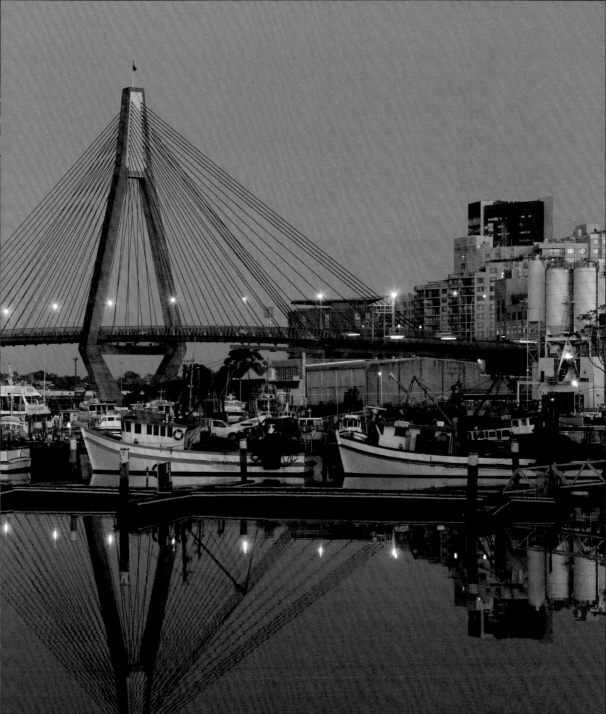

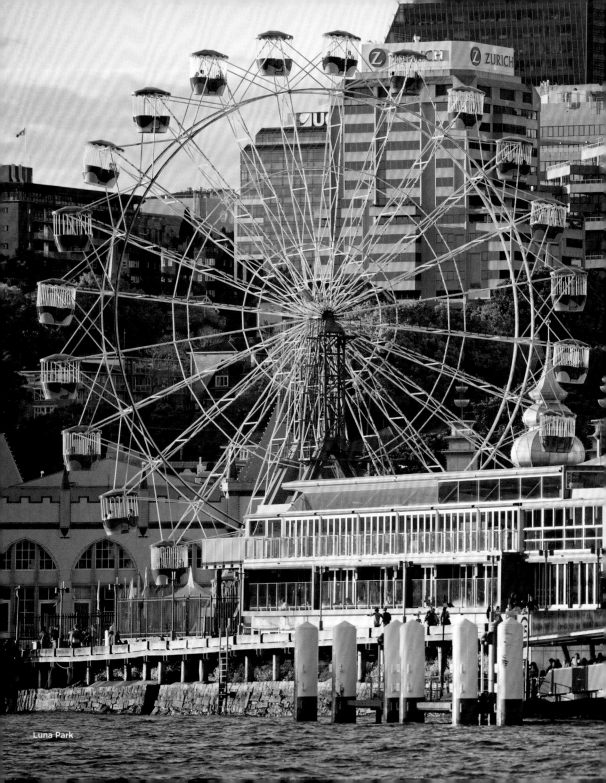

Luna Park

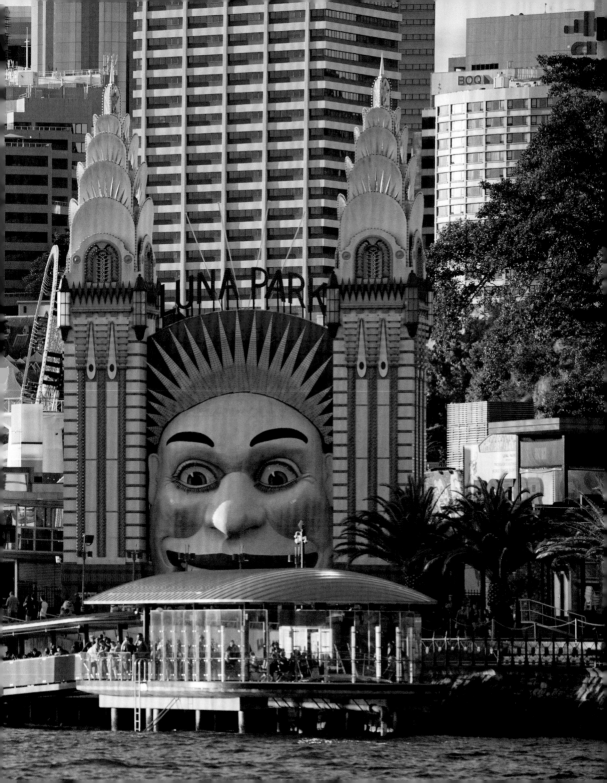

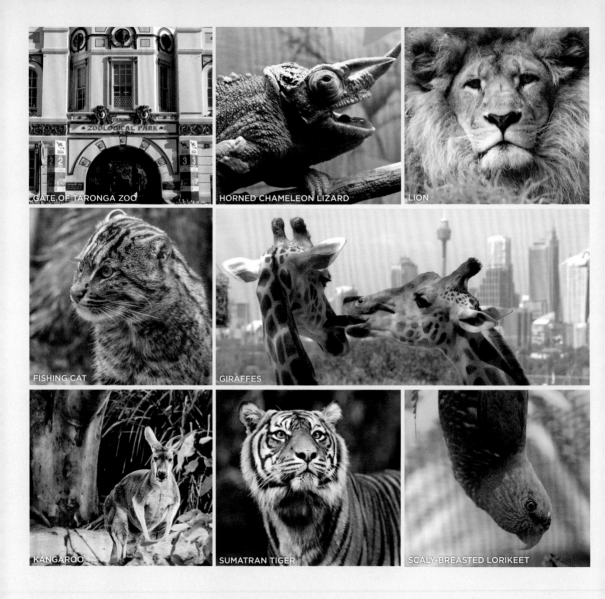

GATE OF TARONGA ZOO

HORNED CHAMELEON LIZARD

LION

FISHING CAT

GIRAFFES

KANGAROO

SUMATRAN TIGER

SCALY-BREASTED LORIKEET

Taronga Zoo

This century old zoo sits on a series of dramatic tumbling terraces over looking the harbour, a 15-minute ferry ride from the centre. Its over 4000 animals include a large number of native species, from koalas and quokka, to kangaroos and platypus, sea lions, seals and penguins, along with international guests like giraffes, pandas, lions and elephants.

Zoo de Taronga

Ce zoo centenaire est situé sur une série de terrasses spectaculaires surplombant le port, à 15 minutes en ferry du centre. Parmi ses plus de 4000 animaux, on trouve un grand nombre d'espèces indigènes – des koalas et quokkas aux kangourous et ornithorynques, en passant par des otaries, des phoques et des pingouins, ainsi que des hôtes internationaux comme des girafes, pandas, lions et éléphants.

Taronga Zoo

Dieser über 100 Jahre alte Zoo liegt auf einer Reihe von dramatischen, stürzenden Terrassen mit Blick auf den Hafen, eine 15-minütige Fährfahrt vom Zentrum entfernt. Zu den über 4000 Tieren gehören neben einheimischer Arten, von Koalas und Quokka über Kängurus, Schnabeltiere, Seelöwen, Robben und Pinguine bis hin zu internationalen Gästen wie Giraffen, Pandas, Löwen und Elefanten.

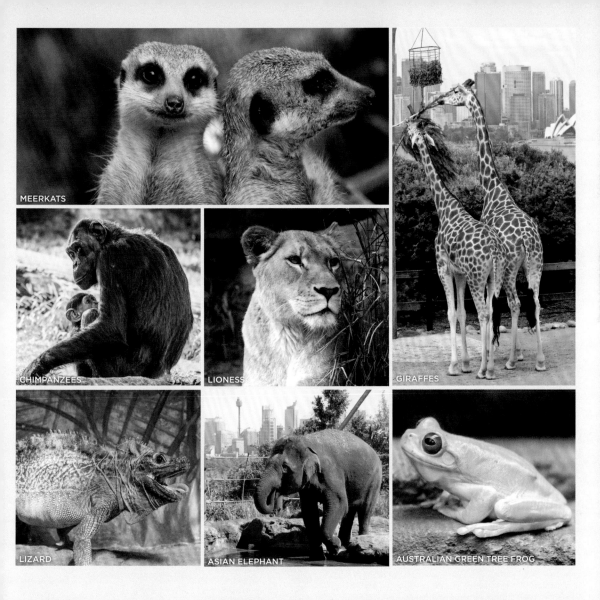

MEERKATS

CHIMPANZEES

LIONESS

GIRAFFES

LIZARD

ASIAN ELEPHANT

AUSTRALIAN GREEN TREE FROG

Taronga Zoo

Este zoológico centenario se encuentra en una serie de espectaculares terrazas con vistas al puerto, a 15 minutos en ferri desde el centro. Entre sus más de 4.000 animales se incluyen un gran número de especies nativas, desde koalas y quokka, hasta canguros y ornitorrincos, lobos marinos, focas y pingüinos, junto con especies internacionales como jirafas, pandas, leones y elefantes.

Taronga Zoo

Questo zoo centenario si trova su una serie di spettacolari terrazze che si affacciano sul porto, a 15 minuti di traghetto dal centro. Tra i suoi oltre 4.000 animali è presente un numero notevole di specie autoctone, tra cui koala e quokka, canguri e ornitorinchi, leoni marini, foche e pinguini, oltre a ospiti internazionali come giraffe, panda, leoni ed elefanti.

Taronga Zoo

Deze meer dan een eeuw oude dierentuin ligt op een reeks dramatisch afhangende terrassen met uitzicht over de haven, op 15 minuten varen met de pont van het centrum. Tot de ruim 4.000 dieren behoren veel inheemse soorten, van koala's en quokka's tot kangoeroes en vogelbekdieren, zeeleeuwen, zeehonden en pinguïns. Daarnaast zijn er internationale gasten zoals giraffen, panda's, leeuwen en olifanten.

Sydney to Hobart Yacht Race

Boxing Day (the day following Christmas) sees one of Sydney Harbour's most spectacular occasions: the starting line of a 630 nautical mile race south to Tasmania's capital Hobart. It's widely considered the most difficult race in the world and attracts a flotilla of international super maxi yachts. Spectators line the foreshore, take to the harbour in small craft, or vie for tickets aboard the Manly ferry to catch the start.

Course de voiliers de Sydney à Hobart

Le lendemain de Noël a lieu l'un des événements les plus spectaculaires du port de Sydney : on y donne le départ d'une course de 630 miles vers Hobart, la capitale de la Tasmanie, au sud. Largement considérée comme la course la plus difficile au monde, elle attire une flotte d'énormes voiliers internationaux. Les spectateurs s'amassent sur le littoral, se rendent au port à bord de petites embarcations ou se disputent des places à bord du ferry Manly pour y admirer le départ depuis la baie.

Sydney-Hobart-Regatta

Am Tag nach Weihnachten findet eines der spektakulärsten Ereignisse im Hafen von Sydney statt: der Start des 630 Seemeilen langen Rennens zur tasmanischen Hauptstadt Hobart. Es gilt als das schwierigste Rennen der Welt und zieht eine Flotte von internationalen Super-Maxi-Yachten an. Die Zuschauer säumen das Vorland, fahren mit kleinen Booten zum Hafen oder kämpfen um Tickets an Bord der Manly-Fähre.

Carrera de yates de Sídney a Hobart

El *Boxing Day* (el día después de Navidad) es uno de los eventos más espectaculares del puerto de Sídney: allí de da el pistoletazo a una carrera de 630 millas náuticas hacia el sur, hasta la capital de Tasmania, Hobart. Esta regata está considerada como la más difícil del mundo y atrae a una flotilla de yates internacionales de grandes dimensiones. Los espectadores se alinean en la playa, se dirigen al puerto en pequeñas embarcaciones o compiten por las entradas a bordo del ferri hacia Manly.

Regata Sydney-Hobart

Il giorno di Santo Stefano (*Boxing Day* in inglese) prende avvio una delle manifestazioni più spettacolari del porto di Sydney: la regata di 630 miglia nautiche, verso sud, in direzione della capitale della Tasmania, Hobart. Questa è considerata la regata più difficile al mondo e attira una flotta di potenti maxi-yacht internazionali. Gli spettatori si dispongono lungo la battigia, giungono al porto su piccole imbarcazioni o si contendono i biglietti a bordo del traghetto Manly per assistere alla partenza.

Race van Sydney naar Hobart

Op tweede kerstdag vindt in de haven een van de spectaculairste evenementen van Sydney plaats: de start van een race over 630 zeemijl zuidwaarts naar de hoofdstad van Tasmanië, Hobart. Hij geldt algemeen als de moeilijkste race ter wereld en trekt een vloot internationale super-maxi-jachten aan. Toeschouwers staan langs de oever, gaan met kleine bootjes naar de haven of vechten om kaartjes aan boord van de Manly-veerboot.

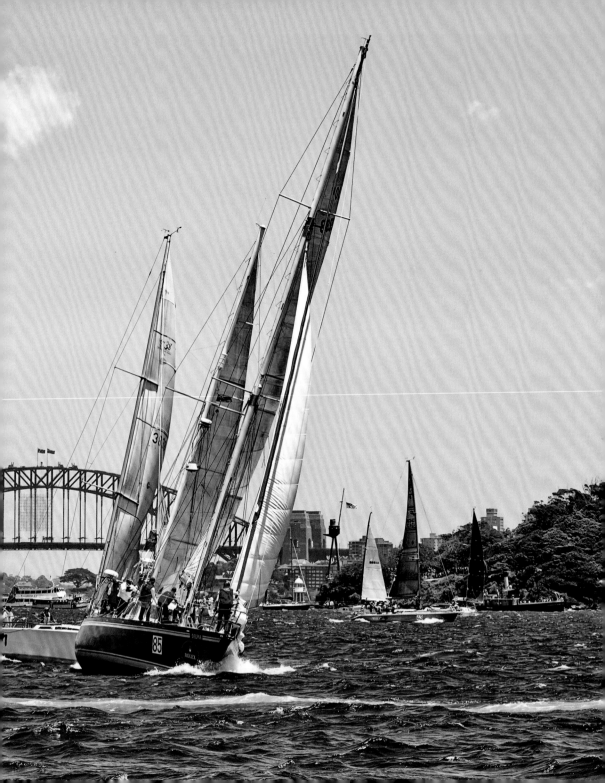

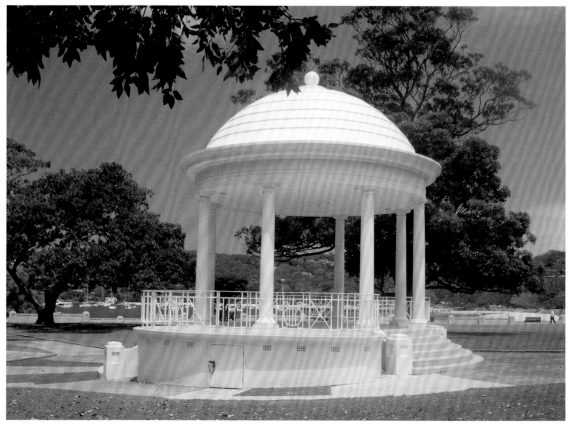

Rotunda at Balmoral Beach

Balmoral

On Sydney's Lower North Shore, what is known as Balmoral Beach actually consists of two beaches—Balmoral and Edwards. Property prices around here are some of the highest in Sydney, thanks to its genteel atmosphere and harborfront views, including towards Manly. The sense of an upscale beach resort from another age is enhanced by the layout and numerous buildings dating back to the 1930s—the esplanade, promenade, Rotunda and Bathers' Pavilions are all heritage-listed and protected as part of a local conservation area. It was named after Balmoral Castle in Scotland.

Balmoral

Sur le littoral inférieur du nord de Sydney, Balmoral Beach se compose en fait de deux plages – Balmoral et Edwards. Les prix de l'immobilier y sont parmi les plus élevés de Sydney, grâce à son atmosphère raffinée et ses vues sur le port, y compris vers Manly. L'atmosphère de station balnéaire haut de gamme d'un autre âge est renforcée par l'aménagement et les nombreux bâtiments datant des années 1930 – l'esplanade, la promenade, la rotonde et les pavillons des baigneurs sont tous classés au patrimoine et protégés en tant que zone de conservation locale. Le lieu tient son nom du château de Balmoral en Écosse.

Balmoral

An Sydneys Lower North Shore besteht der so genannte Balmoral Beach aus zwei Stränden – Balmoral und Edwards. Die Immobilienpreise hier gehören zu den höchsten der Stadt, dank der noblen Atmosphäre, der Aussicht auf den Hafen und Manly. Das Gefühl eines gehobenen Badeortes aus einer anderen Epoche wird durch die zahlreichen Gebäude aus den 1930er-Jahren verstärkt – die Esplanade, Promenade, Rotunde und die Badepavillons stehen unter Denkmalschutz und sind als Teil eines lokalen Naturschutzgebietes geschützt. Benannt wurde der Ort nach Balmoral Castle in Schottland.

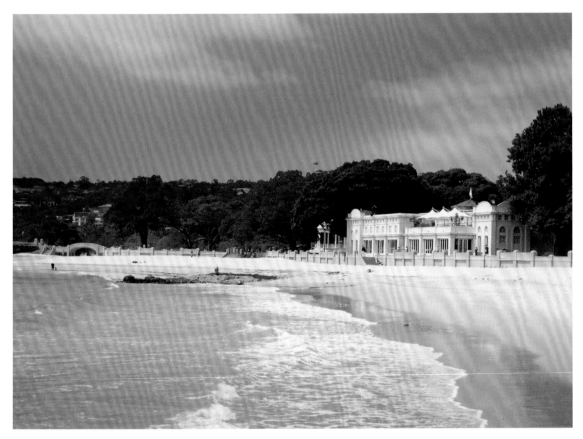

Bather's Pavilion Restaurant, Balmoral Beach

Balmoral

En la costa norte baja de Sídney, la denominada playa Balmoral consta en realidad de dos playas: Balmoral y Edwards. Los precios de las propiedades inmobiliarias por aquí son de los más altos de Sídney gracias a su elegante atmósfera y a las vistas del puerto, incluso a Manly. La distribución y los numerosos edificios que datan de los años 30, como la explanada, el paseo marítimo, la rotonda y los pabellones de los bañistas, son patrimonio de la ciudad y están protegidos como parte de un área de conservación local. Su nombre se debe al Castillo de Balmoral en Escocia.

Balmoral

La Lower North Shore di Sydney, quella che è conosciuta come Balmoral Beach, consiste in realtà di due spiagge – Balmoral e Edwards. Per via della sua atmosfera signorile e della vista sul porto, i prezzi degli immobili qui intorno e in direzione di Manly sono tra i più alti di Sydney. Il fascino da località balneare di lusso di un'altra epoca è reso ancora più evidente dalla posizione e dai numerosi edifici risalenti agli anni '30 del secolo scorso – quelli della "Esplanade" e sul lungomare, così come la rotonda e i padiglioni dei bagnanti sono tutti patrimonio dell'umanità e parte di un'area protetta. Il luogo prende il nome dal castello di Balmoral in Scozia.

Balmoral

Op Sydney's Lower North Shore bestaat de zogenaamde Balmoral Beach uit twee stranden: Balmoral en Edwards. Onroerendgoedprijzen hier behoren tot de hoogste van Sydney, dankzij de sfeer en het uitzicht op de haven en Manly. Het gevoel van een luxebadplaats uit een vervlogen tijd wordt versterkt door de talrijke gebouwen uit de jaren dertig: de esplanade, promenade, rotonde en strandpaviljoens staan allemaal op de monumentenlijst en worden als onderdeel van een plaatselijk natuurgebied beschermd. De plek is genoemd naar het Schotse Balmoral Castle.

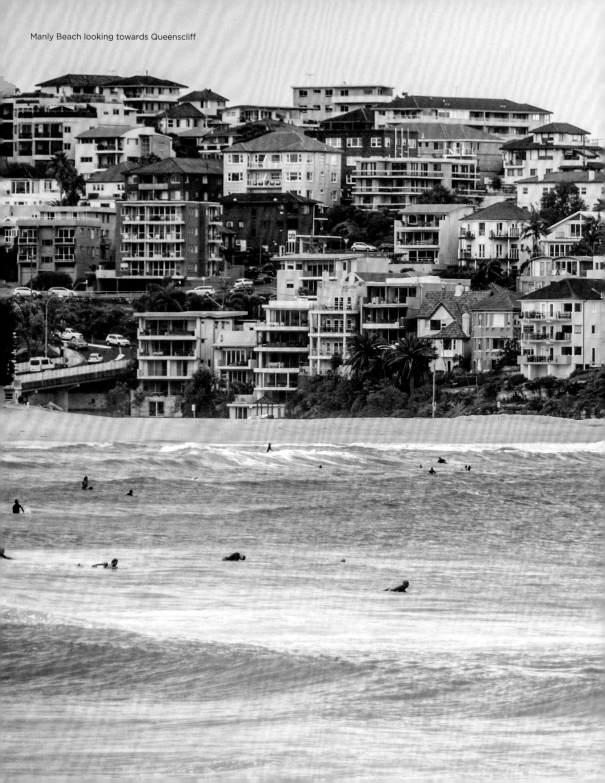

Manly Beach looking towards Queenscliff

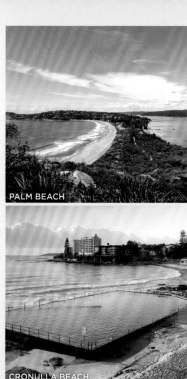
PALM BEACH

MAROUBRA BEACH

CRONULLA BEACH

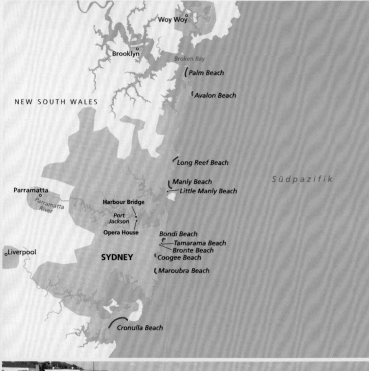

Woy Woy

Brooklyn

Broken Bay

Palm Beach

NEW SOUTH WALES

Avalon Beach

Long Reef Beach

Parramatta

Parramatta River

Manly Beach

Little Manly Beach

Südpazifik

Harbour Bridge

Port Jackson

Opera House

Bondi Beach

Tamarama Beach

Bronte Beach

SYDNEY

Coogee Beach

Liverpool

Maroubra Beach

Cronulla Beach

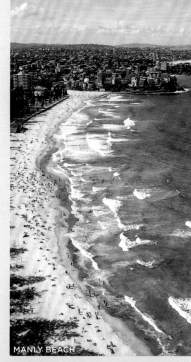
MANLY BEACH

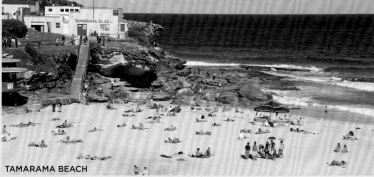
TAMARAMA BEACH

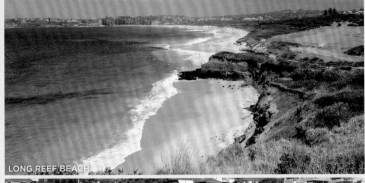

LONG REEF BEACH

LITTLE MANLY BEACH

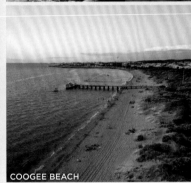

COOGEE BEACH

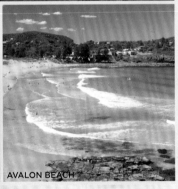

AVALON BEACH

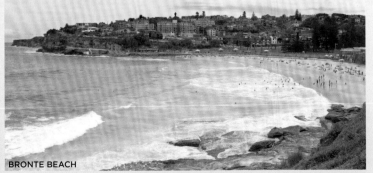

BRONTE BEACH

Surfing

Bondi Beach is Australia's most famous beach, with a perfect arc of sand, and some good breaks. Bronte Beach, just south of Bondi is more challenging when it comes to surfing. Manly, world-famous surf beach lies a ferry ride away from the CBD. Palm Beach is an upscale surf beach, with the best surfing at the northern end. Finally, Avalon is popular with everyone.

Surfer

Bondi Beach est la plage la plus célèbre d'Australie, avec son arc de sable parfait et ses bonnes vagues. Bronte Beach, juste au sud, est plus exigeante pour les surfeurs. La plage de Manly, célèbre dans le monde entier, se trouve à un trajet de ferry du centre-ville. Palm Beach est également une plage haut de gamme, qui offre le meilleur spot de surf de l'extrémité nord. Enfin, Avalon Beach est populaire auprès de tous.

Surfen

Bondi Beach ist Australiens berühmtester Strand, mit perfekten Sandbogen und guten *Breaks*. Bronte Beach ist eine größere Herausforderung beim Surfen. Der weltbekannte Manly Beach liegt eine Fährfahrt von der CBD entfernt. Palm Beach ist gehobener, mit dem besten Surfing am nördlichen Ende. Und Avalon ist bei allen beliebt,

Surfear

Bondi Beach es la playa más famosa de Australia, con un arco de arena perfecto y algunos buenos lugares de descanso. Bronte Beach, al sur de Bondi, es más exigente cuando se trata de surfear. Manly, la playa de surf mundialmente conocida se encuentra a un paseo en ferri del CBD. Palm Beach es una playa de surf de lujo, la mejor para surfear en el extremo norte. Finalmente, Avalon es popular entre todos.

Fare surf

Bondi Beach è la spiaggia più famosa d'Australia, con una sabbia fine lungo un arco perfetto e ottimi *break*. Bronte Beach, poco più a sud di Bondi, offre ai surfisti un litorale più impegnativo. Manly, spiaggia per il surf famosa in tutto il mondo, si trova a un traghetto di distanza dal CBD. Palm Beach è una spiaggia di lusso per il surf, con il miglior spot nella parte più a nord. Infine, Avalon è popolare tra tutti.

Surfen

Bondi Beach is het beroemdste strand van Australië, met een perfecte boog van zand en enkele goede breaks. Bronte Beach is een grotere uitdaging voor surfers. De wereldberoemde Manly Beach is met de veerboot bereikbaar van het CBD. Palm Beach is luxer, met de beste surfplekken aan de noordkant. Avalon is geliefd bij iedereen.

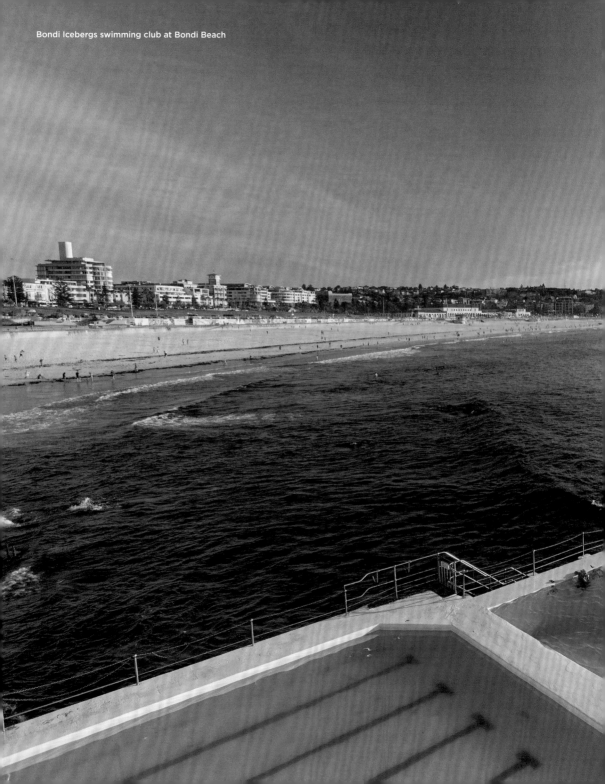

Bondi Icebergs swimming club at Bondi Beach

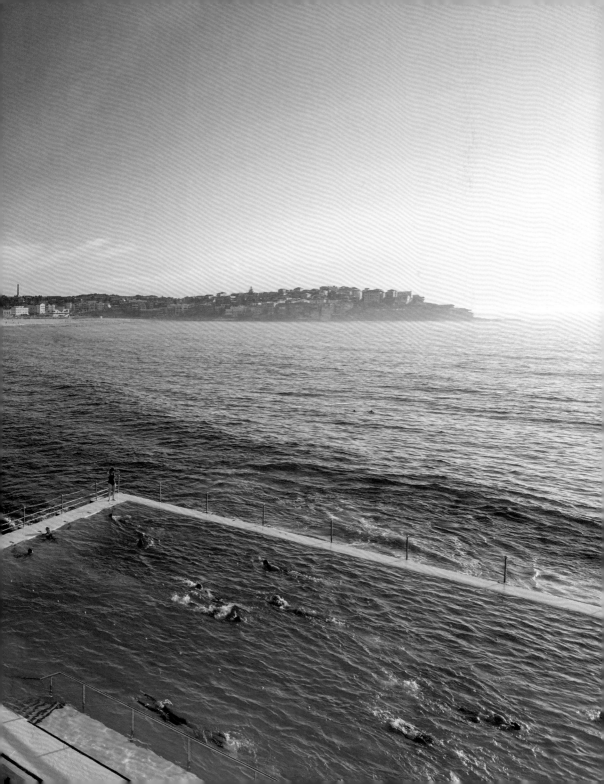

Australian Classics

Australia has a hybrid culinary history that reflects the traditions of its Anglo-Celtic colonial past, the tastes of subsequent groups of migrants from around the world and the original foraged foods and fresh produce of its indigenous people. Meat pies, Vegemite sandwiches and passionfruit-topped pavlova are old favourites that are still widely loved, though a new wave of dishes have joined them to become modern classics. These include the café stapes of smashed avocado on sourdough toast, banana bread and flat white coffees, while for lunch and dinner South-East Asian and Mediterranean dishes like noodle salads, curries and rice paper rolls or pasta, risotto, falafel or pizza pop up as often as roasts and BBQs both at home and on restaurant menus.

Classiques australiens

L'Australie a une histoire culinaire hybride, qui reflète les traditions de son passé colonial anglo-celtique, les goûts des groupes ultérieurs de migrants venus du monde entier et les aliments et produits frais d'origine, consommés par ses peuples autochtones. Les tartes à la viande, les sandwichs aux légumes et la pavlova garnie de fruits de la passion sont toujours très appréciés, mais ils ont depuis été rejoints par une nouvelle vague de plats, devenus des classiques modernes. Pour le déjeuner et le dîner, à la maison comme au restaurant, les plats d'Asie du Sud-Est et de Méditerranée, comme les salades de nouilles, les curries et les rouleaux de printemps, les pâtes, le risotto, les fallafels ou les pizzas, sont devenus aussi communs que les rôtis et les barbecues.

Australische Klassiker

Australien hat eine hybride kulinarische Geschichte, die die Traditionen seiner anglo-keltischen Kolonialzeit, den Geschmack der nachfolgenden Gruppen von Migranten aus der ganzen Welt und die ursprünglichen gesammelten Lebensmittel und frischen Produkte seiner Ureinwohner widerspiegelt. Fleischpasteten, Vegemite-Sandwiches und Passionsfrucht-Spitzen-Pavlova sind alte Favoriten, die immer noch sehr beliebt sind, obwohl eine neue Welle von Gerichten sie zu modernen Klassikern gemacht hat. Dazu gehören die zerdrückten Avocado auf Sauerteigtoast, Bananenbrot zum Milchkaffee, während zum Mittag- und Abendessen südostasiatische und mediterrane Gerichte wie Nudelsalate, Currys und Reispapierrollen oder Nudeln, Risotto, Falafel oder Pizza serviert werden wie Braten und natürlich BBQ, ob zu Hause oder im Restaurant.

Clásicos australianos

Australia tiene una historia culinaria mestiza que refleja las tradiciones de su pasado colonial anglo-céltico, los gustos de grupos posteriores de migrantes de todo el mundo y los alimentos forrajeros originales y los productos frescos de sus pueblos indígenas. Los pasteles de carne, los sándwiches vegetarianos y la Pavlova de maracuyá son los platos favoritos clásicos que siguen siendo muy apreciados, aunque una nueva ola de platos se ha unido a ellos para convertirse en clásicos modernos. Estos incluyen el aguacate machacado sobre pan tostado, pan de plátano y café, mientras que en el almuerzo y la cena, se ofrecen platos del sudeste asiático y mediterráneos como ensaladas de fideos, curry y rollos de papel de arroz o pasta, risotto, falafel o pizza que son tan comunes como los asados y las barbacoas, tanto en casa como en los menús de los restaurantes.

Classici australiani

L'Australia ha una storia culinaria ibrida che riflette le tradizioni del suo passato coloniale anglo-celtico e i gusti dei gruppi di migranti che giunsero qui da tutte le parti del mondo a cui si aggiungono i cibi tradizionali e i prodotti genuini delle sue popolazioni indigene. Torte farcite a base di carne, sandwich alla Vegemite e pavlova al frutto della passione sono tuttora amati come un tempo, anche se si è aggiunta una nuova ondata di piatti, diventati ormai i nuovi classici di oggi. Tra questi l'avocado spalmato su toast a base di lievito naturale e il pane alla banana che accompagna il caffellatte, mentre per pranzo e cena la cucina del sud-est asiatico e quella mediterranea – con insalate di pasta, curry e involtini di carta di riso ma anche noodle, risotto, falafel e pizza – sono frequenti tanto quanto gli arrosti e la carne al barbecue, sia a casa che nei menù dei ristoranti.

Klassieke Australische gerechten

Australië heeft een hybride culinaire geschiedenis waarin tradities van het Anglo-Keltische koloniale verleden, de smaken van latere groepen migranten afkomstig uit de hele wereld en de oorspronkelijk verzamelde levensmiddelen van de inheemse bevolking worden weerspiegeld. Vleespasteien, sandwiches met Vegemite en pavlova met passievruchten zijn klassiekers die nog altijd zeer geliefd zijn, ook nu een nieuwe stroom gerechten zich heeft aangediend als moderne klassiekers. Daartoe behoren geprakte avocado op zuurdesemtoast, bananenbrood met koffie verkeerd, terwijl voor lunch en avondeten net zo vaak Zuidoost-Aziatische en mediterrane gerechten zoals noedelsalades, curry's en loempia's of pasta, risotto, falafel en pizza's op het menu staan als gebraden vlees en barbecuegerechten, zowel thuis als in restaurants.

FISH & CHIPS

AUSTRALIAN BEER

SEAFOOD PLATE

KANGAROO STEAK

EASTERN ROCK LOBSTER
RESTAURANT OTTO

LAMINGTON ICE CREAM POPS

PILED UP FOOD

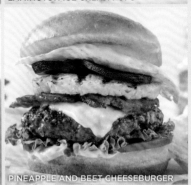

PINEAPPLE AND BEET CHEESEBURGER

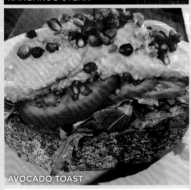

AVOCADO TOAST

CHEDDAR & CHIVE BEER
DAMPERS, COFFEE

SURF AND TURF, FILET
STEAK WITH SEAFOOD

VEGEMITE

CAKE "PAVLOVA" WITH
SUMMER BERRIES.

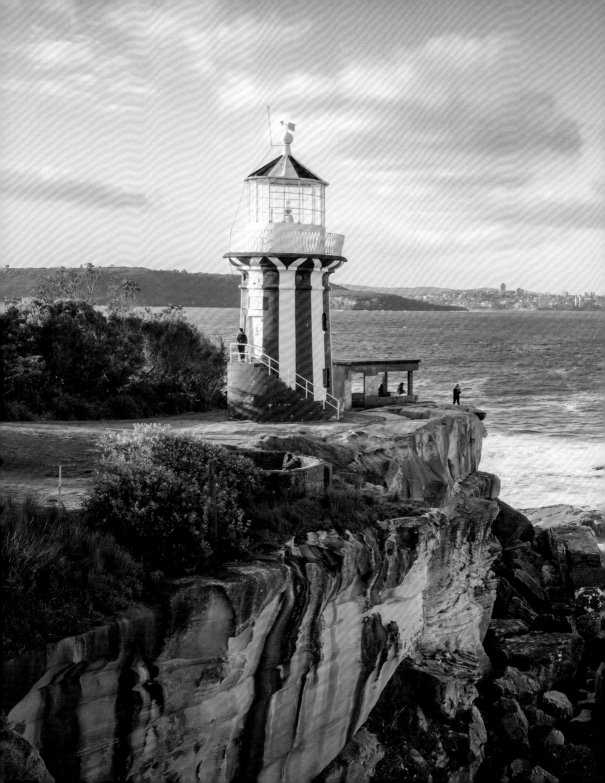

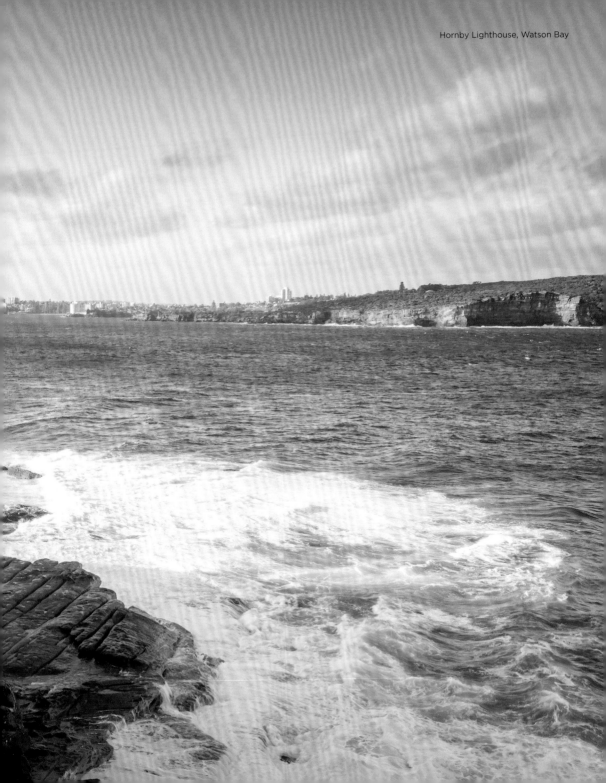

Hornby Lighthouse, Watson Bay

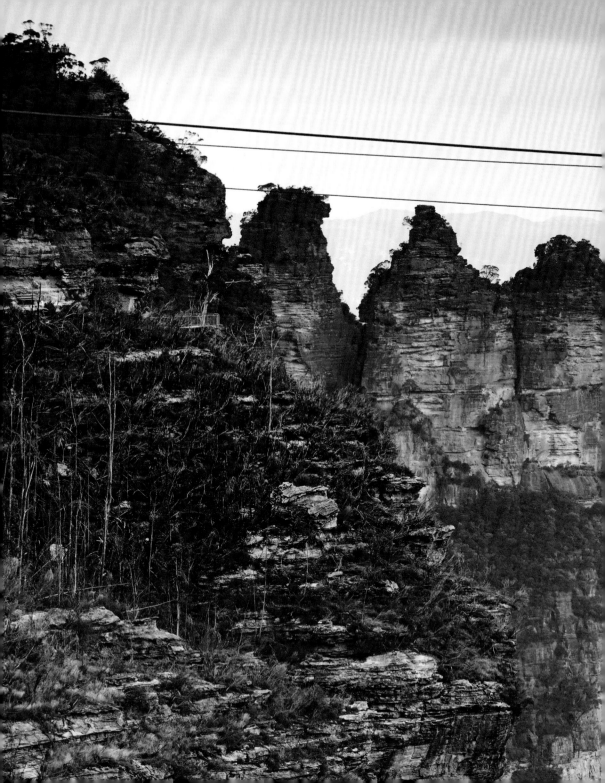

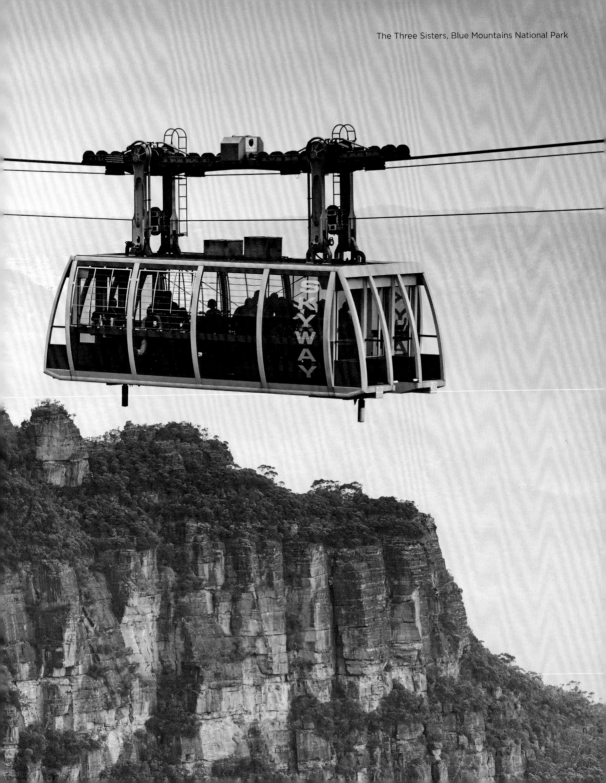

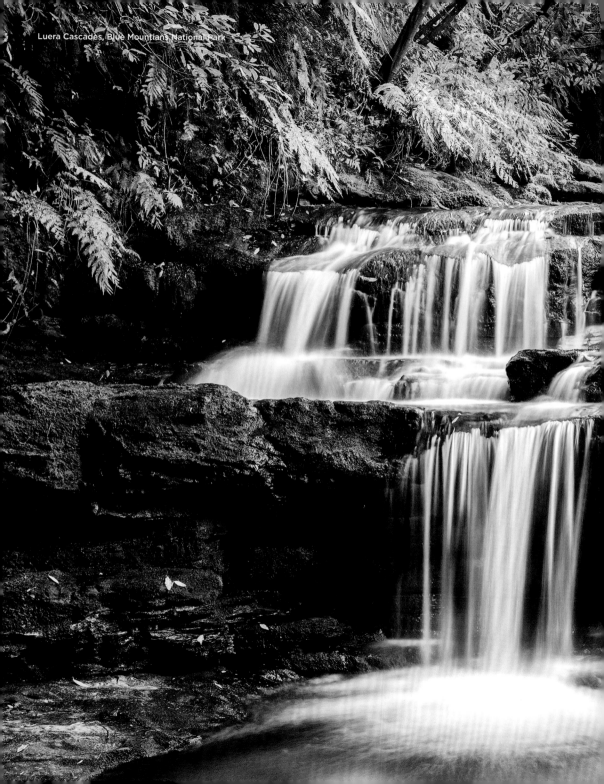
Luera Cascades, Blue Mountians National Park

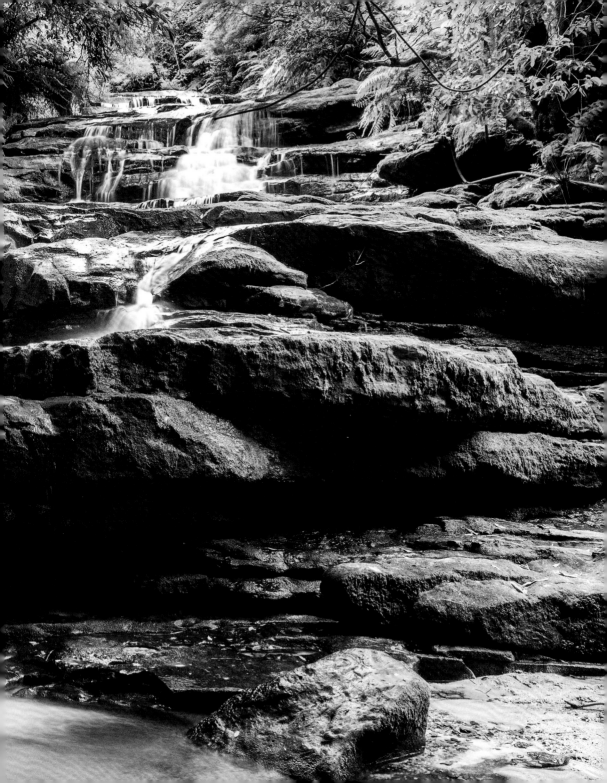

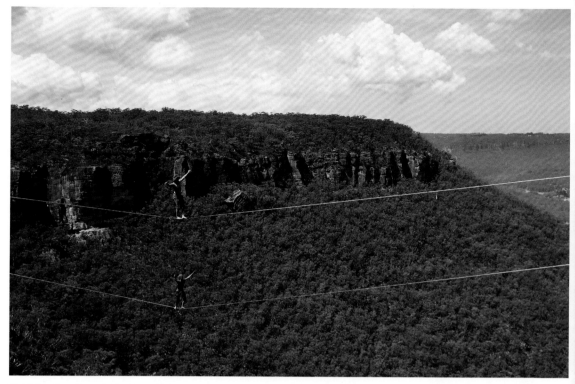

Highlining, Corroboree Walls, Mount Victoria

Blue Mountains

Immediately to the west of Sydney, this World Heritage region rises steeply from the city's sprawl, its sandstone ridges and outcrops, including the tri-peaked 'Three Sisters', ringing deeply forested valleys. Named for the blue haze that occasionally appears above its canopied eucalypts, this has been a place to walk, rest or simply gaze since Sydney's early days.

Blue Mountains

Immédiatement à l'ouest de Sydney, cette région inscrite au patrimoine mondial se distingue abruptement de l'étendue urbaine, avec ses crêtes de grès et ses affleurements, parmi lesquels la formation rocheuse des « Trois Sœurs », dont les trois sommets sont cernés de vallées profondément boisées. Nommée d'après la brume bleue qui apparaît occasionnellement au-dessus de la canopée de ses forêts d'eucalyptus, c'est un endroit idéal pour marcher ou se ressourcer.

Blue Mountains

Westlich von Sydney erhebt sich diese Weltnaturerbe-Region; ihre Sandsteingrate und Felsvorsprünge, mit den dreispitzigen „Drei Schwestern", umrahmen dichtbewaldete Täler. Benannt nach dem blauen Dunst, der gelegentlich über seinen überdachten Eukalyptusbäumen auftaucht, war dies schon früh ein Ort zum Spazierengehen, Ausruhen oder zum Staunen.

Blue Mountains

Inmediatamente al oeste de Sídney, esta región Patrimonio de la Humanidad se eleva abruptamente desde la extensión de la ciudad con sus crestas de arenisca y salientes, incluyendo las "Tres Hermanas" de tres picos, que rodean los valles profundamente boscosos. Reciben su nombre por la neblina azul que aparece ocasionalmente sobre sus frondosos eucaliptos. Este es un lugar para caminar, descansar o simplemente contemplar Sídney.

Blue Mountains

Dalla periferia cittadina immediatamente ad ovest di Sydney, si erge ripida questa regione montuosa patrimonio dell'umanità, con le sue creste di arenaria e i suoi affioramenti, tra cui le "Tre Sorelle" a tre punte, che incoronano valli molto boscose. La zona prende il nome dalla foschia bluastra che appare occasionalmente sopra le chiome degli eucalipti. Sin da quando Sydney è stata fondata, questo è il luogo ideale per camminare, riposare o semplicemente godersi il panorama.

Blue Mountains

Deze werelderfgoedregio verrijst ten westen van Sydney; de zandstenen bergkammen en dagzomende aardlagen, waaronder de drie pieken van de 'Three Sisters', omzomen dichtbeboste dalen. Deze plek, genoemd naar de blauwe waas die af en toe boven de kruinen van de eucalyptusbomen hangt, is al sinds de begindagen van Sydney geschikt om te wandelen, rusten of te bewonderen.

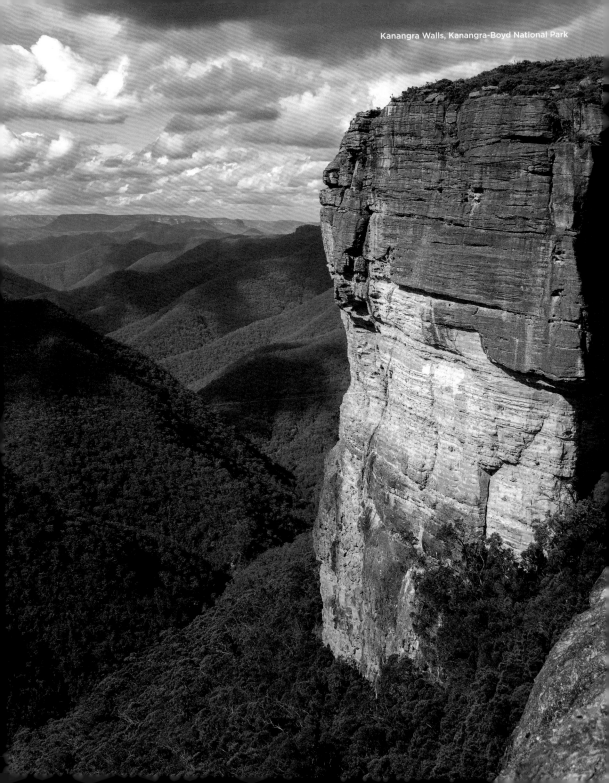

Kanangra Walls, Kanangra-Boyd National Park

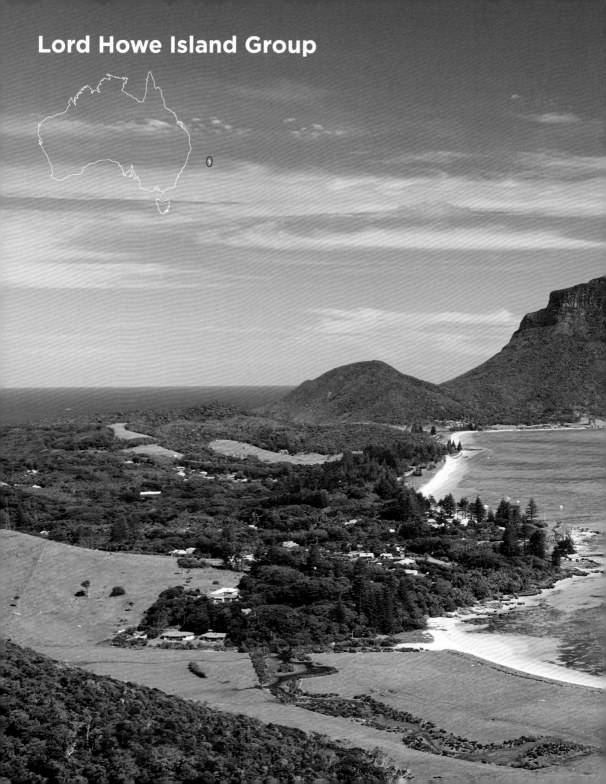

Lord Howe Island Group

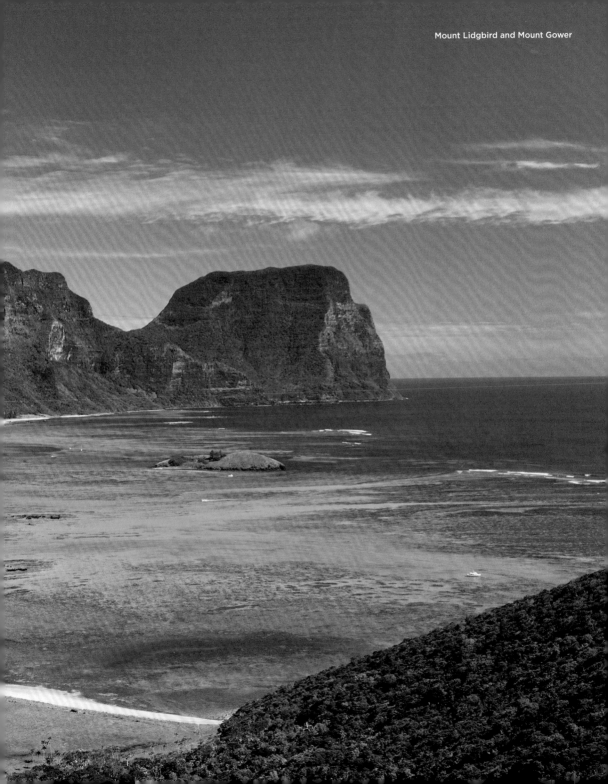

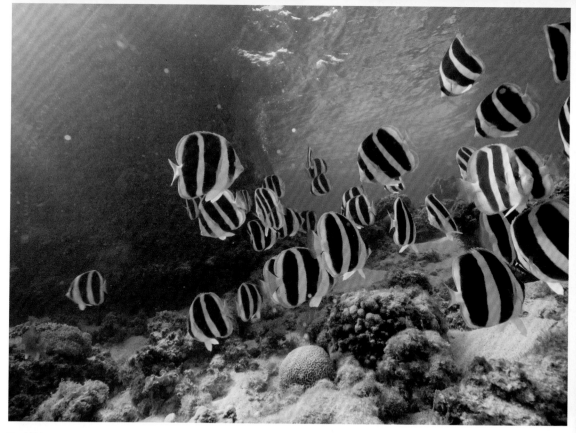

Reef Fish, Lord Howe Island

Lord Howe Island Group
This spectacular island group was once, around 7 million years ago, a large volcano and it possesses a geological and natural world quite distinct from the far more ancient mainland. It's tiny size, rugged terrain and sheer remoteness—it sits 600 km off the coast of NSW—makes it a special, and exclusive, place to visit indeed. Jutting from the sea round the main island lies 28 islands and islets.

Lord Howe Island Group
Este espectacular archipiélago fue una vez, hace unos 7 millones de años, un gran volcán y posee un entorno geológico y natural muy distinto al del continente, que es mucho más antiguo. Su pequeño tamaño, su terreno escarpado y su gran lejanía,se encuentra a 600 km de la costa de Nueva Gales del Sur, lo convierten en un lugar especial y exclusivo para visitar. Saliendo del mar alrededor de la isla principal se encuentran 28 islas e islotes.

Archipel de Lord Howe
Ce spectaculaire archipel était autrefois – il y a environ 7 millions d'années – un grand volcan ; son environnement géologique et naturel est donc bien distinct de la terre ferme, beaucoup plus ancienne. Sa petite taille, son relief accidenté et son isolement – il se trouve à 600 km au large de la côte de la Nouvelle-Galles du Sud – en font un endroit rare et singulier. Autour de l'île principale, on trouve 28 îles et îlots.

Lord Howe Island Group
Questo spettacolare gruppo di isole era un tempo, circa 7 milioni di anni fa, un grande vulcano, con un ambiente geologico e naturale ben distinto dalla terraferma molto più antica. Le sue dimensioni ridotte, il terreno accidentato e la lontananza – si trova a 600 km dalla costa del Nuovo Galles del Sud – ne fanno un luogo speciale ed esclusivo da visitare. Il mare intorno all'isola principale è costellato da altri 28 tra isole e isolotti.

Lord Howe Island Group
Die spektakuläre Inselgruppe war vor ca. 7 Millionen Jahren ein großer Vulkan, dessen geologische Welt sich vom weitaus älterem Festland unterscheidet. Ihre geringe Größe, das zerklüftete Gelände und die Abgeschiedenheit – 600 km vor der Küste – machen sie zu einem besonderen, exklusiven Ort. Um die Hauptinsel herum ragen 28 Inseln und Inselchen aus dem Meer.

Lord Howe Island Group
Deze spectaculaire eilandengroep was ooit, zo'n 7 miljoen jaar geleden, een grote vulkaan en bezit een geologie en natuur die zich duidelijk onderscheiden van het veel oudere vasteland. De kleinschaligheid, het ruige terrein en de afzondering – de groep ligt 600 km uit de kust van NSW – maakt het een bijzondere plek om te bezoeken. Rond het hoofdeiland steken 28 eilanden en eilandjes op uit zee.

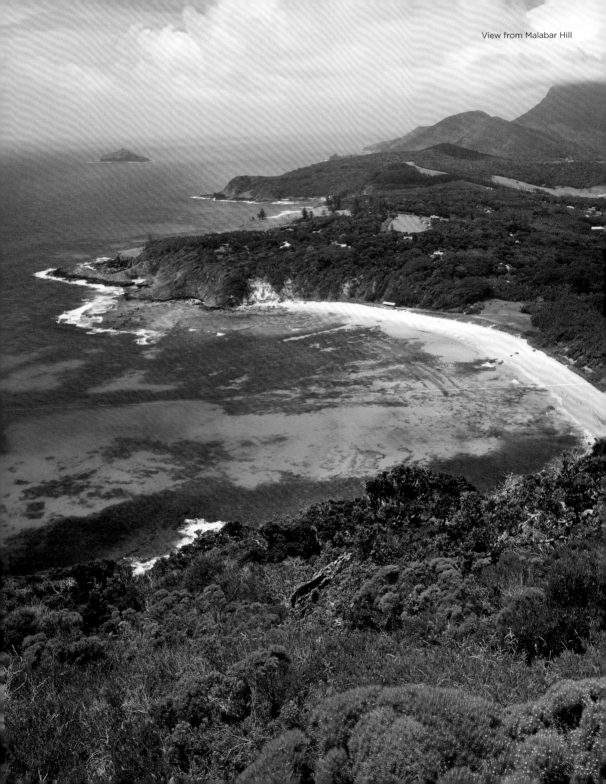
View from Malabar Hill

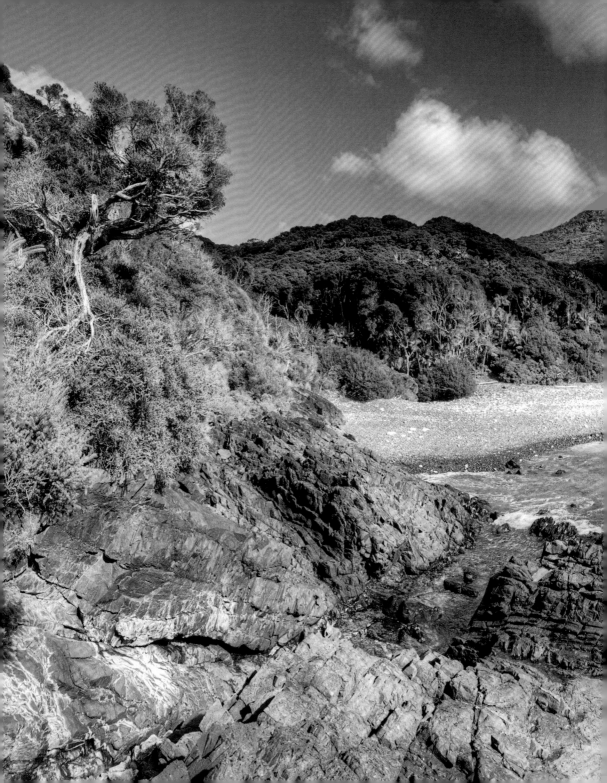

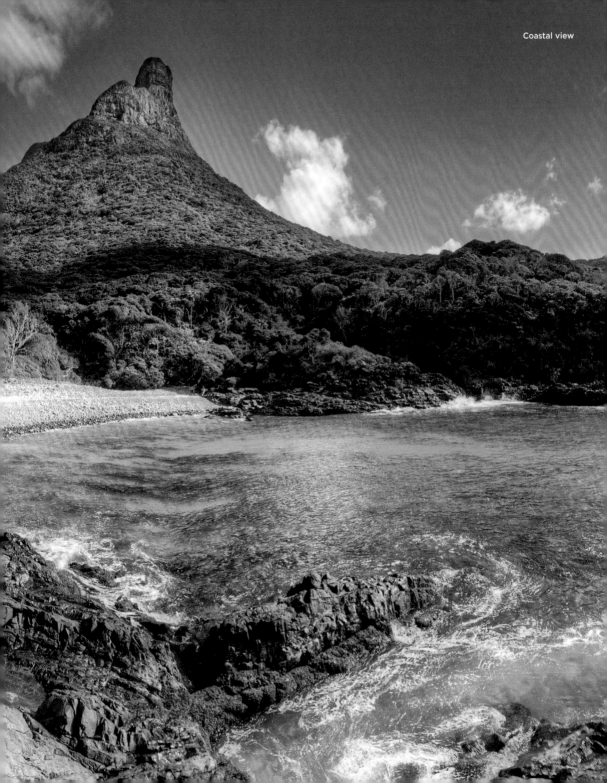
Coastal view

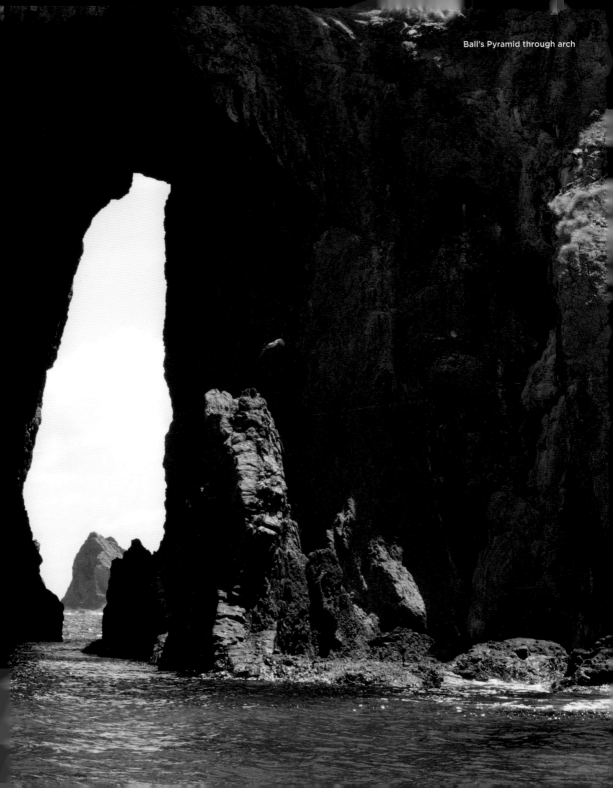
Ball's Pyramid through arch

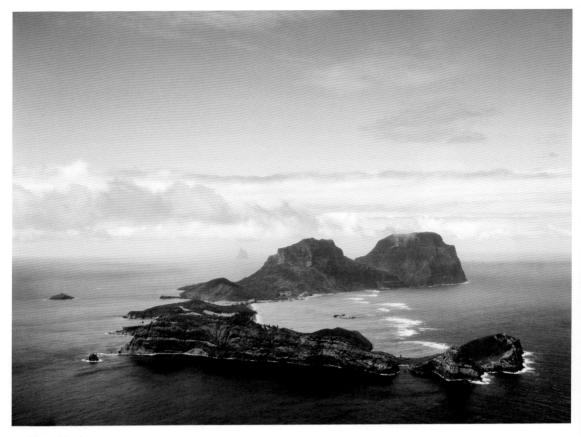

Lord Howe Island

Ball's Pyramid

The world's tallest sea stake and a world class diving site lie some 23 km east of Lord Howe at Ball's Pyramid. The imposing basalt spearhead towers 551 m into the sky but its no less impressive underwater, where a submarine shelf and network of caves secret huge schools of fish as well as marlin, dolphins and turtles. Climbing is not forbidden but is strictly controlled; the last successful attempt in 2014 was an unauthorized one.

Pyramide de Ball

Plus haut piton rocheux marin du monde, la pyramide de Ball, à quelques 23 km à l'est de Lord Howe, est un site de plongée de renommée mondiale. L'imposante aiguille de basalte s'élève à 551 m dans le ciel mais n'en demeure pas moins impressionnante également sous l'eau, où un plateau sous-marin et un réseau de grottes abritent d'énormes bancs de poissons ainsi que des marlins, dauphins et tortues. L'escalade n'est pas interdite mais strictement contrôlée ; la dernière tentative réussie, en 2014, n'avait d'ailleurs pas été autorisée.

Ball's Pyramid

Die höchste Felseninsel der Welt und ein erstklassiger Tauchplatz liegt etwa 23 km östlich von Lord Howe. Die imposante Basaltspitze ragt 551 m in den Himmel, aber nicht weniger beeindruckend ist es unter Wasser, wo ein unterseeisches Riff und ein Höhlennetz riesigen Fischschwärmen, Speerfischen, Delfinen und Schildkröten Schutz bieten. Klettern ist nicht verboten, wird aber streng reglementiert; der letzte erfolgreiche Versuch im Jahr 2014 war ein unbefugter.

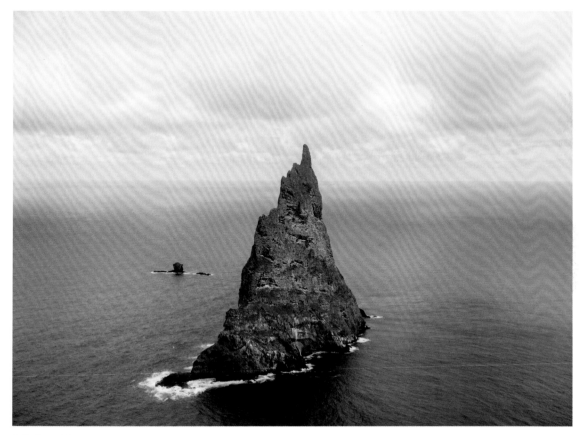

Ball's Pyramid

Ball's Pyramid

La Pirámide de Ball es la estaca marina más alta del mundo y un lugar de buceo con fama mundial, se encuentra a unos 23 km al este de Lord Howe. La imponente punta de lanza de basalto se eleva 551 m hacia el cielo, pero no menos impresionante es su fondo submarino, donde una plataforma submarina y una red de cuevas esconden enormes bancos de peces, así como marlines, delfines y tortugas. La escalada no está prohibida pero está muy controlada; el último intento que acabó con éxito tuvo lugar en 2014, pero no estaba autorizado.

Ball's Pyramid

Il faraglione più alto al mondo nonché sito per immersioni di prima classe su scala mondiale si trova a circa 23 km a est dell'isola di Lord Howe, a Ball's Pyramid. L'imponente roccia di basalto a punta di lancia si erge per 551 m in cielo, ma sott'acqua non è meno impressionante: qui la scogliera e una rete di grotte sono il nascondiglio di enormi banchi di pesci, ma anche di marlin, delfini e tartarughe. Arrampicarsi non è proibito ma rigorosamente controllato – anche se l'ultimo tentativo riuscito nel 2014 non era stato autorizzato.

Ball's Pyramid

Het hoogste rotseiland ter wereld en tevens een perfecte duiklocatie ligt zo'n 23 km ten oosten van Lord Howe. De imposante punt van basalt steekt 551 m hoog de lucht in, maar is niet minder indrukwekkend onder water, waar een onderzees rif en een netwerk van grotten grote scholen vissen, marlijnen, dolfijnen en schildpadden een schuilplaats bieden. Klimmen is niet verboden, maar is onderhevig aan strenge regels; de laatste succesvolle poging in 2014 was clandestien.

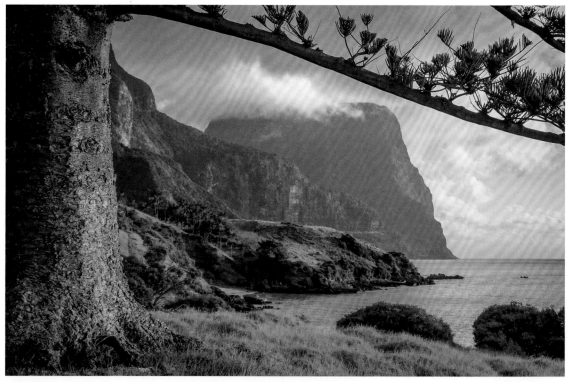

Mount Gower

Mount Gower

This iconic peak is, at 875 m, Lord Howe's highest mountain. An eight hour return trek over 14 km of rugged, often steep, terrain, is considered one of the country's best day walks, if a hugely challenging one. Rope climbing and sheer drops lead to spectacular views from his wooded peak, including many rare species of plants and wildlife.

Monte Gower

Este pico icónico es, con sus 875 m, la montaña más alta de Lord Howe. Ofrece una caminata de ocho horas de ida y vuelta a lo largo de 14 km de terreno escarpado, a menudo empinado, que está considerada como una de las mejores del país, si bien se trata de una caminata de gran exigencia. La escalada con cuerdas y las caídas libres conducen a vistas espectaculares desde su cima boscosa, incluyendo muchas especies raras de plantas y vida silvestre.

Le Mont Gower

Ce sommet emblématique est, avec ses 875 m d'altitude, la plus haute montagne de Lord Howe. L'aller-retour de huit heures, sur 14 km de terrain accidenté et souvent escarpé, est considéré comme l'une des meilleures randonnées d'une journée du pays, même si elle est extrêmement difficile. L'escalade à la corde de chutes abruptes permet d'admirer des vues spectaculaires depuis son sommet boisé, mais aussi de nombreuses espèces rares de plantes et d'animaux sauvages.

Mount Gower

Con i suoi 875 m questa vetta iconica è la montagna più alta di Lord Howe. Un percorso di ritorno di otto ore su 14 km di terreno accidentato, spesso ripido, è considerato una delle migliori escursioni giornaliere del paese, seppur molto impegnativo. L'arrampicata su corda e pareti a strapiombo porta a punti di vista spettacolari dalla cima boscosa, che ospita molte specie rare di piante e animali selvatici.

Mount Gower

Dieser legendäre Gipfel ist mit 875 m der höchste Berg von Lord Howe. Ein achtstündiger Rückweg über 14 km zerklüftetes, steiles Gelände gilt als einer der anspruchsvollen Tageswanderungen des Landes. Seilklettern und steile Tropfen führen zu spektakulären Aussichten auf bewaldete Gipfel und viele seltene Pflanzen- und Tierarten.

Mount Gower

Deze iconische berg is met zijn 875 m de hoogste van Lord Howe. Een acht uur durende terugreis over 14 km ruig, vaak steil terrein wordt beschouwd als een van de beste dagtochten van het land. Klimpartijen langs steile afgronden leiden naar een spectaculair uitzicht vanaf zijn beboste top. Hier leven ook veel zeldzame plantensoorten en wilde dieren.

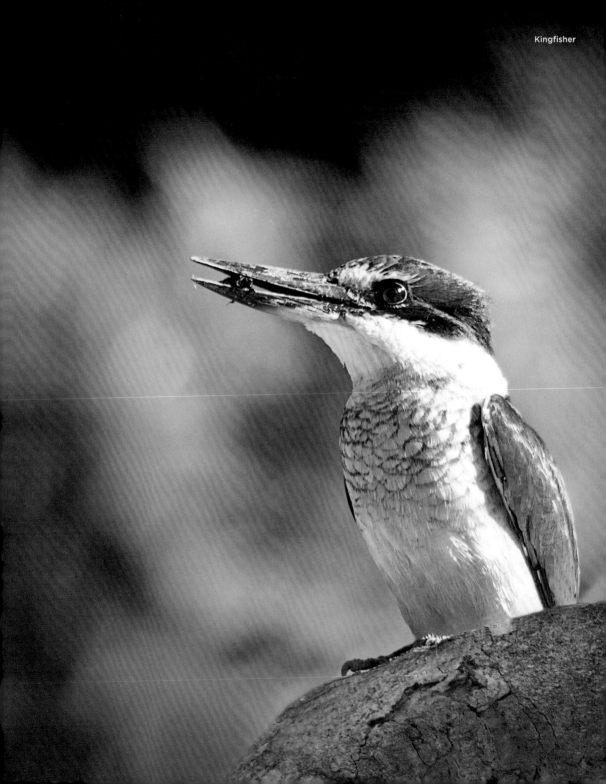

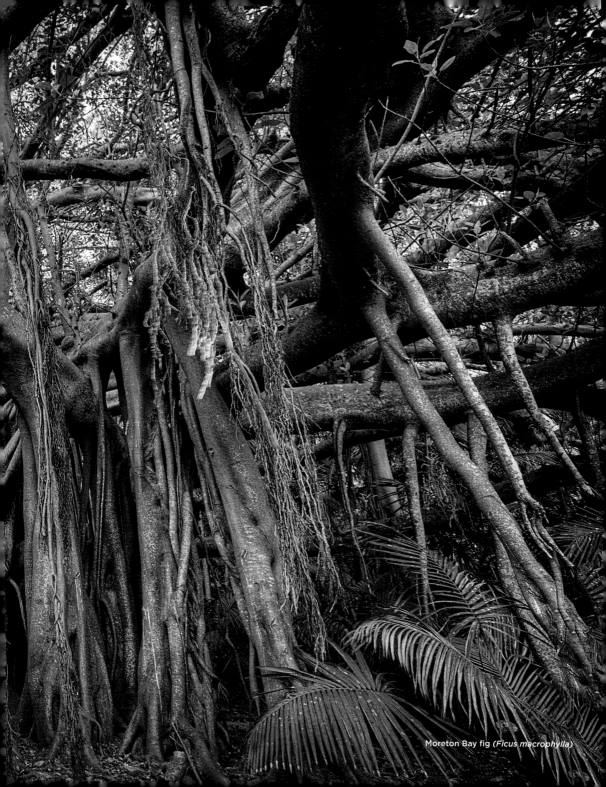

Moreton Bay fig (*Ficus macrophylla*)

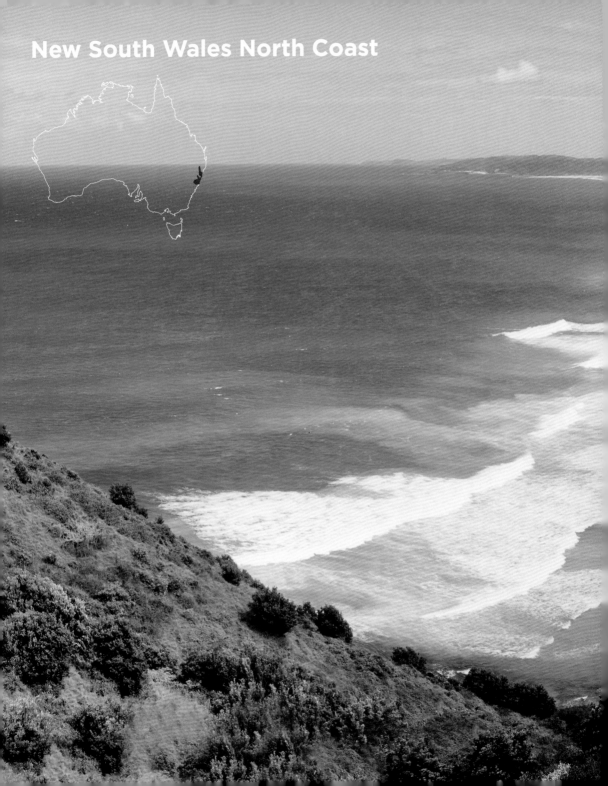

New South Wales North Coast

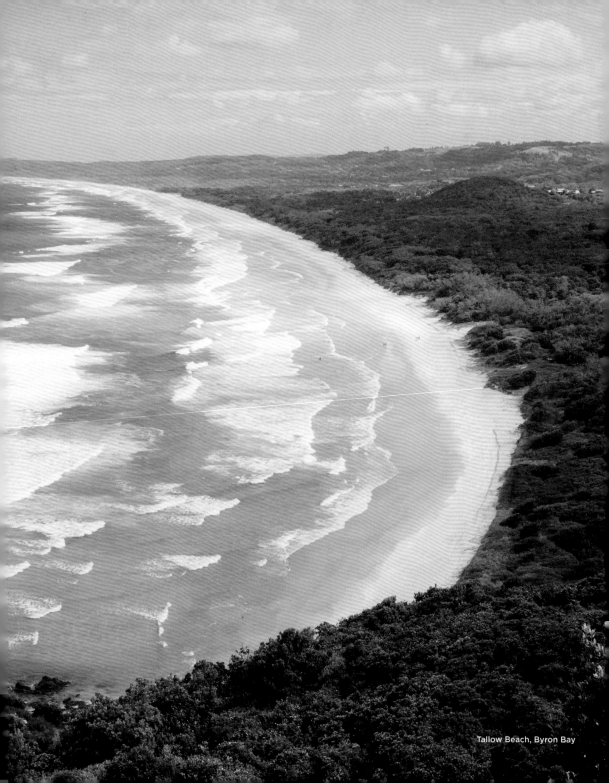
Tallow Beach, Byron Bay

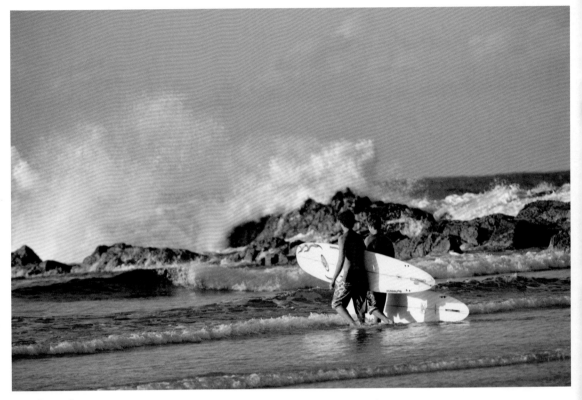

Byron Bay surfers

New South Wales North Coast
This quintessentially Australian stretch of sun-drenched coast is dotted with holiday hamlets, hippy hinterland towns and beach fringed national parks. Just before the Queensland border is blissed out Byron Bay, a low slung former logging and whaling town now known for its surf breaks, yoga retreats, organic markets and stylish bars and cafes.

Côte nord de la Nouvelle-Galles du Sud
Cette partie de la côte australienne est parsemée de petits villages de vacances, de villes hippies de l'arrière-pays et de parcs nationaux bordés de plages : c'est en quelque sorte la quintessence de l'Australie. Juste avant la frontière du Queensland, Byron Bay, ancienne ville de bûcherons et de baleiniers, est connue aujourd'hui pour ses vagues idéales pour le surf, ses lieux de retraites de yoga, ses marchés bio et ses élégants bars et cafés.

Nordküste von New South Wales
Dieser Teil der sonnenverwöhnten Küste ist Australien pur: übersät mit Feriendörfern, Hippie-Städten im Hinterland und strandgesäumten Nationalparks. Kurz vor der Grenze zu Queensland liegt Byron Bay, eine ehemalige Walfang- und Holzfällerstadt, die heute für ihre Surfbreaks, Yoga-Retreats, Bio-Märkte und stylischen Bars und Cafés bekannt ist.

Costa Norte de Nueva Gales del Sur
Este es el tramo de la costa australiana, por excelencia. Está salpicado de localidades vacacionales, pueblos hippies del interior y parques nacionales rodeados de playas. Justo antes de la frontera con Queensland, se encuentra Byron Bay, una antigua ciudad maderera y ballenera, ahora conocida por sus olas de surf, sus retiros de yoga, sus mercados orgánicos y sus elegantes bares y cafés.

La costa settentrionale del Nuovo Galles del Sud
Questo tratto di costa soleggiata tipicamente australiana è costellato di villaggi turistici, città popolate da hippy nell'entroterra e parchi nazionali orlati di spiagge. Poco prima del confine con il Queensland si trova Byron Bay, un'antica città di pescatori e balenieri oggi nota tra i surfisti per le sue onde, ma anche per i ritiri di yoga, i mercati biologici, i bar e i caffè alla moda.

Noordkust van New South Wales
Dit typisch Australische stuk zonovergoten kust is bezaaid met vakantiedorpjes, hippiestadjes in het achterland en nationale parken langs de stranden. Vlak voor de grens met Queensland ligt Byron Bay, een voormalig houtkap- en walvisjachtstadje dat nu bekend is om zijn surfbreaks, yogacentra, biologische markten en stijlvolle bars en cafés.

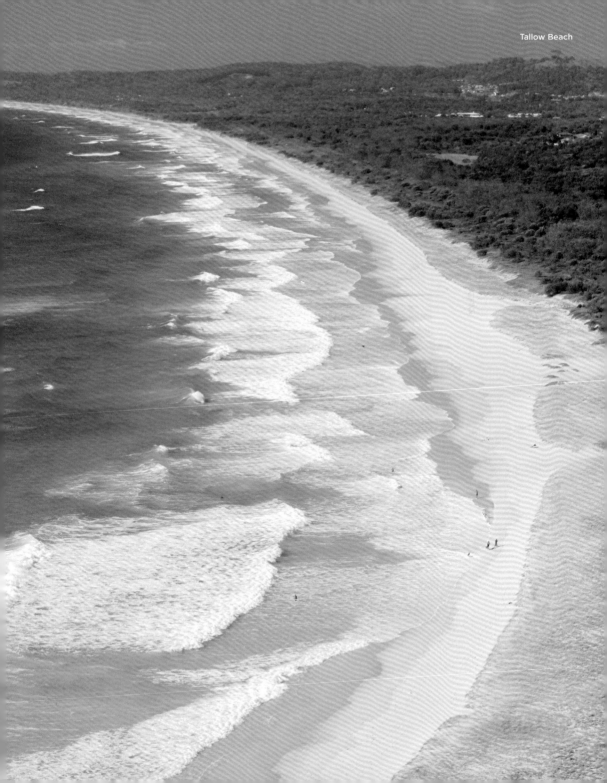

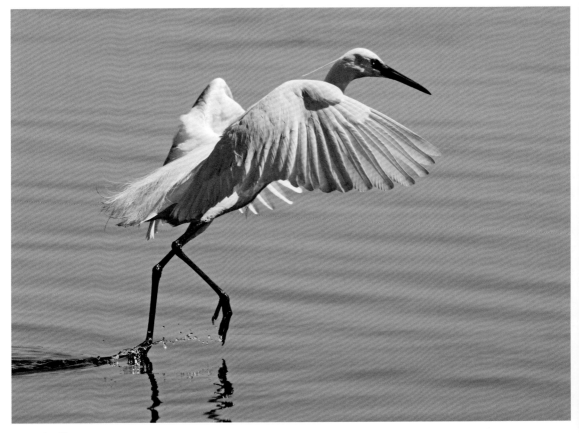
Egret takeoff

Port Macquarie

Port Macquarie is one of the oldest settlements on the northern New South Wales coast, its centre dominated by 19th-century stone buildings that point to colonial times when the town was an important administrative centre for the surrounding region. The town is also home to a koala rescue centre and hospital and some of the best beaches along the entire coastal stretch. Port Macquarie makes an ideal base for world-class hiking trails in nearby national parks.

Port Macquarie

Port Macquarie est l'une des plus anciennes agglomérations de la côte nord de la Nouvelle-Galles du Sud. Son centre est dominé par des bâtiments en pierre du XIXᵉ siècle qui rappellent l'époque coloniale, durant laquelle la ville était un important centre administratif pour la région environnante. Port Macquarie abrite également un hôpital et centre de sauvetage pour koalas et certaines des meilleures plages de la côte. La ville est aussi le point de départ idéal de sentiers de randonnée de renommée mondiale qui serpentent dans les parcs nationaux avoisinants.

Port Macquarie

Port Macquarie ist eine der ältesten Siedlungen an der nördlichen Küste von New South Wales, deren Zentrum von Steinhäusern aus dem 19. Jahrhundert dominiert wird, die auf die Kolonialzeit hinweisen, als die Stadt ein wichtiges Verwaltungszentrum für die umliegende Region war. Die Stadt beherbergt auch ein Koala-Rettungszentrum und ein Krankenhaus sowie einige der besten Strände entlang der gesamten Küstenstrecke. Port Macquarie ist ein idealer Ausgangspunkt für erstklassige Wanderwege in den nahegelegenen Nationalparks.

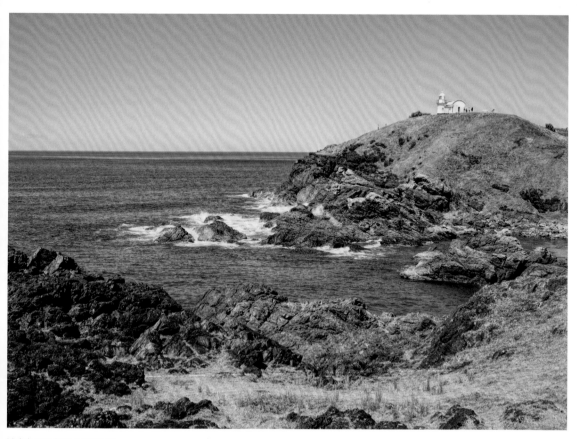

Lighthouse Port Macquarie

Port Macquarie

Port Macquarie es uno de los asentamientos más antiguos de la costa norte de Nueva Gales del Sur, cuyo centro está dominado por edificios de piedra del siglo XIX que apuntan a la época colonial, cuando la ciudad era un importante centro administrativo para la región circundante. En la ciudad también hay un centro de rescate y un hospital de koalas y algunas de las mejores playas de todo el tramo costero. Port Macquarie es una base ideal para rutas de senderismo de primera categoría en los parques nacionales cercanos.

Port Macquarie

Port Macquarie è uno degli insediamenti più antichi della costa settentrionale del Nuovo Galles del Sud. Al centro fanno mostra di sé vari edifici in pietra del XIX secolo che rievocano il periodo coloniale, quando la città era un importante centro amministrativo per la regione circostante. Qui si trovano un centro di soccorso e un ospedale per koala e alcune delle migliori spiagge lungo tutto il tratto di costa. Port Macquarie è la base ideale per sentieri escursionistici apprezzati internazionalmente nei vicini parchi nazionali.

Port Macquarie

Port Macquarie is een van de oudste nederzettingen aan de noordkust van New South Wales. Het centrum wordt gedomineerd door 19e-eeuwse stenen gebouwen die wijzen op de koloniale tijd, toen de stad een belangrijk administratief centrum was voor de omliggende regio. De stad bezit ook een koala-opvangcentrum en een ziekenhuis, evenals enkele van de beste stranden langs de hele kuststrook. Port Macquarie is een ideaal vertrekpunt voor de uitstekende wandelpaden in de nabijgelegen nationale parken.

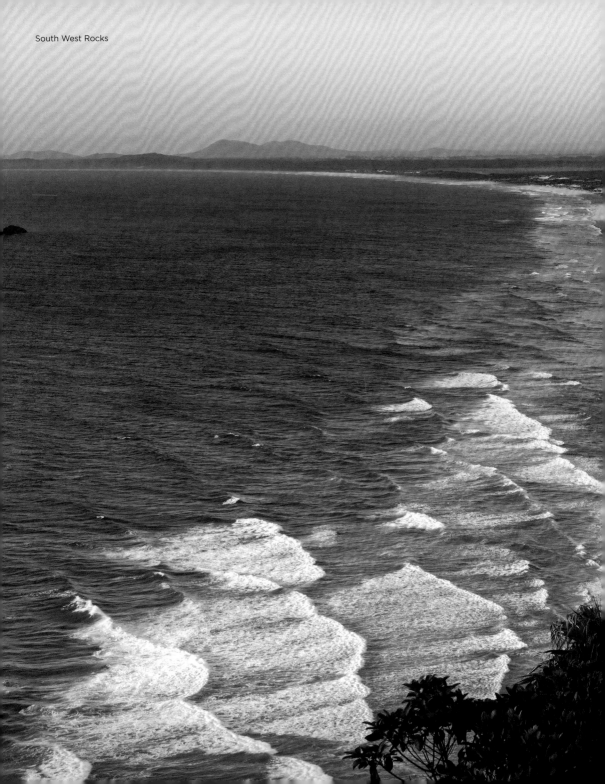

South West Rocks

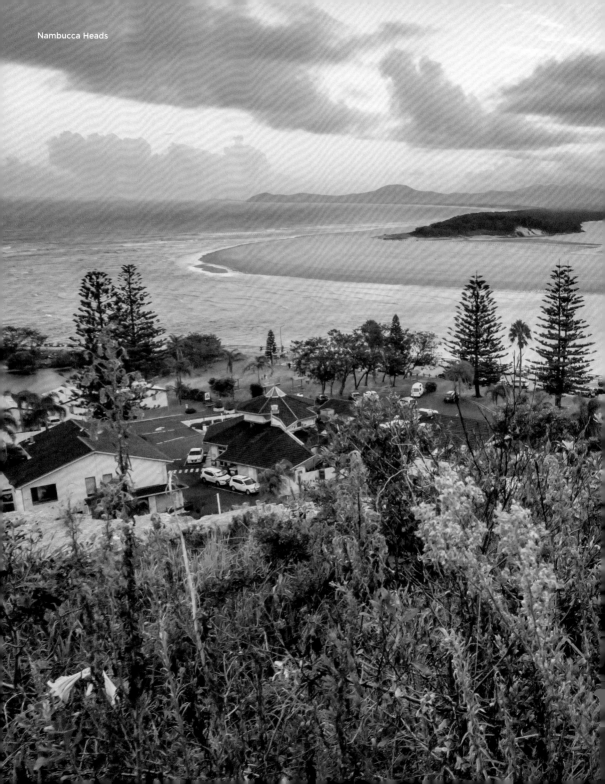

Guesthouse near Byron Bay

Natural Beauty

For such a popular and relatively developed stretch of coastline, the northern New South Wales coast is really rather beautiful. Koalas and other wildlife is abundant all along the coastal fringe, whales pass along this coast in great numbers from May to November, and native Australian plants are essential part of the region's considerable natural appeal. Wild beaches also seem to stretch to eternity and small towns and national parks, bypassed by roads and tourists, speak to the traveler's need for quiet beauty and an off-the-beaten track sense of discovery.

Beauté naturelle

Pour un littoral aussi populaire et tout de même assez développé, la côte nord de la Nouvelle-Galles du Sud est magnifique. Les koalas et autres espèces sauvages abondent tout le long du littoral, les baleines le longent en grand nombre de mai à novembre, et les plantes indigènes australiennes font partie intégrante de l'attrait naturel considérable de la région. Les plages sauvages semblent s'étendre à perte de vue et les petites villes et les parcs nationaux, contournés par les routes et les touristes, témoignent de l'attrait des voyageurs pour la beauté tranquille et de leur envie de découverte, hors des sentiers battus.

Natürliche Schönheit

Für einen so beliebten und relativ entwickelten Küstenabschnitt ist die nördliche Küste von New South Wales wirklich sehr schön. Koalas und andere Wildtiere sind entlang des Küstenrands reichlich vorhanden, Wale ziehen von Mai bis November in großer Zahl an dieser Küste vorbei, und einheimische australische Pflanzen sind ein wesentlicher Bestandteil der beträchtlichen natürlichen Attraktivität der Region. Wilde Strände scheinen sich bis in die Ewigkeit zu erstrecken, und kleine Städte und Nationalparks, umringt von Straßen und Touristen, sprechen für das Bedürfnis des Reisenden nach stiller Schönheit und Entdeckungen abseits der ausgetretenen Pfade.

Red silky oak *(Grevillea banksi)*

Belleza natural
Para ser un tramo de costa tan popular y relativamente desarrollado, la costa norte de Nueva Gales del Sur es realmente hermosa. Los koalas y otros animales silvestres abundan a lo largo de la franja costera, las ballenas pasan por esta costa en gran número de mayo a noviembre, y las plantas nativas australianas son parte esencial del considerable atractivo natural de la región. Las playas salvajes también parecen extenderse hasta el infinito y los pequeños pueblos y parques nacionales, sin carreteras ni turistas, hablan de la necesidad del viajero de una belleza tranquila y de un sentido de descubrimiento fuera de lo común.

Bellezza naturale
Nonostante sia così popolare e molto attrezzata, la costa settentrionale del Nuovo Galles del Sud è davvero molto bella. Koala e altri animali selvatici popolano numerosi questa zona, da maggio a novembre sono molte le balene che nuotano lungo questi fondali e varie piante autoctone vanno ad aumentare il notevole fascino naturale della regione. Le spiagge selvagge sembrano estendersi all'infinito e le piccole città e i parchi nazionali, attraversati da sentieri e turisti, mostrano quanto chi viaggia abbia bisogno di godersi della bellezza del luogo in tranquillità e di possibilità di fare scoperte fuori dai percorsi battuti.

Natuurlijke schoonheid
Voor zo'n populaire en tamelijk toeristische kustlijn is de noordkust van New South Wales echt heel mooi. Koala's en andere wilde dieren zijn in overvloed aanwezig langs de hele kuststrook, terwijl grote aantallen walvissen er van mei tot november langs zwemmen. Inheemse Australische planten zijn een wezenlijk onderdeel van de aantrekkingskracht van de regio. Wilde stranden lijken zich eindeloos uit te strekken en kleine steden en nationale parken, gemeden door wegen en toeristen, spreken de behoefte aan stille schoonheid en ontdekkingslust buiten de gebaande paden om van reizigers aan.

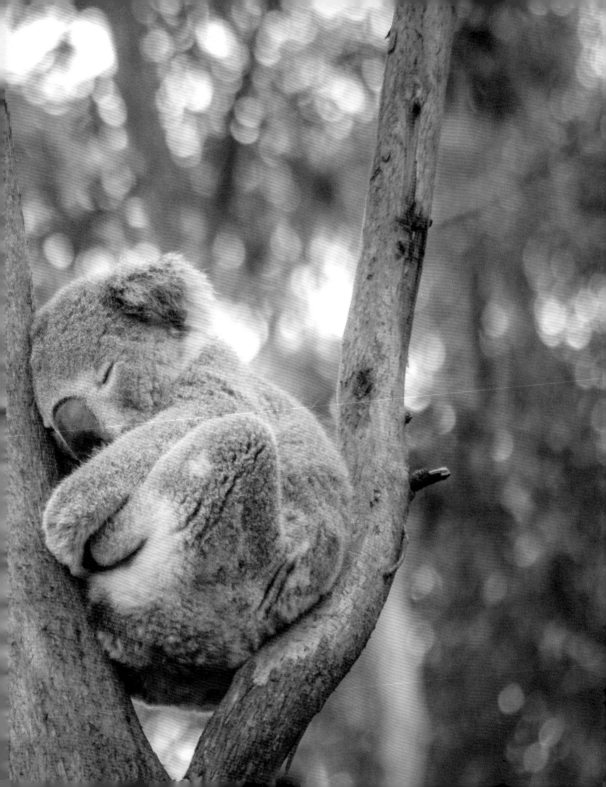

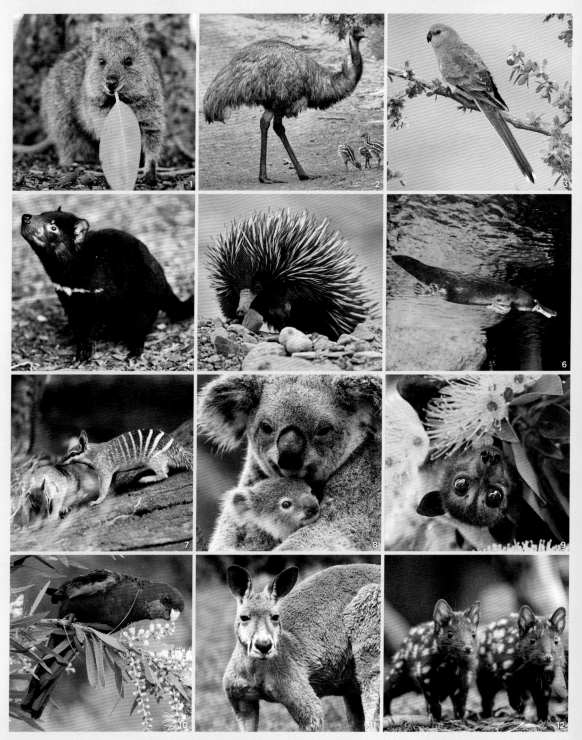

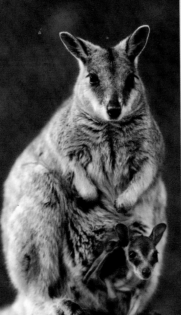

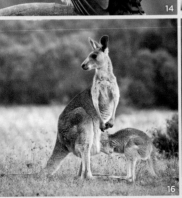

1 Quokka; Kurzschwanzkänguru

2 Emu; Émeu ; Großer Emu; Emú; Emoe

3 Red-rumped Parrot; Perruche à croupion rouge ; Singsittich; Loro de grupa roja; Parrocchetto dal groppone rosso; Roodrugparkiet

4 Tasmanian Devil; Diable de Tasmanie ; Tasmanischer Teufel; Diablo de Tasmania; Diavolo della Tasmania; Tasmaanse duivel

5 Short-beaked Echidna; Échidné à nez court ; Kurzschnabeligel; Equidna de hocico corto; Echidna dal becco corto; Australische mierenegel

6 Platypus; Ornithorynque ; Schnabeltier; Ornitorrinco; Ornitorinco; Vogelbekdier

7 Numbats; Numbat; Buidelmiereneter

8 Koalas; Koala's

9 Spectacled flying fox; Renard volant à lunettes ; Eigentlicher Flughund: Zorro volador de anteojos; Volpe volante dagli occhiali; Vleerhond

10 Crimson Rosella; Perruche de Penant ; Pennantsittich; rosella roja; Rosella cremisi; Pennantrosella

11 Red Kangaroo; Kangourou roux ; Rotes Riesenkänguru; Canguro rojo; Canguro rosso; Rode reuzenkangoeroe

12 Eastern Quolls; Chats marsupiaux mouchetés ; Beutelmarder; Quoles orientales; Quoll orientale; gevlekte Buidelmarter

13 Lumholtz's Tree-Kangaroo; Dendrolague de Lumholtz ; Lumholtz-Baumkänguru; *Dendrolagus lumholtzi;* Canguro arboricolo di Lumholtz; Lumholtzboomkangoeroe

14 Laughing Kookaburra, Martin-chasseur géant ; Jägerliest/Lachender Hans: Cucaburra común: Kookaburra: Kookaburra

15 Mareeba Rock-Wallabies; Pétrogale mareeba ; Mareeba-Felskänguru; Wallaby de roca Mareeba; Wallaby delle rocce di Mareeba; Rotskangoeroe

16 Eastern Grey Kangaroos; Kangourou gris de l'Est ; Östliche Graue Riesenkängurus; Kanguros grises orientales; Kanguri grigi orientali; Grijze reuzenkangoeroe

17 Dingos; Dinghi ; Dingo's

18 Wombats

19 Sugar Glider; Phalanger volant ; Kurzkopfgleitbeutler; Petauro del azúc; Petauro dello zucchero; Suikereekhoorn

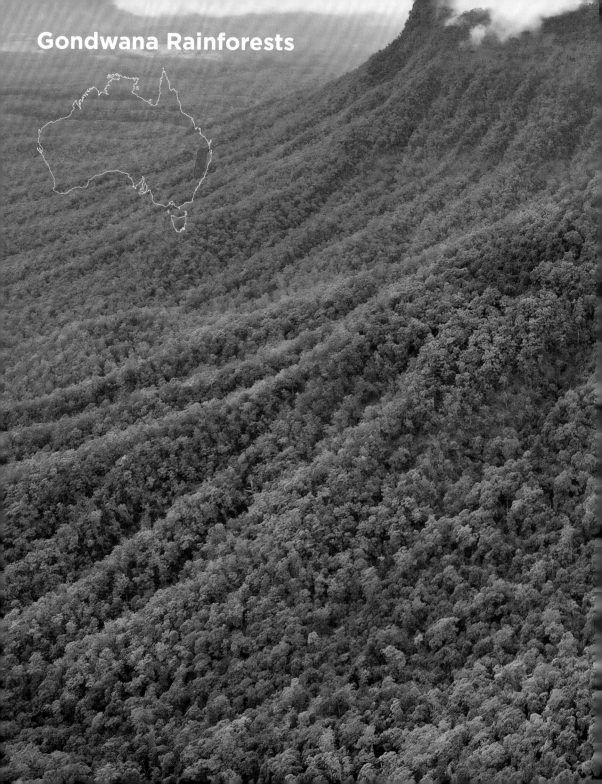

Gondwana Rainforests

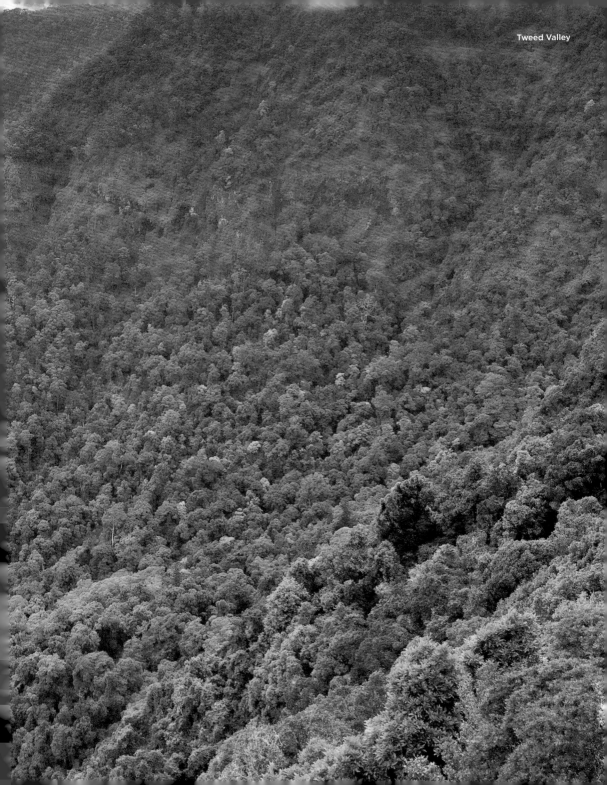

Crimson Rosella *(Platycercus elegans),* Lamington National Park

Gondwana Rainforests

Stretching from north of Sydney all the way to Brisbane's hinterland, Australia's Gondwana Rainforests represent what are believed to be the most extensive area of sub-tropical rainforest on earth. It dates back to the super-continent of Gondwana some 320 million years ago, and includes national parks such as Dorrigo and Lamington.

Gondwana Rainforests

Desde el norte de Sídney hasta el interior de Brisbane, los bosques pluviales Gondwana, de Australia representan lo que se cree que es el área más extensa de bosque pluvial subtropical de la tierra. Esta zona procede del supercontinente de Gondwana hace unos 320 millones de años, e incluye parques nacionales como los de Dorrigo y Lamington.

Forêts tropicales du Gondwana

S'étendant du nord de Sydney jusqu'à l'arrière-pays de Brisbane, les forêts pluviales du Gondwana, en Australie, sont probablement la plus vaste zone de forêt humide subtropicale de la planète. Elle date de l'époque du supercontinent du Gondwana, il y a environ 320 millions d'années, et comprend des parcs nationaux tels que Dorrigo et Lamington.

Gondwana Rainforests

Da nord di Sydney fino all'entroterra di Brisbane, le foreste pluviali del Gondwana rappresentano quella che si ritiene sia la più estesa area di foresta pluviale subtropicale del pianeta. Le sue origini risalgono al supercontinente del Gondwana, circa 320 milioni di anni fa. Qui si trovano vari parchi nazionali come quello di Dorrigo e quello di Lamington.

Gondwana Rainforests

Die australischen Gondwana-Regenwälder erstrecken sich von Sydney bis ins Hinterland von Brisbane und sind vermutlich das ausgedehnteste Gebiet subtropischer Regenwälder auf der Welt. Sie gehen auf den Superkontinent Gondwana vor 320 Millionen Jahren zurück und beheimaten Nationalparks wie Dorrigo und Lamington.

Gondwana Rainforests

De Australische regenwouden van Gondwana strekken zich uit van het noorden van Sydney tot aan het achterland van Brisbane en vertegenwoordigen vermoedelijk het meest uitgestrekte subtropisch regenwoud op aarde. Ze gaan terug tot het supercontinent Gondwana, zo'n 320 miljoen jaar geleden, en omvatten nationale parken zoals Dorrigo en Lamington.

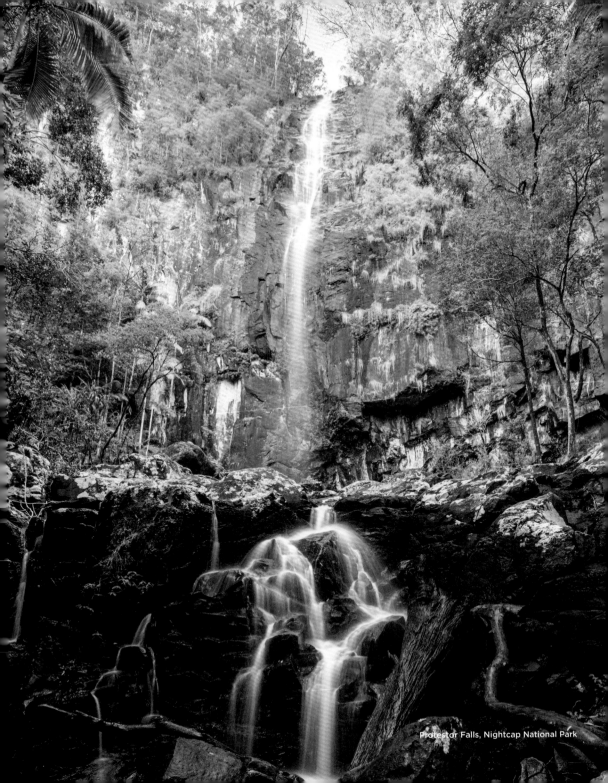

Protestor Falls, Nightcap National Park

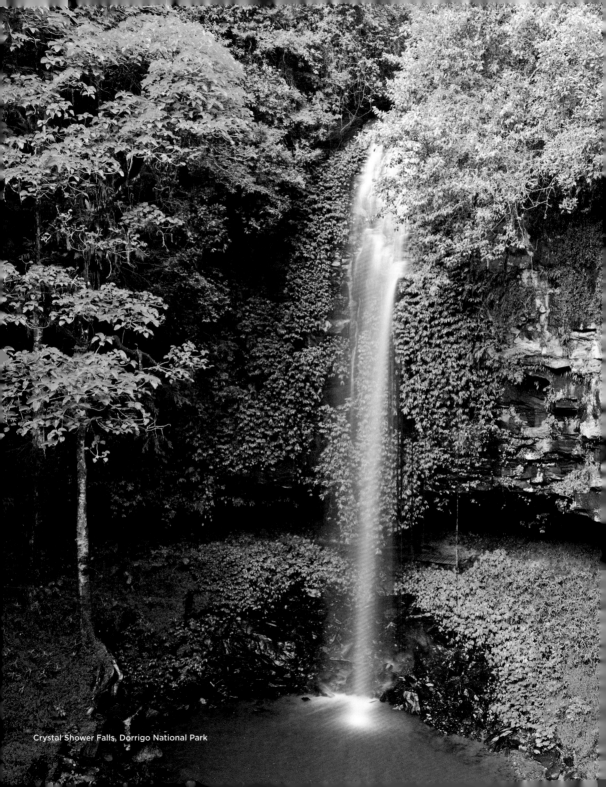

Crystal Shower Falls, Dorrigo National Park

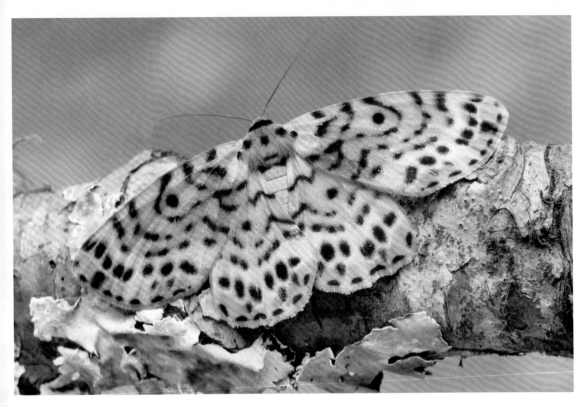

Arch Moth *(Bracca matutinata)*, Lamington National Park

Unesco Recognition

The rainforests of northern NSW and southern Queensland were inscribed on Unesco's list of World Heritage sites in 1986, and extended in 1994. It covers 50 reserves and 366,500 hectares. It was chosen for showcasing what Unesco described as "major stages of the Earth's evolutionary history" and "exceptional biological diversity".

Reconocimiento de la Unesco

Las selvas tropicales del norte de Nueva Gales del Sur y el sur de Queensland fueron registradas en la lista del Patrimonio Mundial de la UNESCO en 1986, y ampliadas en 1994. Abarcan 50 reservas y 366.500 hectáreas. Fueron seleccionadas para resaltar lo que la Unesco describió como "grandes etapas de la historia evolutiva de la Tierra" y "diversidad biológica excepcional".

Reconnaissance de l'Unesco

Les forêts tropicales humides du nord de la Nouvelle-Galles du Sud et du sud du Queensland ont été inscrites sur la liste du patrimoine mondial de l'Unesco en 1986 et leur domaine a ensuite été étendu en 1994. Il couvre aujourd'hui 50 réserves et 366 500 hectares. Il a été choisi parce qu'il représente ce que l'Unesco a qualifié de « grandes étapes de l'histoire de l'évolution de la Terre » et de « diversité biologique exceptionnelle ».

Il riconoscimento dell'Unesco

Le foreste pluviali nel parte settentrionale del Nuovo Galles del Sud e nel Queensland meridionale sono state iscritte nella lista del patrimonio dell'umanità dell'Unesco nel 1986, riconoscimento poi ulteriormente esteso nel 1994 a coprire un totale di 50 riserve e 366.500 ettari. Queste regioni sono state scelte per presentare quelle che l'Unesco ha definito come le "principali tappe della storia evolutiva della Terra" di "eccezionale diversità biologica".

Unesco-Anerkennung

Die Regenwälder des nördlichen NSW und des südlichen Queensland wurden 1986 in die Liste des Weltnaturerbes der UNESCO aufgenommen und 1994 erweitert. Sie umfassen 50 Reservate und 366 500 Hektar Fläche. Sie wurden ausgewählt, um das zu repräsentieren, was die Unesco als „große Etappen der Erdgeschichte" und „außergewöhnliche biologische Vielfalt" bezeichnet.

Erkenning door Unesco

De regenwouden in het noorden van NSW en het zuiden van Queensland werden in 1986 op de werelderfgoedlijst van de Unesco gezet, hetgeen in 1994 werd verlengd. Ze beslaan 50 reservaten en 366.500 hectare. Ze werden uitgekozen om dat te laten zien wat de Unesco omschreef als "belangrijke stadia van de evolutiegeschiedenis van de aarde" en "uitzonderlijke biologische diversiteit".

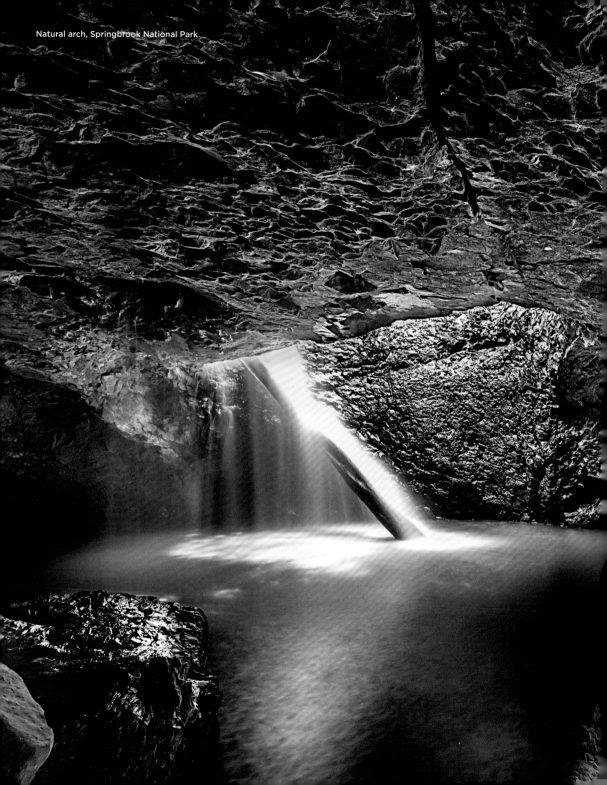
Natural arch, Springbrook National Park

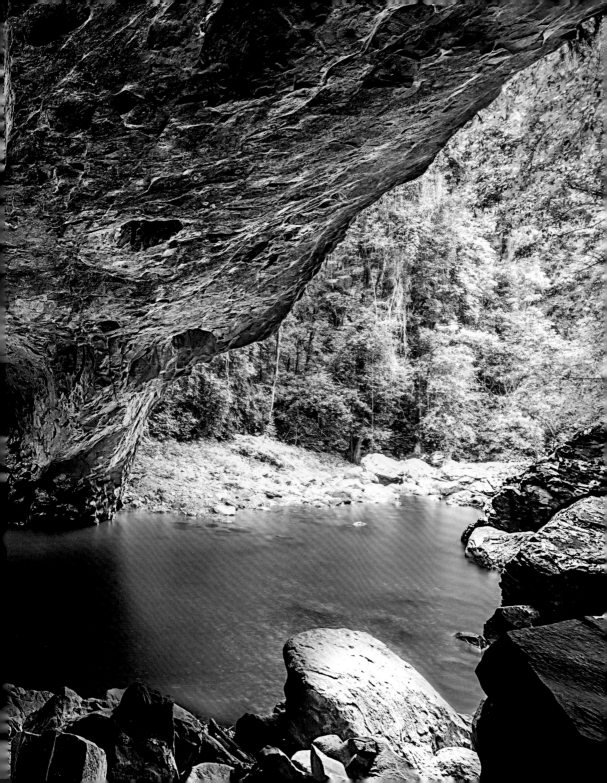

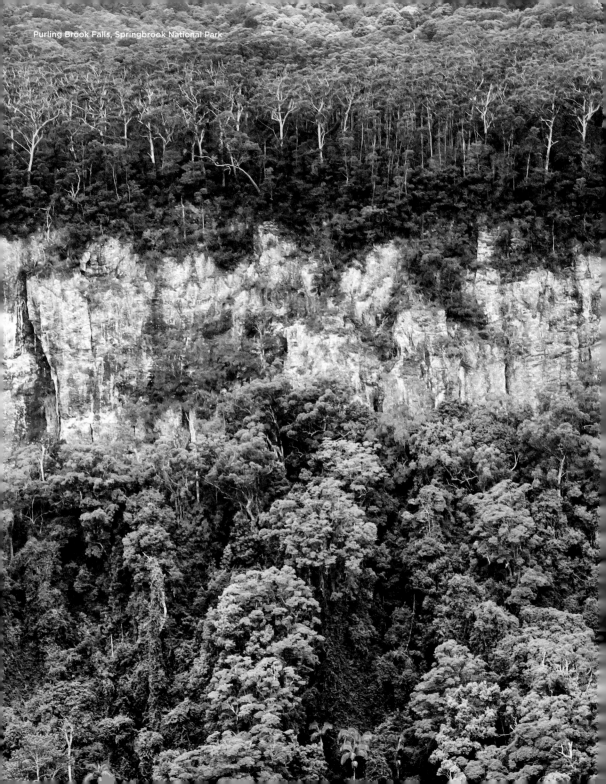

Purling Brook Falls, Springbrook National Park

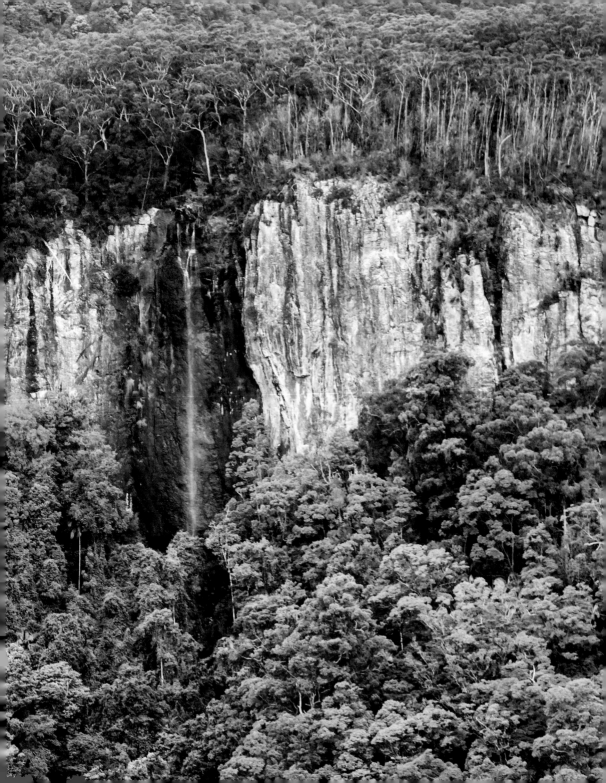

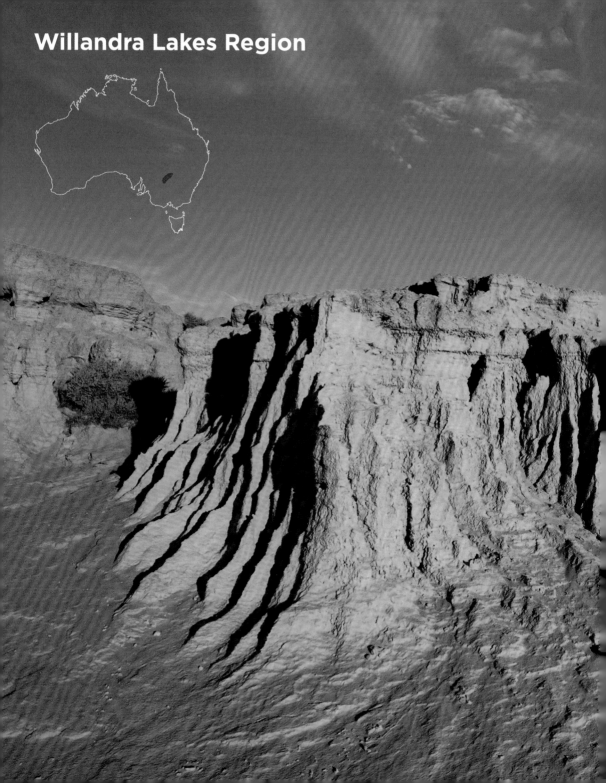

Willandra Lakes Region

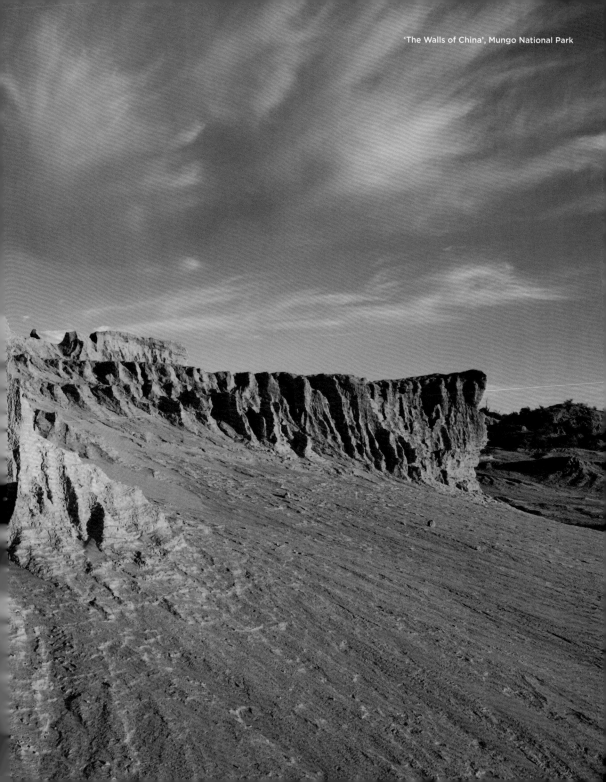

'The Walls of China', Mungo National Park

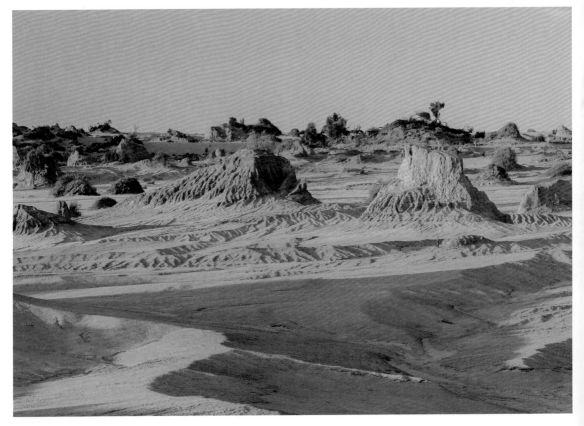

'The Walls of China', Mungo National Park

Willandra Lakes Region

In far western New South Wales and one of the major attractions of the Australian Outback, the Unesco World Heritage-listed Willandra Lakes region encompasses fossil lakes that date back to the Pleistocene era. The region is of profound significance to the land's traditional indigenous owners, the Muthi Muthi, Nyiampaar and Barkinji people.

Región de los Lagos Willandra

En el extremo oeste de Nueva Gales del Sur se halla una de las mayores atracciones del interior de Australia, la región de los Lagos Willandra, Patrimonio Mundial de la Unesco, que comprende lagos fósiles que datan de la era del Pleistoceno. La región tiene una profunda importancia para los propietarios indígenas tradicionales de la tierra, los pueblos Muthi Muthi, Nyiampaar y Barkinji.

Région des lacs Willandra

Située dans l'extrême ouest de la Nouvelle-Galles du Sud, la région des lacs Willandra, inscrite au patrimoine mondial de l'Unesco, est l'une des principales attractions de l'Outback australien. On y trouve des lacs fossiles datant de l'époque du Pléistocène. La région revêt une importance profonde pour les traditionnels propriétaires autochtones tels que les Muthi Muthi, les Nyiampaar et les Barkinji.

Regione dei laghi di Willandra

Nell'estremo ovest del Nuovo Galles del Sud, una delle maggiori attrazioni dell'outback australiano, la regione dei laghi di Willandra, riconosciuta come patrimonio dell'umanità dall'Unesco, è la sede di laghi fossili risalenti al pleistocene. La regione riveste un profondo significato per i Muthi Muthi, i Nyiampaar e i Barkinji, gli aborigeni che da sempre vivono in queste terre.

Willandra-Seenregion

Im fernen Westen von New South Wales gelegen ist eine der Hauptattraktionen des australischen Outbacks: die ebenfalls zum Welterbe der Unesco gehörende Willandra Lakes-Region, deren fossile Seenaus der Pleistozänzeit stammen. Die Region ist von großer Bedeutung für die traditionellen indigenen Besitzer des Landes, die Muthi Muthi, Nyiampaar und Barkinji.

Merengebied Willandra

De Willandra Lakes Region in het uiterste westen van New South Wales is een van de belangrijkste attracties van de Australische outback en staat eveneens op de werelderfgoedlijst van de Unesco. De regio omvat fossiele meren die stammen uit het pleistoceen en is van groot belang voor de oorspronkelijke bewoners van het land: de Muthi Muthi, Nyiampaar en Barkinji.

Galah *(Cacatua roseicapilla)*, Mungo National Park

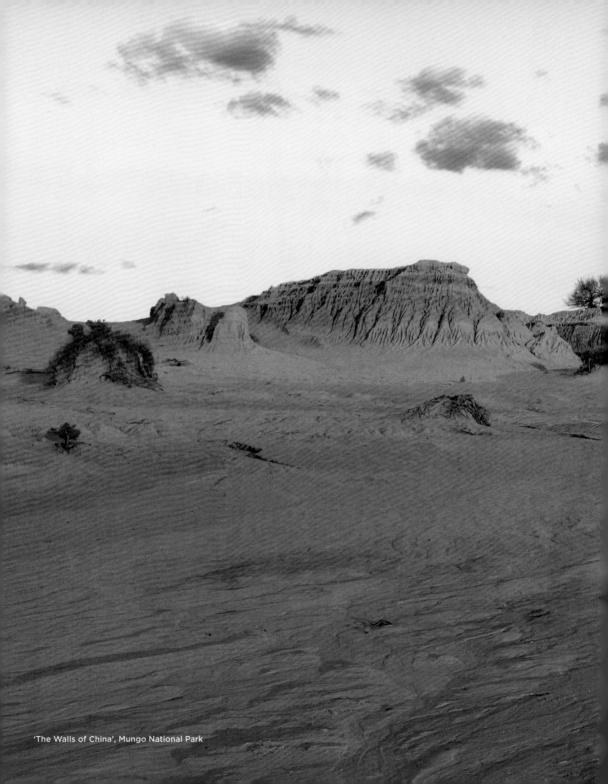

'The Walls of China', Mungo National Park

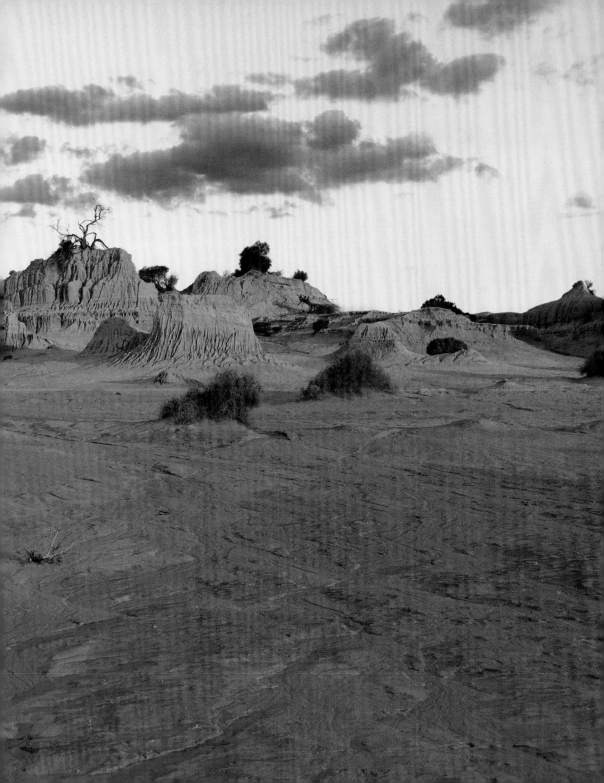

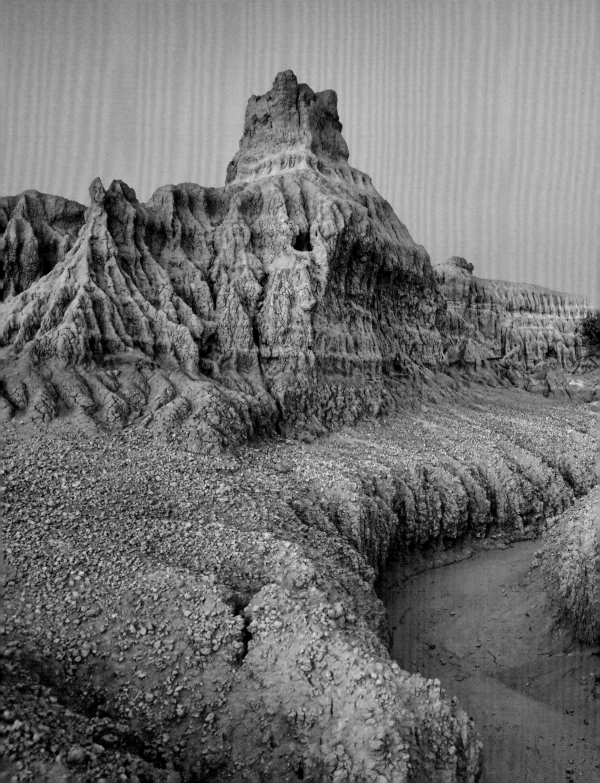

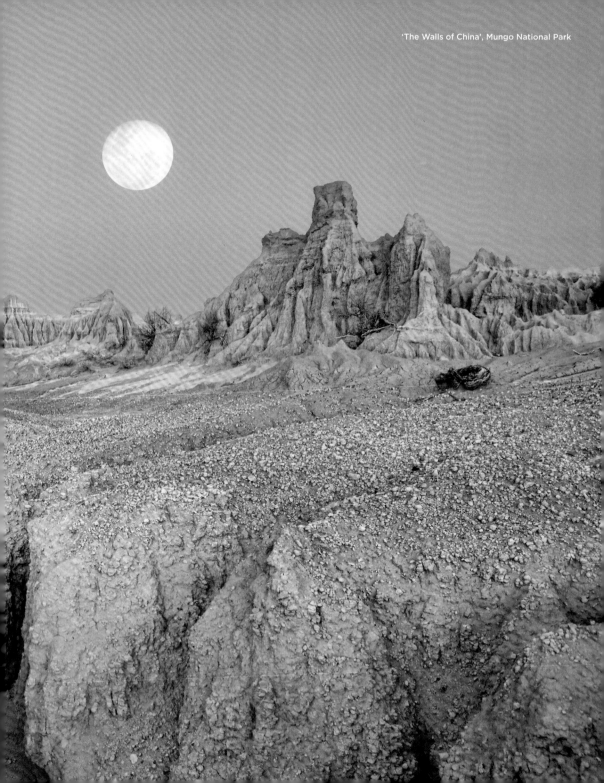

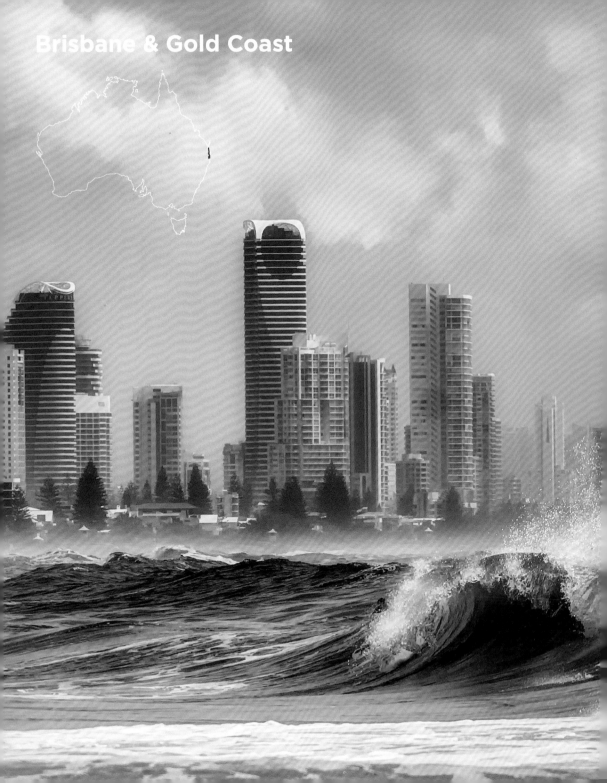

Brisbane & Gold Coast

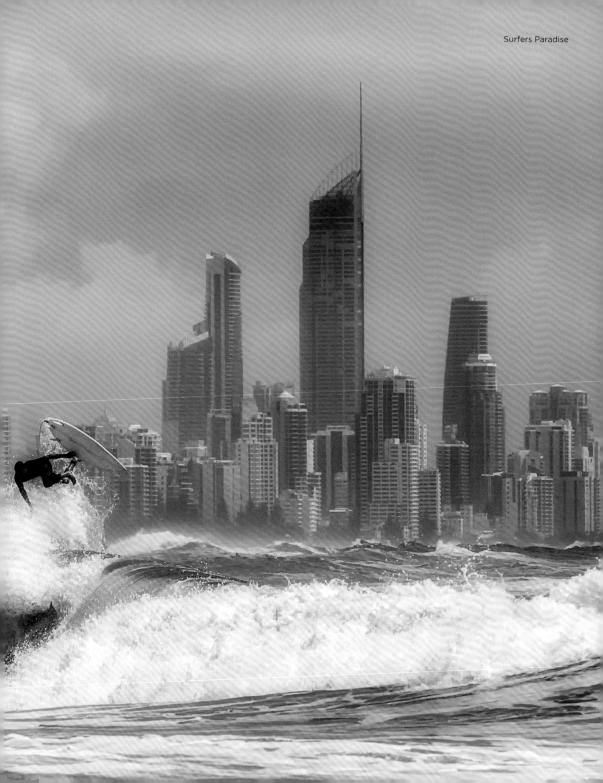

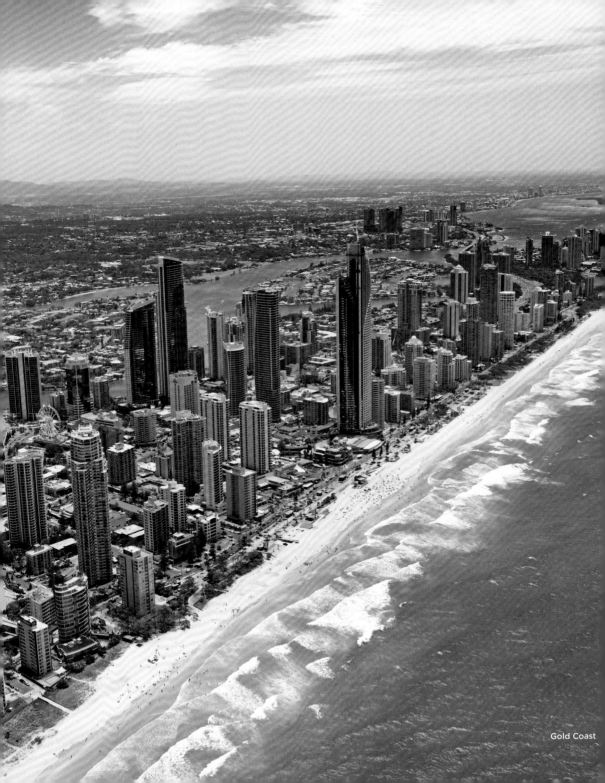

Gold Coast

Surfers Paradise Beach

Brisbane & Gold Coast

Many Australian children have fond memories of the Gold Coast, and despite its reputation for over-development, the fact remains that this is one of the longest stretches of sand in eastern Australia. Brisbane is Australia's third-largest city with around 2.5 million people and has a growing reputation as an emerging cultural centre.

Brisbane & Gold Coast

Muchos niños australianos tienen buenos recuerdos de la Costa Dorada y, a pesar de su reputación de desarrollo excesivo, el hecho es que se trata de uno de los tramos de arena más largos del este de Australia. Brisbane es la tercera ciudad más grande de Australia con alrededor de 2,5 millones de habitantes y tiene una reputación creciente como centro cultural emergente.

Brisbane & Gold Coast

Beaucoup d'enfants australiens gardent de bons souvenirs de la Gold Coast, et malgré sa réputation de surdéveloppement, il n'en demeure pas moins qu'il s'agit de l'une des plus longues étendues de sable de l'est de l'Australie. Brisbane est, avec environ 2,5 millions d'habitants, la troisième ville d'Australie et jouit d'une réputation croissante en tant que centre culturel émergent.

Brisbane & Gold Coast

Molti bambini australiani hanno bei ricordi della Gold Coast e, nonostante la sua reputazione di essere soggetta di sovrasviluppo, rimane il fatto che questa è una delle più lunghe distese di sabbia dell'Australia orientale. Brisbane è la terza città australiana per grandezza, con circa 2,5 milioni di abitanti, e gode di una crescente reputazione come centro culturale emergente.

Brisbane & Gold Coast

Viele australische Kinder haben schöne Erinnerungen an die Gold Coast, und trotz ihres Rufs der Überentwicklung bleibt die Tatsache bestehen, dass dies eine der längsten Sandflächen im Osten Australiens ist. Brisbane ist mit rund 2,5 Millionen Einwohnern die drittgrößte Stadt Australiens und gilt als aufstrebendes Kulturzentrum.

Brisbane & Gold Coast

Veel Australische kinderen hebben mooie herinneringen aan de Gold Coast. Ondanks zijn supertoeristische reputatie blijft het feit dat de Gold Coast een van de langste stukken zand van Oost-Australië is. Brisbane is met circa 2,5 miljoen inwoners de op twee na grootste stad van Australië en wordt gezien als een opkomend cultureel centrum.

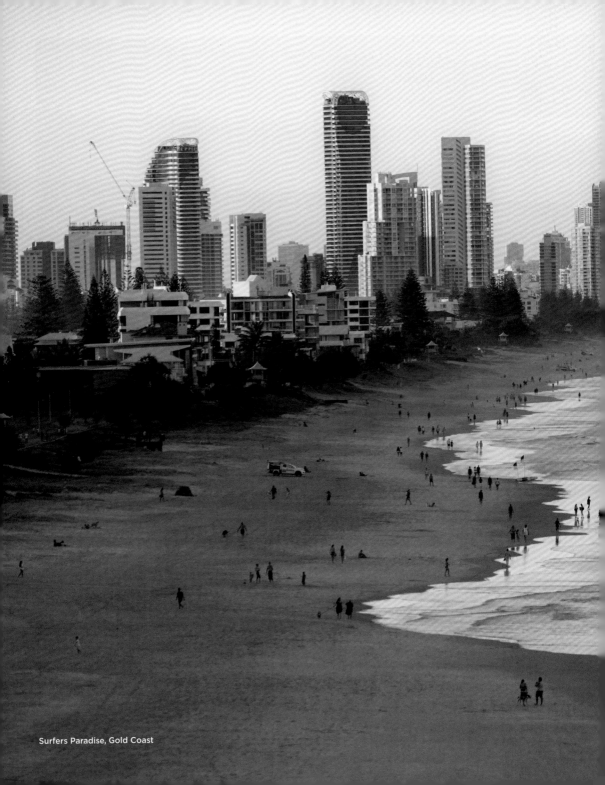

Surfers Paradise, Gold Coast

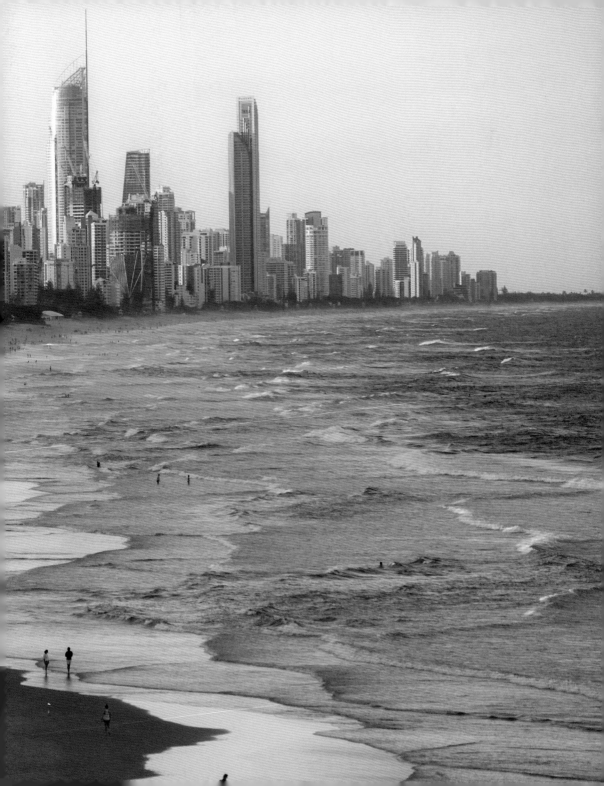

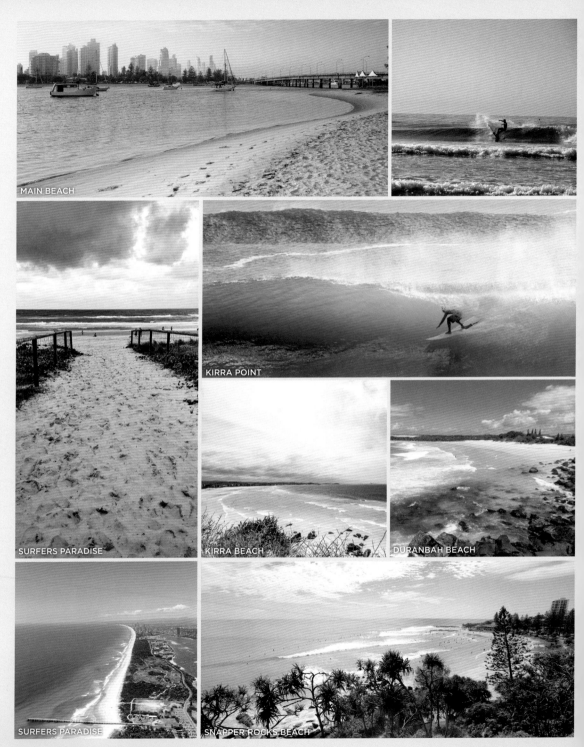

MAIN BEACH

KIRRA POINT

SURFERS PARADISE

KIRRA BEACH

DURANBAH BEACH

SURFERS PARADISE

SNAPPER ROCKS BEACH

GREENMOUNT BEACH

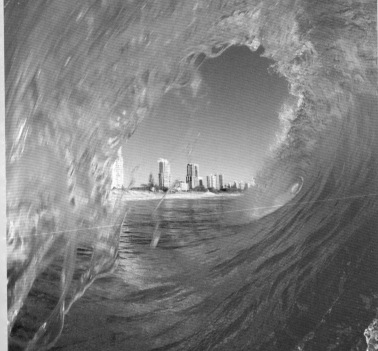

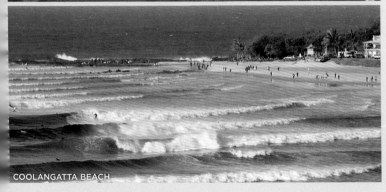

COOLANGATTA BEACH

Surf Spots

The Gold Coast's 70 km strip of pristine sand is home to some of the longest, hollowest and most consistent waves in the world. Standout spots include Currumbin's right-hander, Burleigh's legendary barrels and Snapper Point's longboard-friendly point break.

Spots de surf

La bande de sable vierge qui court le long des 70 km de la Gold Coast abrite certaines des vagues les plus longues, les plus creuses et les plus régulières du monde. Parmi les meilleurs spots, *citons* Currumbin, les vagues tubulaires légendaires de Burleigh, le *point break* de Snapper, idéal pour les longboards.

Surfspots

Der 70 km lange Streifen unberührten Sandes an der Gold Coast beherbergt einige der längsten, hohlsten und beständigsten Wellen der Welt. Zu den bekanntesten Spots gehören Burleigh's legendäre *Barrels* und Snapper Point's Longboard-freundlicher *Point Break*.

Puntos de surf

La franja de 70 km de arena prístina de la Costa Dorada es el hogar de algunas de las olas más largas, huecas y consistentes del mundo. Entre los lugares destacados se encuentran "Currumbin's *right-hander*, Burleigh's legendary *barrels* y el punto de encuentro Snapper Point.

Posti per il surf

La striscia di 70 km di sabbia incontaminata della Gold Coast è nota per alcune delle onde più lunghe, cave e di grande portata al mondo. Tra gli highlight ci sono le *right-hander* di Currumbin, ossia le onde da destra, le leggendarie *barrel* di Burleigh, cioè le onde a tubo, e il *point break* di Snapper Point, particolarmente apprezzato dai surfisti di longboard.

Surfplekken

Langs de 70 km lange strook ongerept zand van de Gold Coast vind je enkele van de langste, holste en meest consistente golven ter wereld. Opvallende plekken zijn de legendarische barrels van Burleigh en de longboard-vriendelijke point break van Snapper Point.

Australian Pelicans *(Pelecanus conspicillatus)*

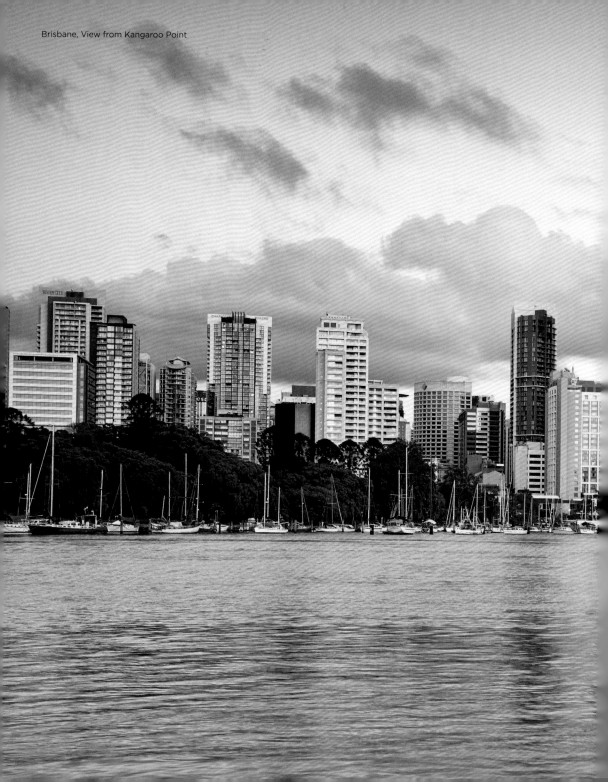

Brisbane, View from Kangaroo Point

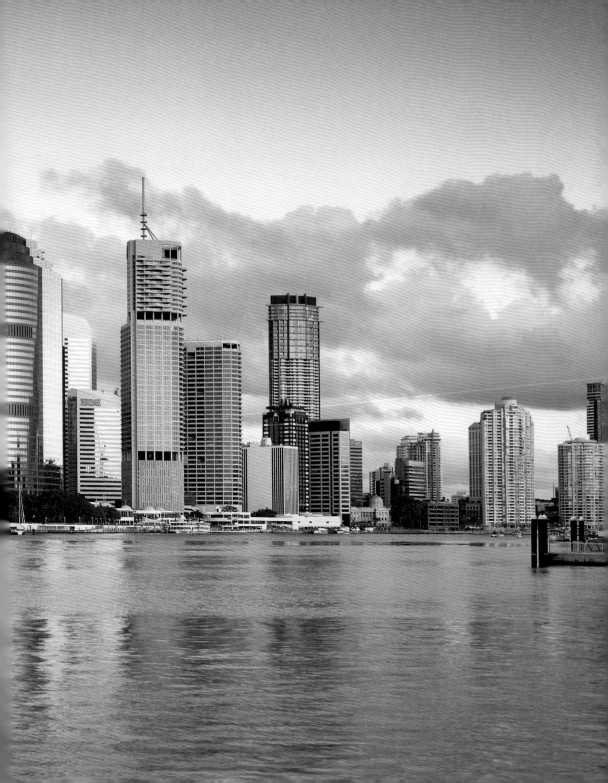

Wheel of Brisbane

Nepalese Peace Pagoda at South Bank Parklands, Brisbane

South Bank Parklands

This lush riverfront expanse has outdoor attractions like swimming areas, picnic grounds and walking tracks, restaurant and café streets as well as Brisbane's densest cultural precinct where you'll find Queensland Performance Arts Centre, Queensland Museum and Sciencentre, the Queensland Art Gallery and Gallery of Modern Art and the State Library of Queensland.

South Bank Parklands

Esta exuberante extensión frente al río tiene atracciones al aire libre como zonas de baño, zonas de picnic y senderos para caminar, calles de restaurantes y cafeterías, así como el recinto cultural más denso de Brisbane, donde se encuentra el Centro de Artes Escénicas de Queensland, el Museo y Centro Científico, la Galería de Arte y la Galería de Arte Moderno y la biblioteca estatal.

Parc de South Bank

Ces rives luxuriantes abritent des attractions en plein air comme des zones de baignade, des aires de pique-nique et des sentiers pédestres, mais aussi des rues entières de restaurants et de cafés ainsi que le quartier culturel le plus dense de Brisbane où vous trouverez le Queensland Performance Arts Centre, le Queensland Museum and Sciencentre, la Queensland Art Gallery et la Gallery of Modern Art et la State Library of Queensland.

South Bank Parklands

Questa lussureggiante area lungo le rive del fiume offre attrazioni all'aperto quali aree balneari, aree picnic e sentieri per passeggiate, ristoranti e caffè. Essa è anche la zona culturale più densa di Brisbane, dove si trovano il Queensland Performance Arts Centre, il Queensland Museum and Sciencentre, la Queensland Art Gallery and Gallery of Modern Art e la State Library of Queensland.

South Bank Parklands

Diese üppige Uferpromenade bietet Outdoor-Attraktionen wie Badeplätze, Picknickplätze, Restaurant- und Caféstraßen sowie Brisbanes dichtestes Kulturangebot, in dem sich das Queensland Performance Arts Centre, das Queensland Museum and Sciencentre, die Queensland Art Gallery und die Gallery of Modern Art befinden.

South Bank Parklands

Deze weelderige rivieroever heeft buitenattracties zoals zwembaden, picknickplaatsen en wandelpaden, straten met restaurants en cafés, maar ook het grootste culturele aanbod van Brisbane, vanwege de aanwezigheid van het Queensland Performance Arts Centre, Queensland Museum en Sciencentre, de Queensland Art Gallery en Gallery of Modern Art.

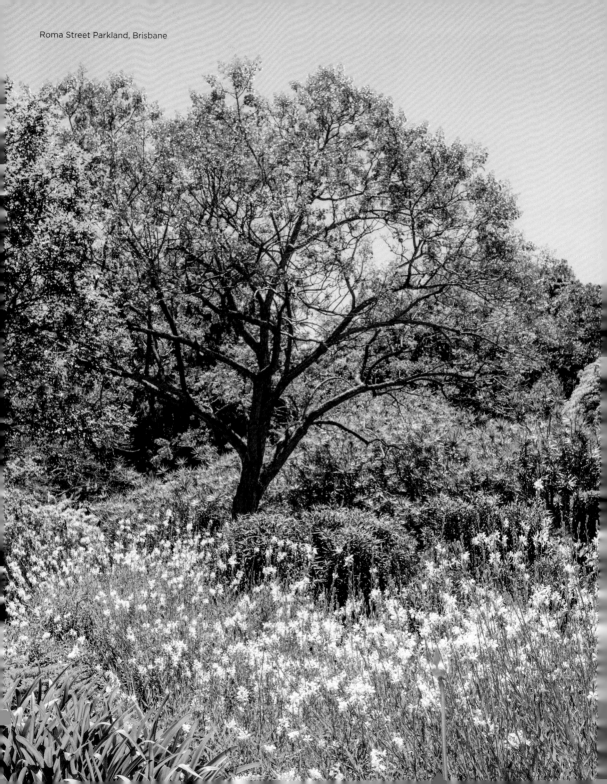
Roma Street Parkland, Brisbane

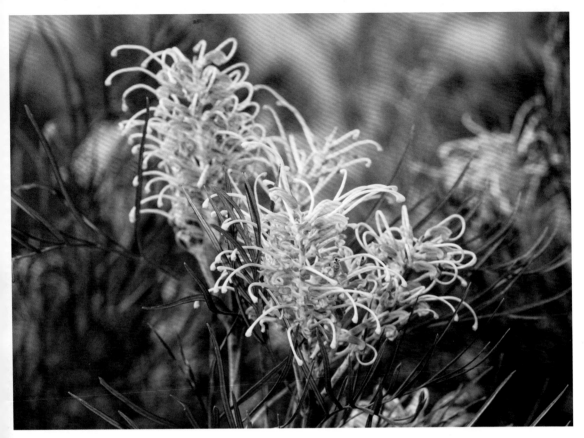

Red silky oak *(Grevillea banksi)*

Roma Street Parkland

The designer gardens and sprawling lawns here draw garden and plant enthusiasts for its exceptional horticultural standards, and is the largest subtropical city garden in the world. Groves of pandanus, palm and paperbark forests and fern gullies mix with 50 themed gardens that pop with colour and sculptural forms.

Parc de la rue Roma

Les jardins design et les vastes étendues d'herbe attirent les amateurs d'horticulture pour leur qualité exceptionnelle. C'est le plus grand jardin urbain subtropical du monde. Des bosquets de pandanus, des forêts de palmiers et de niaoulis et des rigoles de fougères se mêlent à 50 jardins thématiques qui se parent de couleurs et de formes sculpturales.

Roma Street Parkland

Die Designer-Gärten und weitläufigen Rasenflächen ziehen Garten- und Pflanzenliebhaber wegen ihres außergewöhnlichen Gartenbaus an und sind der größte subtropische Stadtgarten der Welt. Schraubenbäume und Palmwälder, Myrtenheide und Farnschluchten wechseln sich ab mit 50 Themengärten, die mit farbigen und skulpturalen Formen bezaubern.

Roma Street Parkland

Los jardines de diseño y los extensos céspedes atraen a los entusiastas de la jardinería y las plantas por su excepcional calidad hortícola. Es el mayor jardín urbano subtropical del mundo. Bosques de pandanáceas, bosques de palmeras y de maleleucas y barrancos de helechos se mezclan con 50 jardines temáticos que se llenan de color y formas escultóricas.

Roma Street Parkland

Per i loro eccezionali standard di orticoltura, i giardini in stili diversi e i vasti prati che si trovano qui attirano gli appassionati di giardini e piante. Questo è il più grande orto botanico cittadino subtropicale al mondo. Boschi di pandanus, foreste di palme e di niaouli e calanchi di felci si mescolano a 50 giardini tematici ricchi di colori e forme scultoree.

Roma Street Parkland

De aangelegde tuinen en uitgestrekte gazons trekken tuin- en plantenliefhebbers aan vanwege hun uitzonderlijke ontwerp en vormen de grootste subtropische stadstuin ter wereld. Bosjes schroefpalmen en palmen, mirtenheide en kloven met varens worden afgewisseld door 50 thematuinen die betoveren door hun kleuren en sculpturale vormen.

Queenslander House, Brisbane Southpark

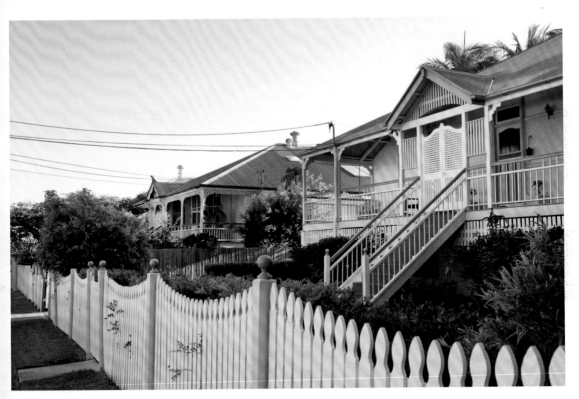

Queenslander House

Queenslander Houses
Brisbane's almost year round balmy, humid climate gave rise to a tropical style of vernacular architecture known as the "Queenslander". Built on stumps and with large shaded return verandahs and decorative screens, these simple but beautiful wooden structures allow breezes to circulate and give residents a shaded outdoor place to relax and socialise during scorching days or torrential downpours.

Casas de Queenslander
El clima húmedo y templado de Brisbane dio lugar a un estilo tropical de arquitectura conocido como "Queenslander". Estas sencillas pero hermosas estructuras de madera,construidas sobre tocones y con grandes terrazas sombreadas, permiten que las brisas circulen y ofrecen a los residentes un lugar sombreado al aire libre para relajarse y socializar durante los días abrasadores o los chaparrones torrenciales.

Maisons Queenslander
Le climat doux et humide de Brisbane, identique quasiment toute l'année, a donné naissance à un style d'architecture connu sous le nom de « Queenslander ». Construites sur un sous-sol en bois ou en béton et présentant de grandes vérandas ombragées et des moustiquaires décoratives, ces structures en bois permettent à la brise de circuler et offrent aux résidents un endroit couvert à l'extérieur pour se détendre et socialiser lors de journées torrides ou de pluies torrentielles.

Le case "Queenslander"
Il clima mite e umido di Brisbane invariato per quasi tutto l'anno, ha dato origine a uno stile tropicale di architettura vernacolare noto come "Queenslander". Costruite su pilastri e con ampie verande ombreggiate da paraventi decorativi, queste semplici ma belle strutture in legno permettono alla brezza di circolare offrendo riparo dal sole, un posto ideale per rilassarsi e socializzare durante le giornate torride o gli acquazzoni torrenziali.

Queensland Häuser
Das milde, feuchte Klima in Brisbane führte zu einem tropischen Stil volkstümlicher Architektur, der als „Queenslander" bekannt ist. Diese einfachen, aber schönen Holzkonstruktionen, die auf Stümpfen gebaut und mit großen schattigen Rückterrassen und dekorativen Schirmen ausgestattet sind, ermöglichen eine gute Durchlüftung und erlauben es den Bewohnern immer, einen schattigen Platz im Freien zu finden.

Huizen van Queensland
Het zwoele, vochtige klimaat van Brisbane heeft geleid tot een volkse, tropische architectuurstijl die ook bekend is als "Queenslander". Deze eenvoudige maar mooie houten gebouwen, gebouwd op boomstronken en voorzien van grote schaduwrijke veranda's en decoratieve schermen, staan een goede ventilatie toe en bieden de bewoners altijd een schaduwrijke plek buiten.

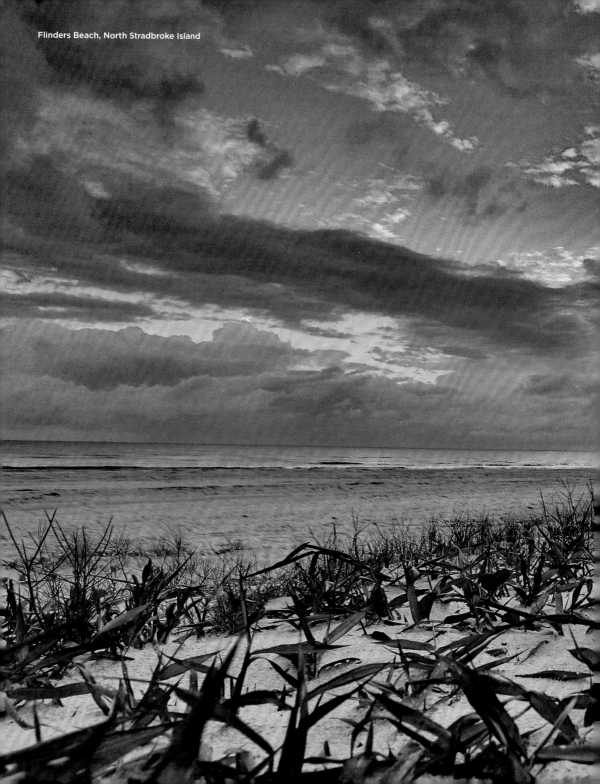
Flinders Beach, North Stradbroke Island

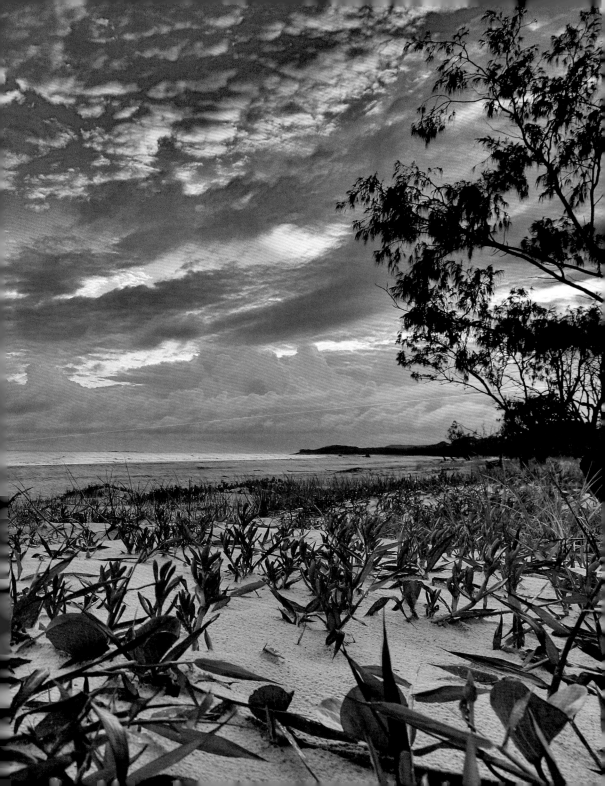

Fraser Island

Great Sandy National Park

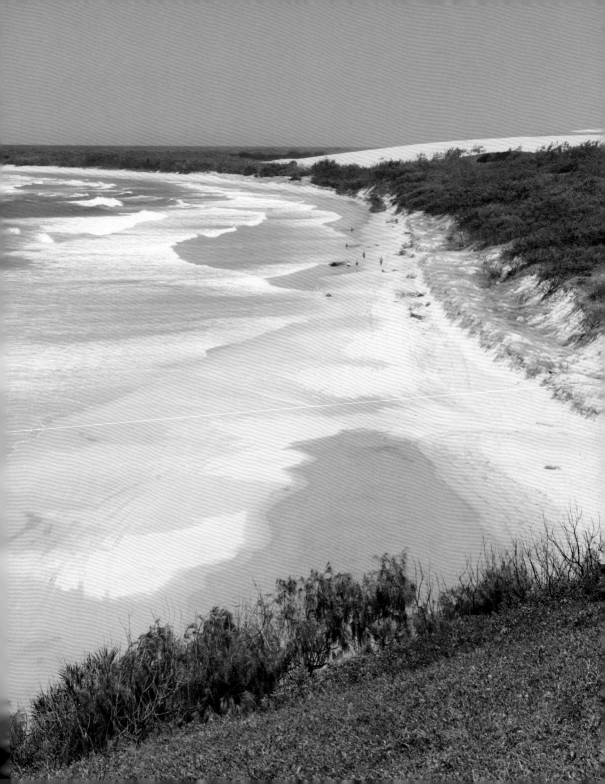

Seventy Five Mile Beach, Great Sandy National Park

Fraser Island

Forget all the clichés about island paradises: here is one in true life. The world's largest sand island has the pristine beaches and sculpted dunes you'd expect, along with many surprises, including over one hundred freshwater lakes, scrubby heathland and unique sand-rooted rainforest. Wildlife is everywhere, from beach-going dingoes to frolicking dugongs.

Île Fraser

Oubliez tous les clichés sur les paradis insulaires : en voici un véritable. La plus grande île de sable au monde possède des plages vierges et des dunes sculptées, mais offre aussi de nombreuses surprises, dont plus d'une centaine de lacs d'eau douce, des landes broussailleuses et une forêt tropicale unique qui pousse sur le sable. La faune est partout, des dingos sur la plage aux dugongs qui s'ébattent.

Fraser Island

Vergessen Sie alle Klischees über Inselparadiese: Hier ist eines im wahren Leben. Die größte Sandinsel der Welt hat die unberührten Strände und Dünen, die Sie erwarten würden, bietet aber auch viele Überraschungen wie über hundert Süßwasserseen, Heidegebiete und einen einzigartigen Sandregenwald. Die einmalige Tierwelt der Insel ist allgegenwärtig, vom Dingos am Strand bis zu den sich im Wasser tummelnden Dugongs.

Seventy Five Mile Beach, Great Sandy National Park

Fraser Island

Olvídese de todos los clichés sobre las islas paradisíacas: esta es real. La isla de arena más grande del mundo tiene las playas prístinas y las dunas esculpidas que uno esperaría, junto con muchas sorpresas, incluyendo más de cien lagos de agua dulce, matorrales de brezales y un bosque pluvial único enraizado en la arena. La vida salvaje está en todas partes, desde los dingos que van a la playa hasta los dugongos que retozan.

Fraser Island

Dimenticate tutti i cliché sui paradisi insulari: questo è realtà. L'isola di sabbia più grande al mondo ha spiagge incontaminate e dune scolpite come da cartolina, insieme a molte sorprese, tra cui più di un centinaio di laghi d'acqua dolce, brughiere e una foresta pluviale con radici che affondano nella sabbia, unica nel suo genere. Gli animali selvatici si aggirano ovunque, i dingo sulla spiaggia mentre i dugonghi in acqua sono sempre in movimento.

Fraser Island

Vergeet alle clichés over eilandparadijzen: hier is er één in het echte leven. Het grootste zandeiland ter wereld heeft de ongerepte stranden en duinen die je zou verwachten, maar ook een heleboel verrassingen, zoals meer dan honderd zoetwatermeren, heidevelden en een uniek zandregenwoud. Er zijn overal wilde dieren, van dingo's op het strand tot stoeiende doejongs.

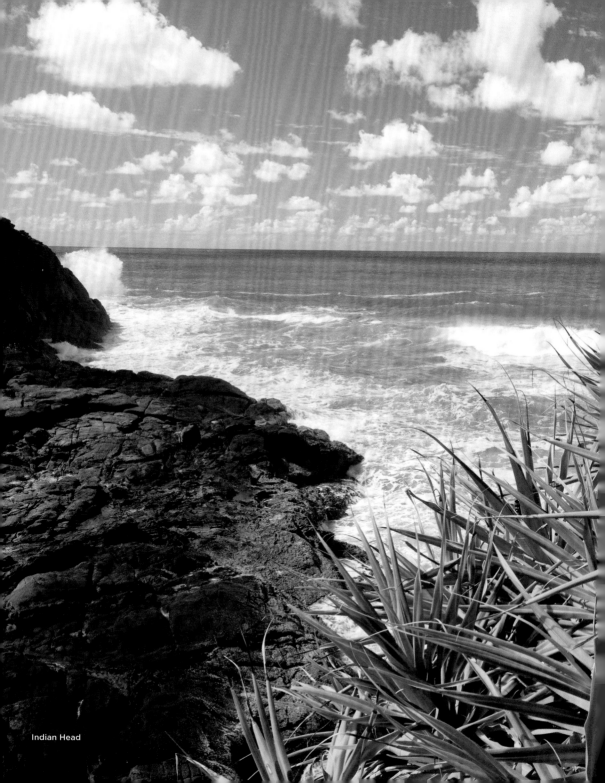

Indian Head

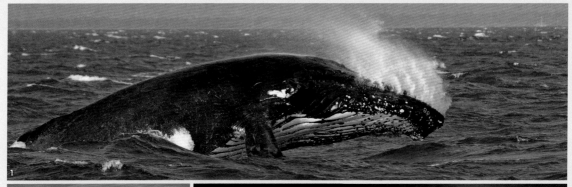

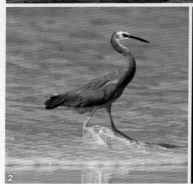

1 Humpback Whale; Baleine à bosse ; Buckelwal; Ballena jorobada; Megattera; Bultrugwalvis

2 White-faced Heron; Héron à face blanche ; Weißwangenreiher; Garza cariblanca; Garzetta facciabianca; Witwangreige

3 Laughing Kookaburra; Martin-chasseur géant ; Jägerliest/Lachender Hans; Cucaburra común; Kookaburra

4 Dingo

5 Soldier Crab; Crabe soldat ; Soldatenkrabbe; Cangrejo soldado; Granchio soldato; Krab *Mictyris longicarpus*

6 Whale Watching; Observation des baleines ; Walbeobachtung; Avistamiento de ballenas; Osservazione delle balene; Walvissen spotten

7 Pied Oystercatcher; Huîtrier pêcheur ; Australischer Austernfischer; Ostrero pío australiano; Beccaccia di mare orientale; Australische bonte scholekster

8 Sanderling; Bécasseau sanderling ; Sanderling; Correlimos tridáctilo; Piovanello tridattilo; Drieteenstrandloper

9 Sand Goana; Varan des sables ; Gaulds Waran; Goana de arena; Varano di Gould; Goulds varaan

10 Ship wreck; Épave de navire ; Schiffswrack; Embarcaciones naufragadas; Nave naufragata; Scheepswrak

Dingo

Dingos and Whales—a perfect pair!

The majestic southern humpback leaves its Antarctic feeding grounds in late autumn and travels north before settling in the warm waters of the Whitsundays to breed. The fifth largest of all the dolphins and whales, adults grow up to 15 m and weigh up to 40 tonnes. Returning south, they often stay and frolic in Fraser waters with their calves. The Fraser Island dingoes, golden furred with white chests, tail tips and socks, are the purest strain of dingo on the eastern Australian seaboard and perhaps across Australia. They are protected animals and allowed to live as naturally as possible, roaming in male-dominated packs of between three and a dozen animals.

Dingos et baleines – un parfait duo !

La majestueuse baleine à bosse méridionale quitte ses zones d'alimentation antarctiques à la fin de l'automne et se dirige vers le nord avant de s'établir dans les eaux chaudes des Whitsundays pour se reproduire. Cinquième plus grand mammifère marin parmi tous les dauphins et baleines, les adultes atteignent 15 m et pèsent jusqu'à 40 tonnes. De retour vers le sud, ils demeurent souvent dans les eaux du Fraser avec leurs petits. Les dingos de l'île Fraser, dont la fourrure dorée est ornée de blanc sur la poitrine et au bout de la queue et des pattes, sont la plus pure souche de dingo de la côte est et peut-être de toute l'Australie. Ce sont des animaux protégés, que l'homme laisse vivre aussi naturellement que possible. Ils se déplacent en meute de trois à douze animaux, principalement mâles.

Dingos und Wale – ein perfektes Paar!

Der majestätische Buckelwal verlässt im Spätherbst sein antarktisches Nahrungsgebiet und reist nach Norden, bevor er sich in den warmen Gewässern der Whitsundays niederlässt, um zu brüten. Als fünftgrößter aller Delfine und Wale werden Erwachsene bis zu 15 M groß und wiegen bis zu 40 Tonnen. Wenn sie nach Süden zurückkehren, bleiben sie oft vor Fraser und toben mit ihren Kälbern. Die Fraser-Dingos, mit goldenem Fell, weißer Brust, Schwanzspitzen und Pfoten, sind die reinste Dingo-Sorte an der Ostküste und vielleicht ganz Australiens. Die Tiere sind geschützt und leben so natürlich wie möglich in von Männchen dominierten Rudeln von drei bis einem Dutzend Tieren.

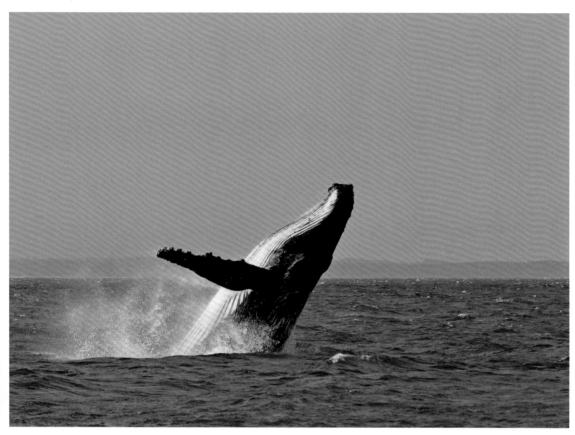

Humpback whale *(Megaptera novaeangliae*

Dingos y ballenas – ¡una pareja perfecta!

La majestuosa ballena jorobada del sur abandona su zona de alimentación antártica a finales de otoño y viaja hacia el norte antes de establecerse en las cálidas aguas de las islas Whitsundays para reproducirse. Esta especie es la quinta de mayor tamaño entre los delfines y ballenas, los adultos crecen hasta 15 m y pesan hasta 40 toneladas. Al regresar al sur, a menudo se quedan y retozan en las aguas de Fraser con sus crías. Los dingos de la isla de Fraser, de pelo dorado con pechos blancos, puntas de cola y calcetines, son la variedad más pura de dingos de la costa oriental de Australia y quizás de toda Australia. Son animales protegidos y se les permite vivir de la manera más natural posible, vagando en manadas dominadas por machos de a tres y una docena de animales.

Dinghi e balene – una coppia perfetta!

La maestosa megattera lascia i suoi pascoli antartici nel tardo autunno e viaggia verso nord prima di stabilirsi nelle calde acque dell'isoli Whitsunday per riprodursi. Quinta sulla scala di grandezza di delfini e balene, gli adulti di questo mammifero crescono fino a raggiungere una lunghezza di 15 m e 40 tonnellate di peso. Sulla via del ritorno verso sud rimangono spesso nelle acque intorno all'isola di Fraser, giocando con i loro piccoli. I dingo dell'isola, dal pelo dorato e con petto, coda e zampe bianchi, appartengono a una famiglia di dingo più pura che non quella della costa orientale australiana, addirittura forse di tutta l'Australia. Sono animali protetti e possono vivere nel modo più naturale possibile, vagando in branchi guidati dagli esemplari maschi che comprendono da tre a una dozzina di esemplari.

Dingo's en walvissen – een perfect paar!

De majestueuze bultrug verlaat in de late herfst zijn Antarctische foerageergebied en reist naar het noorden voordat hij zich in de warme wateren van de Whitsundayeilanden voortplant. De volwassen dieren, de op vier na grootste van alle dolfijnen en walvissen, worden wel 15 m lang en kunnen 40 ton wegen. Op hun terugweg naar het zuiden blijven ze vaak met hun jongen voor Fraser Island ravotten. De dingo's op het Fraser Island, met goudkleurige vacht, witte borst, staartpunt en sokken, zijn de zuiverste dingosoort aan de oostkust en misschien wel van heel Australië. Het zijn beschermde dieren en leven zo natuurlijk mogelijk in door mannetjes gedomineerde roedels die variëren van drie tot twaalf dieren.

Lake Wabby

Fraser Island's Lakes

Fraser's 40 lakes are some of the most pristine freshwater bodies in the world, and the second highest concentration of lakes in Australia. It also has the most 'perched lakes' in the world, with the rust-hued Lake Boomanjin also the world's largest. Lake McKenzie, with its clear blue water and white silica shore, is the island's most beautiful.

Los lagos de Fraser Island

Los 40 lagos de la isla de Fraser constituyen algunas de las reservasdas agua dulce más puras del mundo. Se trata de la segunda mayor concentración de lagos de Australia. También son los lagos más 'altos' del mundo, y concretamente el lago Boomanjin, de color herrumbre, también es el más grande del mundo. El lago McKenzie, con sus claras aguas azules y su blanca orilla de sílice, es el más bello de la isla.

Lacs de l'île Fraser

Les 40 lacs de l'île Fraser comptent parmi les plans d'eau douce les plus vierges du monde et leur concentration est la seconde plus importante d'Australie. L'île possède également les lacs les plus « perchés » du monde, comme le lac Boomanjin, aux teintes de rouille – qui en est aussi le plus grand. Le lac McKenzie, avec ses eaux bleu clair et son rivage de silice blanche, est le plus beau de l'île.

Laghi del Fraser Island

I 40 laghi di Fraser sono tra i bacini d'acqua dolce più incontaminati al mondo. Questa è la seconda regione per concentrazione di laghi in Australia, dove si trova anche il maggior numero di laghi con acqua freatica al mondo. Tra questi, il lago Boomanjin, con le sue acque rosse, è anche tra i più grandi. Il lago McKenzie, con le sue acque cristalline e le sponde di silice bianca, è il più bello dell'isola.

Seen auf Fraser Island

Die 40 Seen von Fraser gehören zu den unberührtesten Süßwassergewässern der Welt und bieten die zweithöchste Dichte an Seen in Australien. Es gibt hier auch die meisten Grundwasserseen der Welt, und mit dem rostfarbenen See Boomanjin zugleich den größten. Der McKenzie-See mit seinem klaren blauen Wasser und seinem weißen Sand-Ufer ist der schönste der Insel.

Meren van Fraser Island

De veertig meren van Fraser behoren tot de ongereptste zoetwatermeren ter wereld en vormen de op één na hoogste merendichtheid in Australië. Hier zijn ook de meeste grondwatermeren ter wereld, met het roestkleurige Boomanjin Lake tevens de grootste ter wereld. Lake McKenzie is met zijn helderblauwe water en witte zandoever het mooiste van het eiland.

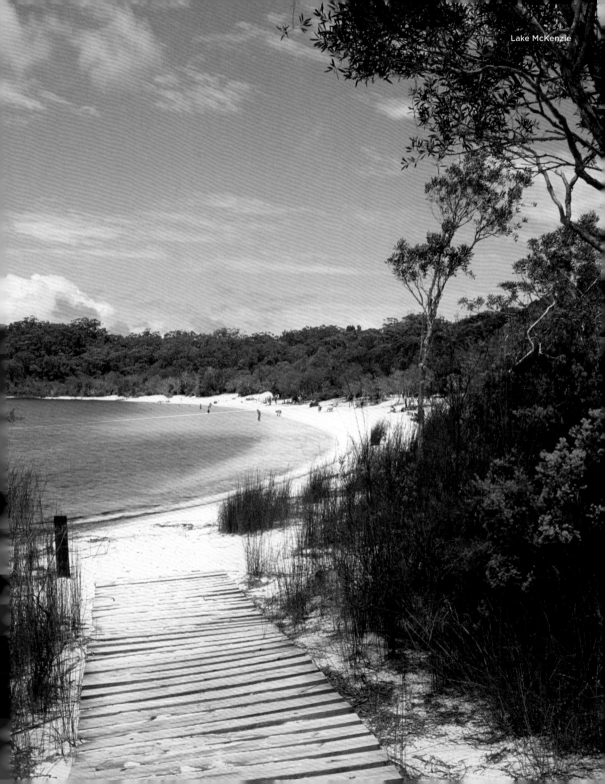

Lake McKenzie

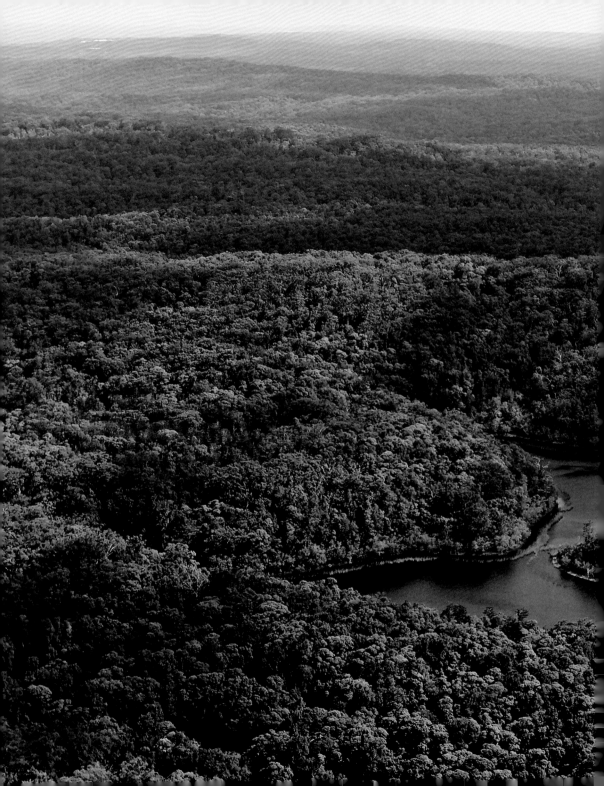

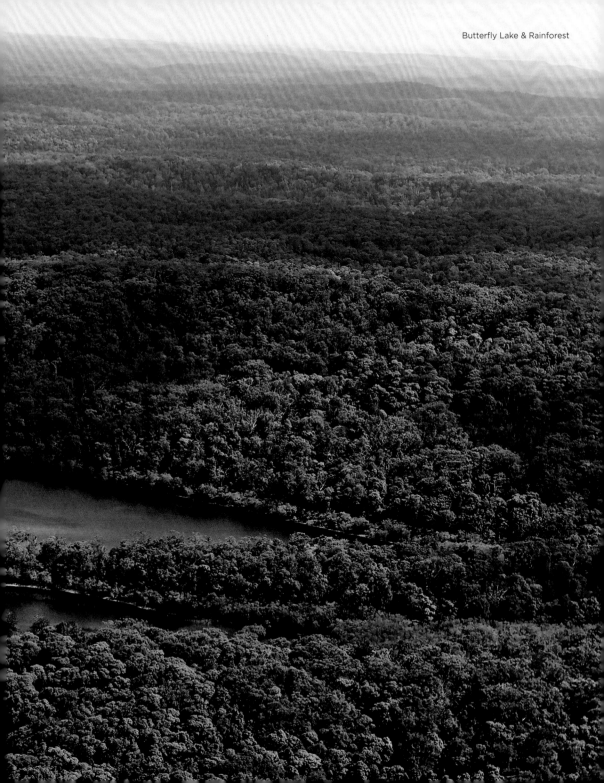

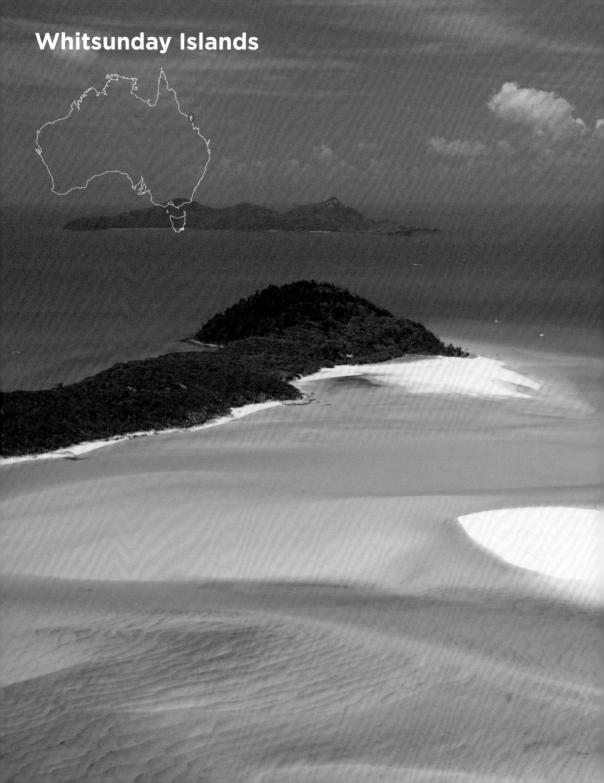

Whitsunday Islands

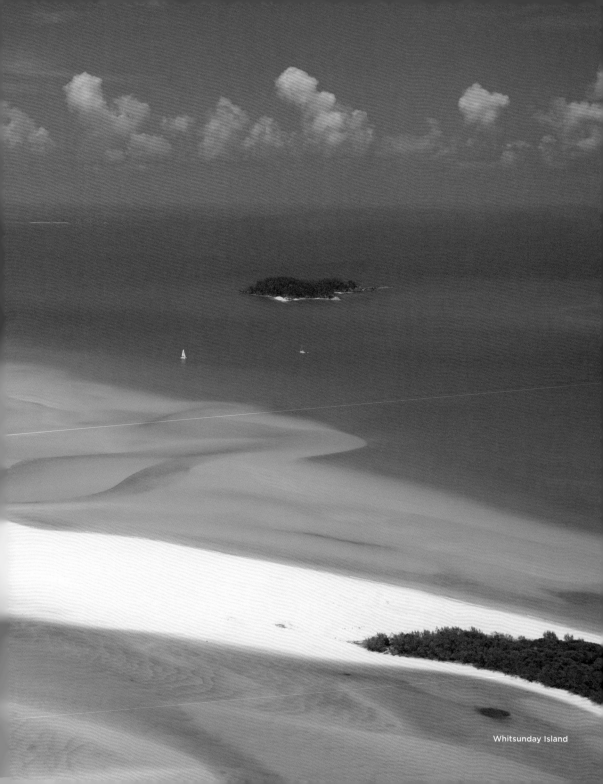

Whitsunday Island

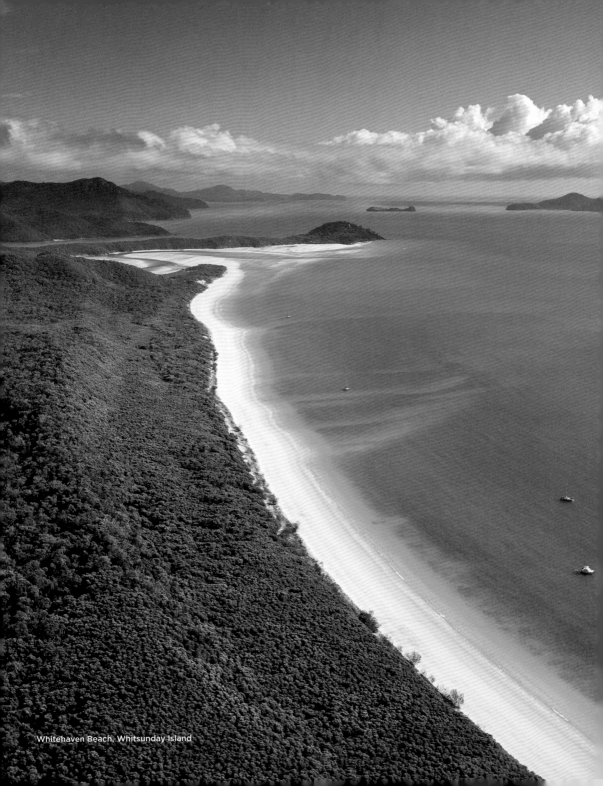

Whitehaven Beach, Whitsunday Island

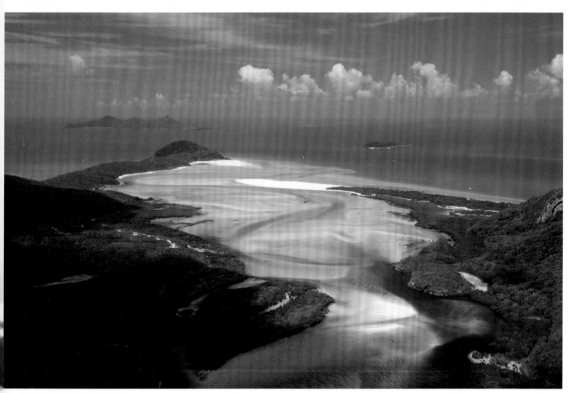

Hill Inlet, Whitsunday Island

Whitsunday Islands

The Whitsunday Islands owe their name to an error by Captain James Cook, who was the first European to lead an exploration of Australia's east coast in 1770. Upon encountering what we now know as the Whitsundays, he recorded in his journal the date as Whitsunday. However, given that it was many years before the International Date Line was recognised, he actually discovered the islands on Whit Monday.

Îles Whitsunday

Les îles Whitsunday doivent leur nom à une erreur du capitaine James Cook, qui fut le premier Européen à mener une exploration de la côte est de l'Australie en 1770. Lorsqu'il en atteignit le rivage, il inscrivit dans son journal la date de Pentecôte (« Whitsunday » en anglais). Cependant, au vu de la ligne de changement de date mise en place depuis, il a en fait découvert les îles le lundi suivant.

Whitsunday Islands

Die Whitsundays verdanken ihren Namen einem Fehler von Captain James Cook, der 1770 als erster Europäer die Erkundung der Ostküste Australiens leitete. Als er auf die heute als die Whitsundays bekannten Inseln stieß, notierte er in seinem Tagebuch das Datum Whitsunday. Wegen der Internationalen Datumsgrenze entdeckte er die Inseln tatsächlich am Pfingstmontag.

Whitsunday Islands

Las islas Whitsunday deben su nombre a un error del capitán James Cook, que fue el primer europeo en dirigir una exploración de la costa este de Australia en 1770. Al encontrar lo que ahora conocemos como las islas "Pentecostés", registró en su diario la fecha como Pentecostés. Sin embargo, dado que pasaron muchos años antes de que se reconociera la línea internacional de cambio de fecha se tardó en conocer que realmente las descubrió el lunes de Pentecostés.

Whitsunday Islands

Le Whitsunday Islands devono il loro nome a un errore del capitano James Cook, che nel 1770 fu il primo europeo a esplorare la costa orientale dell'Australia. Quando giunse a quella che oggi conosciamo come isola di Whitsunday (Pentecoste), annotò la data come Pentecoste. Tuttavia, poiché ciò avvenne molto prima del riconoscimento della linea internazionale del cambio di data, era il lunedì di Pentecoste.

Whitsunday Islands

De Whitsundayeilanden danken hun naam aan een fout van kapitein James Cook, die in 1770 als eerste Europeaan een ontdekkingsreis langs de oostkust van Australië leidde. Toen hij op de nu Whitsundays genoemde eilanden stuitte, schreef hij in zijn logboek als datum Whitsunday. Gezien de later erkende Internationale Datumgrens ontdekte hij de eilanden feitelijk op Tweede Pinksterdag.

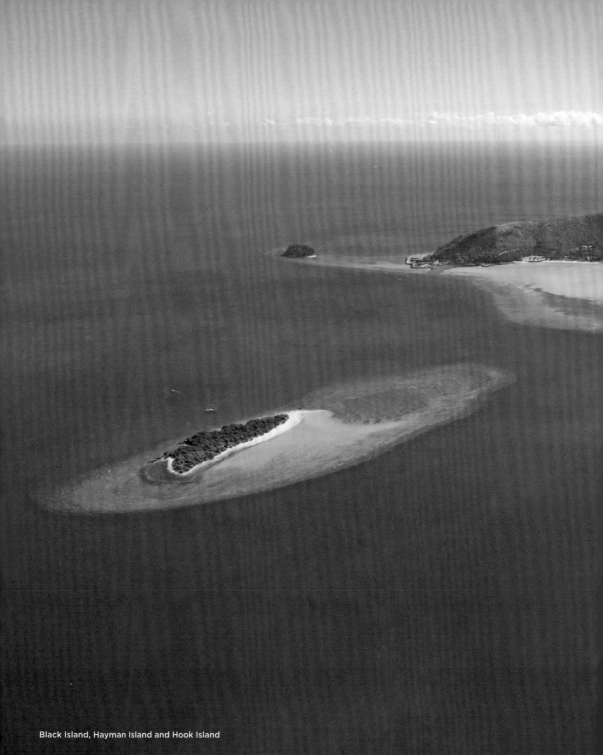

Black Island, Hayman Island and Hook Island

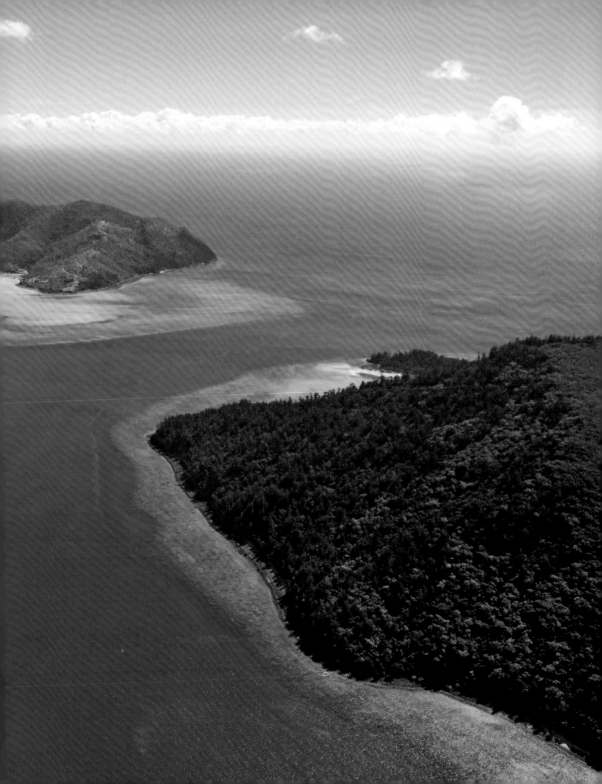

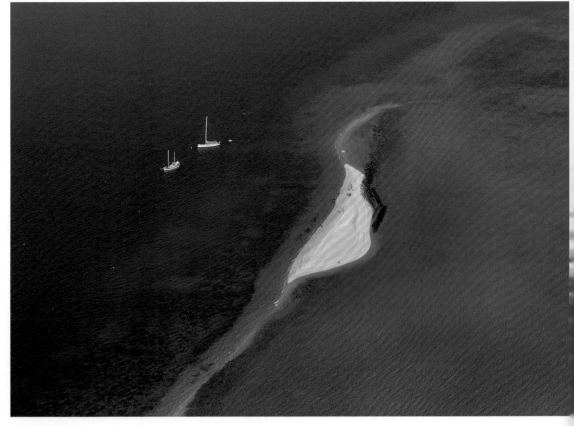

Langford Island

The Islands

The Whitsunday Islands cover 283 km², and most islands that make up the group are tiny, covering less than one km². The largest islands by far are Whitsunday Island (109 km²) and Hook Island (54.87 sq km). All of the islands fall within the Whitsunday Islands National Park, which encompasses part of the Great Barrier Reef and borders the Coral Sea.

Las Islas

Las Islas Whitsunday tienen una superficie de 283 km², y la mayoría que componen el grupo son pequeñas y ocupan menos de un km². Las islas más grandes son la isla de Pentecostés (109 km²) y la isla Hook(54,87 km²). Todo el archipiélago se encuentran dentro del parque nacional de las Islas Whitsunday, que abarca parte de la Gran Barrera de Coral y bordea el Mar del Coral.

Les îles

L'archipel de Whitsunday couvre 283 km², et la plupart des îles qui le composent sont minuscules – souvent moins d'un km². Les plus grandes sont de loin Whitsunday Island (109 km²) et Hook Island (54,87 km²). Toutes font partie du parc national des îles Whitsunday, qui englobe une partie de la Grande Barrière de corail et borde la mer de corail.

Le isole

Le Whitsunday Islands si estendo su 283 km². La maggior parte delle isole che compongono il gruppo sono piccole, con una superficie che spesso non raggiunge il km². Le isole più grandi sono di gran lunga Whitsunday (109 km²) e Hook (54,87 km²). Tutte le isole fanno parte del Whitsunday Islands National Park, che comprende parte della Grande Barriera Corallina e confina con il Coral Sea.

Die Inseln

Die Whitsunday Islands umfassen 283 km². Die meisten der Inseln sind mit einer Fläche von weniger als einem Quadratkilometer winzig. Die größten Inseln sind Whitsunday Island (109 km²) und Hook Island (54,87 km²). Alle Inseln gehören zum Whitsunday Islands Nationalpark, der einen Teil des Great Barrier Reefs umfasst und an das Korallenmeer grenzt.

De eilanden

De Whitsundayeilanden beslaan 283 km². De meeste eilanden waaruit de groep bestaat, zijn klein en minder dan 1 km² groot. Veruit de grootste eilanden zijn Whitsunday Island (109 km²) en Hook Island (54,87 km²). Alle eilanden vallen binnen het Whitsunday Islands National Park, dat een deel van het Groot Barrièrerif omvat en grenst aan de Koraalzee.

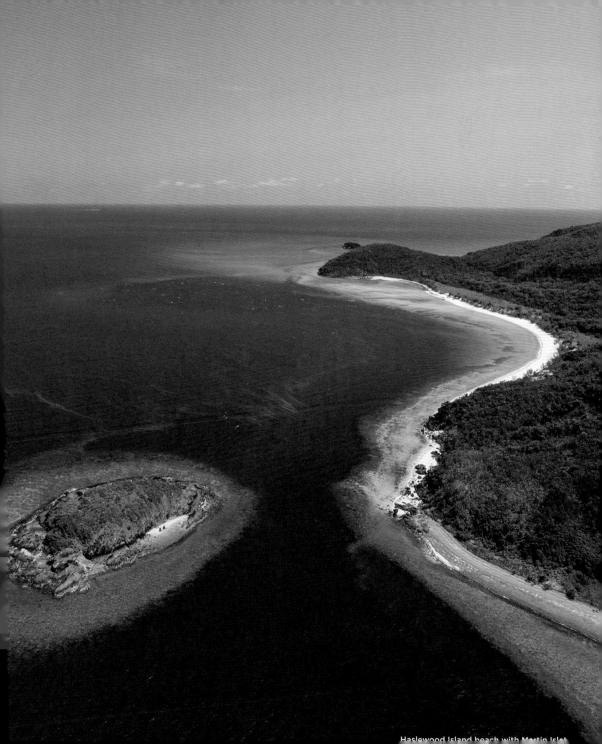
Haslewood Island beach with Martin Islet

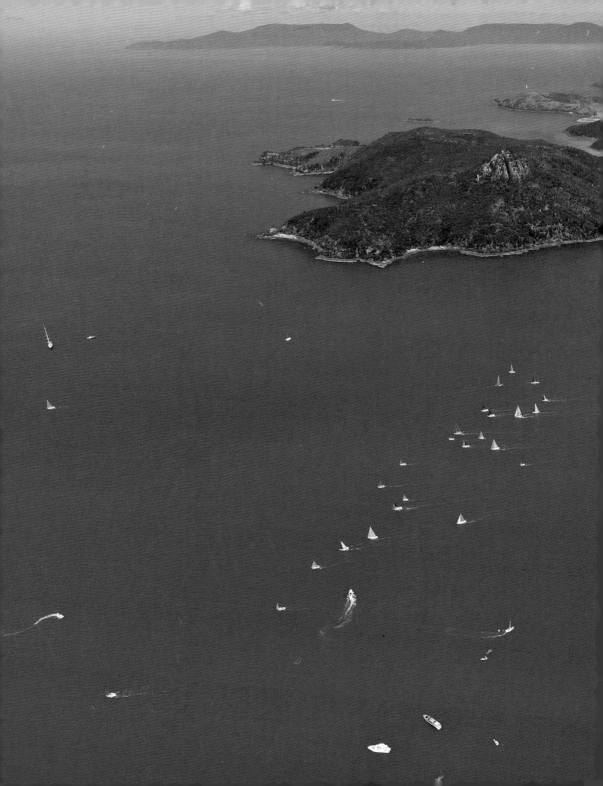

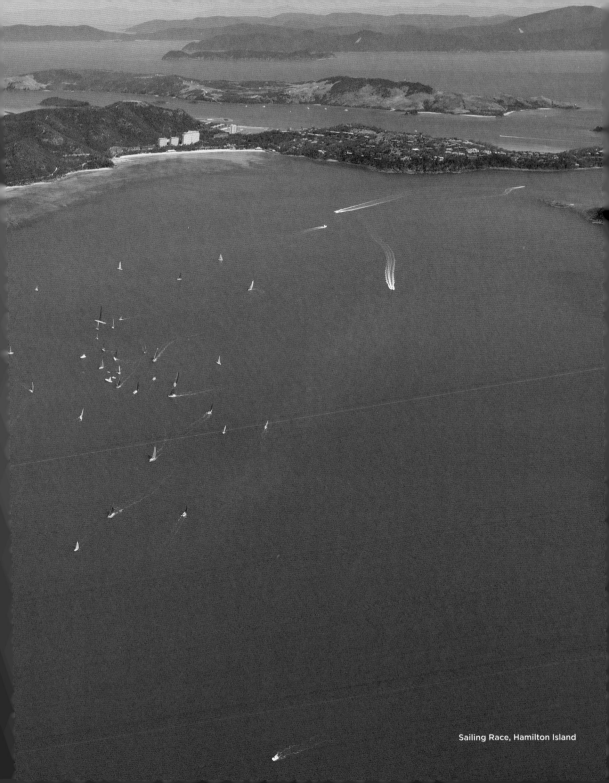

Sailing Race, Hamilton Island

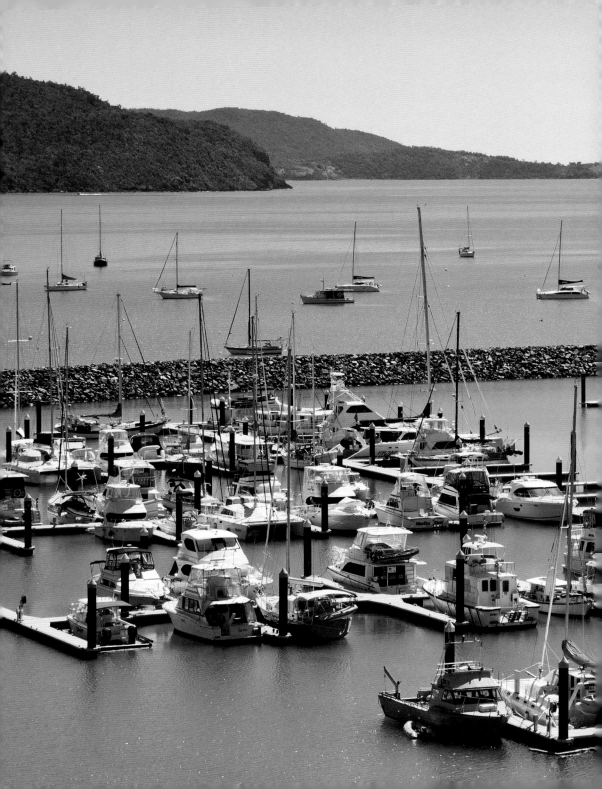

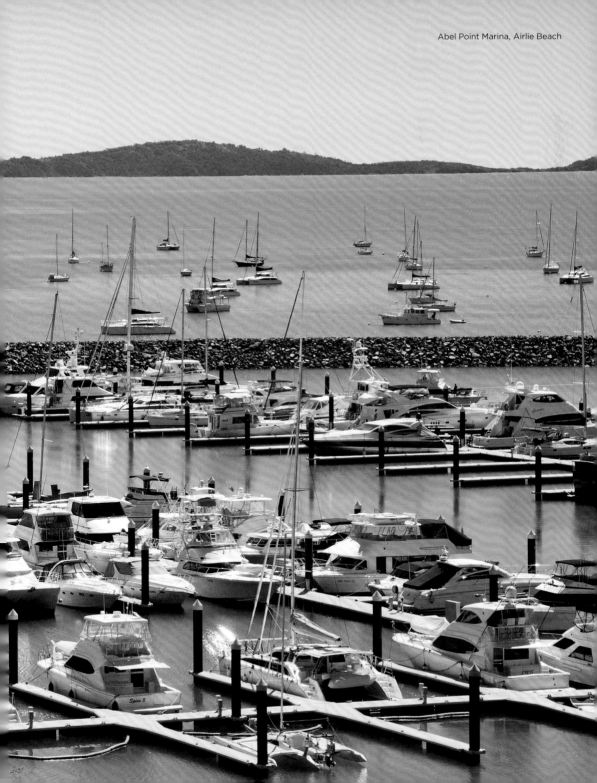

Abel Point Marina, Airlie Beach

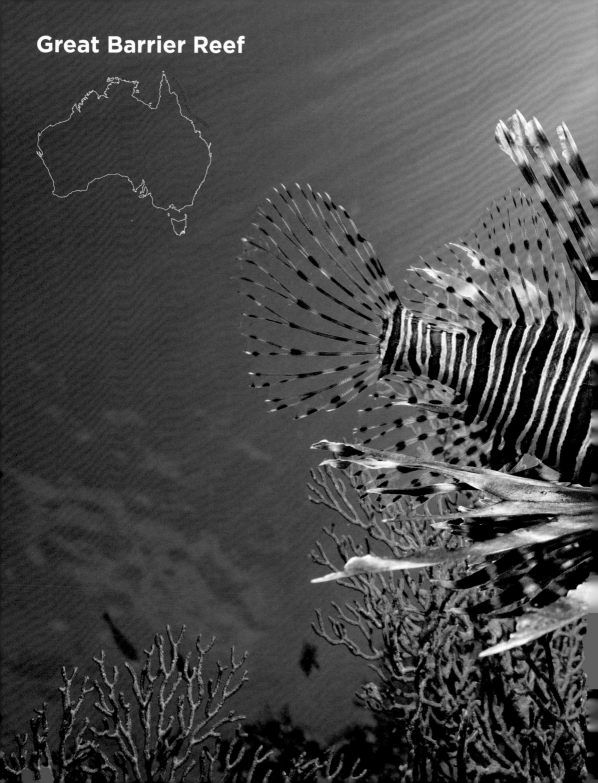

Great Barrier Reef

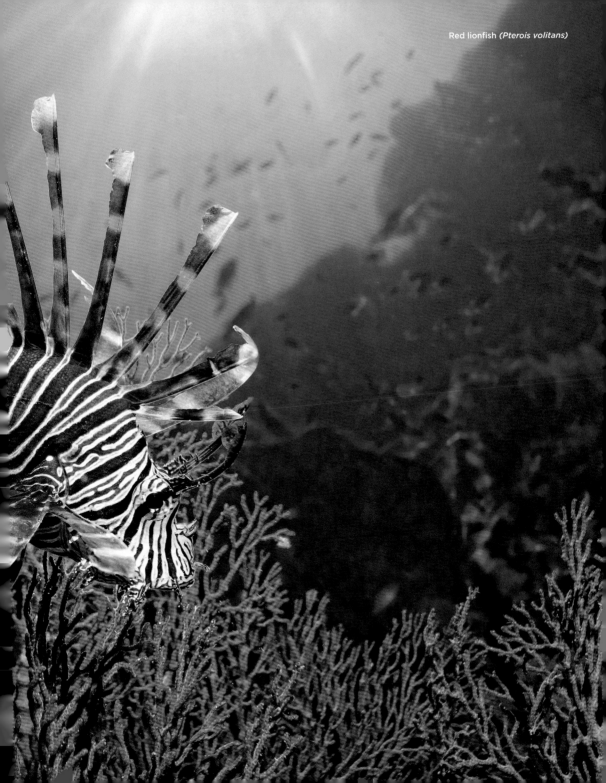

Red lionfish *(Pterois volitans)*

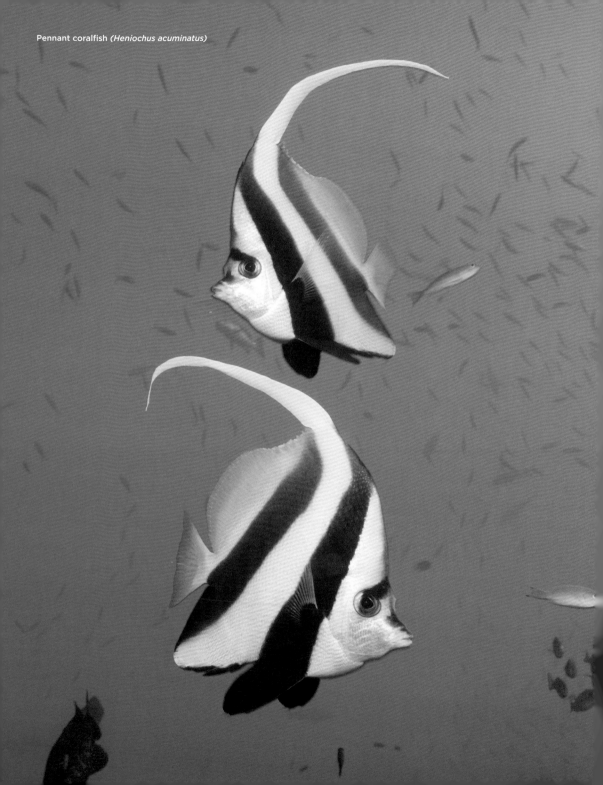
Pennant coralfish *(Heniochus acuminatus)*

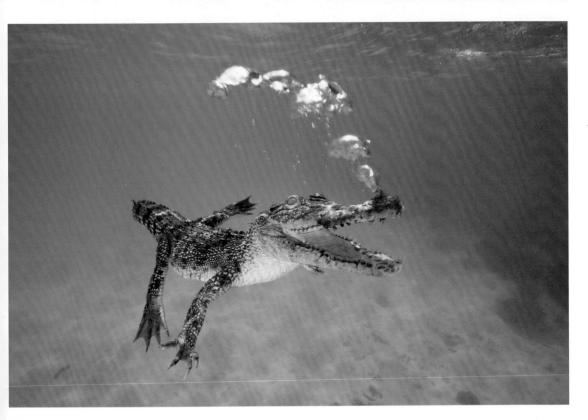

Saltwater crocodile *(Crocodylus porosus)*

Great Barrier Reef

Shadowing the Queensland coast like an underwater echo of paradise, the Great Barrier Reef is one of the natural world's great wonders. Marine life of astonishing diversity, and great coral concentrations that evoke mythical sub-aquatic cities make for some of the best diving and snorkelling on the planet. Onshore, life moves at an agreeably chilled pace.

Great Barrier Reef

La Gran Barrera de Coral, que sigue la costa de Queensland como un eco submarino paradisíaco, es una de las grandes maravillas del mundo natural. Vida marina de asombrosa diversidad y grandes concentraciones de coral que evocan ciudades subacuáticas míticas hacen de este lugar uno de los mejores lugares del planeta para bucear y hacer esnórquel.

La Grande Barrière de corail

Ombrageant la côte du Queensland comme un écho sous-marin du paradis, la Grande Barrière de corail est l'une des plus grandes merveilles naturelles du monde. Une vie marine d'une étonnante diversité et de grandes concentrations de coraux qui évoquent des villes subaquatiques mythiques en font l'un des meilleurs sites de plongée et de snorkelling de la planète. À terre, la vie se déroule à un rythme agréable.

Great Barrier Reef

Seguendo il profilo della costa del Queensland come un paradiso sottomarino, la Grande Barriera Corallina è una delle grandi meraviglie naturali del mondo. Qui, la sorprendente varietà della vita marina e la grande concentrazione di coralli che evocano le mitiche città sottomarine creano il contesto ideale per alcune delle immersioni ed escursioni di snorkeling migliori del pianeta. A terra, la vita si muove a un ritmo piacevolmente rilassato.

Great Barrier Reef

Das Great Barrier Reef, das die Küste von Queensland wie ein Echo des Paradieses unter Wasser beschattet, ist eines der großen Weltwunder. Das Meeresleben von erstaunlicher Vielfalt und große Korallenkonzentrationen, die an mythische Unterwasserstädte erinnern, sorgen für einige der besten Tauch- und Schnorchelmöglichkeiten auf dem Planeten.

Great Barrier Reef

Het Groot Barrièrerif, dat de kust van Queensland als een echo van het paradijs onderwater in de schaduw legt, is een van de grote wereldwonderen. Door het verbazingwekkend diverse zeeleven en de grote koraalconcentraties die aan mythische onderwatersteden doen denken, zijn hier de beste duik- en snorkellocaties ter wereld.

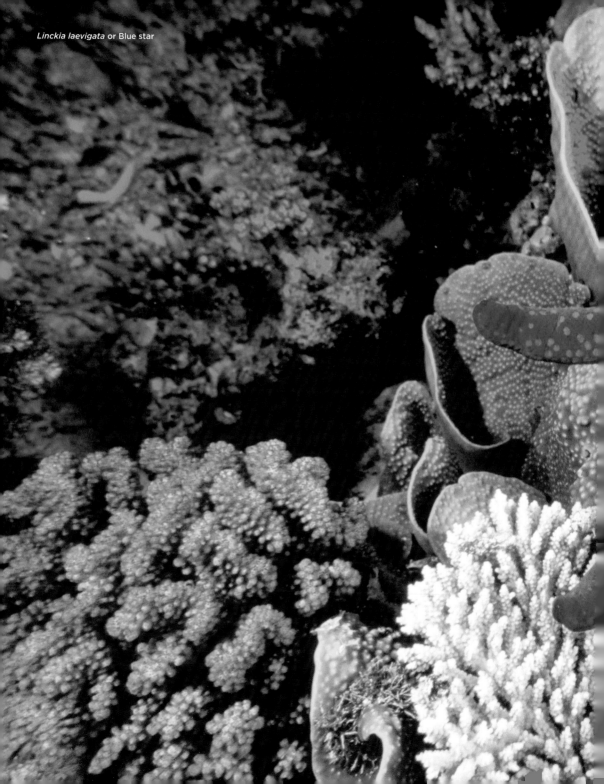

Linckia laevigata or Blue star

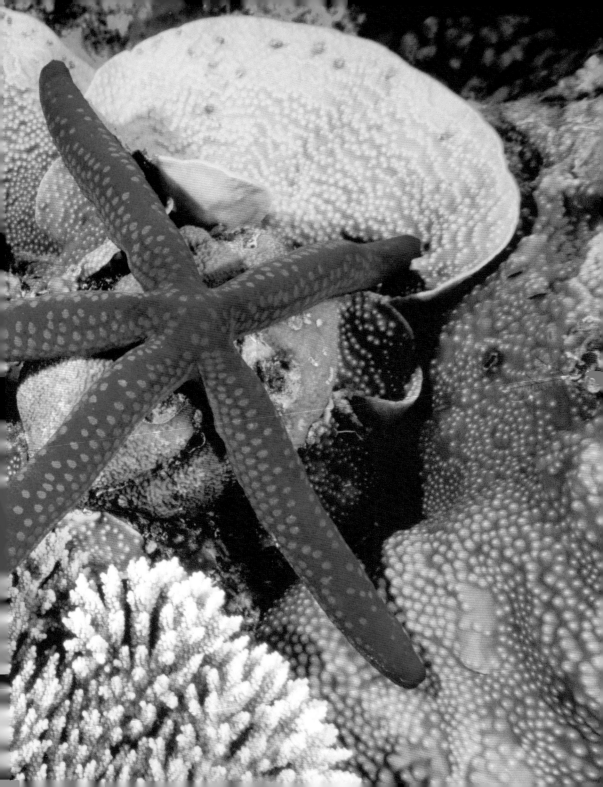

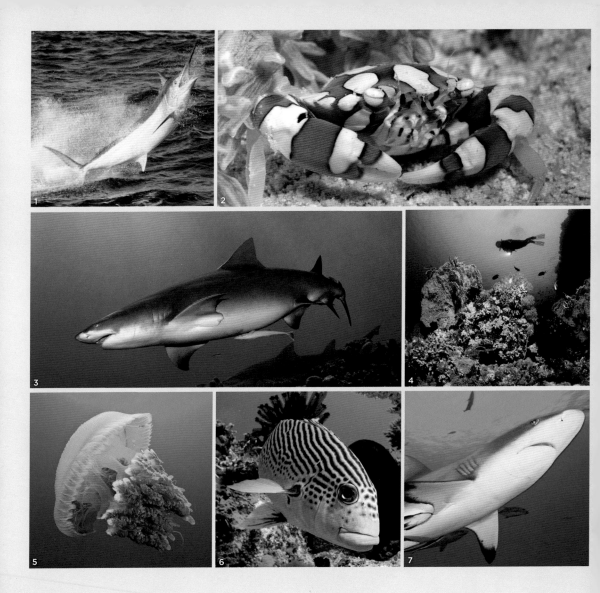

1 Black Marlin; Marlin noir ; Schwarzer Marlin; Marlín negro: Marlin nero: Zwarte marlijn

2 Red-spotted white crab; Crabe blanc à tâches rouges ; Seewalzenkrabbe; Cangrejo blanco con manchas rojas; Granchio arlecchino; *Lissocarcinus orbicularis*

3 Lemon shark; Requin-citron ; Zitronenhai; Tiburón limón; Squalo limone; citroenhaai

4 Diver; Plongeur ; Taucher; Buceador; Subacqueo; Duiker

5 Large jellyfish (Rhizostomae); Méduse à crinière de lion ; Wurzelmundquallen; Rizóstomos; Medusa gigante; Grote kwal

6 Yellowbanded sweetlips; Gaterin à bandes jaunes ; Gelbband-Süßlippen; Plectorhinchus; Grugnitore orientale; *Plectorhinchus lineatus*

7 Grey reef shark; Requin gris de récif ; Grauer Riffhai; Tiburón gris de arrecife; Squalo grigio del reef; Grijze rifhaai

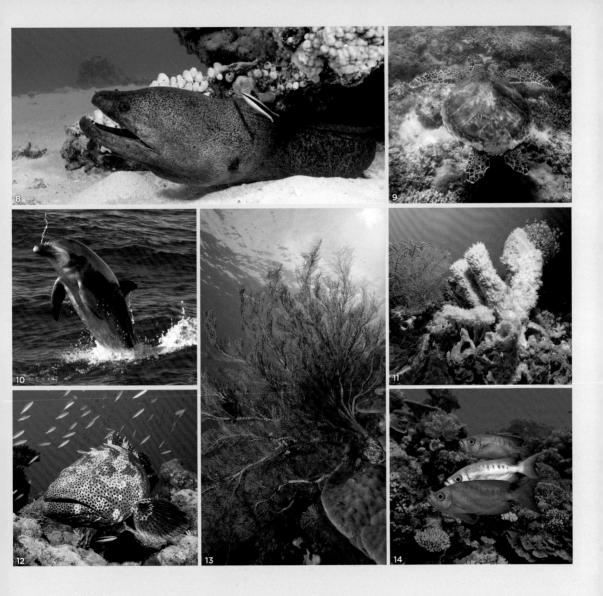

8 Giant moray; Murène géante ; Riesemmuräne; Morena gigante; Murena gigante; Reuzenmurene

9 Green sea turtle; Tortue marine verte ; Grüne Meeresschildkröte; Tortuga marina verde; Tartaruga marina verde; Soepschildpad

10 Bottlenose Dolphin; Grand dauphin ; Großer Tümmler; Delfín mular; Delfino dal naso a bottiglia; Tuimelaar

11 Soft coral; Corail mou ; Weichkorallen; Coral blando; Corallo molle; Zacht koralen

12 Malabar grouper; Mérou malabar ; Malabar-Zackenbarsch, Mero malabar; Cernia di Malabar; Zaagbaars

13 Fan corals; Corail éventail ; Fächerkorallen; Corales abanico; Gorgonie a ventaglio; Hoornkoraal

14 Lunar-tailed bigeye; Gros-yeux commun ; Mondschwanzgroßauge; Catalufa espejuelo; Pesci occhio grosso; Grootoogbaars

1 Green sea turtle; Tortue marine verte ; Grüne Meeresschildkröte; Tortuga marina verde; Tartaruga marina verde; Soepschildpad

2 Dugong; Dugongo; Doejong

3 Reef with soft Corals; Récif avec corail mou ; Riff mit Weichkorallen; Arrecife con corales blandos; Barriera con coralli molli; Rif met zachte koralen.

4 Barracudas; Große Barrakudas

5 Oriental sweetlips; Gaterins rayés ; Orientalische Süßlippe; *Plectorhinchus vittatus;* Grugnitore orientale; Grombaars

6 Piano fangblenny; Blennie à dents acérées ; Piano-Säbelzähner; Blénidos; Blenniidae; *Plagiotremus tapeinosoma*

7 Broadclub cuttlefish, Seiche à larges nageoires ; Breitarm-Sepia; Sepia broadclub; Seppia braccia larghe; *Sepia latimanus*

8 Longfin batfish; Platax à longues nageoires ; Langflossen-Fledermausfisch; Pez murciélago aleta larga; Pesce pipistrello; Langvinvleermuisvis

9 Red lionfish; Rascasse volante ; Pazifischer Rotfeuerfisch; Pez león rojo; Pesce leone; Gewone koraalduivel

10 Blue Club Tunicate; Tuniciers bleus ; Blaue Seescheide; Tunicado azul; Tunicati "blue bell"; Zakpijp

11 Damselfish; Poissons demoiselles ; Grünes Schwalbenschwänzchen; Pez Damisela; Pesci damigella; Blauwgroen juffertje

12 Yellowfin surgeonfish; Chirurgien à nageoires jaunes ; Gelbflossen-Doktorfisch; Pez cirujano de aleta amarilla; Pesce chirurgo pinna gialla; Doktersvis

13 Soft coral; Corail mou ; Weichkorallen; Coral blando; Corallo molle; Zacht koralen

14 Ocellaris Clownfish; Poisson-clown ocellé ; Falscher Clownfisch; Pez payaso; Pesce clown; Driebandanemoonvis

15 Grey reef shark; Requin gris de récif ; Grauer Riffhai; Tiburones grises de arrecife; Squali grigi del reef; Grijze rifhaai

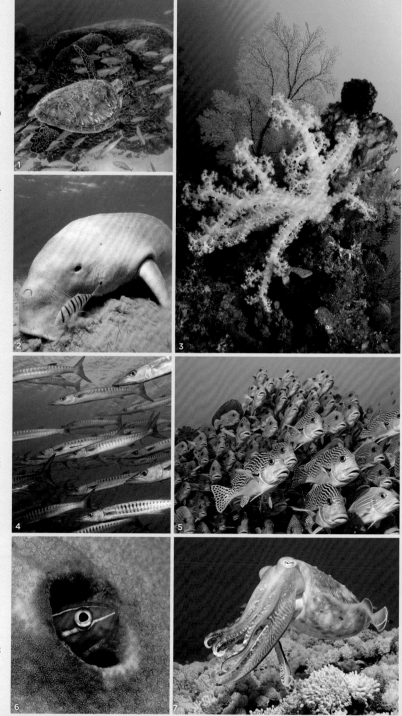

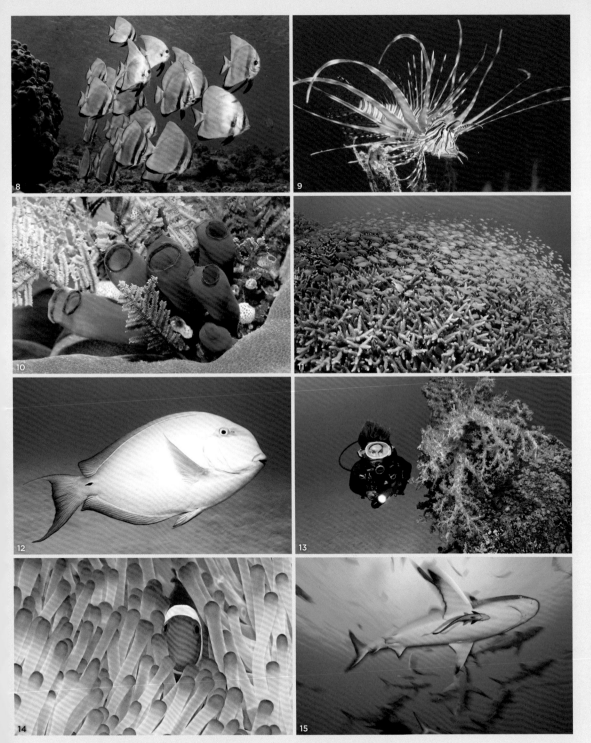

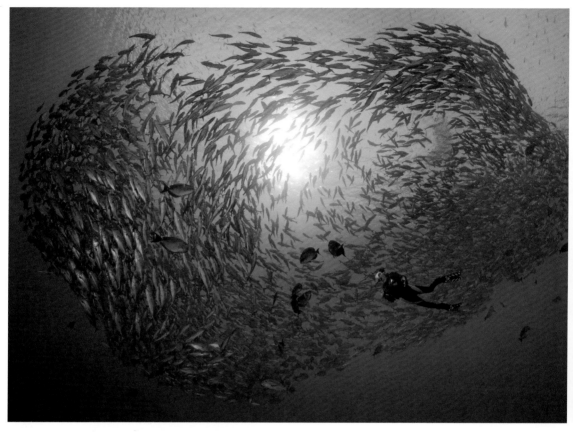

Diver in a shoal of Bigeye trevally *(Caranx sexfasciatus)*

Great Barrier Reef Marine Park

Considered one of the epicenters of Australian conservation and wild beauty, this Unesco World Heritage-listed marine park combines strict protections (on commercial shipping, construction and other potentially harmful activities) with an openness to tourism and related industries. The park protects almost 3000 individual-yet-connected reefs, which is equivalent to 10 % of the world's coral reef areas. Other threats include climate change, the crown-of-thorns starfish, increasing human activities and illegal fishing.

Parc marin de la Grande Barrière de corail

Considéré comme l'un des épicentres de la conservation et de la beauté sauvage australienne, ce parc marin classé au patrimoine mondial de l'Unesco combine une protection stricte (sur la navigation commerciale, la construction et autres activités potentiellement dangereuses) avec une ouverture au tourisme et aux industries connexes. Le parc protège près de 3000 récifs individuels mais connectés entre eux, soit l'équivalent de 10 % de la superficie mondiale des récifs coralliens. Parmi les autres menaces figurent les changements climatiques, l'acanthaster pourpre, l'augmentation des activités humaines et la pêche illégale.

Great Barrier Reef Marine Park

Dieser zum Weltnaturerbe der Unesco gehörende Meerespark, der als eines der Epizentren des australischen Naturschutzes gilt und die Schönheit der Wildnis feiert, kombiniert strenge Schutzmaßnahmen (für die kommerzielle Schifffahrt, das Baugewerbe und andere potenziell schädliche Aktivitäten) mit einer Öffnung für den Tourismus und verwandte Branchen. Der Park schützt fast 3000 individuell miteinander verbundene Riffe, was 10 % der weltweiten Korallenriffgebiete entspricht. Weitere Bedrohungen sind der Klimawandel, der Dornenkronenseestern, zunehmende menschliche Aktivitäten und die illegale Fischerei.

Great Barrier Reef Marine Park

Great Barrier Reef Marine Park

Considerado uno de los epicentros de la conservación australiana y de la belleza salvaje, este parque marino, declarado Patrimonio Mundial por la Unesco, combina una protección estricta (en el transporte marítimo comercial, la construcción y otras actividades potencialmente dañinas) con una apertura al turismo y a las industrias relacionadas. El parque protege casi 3.000 arrecifes individuales que se conectan, lo que equivale al 10 % de las áreas de arrecifes de coral del mundo. Otras amenazas incluyen el cambio climático, la corona de espinas, el aumento de las actividades humanas y la pesca ilegal.

Great Barrier Reef Marine Park

Considerato uno dei luoghi maggiormente tutelati e massima espressione della bellezza naturale dell'Australia, questo parco marino, patrimonio dell'umanità dell'Unesco, combina rigorose misure di protezione (in materia di navigazione commerciale, edilizia e altre attività potenzialmente dannose) con l'apertura al turismo e ai settori correlati. Il parco protegge quasi 3.000 barriere coralline collegate tra di loro, che rappresentano il 10 % delle barriere coralline globali. Altre minacce sono dovute al cambiamento climatico, alla diffusione della stella marina corona di spine, all'aumento delle attività umane e alla pesca illegale.

Great Barrier Reef Marine Park

Dit gebied, dat als beschermd zeegebied op Unesco's werelderfgoedlijst staat, wordt beschouwd als het epicentrum van de Australische natuurbescherming, combineert strenge regels (voor de commerciële scheepvaart, de bouw en andere potentieel schadelijke activiteiten) met openstaan voor het toerisme en aanverwante industrieën. Het park beschermt bijna 3.000 afzonderlijke, maar toch verbonden riffen, wat overeenkomt met 10 % van de koraalriffen wereldwijd. Andere bedreigingen zijn de klimaatverandering, doornenkronen (zeesterren), toenemende menselijke activiteit en de illegale visserij.

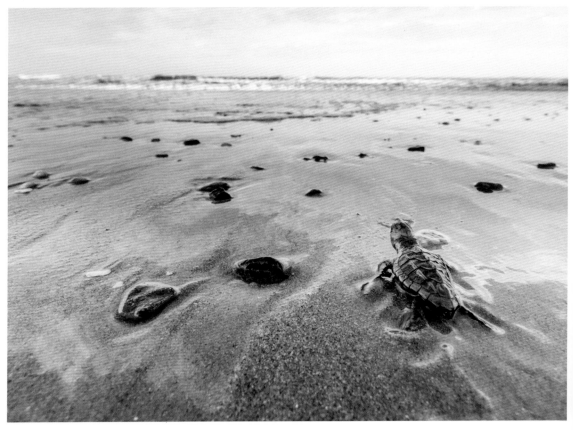

Baby loggerhead turtle *(Caretta caretta)*

Sea Turtles

Six of the world's seven turtle species feed,
breed and lay their eggs in the Whitsunday
and they'll often be encountered when
snorkeling, especially in Tongue Bay,
Apostle Bay and Dugong Inlet. Sea turtles
are sadly vulnerable to human intervention
and five of these species are listed as
endangered or critically endangered.
Local turtle rescue operations treat turtles
afflicted with boat or net injuries, viruses,
plastic debris or malnutrition. Queensland
in fact has the he longest history of marine
turtle conservation and management in
Australia.

Tortues de mer

Six des sept espèces de tortues du monde
se nourrissent, se reproduisent et pondent
leurs œufs dans le Whitsunday et on
les rencontre facilement en faisant du
snorkelling, en particulier dans Tongue Bay,
Apostle Bay et Dugong Inlet. Les tortues
marines sont tristement vulnérables à
l'intervention humaine et cinq de ces
espèces sont inscrites sur la liste des
animaux en voie de disparition ou en
danger critique d'extinction. Les opérations
locales de sauvetage des tortues traitent
les spécimens blessés par des bateaux,
des filets ou des débris plastiques,
atteints par des virus ou de malnutrition.
Le Queensland possède en effet la plus
longue histoire de conservation et de
gestion des tortues marines d'Australie.

Meeresschildkröten

Sechs der sieben Schildkrötenarten
der Welt leben auf den Whitsundays.
Hier vermehren sie sich und legen ihre
Eier ab. Beim Schnorcheln sind sie oft
anzutreffen, besonders in der Tongue
Bay, der Apostelbucht und dem Dugong
Inlet. Seeschildkröten sind leider anfällig
für menschliche Eingriffe, und fünf
dieser Arten werden als gefährdet oder
gar stark gefährdet eingestuft. Lokale
Schildkrötenrettungsstationen behandeln
Schildkröten, die an Boots- oder
Netzverletzungen, Viren, Plastikmüll oder
Unterernährung leiden. Queensland hat
am meisten Erfahrung mit dem Schutz von
Meeresschildkröten in Australien.

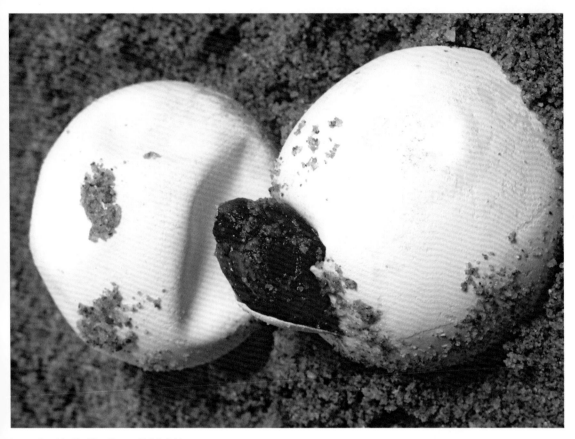

Loggerhead turtle *(Caretta caretta),* hatching

Tortugas marinas

Seis de las siete especies de tortugas del mundo se alimentan, se reproducen y ponen sus huevos en las isla Pentecostés (Whitsunday) y, a menudo, se las encuentra haciendo esnórquel en las bahías de Tongue, Apostle y Dugong. Las tortugas marinas son, por desgracia,vulncrables a la intervención humana y cinco de estas especies están catalogadas como en peligro o en peligro crítico de extinción. Las operaciones locales de rescate de tortugas tratan a las tortugas afectadas con heridas en barcos o redes, virus, desperdicios plásticos o desnutrición. De hecho, Queensland tiene la historia más larga de conservación y manejo de tortugas marinas en Australia.

Tartarughe marine

Sei delle sette specie di tartaruga al mondo si nutrono, si riproducono e depongono le uova nell'isola Whitsunday, dove si incontrano spesso durante lo snorkeling, specialmente a Tongue Bay, Apostle Bay e Dugong Inlet. Le tartarughe marine sono purtroppo vulnerabili all'intervento umano e cinque di queste specie sono elencate come a rischio o addirittura in pericolo critico di estinzione. Grazie agli interventi locali di salvataggio vengono curate le tartarughe con ferite da barca o da rete, che hanno virus o soffrono per l'ingerimento di detriti plastici o di malnutrizione. Il Queensland ha infatti la più lunga storia di tutela e gestione delle tartarughe marine in Australia.

Zeeschildpadden

Zes van de zeven schildpaddensoorten ter wereld eten, paren en leggen hun eieren op de Whitsundayeilanden. Bij het snorkelen zijn ze vaak te zien, vooral in de Tongue Bay, Apostle Bay en Dugong Inlet. Zeeschildpadden zijn helaas erg gevoelig voor menselijk ingrijpen en vijf van deze soorten staan op de lijst van bedreigde of ernstig bedreigde soorten. Lokale reddingsoperaties behandelen door scheepvaart of visnetten verwonde schildpadden of dieren die aan virussen of door plastic afval aan ondervoeding lijden. Queensland heeft de meeste ervaring met de bescherming van zeeschildpadden in Australië.

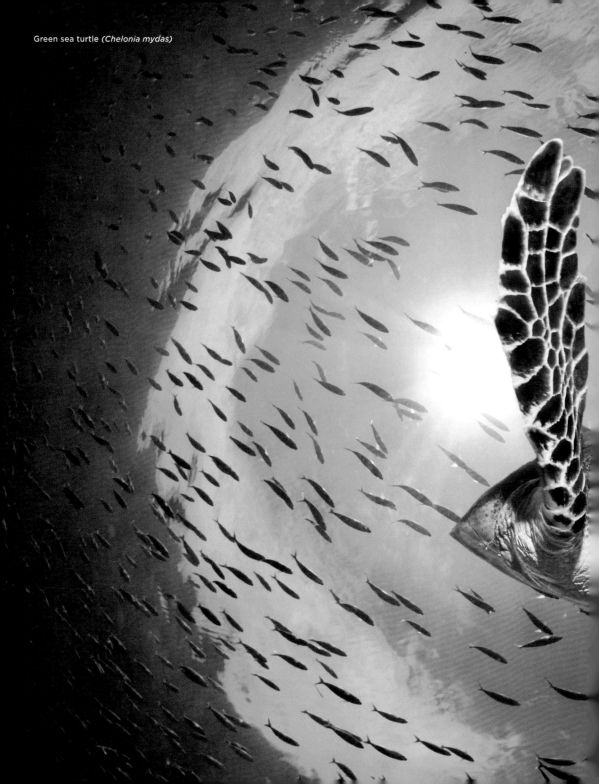
Green sea turtle *(Chelonia mydas)*

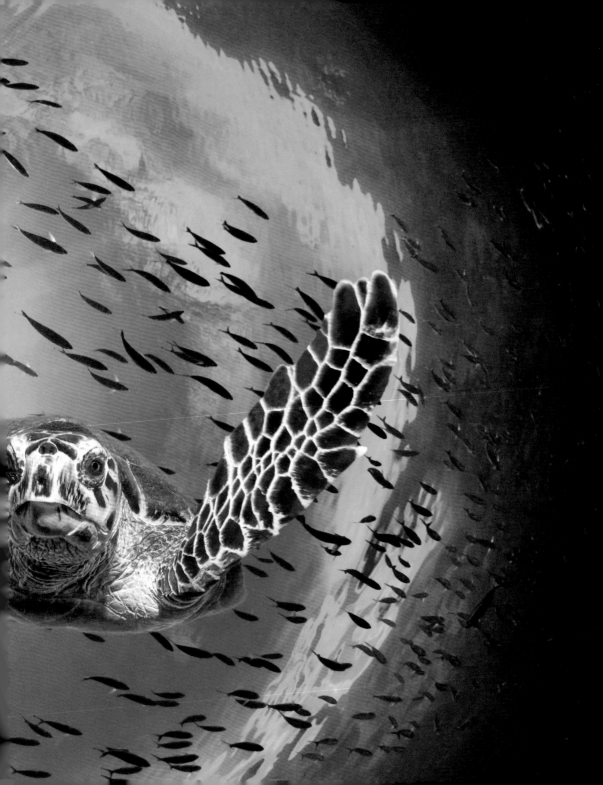

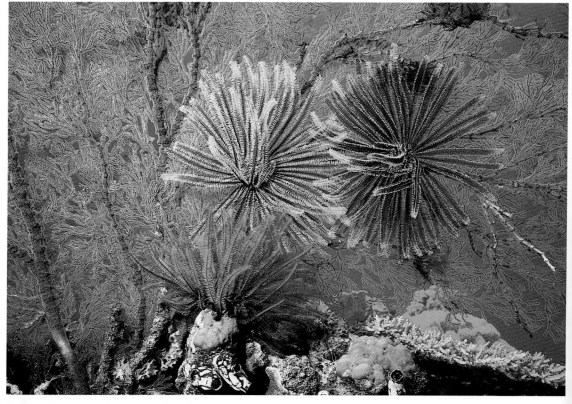

Gorgonian Sea Fan with Feather stars *(Crinoids)*

Marine Wildlife

The Great Barrier Reef also has an impressive portfolio of marine creatures: 30 types of whales and dolphins, 14 species of sea snake, over 130 species of sharks and stingrays, six of the world's seven marine turtles, saltwater crocodiles, and even the endangered dugong. Arguably the stars of the show, however, are the more than 600 types of coral.

Vida silvestre marina

La Gran Barrera de Coral también tiene una impresionante cartera de criaturas marinas: 30 tipos de ballenas y delfines, 14 especies de serpientes marinas, más de 130 especies de tiburones y rayas, seis de las siete tortugas marinas del mundo, cocodrilos de agua salada e incluso el dugongo en peligro de extinción. Sin embargo, podría decirse que las estrellas del espectáculo son los más de 600 tipos de coral.

Faune marine

Dans la Grande Barrière de corail vivent également un très grand nombre de créatures marines : 30 espèces de baleines et de dauphins, 14 espèces de serpents marins, plus de 130 espèces de requins et de raies pastenagues, six des sept types de tortues marines du monde, des crocodiles d'eau salée et même le dugong, espèce en danger. Cependant, le clou du spectacle reste sans doute les plus de 600 sortes de coraux.

Animali marini

La Grande Barriera Corallina ospita anche un'impressionante gamma di creature marine: 30 tipi di balene e delfini, 14 specie di serpenti marini, oltre 130 specie di squali e razze, sei delle sette specie di tartarughe marine esistenti al mondo, coccodrilli marini e persino il dugongo, oggi in via di estinzione. Probabilmente, tuttavia, le vere star di questo spettacolo naturale sono gli oltre 600 tipi di corallo.

Marine Tierwelt

Das Great Barrier Reef verfügt über ein beeindruckendes Spektrum an Meerestieren: 30 Arten von Walen und Delfinen, 14 Arten von Seeschlangen, über 130 Arten von Haien und Stachelrochen, sechs der sieben Meeresschildkrötenarten der Welt, Salzwasserkrokodile und sogar der gefährdete Dugong. Die Stars der Show sind jedoch wohl die mehr als 600 Korallensorten.

Mariene fauna

Het Groot Barrièrerif heeft ook een indrukwekkend scala aan zeedieren: 30 soorten walvissen en dolfijnen, 14 soorten zeeslangen, meer dan 130 soorten haaien en pijlstaartroggen, zes van de zeven zeeschildpaddensoorten ter wereld, zeekrokodillen en zelfs de bedreigde doejong. De sterren van de show zijn echter de meer dan 600 soorten koraal.

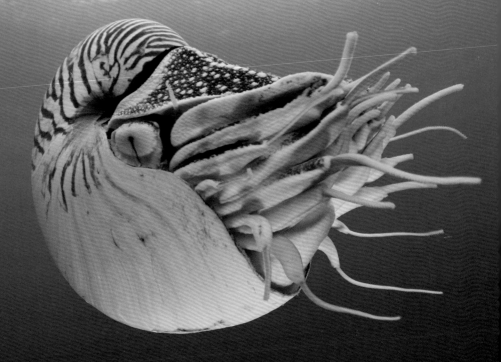

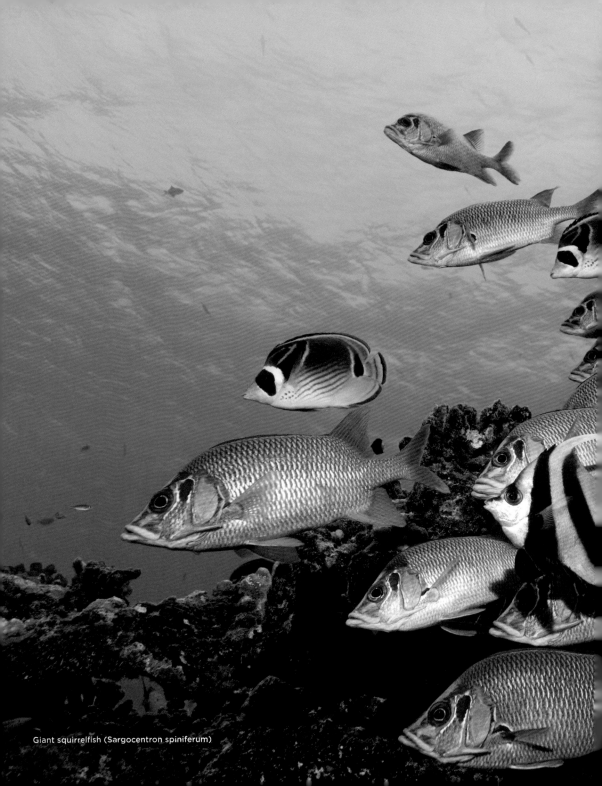

Giant squirrelfish (Sargocentron spiniferum)

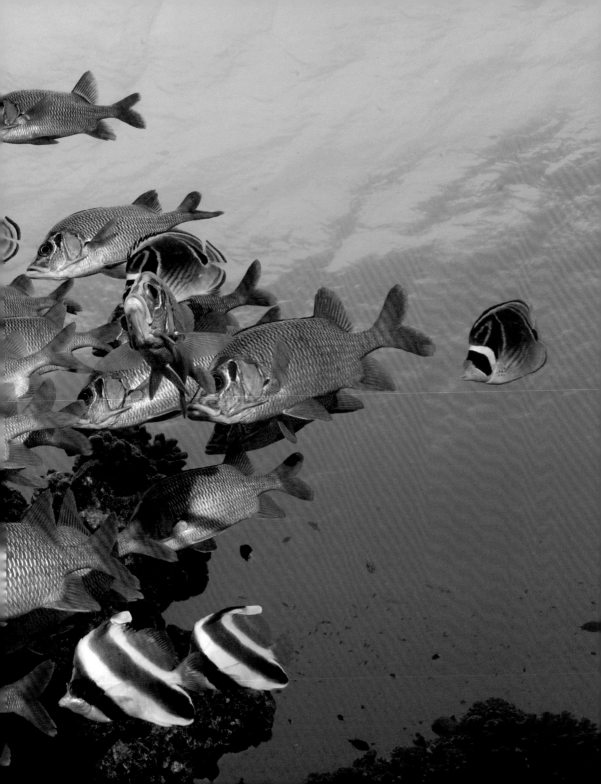

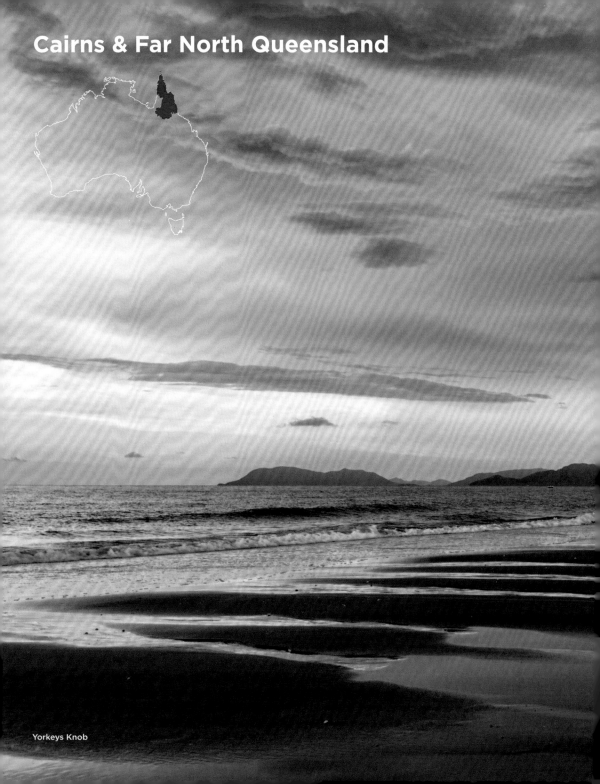

Cairns & Far North Queensland

Yorkeys Knob

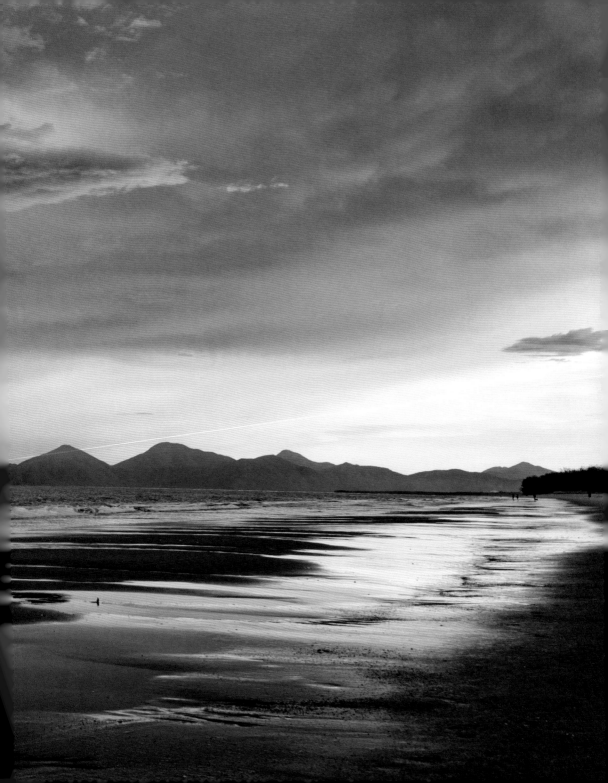

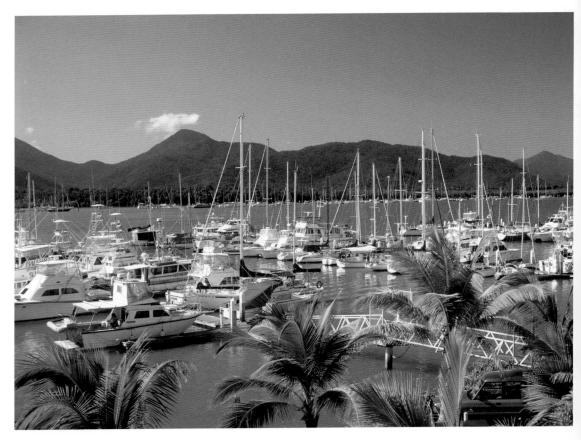

Marlin Marina

Cairns & Far North Queensland

Queensland's tropical 'capital' is an easy-going, tourist town, with fun to be had in its noisy bars and pubs, even if it surprisingly lacks a beach. Never fear, the beaches begin just to the north and grow more idyllic the further north you go. Beyond Port Douglas you'll find the Wet Tropics World Heritage Area, including the lush but traveller-friendly Daintree.

Cairns & Far North Queensland

La « capitale » tropicale du Queensland est une ville touristique et agréable, pleine de bars et de pubs bruyants ; en revanche, fait surprenant, elle ne possède pas de plages ! Elles commencent en fait à peine plus au nord, et deviennent idylliques plus vous remontez. Au-delà de Port Douglas, vous trouverez la zone classée au patrimoine mondial des Tropiques Humides du Queensland, y compris la luxuriante mais accueillante Daintree.

Cairns & Far North Queensland

Queenslands tropische Hauptstadt ist eine unkomplizierte Touristenstadt, die in ihren lauten Bars und Pubs Spaß macht, auch wenn es keinen Strand gibt. Aber keine Sorge, die Strände beginnen genau im Norden und werden immer idyllischer, je weiter man nach Norden geht. Hinter Port Douglas liegt die Welterbe-Region der Wet Tropics, einschließlich des reisefreundlichen Daintree.

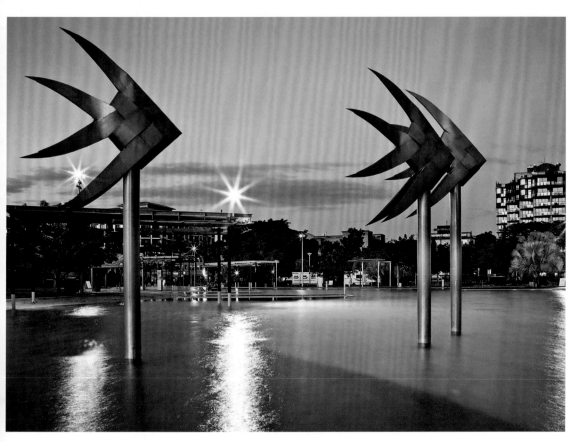

Esplanade Lagoon

Cairns & Far North Queensland

La 'capital' tropical de Queensland es una ciudad turística y tranquila, con mucha diversión en sus ruidosos bares y pubs, aunque sorprendentemente carece de playa. No tema, las playas comienzan justo al norte y se vuelven más idílicas cuanto más al norte nos dirigimos. Más allá de Port Douglas se encuentra el área de Patrimonio Mundial de los Trópicos Húmedos, incluyendo el exuberante pero agradable bosque de Daintree.

Cairns & Far North Queensland

La "capitale" tropicale del Queensland è una città turistica con uno stile di vita disinvolto, da apprezzare nei bar e nei pub rumorosi, pur se sorprendentemente priva di spiagge. Ma non c'è problema: le spiagge si estendono poco più a nord e diventano sempre più idilliache quanto più si procede in quella direzione. Dopo Port Douglas si trova la Wet Tropics World Heritage Area, che include il lussureggiante Daintree, un posto molto piacevole per i viaggiatori.

Cairns & Far North Queensland

De tropische hoofdstad van Queensland is een rustige, toeristische stad, met veel vertier in lawaaierige bars en pubs, ook al ontbreekt het verrassend genoeg aan een strand. Wees niet bang – de stranden beginnen gewoon iets noordwaarts en worden idyllischer naarmate je verder naar het noorden gaat. Voorbij Port Douglas is de werelderfgoedregio van de Wet Tropics, inclusief het weelderige maar reizigersvriendelijke woud Daintree.

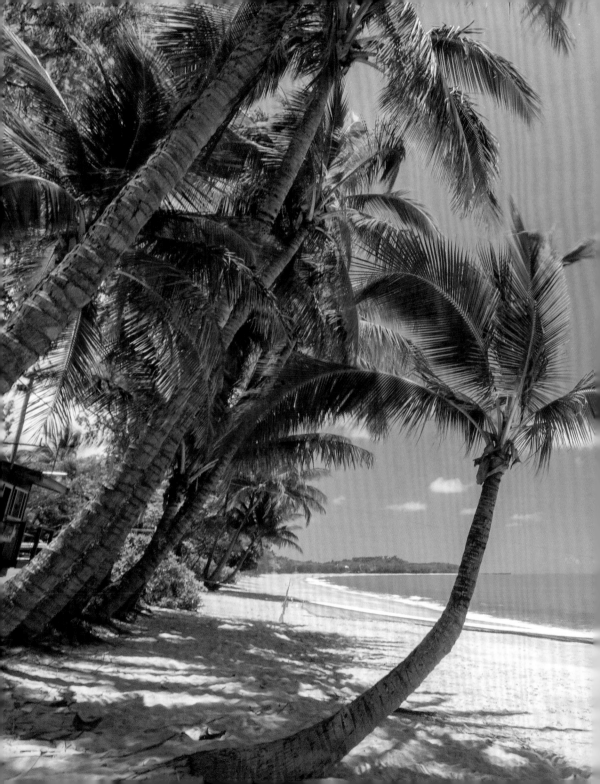

Clifton Beach

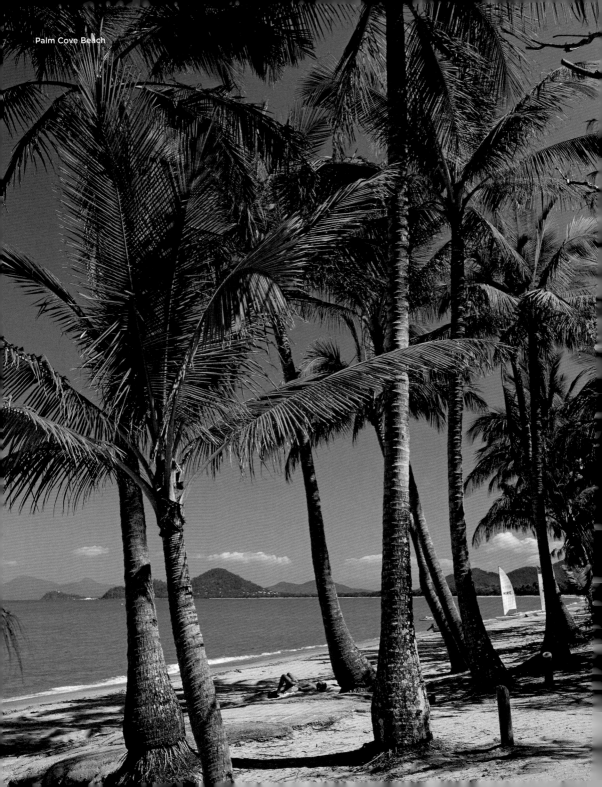

Palm Cove Beach

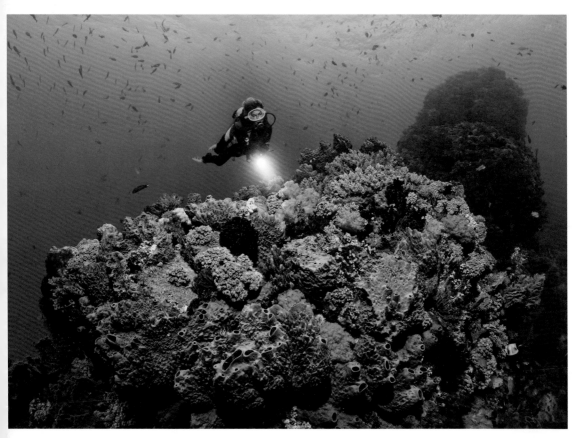

Diver, Great Barrier Reef

Beyond Cairns

Cairns is, for many visitors, either the gateway to the Great Barrier Reef, or a hub for the coast's string of palm-fringed resort towns. Boat and scenic reef flight departures are frequent and have you snorkeling or diving the reef in an hour. Palm Cove, a close by resort village, has a stunning curve of palm-fringed white sand, as does Oak Beach to the north.

Más allá de Cairns

Cairns es, para muchos visitantes, la puerta de entrada a la Gran Barrera de Coral, o un centro neurálgico de las ciudades turísticas de la costa rodeada de palmeras. Palm Cove, un pueblo cercano al complejo turístico, tiene una impresionante curva de arena blanca rodeada de palmeras, al igual que Oak Beach, al norte.

Au-delà de Cairns

Cairns est, pour beaucoup de visiteurs, soit la porte d'entrée de la Grande Barrière de corail, soit le centre de la zone de villégiature côtière, avec ses nombreux hameaux bordés de palmiers. Palm Cove, un village balnéaire tout près, possède une éblouissante courbe de sable blanc bordé de palmiers, tout comme Oak Beach au nord.

Oltre Cairns

Per molti viaggiatori, Cairns rappresenta la porta d'ingresso alla Grande Barriera Corallina o un punto di riferimento per le numerose città turistiche circondate da palme che si allungano lungo la costa. Palm Cove, un villaggio turistico nelle vicinanze, ha una splendida spiaggia incurvata, con sabbia bianca e un perimetro di palme, così come pure Oak Beach a nord.

Jenseits von Cairns

Cairns ist für viele Besucher entweder das Tor zum Great Barrier Reef oder ein Knotenpunkt für die palmengesäumten Kurorte an der Küste. Palm Cove, ein nahegelegener Touristenort, bietet eine atemberaubende Kulisse aus weißem Sand, Palmen und lädt zum Schnorcheln ein

Voorbij Cairns

Cairns is voor veel bezoekers de toegangspoort tot het Groot Barrièrerif of een knooppunt voor de badplaatsen met palmen langs het strand. Palm Cove, een nabijgelegen toeristenplaats, heeft een prachtige baai met wit zand en palmbomen, net als Oak Beach in het noorden.

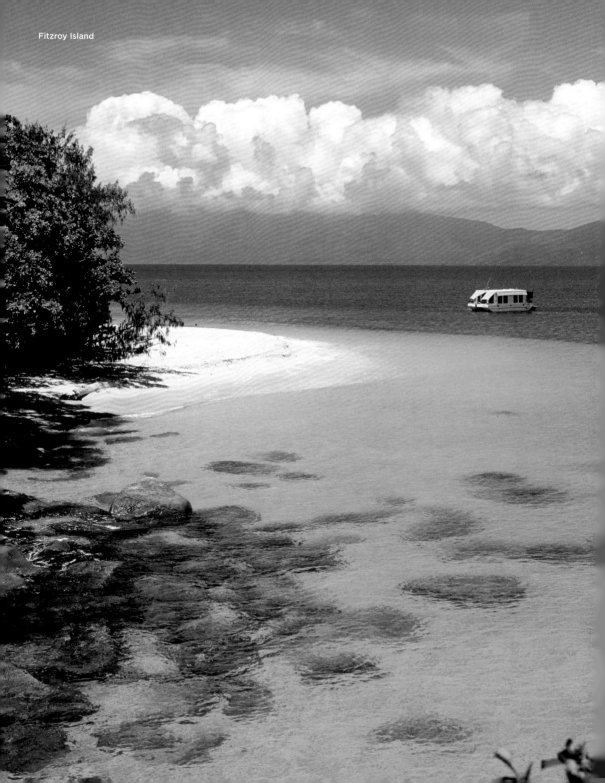

Fitzroy Island

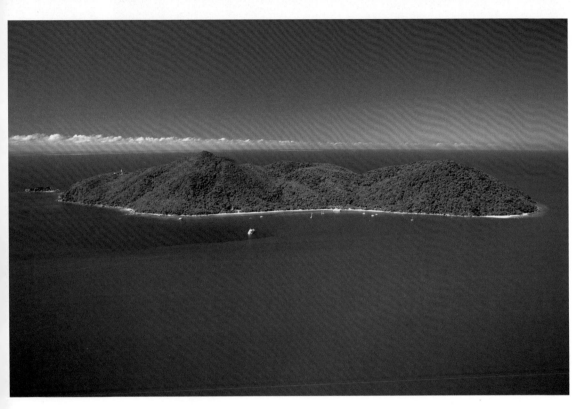

Fitzroy Island

Fitzroy Island

An island national park, 29 km south-east of Cairns, Fitzroy Island's steep centre is densely covered in rainforest, giant boulders. Offshore, it has its own fringe coral reef system, part of the Great Barrier Reef Marine Park. Once important for its lighthouse, it now has one low-key resort and campground and is also a popular day trip from Cairns.

Fitzroy Island

El centro de la isla de Fitzroy, un parque nacional insular situado a 29 km al sudeste de Cairns, está densamente cubierto de bosques pluviales y rocas gigantescas. En el litoral, la isla cuenta con su propio sistema de arrecifes de coralque forma parte del Parque Marino de la Gran Barrera de Coral. La lisla tuvo inportantancia antaño por su faro, pero ahora tiene un turismo de bajo perfil, y la visita constituye una excursión popular de un día desde Cairns.

Île Fitzroy

Parc national insulaire, à 29 km au sud-est de Cairns, l'île Fitzroy présente un intérieur escarpé et densément couvert de forêts tropicales humides et de rochers géants. Au large, elle possède son propre système de récifs coralliens marginaux, qui fait partie du parc marin de la Grande Barrière de corail. Autrefois célèbre pour son phare, elle comporte aujourd'hui une station balnéaire est aussi une excursion populaire d'une journée au départ de Cairns.

Fitzroy Island

Questa isola, al contempo parco nazionale, a 29 km a sud-est di Cairns, ha un centro ripido ricoperto di una fitta foresta pluviale e massi giganti. Lungo la costa è presente un sistema a se stante di barriera corallina, che fa parte del Parco Marino della Grande Barriera Corallina. Un tempo importante per il suo faro, ora dispone di un resort e una meta apprezzata per una gita giornaliera con partenze da Cairns.

Fitzroy Island

Fitzroy Island ist ein Nationalpark 29 km südöstlich von Cairns, dessen steilabfallende Mitte dicht mit Regenwald und riesigen Felsbrocken bedeckt ist. Sein Korallenriff ist Teil des Great Barrier Reef Marine Park. Einst bekannt für seinen Leuchtturm, verfügt die Insel über ein kleines Resort und ist auch ein beliebter Tagesausflug von Cairns aus.

Fitzroy Island

Fitzroy Island is een nationaal park op 29 km ten zuidoosten van Cairns. Het steile hart van Fitzroy Island is begroeid met dicht regenwoud en bedekt met enorme rotsblokken. De koraalriffen voor de kust maken deel uit van het Great Barrier Reef Marine Park. Het eiland was ooit bekend om zijn vuurtoren. Het is een populaire bestemming voor een dagtocht vanuit Cairns.

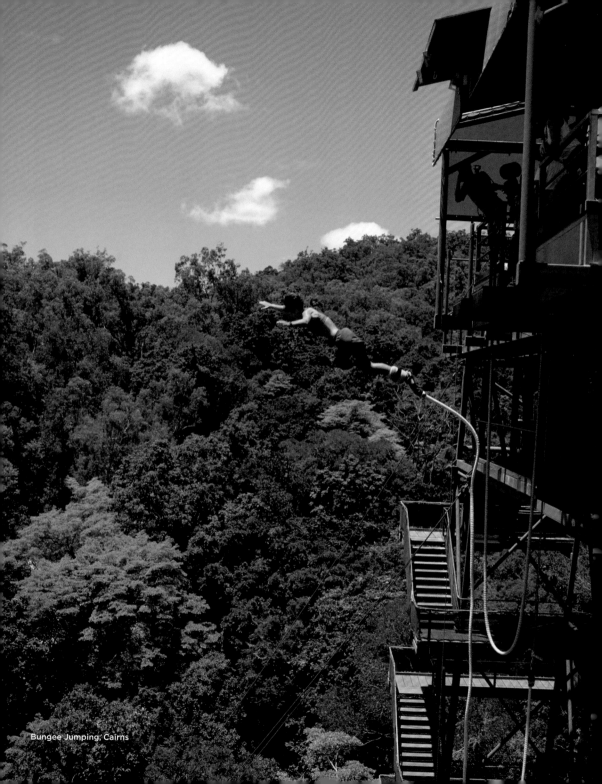

Bungee Jumping, Cairns

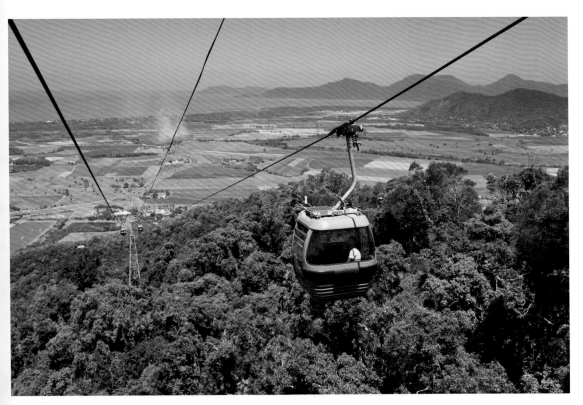

Skyrail Rainforest Cableway, Cairns

Skyrail & Bungee Jumping

Cairn's own bungy tower has a lush tropical setting and affords views of the Coral Sea and Cairn's northern beaches. The glass-bottomed gondolas of Skyrail travel 7.5 km over Barron Gorge and the oldest continually surviving rainforest on earth. From the top station, the rainforest floor can be explored with Djabugay guides, the traditional owners.

Skyrail & Saut à l'élastique

Depuis la plateforme de saut à l'élastique de Cairn, on peut admirer le cadre tropical luxuriant mais aussi la mer de corail et les plages du nord. Les nacelles à fond de verre du téléphérique de Skyrail parcourent 7,5 km au-dessus de la gorge de Barron et de la plus ancienne forêt tropicale encore existante. Depuis la station Barron Falls, la forêt tropicale peut être explorée avec les guides Djabugay, les propriétaires traditionnels.

Skyrail & Bungee Jumping

Der Bungy Tower von Cairns liegt in tropischer Umgebung und bietet einen Blick auf das Korallenmeer und die nördlichen Strände. Die Glasboden-Gondeln des Skyrail führen 7,5 km über die Barron-Schlucht und den ältesten kontinuierlich erhaltenen Regenwald der Welt. Von der Bergstation aus kann der Regenwald mit Djabugay-Führern, den traditionellen Besitzern, erkundet werden.

Skyrail & Bungee Jumping

La propia torre *bungy* de Cairn tiene un exuberante entorno tropical y ofrece vistas del Mar del Coral y de las playas del norte de Cairn. Las góndolas con fondo de cristal de Skyrail viajan 7,5 km sobre el parque nacional Gargante Barrony el bosque pluvial más antiguo de la tierra que sobrevive desde siempre. Desde la estación superior, el suelo de la selva tropical puede ser explorado con los guías aborígenes de Djabugay, los habitantes tradicionales.

Skyrail & Bungee Jumping

La "bungy tower" di Cairns è immersa in un ambiente tropicale lussureggiante e permette di godere degli scenari spettacolari del Coral Sea e delle spiagge settentrionali di Cairns. Le cabine con fondo di vetro dello Skyrail percorrono 7,5 km attraverso la Barron Gorge e la più antica foresta pluviale della terra oggi esistente. Dalla stazione in alto, si scende ad esplorare il folto della foresta pluviale con le guide di Djabugay, gli aborigeni qui residenti.

Skyrail & Bungee jumping

De eigen bungytoren van Cairns staat in een tropische omgeving en biedt uitzicht over de Koraalzee en de noordelijke stranden. De gondels met glazen vloer van Skyrail leggen 7,5 km af boven de Barron Gorge en het oudste regenwoud op aarde. Vanaf het bergstation kunt u de regenwoudbodem verkennen met Djabugay-gidsen, de oorspronkelijke eigenaars.

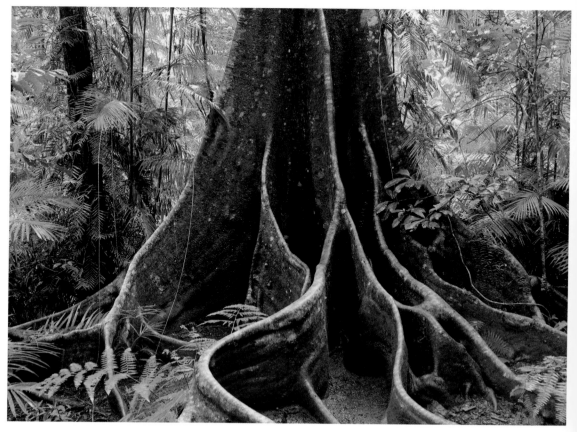

Daintree National Park

Daintree Rainforest
The Daintree, close to Mossman, forms an essential part of Australia's largest expanse of tropical rainforest; the Daintree alone covers 1200 km². Even though it extends across less than 0.1% of Australian territory, the Daintree contains nearly one third of all frog, reptile and marsupial species in Australia and 90% of the country's bats and butterflies.

Forêt tropicale de Daintree
La forêt de Daintree, près de Mossman, est une partie essentielle de la plus grande étendue de forêt tropicale humide d'Australie ; à elle seule, elle couvre 1 200 km². Bien qu'elle s'étende sur moins de 0,1% du territoire australien, on y trouve près d'un tiers de toutes les espèces de grenouilles, reptiles et marsupiaux d'Australie et 90% des chauves-souris et papillons du pays.

Daintree-Regenwald
Der Daintree, in der Nähe von Mossman, nimmt einen wesentlichen Teil von Australiens gesamter tropischer Regenwaldfläche ein; allein der Daintree umfasst 1200 km². Obwohl er sich auf weniger als 0.1% des australischen Territoriums erstreckt, beheimatet er fast ein Drittel aller Frosch-, Reptilien- und Beuteltierarten in Australien und 90% aller Fledermäuse und Schmetterlinge des Landes.

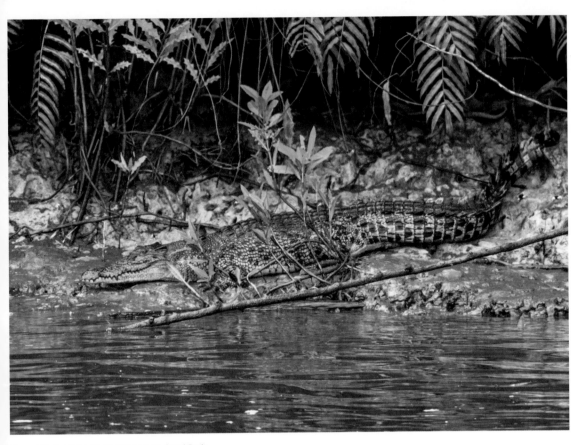
Crocodile, Daintree River, Daintree National Park

Selva de Daintree
El Daintree, cerca de Mossman, forma parte esencial de la mayor extensión de selva tropical de Australia; sólo el Daintree cubre 1200 km². Aunque su extensión representamenos del 0.1% del territorio australiano, el Daintree contiene casi un tercio de todas las especies de ranas, reptiles y marsupiales de Australia y el 90% de los murciélagos y mariposas del país.

Foresta pluviale di Daintree
Il Daintree, nei pressi di Mossman, costituisce una parte essenziale della più grande distesa di foresta pluviale tropicale australiana, che da solo ricopre 1.200 km². Anche se si estende su meno dello 0.1% del territorio australiano, il Daintree ospita quasi un terzo di tutte le specie di rane, rettili e marsupiali dell'Australia e il 90% di pipistrelli e farfalle del paese.

Regenwoud Daintree
Daintree, dicht bij Mossman, vormt een wezenlijk deel van het grootste tropische regenwoud van Australië; Daintree alleen al beslaat 1200 km². Hoewel het zich uitstrekt over minder dan 0,1% van het Australische grondgebied, bevat het woud bijna een derde van alle kikker-, reptielen- en buideldiersoorten in Australië en 90% van de vleermuizen en vlinders.

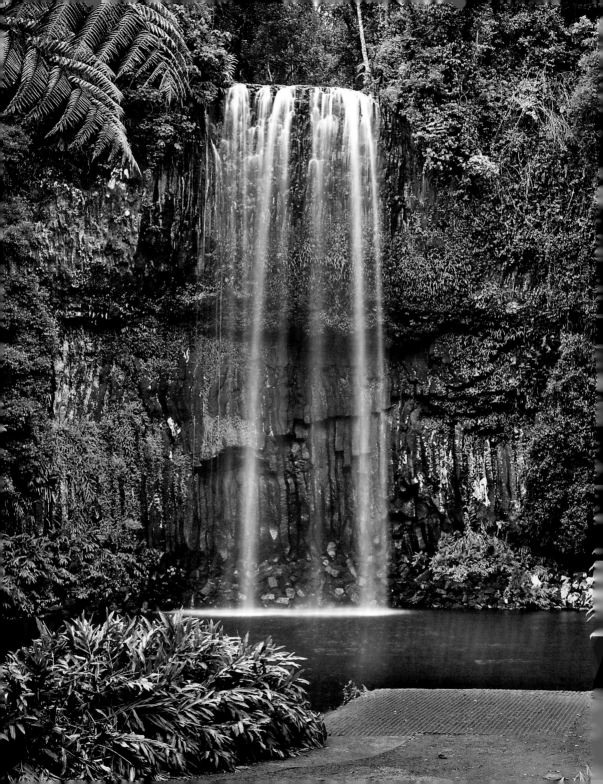

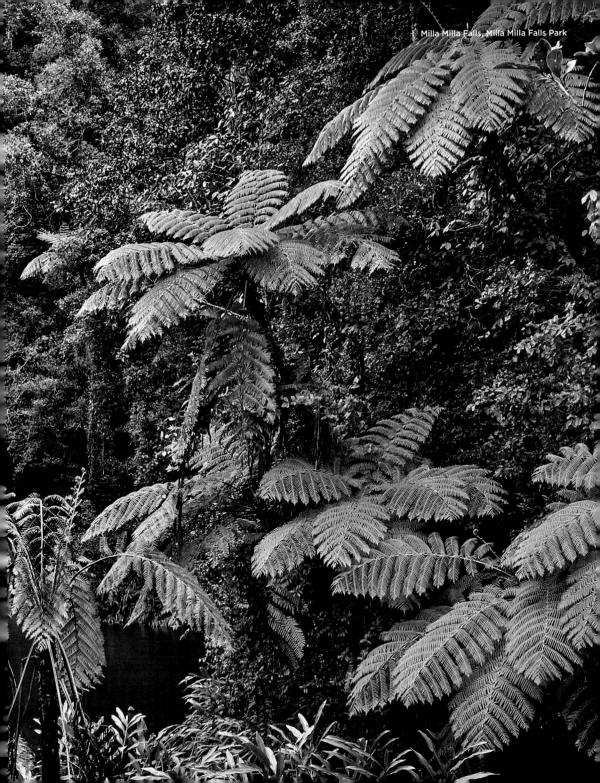

Port Douglas

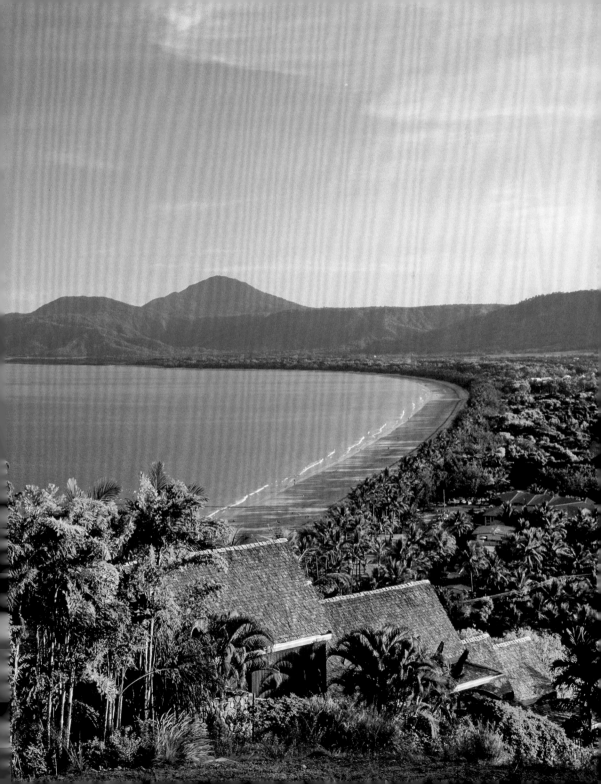

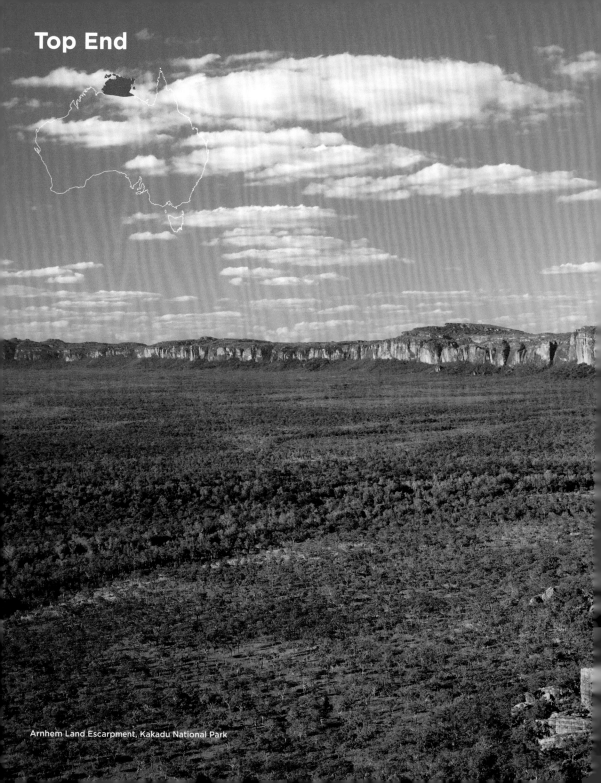

Top End

Arnhem Land Escarpment, Kakadu National Park

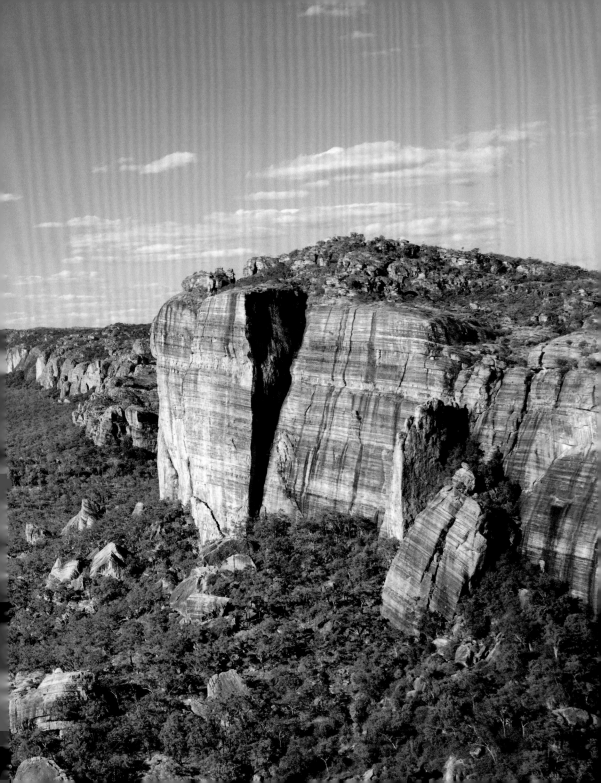

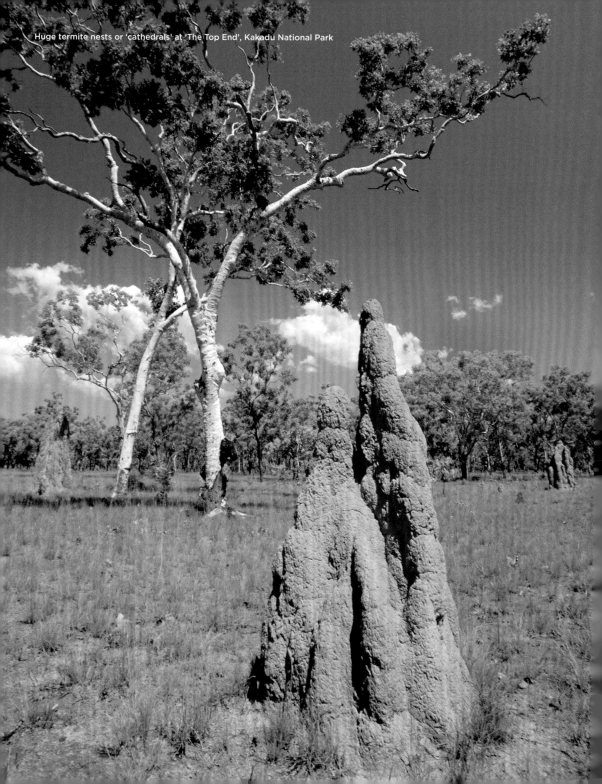
Huge termite nests or 'cathedrals' at 'The Top End', Kakadu National Park

Nourlangie rock, Kakadu National Park

Top End
Australia's Top End include some heavyweight attractions from the country's north. Darwin is a languid tropical city, and the gateway to Kakadu National Park, both rich in wildlife and rugged natural beauty. Arnhem Land is a vast, beautiful and hugely significant homeland for culturally rich and influential Indigenous peoples.

Top End
On trouve dans le Top End australien quelques unes des principales attractions du nord du pays. Darwin est une ville tropicale alanguie, mais également la porte d'entrée du parc national de Kakadu, riche par sa faune sauvage comme par sa beauté naturelle. La Terre d'Arnhem est une vaste et sublime région, extrêmement importante pour les peuples autochtones à la culture foisonnante.

Top End
Australiens Top End bietet einige besondere Attraktionen innerhalb des Northern Territory. Darwin ist eine träge tropische Stadt und das Tor zum Kakadu Nationalpark, reich an Wildtieren und rauer Natur. Arnhem Land ist ein riesiges Gebiet, ebenso schön und enorm wichtig als Heimat für kulturell reiche und einflussreiche indigene Völker.

Top End
El Top End de Australia incluye algunas de las mejores atracciones del norte del país. Darwin es una ciudad tropical lánguida, además de la puerta de entrada al parque nacional de Kakadu, rico en vida silvestre y en una belleza natural escarpada. La Tierra de Arnhem es una vasta región, hermosa y de gran importancia para los pueblos indígenas culturalmente ricos e influyentes.

Top End
Il Top End australiano include alcune delle attrazioni maggiori del nord del paese. Darwin è una tranquilla città tropicale, porta d'ingresso al Parco Nazionale di Kakadu, ricca di fauna selvatica e di aspre bellezze naturali. Arnhem Land è una vasta regione, bella e di enorme importanza quale patria dei popoli indigeni ricchi di cultura.

Top End
Top End bevat enkele bijzondere bezienswaardigheden in het noorden van het land. Darwin is een rustige tropische stad en de toegangspoort tot het nationale park Kakadu, dat rijk is aan wilde dieren en ruig natuurschoon. Arnhem Land is een prachtig uitgestrekt gebied dat een belangrijk thuisland is voor de inheemse volken.

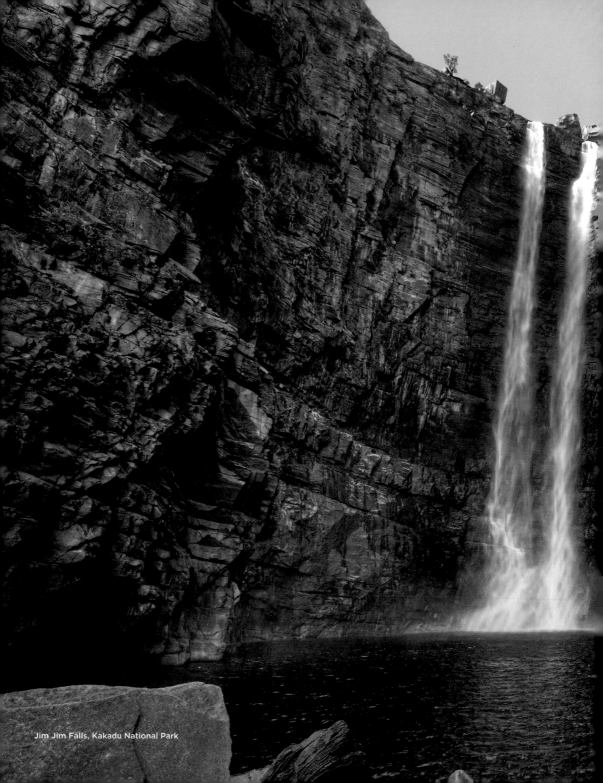

Jim Jim Falls, Kakadu National Park

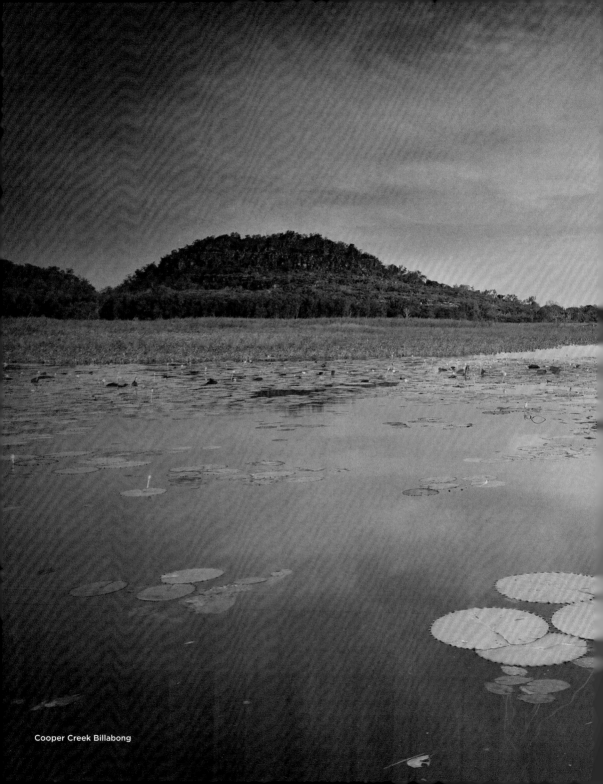
Cooper Creek Billabong

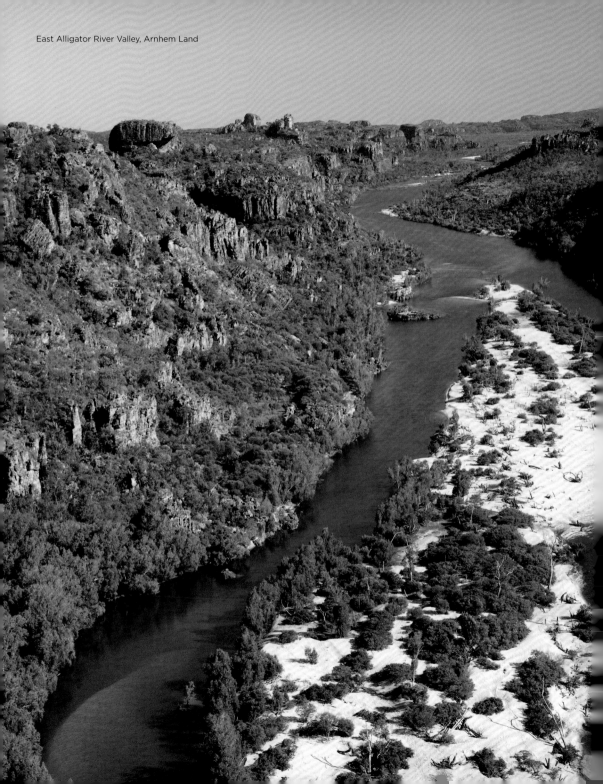
East Alligator River Valley, Arnhem Land

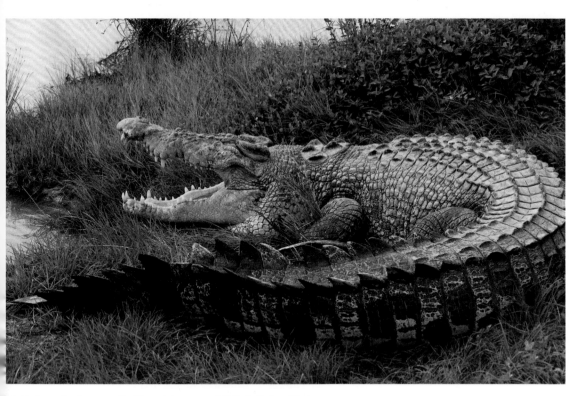

East Indian saltwater crocodile *(Crocodylus porosus)*, Kakadu National Park

Kakadu National Park

This Unesco World Heritage-listed national park is one of Australia's most spectacular protected areas. Wildlife is abundant here, and although the park is famous for its saltwater crocodiles, there are 280 recorded bird species and 60 different types of mammal. The rivers – such as the misnamed East Alligator River, so named by an explorer who mistook crocodiles for alligators—are popular for water-borne exploration.

Parque nacional de Kakadu

Este parque nacional declarado Patrimonio Mundial por la Unesco es una de las áreas protegidas más espectaculares de Australia. La vida silvestre es abundante y, aunque el parque es famoso por sus cocodrilos de agua salada, hay 280 especies de aves registradas y 60 tipos diferentes de mamíferos. Los ríos, como el mal llamado East Alligator River, así denominado por un explorador que confundió cocodrilos con caimanes, son populares por la exploración fluvial.

Parc national de Kakadu

Ce parc national classé au patrimoine mondial de l'Unesco est l'une des zones protégées les plus spectaculaires d'Australie. La faune y est abondante et bien que le parc soit célèbre pour ses crocodiles d'eau salée, on y trouve également 280 espèces d'oiseaux et 60 types de mammifères différents. Les excursions sur les rivières – comme la rivière East Alligator, nommée ainsi par un explorateur ayant confondu les deux animaux – sont très populaires.

Parco Nazionale di Kakadu

Questo parco nazionale, patrimonio dell'umanità dell'Unesco, è una delle aree protette più spettacolari d'Australia. La fauna selvatica è qui abbondante, e anche se il parco è famoso soprattutto per i suoi coccodrilli marini, sono presenti 280 specie di uccelli e 60 tipi di mammiferi. I fiumi – come l'East Alligator River, così chiamato da un esploratore che scambiò i coccodrilli per alligatori – sono popolari per le esplorazioni via acqua.

Kakadu-Nationalpark

Der Weltnaturerbe der Unesco gehörende Nationalpark ist eines der spektakulärsten Schutzgebiete. Die Tierwelt ist sehr artenreich, es gibt 280 registrierte Vogel- und 60 Säugetierarten. Die Flüsse – wie der von einem Entdecker falsch benannte East Alligator River (er hatte Krokodile mit Alligatoren verwechselt) – sind für Ausflüge beliebt.

Nationaal park Kakadu

Dit nationale park, opgenomen op Unesco's werelderfgoedlijst, is een van de spectacuiairste beschermde natuurgebieden van Australië. Wilde dieren zijn hier in overvloed aanwezig, waaronder 280 geregistreerde vogelsoorten en 60 verschillende soorten zoogdieren. De rivieren – zoals de East Alligator River, zo genoemd door een ontdekkingsreiziger die krokodillen aanzag voor alligators – zijn populair voor tochten.

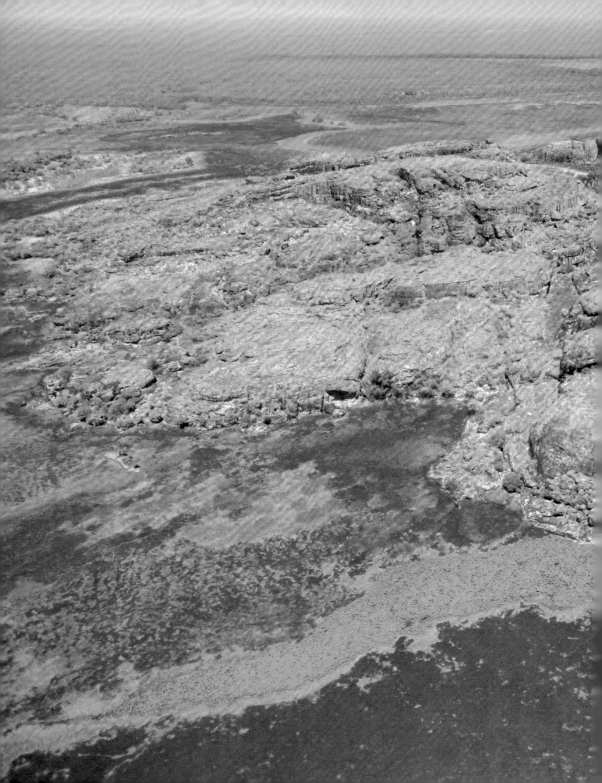

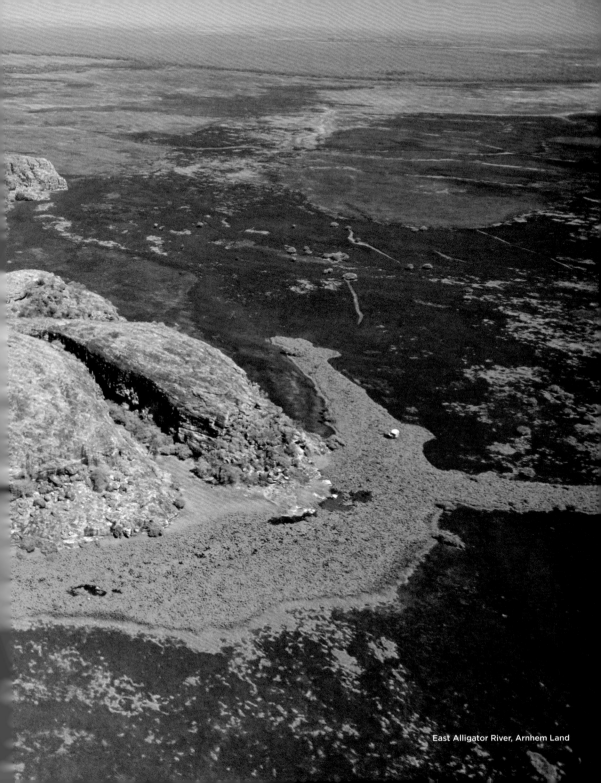

East Alligator River, Arnhem Land

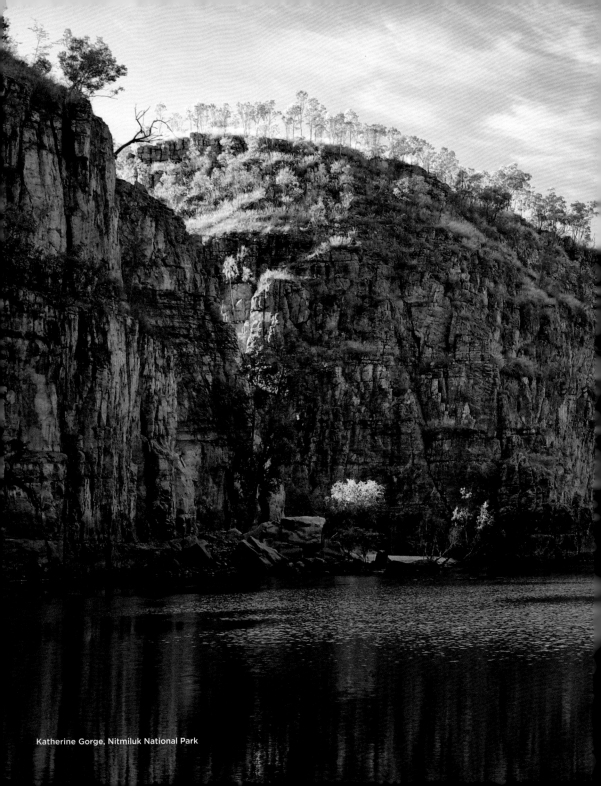

Katherine Gorge, Nitmiluk National Park

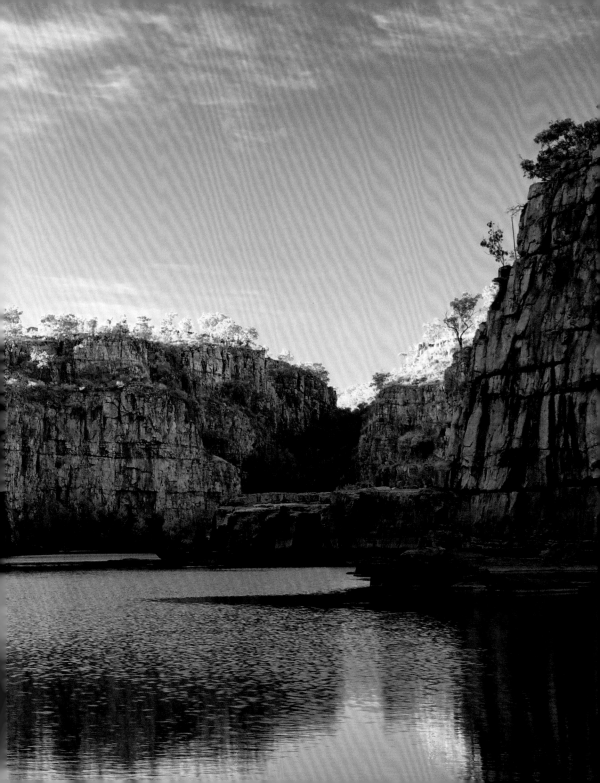

Bay Marina, Darwin

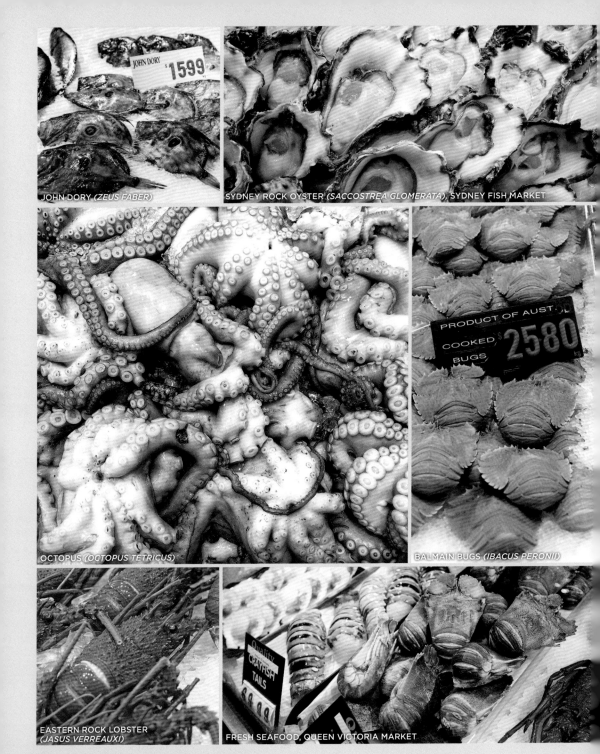

JOHN DORY *(ZEUS FABER)*

SYDNEY ROCK OYSTER *(SACCOSTREA GLOMERATA)*, SYDNEY FISH MARKET

OCTOPUS *(OCTOPUS TETRICUS)*

BALMAIN BUGS *(IBACUS PERONII)*

EASTERN ROCK LOBSTER
(JASUS VERREAUXI)

FRESH SEAFOOD, QUEEN VICTORIA MARKET

TASMANIAN SALMON *(RETROPINNIDAE)*

MURRAY CRAYFISH *(CHERAX DESTRUCTOR)*

KING PRAWNS *(MELICERTUS LATISULCATUS)*

CRAYFISH *(CHERAX QUADRICARINATUS)*

BARRAMUNDI *(LATES CALCARIFER)*

Seafood

Australia's cities lie mainly on its endless coastline, so it's no wonder seafood is a large part of life here. Oysters are produced and tuna caught in its southern waters, while its tropical seas are known for barramundi and prawns. And while it's no longer a sustainable species, Australians traditionally have loved to feast on shark.

Fruits de mer

Les villes d'Australie sont principalement situées sur son infini littoral, il n'est donc pas étonnant que les fruits de mer occupent une grande place dans sa gastronomie. Les huîtres sont produites et le thon pêché dans ses eaux méridionales, tandis que ses mers tropicales sont connues pour le barramundi et les crevettes. Et bien que ce soit aujourd'hui une espèce protégée, les Australiens ont toujours aimé se régaler de requins.

Meeresfrüchte

Australiens Städte liegen hauptsächlich an der Küste, so wundert es nicht, dass Meeresfrüchte so wichtig sind. In den südlichen Gewässern werden Austern produziert und Thunfisch gefangen, während die tropischen Meere für Barramundi und Garnelen bekannt sind. Und obwohl es sich aus Nachhaltigkeitsgründen nicht mehr schickt, aßen Australier traditionell Haie.

Mariscos

Las ciudades de Australia se encuentran principalmente en su interminable costa, por lo que no es de extrañar que los mariscos sean una gran parte de la vida aquí. En sus aguas australes se producen ostras y se pesca atún, mientras que en sus mares tropicales se conocen los barramundis y las gambas. Y aunque ya no es una especie sostenible, a los australianos tradicionalmente les ha encantado darse un festín con los tiburones.

Frutti di mare

Le città australiane si trovano principalmente lungo le infinite coste del paese, quindi non c'è da stupirsi se i frutti di mare siano una parte importante della vita qui. Le ostriche vengono prodotte e il tonno pescato nelle sue acque meridionali, mentre i mari tropicali sono noti per i barramundi e i gamberetti. E per quanto non sia più possibile per questioni di tutela, gli squali sono stati un cibo tradizionale per gli australiani.

Zeevruchten

De steden in Australië liggen voornamelijk langs de eindeloze kustlijn, dus het is geen wonder dat zeevruchten veel gegeten worden. Oesters worden gekweekt en tonijn wordt gevangen in de zuidelijke wateren, terwijl de tropische zeeën bekendstaan om barramundi en garnalen. En hoewel het niet langer een duurzame soort is, smulden Australiërs vroeger van haaien.

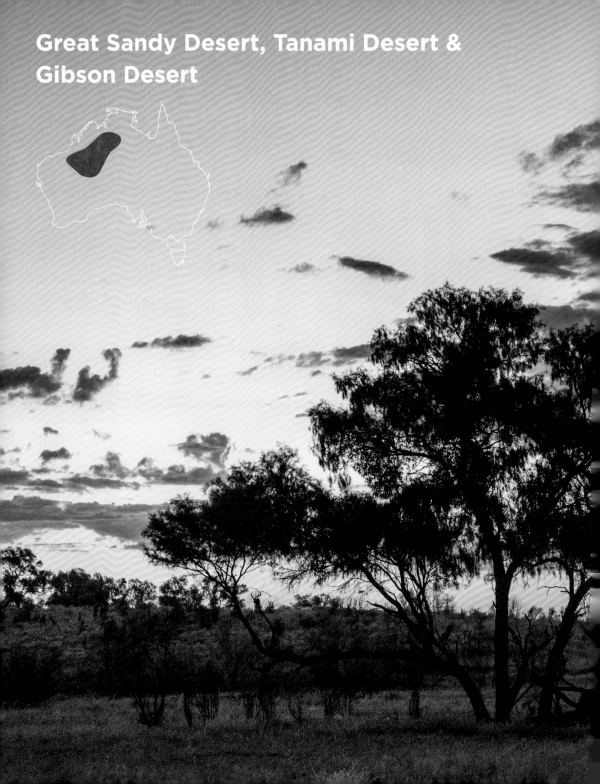

Great Sandy Desert, Tanami Desert & Gibson Desert

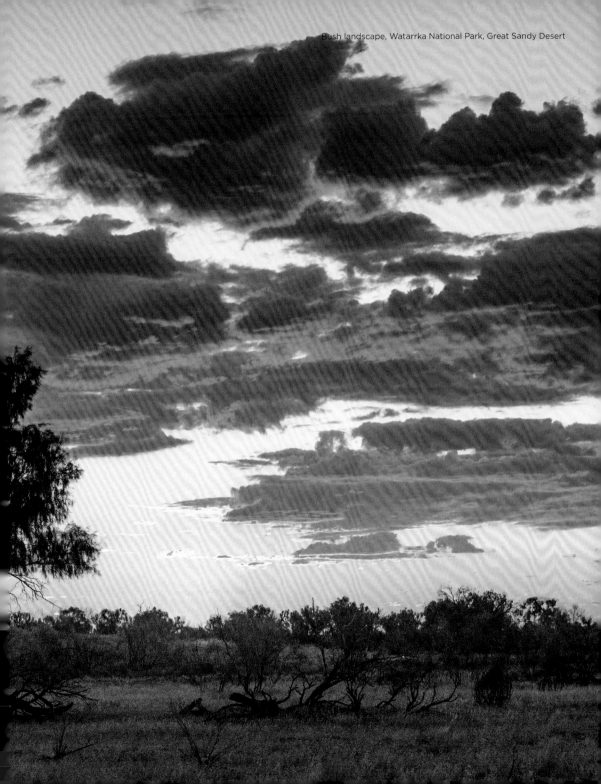
Bush landscape, Watarrka National Park, Great Sandy Desert

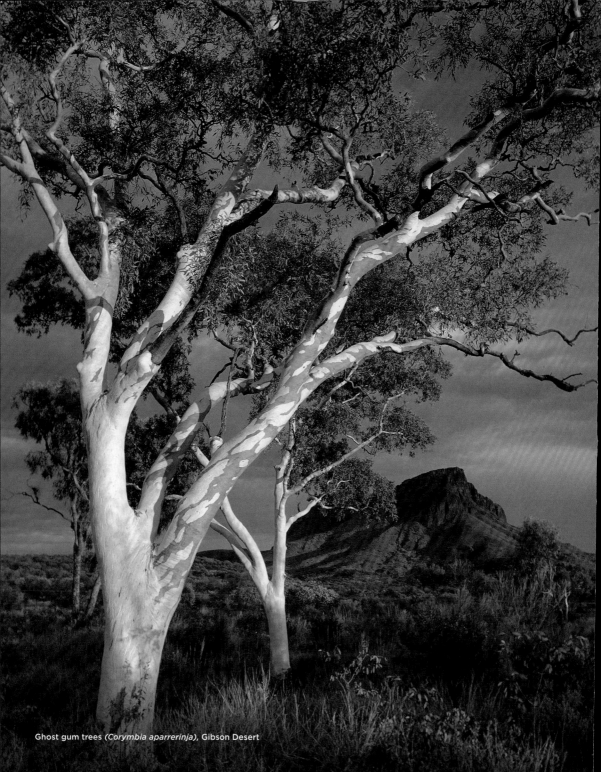

Ghost gum trees *(Corymbia aparrerinja)*, Gibson Desert

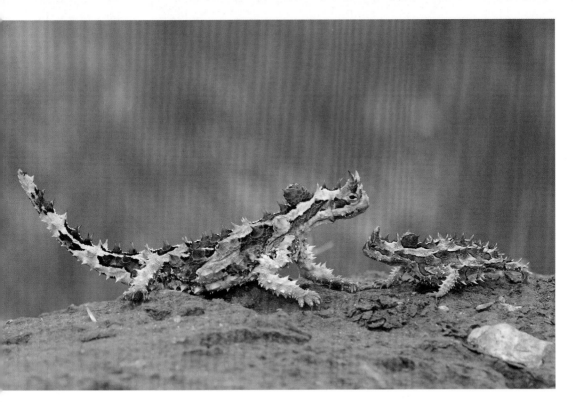

Thorny Devil, Gibson Desert

Great Sandy Desert, Tanami Desert & Gibson Desert

Occupying a vast swathe of the Australian continent's far northwest, these three deserts are remote yet, in parts, hauntingly beautiful. Accessible only to travelers in well-equipped, deep-desert, 4WD expeditions, these deserts were until quite recently home to the last nomadic indigenous peoples of Australia, and some isolated communities remain.

Great Sandy Desert, Tanami Desert & Gibson Desert

Ocupando una vasta franja del extremo noroeste del continente australiano, estos tres desiertos son remotos pero, en algunas zonas sonde una belleza inolvidable. Estos desiertos, accesibles solo para los viajeros en expediciones con 4 x 4 bien pertrechados, estos desiertos fueron hasta hace poco el hogar de los últimos pueblos indígenas nómadas de Australia; algunas comunidades aisladas permanecen en ellos.

Grand désert de sable, désert de Tanami & désert de Gibson

Occupant une vaste partie de l'extrême nord-ouest du continent australien, ces trois déserts sont reculés mais, par endroits, d'une beauté envoûtante. Accessibles uniquement aux voyageurs équipés de 4 x 4, ces déserts abritaient jusqu'à tout récemment les derniers peuples autochtones nomades d'Australie, dont subsistent encore certaines communautés isolées.

Great Sandy Desert, Tanami Desert & Gibson Desert

Occupando una vasta area dell'estremo nord-ovest del continente australiano, questi tre deserti sono in parte remoti ma di una bellezza inquietante. Accessibili solo a chi viaggia su fuoristrada ben attrezzate per il deserto, fino a poco tempo fa questi deserti ospitavano gli ultimi popoli indigeni nomadi dell'Australia. Alcune delle comunità più remote sono tuttora isolate.

Great Sandy Desert, Tanami Desert & Gibson Desert

Diese drei Wüsten, die sich im äußersten Nordwesten des Kontinents befinden, sind abgelegen und berückend schön. Die Wüsten, die nur Reisenden auf gut ausgestatteten Allrad-Expeditionen zugänglich sind, waren bis vor kurzem die Heimat der letzten nomadisierenden indigenen Völker Australiens, und einige isolierte Gemeinschaften sind noch immer vorhanden.

Great Sandy Desert, Tanami Desert & Gibson Desert

Deze drie woestijnen in het uiterste noordwesten van het continent liggen ver weg, maar zijn betoverend mooi. Deze woestijnen, die alleen toegankelijk zijn voor reizigers op goed uitgeruste woestijn- en 4WD-expedities, waren tot voor kort het grondgebied van de laatste nomadische inheemse volken van Australië. En er leven nog altijd enkele geïsoleerde gemeenschappen.

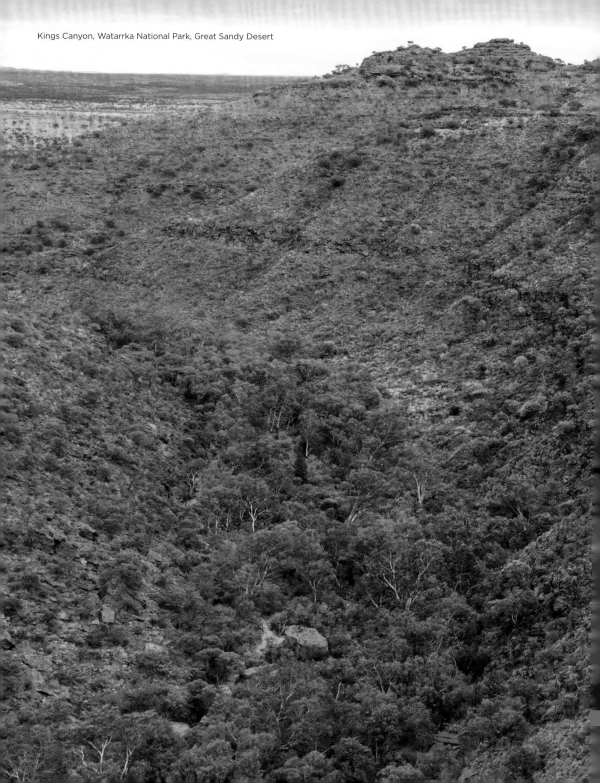

Kings Canyon, Watarrka National Park, Great Sandy Desert

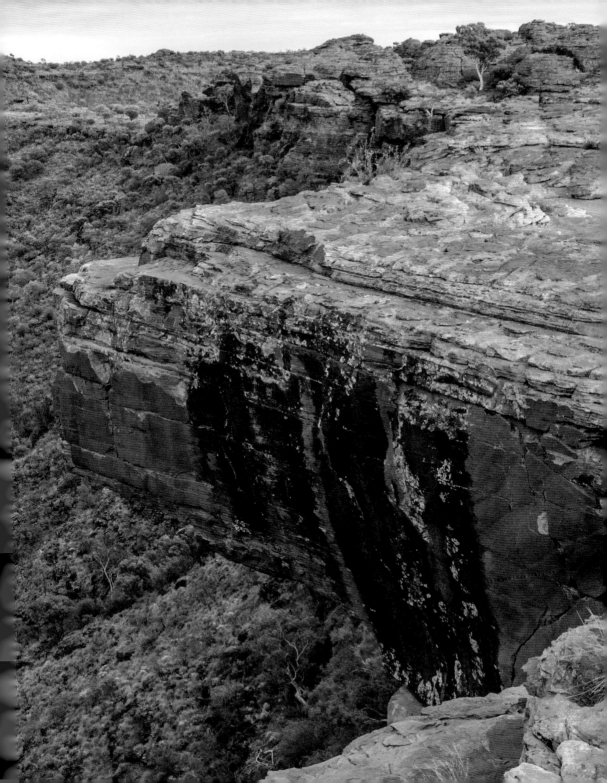

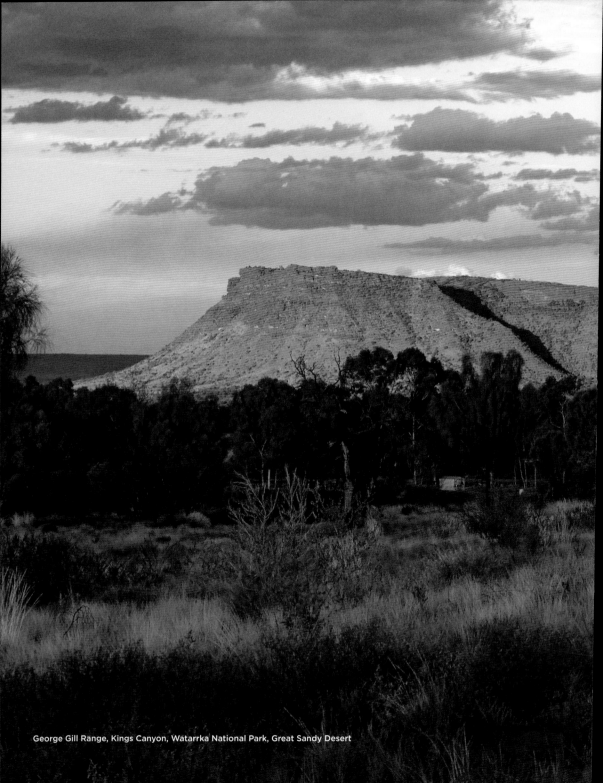

George Gill Range, Kings Canyon, Watarrka National Park, Great Sandy Desert

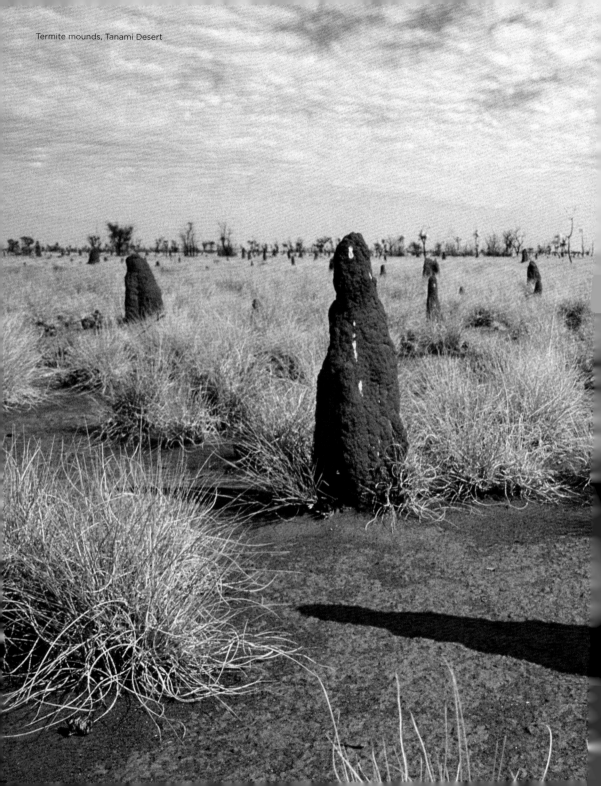
Termite mounds, Tanami Desert

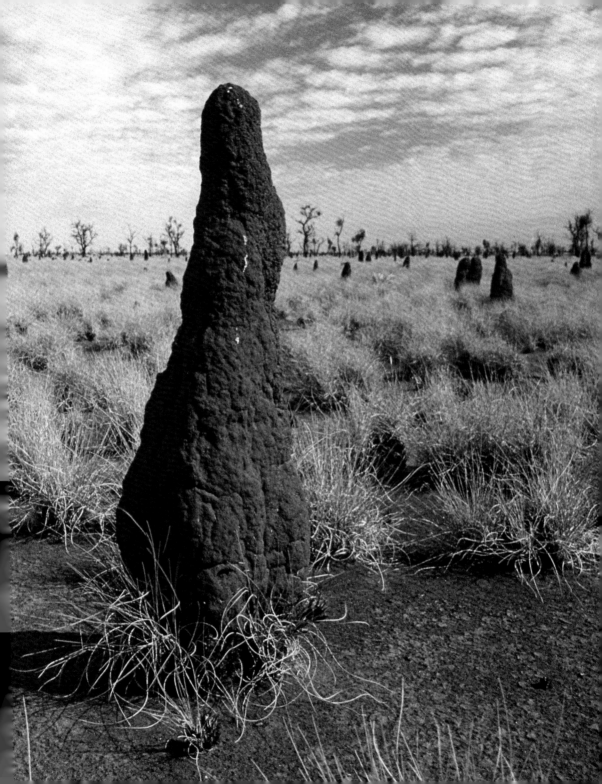

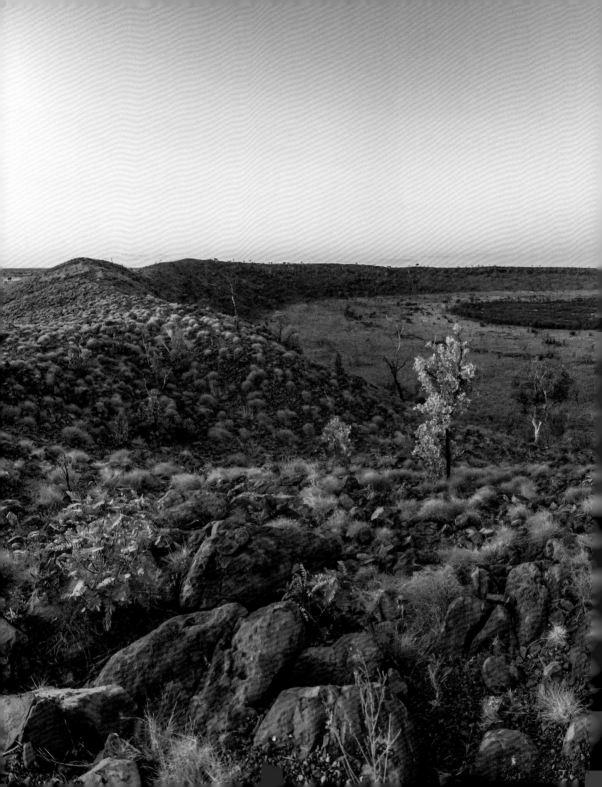

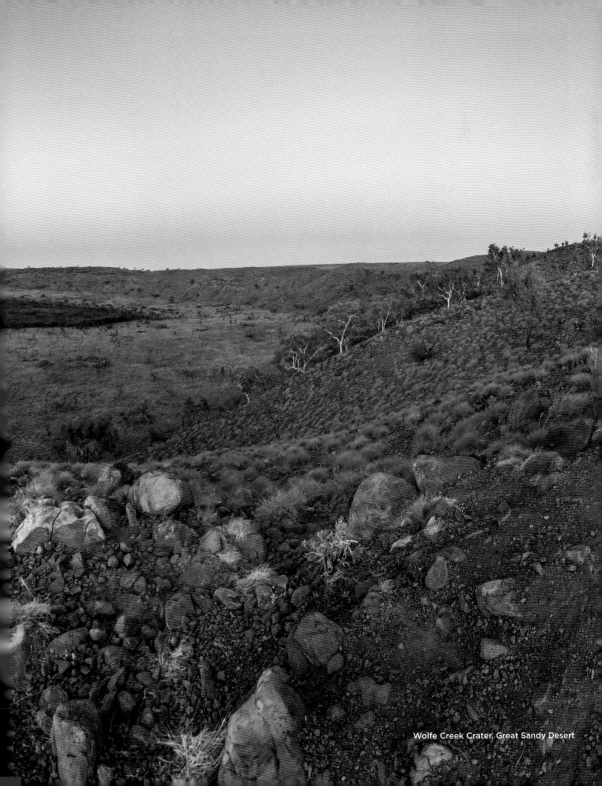

Wolfe Creek Crater, Great Sandy Desert

Great Northern Highway 1

Long distances

Taking in great swathes of both the Northern Territory and Western Australia, these three deserts form much of the Western Desert. Distances here are immense, and ranges across great ergs and undulating red sand to gravel and grass topped hills, but its indigenous inhabitants share a common language group, if many dialects, from the Nullarbor to the Kimberley.

Longues distances

Ces trois déserts, qui s'étendent sur une grande partie du Territoire du Nord et de l'Australie-Occidentale, forment une grande partie du désert de l'Ouest. Les distances y sont immenses et ce territoire comprend des grands ergs et des dunes rouges ondulantes comme des collines couvertes de gravier et d'herbe, mais ses habitants indigènes partagent un groupe linguistique commun – même si, du Nullarbor au Kimberley, il existe beaucoup de dialectes différents.

Große Entfernungen

Die drei genannten Wüsten, die sich über große Teile des Northern Territory und Westaustraliens erstrecken, bilden zugleich einen Großteil der Westwüste. Die Entfernungen hier sind riesig und die Landschaft wechselt von großen Ergs und wellenförmigen roten Sandwüsten bis hin zu Kies- und Grashügeln, und doch teilen sich die indigenen Bewohner eine gemeinsame Sprachgruppe, wenn auch in vielen Dialekte, vom Nullarbor bis zum Kimberley.

Old car wreck, near Devil's Marbles, Tanami Desert

Distancias immensas

Abarcando grandes extensiones tanto del Territorio del Norte como de Australia occidental, estos tres desiertos conforman parte del Desierto occidental. Las distancias son inmensas y se extienden desde grandes ergios y ondulantes dunas rojas hasta colinas de grava y hierba, pero sus habitantes indígenas comparten una ramalingüística común, pero con muchos dialectos, desde el Nullarbor hasta el Kimberley.

Distanze immense

Questi tre deserti, che comprendono grandi aree del Territorio del Nord e dell'Australia Occidentale, costituiscono gran parte della regione del cosiddetto Deserto Occidentale. Le distanze sono immense e il paesaggio ospita sia grandi erg e dune di sabbia rossa ondulata che colline ricoperte di ghiaia ed erba. I suoi abitanti indigeni appartengono allo stesso gruppo linguistico, seppure con molti dialetti, dai Nullarbor ai Kimberley.

Lange afstanden

De drie genoemde woestijnen, die zich over grote delen van het Northern Territory en West-Australië uitstrekken, maken een groot deel van de Westelijke Woestijn uit. De afstanden zijn hier immens en variëren van grote ergs en golvende roodzandvlakten tot grind- en grasheuvels, maar de inheemse bewoners, van de Nullarbor tot de Kimberley, delen een gemeenschappelijke taal, hoewel er veel dialecten zijn.

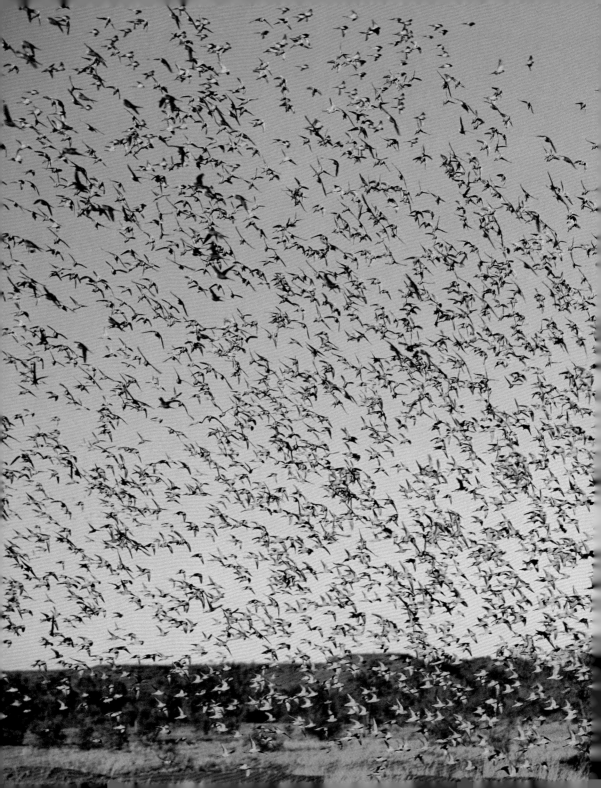

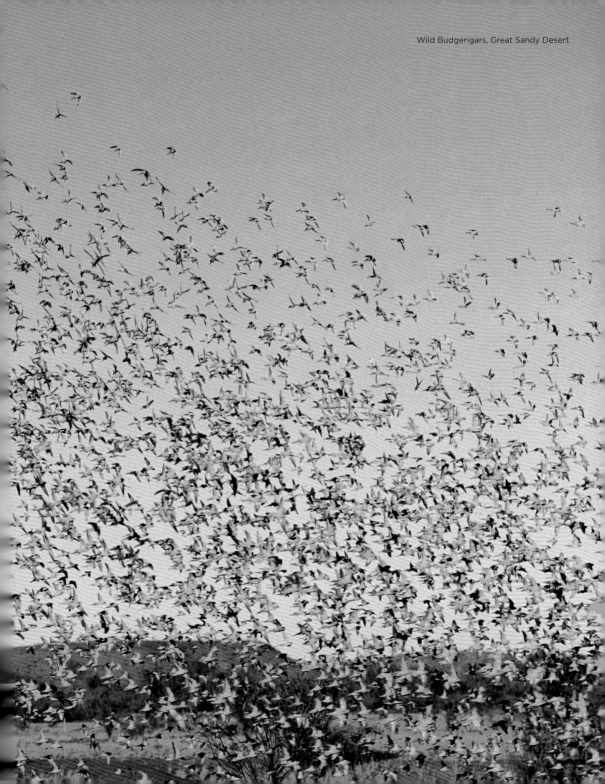

Wild Budgerigars, Great Sandy Desert

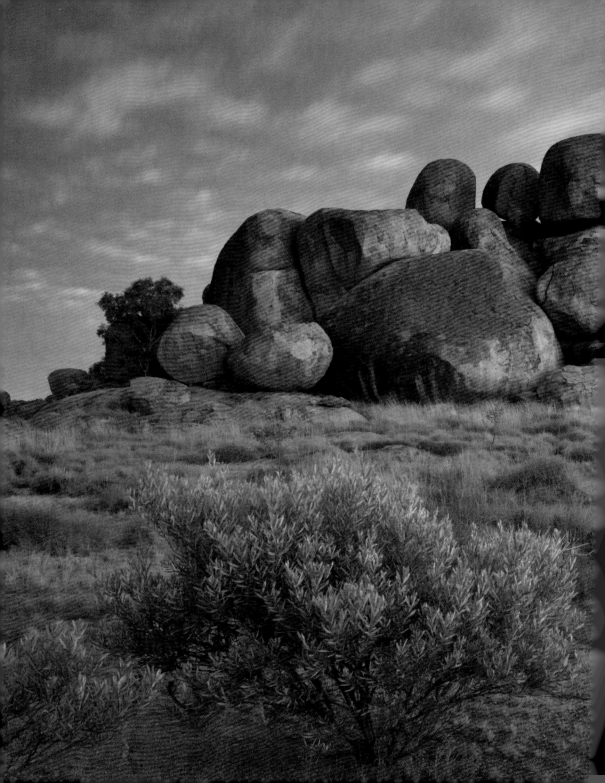

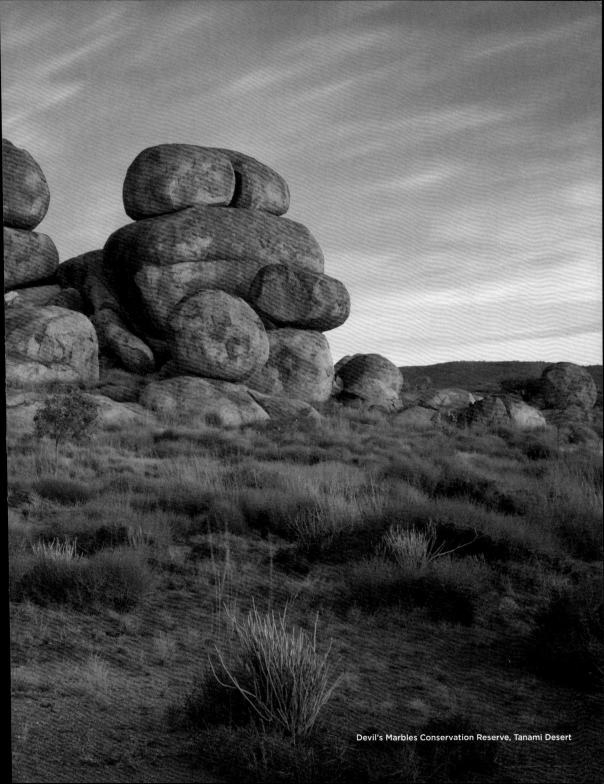
Devil's Marbles Conservation Reserve, Tanami Desert

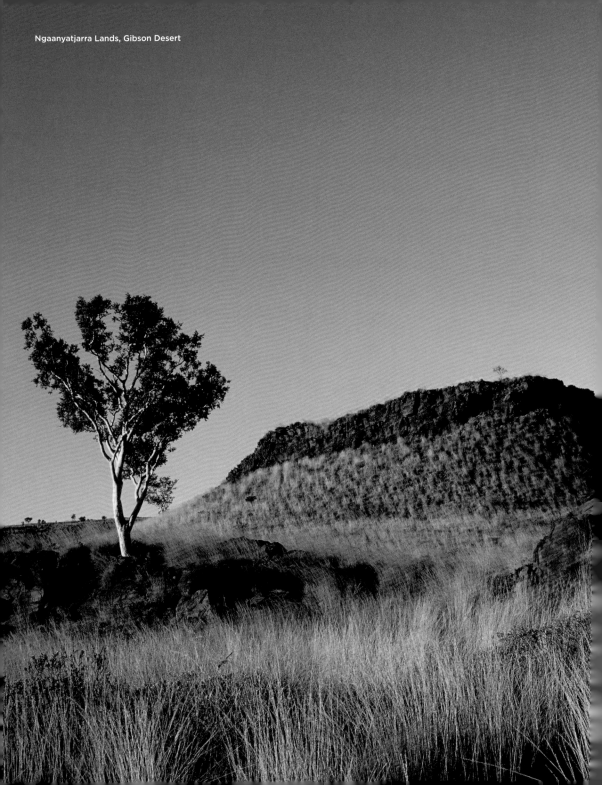

Ngaanyatjarra Lands, Gibson Desert

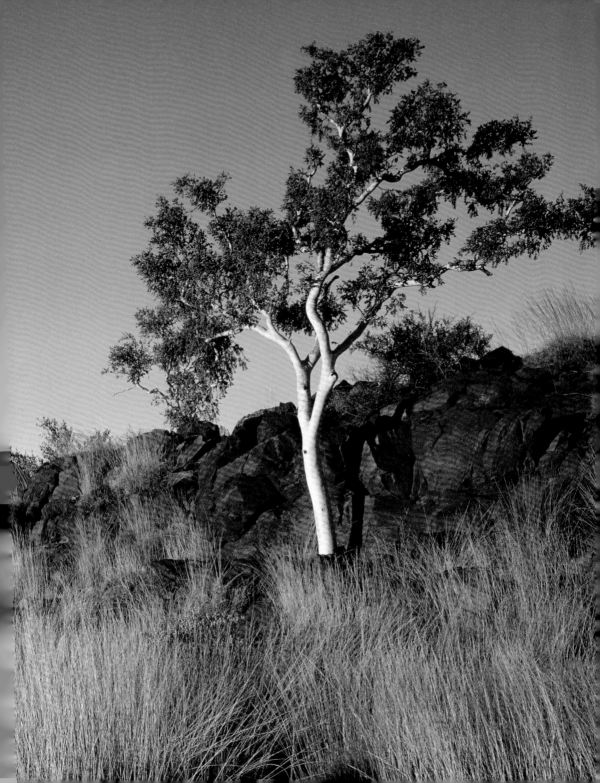

Red Centre

Uluru, Uluru-Kata Tjuta National Park

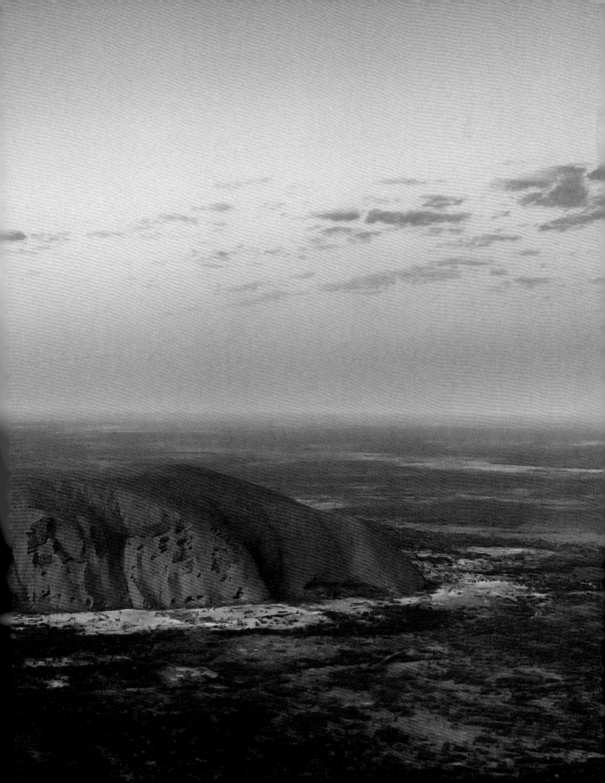

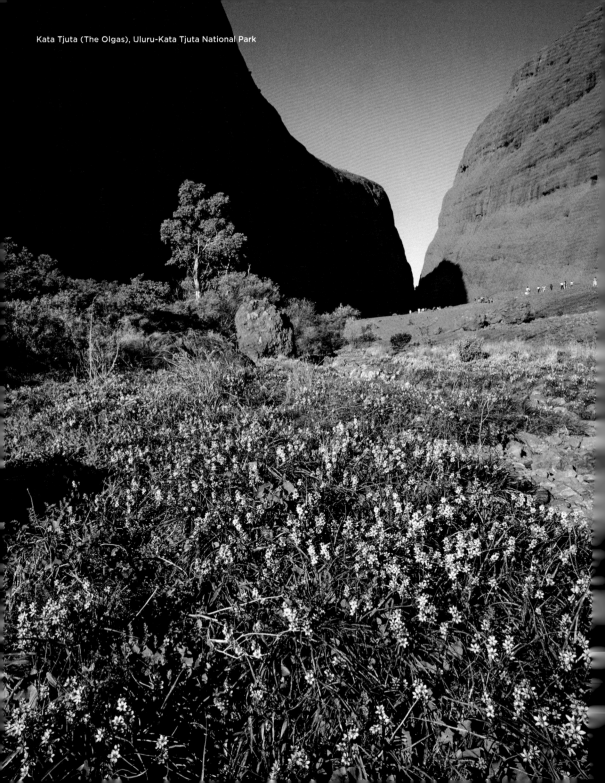

Kata Tjuta (The Olgas), Uluru-Kata Tjuta National Park

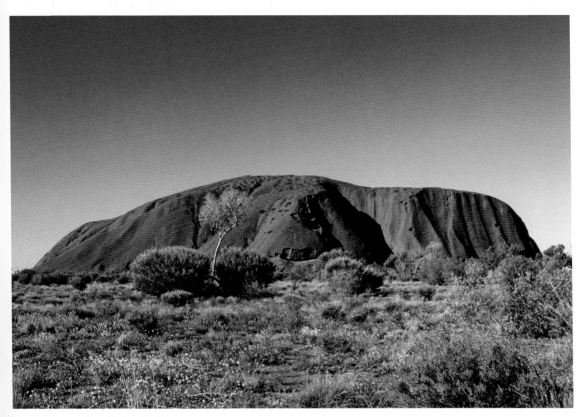

Uluru, Uluru-Kata Tjuta National Park

Red centre

In the red heart of Australia lie some of Australia's most celebrated natural wonders. The MacDonnell Ranges, east and west of Alice Springs, are wonderful worlds of red earth, red escarpments and plenty of wildlife, while soulful Uluru and Kata Tjuta rise as soulful, free-standing apparitions in one of Indigenous Australia's most important strongholds.

Red centre

En el corazón rojo de Australia se encuentran algunas de las maravillas naturales más famosas del país. La cordillera MacDonnell, al este y al oeste de Alice Springs, son mundos maravillosos de tierra y acantilados rojos y abundante vida silvestre, mientras que las emocionantes formaciones de Uluru y Kata Tjuta se erigen independientes en uno de los bastiones más importantes de la Australia indígena.

Red centre

Dans l'intérieur du pays se trouvent quelques-unes des merveilles naturelles les plus célèbres d'Australie. Les chaînes de montagnes MacDonnell, à l'est et à l'ouest d'Alice Springs, sont de merveilleux mondes de terre rouge et de reliefs écarlates, peuplés par une faune abondante, tandis que Uluru et Kata Tjuta se dressent indépendamment et dramatiquement dans l'un des plus importants bastions indigènes australiens.

Red centre

Nel cuore rosso dell'Australia si trovano alcune delle più celebri meraviglie naturali australiane. I MacDonnell Ranges, a est e ovest di Alice Springs, sono uno spettacolare mondo di terra e scarpate rosse e di fauna selvatica, mentre Uluru e Kata Tjuta si ergono come apparizioni quasi indipendenti dal paesaggio circostante, in una delle roccaforti più importanti dell'Australia indigena.

Red centre

In der roten Mitte Australiens liegen die berühmtesten Naturwunder des Landes. Die MacDonnell-Ranges, östlich und westlich von Alice Springs, sind Landschaften aus roter Erde, Steilhängen und mit vielen Tieren, während der seelenvolle Uluru und die Kata Tjuta als freistehende Erscheinungen in einer der wichtigsten Regionen des indigenen Australiens auftauchen.

Red centre

In het rode hart liggen enkele van de beroemdste natuurwonderen van Australië. De MacDonnell Ranges, ten oosten en westen van Alice Springs, zijn prachtige landschappen van rode aarde, met steile hellingen en veel wild, terwijl de bezielde Uluru en Kata Tjuta als vrijstaande verschijningen opdoemen in een van de belangrijkste regio's van inheems Australië.

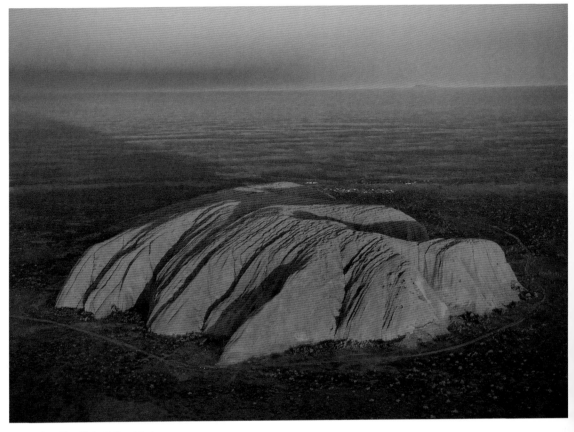

Uluru, Uluru-Kata Tjuta National Park

Uluru

There are few more beautiful sights in Australia than Uluru. Known as Ayers Rock until its return to the local traditional Aboriginal owners, Uluru has a color palette all its own, a deep ochre-hued rock that changes color with the angle of the sun. It rises nearly 350 m above the red-earth plains, but, like an iceberg, it is believed that it extends almost double that distance beneath the sand; it is around 3.6 km in length, although the Base Walk that circumnavigates Uluru will take four hours and covers 10.6 km. Many sections of the rock are considered sacred to the local Anangu people.

Uluru

Uluru est un des plus beaux endroits d'Australie. Connu sous le nom d'Ayers Rock jusqu'à ce qu'il ait été rendu à ses propriétaires aborigènes traditionnels, Uluru présente une palette de couleurs caractéristique, sa roche ocre profonde changeant de ton avec l'angle du soleil. Il s'élève à près de 350 m au-dessus des plaines de terre rouge, mais, comme un iceberg, on raconte qu'il s'étend sur presque le double de cette distance sous le sable ; il fait environ 3,6 km de long, bien que la randonnée appelée Base Walk qui le contourne prenne quatre heures et couvre 10,6 km. De nombreuses sections du rocher sont considérées comme sacrées par le peuple local Anangu.

Uluru

Es gibt nur wenige schönere Sehenswürdigkeiten in Australien als den Uluru. Bekannt als Ayers Rock, bevor er den lokalen Aborigines wieder übereignet wurde. Der Uluru besitzt eine eigene Farbpalette, einen tief ockerfarbenen Felsen, der seine Farbe mit dem Sonnenstand ändert. Er erhebt sich fast 350 m über die Ebenen der roten Wüste, aber wie bei einem Eisberg wird auch hier vermutet, dass er sich fast doppelt so weit unter den Sand erstreckt; er ist etwa 3,6 km lang, dagegen dauert der Spaziergang um den Uluru vier Stunden und ist 10,6 km lang. Viele Abschnitte des Felsens gelten dem lokalen Volk der Anangu als heilig.

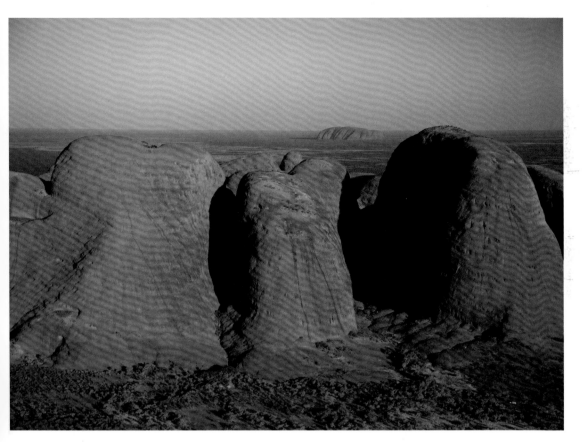

Kata Tjuta (The Olgas), Uluru-Kata Tjuta National Park

Uluru

Hay pocos lugares más hermosos en Australia que Uluru. Conocida como Ayers Rock hasta su regreso a los tradicionales propietarios aborígenes locales, Uluru tiene una paleta de colores propia; se trata deuna roca de un profundo color ocre que cambia de color con el ángulo del sol. Se eleva casi 350 m por encima de las llanuras de la tierra roja, pero, como un iceberg, se cree que se extiende casi el doble de esa distancia bajo la arena; tiene unos 3,6 km de longitud, aunque el Paseo que rodea el Uluru se realiza en cuatro horas y cubre 10,6 km. Muchas secciones de la roca son consideradas sagradas para losAnangu, aborígeneslocales.

Uluru

Ci sono pochi luoghi più belli di questo in Australia. Conosciuto come Ayers Rock fino al suo ritorno ai tradizionali proprietari aborigeni locali, l'Uluru ha una tavolozza di colori tutta sua, per via della roccia di un intenso colo ocra che cambia nell'arco della giornata alla luce del sole. Si erge per quasi 350 m sopra la pianura rossa, ma, come un iceberg, si ritiene che si estenda due volte tanto sotto la sabbia. È lungo circa 3,6 km, anche se la Base Walk che gli gira intorno si estende su 10,6 km e per farla occorrono quattro ore. Molte parti di questa formazione rocciosa sono considerate sacre dal popolo locale degli Anangu.

Uluru

Er zijn weinig mooiere bezienswaardigheden in Australië dan Uluru. Uluru was bekend als Ayers Rock tot die werd teruggegeven aan de lokale Aboriginals. Uluru heeft een eigen kleurenpalet, met diep okerkleurige rotsen die van kleur veranderen met de stand van de zon. Hij steekt bijna 350 m boven de rode aarde uit, maar net als bij een ijsberg vermoedt men dat hij zich twee keer zo diep onder het zand uitstrekt. Hij is zo'n 3,6 km lang, hoewel een wandeling om Uluru heen vier uur kost en over 10,6 km gaat. Veel delen van de rotsen zijn heilig voor het lokale Ananguvolk.

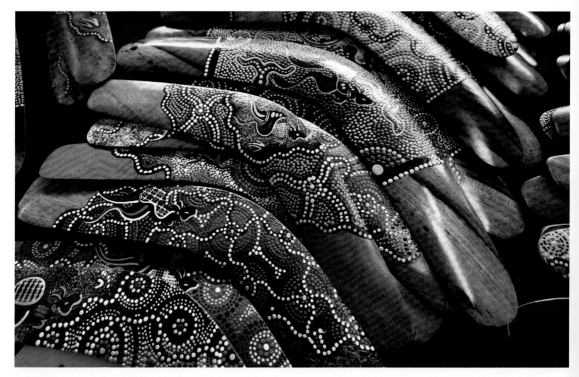

Boomerangs

Indigenous Art

Contrary to popular belief, the instantly recognisable dot-painting style of Australian Indigenous painting is a relatively recent phenomenon. Its birthplace in the 1970s was the small settlement of Papunya, immediately northwest of the West MacDonnell Ranges. A teacher at a local school watched local 'artists' drawing stories in the sand and convinced them to commit their creations to canvas. The result, the world-famous Western Desert style, took hold across the region.

Art indigène

Contrairement à la croyance populaire, le style pointilliste de la peinture indigène australienne est un phénomène relativement récent. Il est né dans les années 1970 dans le petit village de Papunya, situé immédiatement au nord-ouest de la chaîne West MacDonnell Ranges. Un enseignant d'une école locale, qui observait des artistes dessiner dans le sable, les a convaincus d'immortaliser leurs créations sur la toile. Cette technique, aujourd'hui mondialement connue, s'est alors répandue dans toute la région.

Einheimische Kunst

Entgegen der landläufigen Meinung ist der Punkte-Stil der indigenen Malerei ein neues Phänomen. Ihr Geburtsort in den 1970er-ahren war die Siedlung Papunya, nordwestlich der West MacDonnell Ranges. Ein Lehrer beobachtete die Geschichten der lokalen „Künstler" im Sand und ließ sie ihre Kreationen auf Leinwand zu bannen. Das Ergebnis, der weltberühmte Western Desert-Stil.

Arte Indígena

Contrariamente a la creencia popular, el estilo con puntos, es un fenómeno relativamente reciente. En la década de 1970, la cuna de este arte fue el pequeño asentamiento de Papunya, al noroeste de la cordillera West MacDonnell. Un profesor observó a los "artistas" locales dibujando historias en la arena y los convenció de que debían plasmar sus creaciones en lienzos. El resultado: el estilo mundialmente famoso del Desierto Occidental.

Arte indigena

Contrariamente alla credenza popolare, la pittura a punti è un fenomeno relativamente recente. Il suo luogo di nascita negli anni '70 del secolo scorso si trova nel piccolo insediamento di Papunya, a nord-ovest dei West MacDonnell Ranges: dopo aver osservato "artisti" locali che disegnavano storie nella sabbia, un insegnante di una scuola locale li convinse a immortalare le loro creazioni su tela. Il risultato, il famosissimo stile Western Desert.

Inheemse kunst

In tegenstelling tot wat vaak wordt gedacht, is de pointillistische stijl van de inheemse schilderkunst een relatief recent fenomeen. De geboorteplaats rond 1970 was de nederzetting Papunya, direct ten noordwesten van de West MacDonnell Ranges. Een docent keek naar de lokale 'kunstenaars' die verhalen in het zand tekenden en overtuigde hen ervan om hun creaties op doek te zetten. Het resultaat is de wereldberoemde Westerse Woestijnstijl.

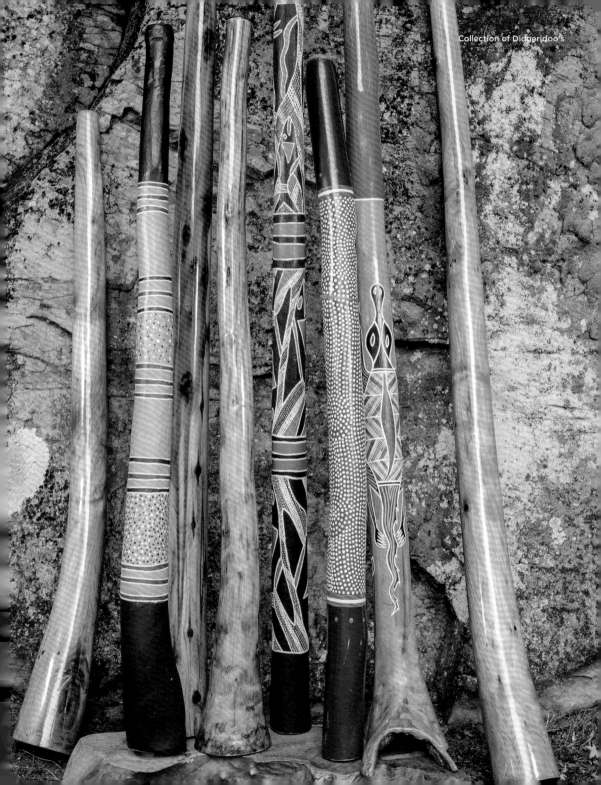

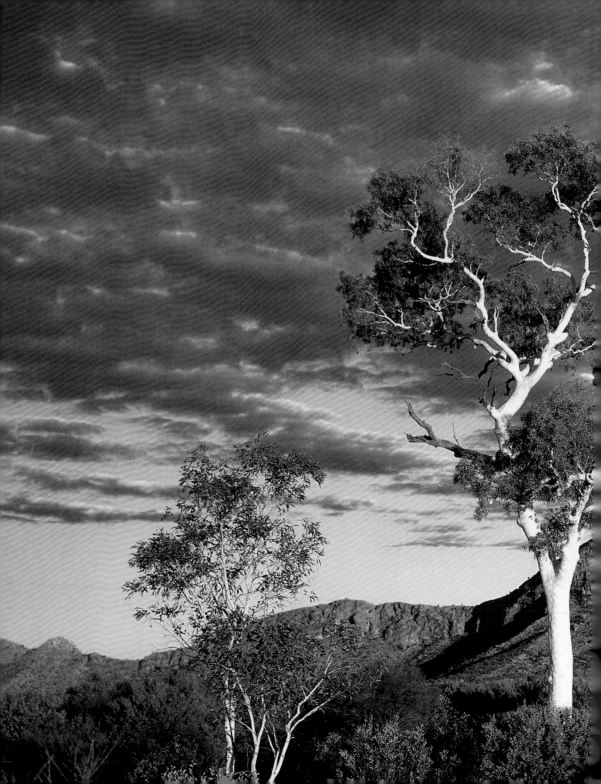

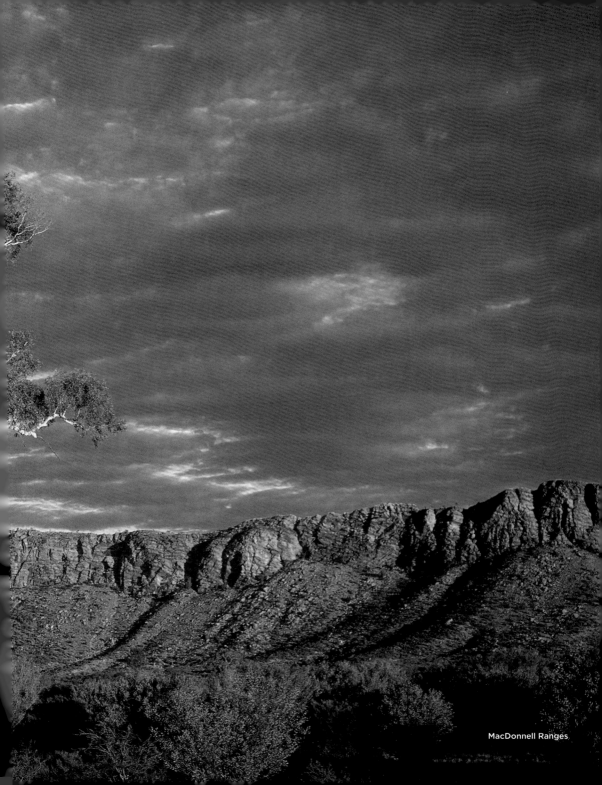

MacDonnell Ranges

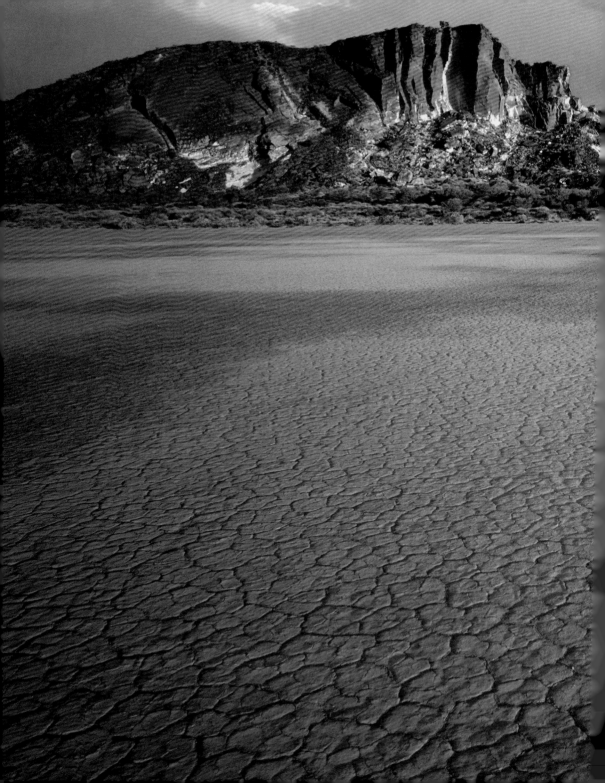

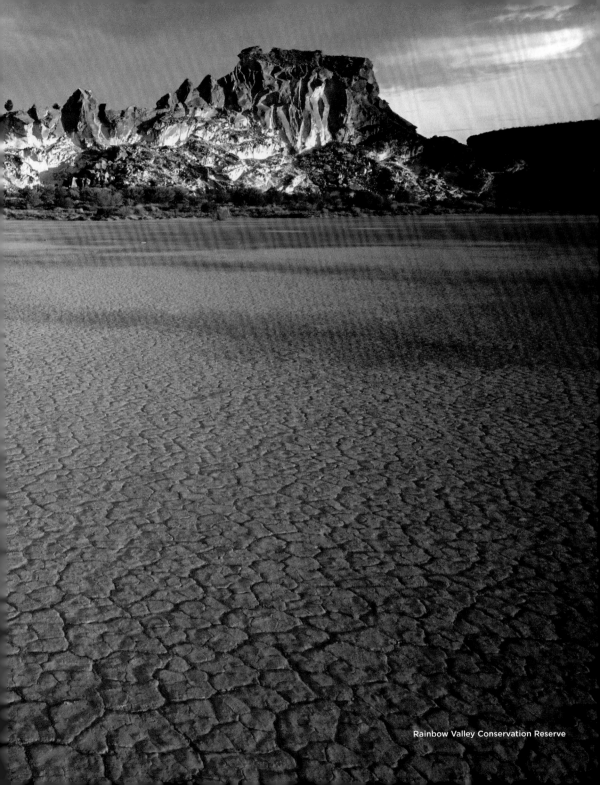

Rainbow Valley Conservation Reserve

Mereenie Loop between Uluru and Alice Springs

Alice Springs

Alice Springs

'The Alice' (as it's known to its friends) is a classic Outback town, roughly equidistant between Darwin and Adelaide and close to the very centre of the continent. The dry Todd River cuts through the town, while the red-hued West and East MacDonnell Ranges extend either side of the town. Approximately one in five of the town's inhabitants is indigenous, and although it stands in the heart of country traditionally inhabited by the Arrente people, the town's population includes Aborigines from across the Northern Territory's various indigenous groups. It is the second-largest town in the Northern Territory after Darwin.

Alice Springs

« L'Alice » (comme l'appellent ses habitants) est une ville classique de l'Outback, située à peu près à égale distance entre Darwin et Adélaïde, et proche du centre même du continent. La rivière Todd, sèche, traverse l'agglomération, tandis que les chaînes de montagnes de MacDonnell Ouest et Est, aux teintes rouges, s'étendent de part et d'autre de la ville. Environ un habitant sur cinq est autochtone, et bien qu'elle se trouve au cœur d'un pays traditionnellement habité par les Arrente, la population de la ville comprend des Aborigènes des différents groupes natifs de la région. C'est la deuxième plus grande ville du Territoire du Nord après Darwin.

Alice Springs

„The Alice" (wie die Stadt auch liebevoll genannt wird) ist eine klassische Outback-Stadt, etwa mittig zwischen Darwin und Adelaide gelegen und nahe der Mitte des Kontinents. Der trockene Todd River durchzieht die Stadt, während sich die Red-Hued West und East MacDonnell Ranges auf beiden Seiten der Stadt erstrecken. Etwa jeder fünfte Einwohner der Stadt ist indigen, und obwohl sie im Herzen eines Landes liegt, das traditionell vom Volk der Arrente bewohnt wird, gehören zur Bevölkerung der Stadt Aborigines aus den verschiedensten indigenen Gruppen des Northern Territory. Nach Darwin ist sie die zweitgrößte Stadt im Northern Territory.

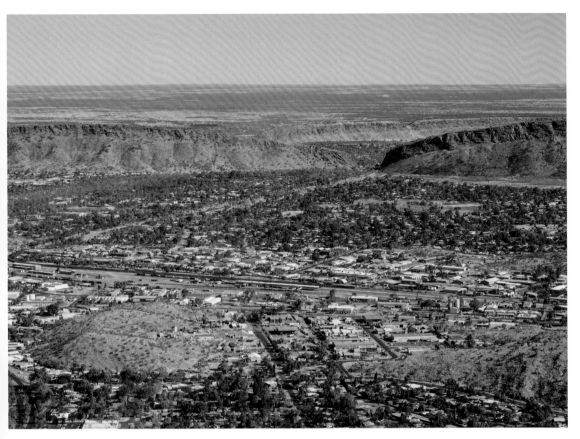

Alice Springs

Alice Springs

El Alice (como es conocido por sus amigos) es una ciudad clásica del Outback, aproximadamente equidistante entre Darwin y Adelaida y cerca del centro del continente. El río seco Todd atraviesa la ciudad, mientras que la cordillera MacDonnell teñida de rojo de Oeste y Este, se extiende a ambos lados de la ciudad. Aproximadamente uno de cada cinco habitantes de la localidad es indígena y, aunque se encuentra en el corazón del país tradicionalmente habitado por el pueblo Arrente, la población de la ciudad incluye aborígenes de todos los grupos indígenas del Territorio del Norte. Es la segunda ciudad más grande de dicho territorio después de Darwin.

Alice Springs

"The Alice" (come è nota a chi la conosce bene) è una classica città dell'outback, approssimativamente equidistante tra Darwin e Adelaide, vicina al centro del continente. Un fiume secco, il Todd, attraversa la città, mentre i Ranges MacDonnell a est e ovest si estendono su entrambi i lati della città. Circa un abitante su cinque qui è indigeno, e sebbene la città si trovi nel cuore della terra tradizionalmente abitata dal popolo Arrente, la popolazione cittadina include aborigeni provenienti da tutto il Territorio del Nord e vari gruppi indigeni. È la seconda città più grande del Territorio del Nord dopo Darwin.

Alice Springs

'The Alice' is een klassieke outbackstad, ongeveer halverwege Darwin en Adelaide en nabij het midden van het continent. De droge Todd River doorsnijdt de stad, terwijl de roodgekleurde West en East MacDonnell Ranges zich aan weerszijden van de stad uitstrekken. Ongeveer een op de vijf inwoners van de stad is inheems, en hoewel het in het hart van het land ligt dat traditioneel bewoond wordt door het Arrentevolk, omvat de bevolking van de stad Aboriginals uit de verschillende inheemse groepen uit het NorthernTerritory. Het is na Darwin de grootste stad van het Northern Territory.

Ormiston Creek, MacDonnell National Park

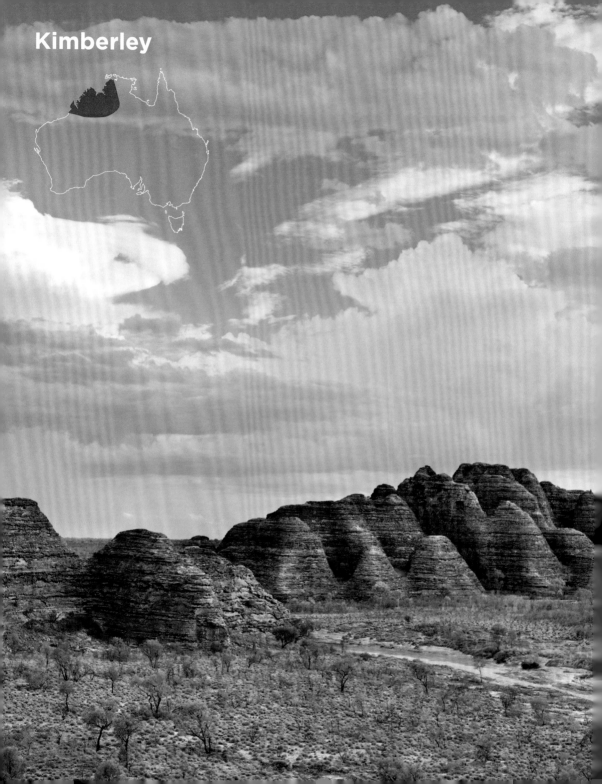

Kimberley

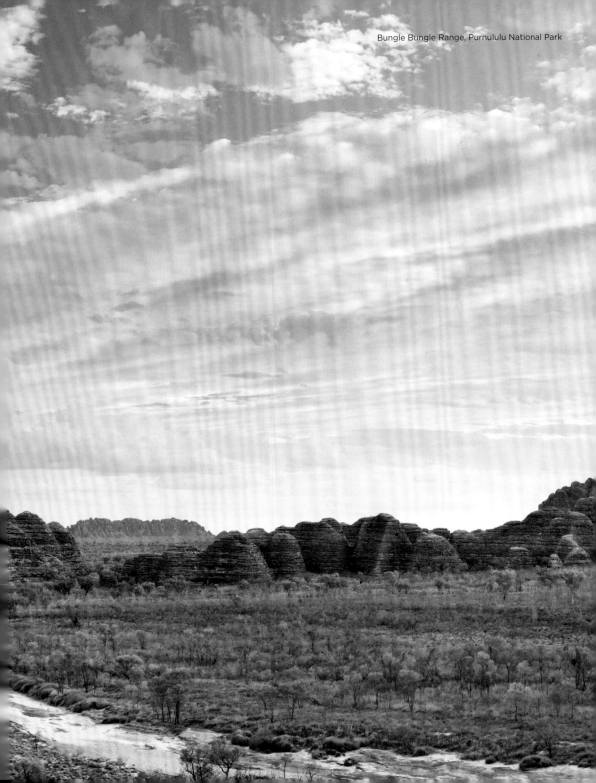

Bungle Bungle Range, Purnululu National Park

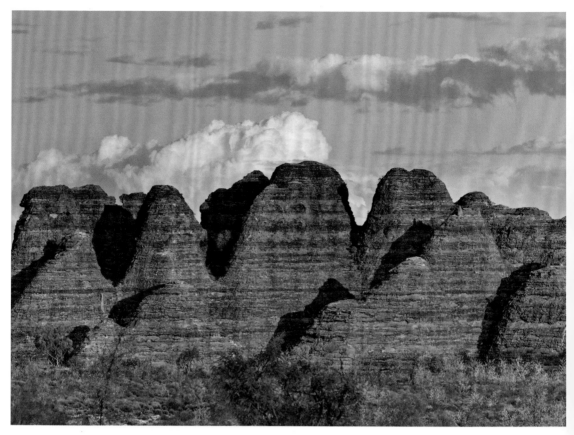

The Bungle Bungles, Purnululu National Park

Kimberley

Three times the size of England, this sparsely populated region takes in the entire northern tip of Western Australia. Pearling, diamond mining and agriculture are big industries, but much of the region remains pristine wilderness. Almost half of the population is of indigenous heritage and many continue to live 'on country'.

Kimberley

Trois fois plus grande que l'Angleterre, cette région peu peuplée englobe toute la pointe nord de l'Australie occidentale. La perle, l'extraction de diamants et l'agriculture y sont de grandes industries, mais une grande partie de la région demeure sauvage et intacte. Près de la moitié de la population est d'origine autochtone et nombre d'entre eux continuent de vivre dans leurs terres

Kimberley

Diese dünn besiedelte Region, dreimal so groß wie England, erstreckt sich über die gesamte Nordspitze Westaustraliens. Perlen, Diamantenabbau und Landwirtschaft sind die wichtigsten Industrien, aber ein Großteil der Region besteht aus unberührter Wildnis. Fast die Hälfte der Bevölkerung hat ein indigenes Erbe und viele leben weiterhin „auf dem Land".

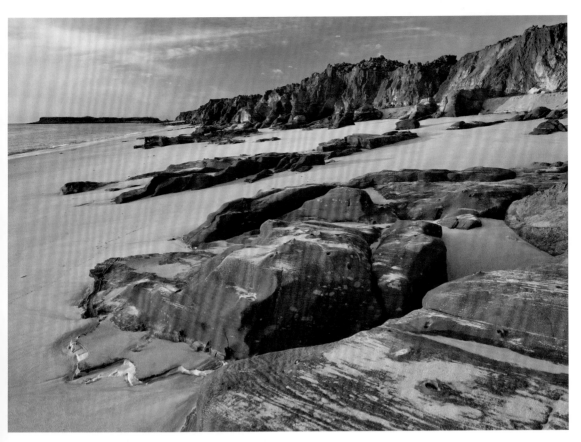

Red cliffs, Cape Leveque, Dampier Peninsula

Kimberley

Tres veces más grande que Inglaterra, esta región escasamente poblada abarca todo el extremo norte de Australia Occidental. El cultivo de perlas, la minería de diamantes y la agricultura son grandes industrias, pero gran parte de la región sigue siendo de una naturaleza prua. Casi la mitad de la población es de origen indígena y muchos siguen viviendo "en el campo".

Kimberley

Tre volte più grande dell'Inghilterra, questa regione scarsamente popolata comprende l'intera punta settentrionale dell'Australia Occidentale. La perlatura, l'estrazione dei diamanti e l'agricoltura sono i maggiori settori commerciali, ma gran parte della regione rimane incontaminata e selvaggia. Quasi la metà della popolazione è di origine indigena e molti continuano a vivere "in campagna".

Kimberley

Dit dunbevolkte gebied is drie keer zo groot als Engeland en beslaat de hele noordelijke punt van West-Australië. Parelduiken, diamantwinning en landbouw zijn grote industrieën, maar een groot deel de regio bestaat uit ongerepte wildernis. Bijna de helft van de bevolking is van inheemse afkomst en velen wonen nog steeds 'op het land'.

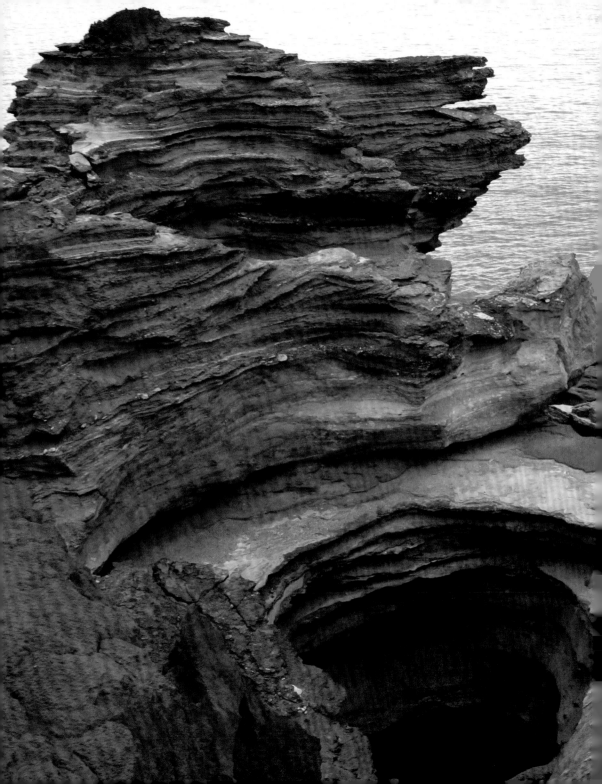

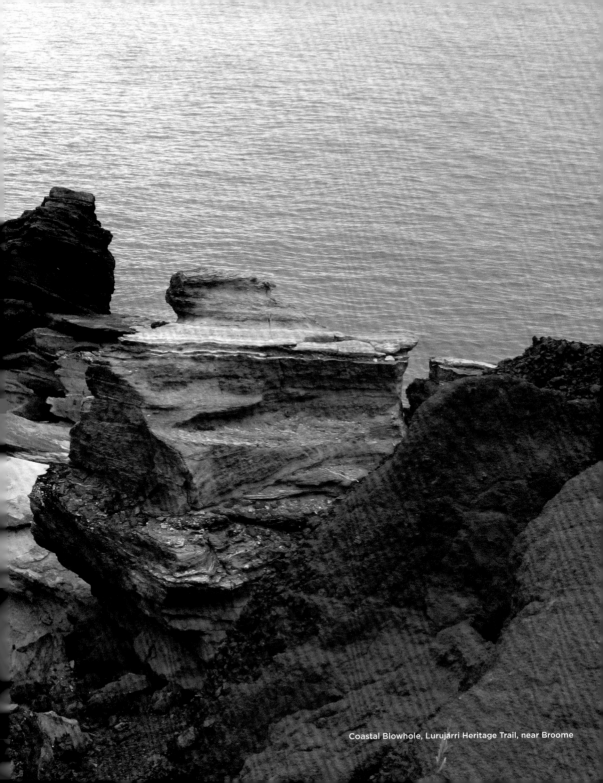

Coastal Blowhole, Lurujarri Heritage Trail, near Broome

Dampier Peninsula

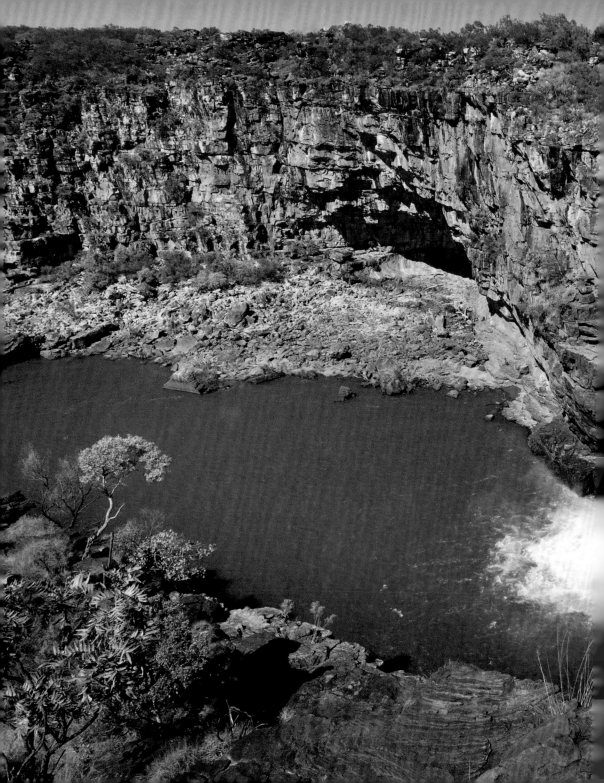

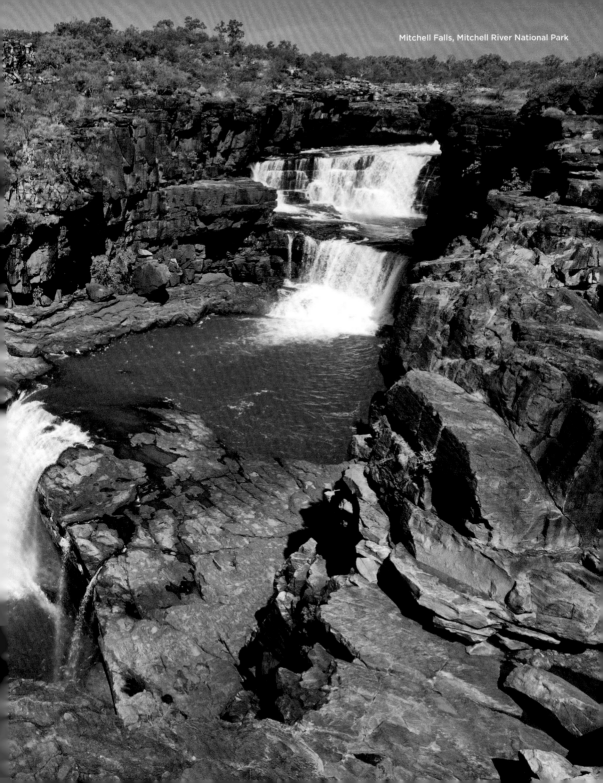

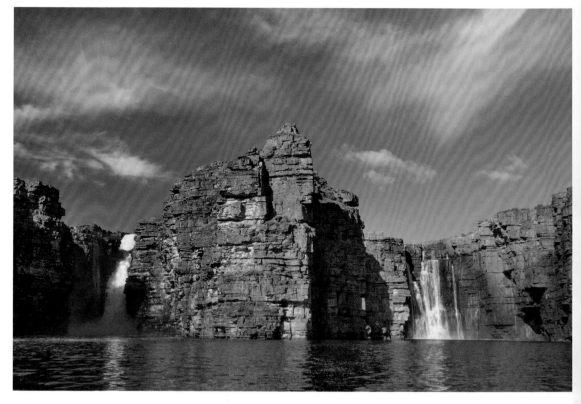

King George Falls

King George Falls

Dropping for around 50 m from 100 m sandstone cliffs, these remote twin waterfalls are the state's highest. The falls can only be accessed by boat or plane and are at their most majestic during 'the wet', from late December through to early May. The local Balanggarra people believe the falls are the male and female Wunkurr (rainbow serpents).

King George Falls

Con un desnivel de unos 50 m desde acantilados de arenisca de 100 m, estas remotas cascadas gemelas son las más altas del Estado. Sólo se puede acceder a las cataratas en barco o en avión y son más majestuosas durante la temporada de "lluvia", desde finales de diciembre hasta principios de mayo. La gente local, losBalanggarra, cree que en las cataratas se encarnan los Wunkurr (serpientes arco iris).

Chutes King George

S'étirant sur une cinquantaine de mètres en haut de falaises de grès de 100 m, ces cascades jumelles reculées sont les plus hautes de l'état. Les chutes ne sont accessibles que par bateau ou par avion et sont encore plus majestueuses pendant la saison des pluies, de fin décembre à début mai. Les habitants de Balanggarra considèrent les chutes comme des Wunkurr (serpents arc-en-ciel) mâles et femelles.

King George Falls

Con il loro salto di circa 50 m da una scogliera in pietra arenaria di 100 m, queste due cascate gemelle remote sono le più alte dello stato. Le cascate sono accessibili solo in barca o in aereo e sono al massimo della loro maestosità durante la stagione delle piogge, da fine dicembre fino all'inizio di maggio. Il popolo Balanggarra crede che le cascate siano il "wunkurr" maschio e femmina, il serpente arcobaleno da loro venerato.

King George Falls

Die abgelegenen Zwillingswasserfälle, die etwa 50 m von 100 m hohen Sandsteinfelsen fallen, sind die höchsten des Staates. Die Wasserfälle können nur mit dem Boot oder Flugzeug erreicht werden und sind am majestätischsten während der Regenzeit, von Ende Dezember bis Anfang Mai. Das ansässige Volk der Balanggarra glaubt, dass sie die männlichen und weiblichen Wungkurr (Regenbogenschlangen) sind.

King George Falls

Deze afgelegen tweelingwatervallen, die circa 50 m naar beneden storten vanaf 100 m hoge zandstenen klippen, zijn de hoogste van de staat. Ze zijn alleen per boot of vliegtuig te bereiken en zijn het imposantst in de 'natte' periode, van eind december tot begin mei. De lokale Balanggarra geloven dat de watervallen de mannelijke en vrouwelijke Wunkurr (regenboogslangen) zijn.

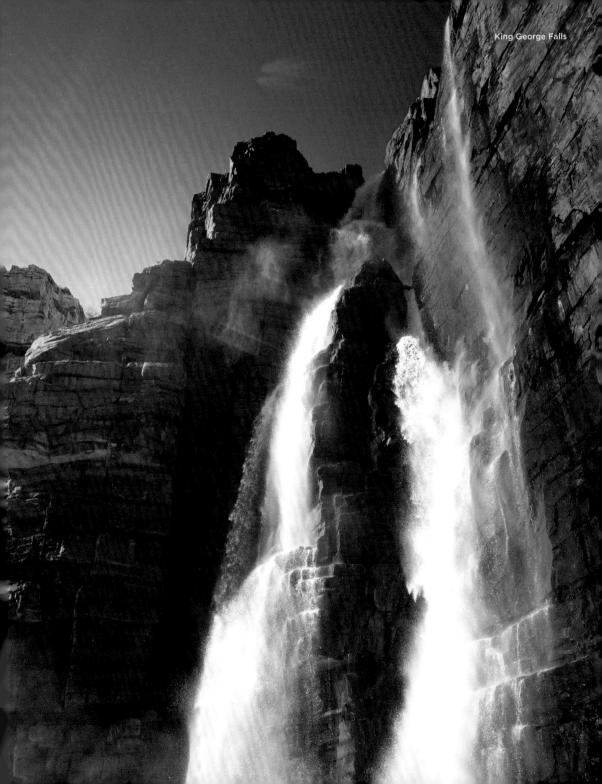
King George Falls

Deadly Animals

Most of the world's most poisonous snakes live in Australia, including the world's most deadly, the inland taipan, with a bite that could kill several adults. Human's nervous systems are exquisitely vulnerable to the funnel web spider's toxins (luckily, an anti-venom has been around for 30 years). Paralysis in minutes, death in 30? That's the blue ring octopus, with a couple of yearly fatalities. A swipe with the tentacles of the box jellyfish or its tiny cousin, the Irukandji, causes severe pain, nausea, vomiting, profuse sweating and agitation (and CPR for survival). Great white sharks and bull sharks also routinely kill or maim, as does the saltwater crocodile.

FUNNEL-WEB SPIDER (*ATRAX ROBUSTUS*)

Animaux mortels

La majorité des serpents les plus venimeux du monde vivent en Australie, y compris le plus mortel, le taipan du désert. L'homme est également vulnérable aux toxines de l'araignée à toile-entonnoir (heureusement, un anti-venin existe depuis 30 ans). Paralysie en quelques minutes, mort en 30 minutes ? C'est l'œuvre de la pieuvre à anneaux bleus, qui tue plusieurs personnes par an. Une piqûre causée par les tentacules de la méduse ou de son minuscule cousin, l'irukandji, provoque des douleurs intenses, des nausées, des vomissements, une transpiration abondante et une agitation (une réanimation cardiaque est nécessaire pour survivre). Les grands requins blancs et les requins-bouledogues tuent ou mutilent aussi régulièrement, tout comme les crocodiles d'eau salée.

Tödliche Tiere

Die giftigsten Schlangen der Welt leben in Australien, darunter die tödlichste, der Taipan: mit einem Biss könnte er mehrere Erwachsene töten. Das Nervensystem des Menschen ist äußerst anfällig für das Gift der Trichternetzspinne (für das es seit 30 Jahren ein Gegengift gibt). Lähmung nach wenigen Minuten, Tod nach 30 Minuten: Das bewirkt die Blaugeringelte Krake, was jährlich zu einigen Todesfällen führt. Ein Streichen mit den Tentakeln der Würfelqualle verursacht starke Schmerzen, Übelkeit, Erbrechen, starkes Schwitzen und Unruhe. Große Weißhaie und Bullenhaie töten oder verstümmeln ebenfalls routinemäßig, wie auch das Leistenkrokodil.

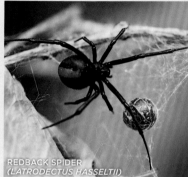

REDBACK SPIDER (*LATRODECTUS HASSELTII*)

Animales Mortales

La mayoría de las serpientes más venenosas del mundo viven en Australia, incluyendo la más mortal del mundo, el taipán del interior, con una mordedura que podría matar a varios adultos. El sistema nervioso humano es tremendamente vulnerable a las toxinas de la araña embudo (afortunadamente, existe un antídoto desde hace 30 años). El pulpo del anillo azul puede causar parálisis en unos minutos y la muerte en madia hora, de hecho, provoca un par de muertes anuales. Un golpe con los tentáculos de la medusa caja o de su prima pequeña, la medusa Irukandji causa dolor intenso, náuseas, vómitos, sudoración profusa y agitación (y reanimación cardiopulmonar para sobrevivir). Los tiburones blancos y los tiburones toro también matan o mutilan a menudo, al igual que el cocodrilo de agua salada.

Animali mortali

Il maggior numero di serpenti più velenosi al mondo vive in Australia, compreso il più letale al mondo, il taipan dell'interno, con un morso che potrebbe uccidere diversi adulti. Il sistema nervoso dell'uomo è molto vulnerabile alle tossine del ragno dalla tela a imbuto (per fortuna un antidoto al veleno esiste da circa 30 anni). Paralisi in pochi minuti, morte in 30 minuti? È il polpo dagli anelli blu, che fa un paio di vittime all'anno. Una strisciata con i tentacoli della medusa cubo o del suo piccolo cugino, la medusa Irukandji, causa forti dolori, nausea, vomito, abbondante sudorazione e tachicardia (e necessita di una rianimazione cardio-polmonare per poter sopravvivere). Anche i grandi squali bianchi e gli squali toro uccidono o mutilano di routine, così come il coccodrillo marino.

Dodelijke dieren

De meeste van 's werelds giftigste slangen leven in Australië, waaronder de dodelijkste ter wereld, de inlandtaipan, met een beet die meerdere volwassenen kan doden. Het zenuwstelsel van de mens is uiterst gevoelig voor de giftige stoffen van de Australische tunnelwebspin (gelukkig is er al 30 jaar een antigif aanwezig). Verlamming binnen minuten, dood na 30 minuten: dat veroorzaakt de blauwgeringde octopus, die jaarlijks een paar dodelijk slachtoffers maakt. Eén veeg met de tentakels van de kubuskwal of zijn kleine neefje, de irukandji, veroorzaakt ernstige pijn, misselijkheid, braken, hevig zweten en opwinding. Grote witte haaien en stierhaaien doden of verminken ook routinematig, net als de zeekrokodil.

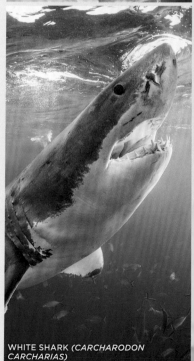

WHITE SHARK (*CARCHARODON CARCHARIAS*)

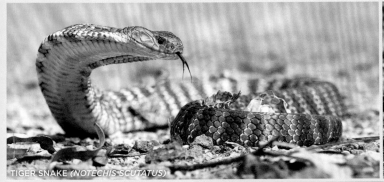
TIGER SNAKE *(NOTECHIS SCUTATUS)*

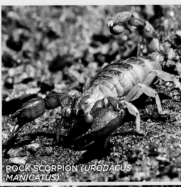
ROCK SCORPION *(URODACUS MANICATUS)*

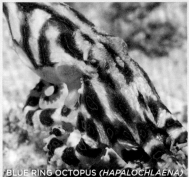
BLUE RING OCTOPUS *(HAPALOCHLAENA)*

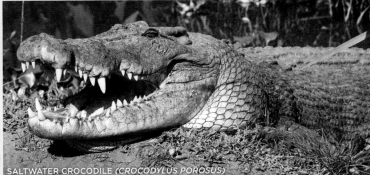
SALTWATER CROCODILE *(CROCODYLUS POROSUS)*

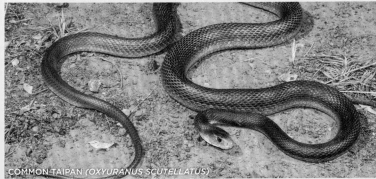
COMMON TAIPAN *(OXYURANUS SCUTELLATUS)*

REEF STONEFISH *(SYNANCEIA VERRUCOSA)*

WOLF SPIDER *(VENATRIX SP)*

SEA WASP *(CHIRONEX FLECKERI)*

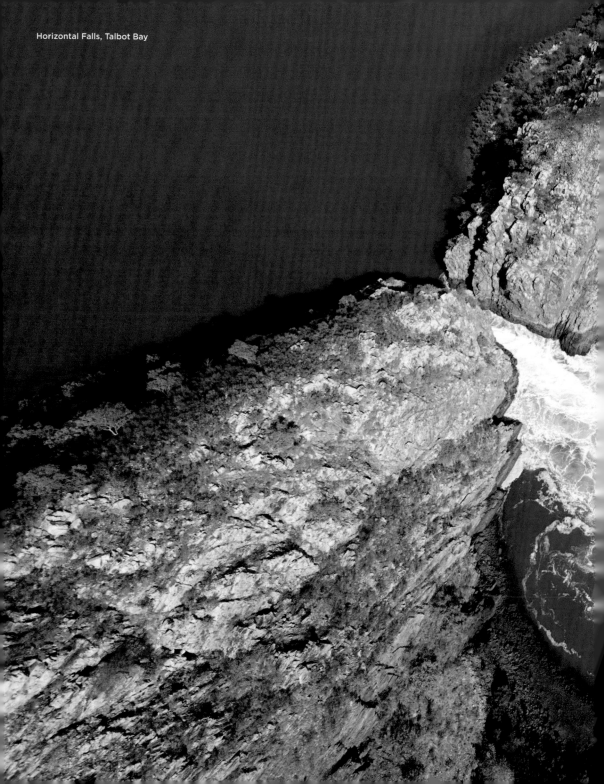

Horizontal Falls, Talbot Bay

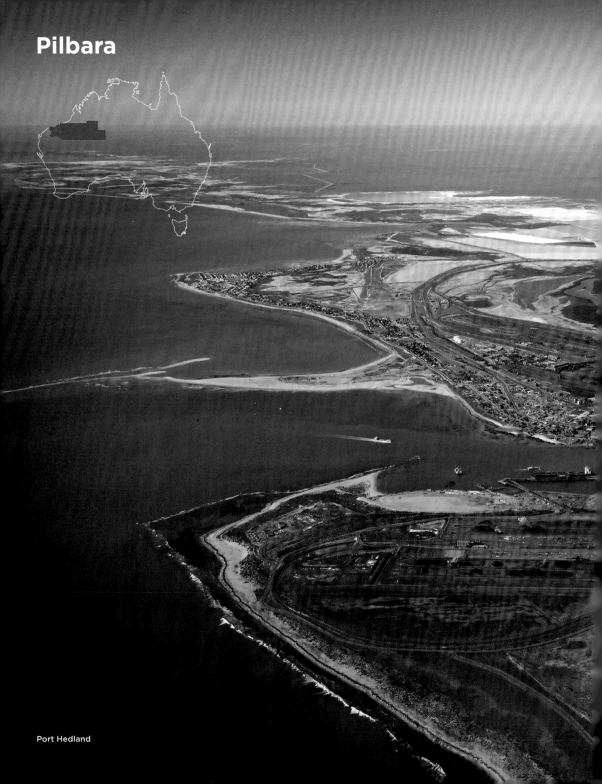

Pilbara

Port Hedland

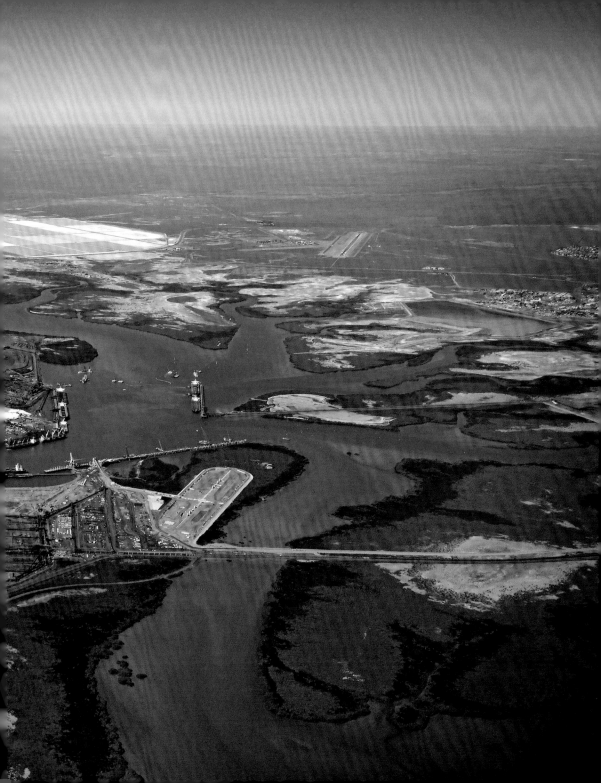

Galahs *(Eolophus roseicapillus)*

Pilbara

Larger in size than California, the Pilbara, which covers more than 507,000 km^2, is home to fewer than 50,000 people; if you took out the coastal mining feeder towns of Port Hedland, Karratha, Marble Bar, Wickham and Newman, there would be scarcely anyone here at all. A coastal sand plain extends inland from the coast, and this is where most of the towns are found. Further inland, the uplands are home to the Pilbara's famous iron-ore mines, while the eastern third is almost arid and barely inhabitable; historically, Indigenous peoples lived a nomadic lifestyle in this interior region, although those that remain live in small, remote settlements.

Pilbara

Plus grand que la Californie, le Pilbara, qui couvre plus de 507 000 km^2, abrite moins de 50 000 habitants ; si l'on exclut les villes côtières de Port Hedland, Karratha, Marble Bar, Wickham et Newman, il ne reste pratiquement personne ici. Une plaine sablonneuse côtière s'étend à l'intérieur des terres à partir de la côte, et c'est là que se trouvent la plupart des agglomérations. Plus à l'intérieur, les hautes terres abritent les célèbres mines de minerai de fer de Pilbara, tandis que le tiers oriental est presque aride et à peine habitable ; historiquement, les peuples autochtones ont vécu comme nomades dans cette région intérieure, mais ceux qui restent vivent aujourd'hui dans de petits villages isolés.

Pilbara

Obwohl die Region mit ihren mehr als 507 000 km^2 größer als Kalifornien ist, leben hier weniger als 50 000 Menschen; rechnete man die Küstenförderstädte heraus, würde hier kaum jemand leben. Eine Sandebene erstreckt sich von der Küste, wo die meisten Städte liegen, bis ins Landesinnere. Im Hochland finden sich die berühmten Eisenerzminen der Pilbara, während das östliche Drittel fast trocken und kaum bewohnbar ist; historisch gesehen lebten die indigenen Völker in dieser Innenregion einen nomadischen Lebensstil, doch leben die noch übrig gebliebenen heute in kleinen, abgelegenen Siedlungen.

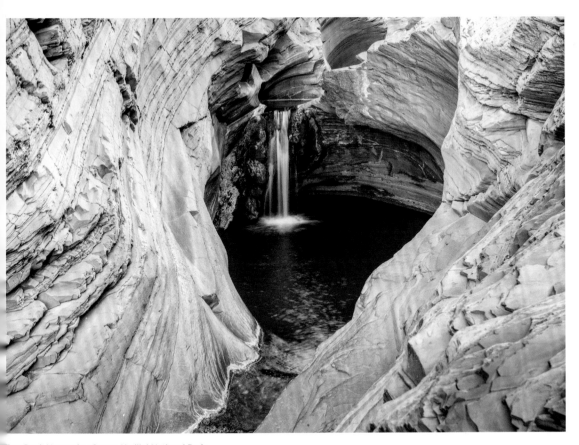

Spa Pool, Hamersley Gorge, Karijini National Park

Pilbara

Más grande que California, Pilbara, que se extiende más de 507.000 km², tiene menos de 50.000 habitantes; si se eliminan las ciudades mineras costeras de Port Hedland, Karratha, Marble Bar, Wickham y Newman, casi estaría desierto, pero en la llanura costera de arena se extiende hacia el interior desde la costaes donde se encuentran la mayoría de los pueblos. Más hacia el interior, las tierras altas albergan las famosas minas de hierro de Pilbara, mientras que el tercio oriental es casi árido y apenas habitable; históricamente, los pueblos indígenas vivieron un estilo de vida nómada en esta región interior, aunque los que quedan viven en pequeños y remotos asentamientos.

Pilbara

Più grande della California, il Pilbara, che copre più di 507.000 km², ospita meno di 50.000 persone; se si togliessero le città minerarie costiere di Port Hedland, Karratha, Marble Bar, Wickham e Newman, qui non vivrebbe quasi nessuno. Una pianura sabbiosa si estende lungo la costa verso l'interno, ed è qui che si trova la maggior parte delle città. Più all'interno, gli altipiani ospitano le famose miniere di ferro del Pilbara, mentre la parte più orientale, che si estende su circa un terzo della regione, è quasi del tutto arida e poco abitabile. Nel passato, le popolazioni indigene hanno seguito uno stile di vita nomade in questa regione dell'interno, anche se quelle che rimangono vivono in insediamenti piccoli e remoti.

Pilbara

Hoewel deze regio met ruim 507.000 km² groter is dan Californië, wonen hier minder dan 50.000 mensen. Als je de kustplaatsen Port Hedland, Karratha, Marble Bar, Wickham en Newman eruit zou halen, zou hier praktisch niemand wonen. Een zandvlakte strekt zich uit van de kust naar het binnenland. Landinwaarts herbergt het hoogland de beroemde ijzerertsmijnen van de Pilbara, terwijl het oostelijke derde deel bijna droog en nauwelijks bewoonbaar is. Van oudsher hadden de inheemse volken een nomadische levensstijl in deze binnenlanden, maar nu wonen ze in kleine, afgelegen nederzettingen.

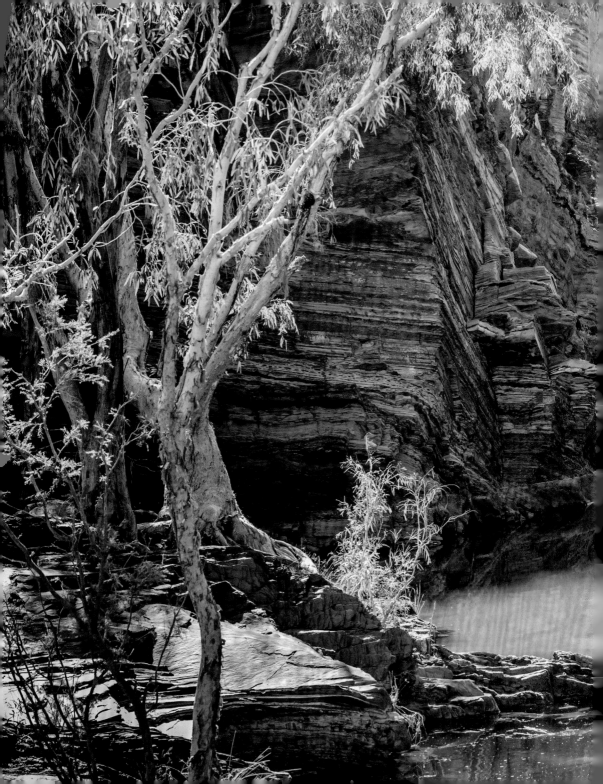

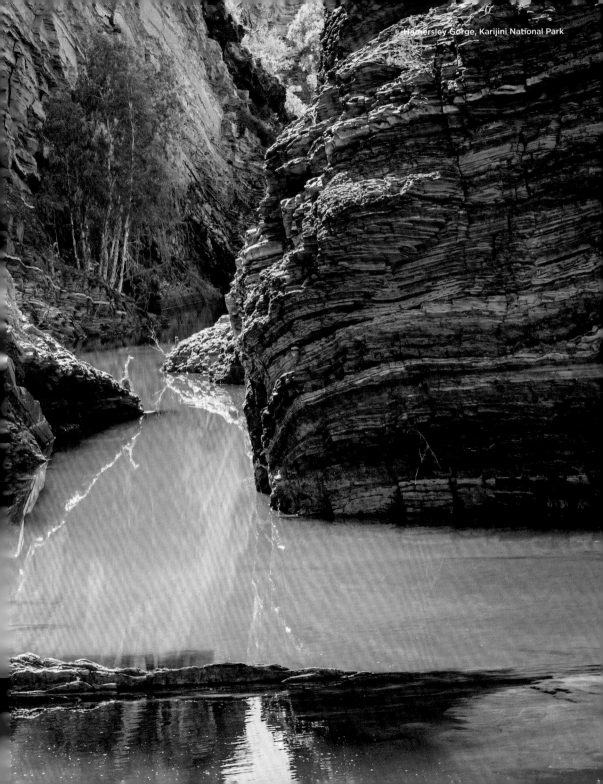

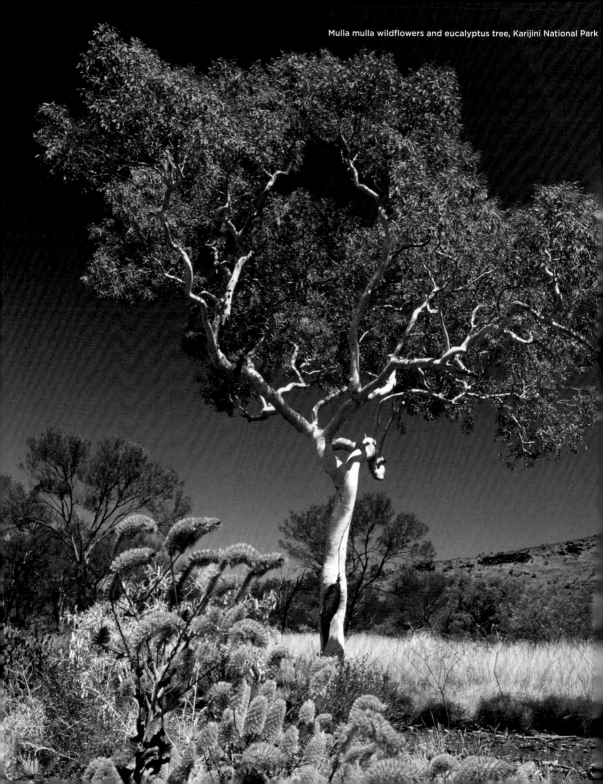

Pink mulla mulla (*Ptilotus exaltatus*)

Karijini National Park

Pilbara wildflowers flourish in the park, especially after the yearly rains. Yellow-flowering wattles (mimosa) and cassias, pink and mauve mulla-mullas and native bluebells appear in the cooler months. Termite mounds and the rock piles of the pebble mound mouse dot spinifex country while bats, red kangaroos, echidnas and reptiles are abundant.

Parque Nacional Karijini

Las flores silvestres de Pilbara florecen en el parque, especialmente después de las lluvias anuales. Las mimosas, las casias, las mullas mullas rosadas y malvas y las campanillas autóctonas aparecen en los meses más fríos. Los termiteros y los tumultos de guijarros conforman el paisaje cubierto de spinifex, mientras que los murciélagos, canguros rojos, equidnas y reptiles son abundantes.

Parc national de Karijini

Les fleurs sauvages de Pilbara prospèrent dans le parc, surtout après les pluies annuelles. Les caroncules à fleurs jaunes (mimosa) et les cassias, les mullas mullas roses et mauves et les jacinthes indigènes apparaissent dans les mois les plus frais. Les termitières, les amas de cailloux des souris à galets et les pousses de spinifex parsèment ce territoire abondamment habité par les chauves-souris, les kangourous rouges, les échidnés et les reptiles.

Parco Nazionale di Karijini

I fiori selvatici di Pilbara fioriscono nel parco specialmente dopo le piogge annuali. Nei mesi più freddi compaiono mimose e cassie, mulla-mulla rosa e malva e campanule autoctone. Tumuli di termiti e cumuli di rocce del topo dei tumuli di ghiaia fanno capolino tra gli spinifex, mentre pipistrelli, canguri rossi, echidne e rettili abbondano ovunque.

Karijini-Nationalpark

Pilbara-Wildblumen gedeihen im Park, besonders nach den jährlichen Regenfällen. Gelb blühende Akazien und Cassia, rosa und lilafarbener Australischer Federbusch und Blauglockenbäume blühen in den kühleren Monaten. Es gibt eine üppige Population von Fledermäusen, roten Kängurus, Ameisenigeln und Reptilien.

Nationaal Park Karijini

Wilde bloemen bloeien in dit nationale park, vooral na de jaarlijkse regenbuien. In de koelere maanden verschijnen geelbloeiende acacia's en cassia's, roze en lila *Pilotus exaltus* en blauwe wilde hyacinten. Vleermuizen, rode reuzenkangoeroes, mierenegels en reptielen zijn in overvloed aanwezig, evenals termietenheuvels.

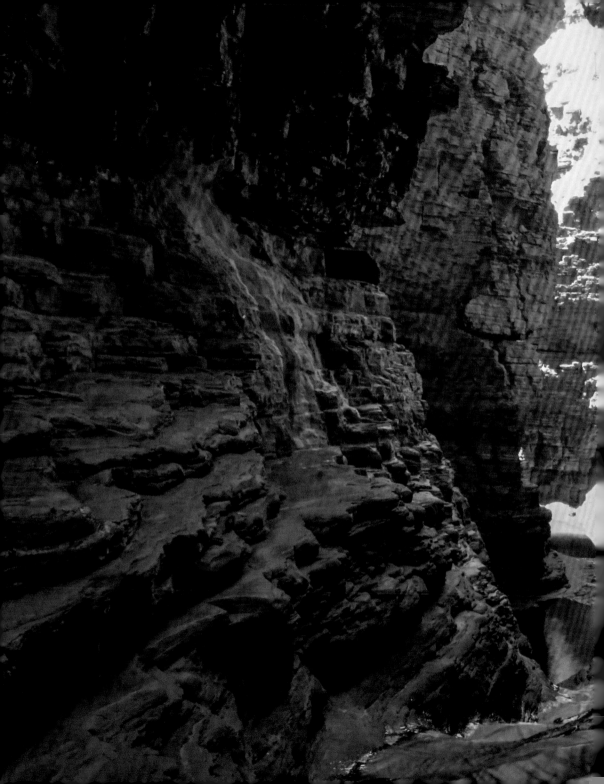

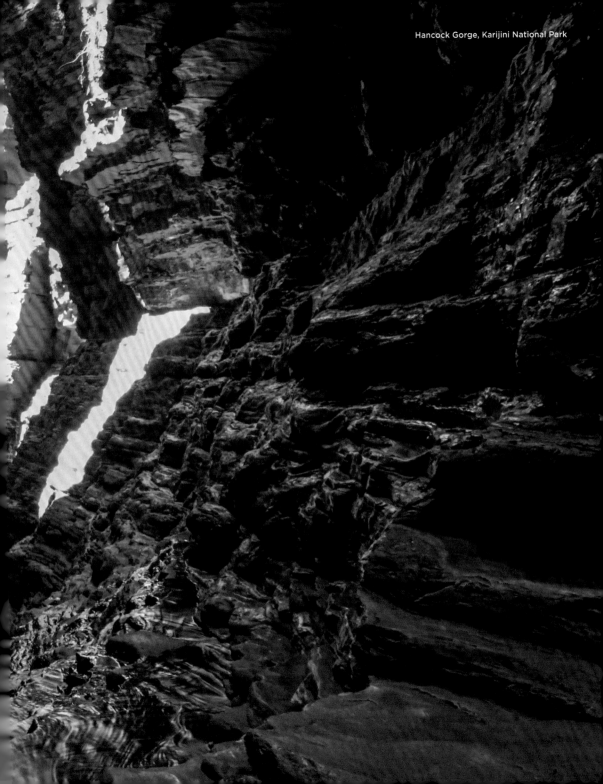

Hancock Gorge, Karijini National Park

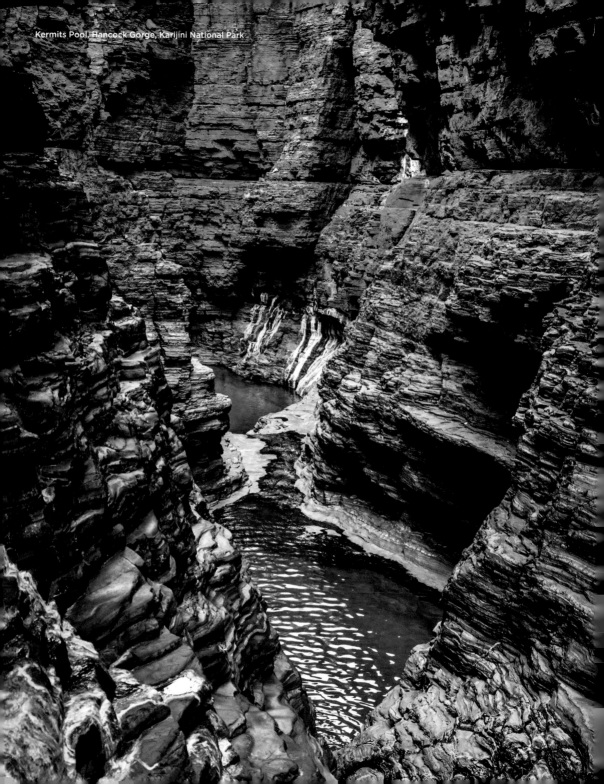

Kermits Pool, Hancock Gorge, Karijini National Park

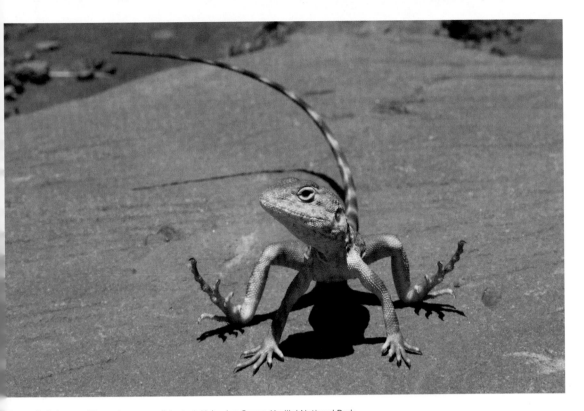

Ring-tailed dragon *(Ctenophorus caudicinctus)*, Kalamina Gorge, Karijini National Park

Karijini National Park

The extraordinary gorges and rockpools of Karijini dissect the red terraces of a high plateau in a series of streams, pools, waterfalls, slot canyons and deep water holes. Ancient rocks, some of the oldest on the planet, surround sheer-sided chasms up to 100 m deep. While some of the gorges are easily accessible, many require high levels of fitness.

Parc national de Karajini

Les extraordinaires gorges et piscines naturelles de Karijini découpent les terrasses rouges de ce haut plateau en une série de ruisseaux, de mares, de cascades, de canyons et de trous d'eau profonds. Des roches anciennes, parmi les plus âgées de la planète, entourent des gouffres aux parois abruptes atteignant 100 m de profondeur. Bien que certaines soient facilement accessibles, beaucoup d'entre elles exigent pour les visiter une bonne condition physique.

Karijini-Nationalpark

Die außergewöhnlichen Schluchten von Karijini teilen die roten Terrassen des Hochplateaus in eine Reihe von Bächen, Pools, Wasserfällen, Schlitzschluchten und tiefen Wasserlöchern. Alte Felsen, einige der ältesten auf dem Planeten, umgeben 100 m tiefen Schluchten. Während einige der Schluchten leicht zugänglich sind, erfordern viele ein hohes Maß an Fitness.

Parque Nacional Karajini

Las extraordinarias gargantas y pozas de Karijini atraviesan las terrazas rojas de una meseta alta formando de arroyos, pozas, cascadas, cañones de ranura y pozas profundas. Antiguas rocas, algunas de las más antiguas del planeta, rodean simas de hasta 100 m de profundidad. Aunque algunas de las gargantas son de fácil acceso, muchas requieren un alto nivel de forma física.

Parco Nazionale di Karijini

Le straordinarie gole e le piscine rocciose di Karijini suddividono le terrazze rosse di un altopiano in una serie di ruscelli, piscine naturali, cascate, canyon e buche d'acqua profonda. Le rocce, alcune tra le più antiche del pianeta, circondano voragini a strapiombo che scendono fino a 100 m di profondità. Mentre alcune delle gole sono facilmente accessibili, molte richiedono alti livelli di fitness.

Nationaal Park Karijini

De buitengewone kloven en rotspoelen van Karijini ontleden de rode hoogvlakteterrassen in een reeks beken, poelen, watervallen, canyons en diepe watergaten. Oude rotsen, enkele van de oudste ter wereld, omringen steile kloven tot 100 m diep. Hoewel sommige gemakkelijk bereikbaar zijn, vereisen veel kloven een goede conditie.

Citcular Pool, Dales Gorge, Karijini National Park

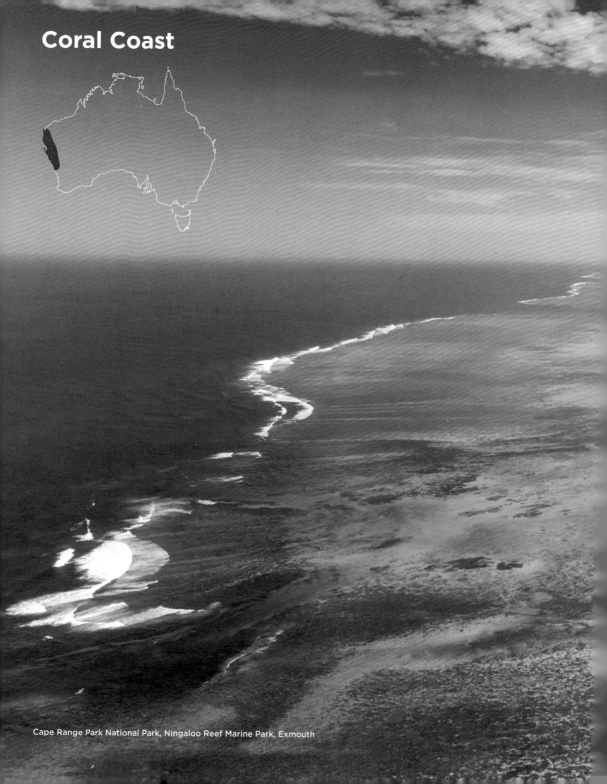

Coral Coast

Cape Range Park National Park, Ningaloo Reef Marine Park, Exmouth

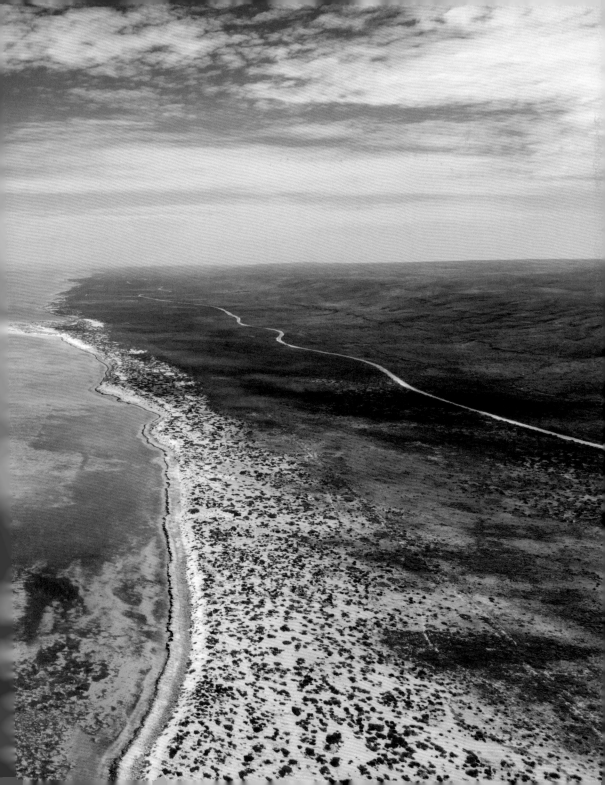

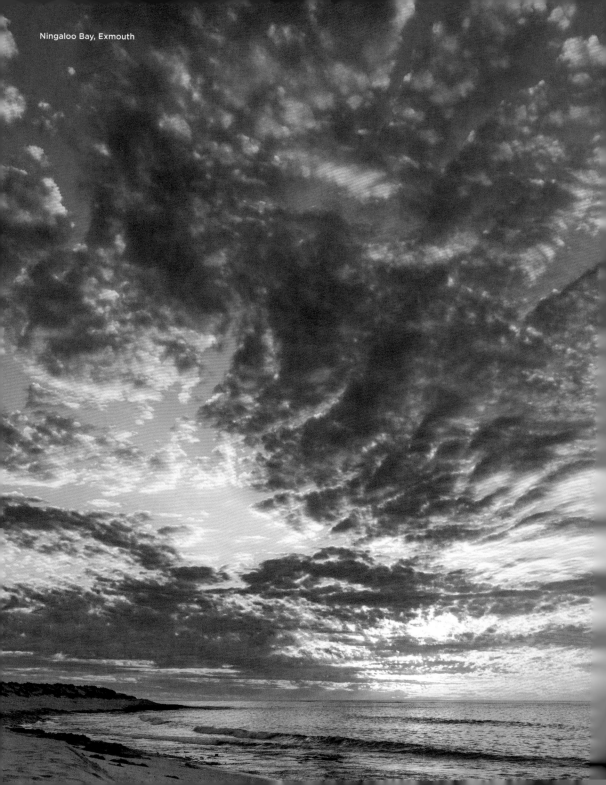
Ningaloo Bay, Exmouth

Ningaloo Coast

Coral Coast

The shallow, tranquil waters of the Ningaloo Coast are an underwater wonderland for divers and snorkelers. Protected by the world's largest fringing reef, turtles, tropical fish, rays, humpback whales and shy whale sharks congregating in its wild bays, beaches and lagoons. There's also desert national parks and a surprising wildflower trail.

Coral Coast

Las aguas tranquilas y poco profundas de la costa de Ningaloo son una maravilla submarina para buzos y esnorquelistas. La zona está protegida por el arrecife más grande del mundo; tortugas, peces tropicales, rayas, ballenas jorobadas y tímidos tiburones ballena se congregan en sus bahías, playas y lagunas salvajes. También hay parques nacionales desérticos y un sorprendente sendero de flores silvestres.

Côte de corail

Les eaux tranquilles et peu profondes de la côte de Ningaloo sont une merveille sous-marine pour les plongeurs et les snorkelleurs. Protégés par le plus grand récif frangeant du monde, les tortues, les poissons tropicaux, les raies, les baleines à bosse et les requins baleines timides se rassemblent dans ses baies, plages et lagons sauvages. On trouve également dans la région des parcs nationaux désertiques et un surprenant sentier de fleurs sauvages.

Coral Coast

Le acque poco profonde e tranquille della costa di Ningaloo sono un vero e proprio paese delle meraviglie sottomarine per i subacquei e gli amanti dello snorkeling. Protetti dalla più grande barriera corallina del mondo, tartarughe, pesci tropicali, razze, megattere e timidi squali balena si riuniscono nelle sue baie selvagge, spiagge e lagune. Ci sono anche parchi nazionali desertici e un sorprendente sentiero di fiori selvatici.

Coral Coast

Die flachen, ruhigen Gewässer der Ningaloo Coast sind ein Unterwasser-Wunderland für Taucher und Schnorchler. Geschützt durch das größte Saumriff der Welt, sammeln sich hier Schildkröten, tropische Fische, Rochen, Buckelwale und scheue Walhaie in wilden Buchten, Stränden und Lagunen. Es gibt auch Wüsten-Nationalparks und einen überraschenden Wildblumenpfad.

Coral Coast

De ondiepe, rustige wateren van de Ningaloo Coast zijn een onderwaterparadijs voor duikers en snorkelaars. Beschermd door 's werelds grootste franjerif komen in de wilde baaien, op de stranden en in lagunes schildpadden, tropische vissen, roggen, bultruggen en schuwe walvishaaien samen. Er zijn ook beschermde woestijngebieden en een verrassend wildebloemenpad.

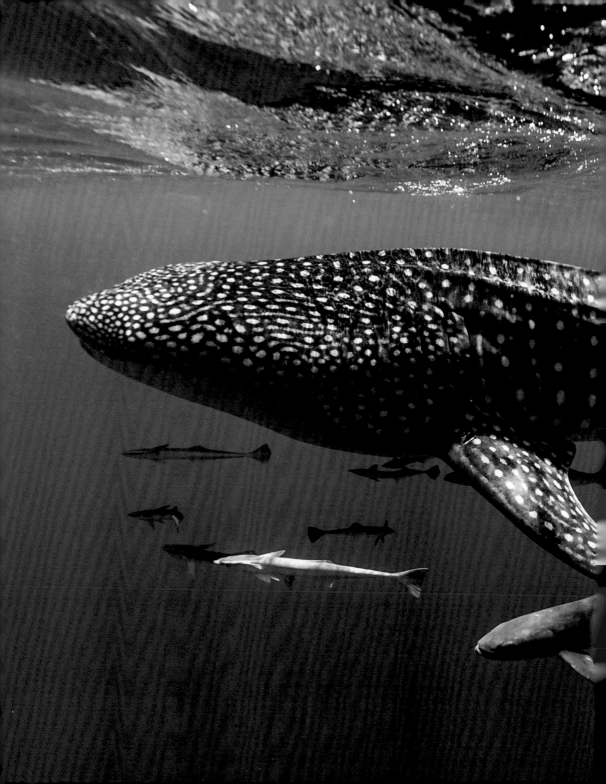

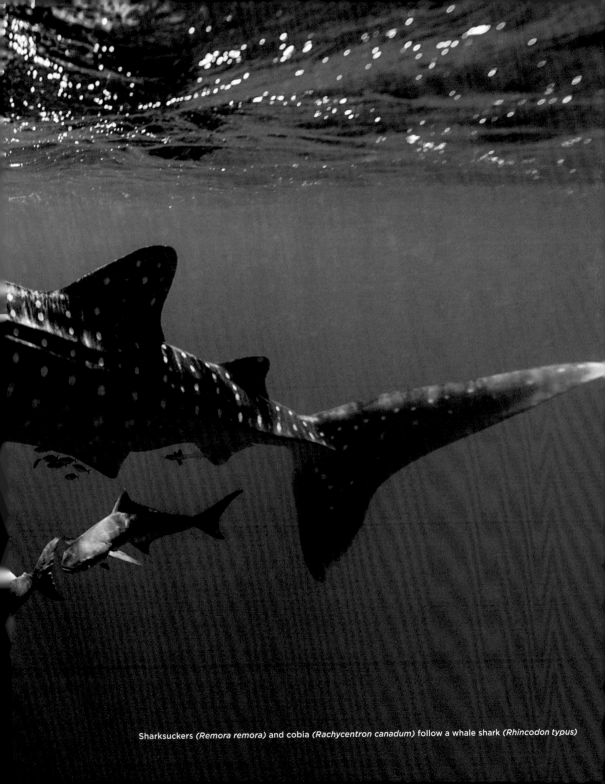

Sharksuckers *(Remora remora)* and cobia *(Rachycentron canadum)* follow a whale shark *(Rhincodon typus)*

Francois Peron National Park

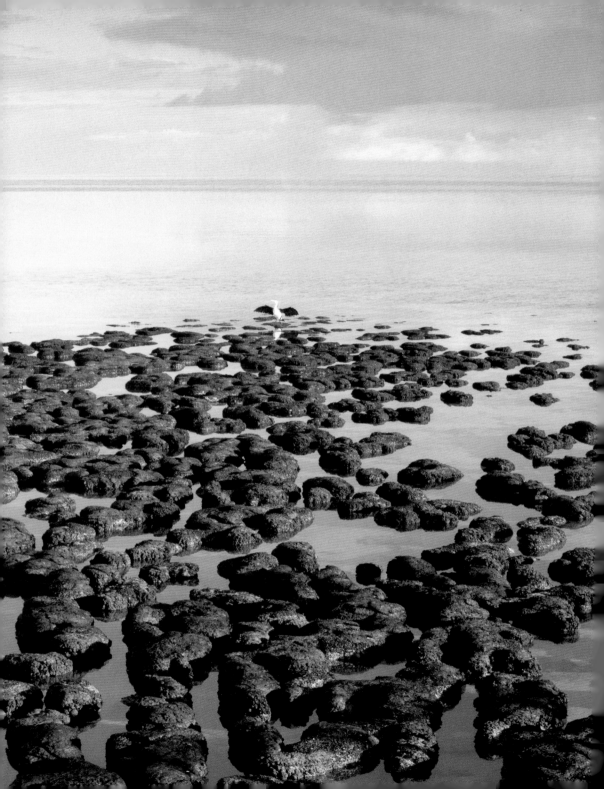

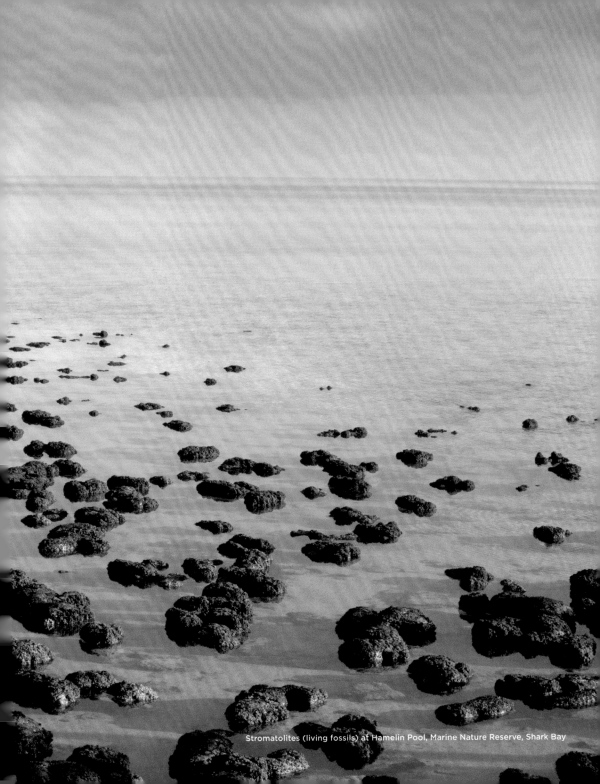

Stromatolites (living fossils) at Hamelin Pool, Marine Nature Reserve, Shark Bay

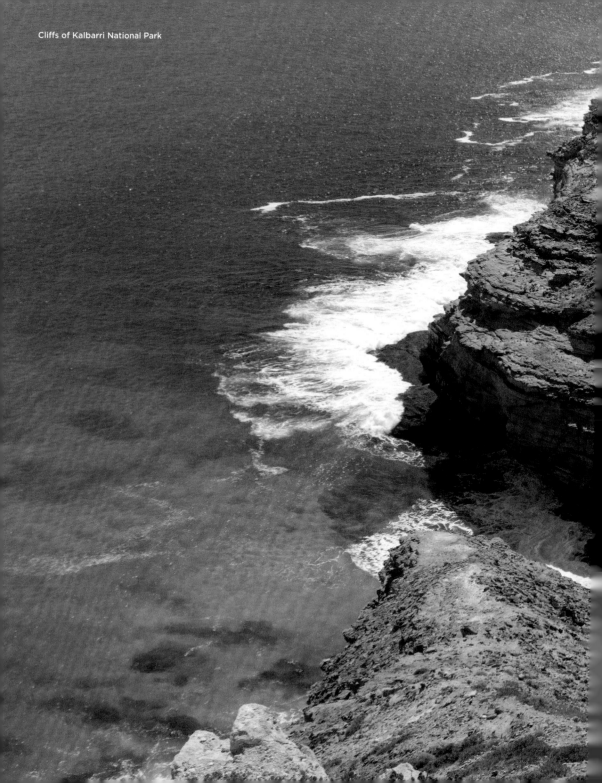

Cliffs of Kalbarri National Park

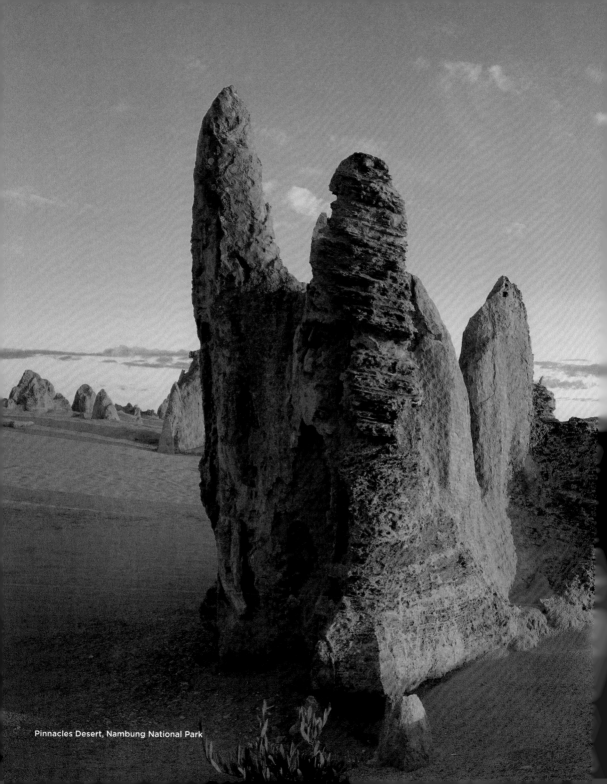

Pinnacles Desert, Nambung National Park

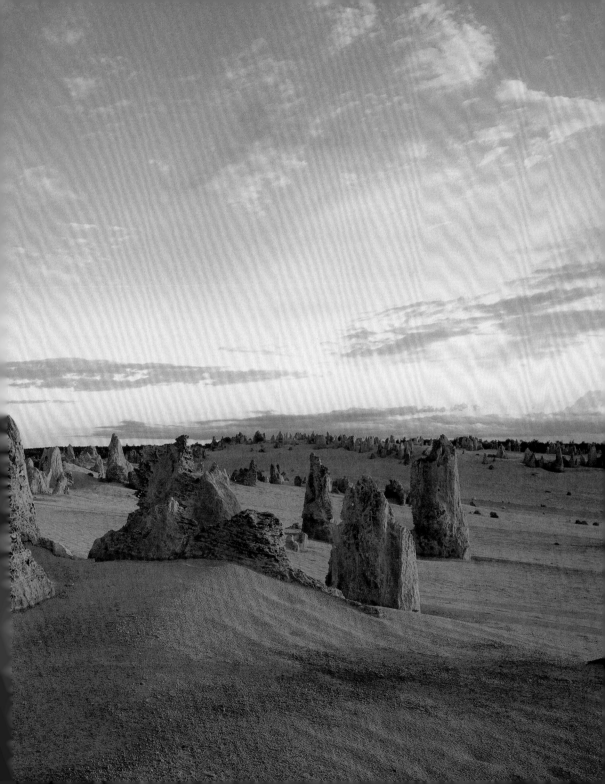

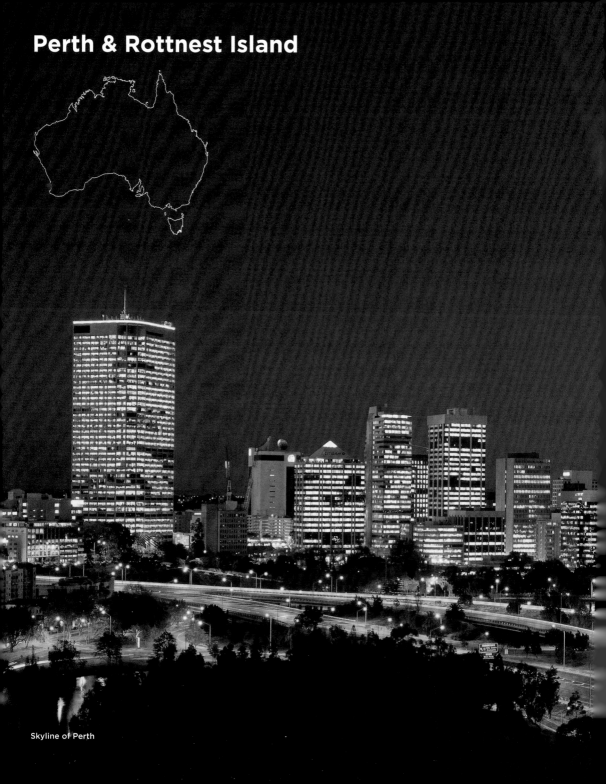

Perth & Rottnest Island

Skyline of Perth

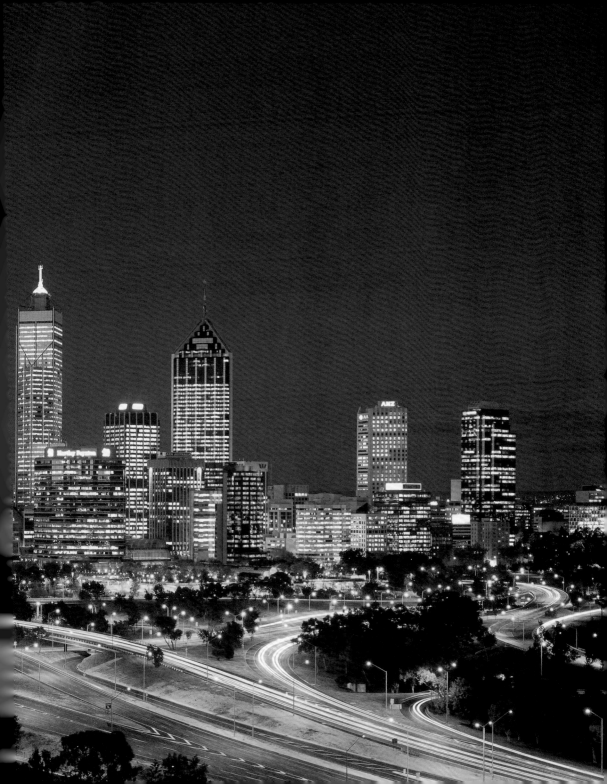

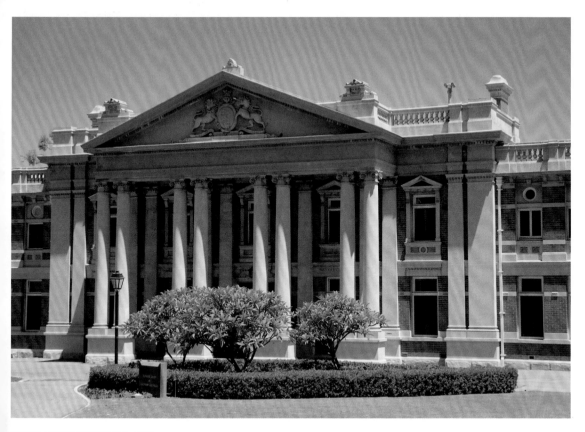

Supreme Court of Western Australia

Perth & Rottnest Island
Perth, named after Perth in Scotland, is Australia's fourth most populous city with a little over two million people. Founded in 1829, it has, for much of its history, been enriched by the numerous mining operations elsewhere in Western Australia, most notably the Kalgoorlie gold rush in the late 19th century and the late-20th-century minerals boom.

Perth & Rottnest Island
Perth, homónima de la localidad escocesa, es la cuarta ciudad más poblada de Australia, con poco más de dos millones de habitantes. Fundada en 1829, durante gran parte de su historia se ha enriquecido con las numerosas operaciones mineras en otras partes de Australia Occidental, en particular la fiebre del oro de Kalgoorlie a finales del siglo XIX y el auge de los minerales a finales del siglo XX.

Perth & Rottnest Island
Perth, du nom de la cité écossaise, est, avec un peu plus de deux millions d'habitants, la quatrième ville la plus peuplée d'Australie. Fondée en 1829, elle s'est enrichie, pendant une grande partie de son histoire, grâce aux nombreuses exploitations minières d'Australie-Occidentale, notamment lors de la ruée vers l'or de Kalgoorlie, à la fin du XIXe siècle, et du boom minier de la fin du XXe siècle.

Perth & Rottnest Island
Con poco più di due milioni di abitanti, Perth, che prende il nome dall'omonima cittadina in Scozia, è la quarta città più popolosa dell'Australia. Fondata nel 1829, per gran parte della sua storia si è arricchita grazie alle numerose attività minerarie in altre parti dell'Australia occidentale, in particolare grazie alla corsa all'oro delle Kalgoorlie, alla fine del XIX secolo, e al boom minerario alla fine del XX secolo.

Perth & Rottnest Island
Perth, benannt nach Perth in Schottland, ist Australiens viertgrößte Stadt, mit etwas mehr als zwei Millionen Einwohnern. Gegründet 1829, erlangte sie ihren Wohlstand lange durch zahlreiche Minen an anderen Orten Westaustraliens, vor allem durch den Goldrausch von Kalgoorlie im späten 19. Jahrhundert und den Mineralienboom im späten 20. Jahrhundert.

Perth & Rottnest Island
Perth is met iets meer dan 2 miljoen inwoners de op drie na grootste stad van Australië. De stad, opgericht in 1829, vergaarde zijn rijkdom lange tijd door de vele mijnbouwactiviteiten elders in West-Australië, vooral door de goudkoorts van Kalgoorlie eind 19e eeuw en de toegenomen vraag naar mineralen eind 20e eeuw.

MARKETS ENTRANCE

HARBOUR

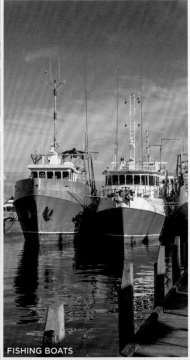
FISHING BOATS

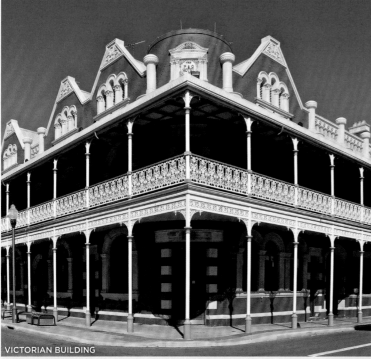
VICTORIAN BUILDING

UNIVERSITY OF NOTRE DAME AUSTRALIA

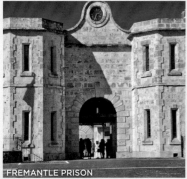
FREMANTLE PRISON

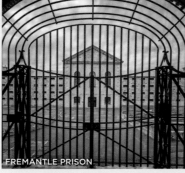
FREMANTLE PRISON

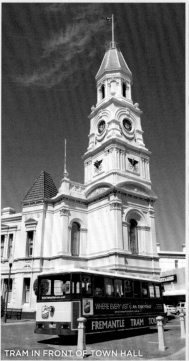
TRAM IN FRONT OF TOWN HALL

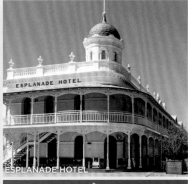
ESPLANADE HOTEL

VICTORIAN BUILDING

MARKET

TRADES HALL

VICTORIAN BUILDING

Fremantle

This riverside city has been Perth's major port since the beginning of European settlement. Its heritage streetscapes are the best-preserved example of a 19th-century port town in the world. Its West End neighbourhood alone has over 250 heritage-listed buildings, a distinctly maritime mix of former warehouses, banks, shipping companies, pubs and hotels.

Cette ville riveraine a été le principal port de Perth dès le début de la colonisation européenne. Son historique paysage urbain est l'exemple le mieux préservé au monde d'une ville portuaire du XIXᵉ siècle. Le quartier de West End compte à lui seul plus de 250 bâtiments classés au patrimoine, un mélange nettement maritime d'anciens entrepôts, banques, compagnies de navigation, pubs et hôtels.

Diese Stadtteil ist seit Beginn der europäischen Besiedlung der wichtigste Hafen von Perth. Seine denkmalgeschützten Bauten sind das weltweit besterhaltene Beispiel einer Hafenstadt aus dem 19. Jahrhundert. Allein im West End gibt es über 250 denkmalgeschützte Gebäude, eine ausgesprochen maritime Mischung aus ehemaligen Lagerhallen, Banken, Reedereien, Pubs und Hotels.

Esta ciudad ribereña ha sido el principal puerto de Perth desde el comienzo de la colonización europea. Sus paisajes urbanos tradicionales son el ejemplo mejor conservado de una ciudad portuaria del siglo XIX en el mundo. Sólo su barrio del West End cuenta con más de 250 edificios que forman parte del patrimonio, formando una distinguida mezcla claramente marítima de antiguos almacenes, bancos, compañías navieras, bares y hoteles.

Questa città fluviale è stato il principale porto di Perth fin dalle origini dell'insediamento europeo. Le sue strade storiche sono il miglior esempio al mondo di una città portuale del XIX secolo ancora intatta. Nel solo quartiere di West End sono presenti oltre 250 edifici classificati patrimonio dell'umanità, un mix decisamente marittimo di ex magazzini, banche, compagnie di navigazione, pub e alberghi.

Deze rivierstad is sinds het begin van de Europese kolonisatie de belangrijkste haven van Perth. De monumentale gebouwen vormen wereldwijd het best bewaarde voorbeeld van een 19e-eeuwse havenstad. Alleen al in de wijk West End staan meer dan 250 gebouwen op de monumentenlijst, een duidelijke maritieme mix van voormalige pakhuizen, banken, rederijen, cafés en hotels.

Lotterywest Federation Walkway Bridge, Kings Park & Botanic Garden

Banksia flowers in Banksia garden, Kings Park & Botanic Garden

Kings Park & Botanic Garden

Overlooking the waters of the Swan River, and at night, the lights of the city, this park is where locals come to picnic, relax and exercise. Its cultivated gardens and swathes of bushland contain a significant collection of Western Australian flora and fauna, with 319 species of native plants, including spring wildflower, and around 80 bird species.

Kings Park & Botanic Garden

Con vistas a las aguas del río Swan y por la noche, a las luces de la ciudad, este parque es donde los lugareños vienen a hacer picnic, relajarse y hacer ejercicio. Sus jardines cultivados y extensiones de arbustos contienen una importante colección de flora y fauna de Australia Occidental, con 319 especies de plantas autóctonas, incluyendo flores silvestres de primavera, y alrededor de 80 especies de aves.

Parc et jardin botanique Kings

Surplombant les eaux de la Swan River et, la nuit, les lumières de la ville, ce parc est l'endroit où les habitants viennent pique-niquer, se détendre et faire du sport. Ses jardins cultivés et ses étendues en friche abritent une importante variété de flore et de faune d'Australie occidentale, avec 319 espèces de plantes indigènes – dont la fleur sauvage du printemps – et environ 80 espèces d'oiseaux.

Kings Park & Botanic Garden

Affacciato sulle acque del fiume Swan e, di notte, sulle luci della città, questo parco è il luogo dove la gente del posto viene a fare picnic, esercizio fisico o rilassarsi. I suoi giardini coltivati e le aree boschive ospitano una significativa collezione di flora e fauna dell'Australia occidentale, con 319 specie di piante autoctone, tra cui fiori selvatici primaverili e circa 80 specie di uccelli.

Kings Park & Botanic Garden

Mit Blick auf das Wasser des Swan River und nachts auf die Lichter der Stadt ist dieser Park der Ort, an dem die Einheimischen zum Picknick, zur Entspannung und Bewegung kommen. Seine kultivierten Gärten und Buschlandstreifen sind Heimat von 319 Arten einheimischer Pflanzen, darunter Frühlingswildblumen sowie etwa 80 Vogelarten.

Kings Park & Botanic Garden

Met uitzicht op het water van de Swan River, en 's nachts de lichten van de stad, komt de lokale bevolking naar dit park om te picknicken, relaxen en sporten. In de aangelegde tuinen en stukken struikgewas groeien 319 inheemse plantensoorten, waaronder wilde lentebloemen, en leven zo'n 80 vogelsoorten.

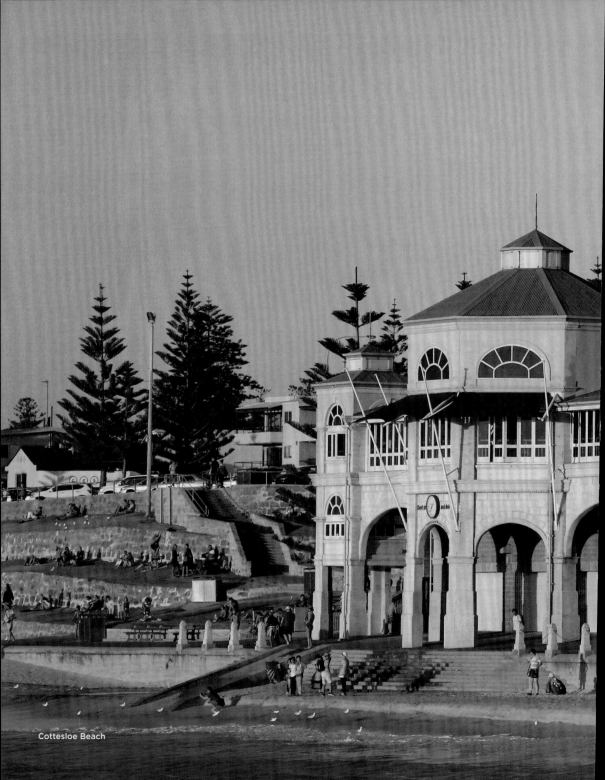

Cottesloe Beach

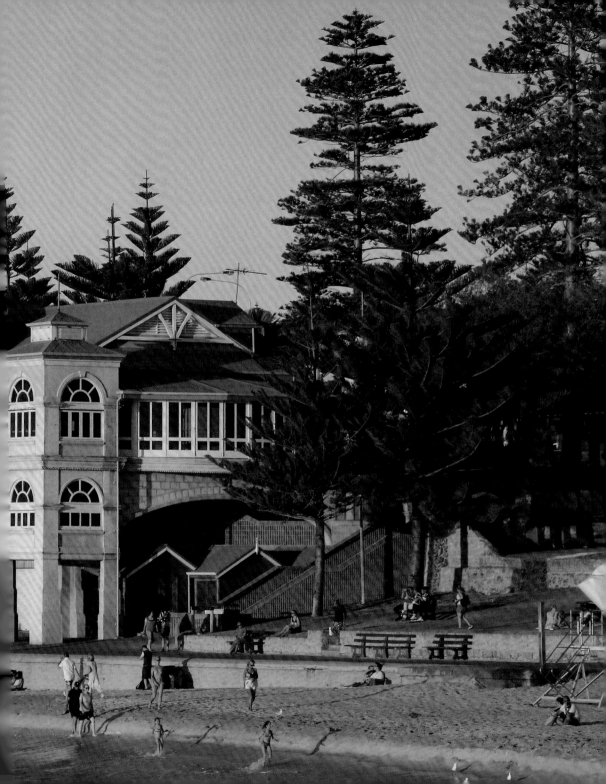

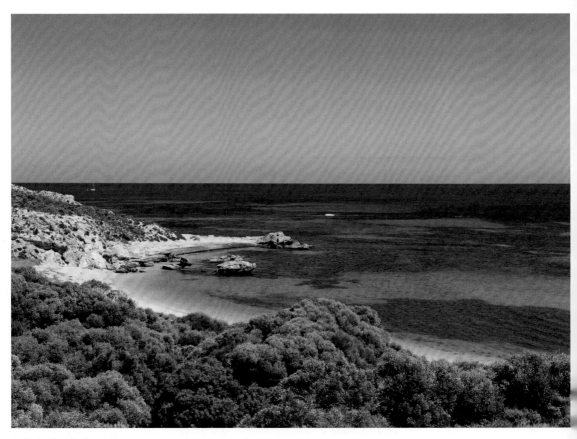

Catherine Bay, Rottnest Island

Rottnest Island

Eighteen kilometres offshore from
Fremantle, Rottnest Island (or Wadjemup
to the local Aboriginal people), covers
19 km². Its permanent population of around
300, swells with the annual arrival of more
than 500,000 visitors. But Rottnest's most
famous inhabitants are its quokkas, a small
native marsupial—Rottnest is considered
the quokka's last refuge.

Île Rottnest

À dix-huit kilomètres au large de
Fremantle, l'île Rottnest (Wadjemup
pour la population autochtone locale)
s'étend sur 19 km². Sa population
permanente, d'environ 300 habitants,
augmente avec l'arrivée annuelle de plus
de 500 000 visiteurs. Mais les habitants
les plus célèbres de Rottnest sont ses
quokkas, un petit marsupial indigène – l'île
est considérée comme le dernier refuge de
cet animal.

Rottnest Island

18 km vor Fremantle liegt die 19 km² große
Insel Rottnest Island (oder Wadjemup
in der Sprache der dort ansässigen
Ureinwohner). Neben den 300 Bewohnern
besuchen mehr als 500 000 Menschen
die Insel jährlich. Aber die berühmtesten
Bewohner von Rottnest sind seine
Quokkas, ein kleines einheimisches
Beuteltier.

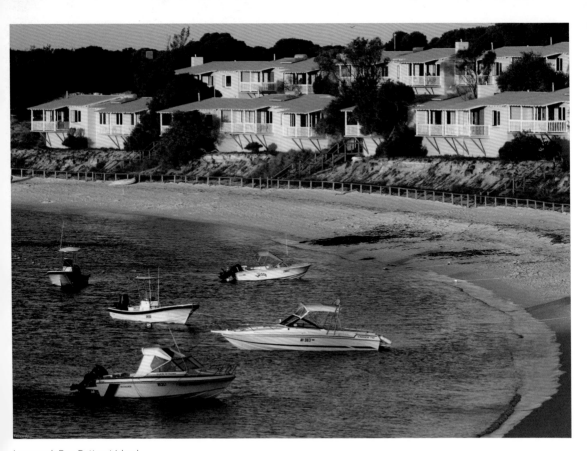

Longreach Bay, Rottnest Island

Rottnest Island

A 18 kilómetros de Fremantle, la isla Rottnest (o Wadjemup para los aborígenes locales) tiene una superficie de 19 km². Su población permanente de alrededor de 300 habitantes, aumenta con la llegada anual de más de 500.000 visitantes. Pero los habitantes más famosos de Rottnest son sus quokkas, un pequeño marsupial autóctono que encuentra en esta isla su último refugio.

Rottnest Island

Diciotto chilometri al largo di Fremantle, Rottnest Island (o Wadjemup, come viene chiamata dalla popolazione aborigena locale), si estende su 19 km². La sua popolazione permanente di circa 300 abitanti aumenta in maniera smisurata ogni anno, con l'arrivo di oltre 500.000 visitatori. Ma gli abitanti più famosi di Rottnest sono i quokka, un piccolo marsupiale autoctono – di cui Rottnest è l'ultimo rifugio.

Rottnest Island

Op 18 km van de kust van Fremantle ligt het 19 km² grote Rottnesteiland (of Wadjemup, in de taal van de lokale Aboriginals). De permanente populatie van circa 300 mensen neemt jaarlijks aanzienlijk toe met de komst van ruim 500.000 bezoekers. Maar de beroemdste inwoners van Rottnest zijn de quokka's, een klein inheems buideldier.

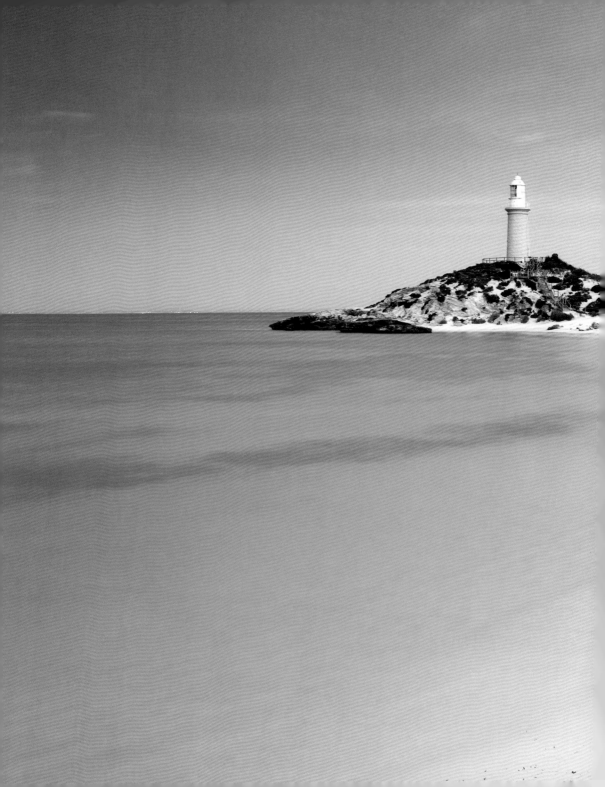

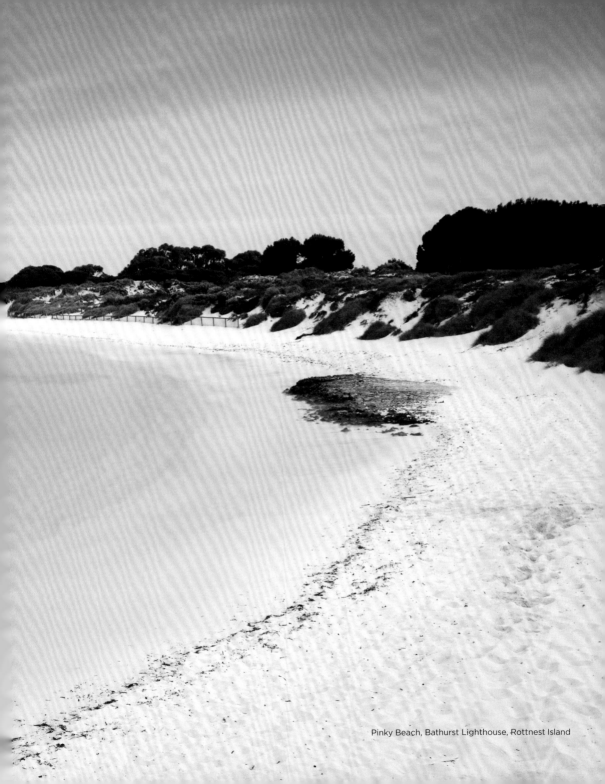

Pinky Beach, Bathurst Lighthouse, Rottnest Island

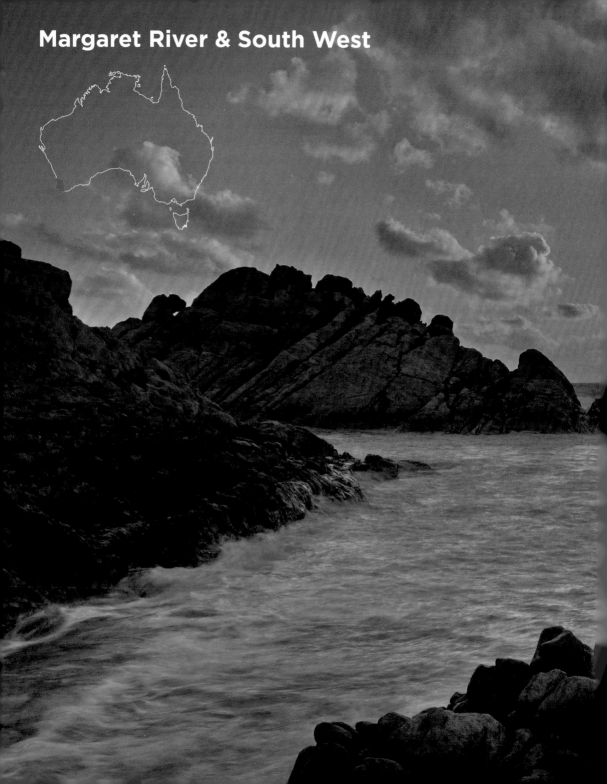

Margaret River & South West

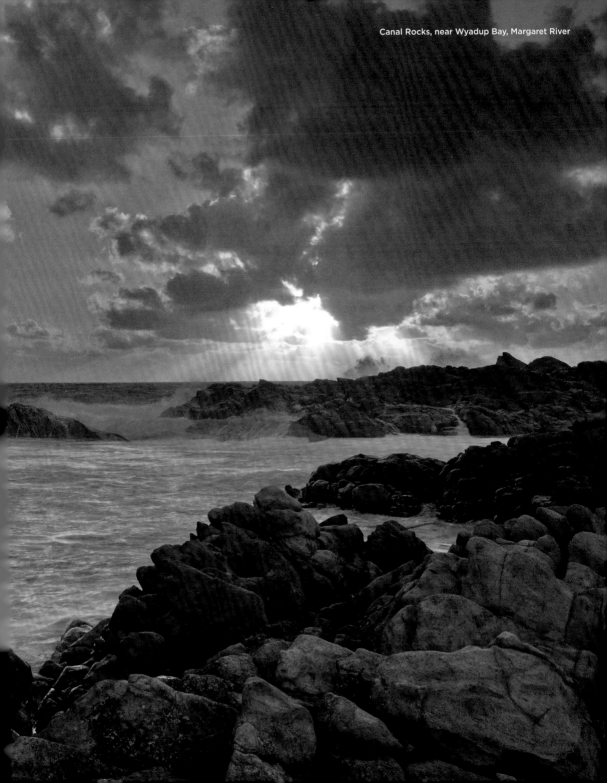

Canal Rocks, near Wyadup Bay, Margaret River

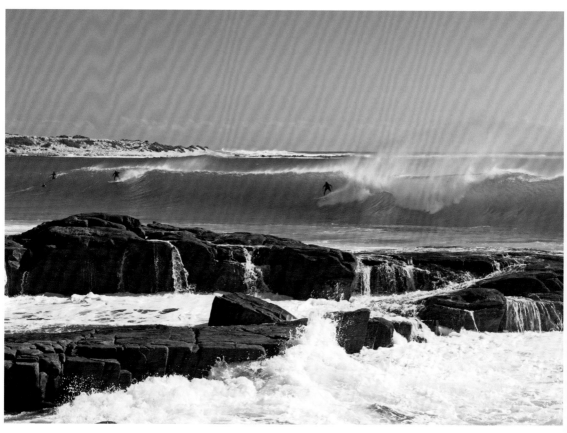

North Point Beach

Margaret River & South West

While much of the west is given over to the red earth of the desert, this far southern corner of the state is a lush, green, abundant place. It's a legendary surf spot as well as one of Australia's best-known wine growing districts. Beyond the farms lay woodlands, jarrah and marri forests as well as stunning walking and cycling trails.

Margaret River & South West

Alors qu'une grande partie de l'ouest est recouverte de terre rouge du désert, ce coin méridional de l'état est un endroit luxuriant, vert et fertile. Spot de surf légendaire, c'est aussi l'un des districts viticoles les plus connus d'Australie. Au-delà des fermes se trouvent des bois, des forêts de jarrahs et de marris ainsi que de superbes sentiers pédestres et cyclables.

Margaret River & South West

Während ein Großteil des Westens von der roten Erde der Wüste geprägt ist, ist diese weit südliche Ecke des Staates ein üppiger, grüner Ort. Es ist ein legendärer Surfspot und eines der bekanntesten Weinanbaugebiete Australiens. Jenseits der Farmen liegen ausgedehnte Waldgebiete, Eukalyptus- und Marri-Wälder sowie atemberaubende Wander- und Radwege.

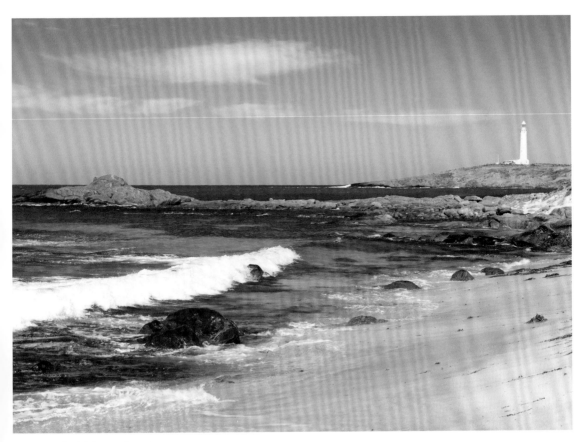

Cape Leeuwin Lighthouse, Augusta

Margaret River & South West

Mientras que gran parte del oeste está dedicado a la tierra roja del desierto, este extremo sur del Estado es un lugar exuberante, verde y generoso. Es un legendario lugar para la práctica del surf y uno de los distritos vitivinícolas más conocidos de Australia. Más allá de las granjas hay bosques, Jarrahs y bosques de castaños, así como impresionantes senderos para caminar y montar en bicicleta.

Margaret River & South West

Mentre gran parte dell'ovest è occupato dalla terra rossa del deserto, questo angolo nell'estremo sud dello stato è un luogo lussureggiante, verde e prosperoso. Non solo: è anche un posto leggendario per il surf e uno dei distretti vinicoli più famosi d'Australia. Oltre le fattorie si trovano boschi, foreste di jarrah e marri, così come pure splendidi sentieri per passeggiate a piedi e in bicicletta.

Margaret River & South West

Terwijl een groot deel van het westen wordt gekenmerkt door de rode woestijnaarde is deze zuidelijke uithoek van de staat een weelderig groene plek. Het is een legendarische surfspot en een van de bekendste wijnbouwgebieden van Australië. Voorbij de boerderijen liggen uitgestrekte bosgebieden en prachtige wandel- en fietspaden.

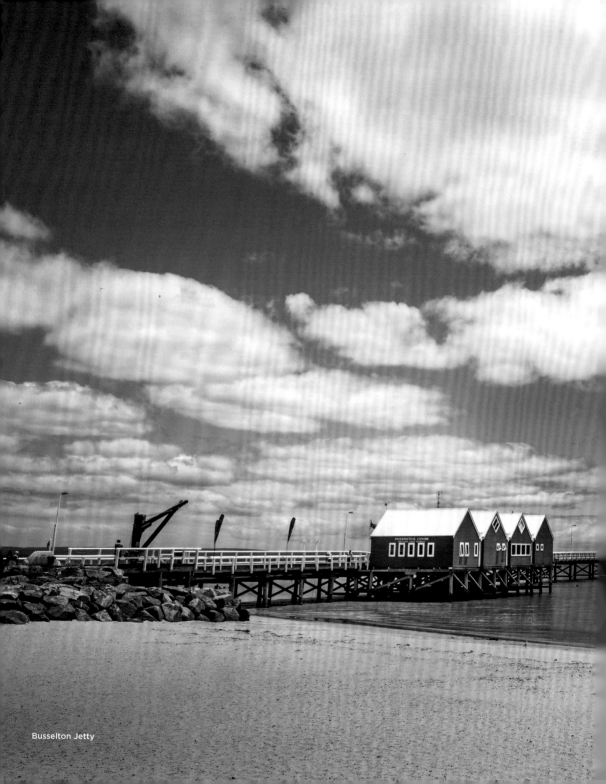

Busselton Jetty

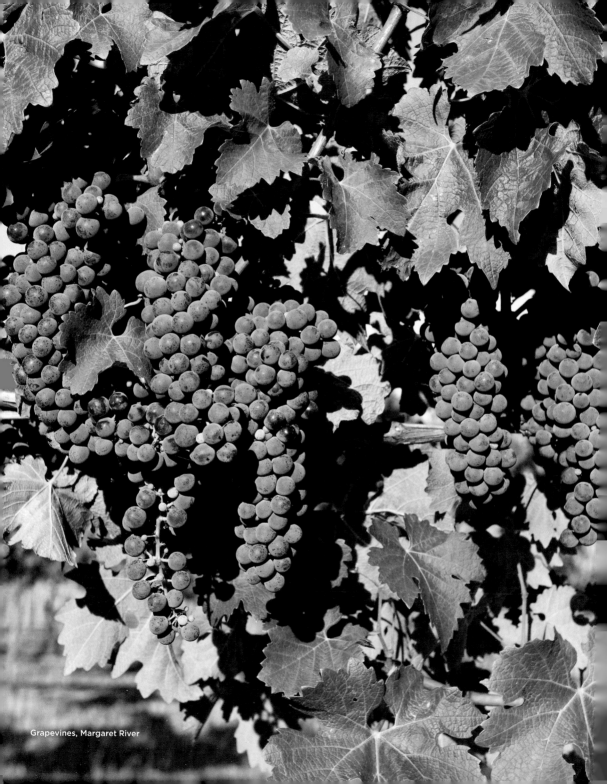
Grapevines, Margaret River

Vineyard, Margaret River

Wine production

Margaret River, southwest of Perth, is known for the variety of its attractions, from world-class surf beaches to wine-producing and culinary excellence. Home to nearly 140 wineries, it's the domain of boutique, rather than large-scale wineries—Margaret River produces less than 5% of Australia's wines, but provides a disproportionate 20% of the country's premium wine market.

Producción de vino

Margaret River, al suroeste de Perth, es conocida por la variedad de sus atracciones, desde playas de surf de primera clase hasta la excelencia culinaria y vinícola. Esta localidad está dominada por la presencia de grandes boutiques, pese a ser el hogar de casi 140 bodegas. Margaret River produce menos del 5% de los vinos de Australia, pero aporta una cuota de mercado desproporcionada del 20% de los vinos de primera calidad del país.

Production de vin

Margaret River, au sud-ouest de Perth, est connue pour ses nombreuses attractions, ses plages de surf d'envergure internationale mais aussi pour sa production de vin et l'excellence de sa scène gastronomique. Abritant près de 140 établissements vinicoles, on y trouve surtout de petites boutiques – Margaret River produit moins de 5% des vins australiens, mais occupe une part étonnamment élevée du marché des vins haut de gamme du pays – 20%

Viticoltura

Margaret River, a sud-ovest di Perth, è conosciuta per la varietà delle sue attrazioni, dalle spiagge per il surf di alto livello alla produzione di vino e all'eccellenza culinaria. Sede di quasi 140 aziende vinicole, è il dominio di viticoltori piccoli e ricercati piuttosto che di grandi cantine – Margaret River produce meno del 5% dei vini australiani, ma fornisce uno sproporzionato 20% dei vini di alto livello al mercato vinicolo del paese.

Weinproduktion

Margaret River, südwestlich von Perth, ist bekannt für seine vielen Attraktionen, von Weltklasse-Surfstränden bis zu ausgezeichneten Weine und Restaurants. Mit fast kleineren 140 Weingütern werden hier weniger als 5% der australischen Weine produziert. Dafür hat die Region aber einen überproportionalen Anteil von 20% am Premium-Weinmarkt des Landes.

Wijnproductie

De Margaret, ten zuidwesten van Perth, staat bekend om allerlei attracties, van ideale surfstranden tot uitstekende wijngoederen en restaurants. Met bijna 140 wijnhuizen is dit het domein van de exclusieve in plaats van grote wijnhuizen – hier wordt minder dan 5% van de Australische wijnen geproduceerd, zij het met een onevenredig aandeel van 20% in de premiumwijnmarkt.

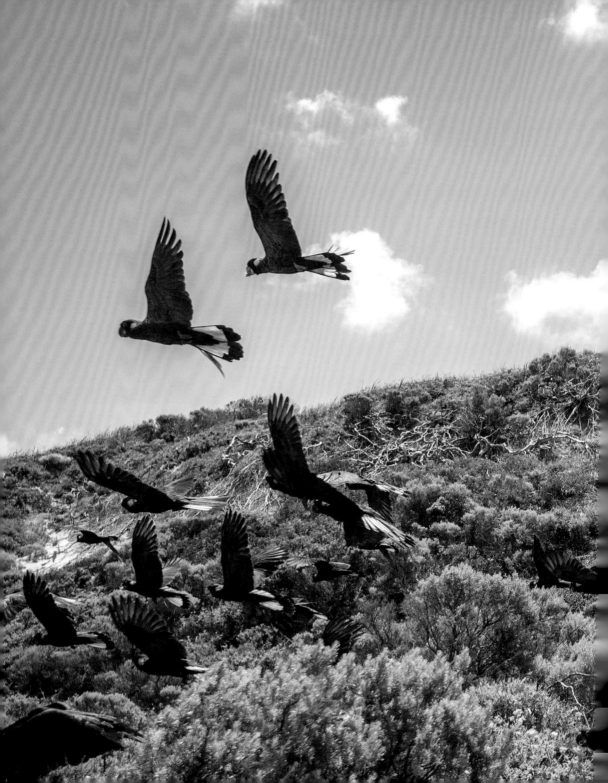

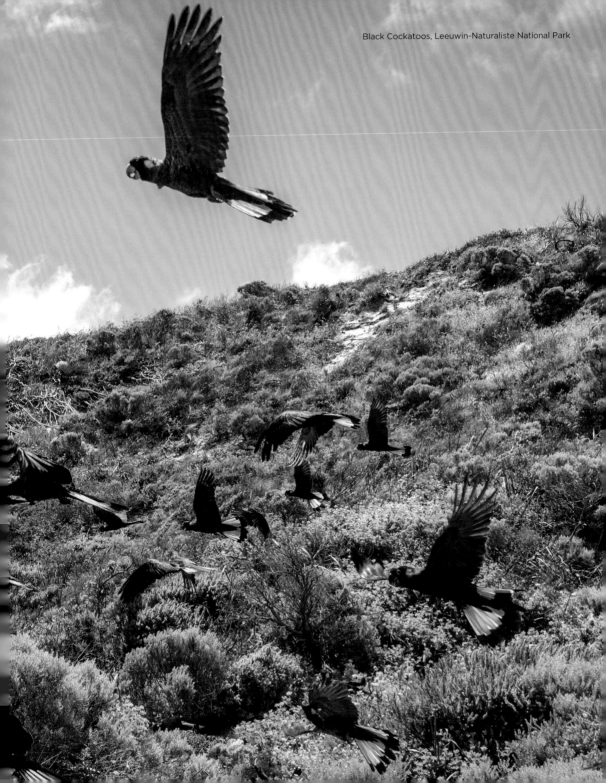

Black Cockatoos, Leeuwin-Naturaliste National Park

Denmark & Albany

The wild southern coast of southwestern Australia stands in stark contrast to its appealing towns. Exceptional beaches and deep forests surround artsy Denmark, with its mix of creative types, small-scale wineries in the hinterland, and a small fishing fleet. Not far to the east, and the point where the Australian coast begins its arc away to the northeast, Albany is Western Australia's oldest town (1826), with colonial-era architecture providing a pretty public face.

Denmark & Albany

L'aspect sauvage de la côte méridionale du sud-ouest de l'Australie contraste fortement avec ses villes attrayantes. Des plages exceptionnelles et des forêts profondes entourent l'esthétique Denmark, avec son mélange d'événements créatifs, de petits vignobles dans l'arrière-pays et sa petite flotte de pêche. Située non loin à l'est, à l'endroit où la côte australienne commence son arc au nord-est, Albany est la plus vieille ville d'Australie occidentale (1826), et son architecture de l'époque coloniale lui donne une allure élégante.

Denmark & Albany

Die wilde Südküste Südwestaustraliens steht im starken Kontrast zu den attraktiven Städten. Außergewöhnliche Strände und dichte Wälder umgeben das für sein Kunsthandwerk bekannte Denmark mit seiner Mischung aus kreativen Typen, kleinen Weingütern im Hinterland und einer kleinen Fischereiflotte. Nicht weit davon im Osten und an jenem Punkt, an dem die australische Küste ihren Bogen zurück in den Nordosten beginnt, liegt Albany, die älteste Stadt Westaustraliens (1826), deren Architektur aus der Kolonialzeit hübsch anzusehen ist.

Denmark & Albany

La salvaje costa sur del suroeste de Australia contrasta con sus atractivas ciudades. Excepcionales playas y bosques profundos rodean la creativa Denmark, con su mezcla de artistas, sus bodegas a escala reducida en el interior y una pequeña flota pesquera. No muy lejos, hacia el este, en el punto donde la costa australiana comienza su arco hacia el noreste, se encuentra Albany, la ciudad más antigua de Australia Occidental (1826), con una arquitectura de la era colonial que le aporta una bonita fachada.

Denmark & Albany

La selvaggia costa meridionale dell'Australia sudoccidentale è in netto contrasto con le sue affascinanti città. Spiagge eccezionali e foreste folte circondano il distretto di Denmark, famoso per l'artigianato, con il suo mix di tipi creativi, piccole cantine nell'entroterra e una piccola flotta da pesca. A est, non lontano da qui, nel punto in cui la costa australiana inizia il suo arco verso nord-est, si trova Albany, la città più antica dell'Australia Occidentale (1826), con un'architettura coloniale che fa bella mostra di sé agli occhi dei passanti.

Denmark & Albany

De wilde zuidkust van Zuidwest-Australië vormt een schril contrast met de aantrekkelijke steden. Buitengewone stranden en dichte bossen omringen het om zijn kunstnijverheid bekende Denmark, met zijn mix van artistieke types, kleinschalige wijnmakerijen in het achterland en een kleine vissersvloot. Albany, de oudste stad van West-Australië (1826) met aantrekkelijke koloniale gebouwen, ligt niet ver naar het oosten, op het punt waar de Australische kust zijn boog naar het noordoosten begint.

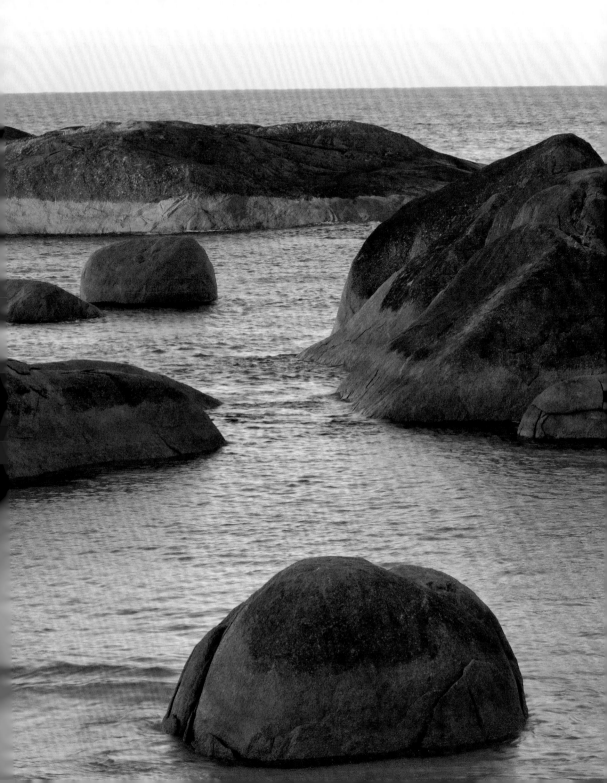

Lake Hillier, Recherche Archipelago Nature Reserve

Recherche Archipelago Nature Reserve

Treacherous for shipping, if visually stunning, this series of at least 104 islands and surrounding reefs, islets and rocks. Access is limited to only one, Middle Island and only by tour. Its pink lake, Lake Hillier, was a source of salt for early explorer Matthew Flinders. Apart from birdlife, the island is home to tammar wallabies and the bush rats.

Réserve naturelle de l'archipel de la Recherche

Cette archipel d'au moins 104 îles, entouré de récifs, îlots et rochers, est dangereux pour la navigation, même s'il est visuellement étonnant. Il n'est cependant possible d'accéder qu'à l'Île du Milieu, et uniquement dans le cadre d'excursions. Son lac rose, le lac Hillier, a été une source de sel pour le premier explorateur Matthew Flinders. Outre les oiseaux, l'île abrite des wallabies de l'île Eugène et des rats de brousse.

Naturschutzgebiet Recherche-Archipel

Gefährlich für die Schifffahrt, doch optisch atemberaubend, ist diese Gruppe von mindestens 104 Inseln und umliegenden Riffen, Inselchen und Felsen. Zugänglich ist nur eine, Middle Island. und dies auch nur mit Führung. Der rosa See, Lake Hillier, war eine Salzquelle für den Forschungsreisenden Matthew Flinders. Abgesehen von der Vogelwelt ist die Insel auch Heimat von Tammar-Wallabies und Buschratten.

Recherche Archipelago Nature Reserve

Reserva Natural del Archipiélago de Recherche

Este archipiélago es traicionero para el transporte marítimo, aunque visualmente es impresionante. Está compuesto por una serie de al menos 104 islas y arrecifes circundantes, islotes y rocas. El acceso está limitado a una sola isla, Middle Island, y sólo se ofrecen rutas organizadas. Su lago rosado, el Lago Hillier, fue una fuente de sal para el explorador Matthew Flinders. Además de la avifauna, la isla alberga a los walabíes de Tammar y a las ratas de monte.

Recherche Archipelago Nature Reserve

Questa serie di circa 104 tra isole, isolotti, faraglioni e rocce non è certo facile per la navigazione ma è di sicuro uno spettacolo per la vista. L'accesso è limitato a un'unica isola, Middle Island, e solo nell'ambito di una visita guidata. Il suo lago rosa, il lago Hillier, è stato una fonte di sale per uno dei primi esploratori qui giunti, Matthew Flinders. Oltre all'avifauna, l'isola ospita i wallaby tammar e i ratti del bush.

Natuurgebied Archipelago of the Recherche

Verraderlijk voor de scheepvaart, maar visueel verbluffend is deze serie van minstens 104 eilanden en omringende riffen, eilandjes en rotsen. Slechts één eiland is toegankelijk, Middle Island, en dat alleen tijdens een rondleiding. Het roze meer, Lake Hillier, was een zoutbron voor de vroege ontdekkingsreiziger Matthew Flinders. Behalve vogels huisvest het eiland tammarwallaby's en bushratten.

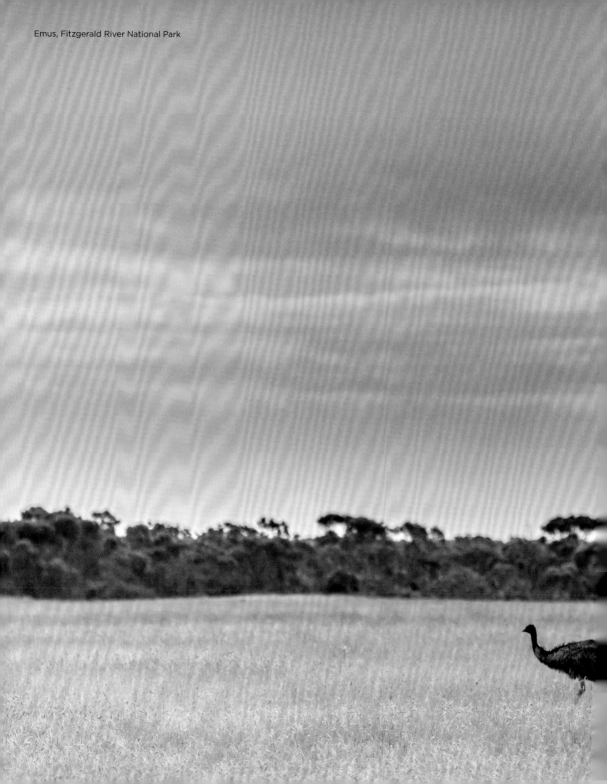

Emus, Fitzgerald River National Park

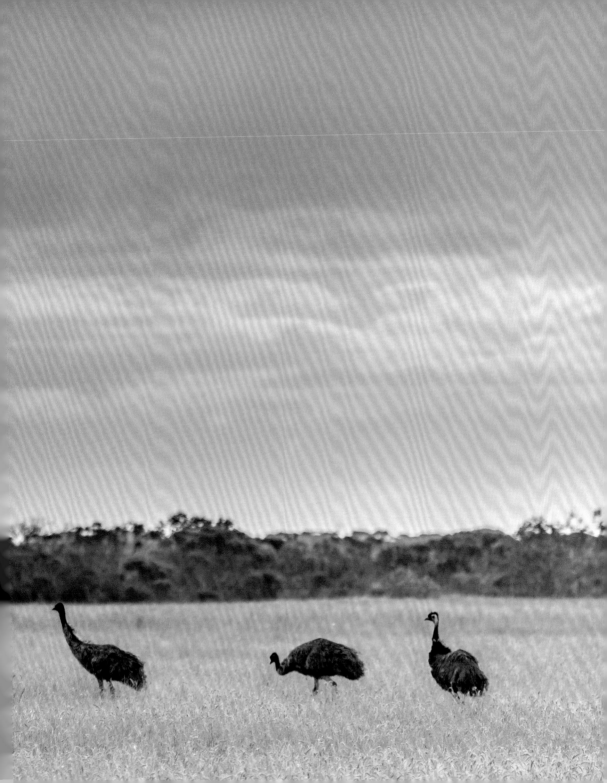

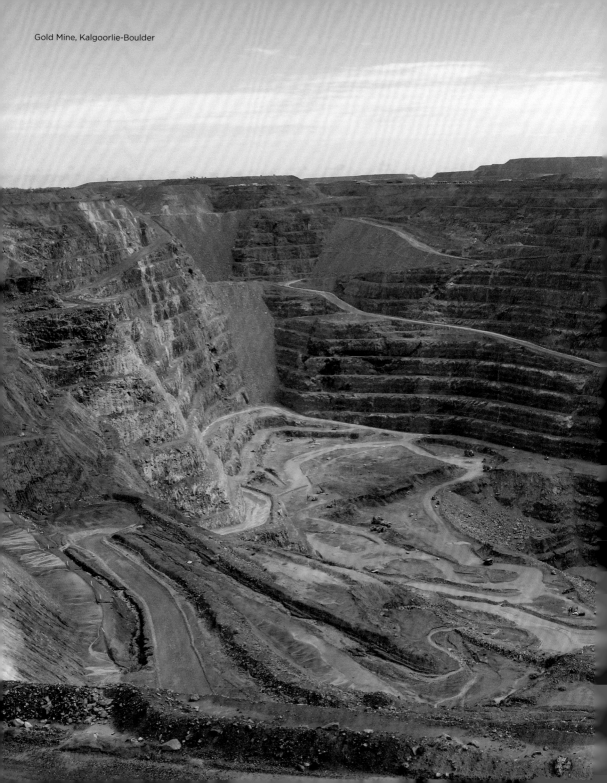

Gold Mine, Kalgoorlie-Boulder

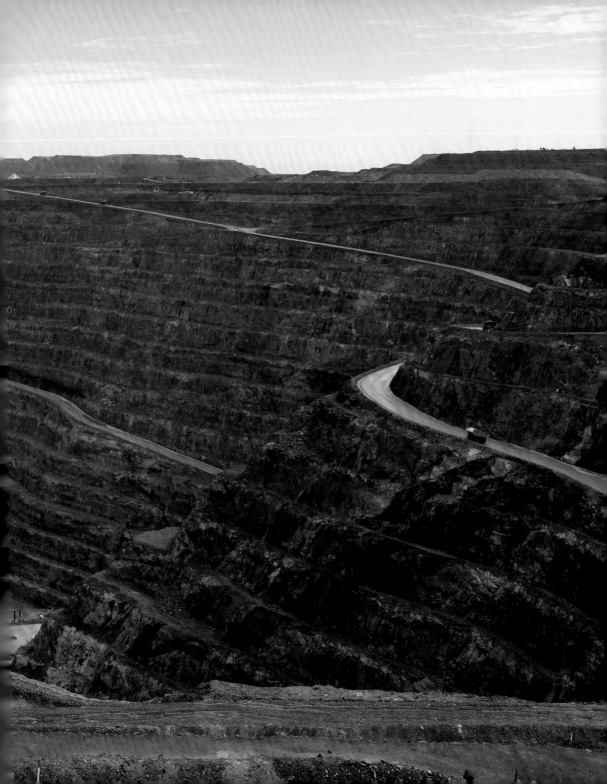

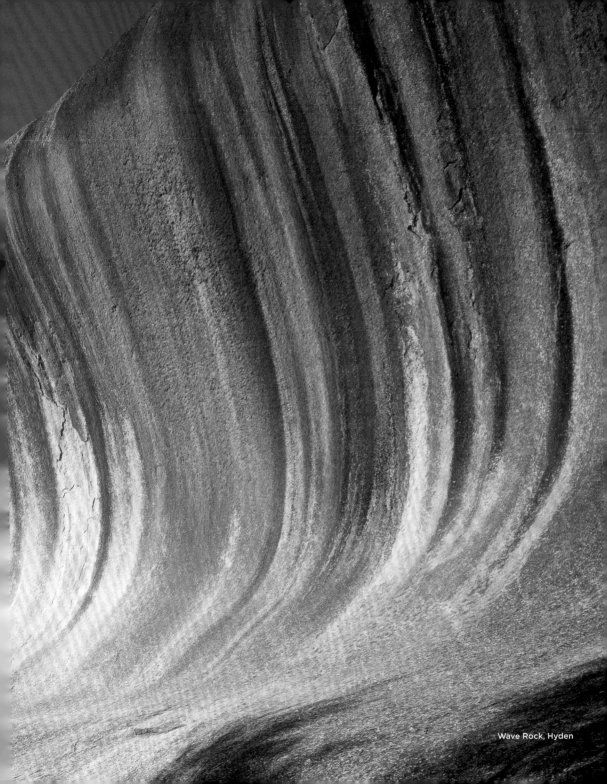

Wave Rock, Hyden

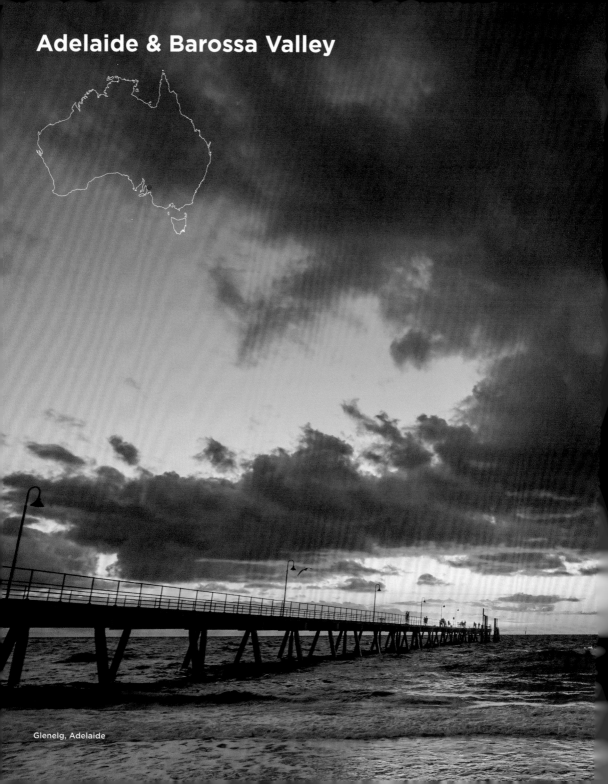

Adelaide & Barossa Valley

Glenelg, Adelaide

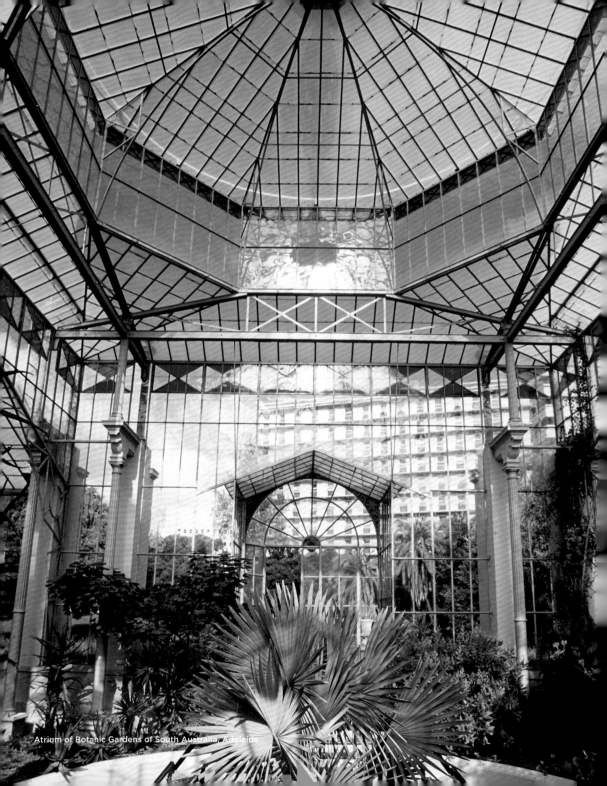

Atrium of Botanic Gardens of South Australia, Adelaide

Rainbow Lorikeets, Botanic Gardens of South Australia, Adelaide

Adelaide & Barossa Valley

Once known as the 'city of churches' this small, cultured capital has cast off its dour image to become a food, wine and festival destination. A planned grid of wide streets lends it the feel of a country town, albeit an elegant one, and beyond lay gentle bay beaches or the German-settler accented "Hills"; further on you'll find the red wine producing vineyards of the Barossa.

Adélaïde & Barossa Valley

Autrefois connue sous le nom de « ville des églises », cette petite capitale cultivée s'est débarrassée de son image terne pour devenir une destination gastronomique, vinicole et festive idéale. Ses larges rues, organisées en grille, lui donne l'allure d'une ville de campagne, quoiqu'élégante. Au-delà s'étendent les plages de la baie et les collines fortement marquées par l'influence des premiers colons allemands ; plus loin, on y rencontre les vignobles de la Barossa.

Adelaide & Barossa Valley

Einst als „Stadt der Kirchen" bekannt, hat diese kleine Hauptstadt ihr mürrisches Image abgelegt und sich zum Wein- und Festivalziel entwickelt. Ein Netz von breiten Straßen verleiht ihr die Anmutung einer ländlichen Stadt, wenn auch eine elegante. Jenseits liegen sanfte Buchten und die von deutschen Siedlern geprägten „Hills" noch etwas weiter finden Sie die Rotwein produzierenden Hänge der Barossa.

Adélaïde & Barossa Valley

A esta localidad se la conocía como la "ciudad de las iglesias", pero esta capital de cultura se ha despojado de su imagen adusta para convertirse en un destino gastronómico y vinícola. Suentramado de calles anchas le da una sensación de ciudad de campo elegante, que vamás allá de las playas de la bahía o de las colinas de los colonos alemanes; más adelante encontrará los viñedos productores de vino tinto de la Barossa.

Adelaide & Barossa Valley

Un tempo detta la "città delle chiese", questa piccola e colta città ha abbandonato la sua immagine austera per diventare sede di eventi enogastronomici e festival. Una griglia pianificata di strade larghe le dà l'aspetto di un'elegante città di campagna, oltre cui si estendono le dolci spiagge delle sue baie o le "Hills", popolate un tempo dai coloni tedeschi; più avanti si trovano i vigneti di Barossa, noti per il vino rosso.

Adelaide & Barossa Valley

Deze kleine hoofdstad, die ooit bekendstond als 'stad van de kerken', heeft zijn stugge imago afgeworpen en is uitgegroeid tot een wijn- en festivalbestemming. Een netwerk van brede straten geeft hem de sfeer van een landelijke, zij het elegante stad. Daarachter liggen zachte baaien en de door Duitse kolonisten beïnvloede "Hills". Iets verderop liggen de wijngaarden van de Barossa, die rode wijn opleveren.

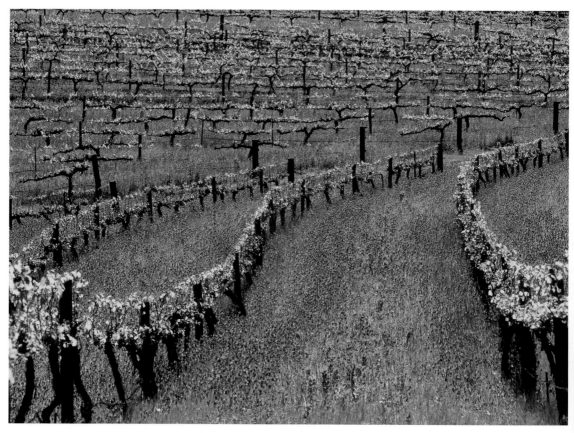

Vineyards & Paterson's curse *(Echium plantagineum)* or Salvation Jane, Clare Valley

Adelaide Region Wines

Some of the oldest and most respected wine regions in Australia lie within reach of Adelaide – while most can be visited on a day trip, most reward unhurried road trips over several days. The Adelaide Hills, with its dry, cool climate, have produced some spectacular wines and pretty villages, such as Hahndorf which can feel like Germany but with nice weather. The German theme continues throughout the Barossa Valley, from where nearly a quarter of Australian wines come – Shiraz and Riesling are the dominant grapes. Also within striking distance of Adelaide is MacLaren Vale, also known for its bold Shiraz varieties, while Coonawarra out west.

Vins de la région d'Adélaïde

Certaines des régions viticoles les plus anciennes et les plus côtées d'Australie se trouvent à proximité d'Adélaïde – alors que la plupart peuvent être visitées lors d'une excursion d'une journée, les séjours de plusieurs jours, plus tranquilles, seront également d'un grand intérêt. Les collines d'Adélaïde, avec leur climat sec et frais, donnent naissance à des vins spectaculaires mais aussi à de jolis villages, comme Hahndorf, aux faux-airs de bourg allemand mais avec une météo agréable. Un caractère germanique qui se poursuit d'ailleurs dans toute la vallée de la Barossa, d'où proviennent près d'un quart des vins australiens, puisque le Shiraz et le Riesling sont les cépages dominants. McLaren Vale, également connue pour ses variétés audacieuses de Shiraz, se trouve aussi à une courte distance d'Adélaïde, tandis que Coonawarra se situe plus à l'ouest.

Weine aus der Region Adelaide

Einige der ältesten und angesehensten Weinregionen Australiens liegen im Umkreis von Adelaide – während die meisten auf einem Tagesausflug besucht werden können, lohnen sich bei vielen auch gemütliche Roadtrips über mehrere Tage. Die Adelaide Hills mit ihrem trockenen, kühlen Klima haben einige spektakuläre Weine und hübsche Dörfer wie Hahndorf hervorgebracht, die an Deutschland erinnern, aber mit schönem Wetter. Das deutsche Thema zieht sich durch das Barossa-Tal, aus dem fast ein Viertel der australischen Weine stammen – Shiraz und Riesling sind die dominierenden Trauben. Ebenfalls in Reichweite von Adelaide befindet sich MacLaren Vale, das auch für seine kühnen Shiraz-Sorten bekannt ist, während Coonawarra weiter im Südosten liegt.

Hahndorf, Adelaide Hills

Vinos de la región de Adelaida

Algunas de las regiones vitivinícolas más antiguas y respetadas de Australia se encuentran en la región de Adelaida, mientras que muchas de estas regiones puede visitarse en una excursión de un día, merece la pena en su mayoría realizar un viaje sin prisas durante varios días. Las colinas de Adelaida, con su clima seco y fresco, han producido algunos vinos espectaculares y albergan bonitos pueblos, como Hahndorf, de similitud alemana, pero con un clima agradable. El tema alemán continúa en todo el valle de Barossa, de donde proviene casi un cuarto de los vinos australianos, siendo las variedades de Shiraz y Riesling las uvas dominantes. A una llamativa distancia de Adelaida se encuentra MacLaren Vale, también conocido por sus características variedades de Shiraz, mientras que Coonawarra se sitúa más al oeste.

Vini della regione di Adelaide

Alcune delle regioni vinicole più antiche e rispettate dell'Australia sono poco distanti da Adelaide, ma mentre la maggior parte di esse può essere visitata in giornata, per altre bisogna programmare un viaggio in auto di qualche giorno. Le Adelaide Hills, con il loro clima secco e fresco, sono la patria di vini spettacolari e graziosi villaggi, come Hahndorf, che porta qui un alito di Germania segnato però dal bel tempo. Il tema tedesco si protrae per tutta la Barossa Valley, da dove proviene quasi un quarto dei vini australiani. Shiraz e Riesling sono qui le uve dominanti. A breve distanza da Adelaide si trova anche la MacLaren Vale, nota anche per le sue audaci varietà di Shiraz, mentre Coonawarra è più a ovest.

Wijnen uit de regio Adelaide

Enkele van de oudste en meest gerespecteerde wijngebieden in Australië liggen in de omgeving van Adelaide – terwijl veel ervan tijdens een dagtocht kunnen worden bezocht, zijn voor de meeste ongehaaste autotochten van meerdere dagen de moeite waard. De Adelaide Hills met hun droge, koele klimaat hebben enkele spectaculaire wijnen en mooie dorpjes voortgebracht, zoals Hahndorf, die aan Duitsland doen denken, maar dan met mooi weer. Het Duitse thema zet zich voort in de Barossa Valley, waar bijna een kwart van de Australische wijnen vandaan komt (shiraz en riesling zijn de dominante druiven). Eveneens binnen het bereik van Adelaide ligt MacLaren Vale, ook bekend om zijn shiraz-variëteiten, terwijl Coonawarra verder naar het zuidoosten ligt.

Wine

Australian winemakers are best known for their bold Syrah, 'Cab Sav', Chardonnay and Merlot. While South Australia produces over 50 percent of the country's wine, in terms of quality, it's been eclipsed over the last decades by Tasmania, Victoria and Canberra, for their elegant Italian-varietal whites and Pinot Noirs from cold-climate small producers.

Vins

Les vignerons australiens sont surtout connus pour leurs Syrah, leurs « Cab Sav » (le surnom donné au Cabernet Sauvignon), leurs Chardonnay et leurs Merlot. Alors que l'Australie-Méridionale produit plus de 50 % du vin du pays, il a été qualitativement un peu éclipsé au cours des dernières décennies par la Tasmanie, Victoria et Canberra, qui élaborent d'élégants blancs de variétés italiennes ainsi que des Pinots Noirs cultivés en climat froid par de petits producteurs.

Wein

Australische Winzer sind vor allem für ihren kühnen Syrah, Cabernet Sauvignon, Chardonnay und Merlot bekannt. Während Südaustralien mehr als 50% des australischen Weines produziert, wurde er in den letzten Jahrzehnten von Tasmanien, Victoria und Canberra mit ihren eleganten Weißweinen aus italienischen Rebsorten und ihren Pinot Noirs von kleinen Produzenten in den Schatten gestellt.

Vino

Los enólogos australianos son más conocidos por sus atrevidos Syrah, Cab Sav, Chardonnay y Merlot. Mientras que en el sur de Australia se produce más del 50 por ciento del vino del país, en términos de calidad, esta zona ha sido eclipsada en las últimas décadas por Tasmania, Victoria y Canberra, que ofrecen elegantes blancos varietales italianos y Pinot Noirs de pequeños productores de clima frío.

Vino

I viticoltori australiani sono famosi soprattutto per i loro audaci Shiraz, il "Cab Sav", ossia il Cabernet Sauvignon, lo Chardonnay e il Merlot. Mentre l'Australia del Sud produce oltre il 50% del vino del paese, in termini di qualità lo stato è stato eclissato negli ultimi decenni da Tasmania, Victoria e Canberra, che oggi producono eleganti bianchi da varietà italiane e Pinot Nero di piccoli produttori delle zone a clima freddo.

Wijn

Australische wijnmakers zijn vooral bekend om hun gedurfde syrah, cabernet sauvignon, chardonnay en merlot. Terwijl Zuid-Australië meer dan 50 procent van de wijn produceert, wordt het gebied de afgelopen decennia in termen van kwaliteit overschaduwd door Tasmanië, Victoria en Canberra, vanwege hun elegante witte wijnen van Italiaanse druivenrassen en pinot noirs van kleine producenten.

YERING CABERNET SAUVIGNON, YARRA VALLEY

WINETASTING, HUNTER VALLEY

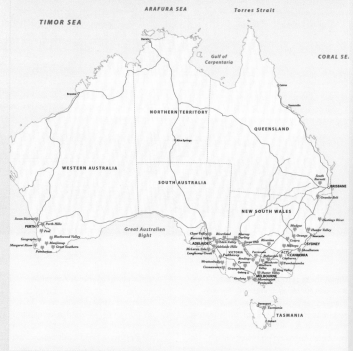

VINEYARD, COONAWARRA

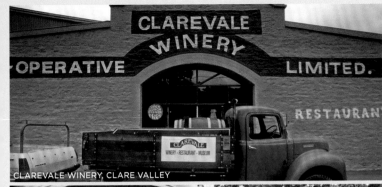

CLAREVALE WINERY, CLARE VALLEY

SYRAH (SHIRAZ), HUNTER VALLEY

WINE BARREL, SEVENHILL CELLARS, CLARE VALLEY

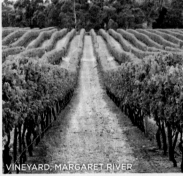

VINEYARD, MARGARET RIVER

TANUNDA WINERY, BAROSSA VALLEY

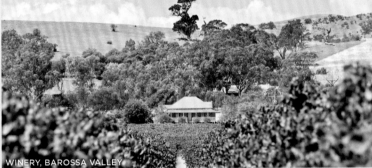

WINERY, BAROSSA VALLEY

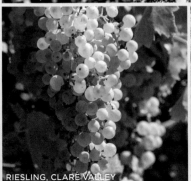

RIESLING, CLARE VALLEY

VINEYARD, MARGARET RIVER

St Aloysius' Church, Clare Valley

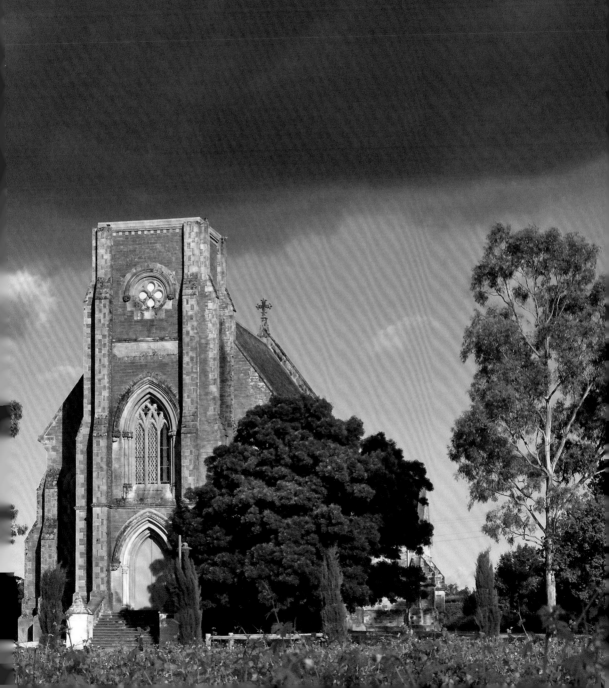

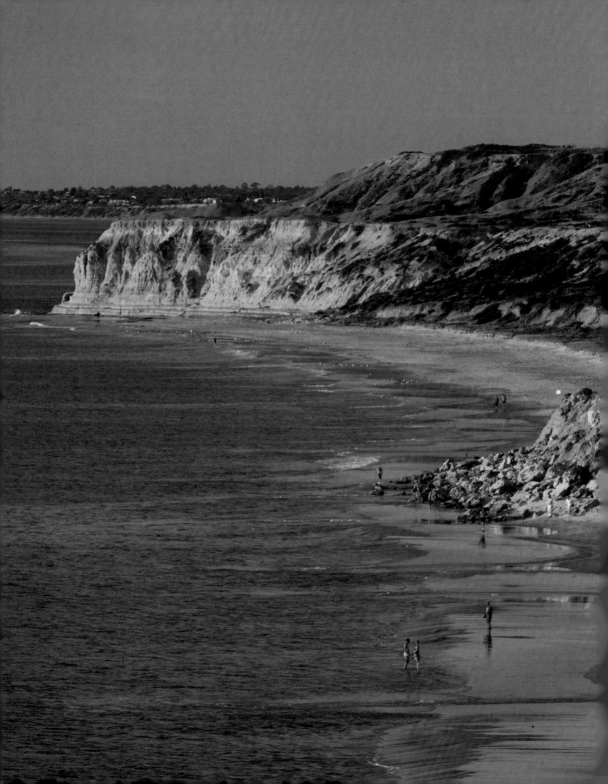

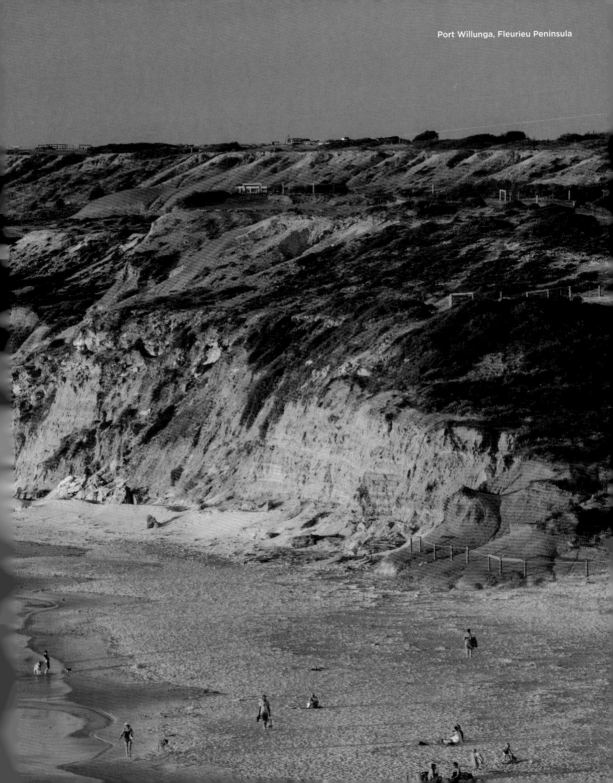

The Sugerloaf, Hallett Cove

Hallett Cove

This protected conservation site is one of the country's most important archeological and geological areas. Scattered on a suburban beach, 'erratic rocks' were carried from Port Eliott some 280 million years ago, while outstanding Permian glacial pavements run along the northern cliff tops. Evidence of indigenous life here also dates back 12,000 years.

Hallett Cove

Ce site de conservation protégé est l'une des zones archéologiques et géologiques les plus importantes du pays. Dispersés sur une plage de banlieue, des blocs erratiques ont été transportés de Port Eliott il y a environ 280 millions d'années, lorsque des routes glaciaires du Permien longeaient les sommets des falaises du nord. Les témoignages de la vie indigène ici remontent également à 12 000 ans.

Hallett Cove

Das Naturschutzgebiet ist eines der wichtigsten archäologischen und geologischen Gebiete des Landes. Über einen Vorortstrand verstreut finden sich hier zahlreiche „erratische Blöcke" genannte Findlinge, die vor etwa 280 Millionen Jahren von Port Eliott aus hierher getragen wurden, während sich entlang der nördlichen Klippengipfel Spuren eiszeitlicher Gletscher finden. Auch gibt es hier Belege für seit 12 000 Jahren existierende indigene Lebensformen.

Cala Hallett

Este sitio protegido de conservación
es una de las áreas arqueológicas y
geológicas más importantes del país.
Esparcidas en una playa suburbana, las
"rocas erráticas" fueron desplazadas
desde Port Eliott hace unos 280 millones
de años, mientras que los excepcionales
glaciares pérmicos se extienden a lo
largo de las cumbres de los acantilados
septentrionales. La evidencia de la
vida indígena aquí también se remonta
12.000 años en el tiempo.

Hallett Cove

Questo sito sotto tutela è una delle
più importanti aree archeologiche e
geologiche del paese. Sparse su una
spiaggia suburbana, "rocce erratiche"
sono state trasportate da Port Eliott
circa 280 milioni di anni fa, mentre resti
incredibili di ghiacciai permiani si trovano
lungo le cime delle scogliere a nord. Anche
qui le testimonianze di vita indigena
risalgono a 12.000 ann fa.

Hallett Cove

Dit beschermde natuurgebied is een
van de belangrijkste archeologische
en geologische gebieden van het land.
Verspreid over een strand in een buitenwijk
liggen 'grillige rotsen' die zo'n 280 miljoen
jaar geleden werden meegevoerd uit Port
Eliott, terwijl zich langs de noordelijke
kliptoppen sporen van een gletsjer uit de
ijstijd bevinden. Bewijs van inheems leven
gaat hier ook 12.000 jaar terug.

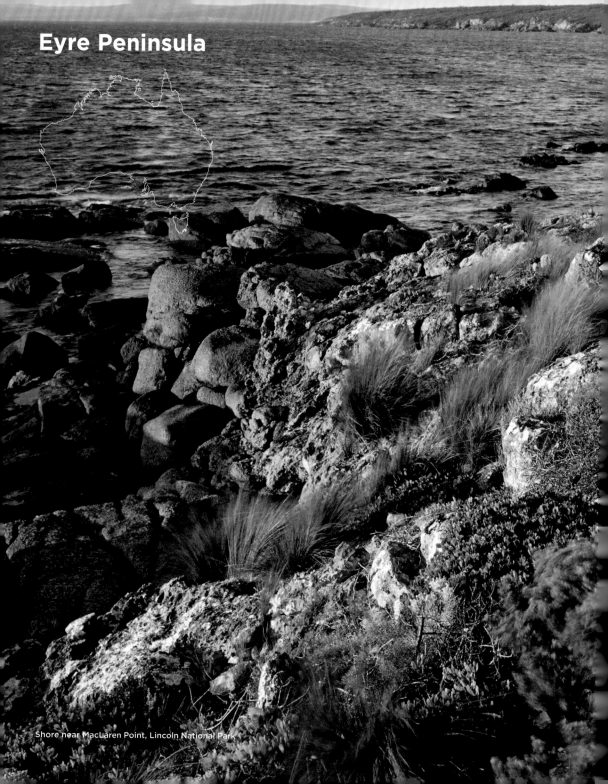

Eyre Peninsula

Shore near MacLaren Point, Lincoln National Park

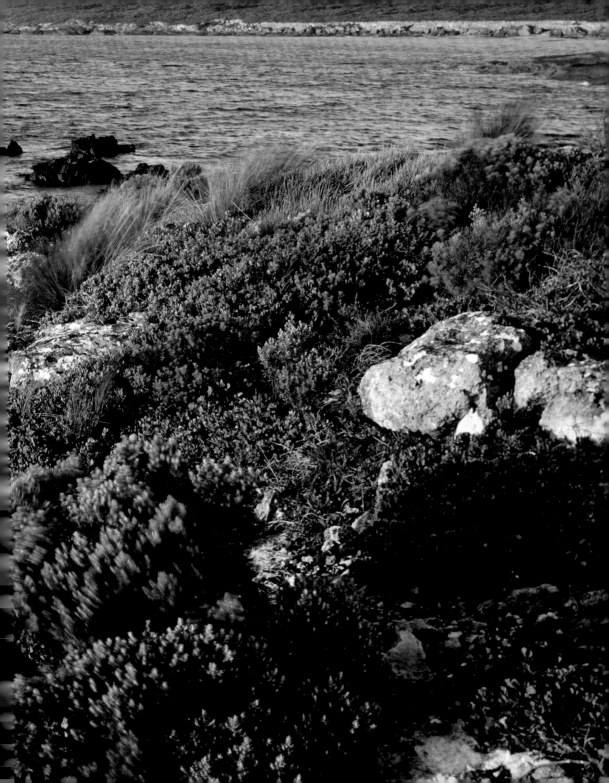

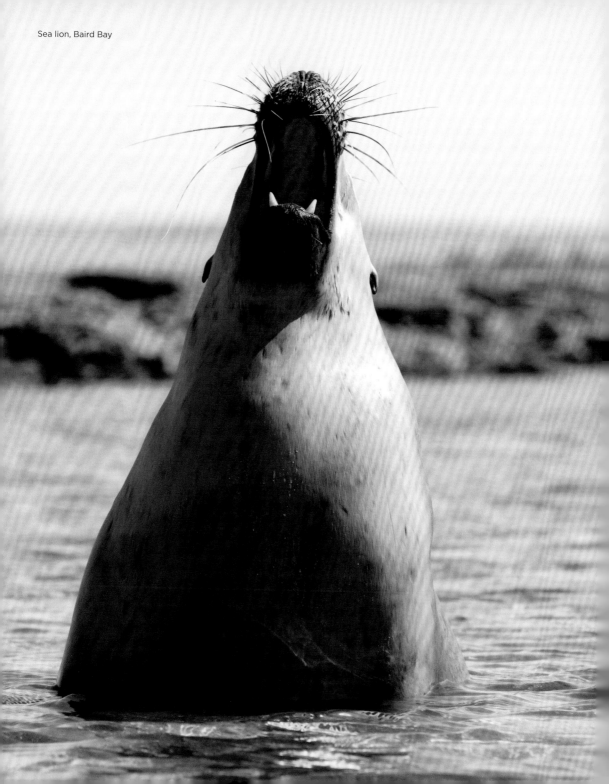

Sea lion, Baird Bay

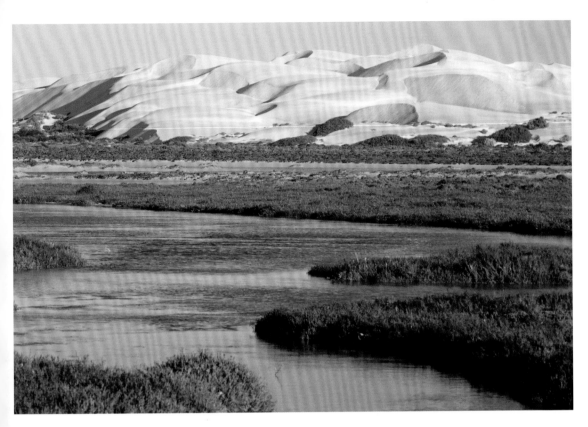

Cactus Beach

Eyre Peninsula

A heady mix of outback colours, epic beaches and teeming sea life—either wild and protected whales and seals or freshly caught tuna and oysters—make this remote southern corner a destination for cross-country roadtrippers, keen fishermen, intrepid surfers and those who come to explore its beautiful national parks.

Eyre Peninsula

Una embriagadora mezcla de colores del Outback, playas épicas y abundante vida marina, conballenas y focas salvajes protegidas o atunes y ostras recién capturados, hacen de este remoto rincón del sur un destino para los amantes de los viajes por carretera, pescadores entusiastas, surfistas intrépidos y aquellos que vienen a explorar sus hermosos parques nacionales.

Péninsule Eyre

Un mélange enivrant de couleurs de l'arrière-pays, de plages épiques et d'une vie marine foisonnante – baleines et phoques sauvages et protégés, thons et huîtres fraîchement pêchés – font de ce coin méridional isolé une destination privilégiée pour les randonneurs, les pêcheurs passionnés, les intrépides surfeurs ainsi que ceux qui viennent explorer ses magnifiques parcs nationaux.

Eyre Peninsula

Un mix inebriante di colori nell'entroterra, spiagge spettacolari e un ambiente marino ricco e variegato – tra cui si annoverano balene e foche, allo stato prado ma sotto tutela, ma anche tonni e ostriche – fanno di questo angolo remoto del sud una destinazione ideale per chi ama spostarsi di posto in posto in auto, per pescatori appassionati, intrepidi surfisti e chiunque voglia esplorare i suoi bellissimi parchi nazionali.

Eyre Peninsula

Eine berauschende Mischung aus Outback-Farben, atemberaubenden Stränden und wimmelndem Meeresleben – ob wilde und geschützte Wale und Robben oder frisch gefangener Thunfisch und Austern – machen diese abgelegene Ecke zu einem Ziel für abenteuerlustige Roadtripper, begeisterte Angler, unerschrockene Surfer und alle, die die schönen Nationalparks erkunden wollen.

Eyre Peninsula

Een onstuimige mix van outbackkleuren, adembenemende stranden en een krioelend zeeleven – wilde en beschermde walvissen en zeehonden, vers gevangen tonijn en oesters – maken van deze zuidelijke uithoek een bestemming voor avontuurlijke roadtrippers, enthousiaste vissers, onverschrokken surfers en iedereen die de prachtige nationale parken komt verkennen.

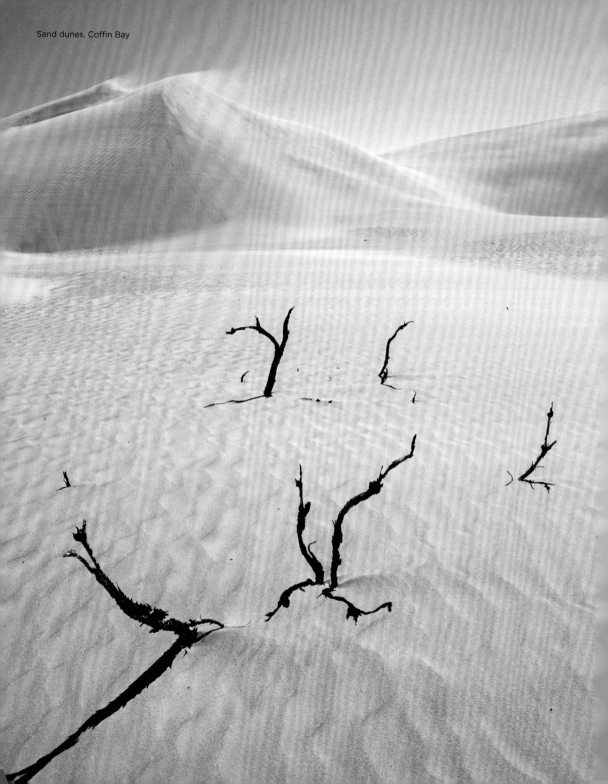
Sand dunes, Coffin Bay

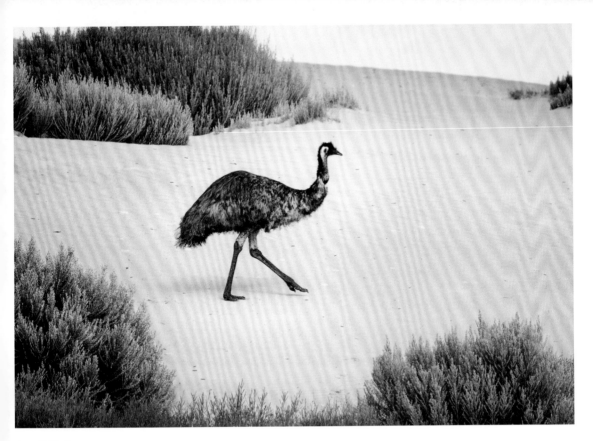

Emu, Coffin Bay

Geography & History
Surrounded on three sides by water, and bounded by the Gawler Ranges to the north, the Eyre Peninsula was first charted by Matthew Flinders in 1801. Port Augusta, Port Lincoln and Whyalla are the major towns. Some of Australia's best oysters come from here, while you can swim with tuna and great white sharks if you're really brave.

Geografía & Historia
Rodeada por tres lados de agua y limitada por la Cordillera Gawler al norte, la península de Eyre fue trazada por primera vez por Matthew Flinders en 1801. Port Augusta, Port Lincoln y Whyalla son las principales ciudades. Algunas de las mejores ostras de Australia provienen de aquí; También se puede nadar con atunes y tiburones blancos si uno se atreve.

Géographie & histoire
Bordée par l'eau sur trois côtés et délimitée au nord par les chaînes Gawler, la péninsule Eyre a été cartographiée pour la première fois par Matthew Flinders en 1801. Port Augusta, Port Lincoln et Whyalla en sont les principales villes. Certaines des meilleures huîtres d'Australie viennent d'ici, mais il est également possible pour les courageux d'y nager avec des thons et des grands requins blancs.

Geografia & storia
Circondata su tre lati dall'acqua e delimitata a nord dai Gawler Ranges, la penisola di Eyre fu riportata su mappa per la prima volta da Matthew Flinders nel 1801. Port Augusta, Port Lincoln e Whyalla sono le città principali. Alcune delle migliori ostriche australiane vengono da qui, mentre per chi è *davvero* coraggioso è possibile avventurarsi in nuotate tra tonni e squali.

Geographie & Geschichte
Die Eyre-Halbinsel, die auf drei Seiten vom Wasser umgeben ist und im Norden von den Gawler Ranges begrenzt wird, wurde 1801 erstmals von Matthew Flinders kartiert. Port Augusta, Port Lincoln und Whyalla sind die wichtigsten Städte. Einige der besten Austern Australiens kommen von hier. Wenn Sie wirklich mutig sind, können Sie mit Thunfischen und großen weißen Haien schwimmen.

Geografie & geschiedenis
Het schiereiland Eyre, aan drie zijden door water omgeven en in het noorden begrensd door de Gawler Ranges, werd in 1801 het voor het eerst in kaart gebracht door Matthew Flinders. Port Augusta, Port Lincoln en Whyalla zijn de belangrijkste steden. Sommige van de beste oesters van Australië komen hier vandaan, terwijl echt moedige mensen met tonijnen en grote witte haaien kunnen zwemmen.

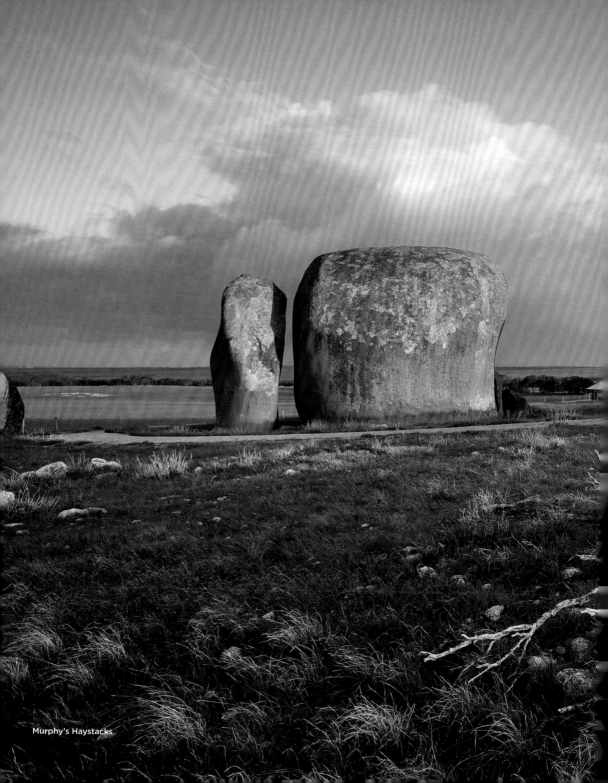

Murphy's Haystacks

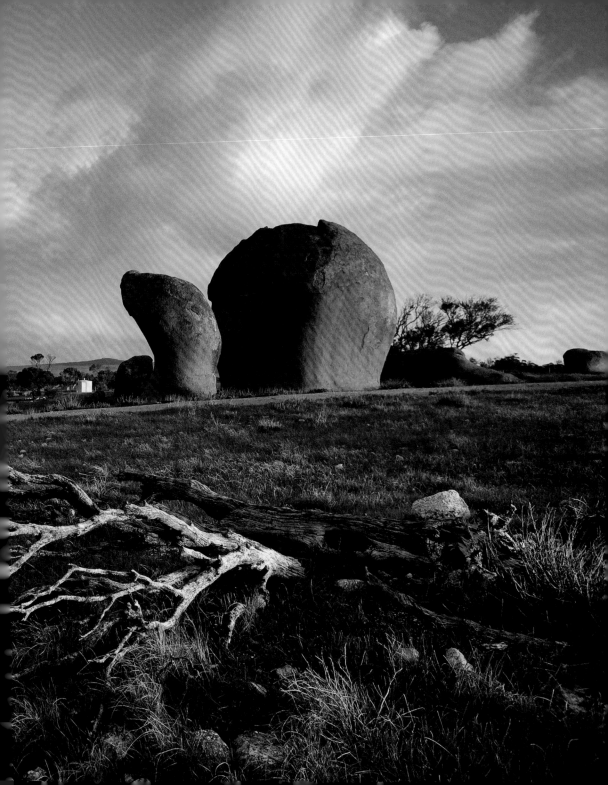

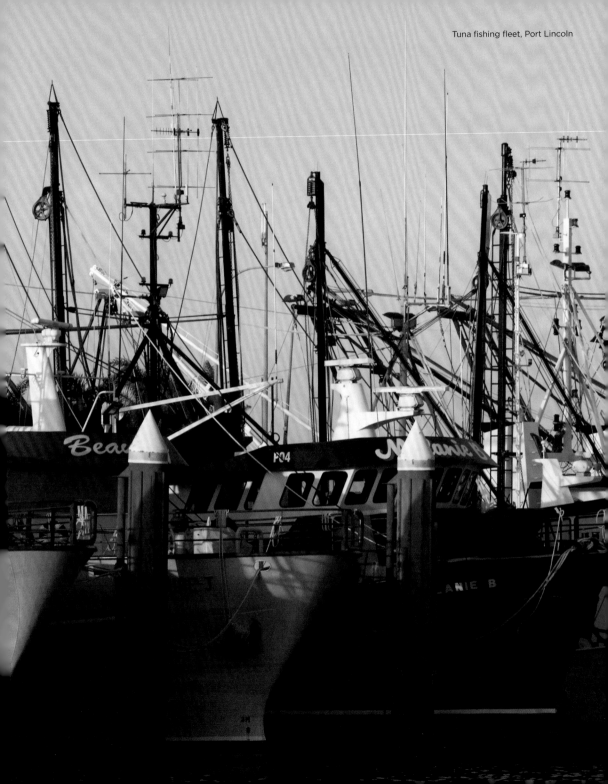
Tuna fishing fleet, Port Lincoln

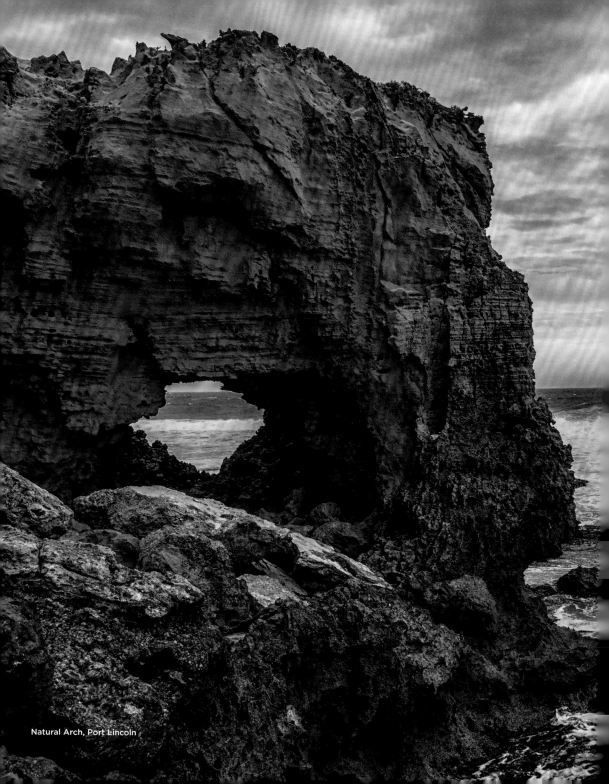

Natural Arch, Port Lincoln

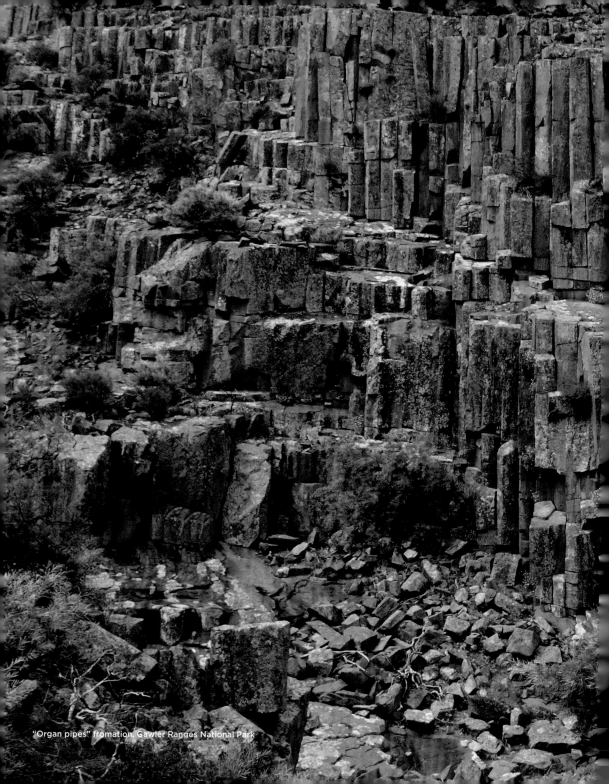

"Organ pipes" fromation, Gawler Ranges National Park

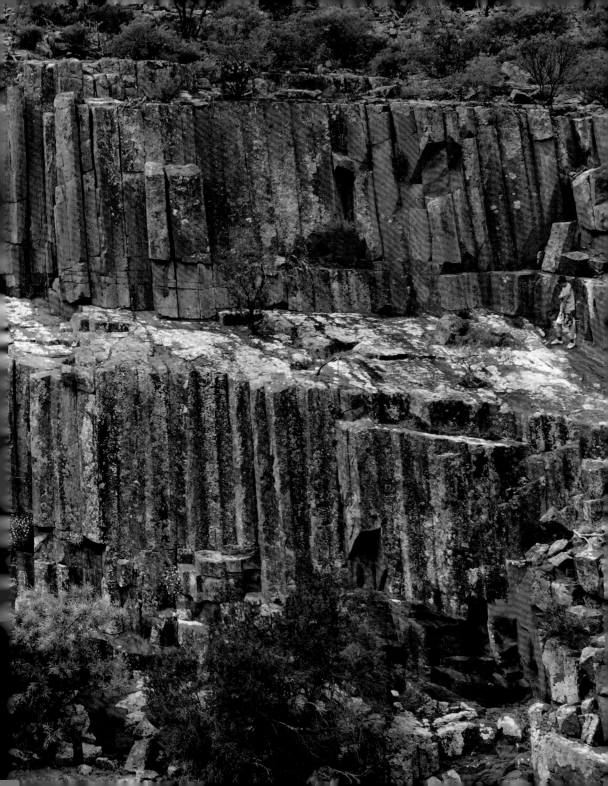

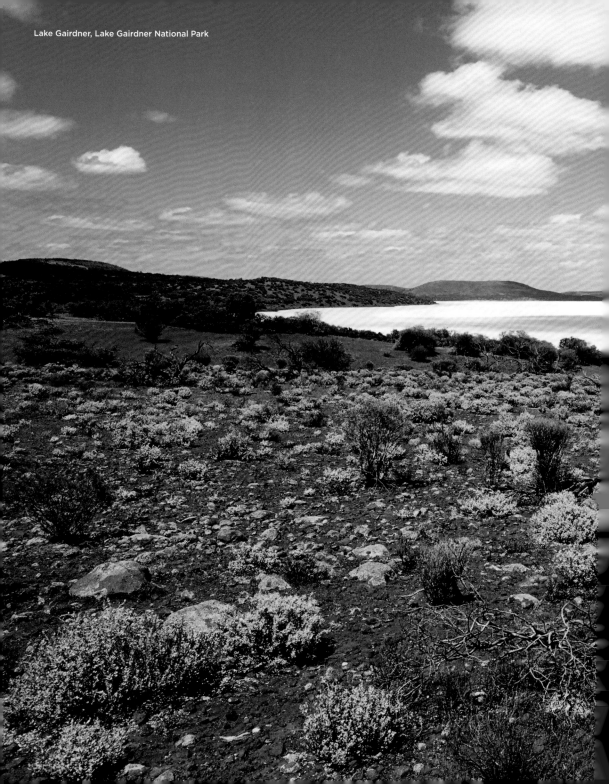
Lake Gairdner, Lake Gairdner National Park

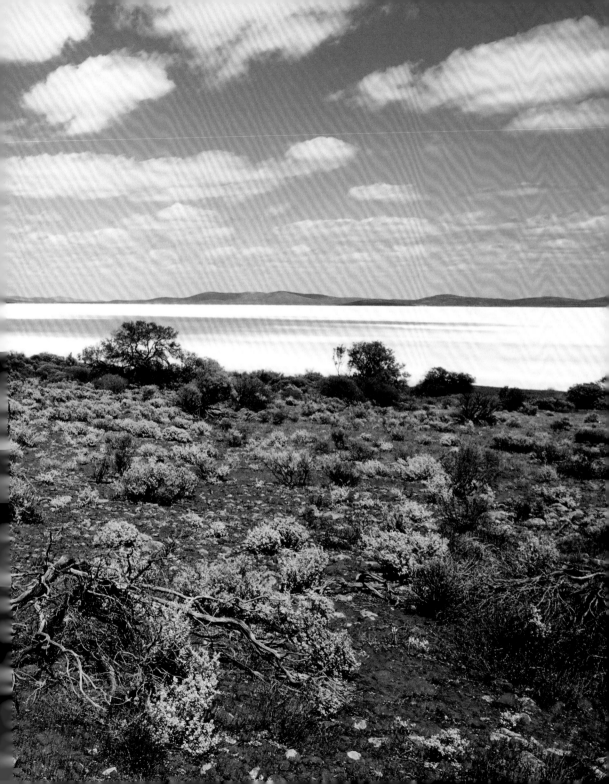

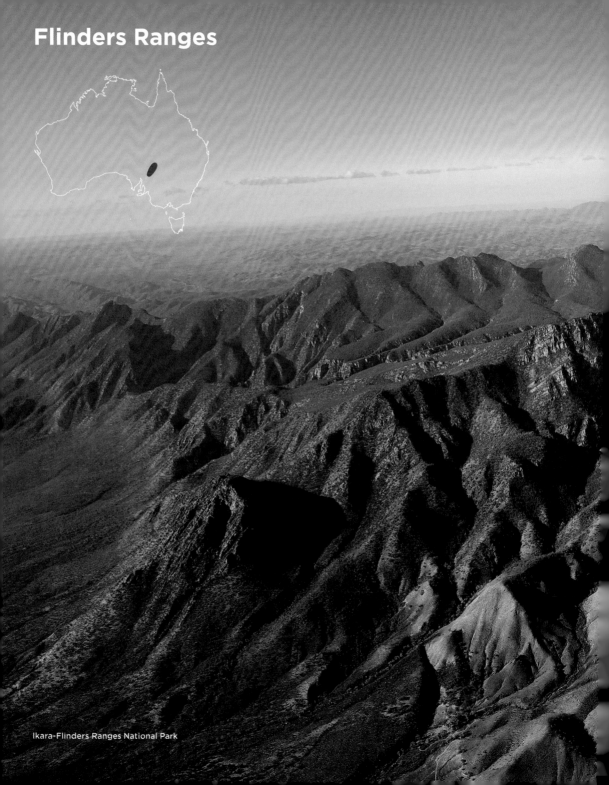

Flinders Ranges

Ikara-Flinders Ranges National Park

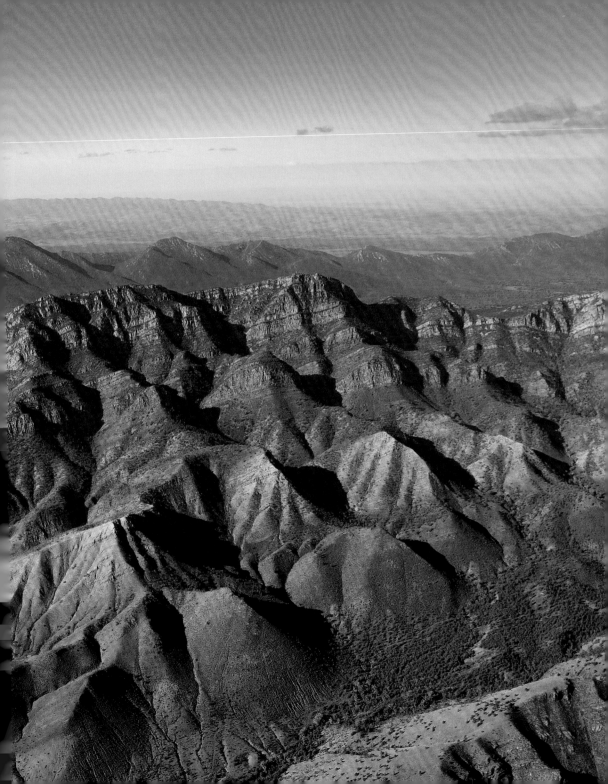

Alligator Gorge, Mount Remarkable National Park

Flinders Ranges

Covering 95,000 hectares some 400 km north of Adelaide, the Flinders Ranges, South Australia's largest mountain range, has recently undergone a name change—'Ikara' was added to the front of the park's name to reflect its long history as a 'meeting place' for the Adnyamathanha Aboriginal peoples of the area. Famous for its flora (such as cypress-pine, black oak, grevillea, lilies and ferns, the ranges are famous too for their wildlife—in the absence of dingoes, which have been eradicated from the area, red kangaroos, western grey kangaroos, euros, yellow-footed rock wallaby, echidnas, dunnarts and goannas all flourish.

Chaîne de Flinders

Couvrant 95 000 hectares à quelques 400 km au nord d'Adélaïde, les Flinders Ranges, la plus grande chaîne de montagnes d'Australie-Méridionale, ont récemment changé d'appellation – « Ikara », qui signifie « lieu de rencontre », a été ajouté à l'avant du nom du parc pour refléter sa longue histoire pour les peuples aborigènes Adnyamathanha de cette région. Célèbre pour sa flore (cyprès, chênes noirs, grevilliers, lys, fougères, etc.) et sa faune (si les dingos ont été éradiqués de la région, on y trouve des kangourous rouges, des kangourous gris de l'ouest, des wallaroos, des wallabies à pieds jaunes, des échidnés, des souris marsupiales et des goannas), les massifs sont en plein essor.

Flinders Ranges

Die Flinderskette, Südaustraliens größte Bergkette, die sich auf einer Fläche von 95 000 Hektar etwa 400 km nördlich von Adelaide erstreckt, hat kürzlich eine Namensänderung erfahren – „Ikara" wurde an die Vorderseite des Parks angefügt, um seine lange Geschichte als Treffpunkt der Adnyamathanha-Aborigines in diesem Gebiet widerzuspiegeln. Berühmt für seine Flora (wie Zypressenkiefer, Schwarz-Eiche, Grevillea, Lilien und Farne), wie für seine Wildfauna: Während die Dingos hier hier ausgerottet wurden, wimmelt es von roten Kängurus, Westlichen Grauen Riesenkängurus, Bergkängurus, gelbfüßigen Felswallabys, Ameisenigeln, Schmalfuß-Beutelmäusenund Waranen.

Emus, Ikara-Flinders Ranges National Park

Flinders Ranges

La cordillera Flinders es la mayor de Australia Meridional.Tiene una extensión de 95.000 hectáreas a unos 400 km al norte de Adelaida y recientemente ha sufrido un cambio de nombre: se ha añadido "Ikara" al principio del nombre del parque para reflejar su larga historia como "lugar de encuentro" de los pueblos aborígenes Adnyamathanha de la zona. Famosa por su flora (como el pino ciprés, el roble negro, el grevillea, los lirios y los helechos), la cordillera también es famosa por su fauna, salvando la excepción de los dingos, que han sido erradicados de la zona. Allí campan los canguros rojos, los canguros grises occidentales, el walabí de patas amarillas, las equidnas, los dunnarts y los goannas.

Flinders Ranges

Con una superficie di 95.000 ettari, i Flinders Ranges, la più grande catena montuosa del South Australia a circa 400 km a nord di Adelaide, hanno recentemente subito un cambio di nome – "Ikara" è stato aggiunto per riflettere la sua lunga storia come "luogo di incontro" delle popolazioni aborigene Adnyamathanha qui residenti. I Flinders Ranges sono famosi tanto per la flora (cipresso-pino, quercia nera, grevillea, gigli e felci) quanto per la fauna selvatica: mentre il dingo non è più presente in queste zone, spopolano qui i canguri rossi e quelli grigi occidentali, i wallaroo orientali, i wallaby delle rocce dai piedi gialli, gli echidna, i dunnart e i varani di Gould.

Flinders Ranges

De Flinders Ranges, de grootste bergketen van Zuid-Australië, beslaan 95.000 hectare en liggen zo'n 400 km ten noorden van Adelaide. Onlangs is het voorvoegsel 'Ikara' toegevoegd aan de naam om de lange geschiedenis als 'ontmoetingsplaats' voor de inheemse Adnyamathanhavolken in het gebied te weerspiegelen. De keten is niet alleen beroemd om zijn flora (zoals callitris, zwarte eik, grevillea, lelies en varens), maar ook om zijn wilde dieren. Bij gebrek aan dingo's, die uit het gebied verdreven zijn, gedijen rode reuzenkangoeroes, westelijke grijze reuzenkangoeroes, wallaroes, geelvoetkangoeroes, mierenegels, smalvoetbuidelmuizen en goanna's.

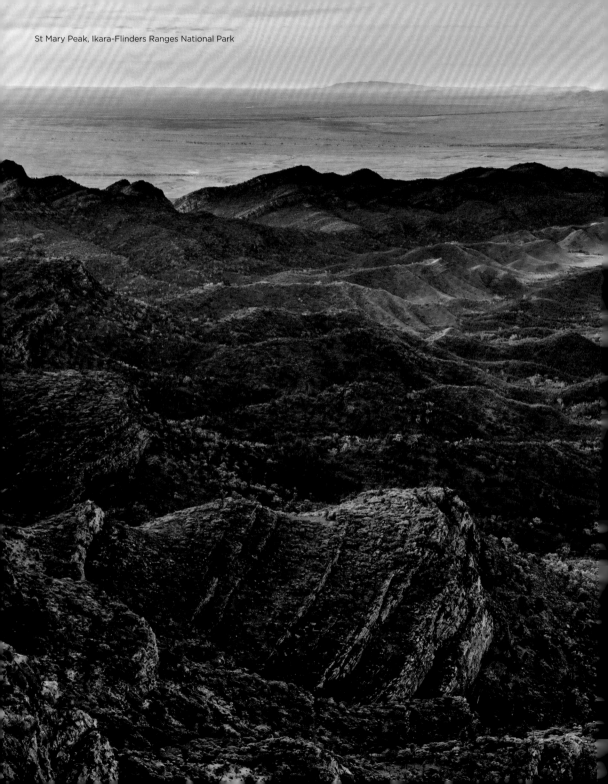
St Mary Peak, Ikara-Flinders Ranges National Park

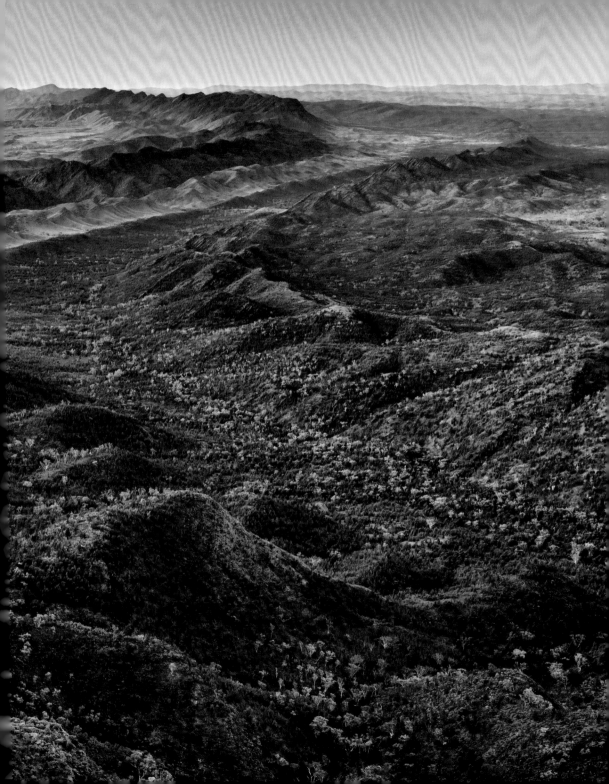

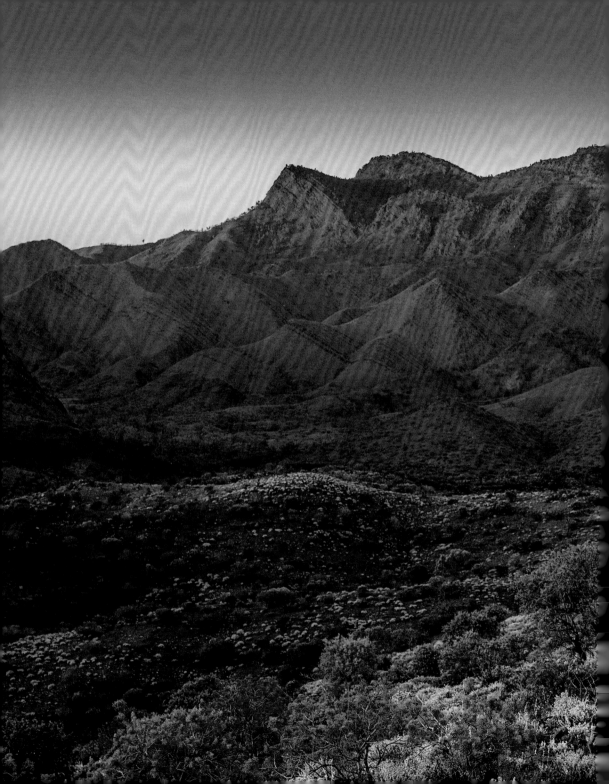

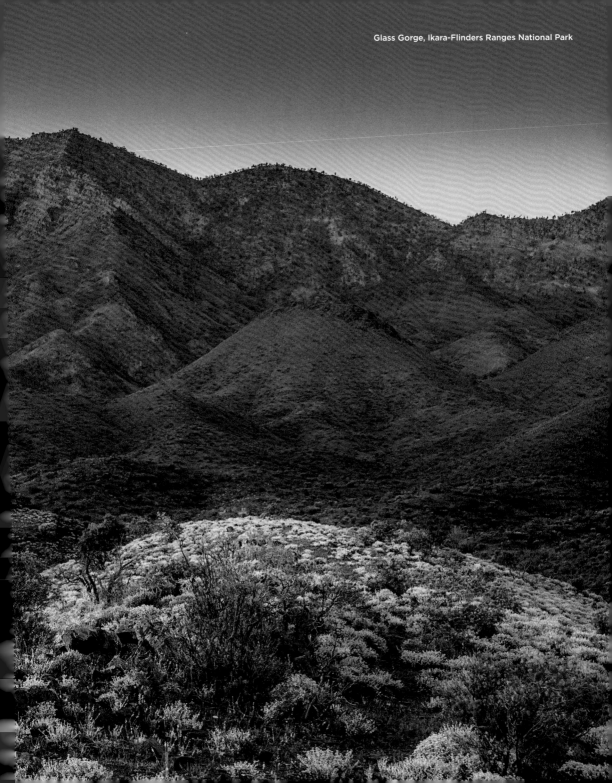

Glass Gorge, Ikara-Flinders Ranges National Park

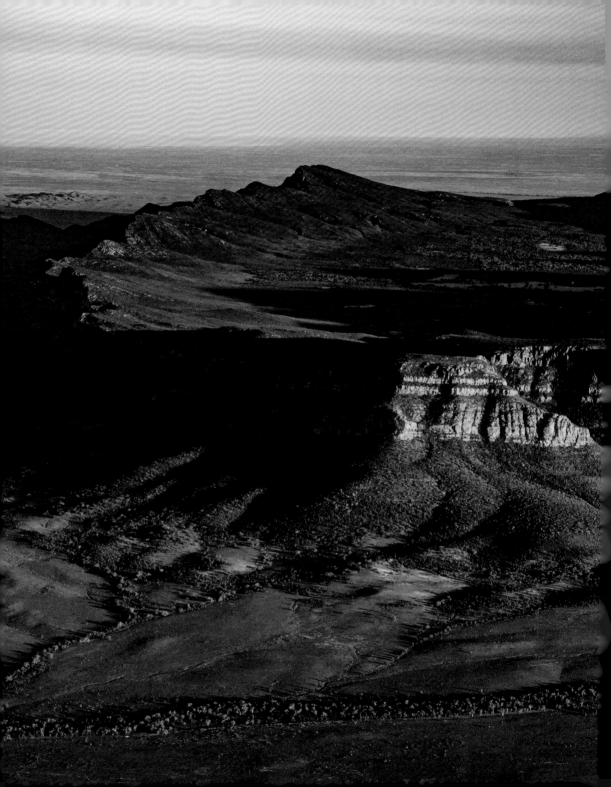

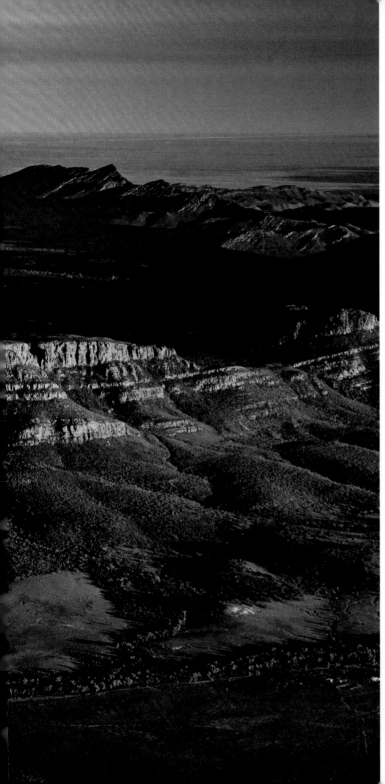

Wilpena Pound, Ikara-Flinders Ranges
National Park

Wilpena Pound

If it wasn't for Wilpena Pound, the
Ikara-Flinders Ranges would be just
another Outback mountain massif. This
extraordinary natural amphitheatre or bowl
covers 80 sq km and resembles a vast
volcanic caldera.

Wilpena Pound

Sans Wilpena Pound, la chaîne de
montagnes Ikara-Flinders ne serait qu'un
autre massif montagneux de l'Outback.
Cet extraordinaire amphithéâtre naturel
de 80 km² ressemble à une vaste caldeira
volcanique.

Wilpena Pound

Ohne den Wilpena Pound wären die Ikara-
Flinders Ranges nur ein weiteres Outback-
Bergmassiv. Dieser außergewöhnliche
Gebirgskessel in Form eines Amphitheaters
ist 80 Quadratkilometer groß und ähnelt
einer riesigen vulkanischen Caldera.

Wilpena Pound

Si no fuera por Wilpena Pound, la
cordillera Ikara-Flinders sería sólo otro
macizo montañoso más del Outback.
Este extraordinario anfiteatro o cuenca
natural tiene una superficie de 80 km² y se
asemeja a una vasta caldera volcánica.

Wilpena Pound

Se non fosse per Wilpena Pound, gli Ikara-
Flinders Ranges sarebbero solo un altro
massiccio montuoso dell'outback. Questo
straordinario anfiteatro naturale si estende
per 80 km² e assomiglia a una vasta
caldera vulcanica.

Wilpena Pound

Zonder Wilpena Pound zouden de
Ikara-Flinders Ranges gewoon weer
een outbackbergmassief zijn. Deze
buitengewone natuurlijke bergketel in de
vorm van een amfitheater beslaat 80 km²
en lijkt op een uitgestrekte vulkanische
caldera.

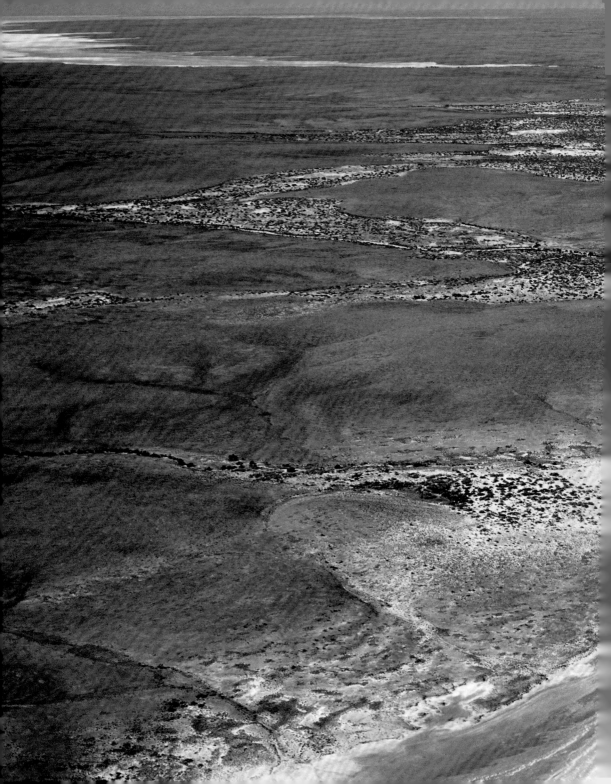

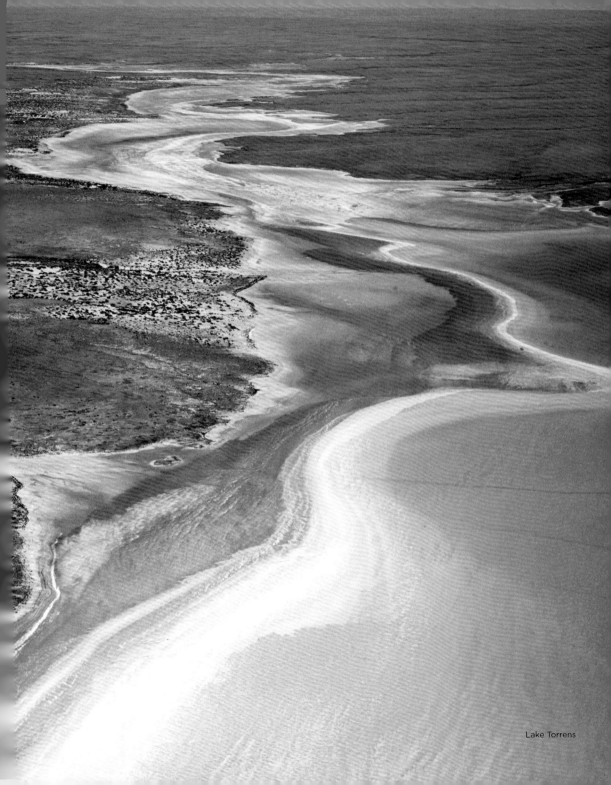

Lake Torrens

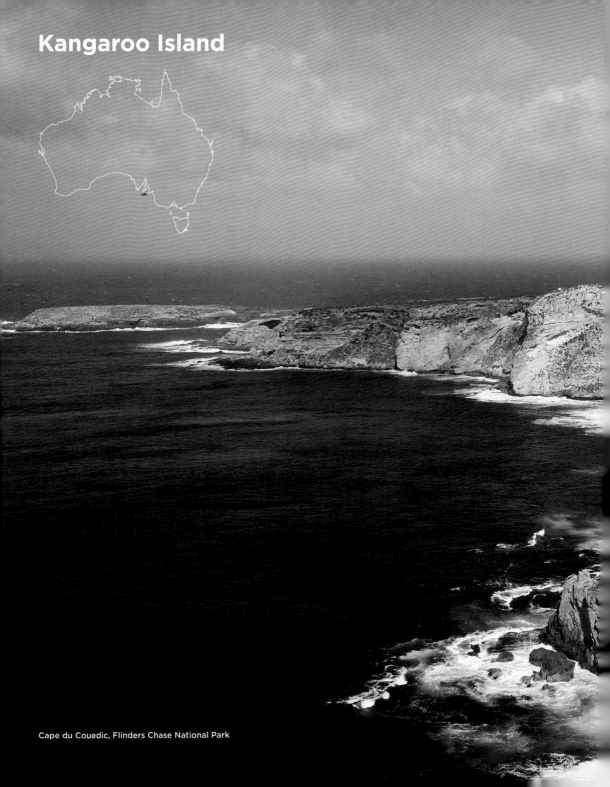

Kangaroo Island

Cape du Couedic, Flinders Chase National Park

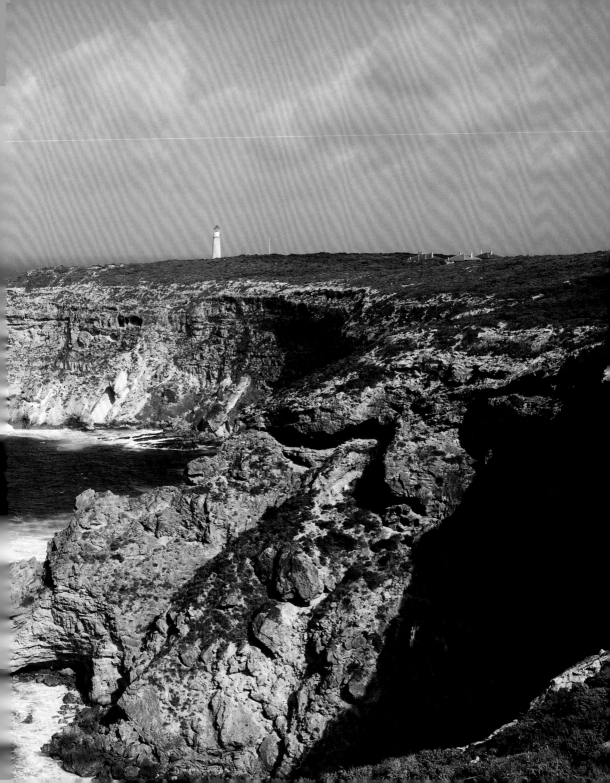

Road to Cape du Couedic, Flinders Chase National Park

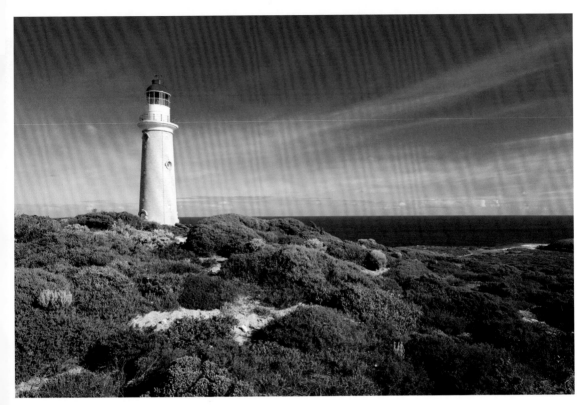

Cape du Couedic, Flinders Chase National Park

Kangaroo Island

Just over 100 km south of Adelaide, this large island is almost entirely given over to national parks. It's natural beauty and wildlife draws visitors and while one of Australia's most luxurious resorts perches on a cliff, it remains a laid back, unfussy place, where locals get around on bicycles and towering cliffs, big sky and endless ocean fill the horizon.

Kangaroo Island

À un peu plus de 100 km au sud d'Adélaïde, cette grande île est presque entièrement consacrée aux parcs nationaux. Sa beauté naturelle, sa faune et sa flore attirent les visiteurs et bien que l'on y trouve l'une des stations balnéaires les plus luxueuses d'Australie, perchée sur une falaise, elle reste un endroit calme et tranquille, où les habitants se déplacent à bicyclette et où les falaises imposantes, le ciel immense et l'océan sans fin remplissent l'horizon.

Kangaroo Island

Circa 100 km südlich von Adelaide liegt die große Insel, die fast vollständig den Nationalparks überlassen ist. Trotz der vielen Besucher und dem auf einer ihrer Klippen gelegenen luxuriösesten Resorts Australiens, bleibt es ein entspannter, schnörkelloser Ort, an dem Einheimische auf Fahrrädern unterwegs sind; turmhohen Klippen, der weite Himmel und das endlose Meer füllen den Horizont.

Kangaroo Island

A poco más de 100 km al sur de Adelaida, esta gran isla está casi totalmente dedicada a albergar parques nacionales. Su belleza natural y su vida salvaje atraen a los visitantes y, aunque sobre un acantilado se ubique uno de los complejos turísticos más lujosos de Australia, sigue siendo un lugar tranquilo, donde los lugareños se desplazan en bicicleta y se contemplan acantilados altísimos, el gran cielo y el océano interminable llenan el horizonte.

Kangaroo Island

Poco più di 100 km a sud di Adelaide, questa grande isola è quasi interamente un parco nazionale. La bellezza naturale e la fauna selvatica attirano numerosi visitatori e nonostante qui si trovi uno dei resort più lussuosi dell'Australia, arroccato su una scogliera, questo rimane un luogo rilassato e semplice, dove la gente del posto si muove in bicicletta e le alte scogliere, il cielo immenso e l'oceano sconfinato riempiono l'orizzonte.

Kangaroo Island

Dit grote eiland iets meer dan 100 km ten zuiden van Adelaide wordt bijna volledig bedekt door nationale parken. Ondanks de vele bezoekers en het op een klip gelegen luxeuze resort, een van de chicste Australië, blijft dit een ontspannen, ongecompliceerde plek, waar de lokale bevolking fietst en aan de horizon torenhoge klippen, een weidse lucht en eindeloze oceaan te zien zijn.

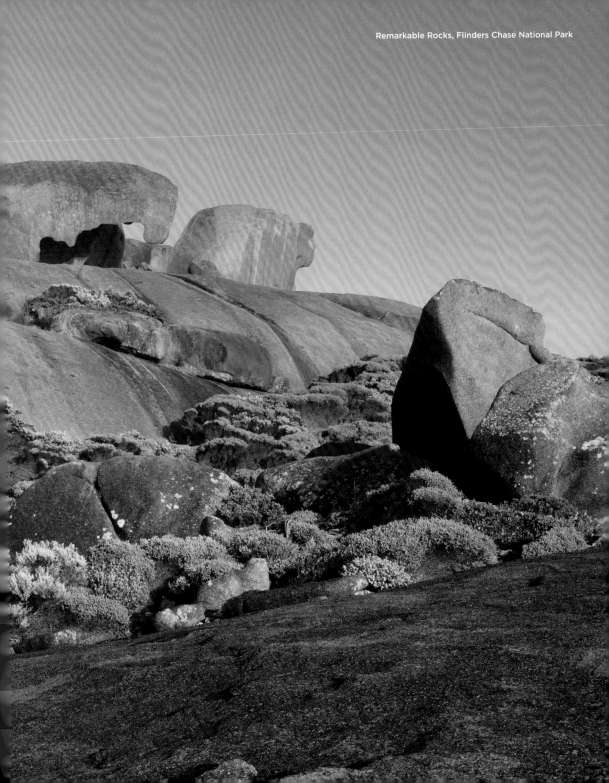

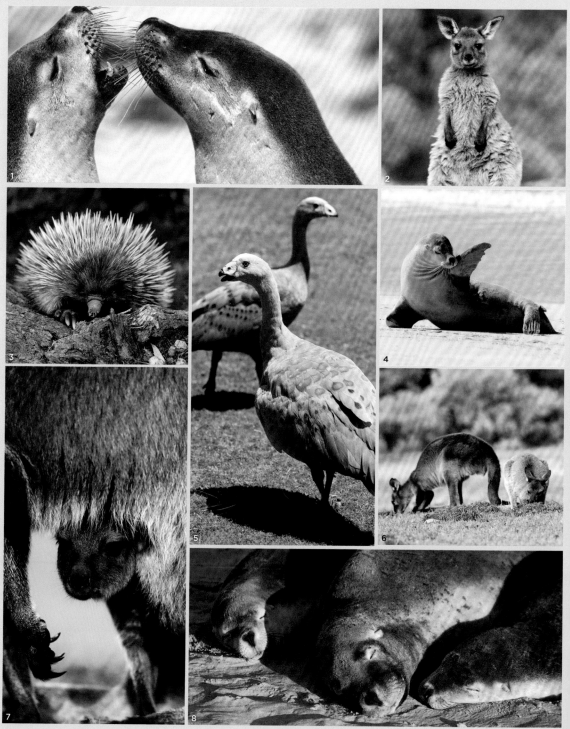

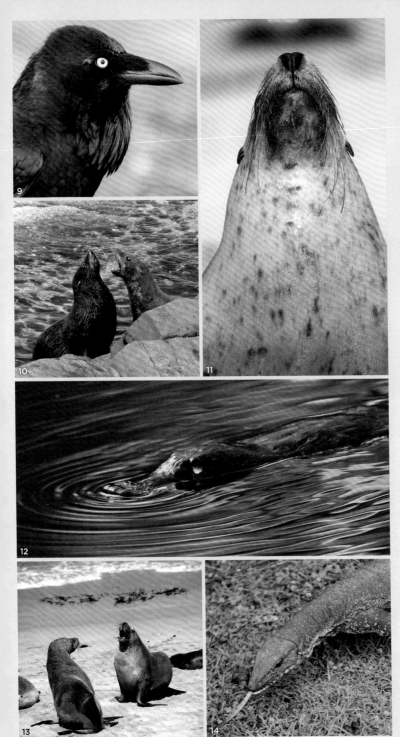

1, 4, 8, 11, 13 Australian Sea Lions; Lions de mer australiens ; Australische Seelöwen; Leones marinos australianos; Leoni marini australiani; Australische zeeleeuwen

2, 6, 7 Western Grey Kangaroo; Kangourous gris de l'Ouest ; Westliches Graues Riesenkänguru; Canguro gris occidental; Canguri grigi occidentali; Westelijke grijze reuzenkangoeroe

3 Short-beaked Echidna; Échidné à nez court ; Kurzschnabeligel; Equidna de hocico corto; Echidna a becco corto; Australische mierenegel

5 Cape Barren Geese; Céréopse cendré ; Kap-Karrengans; Ganso ceniciento; Oche di Cape Barren; Oenderganzen

9 Australian Raven; Corbeau australien ; Australischer Rabe; Cuervo australiano; Corvo australiano; Australische raaf

10 Australian Fur-Seal; Otaries à fourrure australiennes ; Australische Pelzrobbe; Oso marino australiano; Otarie orsine australiane; Kaapse pelsrob

12 Platypus; Ornithorynque ; Schnabeltier; Ornitorrinco; Ornitorinco; Vogelbekdier

14 Rosenberg's Monitor; Varan de Rosenberg ; Rosenberg-Waran; Monitor de Rosenberg; Varano di Rosenberg; Rosenberg's varaan

425

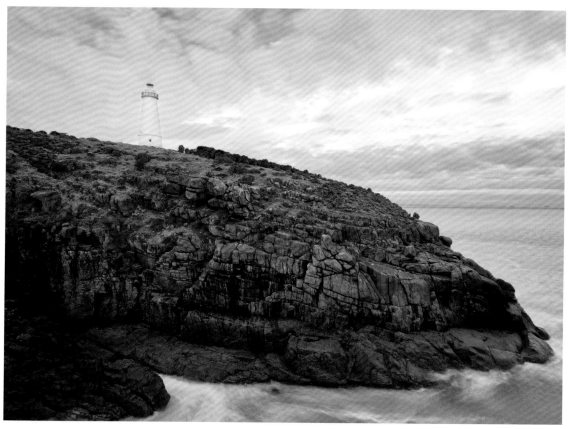

Cape Willoughby Lighthouse

Cape Willoughby
The island's oldest lighthouse, established in 1852, sits on this rocky headland and its early 20th-century lighthouse keeper's cottage welcomes guests to overnight. Climbing to the lighthouse's top rewards with views of Backstairs Passage and the occasional sighting of large schools of salmon, along with humpback, southern right and killer whales.

Cape Willoughby
Le plus ancien phare de l'île, établi en 1852, se trouve sur ce promontoire rocheux. Le chalet du gardien, qui date du début du xx^e siècle, accueille les visiteurs pour la nuit. L'ascension jusqu'au sommet du phare vaut grandement la peine : on y découvre une vue sur le Backstairs Passage et on peut occasionnellement y observer de grands bancs de saumons, ainsi que de baleines à bosse, d'orques et de baleines franches australes.

Cape Willoughby
Auf dieser felsigen Landzunge befindet sich der älteste Leuchtturm der Insel, eingeweiht 1852. Sein Leuchtturmwärterhäuschen aus dem frühen 20. Jahrhundert lädt die Gäste zur Übernachtung ein. Erklimmt man die Spitze des Turms, wird es mit einem Blick auf die Backstairs Passage belohnt und gelegentlich auch auf große Lachsschwärme, Buckelwale, Südkaper und Schwertwale.

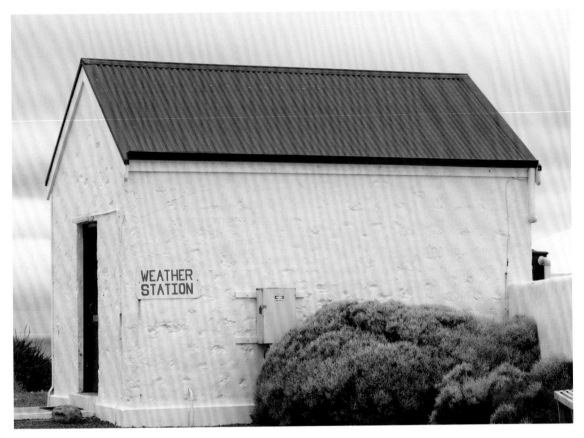

Weather station, Cape Willoughby

Cape Willoughby

El faro más antiguo de la isla, establecido en 1852, se encuentra en este rocoso cabo y su casa de campo de principios del siglo XX da la bienvenida a los huéspedes a pasar la noche. Subir a la cima es la recompensa del faro con vistas del estrecho Backstairs Passage y con el avistamiento ocasional de grandes bancos de salmones, ballenas jorobadas, ballenas francas australes y orcas.

Cape Willoughby

Il faro più antico dell'isola, fondato nel 1852, si trova su questo promontorio roccioso, dove il cottage del guardiano del faro, risalente agli inizi del XX secolo, accoglie gli ospiti per la notte. Salendo verso la cima del faro si possono ammirare il Backstairs Passage e avvistare occasionalmente grandi banchi di salmoni, ma anche megattere, balene franche australi e orche.

Cape Willoughby

De oudste vuurtoren van het eiland, opgericht in 1852, staat op deze rotsachtige landtong en het vroeg-20e-eeuwse vuurtorenwachtershuisje verwelkomt gasten voor de nacht. Een klim naar naar de top van de vuurtoren beloont u met een uitzicht op de Backstairs Passage. Af en toe kunt u grote scholen zalm spotten, samen met bultruggen, zuidkapers en orka's.

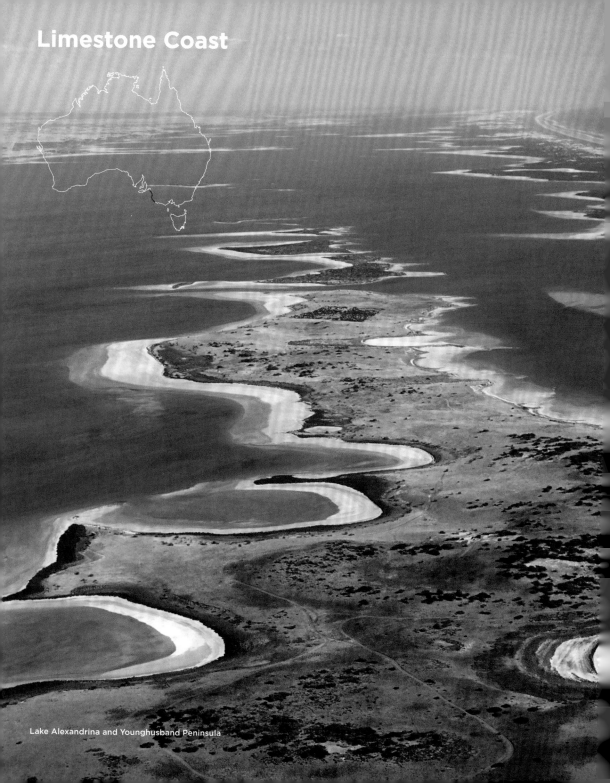

Limestone Coast

Lake Alexandrina and Younghusband Peninsula

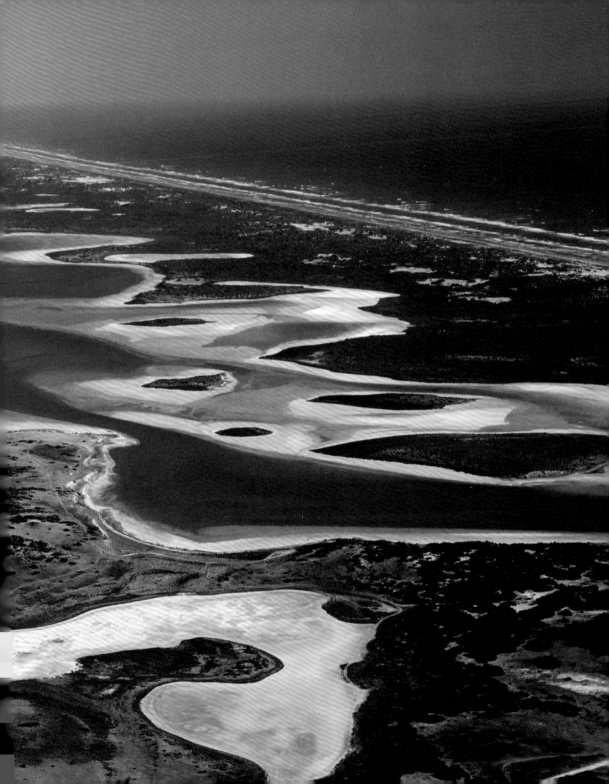

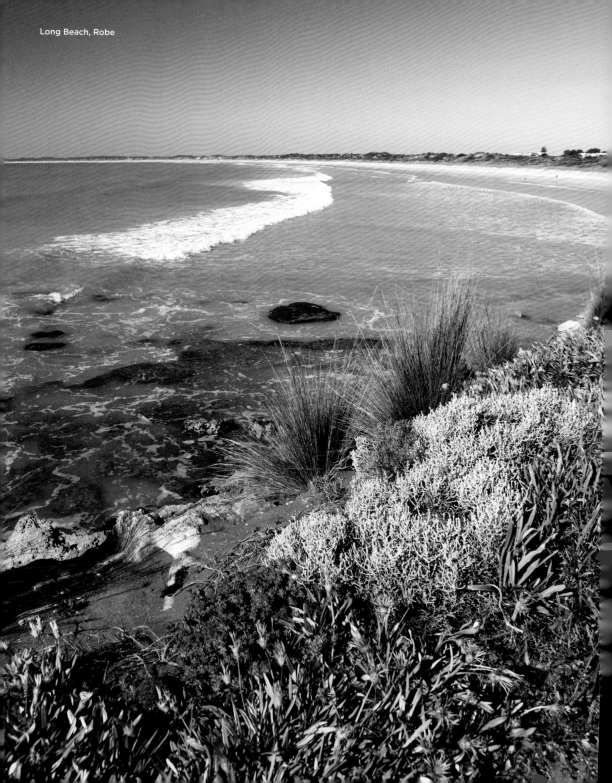

Long Beach, Robe

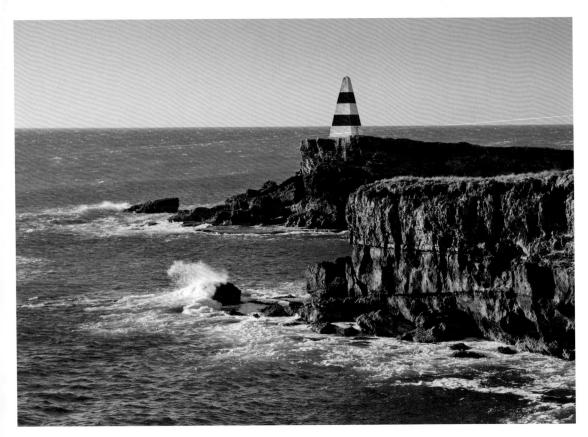

The Obelisk, Cape Dombey, Robe

Limestone Coast
Often passed right through by weary drivers, this southern region is rich with geological intrigue and gentle beauty. Sinkholes, caves and crater lakes add another dimension to its typically Australian coastal mix of surf beaches and fishing hamlets. Its rich soil also produce some of South Australia's most excellent red wines.

Limestone Coast
A menudo atravesada por conductores agotados, esta región del sur es rica en misterios geológicos y posee una belleza suave. Los pozos hundidos, las cuevas y los lagos de cráteres añaden otra dimensión a su típica mezcla costera australiana de playas de surf y aldeas de pescadores. Su tierra rica también produce algunos de los vinos tintos más excelentes de Australia Meridional.

Limestone Coast
Souvent traversée par des conducteurs fatigués, cette région méridionale d'une beauté douce est pleine de mystères géologiques. Des gouffres, grottes et lacs de cratère donnent une autre dimension à son mélange de plages de surf et de hameaux de pêche typiquement australiens. Son sol riche produit également certains des meilleurs vins rouges d'Australie-Méridionale.

Limestone Coast
Spesso attraversata da contadini che procedono lentamente, questa regione meridionale di una delicata bellezza è molto ricca da un punto di vista geologico. Sprofondi, grotte e laghi craterici danno un nuovo spessore al tipico mix costiero australiano di spiagge da surf e villaggi di pescatori. Il suo ricco suolo produce anche alcuni degli eccellenti vini rossi del South Australia.

Limestone Coast
Diese südliche Region, die oft von müden Fahrern nur durchquert wird, ist reich an geologischen Attraktionen und sanfter Schönheit. Senklöcher, Höhlen und Kraterseen verleihen der typisch australischen Küstenmischung aus Surfstränden und Fischerdörfern eine weitere Dimension. Auf dem fruchtbaren Boden wachsen einige der besten Rotweine Südaustraliens.

Limestone Coast
Deze zuidelijke regio, waar vermoeide automobilisten zo snel mogelijk doorheen rijden, is rijk aan geologische intriges en zachte schoonheid. Zinkputten, grotten en kratermeren voegen een extra dimensie toe aan de typisch Australische kustmix van surfstranden en vissersdorpjes. De rijke bodem brengt ook enkele van de beste rode wijnen van Zuid-Australië voort.

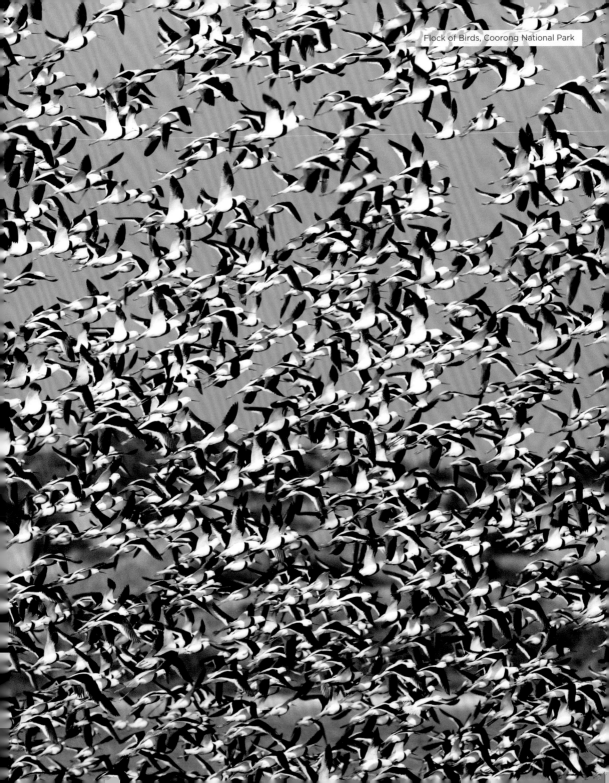

Flock of Birds, Coorong National Park

Arched Rock Formation, Robe

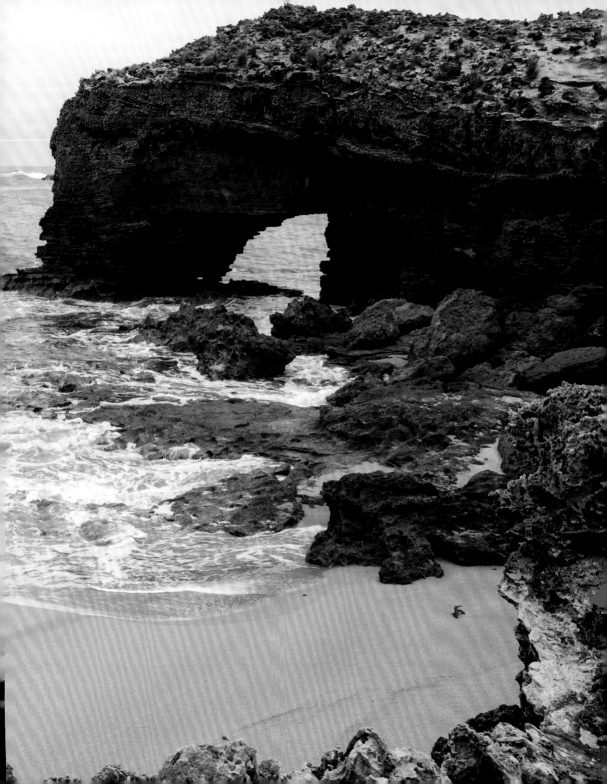

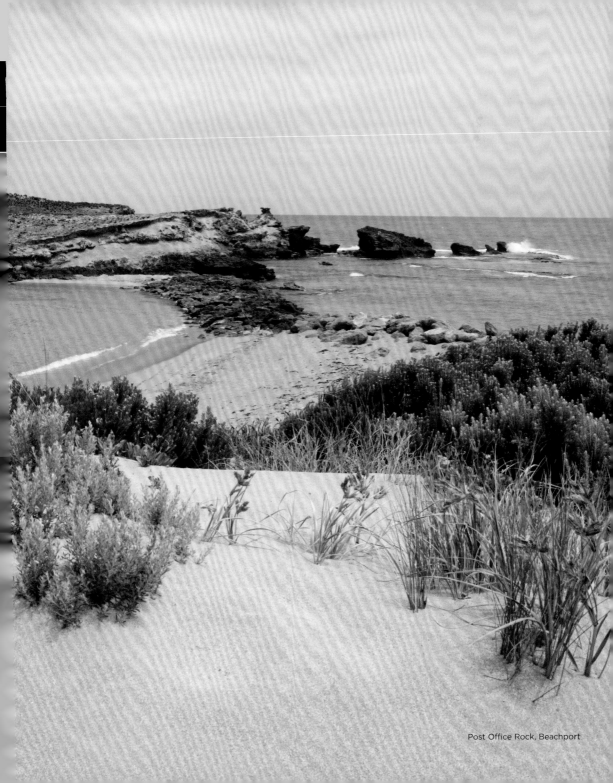

Post Office Rock, Beachport

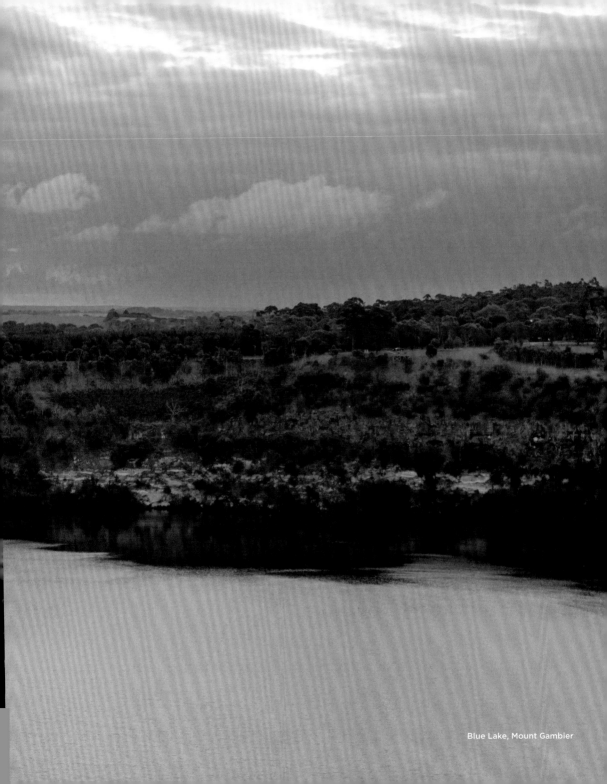
Blue Lake, Mount Gambier

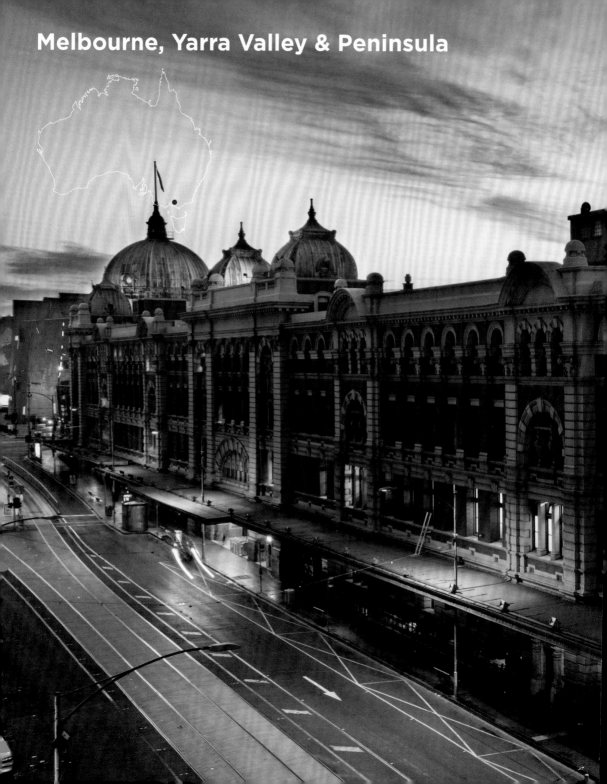

Melbourne, Yarra Valley & Peninsula

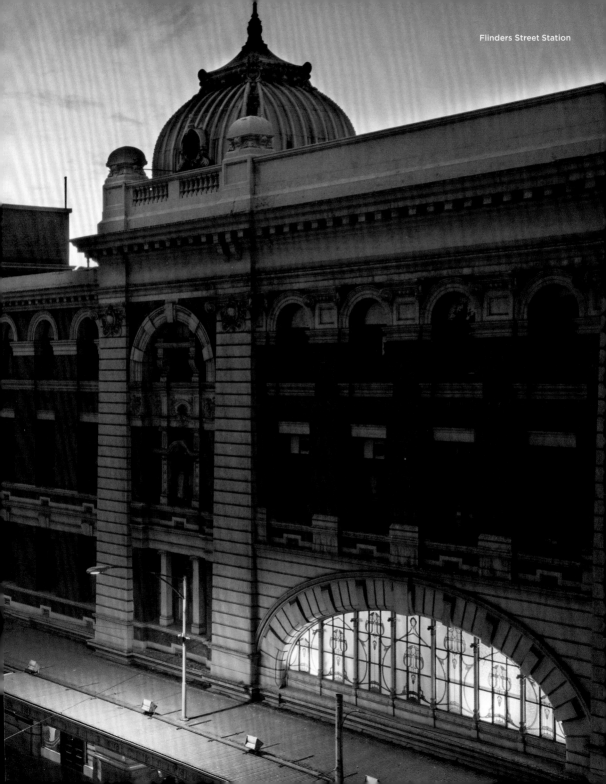

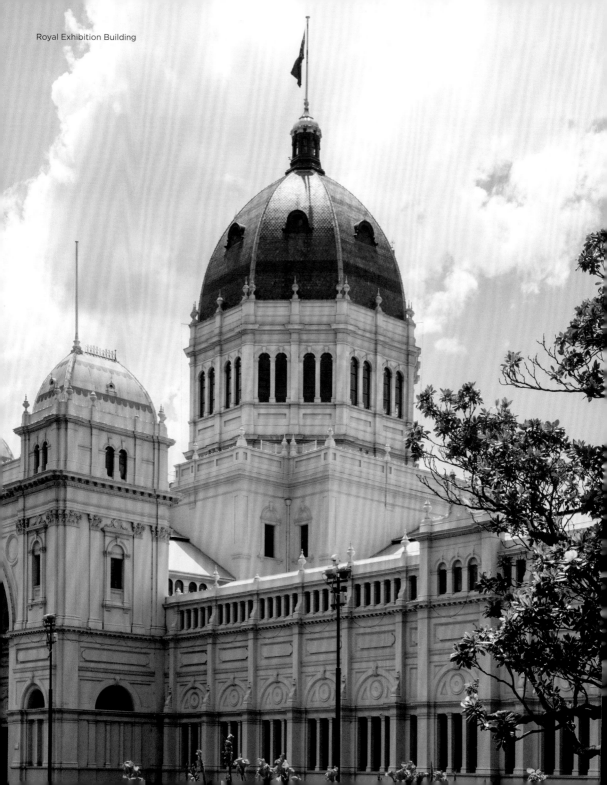

Royal Exhibition Building

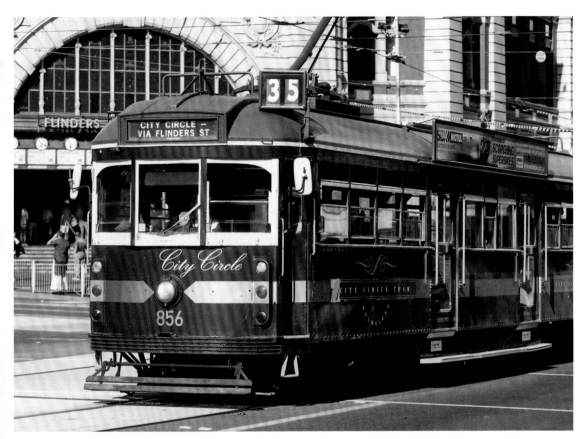

Traditional Tram, Flinders Street Station

Melbourne, Yarra Valley & Peninsula

Australia's second largest metropolis grew rich and powerful due to the 19th-century gold rush. Today it's also the country's most self-consciously European city, where cafes and wine bars fill laneways and locals rarely dress down. Rustic cellar doors dot the Yarra Valley and the Peninsula.

Melbourne, Yarra Valley & Peninsula

La segunda metrópolis más grande de Australia se hizo rica y poderosa debido a la fiebre del oro del siglo XIXa. Hoy en día es también la ciudad más europea del país, donde los cafés y bares de vinos llenan las calles y los locales suelen vestir de gala. Las puertas rústicas de las bodegas salpican el valle del Yarra y la península.

Melbourne, Yarra Valley & the Peninsula

La deuxième plus grande métropole d'Australie est devenue riche et puissante grâce à la ruée vers l'or du XIXᵉ siècle. Aujourd'hui, c'est également la ville la plus européenne du pays, où les cafés et les bars à vin remplissent les ruelles et où les habitants cultivent un style décontracté. Des caves rustiques parsèment la vallée de Yarra comme la péninsule.

Melbourne, Yarra Valley e la Peninsula

La seconda metropoli australiana per grandezza è diventata ricca e potente grazie alla corsa all'oro del XIX secolo. Oggi è anche la città australiana che più risente dell'influsso europeo, dove bar e wine bar riempiono i vicoli e la gente del posto raramente sceglie un abbigliamento casual. Le rustiche cancellate delle cantine punteggiano la Yarra Valley e la Peninsula.

Melbourne, Yarra Valley & Peninsula

Australiens zweitgrößte Metropole wurde durch den Goldrausch des 19. Jahrhunderts reich und mächtig. Heute ist es die selbstbewussteste europäischste Stadt des Landes, in der Cafés und Weinstuben die Gassen füllen und sich die Einheimischen selten leger kleiden. Rustikale Weinkellereien prägen das Yarra-Tal und die Halbinsel.

Melbourne, Yarra Valley & Peninsula

De op een na grootste metropool van Australië werd rijk en machtig door de 19e-eeuwse goudkoorts. Tegenwoordig is het ook de meest Europese stad van het land, waar cafés en wijnbars de lanen vullen en de lokale bevolking zich zelden casual kleedt. Rustieke wijnkelders bepalen de Yarra Valley en het schiereiland.

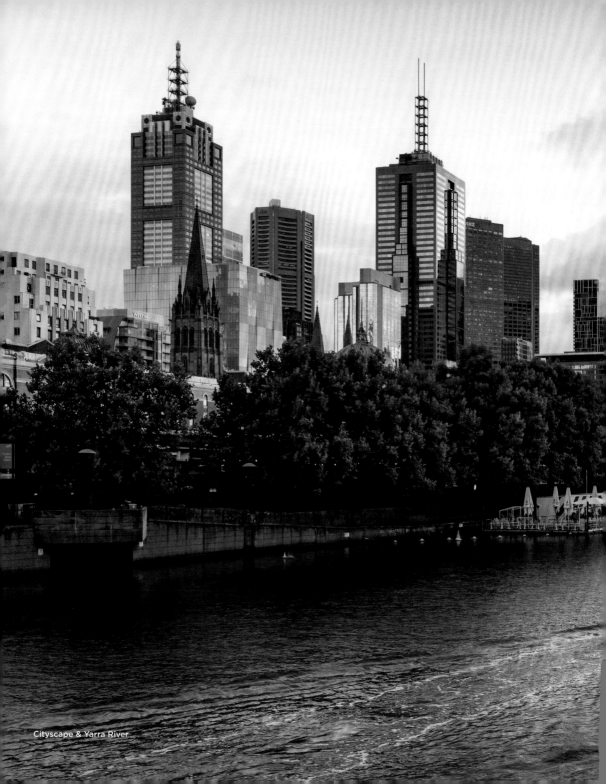
Cityscape & Yarra River

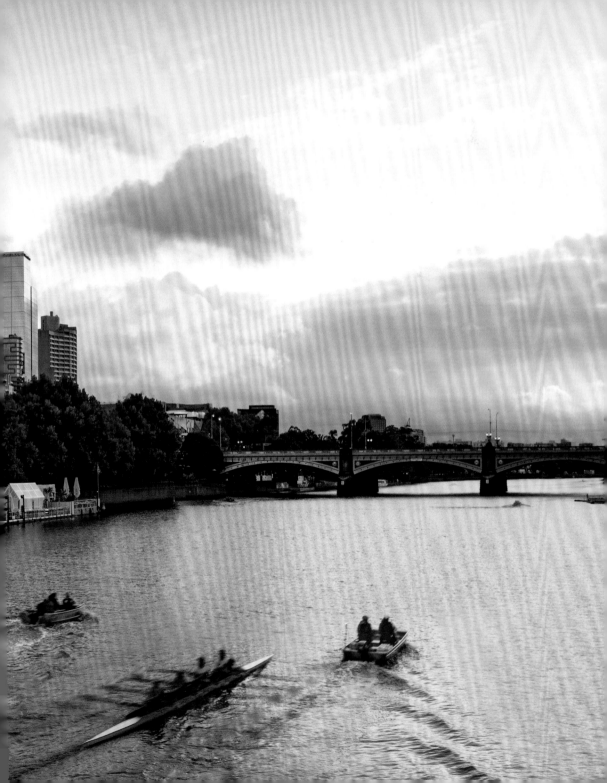

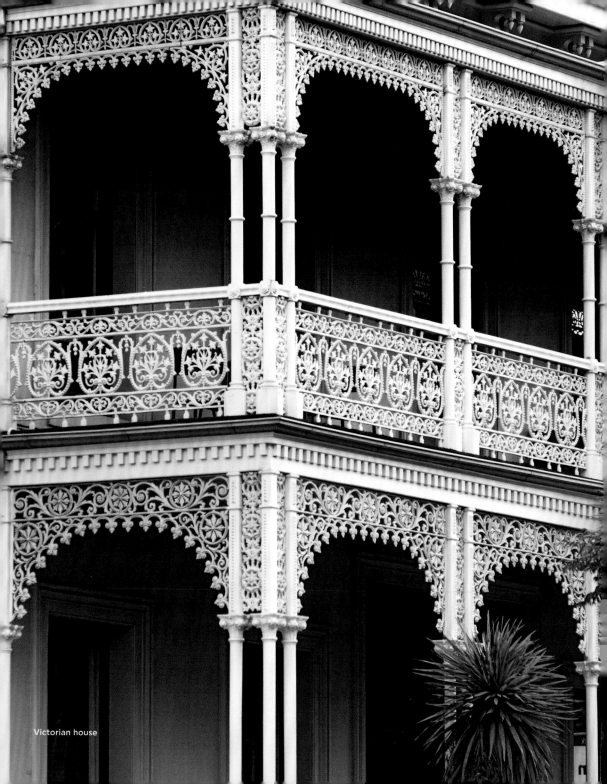

Victorian house

Victorian house

Victorian Architecture

Melbourne's gold rush wealth and population surge resulted in a flurry of housing development during the 1880s and gave birth to an extravagant 'boom style' architecture. Rooflines are often hidden by elaborate parapets, polychrome brickwork is common, and ornate filigree balconies, constructed from cast iron, are ubiquitous.

Arquitectura victoriana

La riqueza de la fiebre del oro y el aumento de la población de Melbourne dieron lugar a un aluvión de desarrollo inmobiliario durante la década de 1880 y nació una extravagante arquitectura, elestilo "boom". Las líneas del tejado suelen estar ocultas por elaborados parapetos, es común el uso de ladrillos policromados, y los balcones de filigrana ornamentados, construidos de hierro fundido, son elementos omnipresentes.

Architecture victorienne

La ruée vers l'or de Melbourne comme l'augmentation de la richesse et de la population ont donné lieu à un très important développement de l'immobilier dans les années 1880 ainsi qu'à la naissance d'une architecture extravagante surnommée « Boom style ». On y trouve des toitures souvent cachées par des parapets élaborés, des briques colorées et des balcons en filigrane ornés, construits en fonte.

Architettura vittoriana

La ricchezza di Melbourne, dovuta alla corsa all'oro, e l'impennata demografica che ne è conseguita hanno dato vita negli anni '80 dell'Ottocento a un boom edilizio e a un'architettura stravagante. I tetti sono spesso nascosti da elaborati parapetti, la muratura in mattoni policromi è molto diffusa e i balconi di ghisa finemente decorati sono onnipresenti.

Viktorianische Architektur

Melbournes Reichtum durch den Goldrausch die und Bevölkerungszunahme führten in den 1880er Jahren zu einem Aufschwung der Wohnbebauung und brachten eine extravagante Architektur hervor. Dachluken werden oft durch aufwendige Brüstungen verdeckt, mehrfarbiges Mauerwerk ist üblich, und aus Gusseisen gebaute, filigran verzierte Balkone sind allgegenwärtig.

Victoriaans Architectuur

Melbournes rijkdom door de goudkoorts en de bevolkingstoename resulteerde rond 1880 in een opleving van de huizenbouw en bracht en extravagante architectuur voort. Daklijnen werden vaak verborgen achter uitgebreide borstweringen, meerkleurig metselwerk is gebruikelijk en sierlijke gietijzeren balkons zijn alomtegenwoordig.

Queen Victoria Market

Fresh vegetables at Melbourne's famous Queen Victoria

Victoria Market

This 19th-century market is still in use today selling fruit and vegetables, meat, seafood and delicatessen goods, as well as a section of clothing and craft. Spread over two full city blocks, it's the largest open-air market in the southern hemisphere. Established in the 1860s, its historic structure includes an intact and atmospheric 19th-century shopping street.

Victoria Market

Este mercado del siglo XIX se sigue utilizando hoy en día para la venta de frutas y verduras, carnes, mariscos y productos selectos, también tiene una sección de ropa y artesanía. Distribuido en dos manzanas completas, es el mercado al aire libre más grande del hemisferio sur; se estableció en la década de 1860 y su estructura histórica conserva intacta una evocadora calle comercial del siglo XIX.

Marché Victoria

Ce marché du XIXᵉ siècle est encore utilisé aujourd'hui pour la vente de fruits et légumes, de viande, de fruits de mer et de charcuterie, mais aussi de vêtements et d'artisanat. Réparti sur deux pâtés de maisons, c'est le plus grand marché en plein air de l'hémisphère sud. Sa structure historique, établie dans les années 1860, comprend une rue commerçante du XIXᵉ siècle restée intacte et toujours baignée d'une atmosphère particulière.

Victoria Market

Questo mercato ottocentesco è ancora oggi utilizzato per la vendita di frutta e verdura, carni, frutti di mare e prodotti di salumeria, oltre ad avere una sezione per l'abbigliamento e l'artigianato. Distribuito su due blocchi, è il più grande mercato all'aperto dell'emisfero sud. Costruita nel 1860, la sua struttura storica comprende una strada per lo shopping ottocentesca intatta e suggestiva.

Victoria Market

Dieser Markt aus dem 19. Jahrhundert findet bis heute statt und bietet Obst und Gemüse, Fleisch, Meeresfrüchte und Feinkost sowie Stände mit Kleidung und Handwerk. Verteilt auf zwei volle Stadtblöcke ist es der größte Open-Air-Markt der südlichen Hemisphäre. Die in den 1860er-Jahren gegründete historische Struktur umfasst eine intakte und stimmungsvolle Einkaufsstraße aus dem 19. Jahrhundert.

Victoria Market

Op deze 19e-eeuwse markt worden nog altijd groenten en fruit, vlees, zeevruchten en delicatessen, evenals kleding en handwerkproducten verkocht. De over twee volle stadsblokken uitgestrekte markt is de grootste openluchtmarkt op het zuidelijk halfrond. Hij is opgericht tussen 1860 en 1870 en omvat een intacte en sfeervolle 19e-eeuwse winkelstraat.

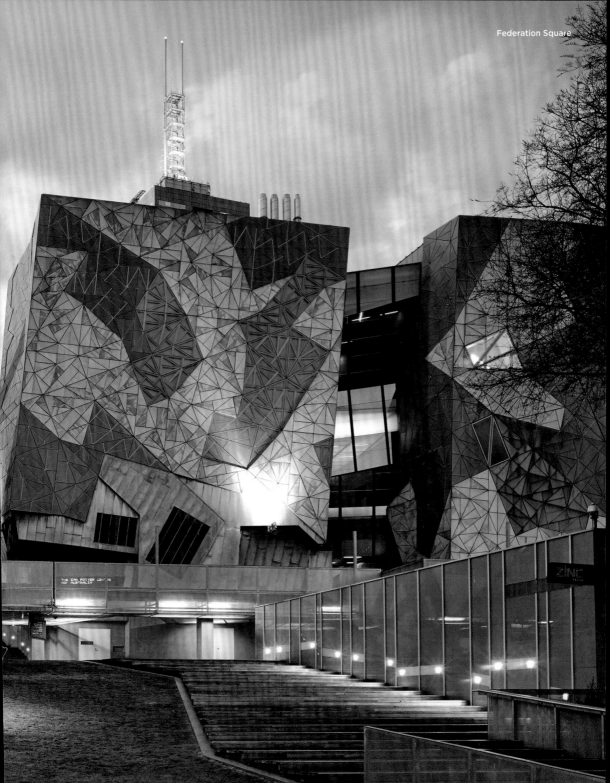

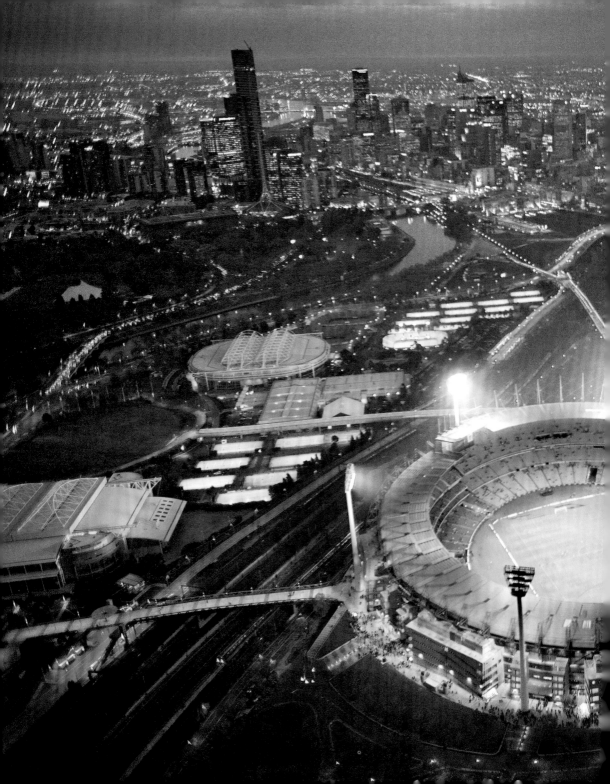

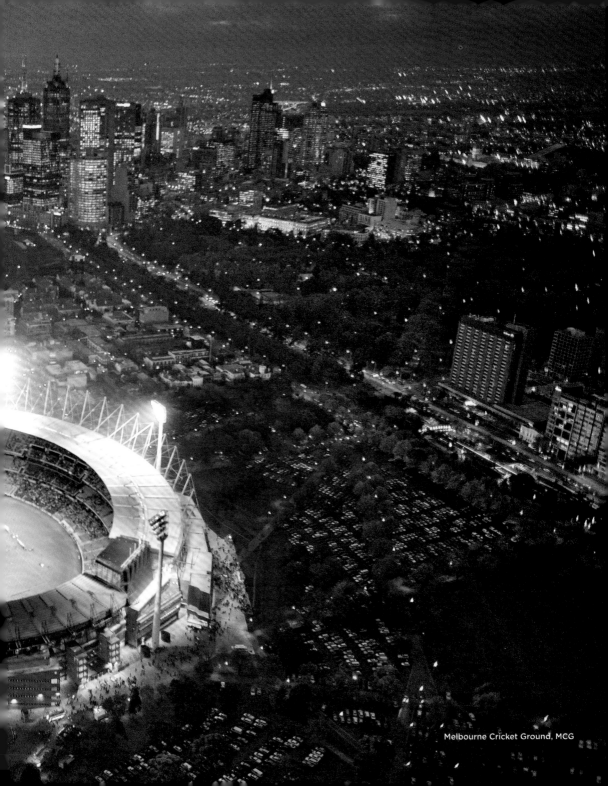

Melbourne Cricket Ground, MCG

RUGBY LEAGUE

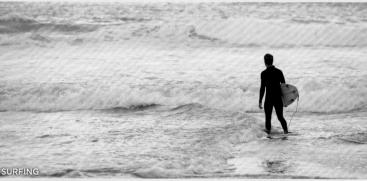
SURFING

BOWLING

WHITE WATER RAFTING

KITESURFING

CRICKET, THE ASHES, AUSTRALIA V ENGLAND

PARAGLIDING

ROCK CLIMBING

SAILING

HORSE RACING, BETOOTA

AUSTRALIAN FOOTBALL, AFL

KAYAKING

KITESURFING

Sport

Australia is a sports mad nation and embraces many sporting and fitness pursuits. Australian Rules football is played nationally and was inspired by indigenous games, while rugby still holds sway in NSW and Queensland. Cricket and soccer are also hugely popular. Aquatic sports—surfing, fishing and swimming—are a daily way of life for many coastal Australians.

Sport

L'Australie est une nation folle de sport et ses habitants s'adonnent à de nombreuses activités physiques. Le football, pratiqué selon les règles australiennes, est joué à l'échelle nationale et s'inspire des jeux autochtones, tandis que le rugby domine toujours en Nouvelle-Galles du Sud et dans le Queensland. Le cricket et le soccer sont également très populaires. Les sports aquatiques – surf, pêche et natation – sont un mode de vie pour les nombreux Australiens vivant près des côtes.

Sport

Australien ist eine sportverrückte Nation. Australian Football wird im ganzen Land gespielt und wurde von indigenen Spielen inspiriert, während Rugby in NSW und Queensland immer noch die Oberhand behält. Cricket und Fußball sind ebenfalls sehr beliebt. Wassersportarten – Surfen, Angeln und Schwimmen – gehören für viele Australier an der Küste zu ihrem Alltag.

Deporte

Australia es una nación muy aficionada a los deportes y abarca muchas actividades deportivas y de acondicionamiento físico. El fútbol australiano se juega a nivel nacional y se inspira en los juegos autóctonos, mientras que el rugby sigue dominando en Nueva Gales del Sur y Queensland. El cricket y el fútbol también son muy populares. Los deportes acuáticos, como surf, pesca y natación, son una forma de vida diaria para muchos australianos de la costa.

Sport

L'Australia è una nazione amante dello sport e sono tante le attività sportive e di fitness qui offerte. Il football australiano viene giocato a livello nazionale ed è stato ispirato da giochi indigeni, mentre il rugby domina ancora nel Nuovo Galles del Sud e nel Queensland. Anche il cricket e il calcio sono molto popolari. Per gli australiani che vivono nei pressi della costa sport acquatici quali il surf, la pesca e il nuoto fanno parte della vita quotidiana.

Sport

Australië is gek op sport en er worden veel sporten beoefend. Australian football wordt in het hele land gespeeld en werd geïnspireerd door inheemse sporten, terwijl rugby nog steeds bovenaan staat in NSW en Queensland. Ook cricket en voetbal zijn enorm populair. Watersporten – surfen, vissen en zwemmen – horen voor veel Australische kustbewoners bij het dagelijks leven.

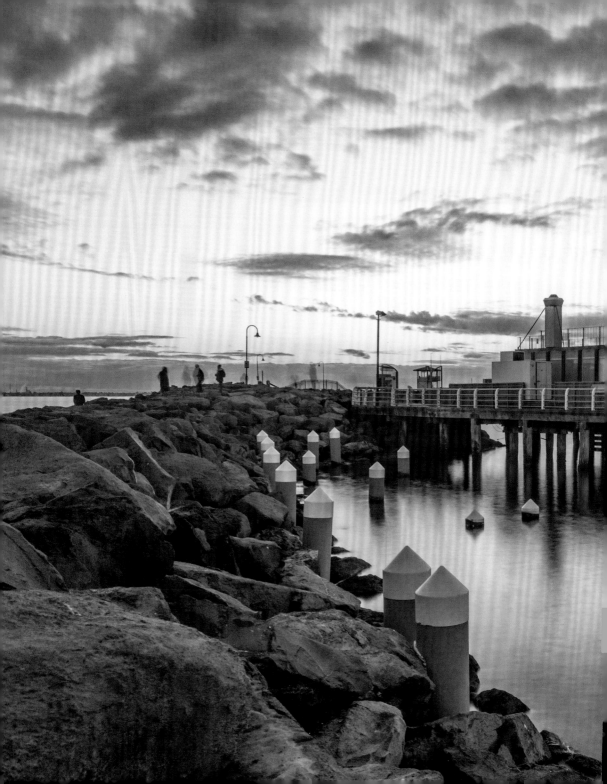

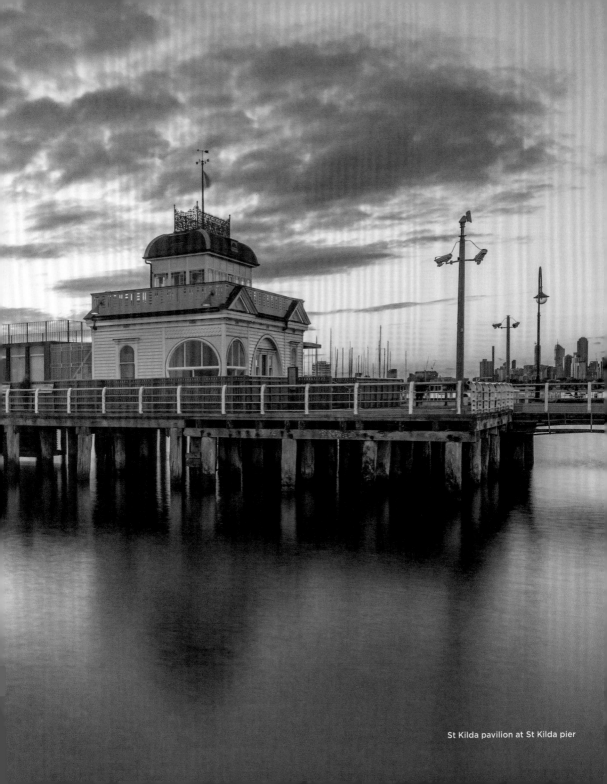

St Kilda pavilion at St Kilda pier

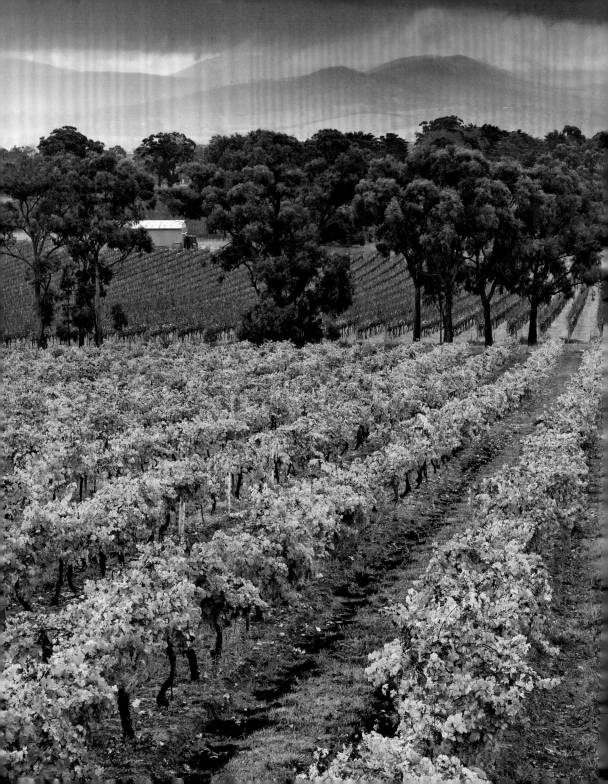

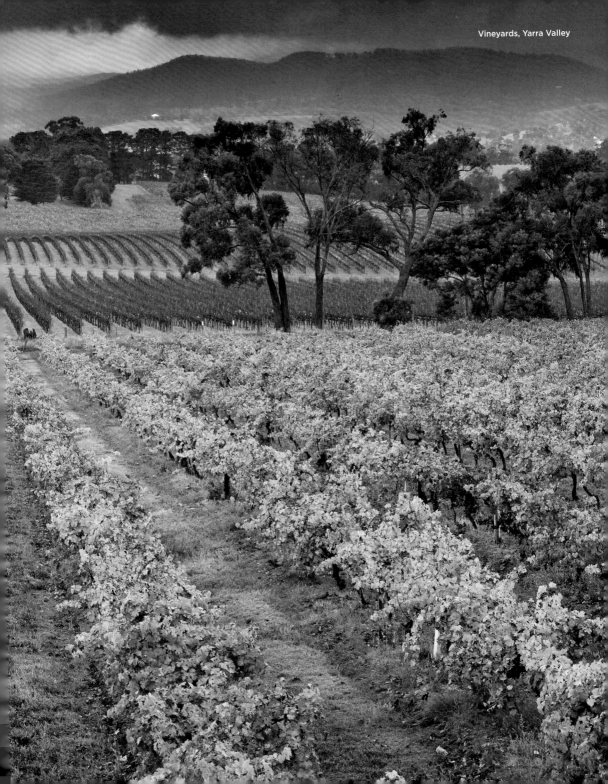

Vineyards, Yarra Valley

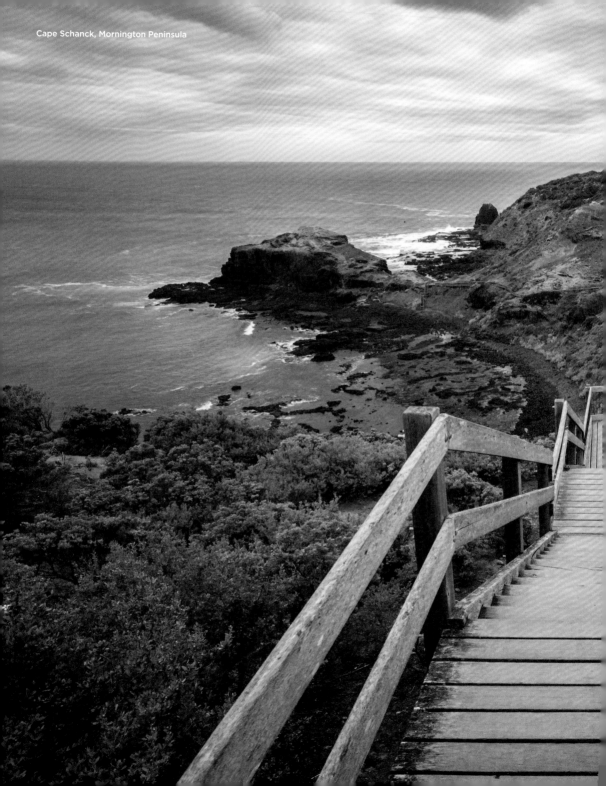

Cape Schanck, Mornington Peninsula

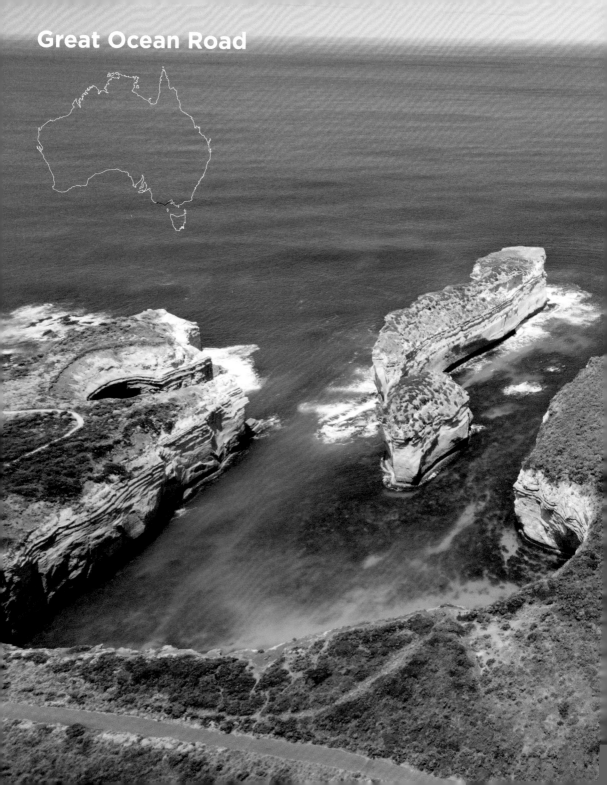

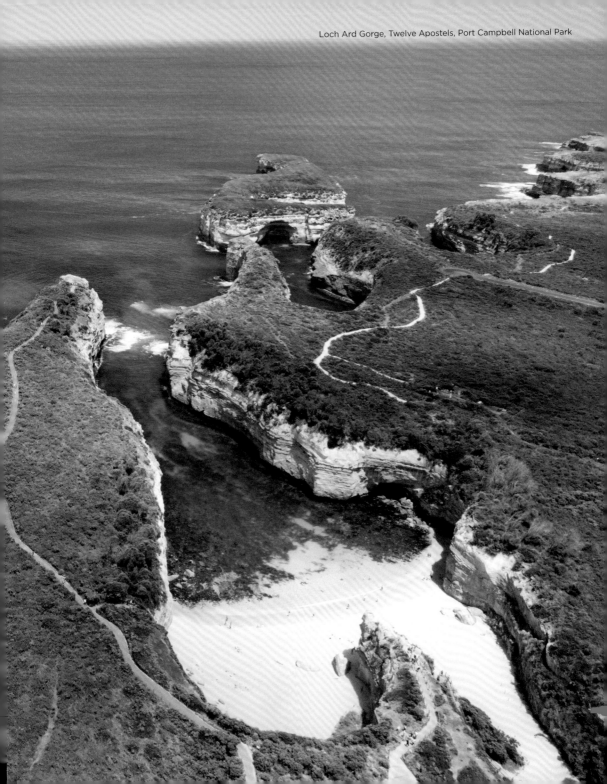

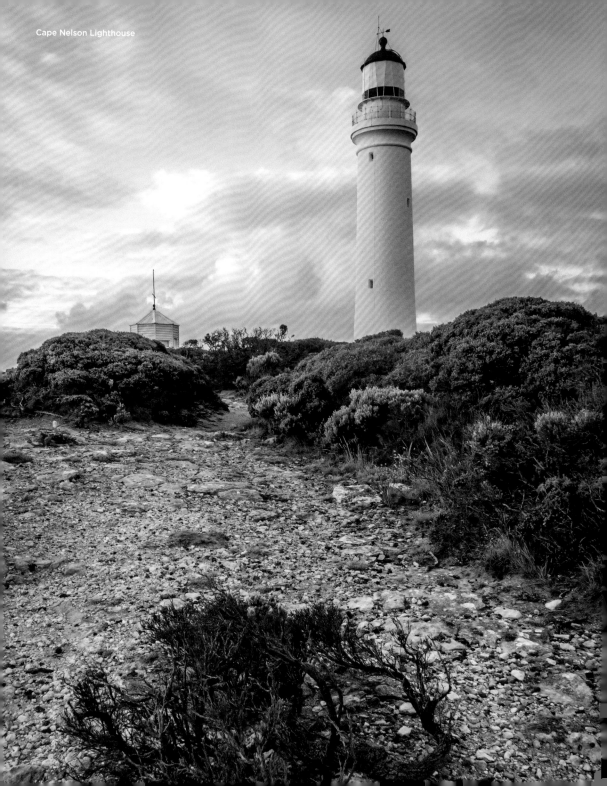

Cape Nelson Lighthouse

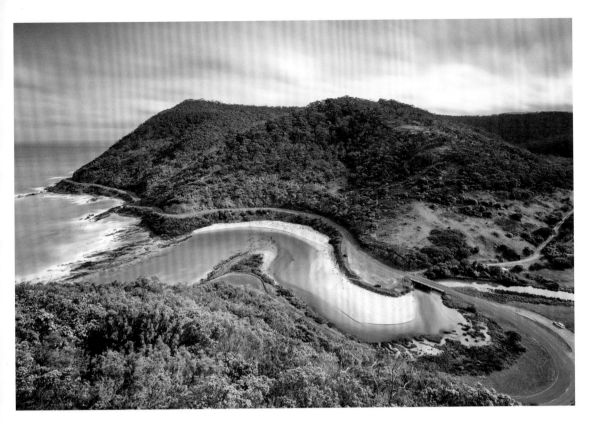

Teddy's Lookout, near Lorne

Great Ocean Road

The Southern Ocean's majesty and might is on show along this fabled stretch of road, one of Australia's great driving routes. Lush, primordial rainforest tumbles down to meet the coast, while a stunning surf beaches and an array of spectacular, ever-eroding limestone cliffs and rock formations unfold before you.

Great Ocean Road

La majestuosidad y el poderío del Océano Antártico se pueden apreciar a lo largo de este legendario tramo de carretera, una de las mejores rutas de conducción de Australia. El exuberante y primigenio bosque pluvial se derrumba para encontrarse con la costa, mientras que se despliegan ante el viajero las impresionantes playas para surfear y una variedad de espectaculares y siempre inquietantes acantilados de piedra caliza y formaciones rocosas.

Great Ocean Road

La majesté et la puissance de l'océan Austral s'expriment intensément le long de ce tronçon de route légendaire, l'une des plus grandes d'Australie. Une forêt tropicale luxuriante s'efface à la rencontre de la côte, tandis que des plages de surf époustouflantes et un éventail de paysages spectaculaires en constante érosion – faits de falaises calcaires et de formations rocheuses – se déploient devant les visiteurs.

Great Ocean Road

La maestosità e la forza dell'Oceano Meridionale danno mostra di sé lungo questo favoloso tratto di strada, uno dei grandi percorsi stradali dell'Australia. Una foresta pluviale lussureggiante e primordiale scende verso la costa, mentre una splendida spiaggia per il surf e una serie di spettacolari scogliere calcaree e formazioni rocciose, in continua trasformazione per via dell'erosione, si dispiegano davanti gli occhi dei visitatori.

Great Ocean Road

Die Majestät und Macht des Südlichen Ozeans zeigt sich auf diesem sagenumwobenen Straßenabschnitt, einer der großartigsten Fahrtrouten Australiens. Der üppige, ursprüngliche Regenwald stürzt hinunter zur Küste, während atemberaubende Surfstrände und eine Reihe von spektakulären, ewig erodierenden Kalksteinfelsen und Felsformationen sich vor Ihnen entfalten.

Great Ocean Road

De grandeur van de Zuidelijke Oceaan is langs dit legendarische stuk weg, een van de prachtige autowegen van Australië, in zijn volle omvang te zien. Weelderig oerwoud tuimelt omlaag naar de kust, terwijl prachtige surfstranden en een scala aan spectaculaire, steeds verder eroderende kalksteenklippen en rotsformaties zich voor u ontvouwen.

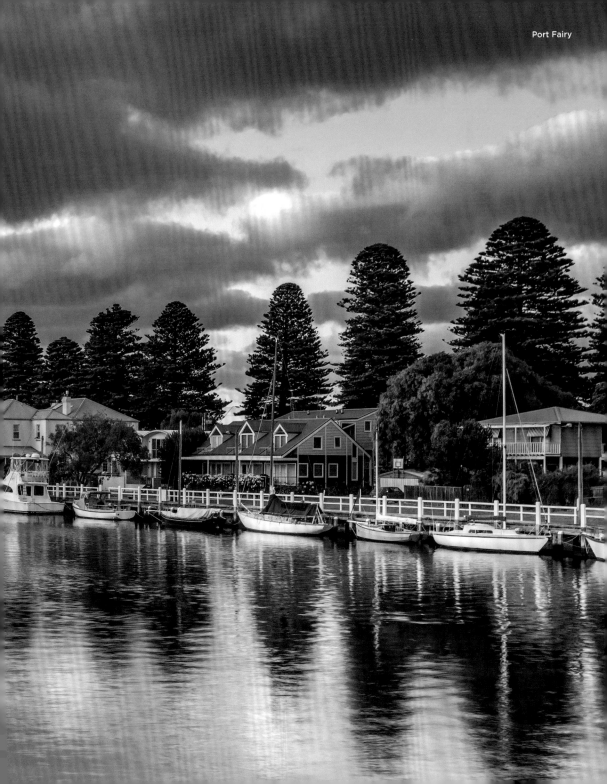

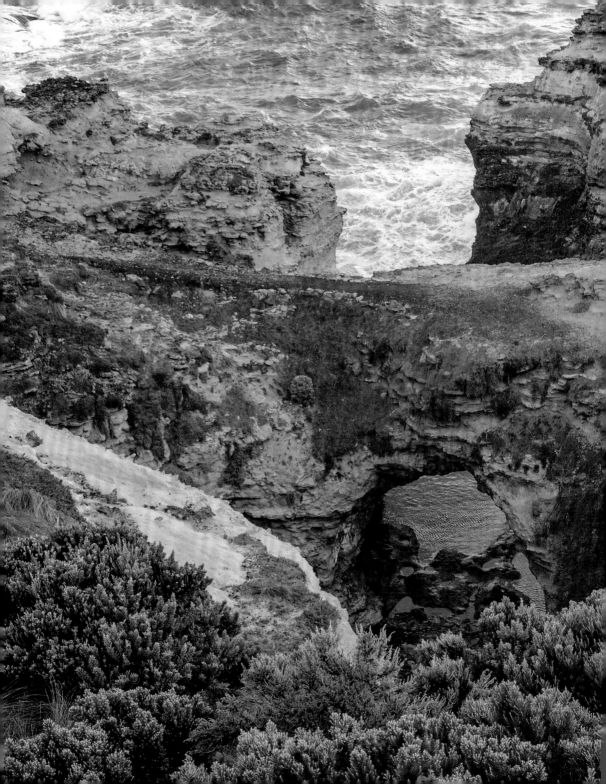

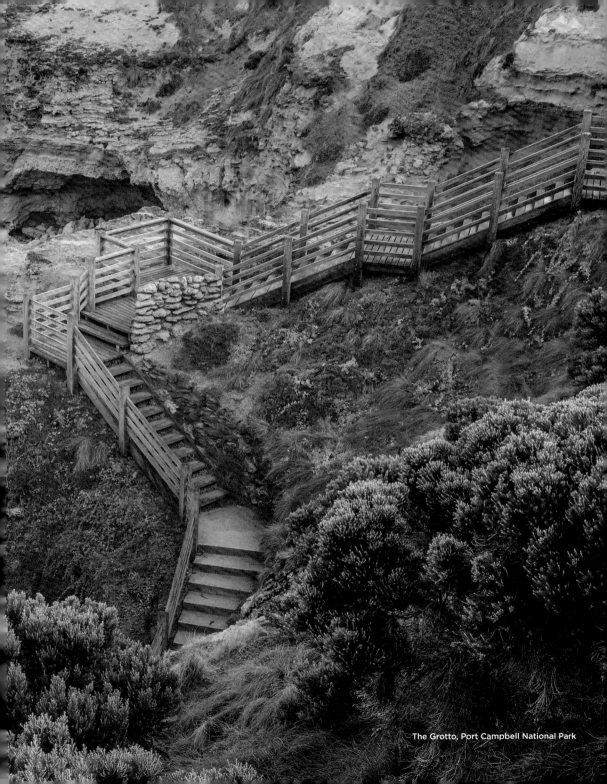

The Grotto, Port Campbell National Park

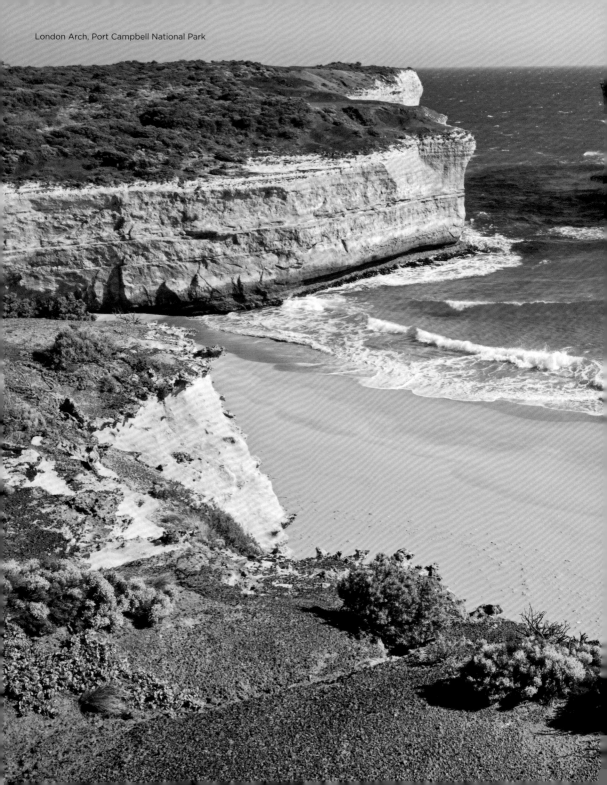

London Arch, Port Campbell National Park

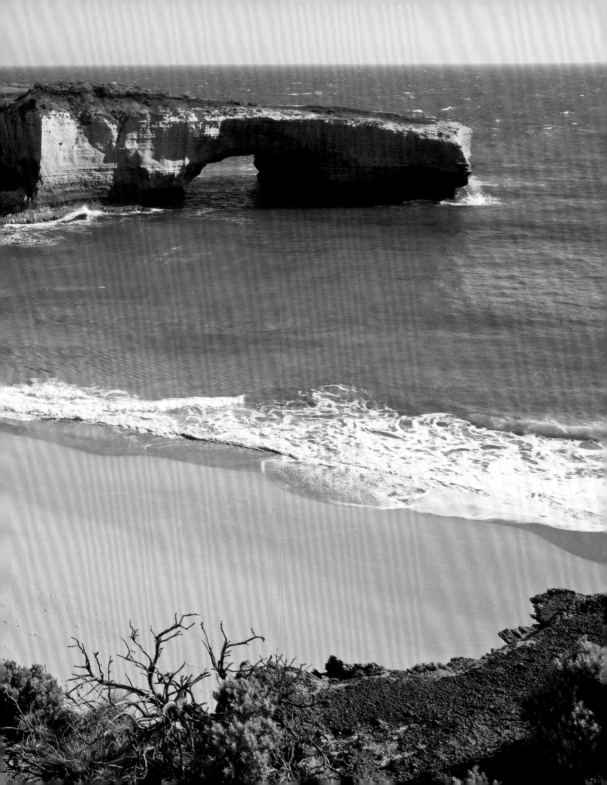

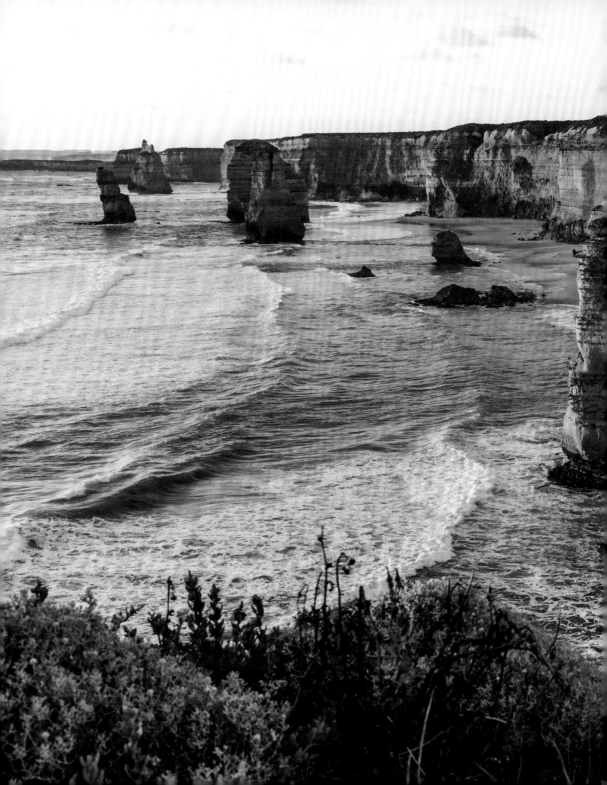

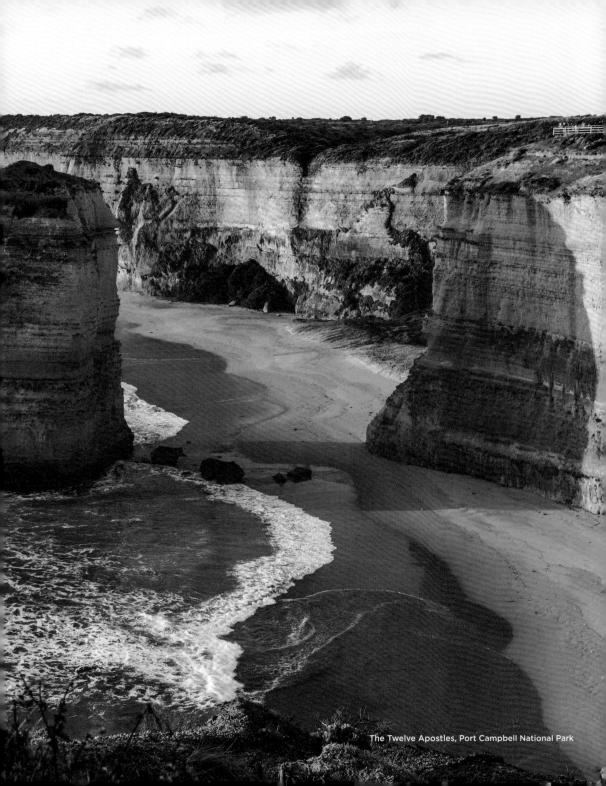

The Twelve Apostles, Port Campbell National Park

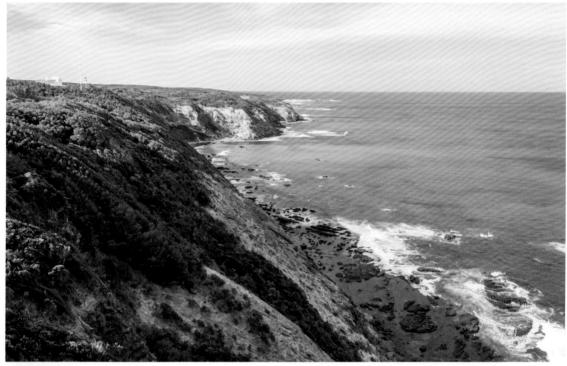

Cape Otway

National Parks

It can be difficult to choose favorites along the Great Ocean Road – there is wonder to be found around every bend. But two national parks provide some of the journey's most memorable views. Port Campbell National Park, with the Twelve Apostles and Loch Ard Gorge provide so many iconic images. And Great Otway National Park – deeply forested and rich in wildlife – is similarly picturesque, with ample camping and quieter roads than elsewhere along this route.

Parques nacionales

Puede ser difícil elegir los lugares favoritos a lo largo de la carretera Great Ocean, ya que en cada curva pueden encontrarse maravillas. Pero hay dos parques nacionales que ofrecen algunas de las vistas más memorables del viaje. El parque de Port Campbell, con "los Doce Apóstoles" y la garganta de Ard, que ofrece imágenes icónicas. El parque del Gran Otway, profundamente boscoso con un caracter pintoresco y amplias zonas de acampada y carreteras tranquilas.

Parcs nationaux

Il est difficile de choisir un endroit favori le long de la Great Ocean Road tant il y a de quoi s'émerveiller à chaque virage, mais ces deux parcs nationaux offrent des points de vue parmi les plus mémorables du voyage. Celui de Port Campbell, avec les aiguilles calcaires surnommées « Les Douze Apôtres » et les gorges du Loch Ard, est iconique. Celui du Great Otway – boisé et riche en faune – est tout aussi pittoresque, avec ses campings et ses sentiers tranquilles.

Parchi nazionali

Può essere difficile stabilire quale sia il posto preferito lungo la Great Ocean Road – dietro ogni curva c'è uno spettacolo in attesa. Ma due parchi nazionali offrono alcuni dei panorami più memorabili del viaggio. Port Campbell National Park, con i Dodici Apostoli e la gola del Loch Ard, è ricco di scenari iconici. Il Cape Otaway National Park – boscoso e ricco di fauna – è altrettanto pittoresco, con ampi campeggi e strade più tranquille che altrove lungo il percorso.

Nationalparks

Was ist der Favorit entlang der Great Ocean Road? Hinter jeder Kurve sind neue Wunder zu entdecken. Aber zwei Nationalparks bieten die schönsten Aussichten der Reise: Port Campbell Nationalpark mit den Zwölf Aposteln und der Loch Ard-Schlucht und der Cape Otway Nationalpark – tief bewaldet und reich an Wildtieren.

Nationale parken

Het valt niet mee om favorieten te kiezen langs de Great Ocean Road: bij elke bocht staat u versteld. Maar twee nationale parken bieden enkele van de meest memorabele uitzichten van de reis: Port Campbell, met de Twelve Apostles en de Loch Ard Gorge, en Great Otway, met dichte bossen en veel wilde dieren.

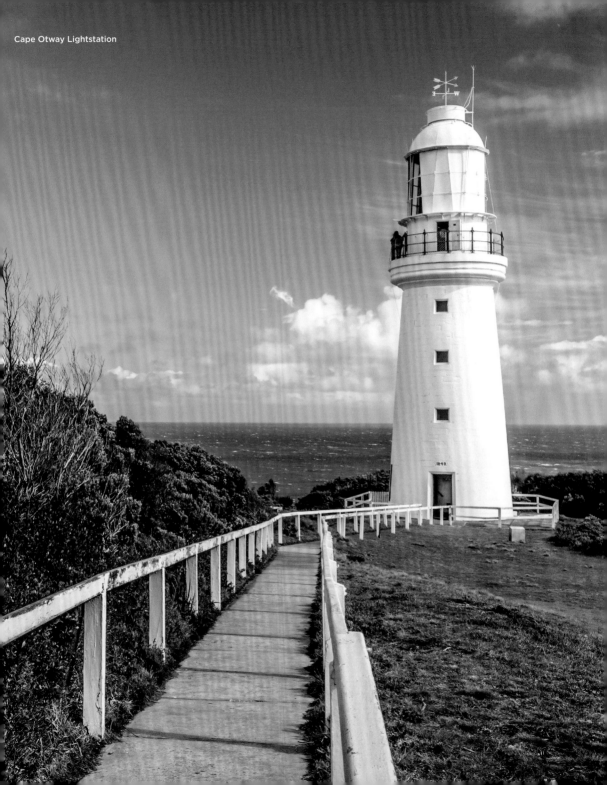

Cape Otway Lightstation

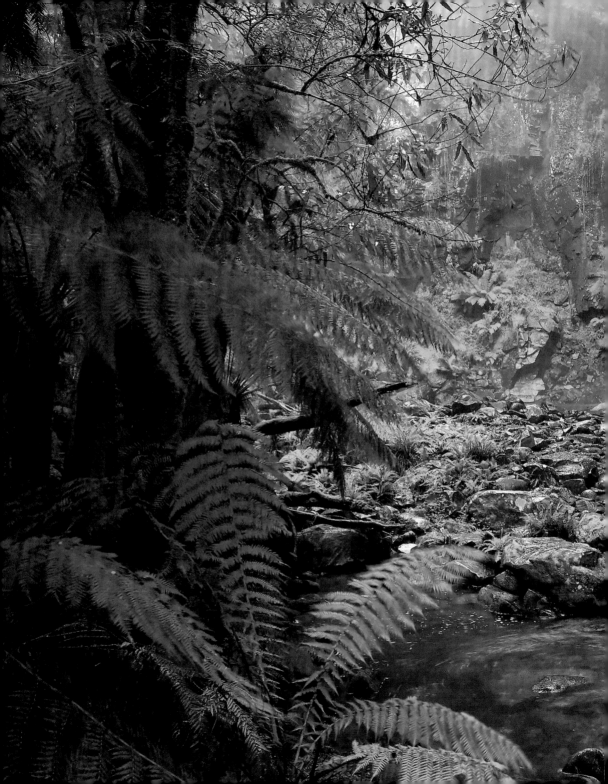

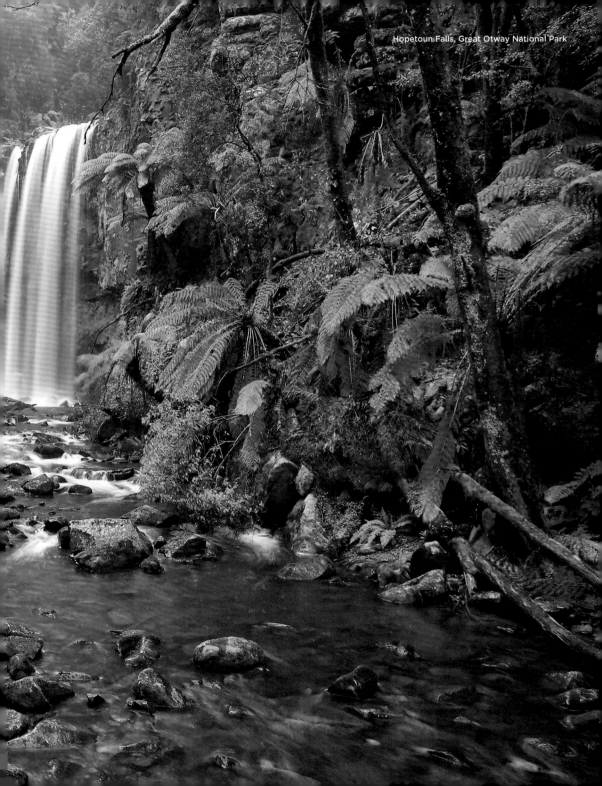

Hopetoun Falls, Great Otway National Park

Bells Beach

One of the world's most celebrated surf beaches, Bells Beach is the spiritual home of Aussie surf culture. With a steep drop off not far from the beach, it rarely gets swimmers but produces some extraordinary breaks beloved by the world's best. Pro-surf events frequently turn up here, and who hasn't swooned over Patrick Swayze riding a monster wave in *Point Break?*

Bells Beach

Bells Beach, l'une des plages de surf les plus célèbres du monde, est le foyer spirituel de la culture surf australienne. Se transformant rapidement en pente douce, elle n'attire que rarement les baigneurs, mais produit des vagues extraordinaires, parmi les meilleures du monde. Les événements autour du surf sont fréquents ici, et qui ne s'est pas pâmé devant Patrick Swayze y surfant une vague monstrueuse dans *Point Break?*

Bells Beach

Bells Beach ist einer der berühmtesten Surfstrände der Welt und die spirituelle Heimat der australischen Surfkultur. Nicht weit vom Strand entfernt geht es steil hinunter, weshalb sich hier nur wenige Schwimmer finden; die außergewöhnlichen Breaks aber ziehen die besten Surfer der Welt an. Pro-Surf-Events sind hier häufig, und wer war nicht von Patrick Swayze begeistert, als er im Film *Point Break* eine Monsterwelle ritt?

Bells Beach

Una de las playas de surf más famosas del mundo, Bells Beach es el hogar espiritual de la cultura surfera australiana. Con un fuerte desnivel no muy lejos de la playa, los nadadores no suelen acudir a ella, pero sí que brinda unos lugares extraordinarios para el descanso que todo el mundo adora. Los eventos profesionales de surf se celebran con frecuencia aquí, y ¿quién no se ha desmayado por Patrick Swayze montando una ola monstruosa en *Point Break* ("Le llaman Bodhi")?

Bells Beach

Una delle spiagge per il surf più famose al mondo, Bells Beach, è la patria spirituale della cultura australiana del surf. Con una ripida discesa poco distante dalla spiaggia, raramente si viene qui per nuotare, poiché i suoi break sono straordinari e amati dai migliori surfisti mondo. Gli eventi intorno al mondo del surf hanno spesso luogo qui – e chi non si è emozionato guardando Patrick Swayze in *Point Break* mentre cavalca un'onda mostruosa?

Bells Beach

Bells Beach, een van de beroemdste surfstranden ter wereld, is de spirituele thuisbasis van de Australische surfscene. Niet ver van het strand gaat het steil omlaag, waardoor hier zelden zwemmers komen. Maar enkele buitengewone breaks trekken de beste surfers ter wereld aan. Hier vinden vaak prof-evenementen plaats, en wie valt er niet in zwijm bij het zien van Patrick Swayze die een monstergolf berijdt in *Point Break?*

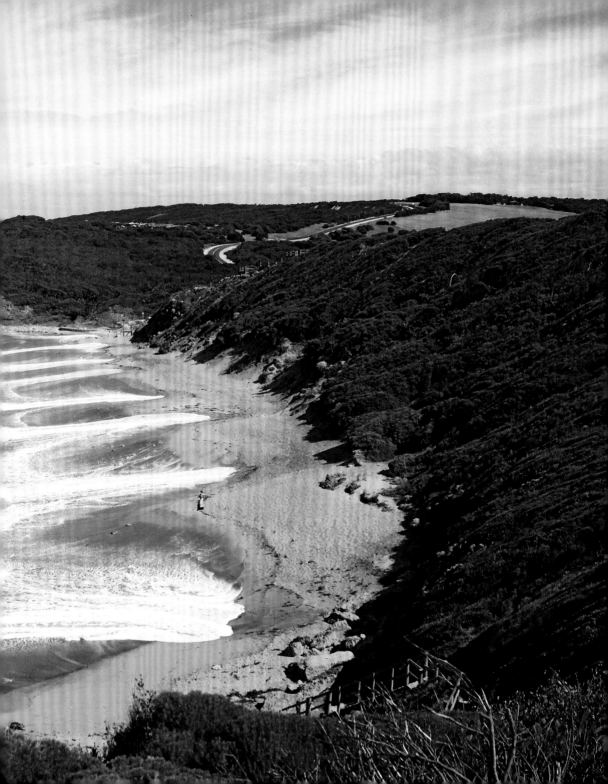

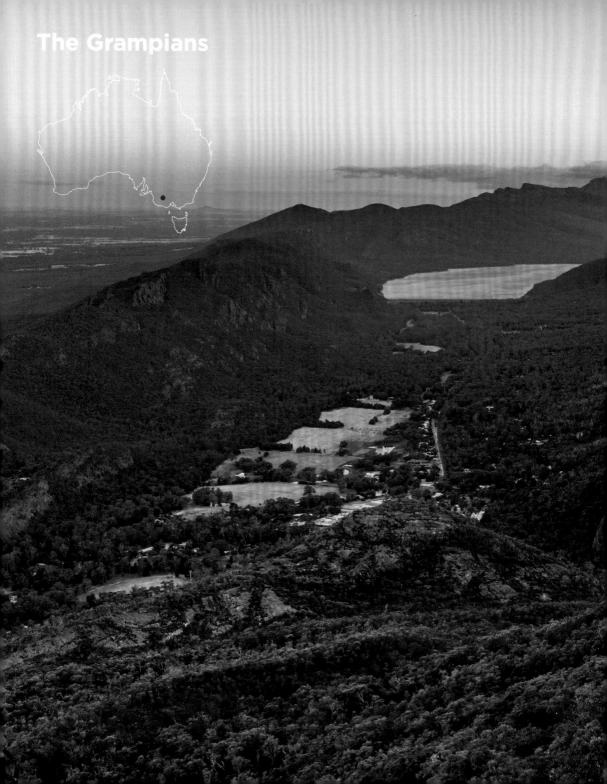

The Grampians

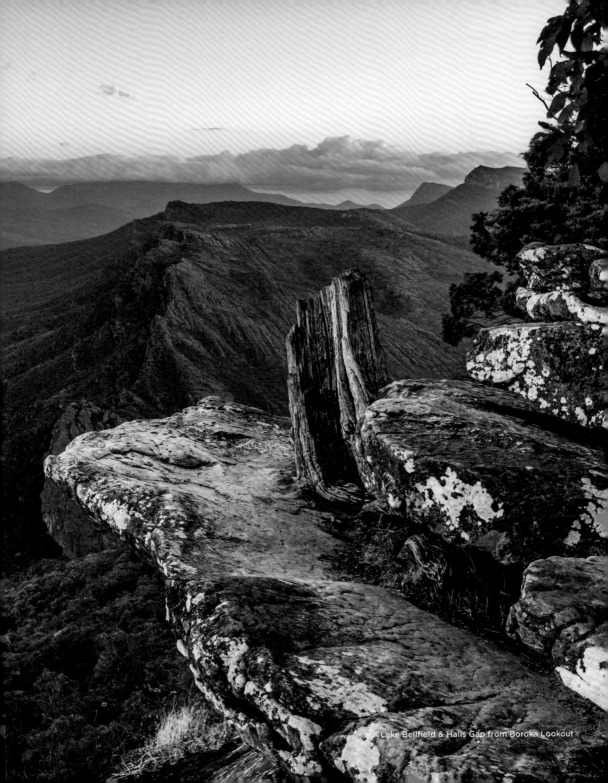

Lake Bellfield & Halls Gap from Boroka Lookout

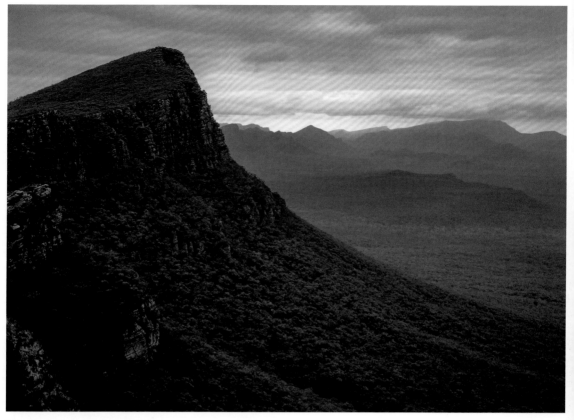

Signal Peak, Grampians National Park

The Grampians

This national park region, known for the beauty of its deeply forested sandstone ranges, is also one of the richest rock art sites in south-eastern Australia. Climbers flock here for its peaks, sheer ascents and lookouts, while walkers are also rewarded with waterfalls and wildlife sightings.

The Grampians

Esta región de parques nacionales, conocida por la belleza de sus cordilleras de arenisca, es también uno de los sitios de arte rupestre más ricos del sureste de Australia. Los escaladores acuden en tropel por sus picos, ascensiones y miradores, mientras que los caminantes también son recompensados con cascadas y avistamientos de vida silvestre.

Les Grampians

Cette région du parc national, connue pour la beauté de ses chaînes de montagne en grès, fortement boisées, est aussi l'un des sites d'art rupestre les plus riches du sud-est de l'Australie. Les grimpeurs y affluent pour ses sommets, ses montées et ses belvédères, tandis que les randonneurs seront également récompensés de leurs efforts par des chutes d'eau et l'observation de la faune.

The Grampians

Questa regione, che ospita un parco nazionale, nota per la bellezza delle sue catene di arenaria ricoperte di boschi, è anche uno dei siti di arte rupestre più ricchi nel sud-est dell'Australia. Gli scalatori si affollano qui per le vette, le salite a strapiombo e gli scenari di cui si può godere, ma anche gli escursionisti sono ricompensati con cascate e avvistamenti di animali selvatici.

The Grampians

Der Nationalpark, bekannt für die Schönheit seiner tief bewaldeten Sandsteingebirge, ist auch eine der reichsten Felskunststätten im Südosten. Kletterer kommen hierher wegen der Gipfel, steilen Anstiege und Aussichtspunkte, während Wanderer mit Wasserfällen und Wildtierbeobachtungen belohnt werden.

The Grampians

Dit nationale park, bekend om de schoonheid van zijn beboste zandsteenbergen, is ook een van de rijkste rotskunstgebieden in het zuidoosten van Australië. Klimmers komen hier voor de bergtoppen, steile beklimmingen en uitkijkposten, terwijl wandelaars beloond worden met watervallen en wildobservaties.

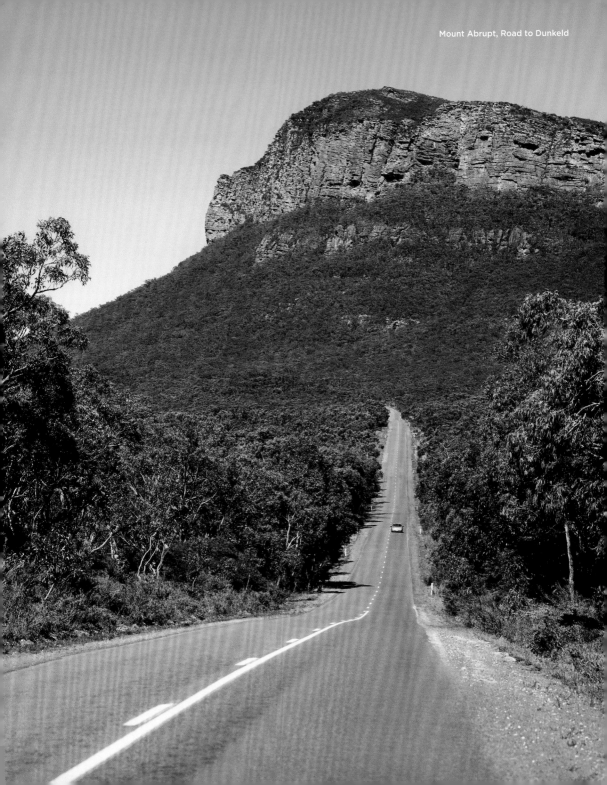

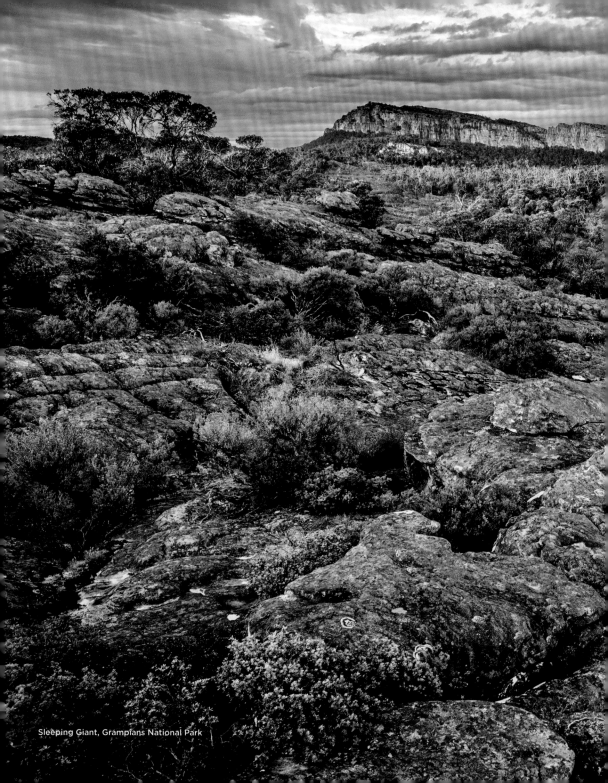
Sleeping Giant, Grampians National Park

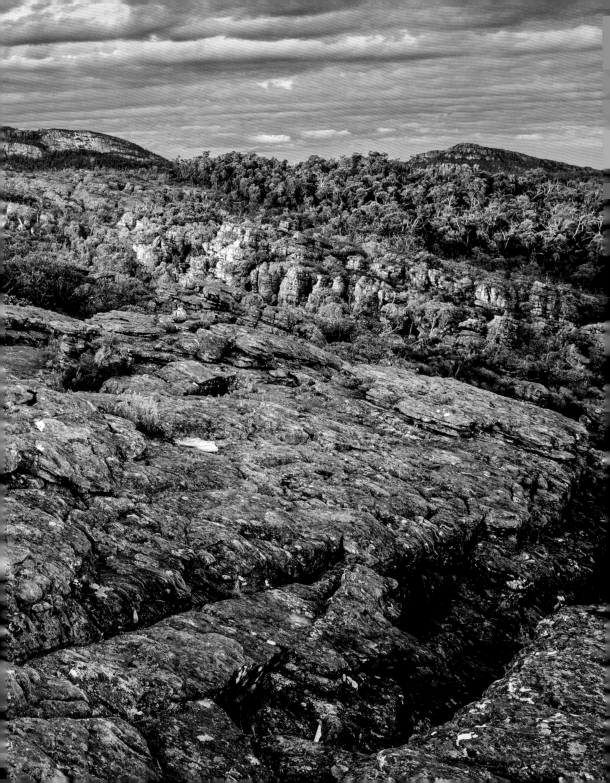

New Holland Honeyeater *(Phylidonyris Novaehollandiae)*

Grampians Wildlife

The Grampians is considered one of the best places to see wildlife anywhere in Victoria. Halls Gap inhabits a long, steep-walled valley with reasonably dense eucalyptus woodlands interspersed with open grasslands and parks. At either end of the town in particular, eastern grey kangaroos and wallabies are commonly seen, while echidnas and wombats are also possible. Birdlife funnels through the valley in great numbers, with resident emus stepping through the long grass, and a soundtrack of screeching galahs, sulphur-crested cockatoos, rosellas, lorikeets and corellas making their presence felt. Various possum species inhabit the forest canopy.

Faune des Grampians

Les Grampians sont considérés comme l'un des meilleurs endroits de Victoria pour observer la faune. Halls Gap est situé dans une longue vallée aux parois abruptes et aux forêts d'eucalyptus relativement denses, parsemée de prairies et de parcs ouverts. On y trouve des kangourous gris de l'Est et des wallabies, principalement aux deux extrémités de la ville, et on peut également y croiser des échidnés et des wombats. La faune aviaire visite également la vallée en grand nombre : les émeus traversent ses herbes hautes, tandis que les cacatoès rosalbins ou à huppe jaune, les platycerques, les loriquets et les licmetis emplissent de leurs cris l'espace sonore. Diverses espèces d'opossums résident également dans la forêt environnante.

Tierwelt der Grampians

Die Grampians gelten als einer der besten Orte, um die Tierwelt in Victoria zu beobachten. Der Ort Halls Gap liegt in einem langen, steilwandigen Tal mit relativ dichten Eukalyptuswäldern, durchzogen von offenen Graslandschaften und Parks. Vor allem an beiden Enden der Stadt werden häufig Östliche Graue Riesenkängurus und Wallabys gesehen, aber auch Ameisenigel und Wombats sind manchmal anzutreffen. Die Vogelwelt bevölkert in großer Zahl das Tal: der Emu stapft durch das lange Gras, dazu ein Soundtrack von kreischenden Galahs, Gelbhaubenkakadus, Plattschweifsittichen, Loris und Nacktaugenkakadus. Auf den Baumwipfeln leben verschiedene Opossumarten.

Grampians Fringe Myrtle *(Calytrix sullivanii)*

Vida silvestre del los Montes Grampianos

Los Montes Grampianosson uno de los
mejores lugares para ver la vida silvestre
en cualquier lugar de Victoria. La localidad
de Halls Gap se ubica en un largo valle
de paredes empinadas con bosques
de eucalipto razonablemente densos,
intercalados con pastizales abiertos y
parques. En cualquiera de los extremos de
la ciudad, son comunes los canguros grises
orientales y los walabíes, los equidnas y
los wombats también se dejan ver, aunque
algo menos. La avifauna atraviesa el valle
en bandada, con emúes comunes pisando
la larga hierba, y una banda sonora de
cacatúas galah, cacatúas galerita, rosellas,
loris y licmetis que se hacen sentir. Varias
especies de zarigüeyas habitan el bosque.

Animali selvatici nei Grampians

I Grampians sono considerati uno dei
posti migliori per osservare da vicino la
fauna selvatica in tutto il Victoria. Halls
Gap si trova in una valle lunga e ripida,
con folti boschi di eucalipto intervallati
da prati e parchi. A entrambe le estremità
della città, in particolare, è facile avvistare
canguri grigi orientali e wallaby, ma non è
insolito vedere anche echidne e wombat.
Numerosi uccelli attraversano la valle, con
gli emù che calpestano l'erba lunga e una
colonna sonora di galah urlanti, cacatua
crestagialla, roselle, lorichetti e corelle che
non perdono occasione di fare sentire la
loro presenza. Diverse specie di opossum
popolano le chiome della foresta.

Dieren in de Grampians

De Grampians is een van de beste plekken
in Victoria om wilde dieren te zien. De
plaats Halls Gap ligt in een lang, steil dal
met relatief dichte eucalyptusbossen,
die worden afgewisseld met open
graslanden en parken. Met name aan
beide uiteinden van de stad zijn de
oostelijke grijze reuzenkangoeroes en
wallaby's te zien, terwijl u soms ook
mierenegels en wombats kunt aantreffen.
Er leven veel vogels in het dal: emoes
stappen door het lange gras tegen de
soundtrack van krijsende roze kaketoes,
grote geelkuifkaketoes, rosella's, lori's en
naaktoogkaketoes. In de boomtoppen
leven verschillende soorten opossums.

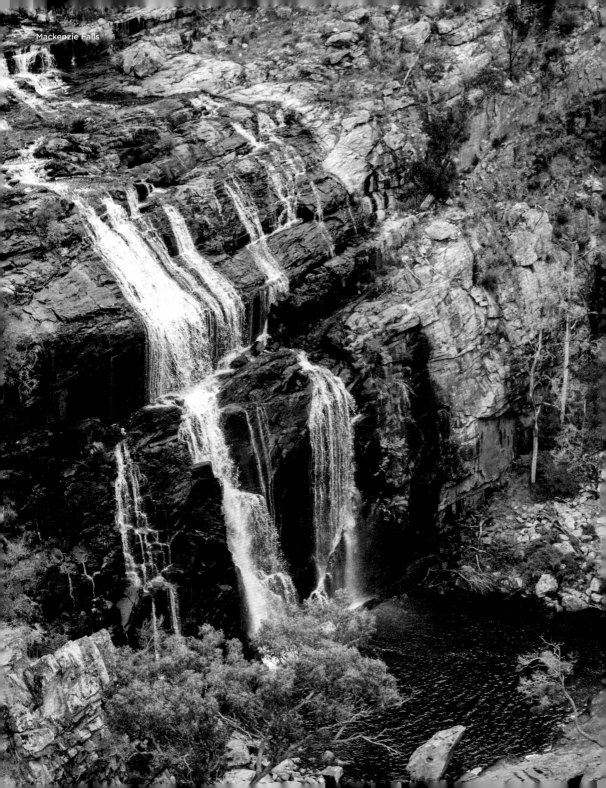
Mackenzie Falls

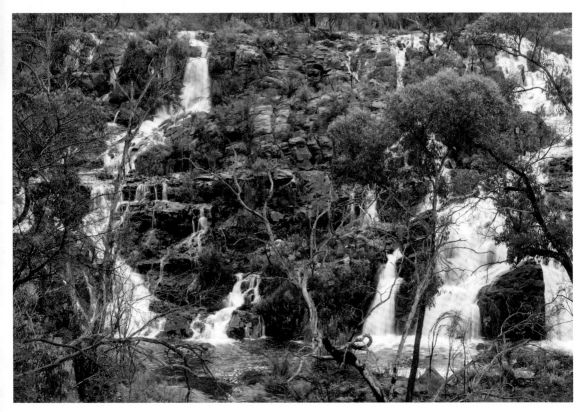

Bridal Falls

Grampians Waterfalls

Early spring heralds waterfall season in the Grampians, with tumultuous thundering flows at many of the falls that dry up in the heat, including Silverband Falls and Wannon Falls (and a fraction of the summer crowds). Wild flowers also abound at this time. MacKenzie Falls and Fish Falls do, however, draw from a reservoir so are at their best year round.

Cascadas de los Montes Grampianos

El comienzo de la primavera anuncia la temporada de cascadas en los Montes Grampianos, con flujos tumultuosos y estruendosos en muchas de las cataratas que se secan con el calor, incluyendo las cataratas Silverband y las Wannon. Las flores silvestres también abundan en esta época. Sin embargo, las cataratas de MacKenzie y las de Fish Falls se nutren de un embalse, por lo que siempre están en su mejor momento.

Cascades de Grampians

Le début du printemps annonce la saison des chutes d'eau dans les Grampians, avec des coulées tumultueuses et tonitruantes dans de nombreuses cascades asséchées par la chaleur, dont Silverband Falls et Wannon Falls. Les fleurs sauvages abondent également à cette époque. Les chutes MacKenzie et Fish Falls, qui puisent dans un réservoir, sont quant à elles à leur meilleur toute l'année.

Grampians Waterfalls

L'inizio della primavera annuncia la stagione delle cascate nei Grampians, con tumultuose correnti che si prosciugano durante il caldo, tra cui quella di Silverband e quella di Wannon. Anche i fiori selvatici abbondano in questo periodo dell'anno. MacKenzie Falls e Fish Falls, tuttavia, devono attingere a un bacino idrico. In questo modo mostrano il loro lato migliore tutto l'anno.

Wasserfälle in den Grampians

Der Frühling kündigt die Wasserfall-Saison in den Grampians an, mit donnernden Strömungen, die in der Hitze versiegen, einschließlich der Silverband Falls und Wannon Falls. Auch Wildblumen gibt es in dieser Zeit im Überfluss. Die MacKenzie Falls und Fish Falls stammen jedoch aus einem Reservoir, weshalb sie sich das ganze Jahr von ihrer besten Seite zeigen.

Watervallen in de Grampians

Het voorjaar luidt het watervalseizoen van de Grampians in, met donderende watermassa's die opdrogen in de hitte, bijvoorbeeld bij de Silverband Falls en Wannon Falls. Ook wilde bloemen zijn er in deze tijd in overvloed. MacKenzie Falls en Fish Falls vinden hun oorsprong in een reservoir en zijn dus het hele jaar door op hun best.

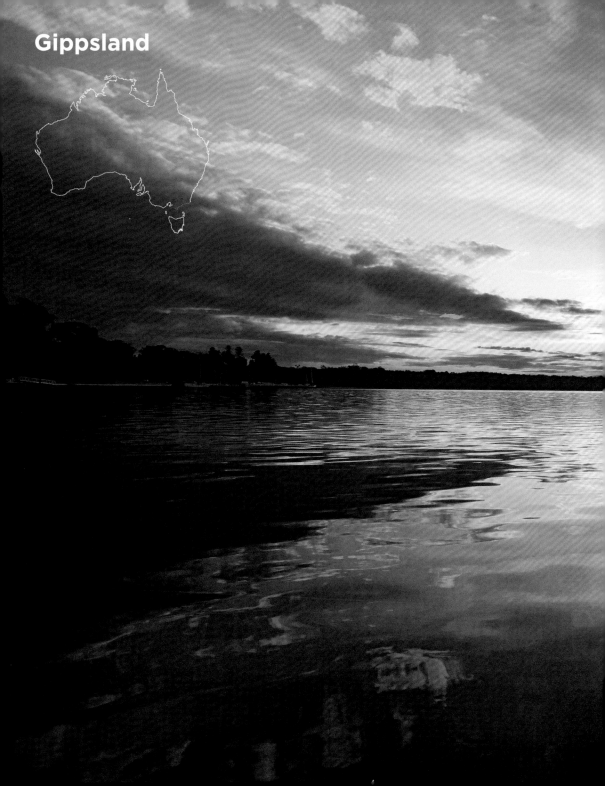

Gippsland

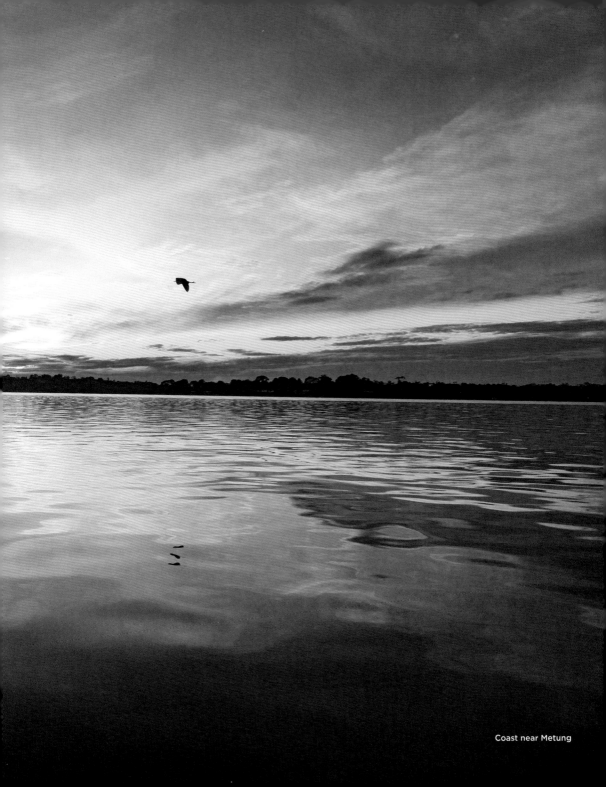

Coast near Metung

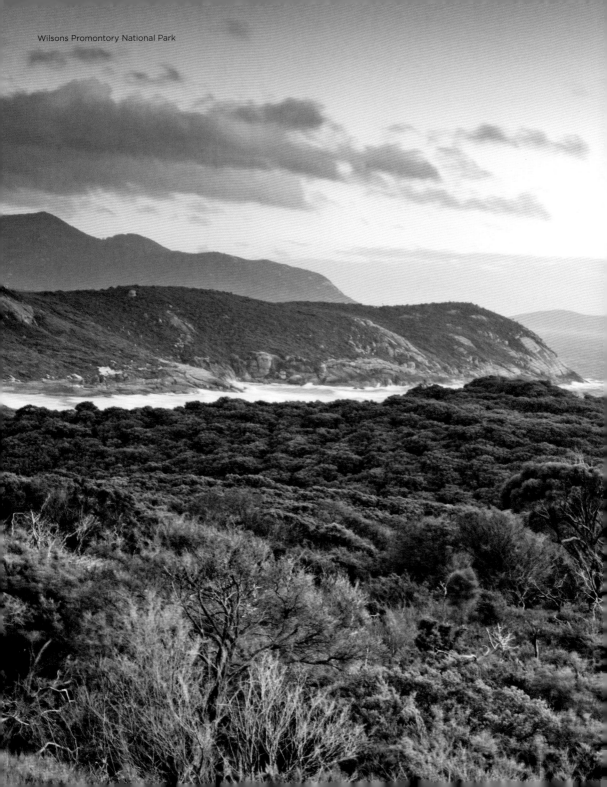

Wilsons Promontory National Park

Bordwalk, Wilsons Promontory National Park

Gippsland

Wilson's Prom, or simply 'the Prom' to locals, is the mainland's most southerly national park and is blessed with beautiful, little touristed beaches, rainforests and wildlife. Ninety Mile Beach and its sweet boat harbours of Lakes Entrance entrance holiday goers with their peace and beauty, pelican parades and endless waves.

Gippsland

El Promontorio Wilsons, o simplemente'el Prom' para los locales, es el parque nacional más austral del continente y está bendecido con hermosas y pequeñas playas turísticas, bosques tropicales y vida silvestre. La playa de las noventa millas, sus dulces puertos de embarcaciones de entrada a los lagos, los visitantes asiduos en vacaciones con su paz y belleza, las procesiones de pelícanos y las olas interminables.

Gippsland

Le parc national du promontoire de Wilson, surnommé « the Prom » par les habitants du coin, est le parc le plus méridional du continent. On y trouve de belles plages peu fréquentées, des forêts tropicales et une faune riche. La plage de Ninety Mile et les ports de plaisance de Lake Entrance ravissent les vacanciers par leur calme et leur beauté, les défilés de pélicans et les vagues sans fin.

Gippsland

Il Wilson's Prom, semplicemente "Prom" per la gente del posto, è il parco nazionale più a sud della terraferma ed è caratterizzato da bellissime spiagge poco frequentate, foreste pluviali e fauna selvatica. Ninety Mile Beach e i porti graziosi di Lakes Entrance affascinano i turisti per la loro pace e bellezza, le sfilate di pellicani e le onde infinite.

Gippsland

Wilson's Prom, oder einfach nur der „Prom" für die Einheimischen, ist der südlichste Nationalpark des Festlandes und gesegnet mit schönen, kleinen touristischen Stränden, Regenwäldern und Wildtieren. Ninety Mile Beach und die schnuckeligen Bootshäfen von Lakes Entrance bezaubern die Urlauber mit ihrer Ruhe und Schönheit, Pelikanparaden und endlosen Wellen.

Gippsland

Wilson's Prom, of gewoon 'de Prom' voor de lokale bevolking, is het zuidelijkste nationale park van het vasteland en is gezegend met mooie, kleine toeristische stranden, regenwouden en wilde dieren. Ninety Mile Beach en de schattige jachthavens van Lakes Entrance betoveren de vakantiegangers met hun rust en schoonheid, pelikanen en eindeloze golven.

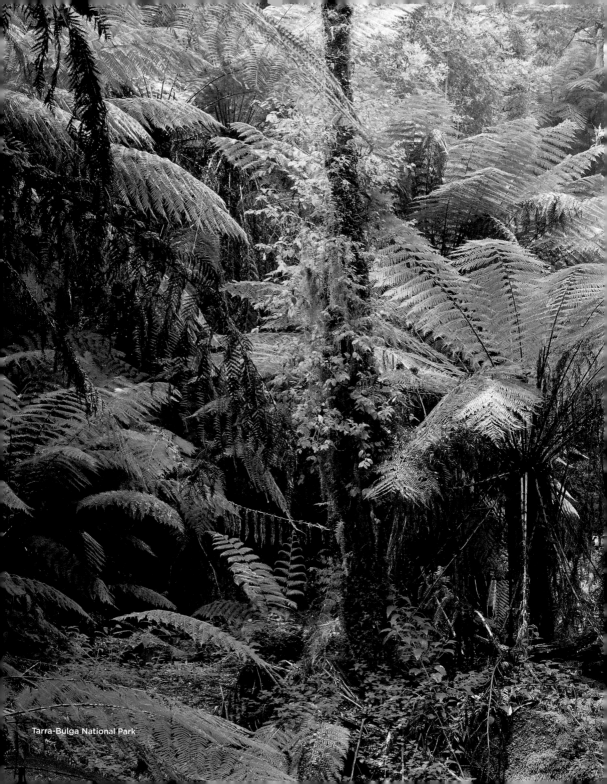

Tarra-Bulga National Park

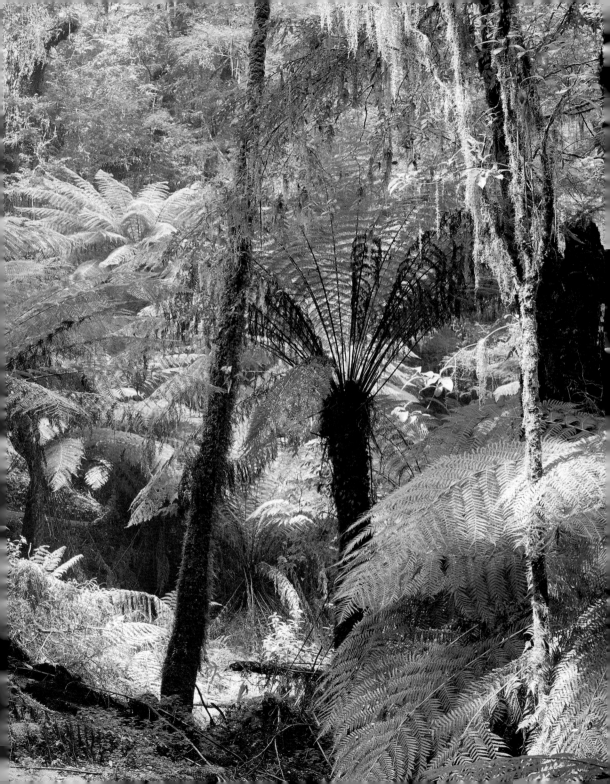

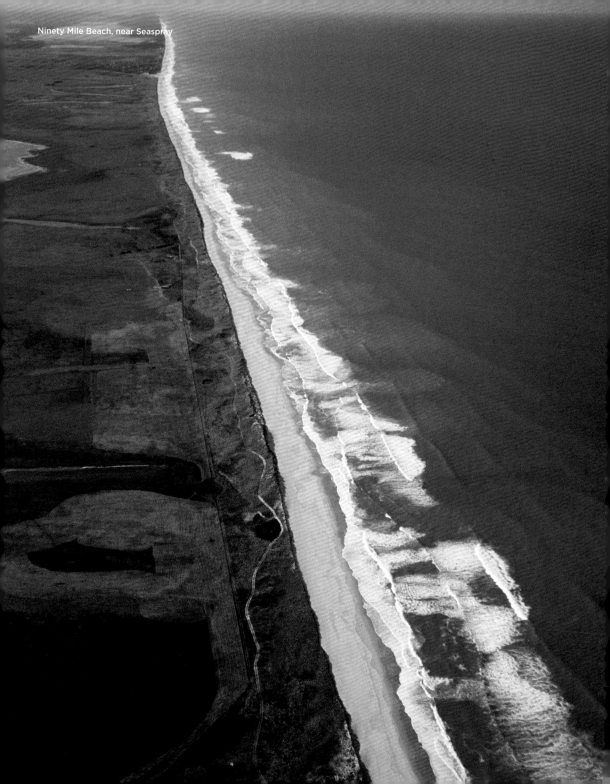

Ninety Mile Beach, near Seaspray

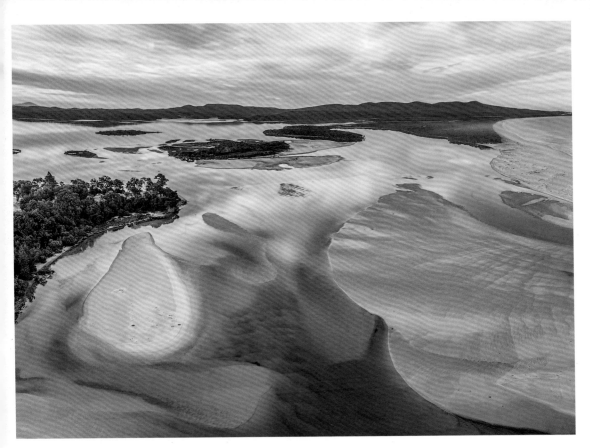
Wallagaraugh River mouth

Tarra Bulga National Park

Considered one of the last remnants of the rainforests that once covered much of Gippsland, Tarra Bulga is distinguished by its mountain ash, myrtle beech, stringybark eucalypt and fern gully forests. Lyrebirds, wombats, swamp wallabies and platypus are among the species found within the park's boundaries.

Tarra Bulga National Park

Considerada uno de los últimos vestigios de los bosques pluviales que cubrían gran parte de Gippsland, Tarra Bulga se distingue por sus bosques de fresnos de montaña, hayas mirto, eucaliptos de corteza fibrosa y barrancos de helechos. Entre las especies que se encuentran dentro de los límites del parque se encuentran aves lira, wombats, walabíes de los pantanos y ornitorrincos.

Parc national de Tarra Bulga

Considéré comme l'un des derniers vestiges de la forêt tropicale qui couvrait autrefois une grande partie du Gippsland, Tarra Bulga se distingue par ses forêts de sorbiers, de hêtres, d'eucalyptus et de fougères. Les ménures, les wombats, les wallabies bicolores et les ornithorynques font partie des espèces observables dans ce parc.

Tarra Bulga National Park

Considerata una delle ultime foreste pluviali tra quelle che un tempo ricoprivano gran parte del Gippsland, Tarra Bulga si distingue per i suoi boschi di frassino di montagna, mirto, faggio, eucalipto dalla corteccia fibrosa e per le foreste di felci. Menure, wombat, wallaby di palude e ornitorinchi sono tra le specie presenti all'interno del parco.

Tarra Bulga National Park

Tarra Bulga gilt als einer der letzten Überreste des Regenwaldes, der einst einen Großteil von Gippsland bedeckte, und zeichnet sich durch seine Bergasche, Myrtenbuche, Stringybark-Eukalyptus und mit Farnen durchzogene Wälder aus. Leierschwänze, Wombats, Sumpf-Wallabys und Schnabeltiere gehören zu den Arten, die im Park vorkommen.

Tarra Bulga National Park

Tarra Bulga geldt als een van de laatste restanten van de regenwouden die ooit een groot deel van Gippsland bedekten en onderscheidt zich door zijn bossen met lijsterbes, *Nothofagus cunninghamii*, Australische eik en varens. Menura's, wombats, moeraswallaby's en vogelbekdieren behoren tot de soorten die in het park voorkomen.

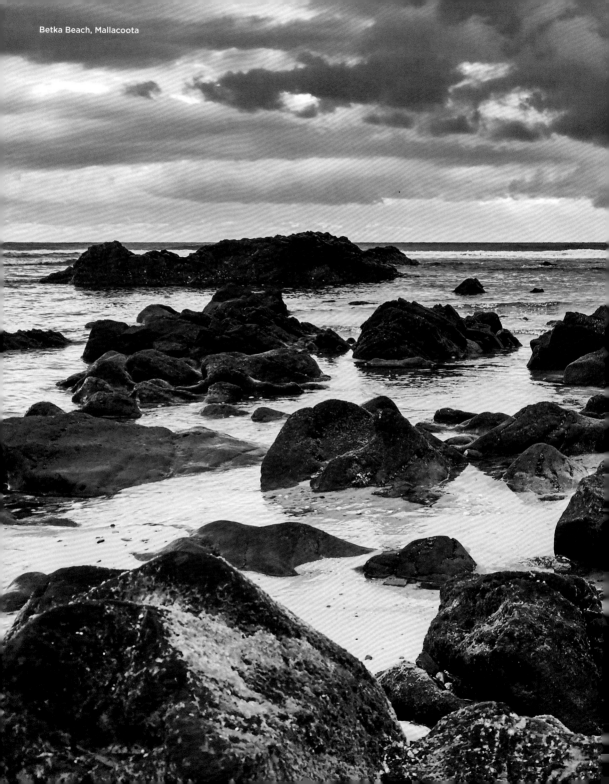

Betka Beach, Mallacoota

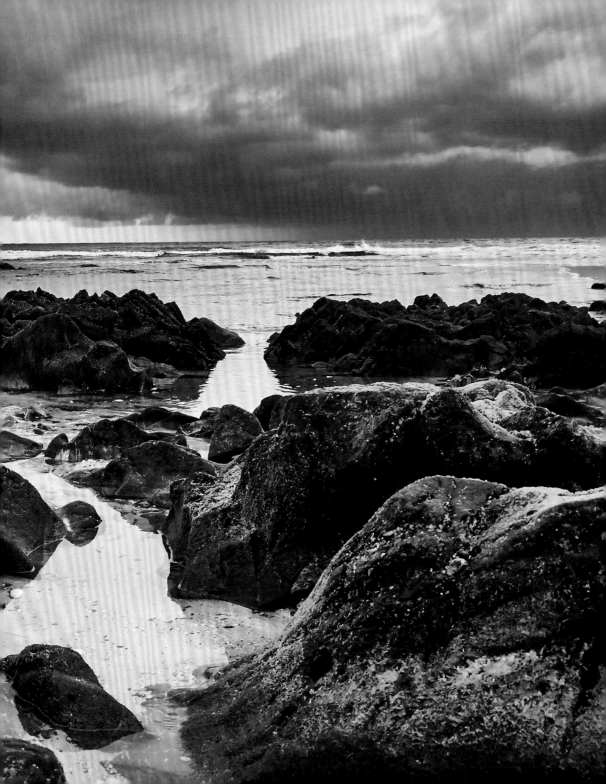

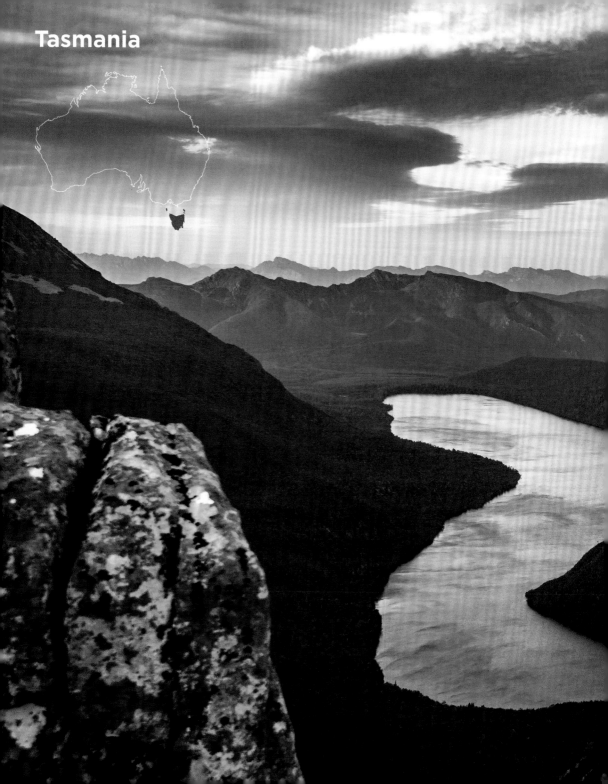

Tasmania

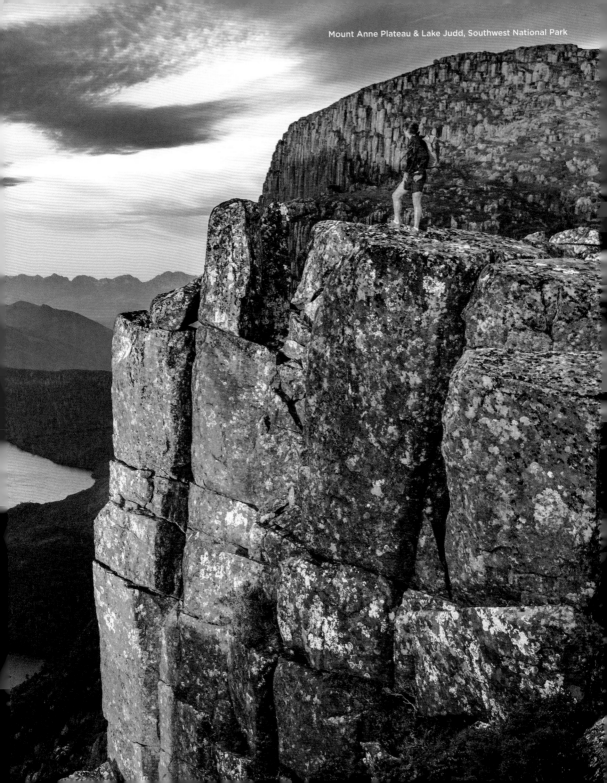

Mount Anne Plateau & Lake Judd, Southwest National Park

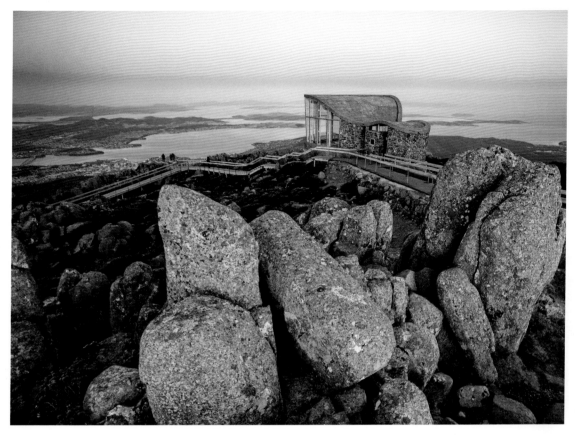

Observation building, Kunanyi (Mount Wellington)

Tasmania & Hobart

The sleepy cousin of other Australian capital cities, Hobart has more going for it than many travelers realise. Arrayed around a series of bays and inlets, and watched over by imposing Mt Wellington, the city has a long colonial history, the most obvious touchstone of which is the sandstone waterfront district known as Salamanca—its Saturday market is a Hobart institution. Nearby Battery Point preserves its 19th-century fishing village feel and is utterly lacking in pretension. And then there's the irresistibly contemporary MONA, accessible by ferry and one of Australia's most dynamic artistic spaces.

Tasmanie & Hobart

Cousine endormie des autres grandes villes australiennes, Hobart a plus d'atouts que beaucoup de voyageurs ne le pensent. Articulée autour d'une série de baies et de criques, et surveillée par l'imposant mont Wellington, la ville a une longue histoire coloniale, dont la pierre angulaire la plus évidente est le quartier de bord de mer en grès appelé Salamanca – son marché du samedi est une institution à Hobart. Tout près, Battery Point conserve son atmosphère de village de pêcheurs du XIXᵉ siècle, tout en humilité. Et puis il y a le MONA, accessible par ferry ; c'est l'un des espaces artistiques les plus dynamiques d'Australie.

Tasmanien & Hobart

Hobart, der verschlafene Cousin anderer australischer Hauptstädte, hat mehr zu bieten, als viele Reisende glauben. Die Stadt, die sich um eine Reihe von Buchten gruppiert und vom imposanten Mount Wellington bewacht wird, hat eine lange koloniale Geschichte, deren offensichtlichstes Merkmal das Sandsteinviertel am Wasser ist, das als Salamanca bekannt ist – der Samstagsmarkt ist eine Institution von Hobart. Battery Point in der Nähe bewahrt das Flair des Fischerdorfes aus dem 19. Jahrhundert und ist sehr unprätentiös. Und dann ist da noch das unwiderstehliche Museum MONA, das mit der Fähre erreichbar ist und einer der dynamischsten Kunsträume Australiens.

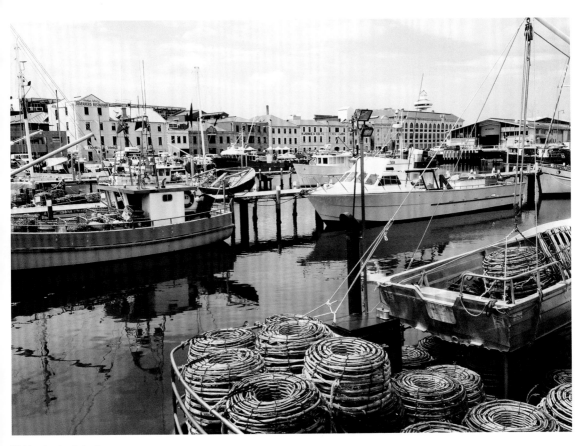

Fishing boats, Hobart

Tasmania & Hobart

Hobart, el primo aburrido de otras
capitales australianas, tiene mucho más
que ofrecer de lo que muchos viajeros
creen. enclavada alrededor de una serie
de bahías y ensenadas, y vigilada por el
imponente Monte Wellington, la ciudad
tiene una larga historia colonial, cuyo
referente más obvio es el distrito costero
de arenisca conocido como Salamanca.Su
mercado de los sábados es una institución
de Hobart, está situado cerca del barrio de
Battery Point, queconserva su ambiente de
pueblo de pescadores del siglo XIX y carece
por completo de pretensiones. También
está el museo MONA, irresistiblemente
contemporáneo, accesible en ferri y que
constituye uno de los espacios artísticos
más dinámicos de Australia.

Tasmania & Hobart

Cugina assonnata di altre città principali
australiane, Hobart ha più successo di
quanto molti viaggiatori pensino. Adagiata
intorno a una serie di baie e insenature,
e sorvegliata dall'imponente Mount
Wellington, la città ha una lunga storia
coloniale, il cui segno più evidente è il
quartiere costiero in pietra arenaria noto
come Salamanca – il suo mercato del
sabato è un'istituzione a Hobart. Il vicino
Battery Point conserva l'atmosfera da
villaggio di pescatori del XIX secolo ed è
completamente privo di pretese. E poi c'è
l'irresistibile museo MONA, accessibile in
traghetto – uno degli spazi per l'arte più
dinamici dell'Australia.

Tasmanië & Hobart

Hobart, het slaperige neefje van andere
Australische hoofdsteden, heeft meer te
bieden dan veel reizigers weten. De stad
heeft een lange koloniale geschiedenis,
waarvan het opvallendste kenmerk de
zandstenen wijk aan het water is, bekend
als Salamanca. De zaterdagmarkt is een
begrip in Hobart. Het nabijgelegen Battery
Point bezit de flair van een 19e-eeuws
vissersdorp en pretendeert niets. En dan
is er nog het onweerstaanbare MONA-
museum, dat per veerboot bereikbaar
is en een van de meest dynamische
kunstinstellingen van Australië is.

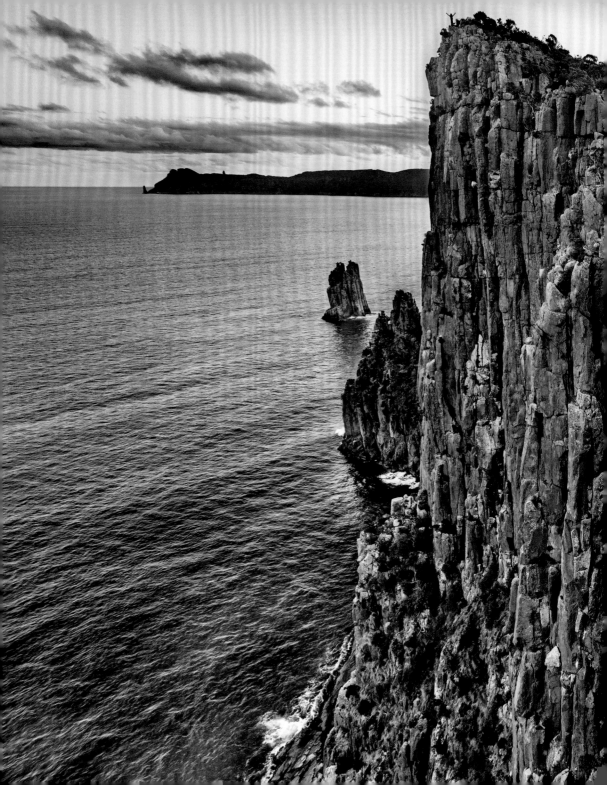

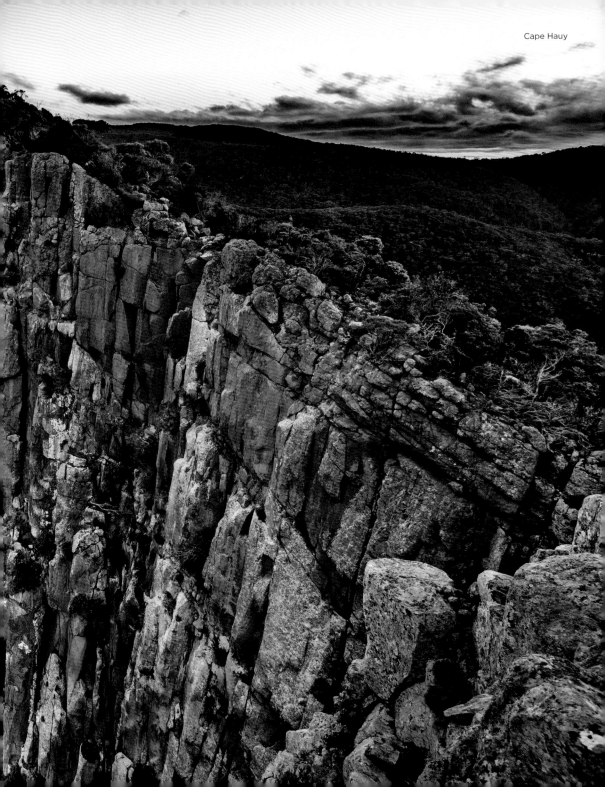

Cape Hauy

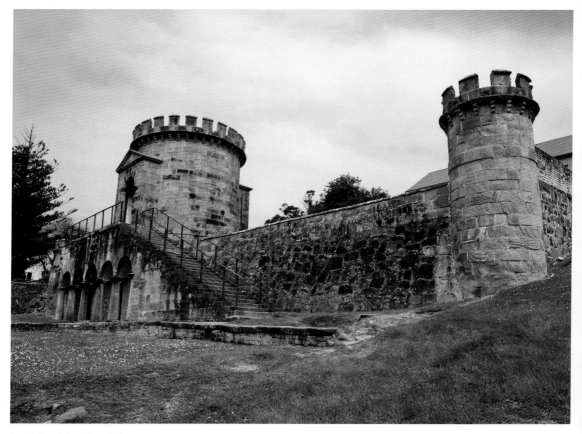

Port Arthur Prison, Port Arthur

Port Arthur

A 19th-century penal settlement that's synonymous with cruelty and hardship, today is an incredibly evocative open-air museum. A sandstone 'model prison' sits at its heart but is surrounded by a guard tower, ruins of another penitentiary and its convict built, non-denominational Gothic-style church. Its remote peninsula setting is as lovely as it is melancholy.

Port Arthur

Cet établissement pénitentiaire du XIXᵉ siècle, synonyme alors de cruauté et de misère, est aujourd'hui un musée en plein air incroyablement puissant. Une « prison modèle » en grès se trouve en son cœur, mais elle est également entourée d'une tour de garde, des ruines d'un autre pénitencier et de son église de style gothique non consacrée construite par un détenu. Sa péninsule reculée est aussi belle que mélancolique.

Port Arthur

Eine Strafkolonie aus dem 19. Jahrhundert, die gleichbedeutend ist mit Grausamkeit und Not, ist heute ein unglaublich eindrucksvolles Freilichtmuseum. Ein aus Sandstein gefertigtes „Modell-Gefängnis" liegt im Inneren, umgeben von einem Wachturm, Ruinen eines anderen Gefängnisses und einer von einem Sträfling errichteten, konfessionslosen gotischen Kirche. Seine abgelegene Lage auf der Halbinsel ist ebenso schön wie melancholisch.

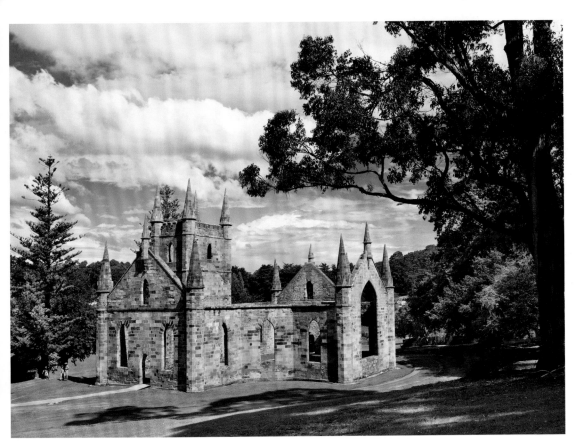
Convict-built church, Port Arthur

Port Arthur
Una colonia penitenciaria del siglo XIX que fue sinónimo de crueldad y penuria, se ha convertido hoy en un museo al aire libre increíblemente evocador. Una 'prisión modelo' de arenisca se asienta en su núcleo, pero está rodeada por una torre de vigilancia, ruinas de otra penitenciaría y una iglesia de estilo gótico aconfesional construida por un convicto. Su remoto entorno peninsular es tan encantador como melancólico.

Port Arthur
Colonia penale ottocentesca, sinonimo di crudeltà e disagi, oggi è un museo a cielo aperto incredibilmente suggestivo. Al suo interno si trova la ricostruzione di una prigione in pietra arenaria, circondata da una torre di guardia, dalle rovine di un altro penitenziario e dalla chiesa in stile gotico non confessionale, costruita da un detenuto. La sua posizione remota sulla penisola è tanto bella quanto malinconica.

Port Arthur
Deze 19e-eeuwse strafkolonie, die synoniem is aan wreedheid en ontberingen, is nu een ongelooflijk indrukwekkend openluchtmuseum. Een zandstenen 'modelgevangenis' staat in het hart van het strafkamp, omgeven door een wachttoren, ruïnes van een andere gevangenis en een door de gevangenen gebouwde kerk in een gotische stijl. De afgelegen ligging op een schiereiland is even mooi als melancholiek.

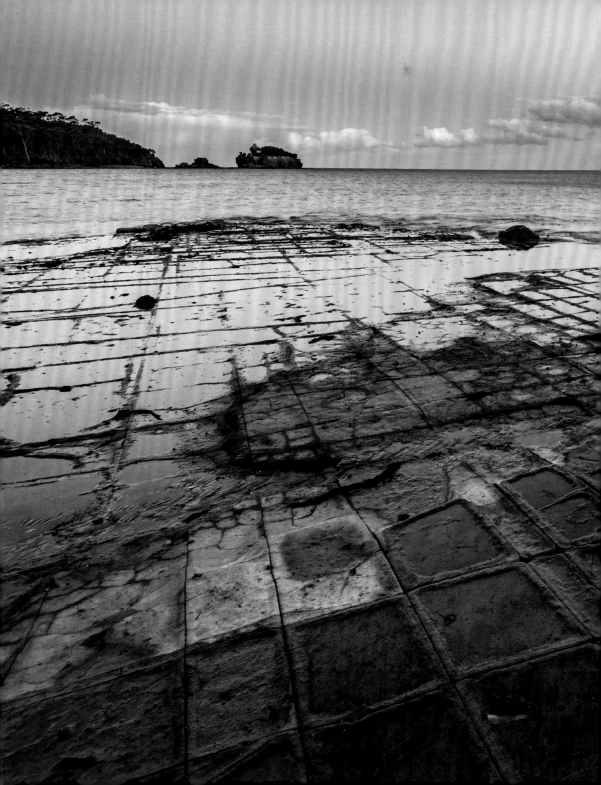

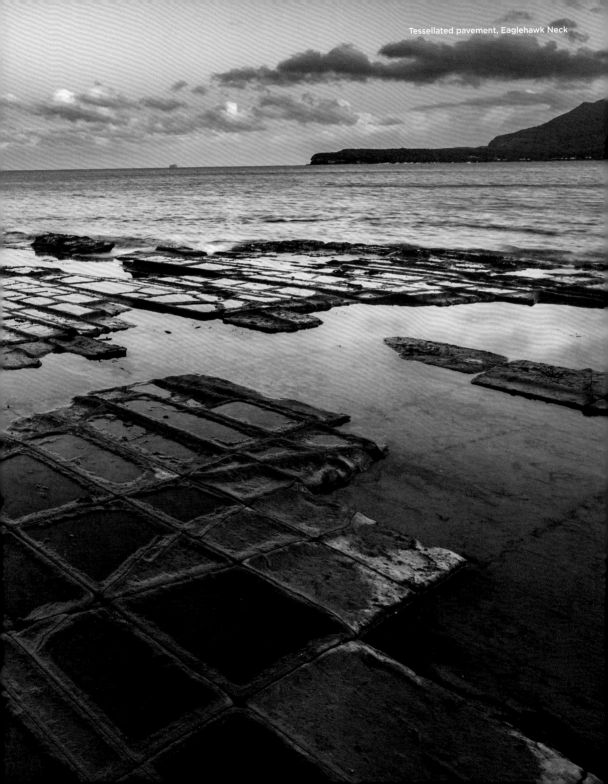

Tessellated pavement, Eaglehawk Neck

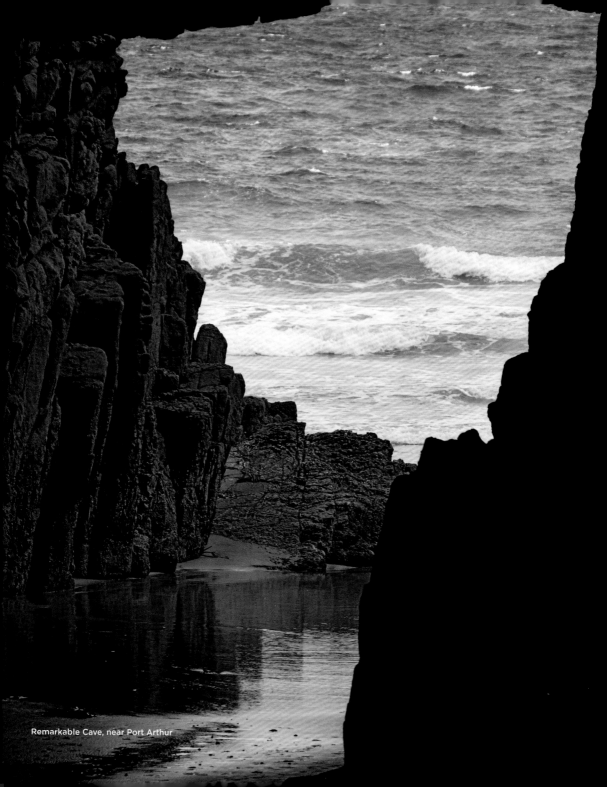

Remarkable Cave, near Port Arthur

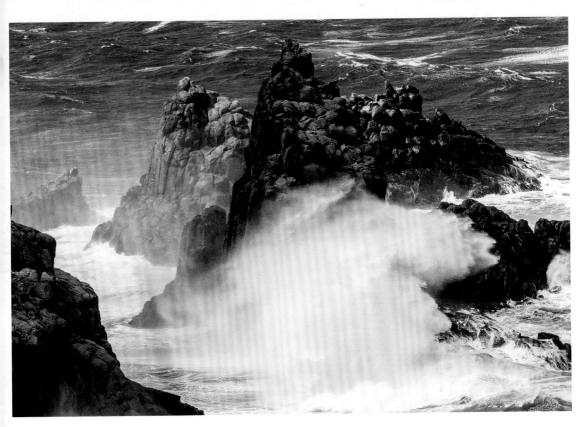

Southport

The Far Southeast

Dramatic, austere sandstone cliffs and rock formations mark Tasmania's rugged southeast coast. Close to Port Arthur, Remarkable Cave is both unique in form but fascinating for the fact its opening resembles the shape of Tasmania. Southport – the most southern township in Australia – has both wild rocky outcrops and gentle white beaches.

El Extremo Sudeste

Dramáticos y austeros acantilados de arenisca y formaciones rocosas marcan la escarpada costa sudeste de Tasmania. Cerca de Port Arthur, la conocida como "cueva extraordinaria" o Remarkable Cave es única en su forma, pero fascinante por el hecho de que su apertura se asemeja a la forma de Tasmania. El barrios de Southport, el municipio más meridional de Australia, cuenta con salientes rocosos salvajes y suaves playas de arena blanca.

L'extrême sud-est

Les falaises de grès et les spectaculaires formations rocheuses singularisent la côte sud-est accidentée de la Tasmanie. Proche de Port Arthur, Remarkable Cave est à la fois unique par sa forme et fascinante par le fait que son ouverture ressemble au tracé de la Tasmanie. Southport – le canton le plus méridional d'Australie – possède à la fois des affleurements rocheux sauvages et de douces plages blanches.

L'estremo sud-est

Scogliere di arenaria e formazioni rocciose drammatiche e ripide segnano la aspra costa sudorientale della Tasmania. Vicino a Port Arthur, Remarkable Cave è unica nella forma e affascina per il fatto che la sua apertura assomigli al profilo della Tasmania. Southport – la comunità più a sud dell'Australia – è caratterizzata sia da affioramenti rocciosi selvaggi che da dolci spiagge bianche.

Der äußerste Südosten

Dramatische, karge Sandsteinfelsen und Felsformationen prägen die zerklüftete Südostküste. In der Nähe von Port Arthur ist die Remarkable Cave, einzigartig in ihrer Form als auch faszinierend durch die Tatsache, dass ihre Öffnung der Form Tasmaniens ähnelt. Southport – die südlichste Gemeinde Australiens – bietet wilde Felsvorsprünge und sanfte weiße Strände.

Het uiterste zuidoosten

Dramatische, kale zandstenen klippen en rotsformaties markeren de woeste zuidoostkust van Tasmanië. Dicht bij Port Arthur is de Remarkable Cave, opmerkelijk door de unieke vorm en doordat de opening qua vorm lijkt op Tasmanië. Southport – de zuidelijkste gemeente van Australië – biedt wilde rotspartijen en zachte witte stranden.

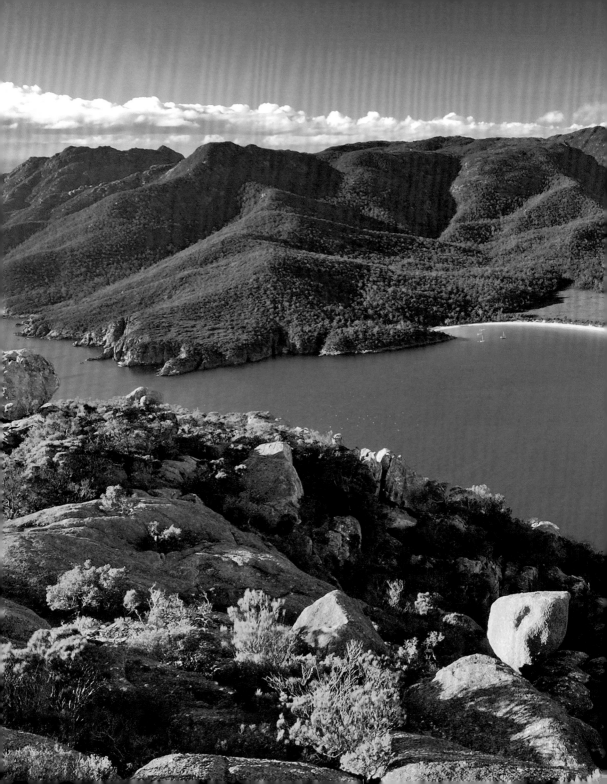

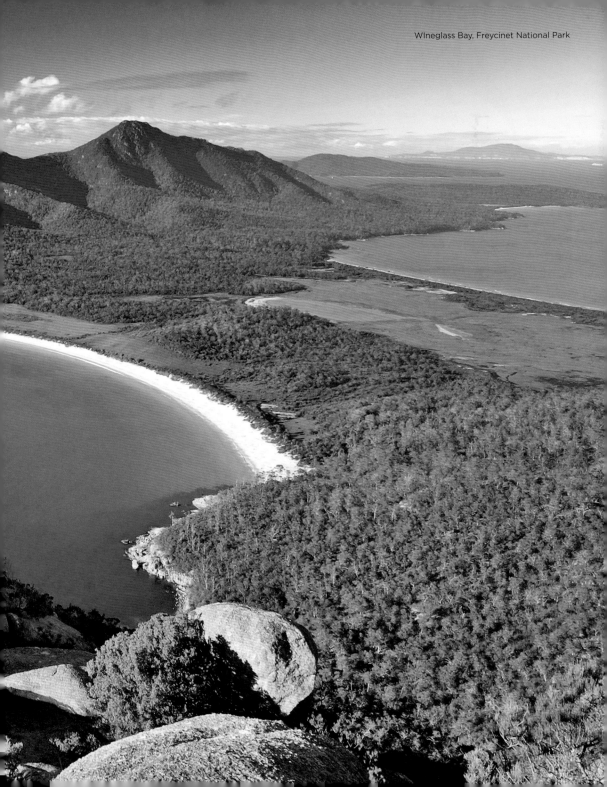

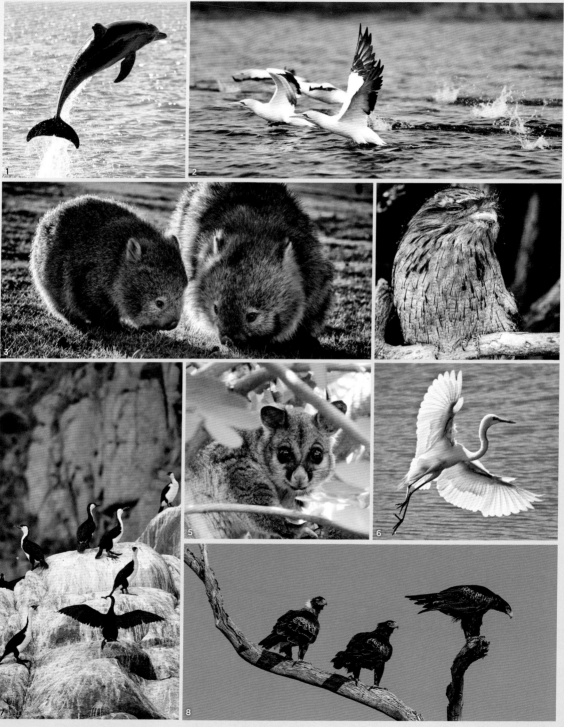

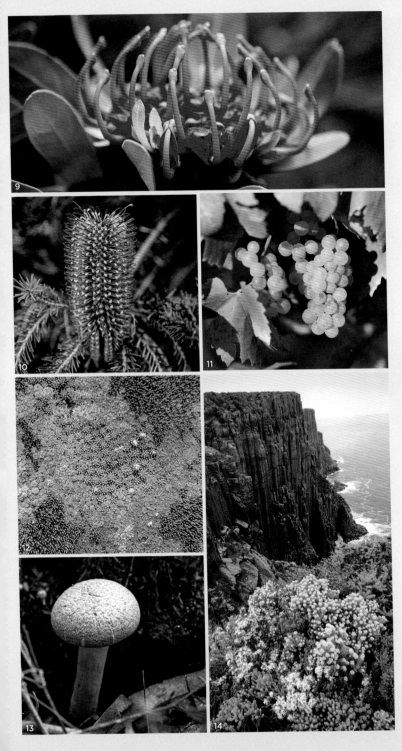

1 Common dolphin; Dauphin commun ; Großer Tümmler; Delfín común; Delfino comune; Gewone dolfijn

2 Australasian Gannets; Fou austral ; Australischer Tölpel; alcatraces australianos; Sule australiane; Pacifische jan-van-genten

3 Wombats

4 Frogmouth; Pordages ; Eulenschwalm; Pogardos; Podargo; Uilnachtzwaluw

5 Possum; Opossum ; zarigüeya

6 Eastern Great Egret; Ardea alba modesta ; Östlicher Silberreiher; Garza real del este; Airone bianco orientale; Oosterse grote zilverreiger

7 Cormorant; Cormoran ; Kormoran; Cormorán; Cormorano; Aalscholvers

8 Wedge-tailed eagles; Aigle d'Australie ; Keilschwanzadler; Águilas de cola de cuña; Aquile cuneate; Wigstaartarenden

9 Tasmanian waratah; Waratah de Tasmanie ; Telopea truncata; Waratah de Tasmania; Telopea

10 Bottlebrush Tree Flower; Fleur de callistemon ; Zylinderputzer; Calistemón; Callistemone; Lampenpoetserplant

11 Wine Grapes; Raisins de cuve ; Weinreben; Uvas de vino; Uva; Druiven

12 Cushionplant; Plante à coussin ; Polsterpflanze; Planta cojín; Arotanella; Kussenplant;

13 Rhubarb bolete; Bolette de rhubarbe ; Rhabarberröhrling; Boleto de ruibarbo; Boleto del rabarbaro; *Boletus osbcurecoccineus*

14 Cape Raoul

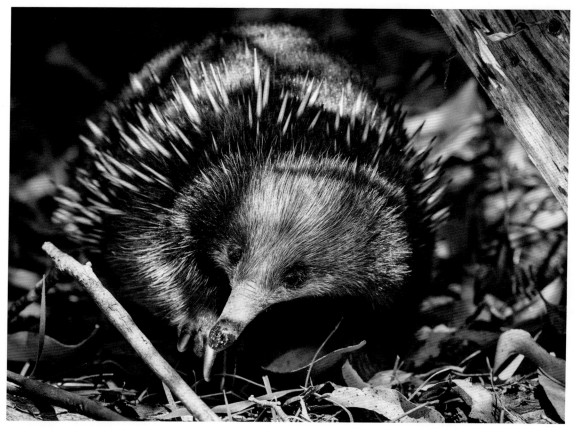

Short-beaked echidna *(Tachyglossus aculeatus)*

Mount Field National Park

A short drive from Hobart, this national park has been popular for over one hundred years. Stunning landscapes, including falls and forested slopes, are filled with incredible plant diversity including many unique alpine species. Wildlife to be seen include the notoriously shy platypus and echidna, the eastern barred bandicoot and the eastern quoll.

Parc national du mont Field

À quelques minutes en voiture de Hobart, ce parc national est populaire depuis plus de cent ans. Ses paysages époustouflants, qui comprennent notamment des cascades et des pentes boisées, sont remplis d'une incroyable diversité de plantes, dont de nombreuses espèces alpines uniques.
Du côté de la faune, on peut y observer des ornithorynques et des échidnés, notoirement timides, des bandicoots rayés de l'Est et des chats marsupiaux mouchetés.

Mount Field National Park

Nur eine kurze Autofahrt von Hobart entfernt, ist dieser Nationalpark seit über hundert Jahren beliebt. Atemberaubende Landschaften, darunter Wasserfälle und bewaldete Hänge, bieten eine unglaubliche Pflanzenvielfalt, darunter viele einzigartige alpine Arten. Zu den Wildtieren, die man sehen kann, gehören das notorisch scheue Schnabeltier und Ameisenigel, der Tasmanische Langnasenbeutler und der Tüpfelbeutelmarder.

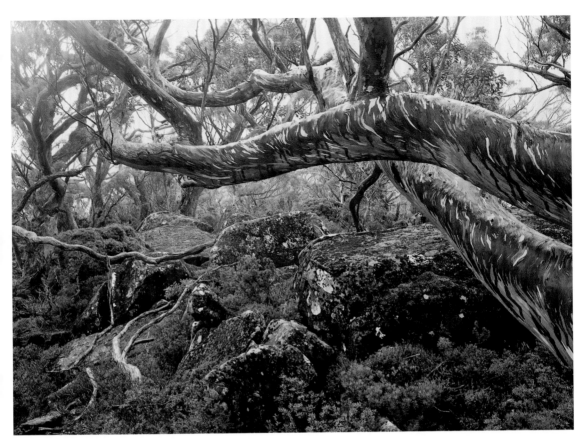

Mount Field National Park

Mount Field National Park

A poca distancia de Hobart, este parque nacional ha sido popular durante más de cien años. Los paisajes impresionantes, incluyendo caídas y laderas boscosas, están llenos de una increíble diversidad de plantas, incluyendo muchas especies alpinas únicas. La fauna silvestre que se puede ver incluye el tímido ornitorrinco y el equidna, el bandicut oriental y el quol oriental.

Mount Field National Park

Questo parco nazionale, a breve distanza in auto da Hobart, è popolare da più di un secolo. Paesaggi mozzafiato, tra cui cascate e pendii boscosi, ospitano un'incredibile varietà di piante, tra cui molte specie alpine uniche. Tra gli animali selvatici da vedere ci sono l'ornitorinco e l'echidna, il bandicoot fasciato orientale e il quoll orientale.

Mount Field National Park

Dit nationale park, met de auto niet ver bij Hobart vandaan, is al meer dan honderd jaar geliefd. Prachtige landschappen, waaronder watervallen en beboste hellingen, zijn gevuld met een enorme verscheidenheid aan planten, waaronder vele unieke alpine soorten. Wilde dieren zijn onder andere het beruchte vogelbekdier en de mierenegel, de Tasmaanse buideldas en de gevlekte buidelmarter.

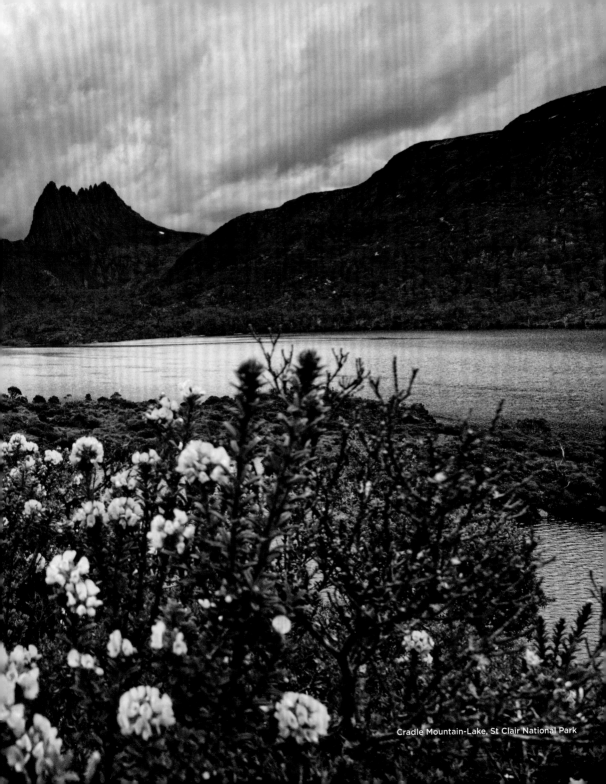

Cradle Mountain-Lake, St Clair National Park

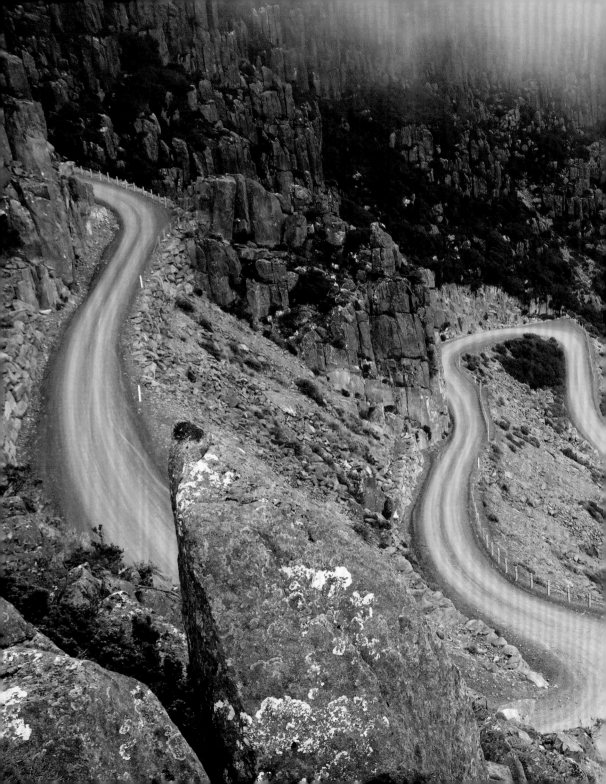

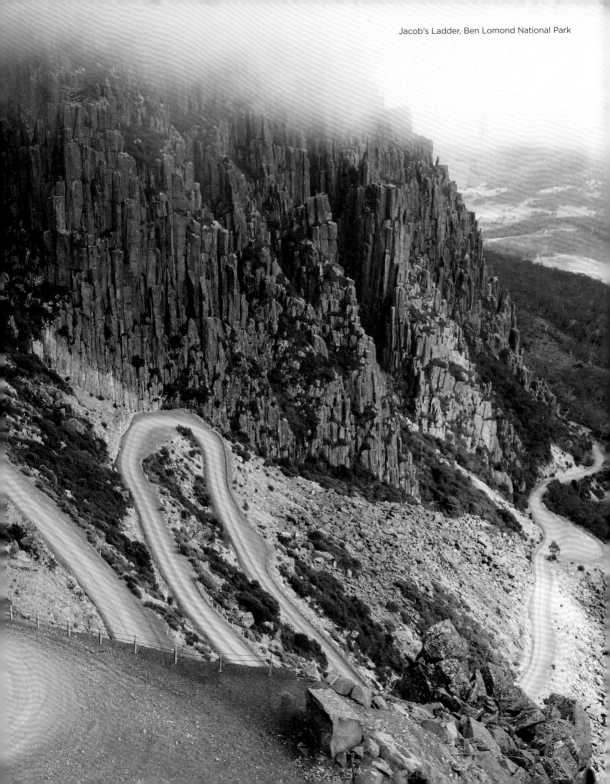

Macquarie Island

A World Heritage Site, Tasmania's second, this small subantarctic island lies somewhere between Antarctica and New Zealand. Geologically significant, it's also known as the 'Galapagos of the Southern Ocean', with four types of penguin, albatrosses, seals, sea lions and unique marine invertebrates.

Île Macquarie

Second site de Tasmanie a avoir été inscrit au patrimoine mondial, cette petite île subantarctique se trouve quelque part entre l'Antarctique et la Nouvelle-Zélande. De forte importance géologique, elle est également connue sous le nom de « Galapagos de l'océan Austral ». On y trouve quatre types de manchots, des albatros, des phoques, des otaries et des invertébrés marins endémiques.

Macquarie Island

Tasmaniens zweite, kleinere subantarktische Insel, die zum Weltnaturerbe gehört, liegt zwischen Antarktis und Neuseeland. Geologisch bedeutsam, gilt sie als „Galapagos des Südlichen Ozeans", mit seinen vier Arten von Pinguinen, Albatrossen, Robben, Seelöwen und einzigartigen wirbellosen Meerestieren.

Macquarie Island

Esta pequeña isla subantártica, Patrimonio de la Humanidad, es la segunda de Tasmania y se encuentra en algún lugar entre la Antártida y Nueva Zelanda. De importancia geológica, también es conocida como la 'Galápagos del Océano Austral', con cuatro tipos de pingüinos, albatros, focas, lobos marinos e invertebrados marinos únicos.

Macquarie Island

Riconosciuto come patrimonio dell'umanità dall'Unesco, il secondo della Tasmania, questa piccola isola subantartica si trova tra l'Antartide e la Nuova Zelanda. Di importanza geologica notevole, è anche conosciuta come le "Galapagos dell'Oceano Meridionale", con quattro tipi di pinguino, albatros, foche, leoni marini e invertebrati marini unici.

Macquarie Island

Dit kleine, geologisch belangrijke eiland ligt tussen Antarctica en Nieuw-Zeeland. Het is ook wel bekend als de 'Galapagos van de Zuidelijke Oceaan', met vier soorten pinguïns, albatrossen, zeehonden, zeeleeuwen en unieke ongewervelde zeedieren.

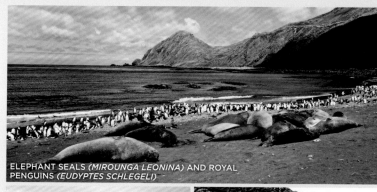

ELEPHANT SEALS *(MIROUNGA LEONINA)* AND ROYAL PENGUINS *(EUDYPTES SCHLEGELI)*

LIGHTHOUSE MACQUARIE ISLAND

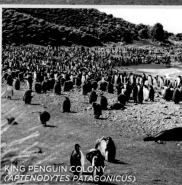

KING PENGUIN COLONY *(APTENODYTES PATAGONICUS)*

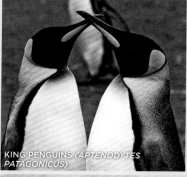

KING PENGUINS *(APTENODYTES PATAGONICUS)*

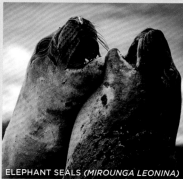

ELEPHANT SEALS *(MIROUNGA LEONINA)*

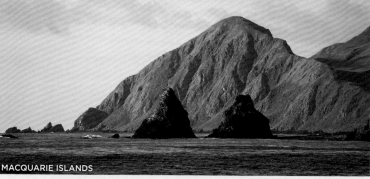

MACQUARIE ISLANDS

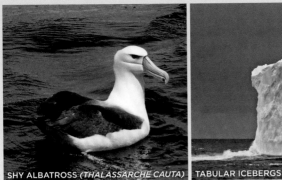
SHY ALBATROSS (*THALASSARCHE CAUTA*)

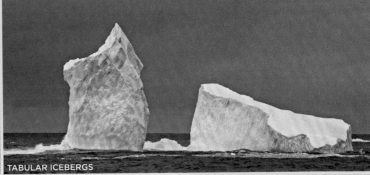
TABULAR ICEBERGS

North Head
Hasselborough
Bay
Handspike Point
Halfmoon Bay
Anare Station
Buckles Bay
Nuggets Point
Mount Eider
Bauer Bay
Mawson Point
Cormorant Point
Sandy Bay
Brothers Point
Aurora Point

Macquarie Island

Mount Waite
Davis Bay
Sandell Bay
Saddle Point
Cape Toutcher
Rockhopper Point
Waterfall Bay
Mount Hamilton
Lusitania Bay
Mount Fletcher
Cape Star
Carrick Bay
Mount Jeffreys
Caroline Point
South West
Point
Hurd Point

0°
Australia
New Zealand
Tasmania
40°
Macquarie Island
Antarctica
80°

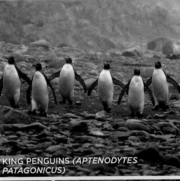
KING PENGUINS (*APTENODYTES PATAGONICUS*)

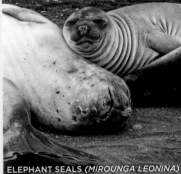
ELEPHANT SEALS (*MIROUNGA LEONINA*)

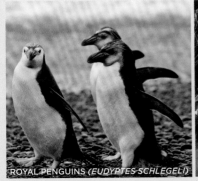
ROYAL PENGUINS (*EUDYPTES SCHLEGELI*)

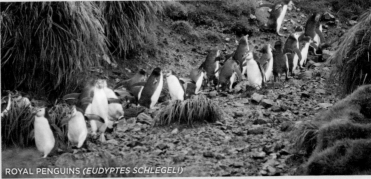
ROYAL PENGUINS (*EUDYPTES SCHLEGELI*)

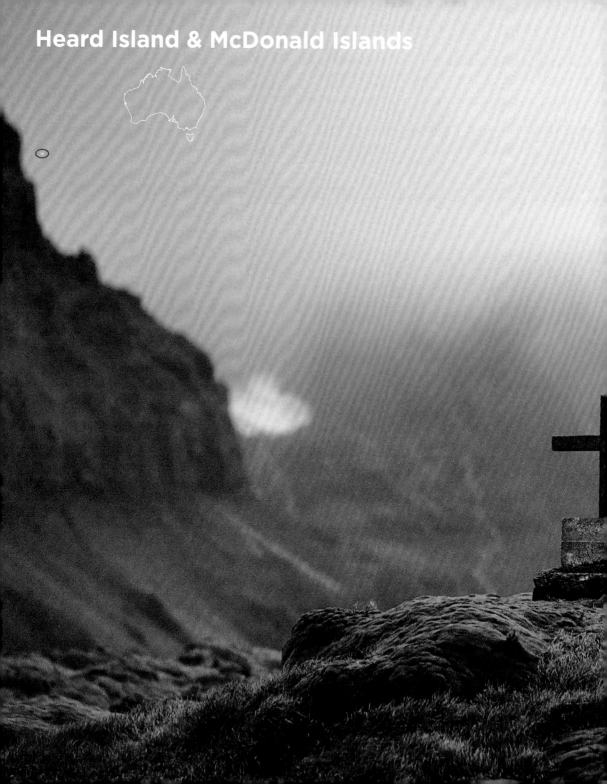

Sealers Grave Site

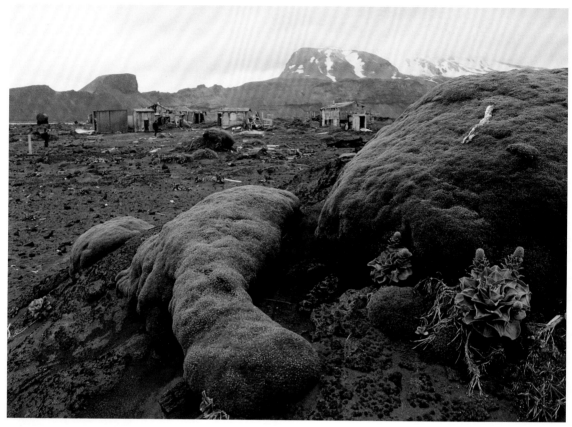

Australian National Antarctic Research Expedition (ANARE), Atlas Cove

Heard Island & McDonald Islands

These barren, glaciated Antarctic islands are an external territory of Australia over 4000 km from Perth in the Southern Ocean. This remote, utterly wild place boasts the country's only active volcanoes and its highest mountain. Seals, birds, rare sealife and what's thought to be the largest colony of macaroni penguins in the world thrive here.

Îles Heard & MacDonald

Ces îles arides et glaciaires de l'Antarctique sont un territoire extérieur de l'Australie situé à plus de 4000 km au large de Perth, dans l'océan Austral. Cet endroit reculé et totalement sauvage possède les seuls volcans actifs du pays mais aussi sa plus haute montagne. Des phoques, des oiseaux, une faune rare et ce que l'on croit être la plus grande colonie au monde de gorfous dorés prospèrent ici.

Heard Island & MacDonald Islands

Diese kargen, vergletscherten antarktischen Inseln sind ein Außengebiet Australiens, das über 4000 km von Perth im Südlichen Ozean entfernt liegt. Dieser abgelegene, völlig wilde Ort verfügt über die einzigen aktiven Vulkane des Landes und seinen höchsten Berg. Robben, Vögel, seltene Meerestierarten und die vermutlich größte Kolonie von Goldschopfpinguinen der Welt gedeihen hier.

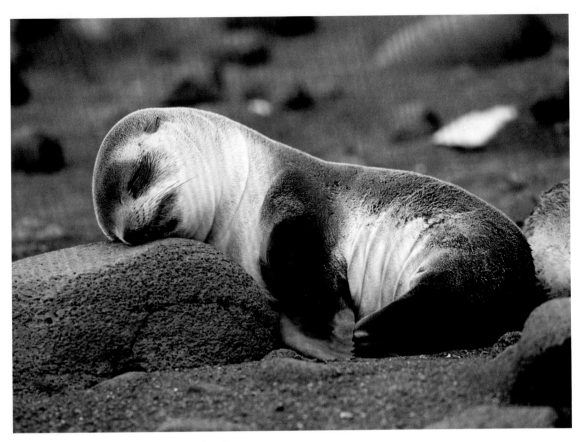

Antarctic Fur Seal *(Arctocephalus gazella)*, Sealers Corner

Islas Heard & MacDonald Islands

Estas islas áridas y glaciares de la Antártida son un territorio externo de Australia a más de 4.000 km de Perth, en el Océano Austral. Este remoto y salvaje lugar cuenta con los únicos volcanes activos del país y su montaña más alta. Aquí prosperan las focas, las aves, la vida marina insólita y la que se cree que es la colonia más grande de pingüinos macarrones del mundo.

Heard Island & MacDonald Islands

Queste isole spoglie e ghiacciate nell'Antartide sono un territorio esterno dell'Australia, a più di 4.000 km da Perth nell'Oceano Australe. Questo luogo remoto e assolutamente selvaggio vanta gli unici vulcani attivi del paese e la montagna più alta. Qui vivono foche, uccelli, animali marini rari e quella che si pensa sia la più grande colonia di pinguini macaroni del mondo.

Heard Island & MacDonald Islands

Deze kale, vergletsjerde subantarctische eilanden zijn een buitengebied van Australië dat op meer dan 4.000 km van Perth in de Zuidelijke Oceaan ligt. Deze afgelegen, volledig wilde plek bezit de enige actieve vulkanen van het land en de hoogste berg. Zeehonden, vogels, zeldzame zeedieren en wat wordt beschouwd als de grootste kolonie macaronipinguïns ter wereld gedijen hier.

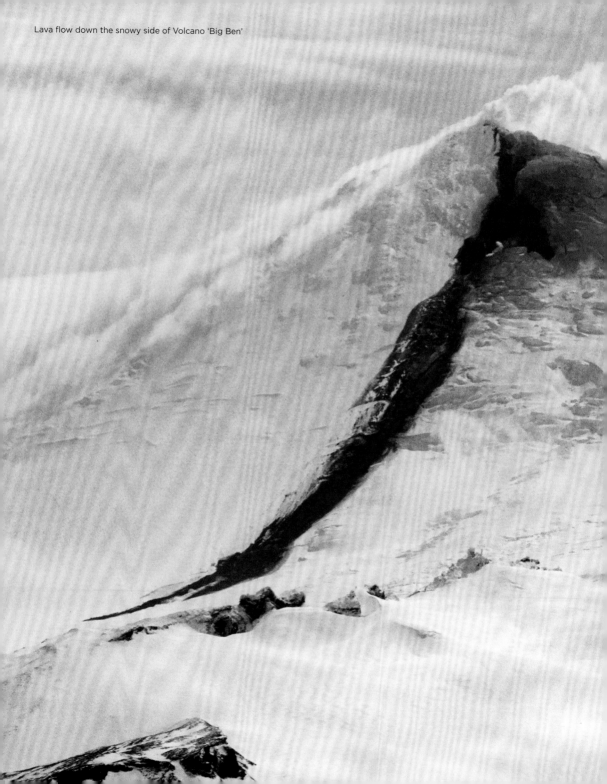

Lava flow down the snowy side of Volcano 'Big Ben'

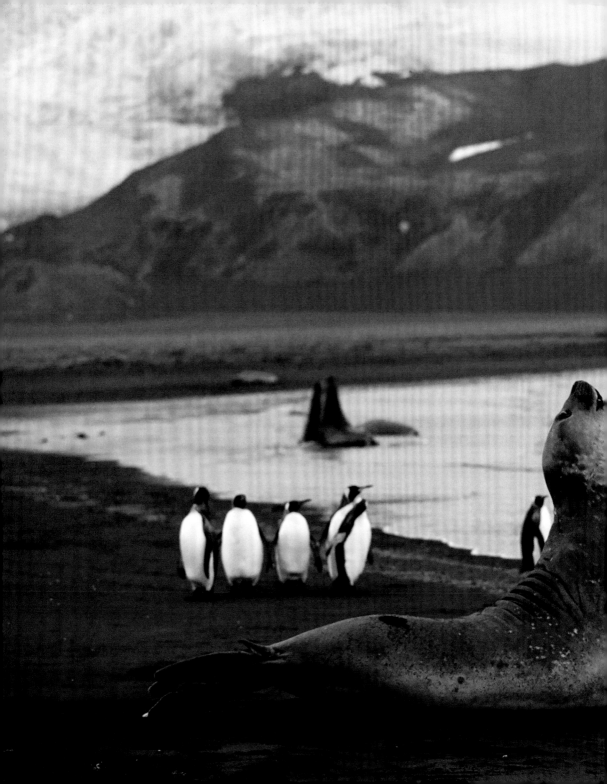

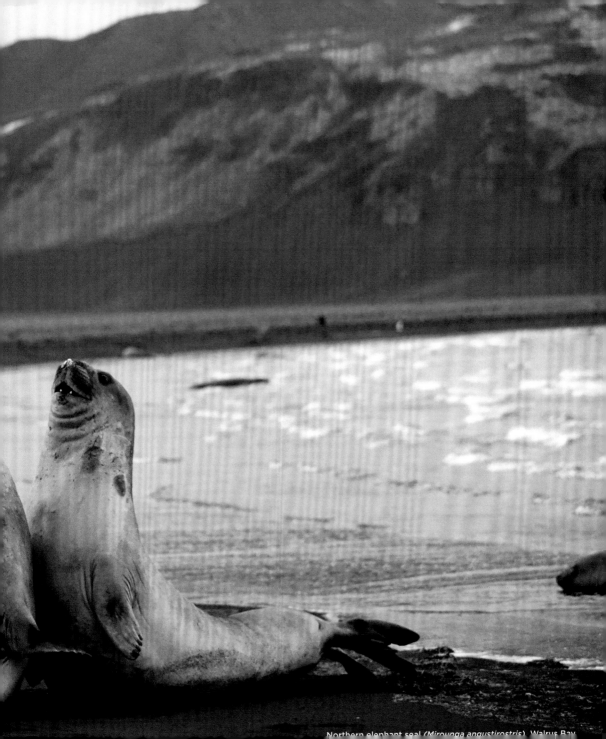

Northern elephant seal *(Mirounga angustirostris)*, Walrus Bay

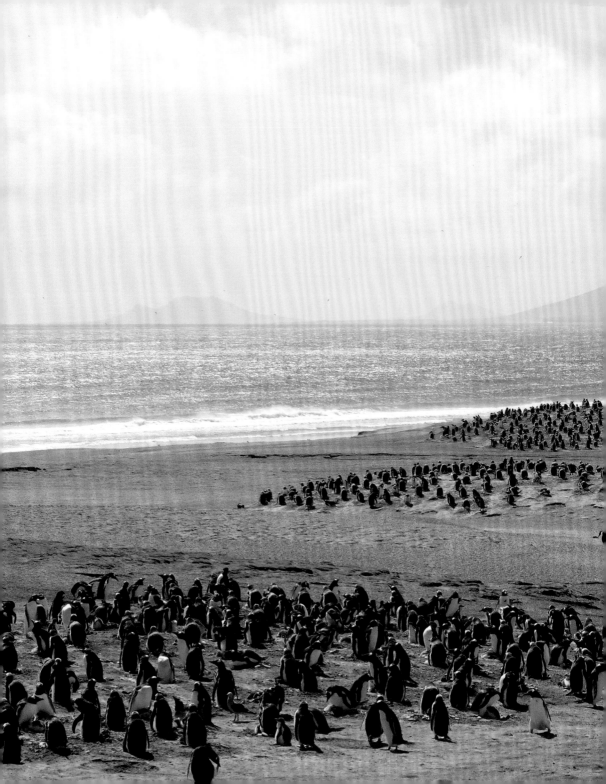

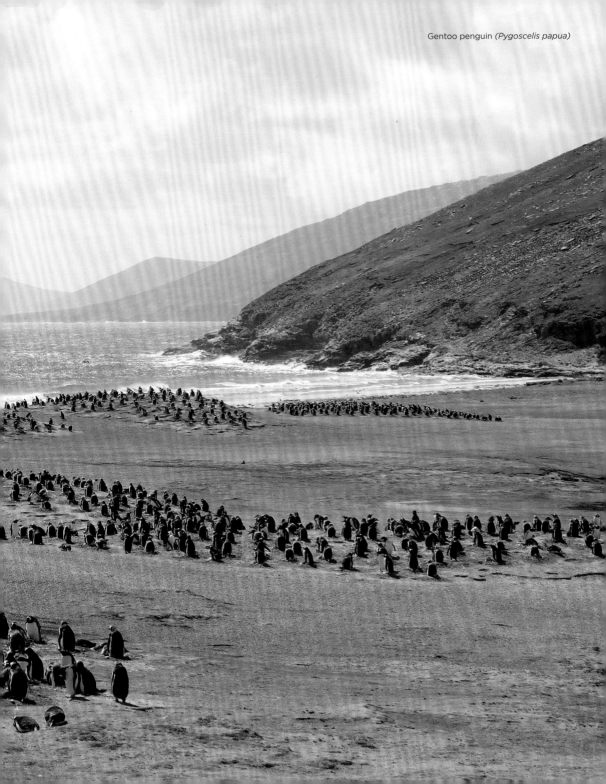

Gentoo penguin *(Pygoscelis papua)*

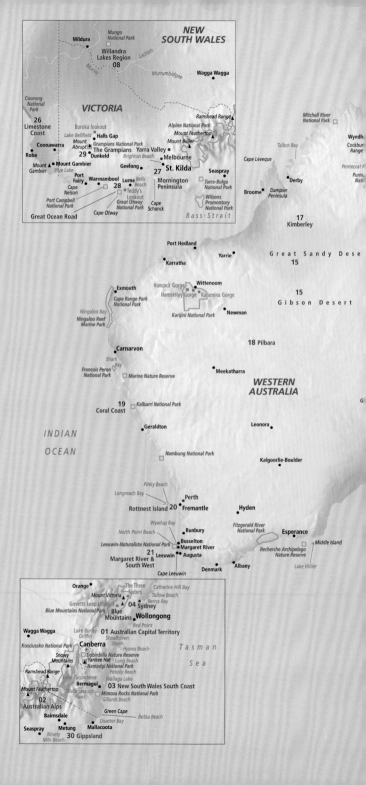

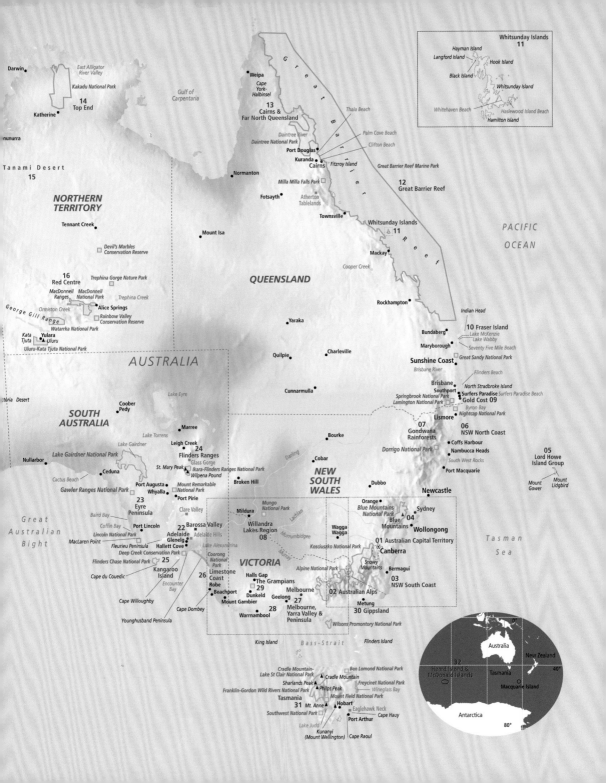

Darwin

East Alligator
River Valley

Kakadu National Park

14
Top End

Katherine

nunurra

Tanami Desert
15

Gulf of
Carpentaria

Weipa

Cape
York-Halbinsel

13
Cairns &
Far North Queensland

Thala Beach

Daintree River
Daintree National Park

Palm Cove Beach

Clifton Beach

Port Douglas

Kuranda
Cairns Fitzroy Island

Great Barrier Reef Marine Park

Normanton

Milla Milla Falls Park

Fotsayth

Atherton
Tablelands

12
Great Barrier Reef

NORTHERN
TERRITORY

Tennant Creek

Devil's Marbles
Conservation Reserve

Mount Isa

Townsville

Whitsunday Islands
11

PACIFIC

OCEAN

16
Red Centre

MacDonnell MacDonnell
Ranges National Park

Trephina Gorge Nature Park

Alice Springs

Ormiston Creek Trephina Creek

George Gill Range

Rainbow Valley
Conservation Reserve

Watarrka National Park

Kata
Tjuta Yulara
Uluru

Uluru-Kata Tjuta National Park

AUSTRALIA

Mackay

Cooper Creek

QUEENSLAND

Yaraka

Rockhampton

Indian Head

10 Fraser Island
Lake McKenzie
Lake Wabby

Bundaberg

Maryborough Seventy Five Mile Beach

Great Sandy National Park

Charleville

Quilpie

Sunshine Coast

Brisbane River

toria Desert

SOUTH
AUSTRALIA

Coober
Pedy

Lake Eyre

Marree

Leigh Creek

Cunnarmulla

Brisbane
Southport North Stradbroke Island

Springbrook National Park Surfers Paradise Surfers Paradise Beach
Lamington National Park **Gold Cost 09**

Byron Bay
Nightcap National Park

Lismore

07
Gondwana
Rainforests

Dorrigo National Park

06
NSW North Coast

Coffs Harbour

Nambucca Heads

South West Rocks

05
Lord Howe
Island Group

Mount
Gower Mount
Lidgbird

Lake Torrens

24
Flinders Ranges

Glass Gorge

St. Mary Peak Wilpena Pound

Ikara-Flinders Ranges National Park

Bourke

Cobar

Darling

NEW
SOUTH
WALES

Dubbo

Port Macquarie

Newcastle

Nullarbor

Lake Gairdner

Lake Gairdner National Park

Ceduna

Cactus Beach

Gawler Ranges National Park

Port Augusta

Whyalla Mount Remarkable
National Park

Port Pirie

Clare Valley

Broken Hill

Mungo
National Park

Mildura

Willandra
Lakes Region
08

Orange
Blue Mountains
National Park

Wagga
Wagga

Lachlan

Murrumbidgee

Blue
Mountains

04

Sydney

Wollongong

T a s m a n

S e a

Great

Australian

Bight

Baird Bay

23
Eyre
Peninsula

Coffin Bay

Port Lincoln

Lincoln National Park

MacLaren Point

Fleurieu Peninsula

Deep Creek Conservation Park

Flinders Chase National Park

22
Adelaide
Glenelg
Hallett Cove

Barossa Valley

Adelaide Hills

Lake Alexandrina

Kosciuszko National Park

01 Australian Capital Territory

Canberra

25

Kangaroo
Island

Encounter
Bay

Cape du Couedic

26

Coorong
National
Park

Limestone
Coast

Robe

VICTORIA

Halls Gap

Beachport **29**
The Grampians

Murray

Alpine National Park

Snowy
Mountains

Bermagui

03
NSW South Coast

Cape Willoughby

Cape Dombey

Younghusband Peninsula

Mount Gambier

28

Dunkeld

Warrnambool

Geelong

27

Melbourne,
Yarra Valley &
Peninsula

Melbourne

02 Australian Alps

Metung

30 Gippsland

Wilsons Promontory National Park

King Island B a s s - S t r a i t Flinders Island

Cradle Mountain-
Lake St Clair National Park Ben Lomond National Park

Sharlands Peak Cradle Mountain Freycinet National Park

Franklin-Gordon Wild Rivers National Park Philps Peak Wineglass Bay

Mount Field National Park

Tasmania

31 Mt. Anne Hobart

Southwest National Park Eaglehawk Neck

Lake Judd Cape Hauy

Kunanyi Port Arthur
(Mount Wellington) Cape Raoul

Whitsunday Islands
11

Hayman Island

Langford Island Hook Island

Black Island

Whitsunday Island

Whitehaven Beach Haslewood Island Beach

Hamilton Island

0°

Australia New Zealand

32 40°

Heard Island &
McDonald Islands Tasmania

Macquarie Island

Antarctica 80°

Index

oto credits

ty Images

1 Cheryl Forbes; 12/13 kokkai; 14/15 Viktor
nov; 21 Gallo Images; 22 Oliver
hard; 24/25 Leelakajonkij; 30/31 4FR;
Daniiielc; 36/37 FiledIMAGE; 39 Stuart
nagan; 40/41 Auscape; 42 tsvibrav;
53 JanelleLugge; 54/55 RugliG; 56 Wayne
den; 57 John Doornkamp; 58 chrisvankan;
61 lovleah; 62/63 StephaneDebove;
67 zetter; 69 raisbeckfoto;
73 simonbradfield; 74 avresa; 76 Wayne
den; 77 Gillianne Tedder; 80 KarenHBlack;
KarenHBlack; 86 Nick Mason; Sandra
dholdt; Allan Baxter; MikeSleigh;
nCarnemolla; Freda Bouskoutas; Freda
skoutas; 87 Maria Swärd; 87 Freda
skoutas; Freda Bouskoutas; AniaKropelka;
ergurl; 88/89 PomInOz; 92/93 Starcevic;
kokkai; Damien Lynch/EyeEm; kokkai;
vesofthevoid; Oliver Strewe; 95 John Crux
tography; kokkai; ClaraNila; Camila1111;
Christopher Kimmel/Aurora Photos;
haface; ClaraNila; 99 Simon McGill;
owski; Brent Hofacker; Pujan Shah/EyeEm;
cinadora; Lesyy; manyakotic; Creativ
dio Heinemann; 100/101 Brook Attakorn;
Cameron Spencer; 107 RugliG; 110 Scott
telli; 112/113 Southern Lightscapes-
stralia; 118 James Stone; 119 Southern
htscapes-Australia; 120/121 Southern
htscapes-Australia; 126 Christina Port
tography; 127 WalkerPod Images;
/129 RugliG; 130/131 StephaneDebove;
Simon McGill; 134/135 Tse Hon Ning;
Eric Bean; Kevin Schafer; Inigo Merriman
tography; Jamie Lamb/elusive-images;
ard Lacz/VWPics; Dave Watts; CraigRJD;
igRJD; 137 Tobias Titz; pigphoto; mlharing;
Turnervisual; 144/145 UpdogDesigns;
/147 PatrikStedrak; 154/155 lovleah;
/157 Thomas Kurmeier; 158 Airphoto
stralia; 159 AlizadaStudios; 160/161 Kieran
ne; 162 dreamtimestudio; AlagnaMarco;
elia Ramon - TellingLife; Ferdinand
indat/EyeEm; OZBEACHES; oxime;
ockphotos; Busteee; 163 sbostock;
aligursky; Jimbo_Cymru; Bradkay;
/165 Steve Clancy Photography;
Onfokus; 169 AlizadaStudios; 170 Daniela
scherl; 171 Daniela Dirscherl; 172 t-s-
73 trigga; 174/175 Greg Conlon;
David Wahl Photo; 183 Tais Policanti;
Adam Benko; 186 Andrew Michael/
; 200/201 Manfred Gottschalk;
Migration Media/Underwater Imaging;
5/227 DarrenTierney; 233 Andrew
tson; 235 Justin Mckinney/EyeEm;
5/247 Auscape; 252/253 Michael
wab; 254/255 Mary Myla Andamon;
5 Yunntiing Lim/EyeEm; olyniteowl;
Graham; 257 georgeclerk; Ewa
biniak/EyeEm; StockFood; burnettj;
Ted Mead; 261 Sylvain Cordier;
2/263 Tini31; 264/265 Simon McGill;
/269 nordseegold; 270 J_Knaupe;
4 Lynn Gail; 285 digitalfarmer;
3/289 Theo Allofs; 296/297 sara_winter;
Manfred Gottschalk; 310 Alastair Pollock;
Waldie; 311 James van den Broek;
mberto Ramirez; Henry Cook; wrangel;
e-Bergwitz; kristianbell; 314/315 Simon
elps; 317 Francesco Riccardo Iacomino;

328/329 SammyVision; 330 Francesco
Riccardo Iacomino; 331 Paula Jones;
332/333 Jason Edwards; 334/335 Auscape/
UIG; 338/339 Caspar Schlageter;
344 fotofritz16; 345 ClaraNila; 346 lleerogers;
349 Gallo Images; 350/351 ClaraNila;
354/355 Andrew Watson; 356/357 Karl
Beath; 360/361 viktor posnov; 362 Frances
Andrijich; 363 tap10; 364/365 viktor posnov;
372/373 ClaraNila; 376/377 moisseyev;
378 Christopher Groenhout; 379 Julian
Kaesler; 380 Robin Smith; 382 bloodstone;
382 Rainer Lesniewski; 383 UWPhotog;
386/387 Danita Delimont; 390/391 Auscape/
UIG; 394 John White Photos;
395 John White Photos; 402/403 tim
phillips photos; 406/407 Southern
Lightscapes-Australia; 412/413 Southern
Lightscapes-Australia; 414/415 Colin
Monteath; 416/417 JohnCarnemolla;
428 Auscape; 430 bloodstone; 431 Cheryl
Forbes; 432/433 Oliver Strewe;
434/435 SharonWills; 436/437 SharonWills;
438/439 SharonWills; 440/441 Boy_
Anupong; 444/445 AlexTIZANO; 446 Tom
Cockrem; 447 Kevin Clogstoun; 448 kokkai;
449 Richard l'Anson; 450/451 Wayne Fogden;
452/453 John Gollings/ArcaidImages;
454 Mark Kolbe; Klaus Vedfelt; Ryan Pierse;
455 Daniel Pockett/AFL Media; 456/457 Boy_
Anupong; 458/459 Richard l'Anson;
460/461 Boy_Anupong; 462/463 4FR;
464 StephaneDebove; 465 Kieran Stone;
466/467 GordonBellPhotography;
468/469 Thurtell; 470/471 Nigel
Pavitt; 472/473 Kieran Stone;
474 rmbarricarte; 476/477 Auscape/
UIG; 480/481 OnPatrolPhoto; 482 Posnov;
483 Australian Scenics; 484/485 Posnov;
486 houani; 487 Australian Scenics; 488 Nigel
Killeen; 489 Givenworks; 490/491 TonyFeder;
492 Bob Stefko; 493 pkujiahe; 497 tsvibrav;
498/499 Travis Chau; 500/501 Posnov;
502 Auscape; 503 Jodie Griggs;
504/505 Posnov; 508/509 Posnov;
511 simon's photo; 514 Janette Asche;
Chasing Light/James Stone james-stone.
com; viktor posnov; keiichihiki; houani;
seanscott; 515 viktor posnov; Ashley
Whitworth/Whitworth Images; Janet K
Scott; Redzaal; Kevin Wells; keiichihiki;
516 Roman Sandoz; 518/519 Paparwin
Tanupatarachai; 522 Richard McManus; Bruce
Mitchell; keiichihiki; Mickrick; 523 Richard
McManus; Cultura RF/Brett Phibbs; Mickrick;
VargaJones; Byronsdad

Huber Images

6/7 Bierbaum Timo; 16/7 Roland Gerth;
102/103 Richard Taylor; 104/105 Brook
Mitchell; 182 Maurizio Rellini; 190/191 Hans
Peter Huber; 192 Maurizio Rellini; 193 Hans
Peter Huber; 209 Hans Peter Huber;
213 Foster Jon; 225 Luigi Vaccarella;
228 Johanna Huber; 230 Johanna
Huber; 236/237 Luigi Vaccarella;
238/239 Johanna Huber; 271 Luigi Vaccarella;
278/279 Maurizio Rellini; 280 Johanna
Huber; 281 Johanna Huber; 283 Hans
Peter Huber; 340/341 Bildagentur Huber/
Hallberg; 342/343 Damm Stefan; 346 Hans
Peter Huber; 352 Sladja Kisic; 358 Sladja

Kisic; 359 Sladja Kisic; 366/367 Sladja Kisic;
370/371 Bierbaum Timo; 374/375 Damm
Stefan; 383 Sladja Kisic; 383 Stefano Scatà;
421 Hans Peter Huber; 422/423 Roland Gerth;
455 Hans Peter Huber; 455 Picture Finder;
455 Tim Draper; 507 Richard Taylor

laif

8/9 Bernd Jonkmanns; 43 Jochen Schlenker/
Robert Harding; 64/65 Taylor Glenn/
Redux; 84/85 MARCO SIMONI; 111 Michael
Runkel/robertharding; 116 Taylor Glenn/
Redux; 117 Taylor Glenn/Redux; 124 Gerald
Haenel; 125 Robert Francis/robertharding;
132 Gerald Haenel; 142 Jochen Schlenker/
Robert Harding; 176/177 Marco Simoni/
robertharding; 180/181 Peter Essick/Aurora;
182 Andrew Michael/robertharding; 187 Sheila
Terry/robertharding; 242 Robert Francis/
robertharding; 243 AUSTEN DAVID/GAMMA/
GAMMA-RAPHO; 250/251 Robert Francis/
robertharding; 258/259 Frank Heuer;
282 Marc Dozier/hemis.fr; 286/287 Herve
Hughes/hemis.fr; 290/291 Frank Heuer;
320 Sergio Pitamitz/robertharding; 381 Jean-
Daniel Sudres/hemis.fr; 384/385 Marc Dozier/
hemis.fr; 526 Arcticphoto; 527 Alexander/
Arcticphoto; 528/529 Frank Todd/
Arcticphoto; 530/531 Arcticphoto

mauritius images

2 Ingo Oeland/Alamy; 18 John Warburton-
Lee/Andrew Watson; 26 Chris Howarth/
Australia/Alamy; 27 Bill Bachman/
Alamy; 28/29 Travelscape Images/Alamy;
32 Iconsinternational.Com/Alamy; 33 Arcaid
Images/Alamy; 35 david sanger photography/
Alamy; 38 StockShot/Alamy; 44/45 Clint
Farlinger/Alamy; 46/47 Ingo Oeland/Alamy;
48/49 David Coleman/Alamy; 50 Cephas
Picture Library/Alamy; 51 Cephas Picture
Library/Alamy; 59 Ingo Oeland/Alamy;
68 David Angel/Alamy; 70 Picturebank/
Alamy; 71 Norman Herfurth/Alamy; 75 richard
sowersby/Alamy; 78 AntipasM/Alamy;
79 Richard Milnes/Alamy; David South/
Alamy; 82/83 Iconsinternational.Com/
Alamy; 86 guichaoua/Alamy; 87 Travelscape
Images/Alamy; Kristine Jensson/Alamy;
90 David Angel/Alamy; 91 David Angel/
Alamy; 95 Angus McComiskey/Alamy;
96/97 Ian Trower/Alamy; 99 Zoonar GmbH/
Alamy; 108/109 age fotostock/Ulana
Switucha; 114/115 Rebecca Hallsmith/Alamy;
122/123 robertharding/Matthew Williams-
Ellis; 136 Minden Pictures/Suzi Eszterhas;
Minden Pictures/Sean Crane; Minden
Pictures/Graeme Guy/BIA; Minden Pictures/
Jan Wegener/BIA; 137 Minden Pictures/
Konrad Wothe; imageBROKER/Jürgen &
Christine Sohns; imageBROKER/Ronald
Wittek; nature picture library/Jurgen Freund;
138/139 Ingo Oeland/Alamy; 140 FLPA/Alamy;
143 FLPA/Alamy; 148/149 Ingo Oeland/
Alamy; 150 Ingo Oeland/Alamy; 151 David
Wall/Alamy; 152/153 imageBROKER/
Horst Mahr; 166/167 Paul Kingsley/
Alamy; 178 imageBROKER/Michael
Weber; 179 Visions from Earth/Alamy;
182 imageBROKER/Michael Weber; Alamy
RF/RooM the Agency; Genevieve Vallee/
Alamy; 183 Genevieve Vallee/Alamy;

539

Crossroads Views travel/Alamy; Genevieve Vallee/Alamy; 185 imageBROKER/ Michael Weber; 188/189 imageBROKER/ Oliver Gerhard; 194/195 Ozimages/Alamy; 196 imageBROKER/Michael Szönyi; 197 nature picture library/Onne van der Wal; 198/199 nature picture library/ Jurgen Freund; 202/203 imageBROKER/ Norbert Probst; 204 Reinhard Dirscherl; 205 Reinhard Dirscherl; 206/207 Juan Carlos Calvin; 208 age fotostock; robertharding/ Louise Murray; nature picture library/ Jurgen Freund; nature picture library/ Jurgen Freund; imageBROKER/Norbert Probst; imageBROKER/Norbert Probst; imageBROKER/Norbert Probst; 209 Reinhard Dirscherl; Reinhard Dirscherl/Alamy; nature picture library/Jurgen Freund; Danita Delimont/David Wall; imageBROKER/ Norbert Probst; imageBROKER/ Norbert Probst; 210 imageBROKER/ Norbert Probst; 211 nature picture library/Jurgen Freund; imageBROKER/ Norbert Probst; 212 imageBROKER/ Norbert Probst; 214 Travelscape Images/ Alamy; 215 Auscape International Pty Ltd/Alamy; 216/217 imageBROKER/ Norbert Probst; 218 age fotostock/ Lin Sutherland; 219 Reinhard Dirscherl; 220/221 imageBROKER/Norbert Probst; 222/223 Genevieve Vallee/Alamy; 224 Udo Siebig; 229 imageBROKER/Norbert Probst; 231 roederPhotography; 232 Paul Thompson Images/Alamy; 234 Alamy RF/Peter Adams Photography Ltd; 240/241 David Wall/Alamy; 244/245 Prisma/ Frommenwiler Fredy; 248 David Wall/ Alamy; 249 United Archives; 256 Go Australia - Neil Sutherland/Alamy; 256 Paul Kingsley/Alamy; Goran Bogicevic/Alamy;

257 Bill Bachman/Alamy; 266/267 Minden Pictures/Mitsuaki Iwago; 272/273 blphoto/ Alamy; 274/275 imageBROKER/Thomas Schenker; 276/277 Cephas Picture Library/ Alamy; 292 richard sowersby/Alamy; 293 Chris Howarth/Australia/Alamy; 294/295 Ingo Oeland/Alamy; 299 Ingo Oeland/Alamy; 300/301 imageBROKER/ Paul Mayall; 302/203 imageBROKER/ Tom Mueller; 304/305 Ingo Oeland/Alamy; 306 Galaxiid/Alamy; 307 Galaxiid/Alamy; 308/309 Radius Images; 310 Gerry Pearce/ Alamy; 311 Peter Fakler/Alamy; Pacific Stock/Doug Perrine; 312/313 Genevieve Vallee/Alamy; 316 Photononstop/Anne Montfort; 318/319 Masterfile RM/R. Ian Lloyd; 321 Photononstop/Anne Montfort; 322/323 imageBROKER/Tom Mueller; 324 Masterfile RM/R. Ian Lloyd; 325 imageBROKER/ Tom Mueller; 326/327 Masterfile RM/R. Ian Lloyd; 336/337 Bob Gibbons/Alamy; 346 imageBROKER/Kim Petersen; Ian Trower/Alamy; David South/Alamy; Ian McAllister/Alamy; Dawn Black/Alamy; 347 Neiliann Tait/Alamy; Jayskyland Images/Alamy; Jason Knott/Alamy; Julia Rogers/Alamy; Angus McComiskey/Alamy; Ann Rayworth/Alamy; 348 Jayskyland Images/Alamy; 353 paul kennedy/Alamy; 368 Auscape International Pty Ltd/Alamy; 369 Suzanne Long/Alamy; 382 Ozimages/ Alamy; Walter Bibikow; 383 Walter Bibikow; AlamySimon Grosset/Alamy; Walter Bibikow; 383 Julio Etchart/Alamy; 388/389 William Robinson/Alamy; 392 Cultura/Philip Lee Harvey; 393 roederPhotography; 396/397 John White Photos/Alamy; 398/399 Philip Game/Alamy; 400/401 Westend61/ Torsten Velden; 404/405 roederPhotography; 408 Clint Farlinger/Alamy; 409 Ingo

Oeland/Alamy; 418/419 Andrew Watson/ Alamy; 420 Genevieve Vallee/Alamy; 424 H Lansdown/Alamy; age fotostock/ Martin Zwick; Bjorn Svensson/Alamy; age fotostock/Martin Zwick; Genevieve Vallee/Alamy; Avalon/Bruce Coleman Inc/Alamy; WorldFoto/Alamy; Auscape International Pty Ltd/Alamy; 425 Minden Pictures/Sean Crane; Nick Hanna/Alamy; WorldFoto/Alamy; H Lansdown/Alamy; Genevieve Vallee/Alamy; frédéric araujo/ Alamy; 426 Ingo Oeland/Alamy; 427 marti berry/Alamy; 442 Robert Wyatt/Alamy; 443 Andrew Michael/Alamy; 454 John Quixley/Alamy; 454 John Warburton-Lee/Andrew Watson; 455 Simo Cowling/Alamy; Gareth McCormack/ Alamy; 475 imageBROKER/Kim Petersen; 478/479 David Wall/Alamy; 494/495 Ceph Picture Library/Alamy; 496 Bill Bachman/ Alamy; 506 imageBROKER/Michael Runke 510 deadlyphoto.com/Alamy; 512/513 Alist Scott/Alamy; 517 Micha Pawlitzki; 520/521 Radius Images; 522 imageBROKE Konrad Wothe; GM Photo Images/Alamy; 524/525 Gavin Newman/Alamy; 532/533 Julio Etchart/Alamy

Daniel Boud
78

Tom Ferguson
79

Merivale
78

Brett Stevens/Nikki To
78/79

KÖNEMANN

© 2020 koenemann.com GmbH
www.koenemann.com

© Éditions Place des Victoires
6, rue du Mail – 75002 Paris
www.victoires.com
Dépôt légal :1er trimestre 2020
ISBN: 978-2-8099-1789-5

Series Concept: koenemann.com GmbH

Responsible Editor: Jenny Tiesler
Picture Editing: Susanne Könemann, Jenny Tiesler
Layout: Christoph Eiden
Colour Separation: Prepress, Cologne
Text: Anthony Ham, Donna Wheeler
Translations: koenemann.com GmbH
Maps: Angelika Solibieda
Front cover: Getty Images/Simon McGill

Printed in China by Shyft Publishing/Hunan Tianwen Xinhua Printing Co., Ltd

ISBN: 978-3-7419-2528-3